Walton J. Lord

THE PELICAN HISTORY OF ART

JOINT EDITORS: NIKOLAUS PEVSNER AND JUDY NAIRN

ART AND ARCHITECTURE OF THE EIGHTEENTH CENTURY
IN FRANCE
WEND GRAF KALNEIN AND MICHAEL LEVEY

Boucher: Triumph of Venus, 1740. *Stockholm, National Museum*

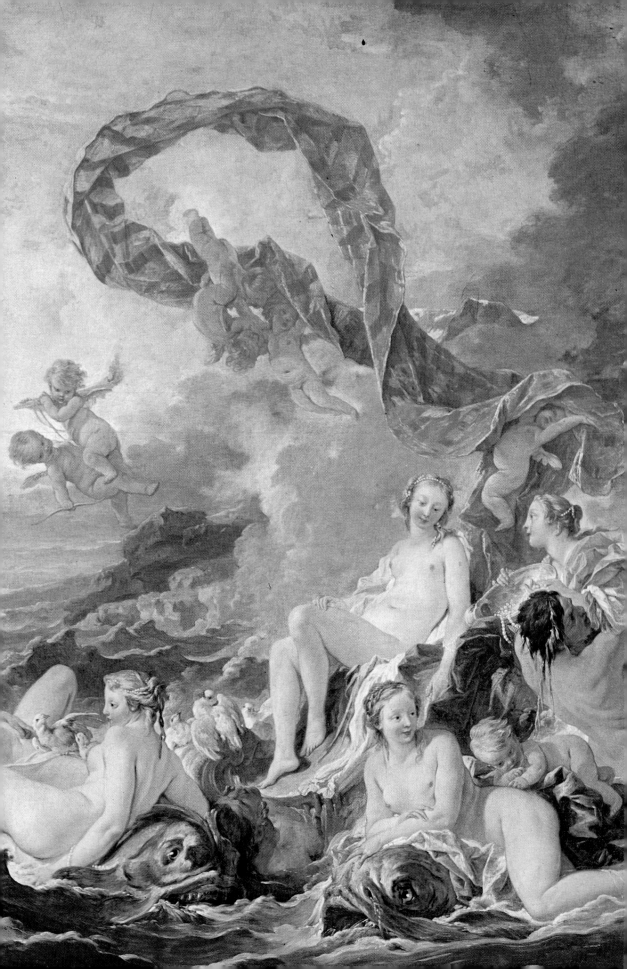

WEND GRAF KALNEIN AND MICHAEL LEVEY

ART AND ARCHITECTURE
OF THE
EIGHTEENTH CENTURY
IN FRANCE

TRANSLATION OF PART TWO BY
J. R. FOSTER

THE · PELICAN · HISTORY · OF · ART

PUBLISHED BY PENGUIN BOOKS

Penguin Books Ltd, Harmondsworth, Middlesex
Penguin Books Inc., 7110 Ambassador Road, Baltimore, Md 21207, U.S.A.
Penguin Books Australia Ltd, Ringwood, Victoria, Australia

★

Text printed by Richard Clay (The Chaucer Press), Ltd, Bungay, Suffolk
Plates printed by The Whitefriars Press Ltd, Tonbridge, Kent
Made and printed in Great Britain

★

★

SBN 14 056037 8

CONTENTS

Part One
Painting and Sculpture
BY MICHAEL LEVEY

v

CONTENTS

Part Two

Architecture

BY WEND GRAF KALNEIN

CONTENTS

The Plates

LIST OF FIGURES

We are grateful to the following artists for redrawing:

Donald Bell-Scott: Figures 2, 6, 7, 8, 9, 11, 26, 28, 29, 34, and for drawing the maps

Sheila Gibson: Figures 1, 4, 5, 24, 25, 27, 30, 31, 35

Paul White: Figures 3, 10, 12, 13, 14, 15, 16, 17, 18, 19, 20, 21, 22, 23, 32, 33

LIST OF PLATES

Unless otherwise noted, copyright in photographs belongs to the gallery, library, museum, private collection, or other institution given as the location, by whose courtesy they are reproduced.

Abbreviations
A.P. Archives Photographiques, Paris
S.D.P. Service de Documentation Photographique, Paris

Frontispiece: Boucher: Triumph of Venus, 1740. *Stockholm, National Museum*

1 Rigaud: Louis XIV, 1701. *Paris, Louvre* (Bulloz, Paris)

2 Charles de La Fosse: Bacchus and Ariadne, *c.* 1699. *Dijon, Musée* (Remy, Dijon)

3 Jean Raoux: Mademoiselle Prévost as a Bacchante, 1723. *Tours, Musée* (Giraudon, Paris)

4 Alexis Grimou: Girl reading, 1731. *Karlsruhe, Kunsthalle*

5 Jean-François Detroy: Reading from Molière. *Marchioness of Cholmondeley* (Newbery, London)

6 Jean-François Detroy: Jason taming the Bulls, 1748. *Birmingham, Barber Institute of Fine Arts*

7 Claude III Audran: Decorative drawing, *c.* 1704. *Stockholm, National Museum*

8 Claude Gillot: Quarrel of the Cabmen. *Paris, Louvre* (Bulloz, Paris)

9 Watteau, engraved by C.-N. Cochin: 'Belles, n'écoutez rien'. *London, British Museum, Print Room*

10 Watteau, engraved by L. Cars: Escorte d'équipages. *London, British Museum, Print Room*

11 Watteau: La Mariée de Village. *Schloss Charlottenburg (Berlin)*

12 Watteau: Pèlerinage à Cythère ('Embarquement'), 1717. *Paris, Louvre* (Agraci, Paris)

13 Watteau: Pèlerinage à Cythère ('Embarquement') (detail), 1717. *Paris, Louvre* (Agraci, Paris)

14 Watteau: Les Fêtes Vénitiennes. *Edinburgh, National Gallery of Scotland* (Annan, Glasgow)

15 Watteau: Gilles. *Paris, Louvre* (S.D.P.)

16 Watteau: Enseigne de Gersaint, 1721(?). *Schloss Charlottenburg (Berlin)* (Steinkopf, Berlin)

17 Watteau: Head of a Negro Boy. Drawing. *London, British Museum, Print Room.*

18 Watteau: Studies of Women's Heads. Drawing. *Paris, Louvre* (A.P.)

19 Nicolas Lancret: La Tasse de Chocolat, 1742. *Knightshayes Court, Sir John Heathcot-Amory* (Royal Academy, London)

20 Jean-Baptiste Pater: Landscape with a Cart. *Schloss Charlottenburg (Berlin)*

21 Jean-Baptiste Oudry: The Dead Wolf, 1721. *London, Wallace Collection*

22 Jean-Baptiste Oudry: The White Duck, 1753. *Marchioness of Cholmondeley* (Newbery, London)

23 Charles Parrocel: Halte de Grenadiers, *c.* 1737. *Paris, Louvre* (A.P.)

24 Charles Coypel: Rinaldo abandoning Armida, 1725. *Paris, Baron Élie de Rothschild* (Bonnefoy, Paris)

25 Charles Coypel: Supper at Emmaus, 1746. *Paris, Saint-Merry* (A.P.)

26 Noël-Nicolas Coypel: Alliance between Bacchus and Venus, 1726. *Geneva, Musée d'Art et d'Histoire*

27 Jean Restout: Death of St Scholastica, 1730. *Tours, Musée* (S.D.P.)

28 François Lemoyne: Baigneuse, 1724. *Leningrad, Hermitage*

29 François Lemoyne: Salon d'Hercule (detail), completed 1736. *Versailles* (S.D.P.)

30 François Lemoyne: Hercules and Omphale, 1724. *Paris, Louvre* (Bulloz, Paris)

31 Guillaume I Coustou: Nicolas Coustou. *Paris, Louvre* (A.P.)

32 Nicolas Coustou: Apollo, 1713-14. *Paris, Tuileries* (Bibliothèque d'Art et d'Archéologie, Paris)

33 Guillaume I Coustou: Daphne, 1713. *Paris, Tuileries* (S.D.P.)

222 Gilles-Marie Oppenordt: Paris, Palais Royal, corner salon, 1719–20, sketch (Cooper-Hewitt Museum, Smithsonian Institution, Washington)

223 Jean Courtonne: Paris, Hôtel de Matignon, 1722–4, garden façade (René-Jacques, Documentation Française, Paris)

224 Jacques Gabriel and Jean Aubert: Paris, Hôtel de Biron, 1728–31, garden façade (Wend Graf Kalnein)

225 Lassurance: Paris, Palais Bourbon, 1722–9, garden façade (Bonnefoy, Paris)

226 Jean Aubert: Chantilly, stables, 1721–33, façade (Giraudon, Paris)

227 Jean-François Blondel: Genthod, Maison Lullin, c. 1722, façade (Bonnefoy, Paris)

228 Beaumont-sur-Vingeanne, 1724, courtyard façade (Marc Foucault)

229 Robert de Cotte: Poppelsdorf, after 1715, air view (Foto Sachsse, Bonn)

230 Robert de Cotte: Buenretiro, first design, 1715, façade (Bibliothèque Nationale, Paris)

231 Robert de Cotte: Strasbourg, Château de Rohan, 1731–42, river façade (Yan, Toulouse)

232 Gilles-Marie Oppenordt: Paris, Palais Royal, Galerie d'Énée, 1717 (Bibliothèque Nationale, Paris)

233 Gilles-Marie Oppenordt: Paris, Palais Royal, Grands Appartements, 1720 (Bibliothèque Nationale, Paris)

234 François-Antoine Vassé: Paris, Hôtel de Toulouse (Banque de France), Galerie Dorée, 1718–19 (La Photothèque, Paris)

235 Robert and Jules-Robert de Cotte: Paris, Bibliothèque Nationale, Cabinet du Roi, 1721–41 (Eric de Maré, London)

236 Germain Boffrand: Paris, Hôtel de Parabère, c. 1720 (Giraudon, Paris)

237 Jean Aubert: Chantilly, Petit Château, Salon de Musique, 1722 (Bibliothèque d'Art et d'Archéologie, Paris)

238 Jean Aubert: Paris, Hôtel de Lassay, Grand Salon, after 1725 (Eric de Maré, London)

239 Paris, Hôtel Gouffier de Thoix, side portal, c. 1730 (Eric de Maré, London)

240 Jean-Michel Chevotet: Champlâtreux, 1733, garden façade (Tel, Paris)

241 Jacques Gabriel: Rennes, town hall, 1736–44 (French Government Tourist Office)

242 Jacques Gabriel: Dijon, Palais des États, staircase, 1733 (Eric de Maré, London)

243 Jacques Gabriel: Bordeaux, Place Royale, 1735–55 (Bibliothèque Nationale, Paris)

244 Emmanuel Héré: Nancy, Place Stanislas, town hall, 1752–5 (Giraudon, Paris)

245 Germain Boffrand: Plan for the Place Dauphine, Paris, 1748 (Freeman, London)

246 Ange-Jacques Gabriel: Paris, Place de la Concorde (originally Place Louis XV), engraving (Bibliothèque Nationale, Paris)

247 Germain Soufflot: Lyon, Hôtel-Dieu, 1741–8, façade (Courtauld Institute, London)

248 Ange-Jacques Gabriel: Fontainebleau, Gros Pavillon, 1750–4 (Esparcieux, Fontainebleau)

249 Ange-Jacques Gabriel: Versailles, Petit Trianon, Pavillon Français, 1749 (French Government Tourist Office)

250 Jules-Robert de Cotte: Paris, Saint-Roch, façade, 1736 (Eric de Maré, London)

251 Jacques Hardouin-Mansart de Sagonne: Versailles, Saint-Louis, 1743–54 (A.P.)

252 Jean-Nicolas Servandoni: Paris, Saint-Sulpice, first design for façade, 1732

253 Jean-Nicolas Servandoni: Paris, Saint-Sulpice, second design for façade, 1736 (Bibliothèque Nationale, Paris)

254 Lunéville, Saint-Jacques, 1730–47, façade (Eric de Maré, London)

255 Nicolas Nicole: Besançon, Sainte-Madeleine, 1746–66, interior (Eric de Maré, London)

256 Nicolas Pineau: Paris, Hôtel de Maisons, Salle de Compagnie, c. 1750 (Bonnefoy, Paris)

257 Germain Boffrand: Paris, Hôtel de Soubise, Salon de la Princesse, 1736–9 (Eric de Maré, London)

258 Ange-Jacques Gabriel and Jacques Verberckt: Versailles, Cabinet de la Pendule, 1738–9 (Eric de Maré, London)

259 Ange-Jacques Gabriel and Jacques Verberckt: Versailles, Cabinet du Conseil, 1755–6 (Eric de Maré, London)

260 Jacques Verberckt: Rambouillet, boudoir of the Comtesse de Toulouse, c. 1735 (Penguin Books)

261 Pierre Contant d'Ivry: Paris, Palais Royal, Chambre de Parade, 1755–60 (Penguin Books)

262 Jean-Laurent Legeay: Engraving from Tombeaux, 1768 (Phaidon Press, London)

263 J.-F. Le Lorrain: Decoration for the Festa della Chinea at Rome, 1746

264 M.-J. Peyre: Design for a cathedral, 1753 (Bibliothèque Nationale, Paris)

265 Ange-Jacques Gabriel: Paris, Place de la Concorde (originally Place Louis XV), façades, 1757–75 (James Austin, Cambridge)

PREFACE TO PART ONE

GIVEN the daunting level of competence and the mass of practitioners – both of painting and of sculpture – in eighteenth-century France, it is obvious that a volume such as the present one must be highly selective. Although obvious, the fact could be forgotten by the devoted student of some comparatively little-known figure who may wonder why Watteau or Bouchardon, say, is discussed at length while his own candidate goes unmentioned. I am sorry for the casualties, yet I believe they were inevitable: not because my choice is historically always the correct one, but because I could write the book no other way. The pages could have been filled with lists of names; something at once more and less than a Bottin du dix-huitième siècle is attempted here.

Inevitably perhaps, it did not prove possible to treat the engravers, the water-colourists, and the miniaturists within the book; some attractive, if not tremendously important, decorative painters have also failed to be included. Nor was there space to offer any sustained discussion of artistic theory in the century – so literate, so lively, and so complicated that it will provide plenty of scope for more books by other authors. I could extend the list of *lacunae*. Yet it may also be worth saying that space has been given particularly to sculptors, some of whom have probably been discussed very rarely in English – and not much in French. With the great artist, whether sculptor or painter, I have often allowed greatness to prevail. In the kingdom of art there are doubtless many mansions, but some will always tower above others. I should add that, with the editor's warm agreement, certain sculptors have been included whose life and work carry one far beyond 1789; they have usually been history's victims – neither eighteenth-century fish nor nineteenth-century fowl. Something is said, then, of Chaudet and Chinard; but there could be no more than a brief reminder that Prud'hon also lived in the same period. I apologize for the inconsistency, as for the faults of omission and commission which are un-avoidable in attempting such a survey.

In tackling it, I have been lucky enough to incur several notable debts. My first major one must be to my editor, Sir Nikolaus Pevsner, by turns patient and impatient, encouraging and goading, kindly and severe. Once or twice it seemed that the terseness of our exchanges pre-luded a breakdown of all communication; yet it was the very terseness of a telegram from Lübeck which gave me in a word generous praise and great encouragement. That telegram became a talisman while I went on with the work; and I am grateful besides for much shrewd editorial comment and help, especially from Mrs Judy Nairn.

There is not room to name all those who have helped me, answered my queries, and sent me photographs. I am especially grateful to museum colleagues in France, in Russia, in America, and elsewhere, who spared time to deal with letters and requests; I know how valuable museum officials' time is and how much of it such demands eat up. Great help was given me also by those who kindly typed my long manuscript, deciphered the notes, and brought order to the often-emended bibliography. In these ways I am indebted once again to Mrs Grace Ginnis and to Robert Cook, supplemented by timely aid from Miss Annette Forward.

Among colleagues and friends I should like to single out gratefully Terence Hodgkinson, Hugh Honour, Pierre Rosenberg, and Robert Rosenblum. Allan Braham and Peter Marlow kindly read portions of the typescript and made comments, for which I am most grateful; the former also read a proof. In Paris, at the Archives Nationales, where my interests were shamefully more in the décor than in documents, I had the agreeable advantage of being guided

round, during a time of interesting restoration work, by Monsieur Jean-Pierre Babelon. At the Institut de France, Monsieur Philippe Brissaud was most kind and co-operative over my quest for the statues of the 'grands hommes'. At the Louvre I am especially indebted to Monsieur Jacques Thirion, Conservateur in the Department of Sculpture. His most kind reception and ever-friendly help have been not only sustaining but essential, since most of the sculpture at the Louvre which I was concerned with was not on public exhibition during much of the time this book was being written. I shall always be deeply grateful for the opportunities he gave me, including those to exchange views in the presence of some of the pieces themselves.

Finally, in no facetious spirit, I am conscious of a debt never repayable to another series of 'grands hommes de France', those nineteenth-century scholars like Montaiglon and Guiffrey and Courajod, as well as their successors such as Furcy-Raynaud, whose labours produced an unrivalled banquet of documentation, still being digested by us today. Their energy equalled their erudition, and with my sense of indebtedness goes a pang of envy.

M. L.

London, 1 January 1970

PREFACE TO PART TWO

THE period covered by this book – the century between Louis XIV and Napoleon – is by no means a uniform one. The intellectual currents flowing through it are so heterogeneous and its architecture so varied that it is almost impossible to do justice to this variety within the limits of a single volume. The eighteenth century in France not only accomplished marvels in the realm of planning, comfortable living, and harmony of proportions; it also ushered in a new era in the history of town-planning. A more extensive treatment would therefore have been appropriate. Many a château in Normandy and many public buildings, squares, and street lay-outs would have merited inclusion. If I have confined myself to comparatively little and omit-ted much of importance, this is only to let the main lines of development emerge clearly and to avoid producing a mere reference book.

On the other hand, interior decoration was to be included. This subject is usually dealt with separately from architecture, but in France in the eighteenth century the exterior and the interior of a building are so closely interrelated that they must be seen as a unity – a unity emphasized again and again by Blondel. The essence of the Rococo style lies precisely in the contrast between outward simplicity and an inner wealth of forms. This leads in turn to a new view of neo-classicism, which was anything but sober and dry, especially in its early stages.

What has suffered particularly through the lack of space is French architecture abroad. I am perfectly conscious that there are big gaps in the picture here, and that nothing is said either about Rémy de la Fosse at the beginning of the century or about Salins de Montfort's opera-tions in Frankfurt and Peyre's designs for Koblenz at the end of it. All I can do is to refer those interested to Pierre du Colombier's excellent and still up-to-date book, *L'Architecture française en Allemagne au XVIIIe siècle*.

For other countries such a survey unfortunately does not yet exist. So many buildings were either erected or planned outside the borders of France that they would need a volume to themselves.

Any attempt to produce a comprehensive picture of the architecture of this period is still rendered difficult by the lack of preliminary work. Although in recent years our knowledge of the second half of the century has happily been enlarged – particularly by the work of Kauf-mann, Petzet, Gallet, Langner, and Pérouse de Montclos – our knowledge of the first half is still largely fragmentary. Only the standard works of Hautecœur and Kimball and the re-searches of Jörg Garms and Runar Strandberg have shed any light on the prevailing darkness. One of the basic prerequisites for the illumination of this period must still be the publication of the architectural drawings in the Bibliothèque Nationale in Paris – particularly those among the papers left by Robert de Cotte – and in the National Museum in Stockholm. Without these it is impossible to construct any firm framework for the whole area of Mansart's succes-sors.

That in spite of the continual emergence of fresh difficulties this book has eventually been brought to a successful conclusion is primarily due to my French colleagues, especially Jacques Dupont, Inspecteur Général des Monuments Historiques, whose comprehensive knowledge and enthusiastic co-operation gave me many ideas and opened many doors for me, and the directors and other officials of the Bibliothèque Nationale in Paris, who for many years gave me their willing support and made the Cabinet des Estampes a pleasant place in which to work. Of my numerous German and Austrian colleagues, it was Johannes Langner and Jörg Garms

PREFACE TO PART TWO

in particular whose advice I needed to call upon and who, in the course of many conversations, passed on to me important pieces of information. Finally, not to forget the equally important technical side of the enterprise, I should like to express my warmest thanks to my colleague Antonie Krüger for all the work she has so uncomplainingly undertaken in connexion with the manuscript, the innumerable corrections, and the correspondence.

<div align="right">W. K.</div>

MAPS

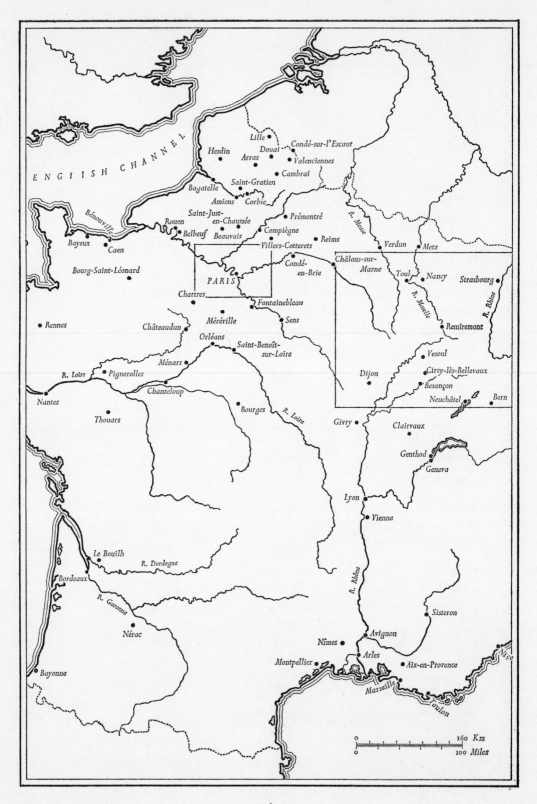

E N G L I S H C H A N N E L

Lille
Condé-sur-l'Escaut
Hesdin
Douai
Arras
Valenciennes
Cambrai
Saint-Gratien
Bagatelle
Amiens
Corbie
R. Meuse
Saint-Just-en-Chaussée
Prémontré
Bénouville
Rouen
Compiègne
Verdun
Metz
Belbeuf
Beauvais
Villers-Cotterets
Reims
Bayeux
Caen
PARIS
Condé-en-Brie
Châlons-sur-Marne
Toul
Nancy
Strasbourg
Bourg-Saint-Léonard
R. Rhine
R. Moselle
Chartres
Fontainebleau
Rennes
Méréville
Sens
Châteaudun
Remiremont
Orléans
Saint-Benoît-sur-Loire
Vesoul
R. Loire
Ménars
Pignerolles
Cirey-lès-Bellevaux
Dijon
Besançon
Chanteloup
Nantes
Bourges
R. Loire
Neuchâtel
Bern
Thouars
Givry
Clairvaux
Genthod
Geneva
Lyon
Vienne
Le Bouilh
R. Dordogne
Bordeaux
R. Rhône
R. Garonne
Sisteron
Nérac
Avignon
Nîmes
Arles
Aix-en-Provence
Bayonne
Montpellier
Nice
Marseille
Toulon

160 Km
100 Miles

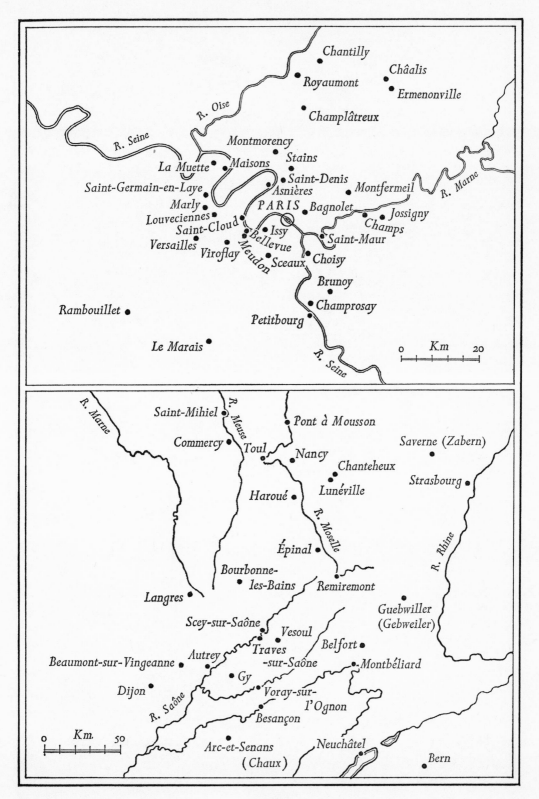

Chantilly

Châalis

Royaumont

Ermenonville

Champlâtreux

R. Oise

R. Seine

Montmorency

Stains

La Muette Maisons

Saint-Germain-en-Laye Saint-Denis

Asnières Montfermeil R. Marne

Marly PARIS Bagnolet

Louveciennes Jossigny

Saint-Cloud Issy Champs

Versailles Bellevue Saint-Maur

Viroflay Meudon Sceaux Choisy

Brunoy

Rambouillet Champrosay

Petitbourg

Le Marais R. Seine

0 Km 20

R. Marne

Saint-Mihiel R. Meuse Pont à Mousson

Commercy Toul Saverne (Zabern)

Nancy

Chanteheux Strasbourg

Haroué Lunéville

R. Moselle

R. Rhine

Épinal

Bourbonne-
les-Bains

Langres Remiremont

Guebwiller
(Gebweiler)

Scey-sur-Saône

Vesoul

Beaumont-sur-Vingeanne Autrey Traves Belfort

-sur-Saône Montbéliard

Dijon Gy

R. Saône Voray-sur-
l'Ognon

Besançon

0 Km. 50

Arc-et-Senans Neuchâtel

(Chaux) Bern

XXV

PART ONE

PAINTING AND SCULPTURE

BY MICHAEL LEVEY

CHAPTER I

THE EARLY YEARS

Painting: From La Fosse to the Death of Lemoyne and the Establishment of the Regular Salon (1737)

Introduction

'L'ANNÉE 1700', Saint-Simon noted, 'commença par une réforme.' Admittedly, this reform was simply that the king had decided to stop contributing to the courtiers' expenses at Versailles. Yet the sentence which introduced the new century in this way turned out to be widely applicable and prophetic, artistically as well as politically.

Reform is not a word usually associated with painting in at least the early years of the century in France; but it is useful to lay emphasis straightaway on that reforming element, in the sense of a return to older standards, which underlay *Rubénisme*, the so-called Rococo, and the development of the *fête galante* – all rather too easily associated with libertarianism and even general licence. When de Piles was received into the Académie he announced that painting could no longer be permitted to be 'errante'.[1] The death of Louis XIV and the relaxed, gaily dissolute court of the regent, the Duc d'Orléans, are not the precipitating factors in creating a new style of painting. Perceptive critics may have noticed that Watteau no more depended on the regent's patronage than he did on the king's.[2] And though the *singerie* was a popular pictorial motif, this did not mean that painters were behaving like monkeys.

The old standard which was re-invoked, with increasing fervour and several changes of definition as the century advanced, was that of nature. Nature returned in just as traditional a manner as ever did classicism; it was found by invoking the great masters of the past like Veronese and Correggio, probably even more than Rubens. Nor did it imply that Antiquity must be rejected, but rather – in the words of Antoine Coypel early in the century – 'il faut joindre aux solides et sublimes beautez de l'Antique, les recherches, la variété, la naïveté et l'ame de la nature' (*Discours prononcez dans les Conférences de l'Académie Royale . . .*).[3] This in itself offers a substantial programme for any period. It might be said that with Watteau, Chardin, Boucher, Greuze, and David – to name no others – French painting throughout the eighteenth century examined these various aspects of nature with unparalleled thoroughness. It is obvious from Coypel's statement that he already places more emphasis on nature than on Antiquity; he quite rightly supposes that 'nature' is the more complex concept. It was not to be followed as a mere release but as a positive, profound discipline which would result in better works of art. Coypel also said of the painter: 'il doit fouiller jusques dans son âme par le secours de la philosophie'.[4] Watteau's drawings alone reveal the disciplined aspect of

3

studying nature – as well as being among the very greatest works of draughtsmanship ever produced. Falconet expresses much of his century when he writes (*Réflexions sur la sculpture*): '... le Beau, celui même qu'on appelle l'idéal, en sculpture comme en peinture, doit être un résumé du Beau réel de la nature'.

Although they were to gain a new importance, such ideas were not new in the eighteenth century. Before there could be a movement of *Rubénisme* there had to be Rubens, and indeed his century is that in which the 'Beau réel de la nature' had triumphed in painting. It was then that new categories of 'natural' picture had been established – genre, landscape, still life – which were to find such distinguished practitioners in the eighteenth century. These categories already challenged, at least tacitly, the respectable history picture, while flourishing European portraiture – with great portraitists in virtually every country – meant that this category of picture could not be kept down by academic disapproval.

What had actually happened was that France, owing to Colbert's policy of subordinating the arts to the state, had become out of step and out of date compared with the rest of Europe. Venice, Naples, the Netherlands, and Holland were artistically to be rediscovered by late-seventeenth-century France. The quarrel there over colour versus drawing was itself a storm in a very miniature teacup. The battle lines were hopelessly muddled – not surprisingly, since one of the leading artists invoked by the party of draughtsmanship and classicism was Poussin, who had in fact greatly admired the colour and 'nature' of Titian. What was at the core of the argument was really connected with the possible pleasure to be gained from a work of art. If more pleasure came from ignoring the ancients and the rules, then surely they should be ignored? That this had to be argued was not only typically French but had already been the subject of argument when Molière wrote *L'École des femmes*. Molière's answer to his critics is the sort of statement which might have shocked Le Brun and which could well seem typical of the 'freedom' of the early eighteenth century: 'If plays which are according to the rules give no pleasure, and those which do are not according to the rules, then it must of necessity be that the rules have been badly formulated.'[5]

In painting, the 'nature' which was to be so much discussed was not merely a matter of past painters. While the Académie at Paris was showing itself better qualified at debating than painting, the court painter in Flanders was the prolific, highly successful David Teniers, who did not die until 1690. The roots of French eighteenth-century painting, like so many of its practitioners', lie deep in the preceding century. Charles de La Fosse was born in Rubens' lifetime; and he lived to see Watteau *agréé* at the Académie. It is a poignant moment in Gersaint's long note about Watteau (*Catalogue de feu M. Quentin de Lorangère*) when he describes the reactions of the aged La Fosse, 'célèbre peintre de ce tems-là', on first seeing Watteau's paintings: 'étonné de voir deux morceaux si bien peints ...'. And, when Watteau himself appeared, Gersaint records La Fosse's words: 'nous vous trouvons capable d'honorer notre Académie'. Such painters as Largillierre, Rigaud, François de Troy, Audran, Santerre, and Antoine Coypel were all born well within the lifetimes of Rembrandt and Frans Hals. Nor are these just flukes of chronology; they serve as reminders that the very painters who seem to preside

4

beneficently over the expanding eighteenth century had been formed by the previous one. When Watteau presented himself before the Académie that body might well recognize in him a genius within an established tradition of the 'natural'; the young David – if one can make the comparison – would probably then have appeared a very disconcerting phenomenon (and to some extent did so appear to the Académie in his own day).

Several of the major painters of the older generation who yet lived long into the eighteenth century have already been dealt with in the previous volume in this series (Anthony Blunt's *Art and Architecture in France 1500 to 1700*).[6] That they remained still significant presences, through their own work and through that of their pupils, is interestingly testified to by the *Mercure de France* in 1725 when reviewing the Salon held that year: 'If anything was lacking to satisfy the public at this exhibition, it was not seeing the work of Messieurs de Boullongne, de Troye, de Largillierre, and Rigault [sic], who, having nothing more to add to their reputations, have acquired fresh glory by believing that they should not exhibit on this occasion, so as to do justice to the work of the young Academicians, the majority of whom are their pupils.' This testimony shows that continuity seemed the keynote; and in many cases it was indeed true in strictly family terms: Jouvenet training his nephew Restout, Antoine Coypel his son Charles, and François de Troy his son Jean-François. Lemoyne was trained by his stepfather, Tournières. In sculpture, incidentally, the family links were equally close and probably more distinguished, the Coysevox–Coustou dynasty, like the Slodtz and the other Lemoyne family, occupying a whole century across the merely chronological dividing line of 1700.

Thus the eighteenth century did not open with any significant burst of artistic freedom. Indeed, it opened rather with the most formal statement of Baroque grandeur in Rigaud's full-length portrait of Louis XIV (Louvre) (Plate 1), painted in 1701. Though the pose of this is commonly said to derive from Van Dyck's *Charles I* (Louvre), the change of ethos is more important than any similarity of pose. Where Van Dyck's king relaxed in the open air, dissembling his royalty and becoming a gentleman, Rigaud makes Louis XIV every inch a monarch; and his inches are increased by the high-heeled shoes and the revelation of royal legs under the looped-up, vast ermine robes – giving the aged, vain, posing figure something of the air of Mistinguett. The swag of tasselled curtain, the massive pillar with bas-relief base, the crown, the sceptre, and the painful proliferation of fleur-de-lis, all help to consecrate the legend which the king himself magnificently enshrines: of an unchanging, benevolent, but majestic sovereign who stands for France. The picture's sheer bravura is a reminder too of how at that moment it was really the portrait painters, above all Rigaud and his friendly rival Largillierre, who represented the most vigorous aspect of painting in France.

An almost fatal dilution had already weakened decorative and history painting, and though Antoine Coypel (1661–1722) and the brothers Bon and Louis de Boullongne require to be mentioned, I am frankly grateful that they have been more than adequately discussed by Blunt. Coypel was probably the most distinguished artist in France in official eyes, Premier Peintre of the regent, named as Premier Peintre (the first since Mignard's death in 1695) to the king on the accession of Louis XV in 1715, and becoming

C

recteur at the Académie the following year. In the last post he replaced Charles de La Fosse (1636–1716), who never became Premier Peintre, but whose work is easily the most robust and attractive – the most sheerly painterly too – of the early-eighteenth-century decorative painters.

The oldest of them all, La Fosse played an important part, only recently recognized, in creating a colourful idiom which was to be developed by François Lemoyne, himself the master of Boucher.[7] The basis of this style lay in Veronese and other Venetians rather than in Rubens. Some of La Fosse's easel paintings suggest affinities too with the work of Jan Liss; and it is significant that La Fosse had spent three years in Venice, having previously studied in Rome. Venice has certainly marked his best pictures, with their rich, almost crumbly paint and strong contrasts of tone. Though the compositions are usually strangely inert, even the encounter of Bacchus and Ariadne (*c.* 1699, Dijon) (Plate 2) being muted to a reposeful dialogue, there is a welcome robustness in the handling of drapery, an awareness of light and a constant response to colour. It is unfortunate that one of the last and largest of his decorative works – a ceiling with the *Birth of Minerva* for the new Parisian house built by Crozat about 1704 (cf. p. 226) – should have been destroyed. There, working for a collector who was also an active patron of the newly resurrected Venetian school represented by artists like Rosalba and Ricci, La Fosse should have felt inspired to produce something airborne, one of the most graceful of allegorical-decorative schemes. A mid-eighteenth-century guidebook speaks of it as among La Fosse's finest works, describing how the sky he had painted gave an illusion of the vault being pierced. It was for exactly this effect that Lemoyne's ceiling in the Salon d'Hercule at Versailles would be praised some thirty years later. A phrase recorded as Largillierre's aptly sums up this love of illusion which characterizes much of the work done by history painters in schemes of decoration during the early years of the century, whether for private houses or for Versailles: 'Je ferai, quand je voudrai, passer votre vue à travers le mur.'[8]

Raoux, Grimou, Detroy

Although there is a chain of decorative illusionistic painting which links La Fosse to Lemoyne, this is only one element in the rich variety of styles and manners with which the eighteenth century opened. As well as the perhaps over-emphasized *Rubénisme*, there also existed a current of '*Rembrandtisme*', suitably a more shadowy phenomenon, but one underlining concern with the more ordinary aspects of life, genre as well as portraiture. Pictures by Rembrandt were owned by or known to several painters, like Rigaud and Santerre; and one at least was also owned by the champion of the *Rubénistes*, Roger de Piles, as well as by other amateurs. It must be remembered that at the time Rembrandt had not been elevated as a sacred name unquestionably above that of any other painter; he was usually classed among the Flemish School, and in stature was not necessarily estimated higher than Dou. Voltaire was not attempting to shock when he remarked that Raoux at his best equalled Rembrandt.[9] As for Grimou, he was to be called 'le Rembrandt français'.

Jean Raoux (1677–1734) has not benefited with posterity from Voltaire's praise.[10] And it must be admitted that his hard, shiny pictures scarcely equal Netscher – not to speak of greater men. Raoux was born at Montpellier and studied there under the scarcely older Ranc (1674–1735), himself a pupil of Rigaud, who was appointed court portrait painter at Madrid in 1724. From Montpellier Raoux moved to Paris and became a pupil of Bon de Boullongne. In 1704 he won first prize at the Académie and was sent to Rome for the usual three-year period. At the end of that time he went to Venice, where he met the Grand Prieur de Vendôme, who became his patron. In his train Raoux returned to Paris, was *agréé* as a history painter at the Académie in 1716, and presented his *morceau de réception* (*Pygmalion falling in love with his Statue of Galatea*; Montpellier) on the very day that Watteau presented the *Pèlèrinage à Cythère*, better known as the *Embarquement pour Cythère*. It is even possible that he later travelled to London with Watteau: the two painters were certainly there for some months in 1720.

Although there is a certain amount of variety in Raoux's work, he became associated particularly with a type of lightly mythologized female portrait, to be developed with more charm and greater suppleness by Nattier. Raoux was by no means the inventor of this type of portrait (a fully *grand siècle* concept, e.g. Nocret's group portrait of *Louis XIV and his Family*, executed in 1670)[11] but his demi-mondaine actress sitters encouraged freedom of interpretation and a not too solemn mood. *Mademoiselle Prévost as a Bacchante* (Tours) (Plate 3) is true to her role as a dancer at the Opéra; the trees that form her setting are patently property ones, stretched to form wings at either side of the stage where she performs, and one hardly needs to be told that the picture records her as a Bacchante in the opera *Philomèle*, first performed in 1723, the year of the portrait. So prominent is the setting here that it helps to explain Dézallier d'Argenville's preference for the flowers and backgrounds painted by Raoux 'comme d'agréables digressions'.

More monotonous in style, but basically a better painter, is Raoux's close contemporary Alexis Grimou (1678–1733). His lack of invention was to be commented on in an obituary notice and he seldom attempted compositions of more than a single half-length figure. Nothing is known of his early training, but possibly François de Troy was his master. He had a modest, unofficial career. Though *agréé* at the Académie in 1705 as a painter of portraits, he never presented his diploma pieces (two portraits, one of Antoine Coypel) and became instead a master painter in the much humbler Académie de Saint-Luc. Legend has made of Grimou a debauched and 'difficult' character, but this is not necessarily accurate.[12]

He had a truer *rapport* with Rembrandt than had Raoux, responding to the mystery of smoky light and shade, and fond of faces staring out of the penumbra with sometimes touching effect. And what the period appreciated in Rembrandt is well expressed by Antoine Coypel, who spoke of works by the Dutch master which had 'autant de suavité et de rondeur' as those of Correggio. It is in that sense that Grimou followed Rembrandt; it is significant that he is recorded as copying also Murillo, because that attractively coloured, sweetened art represented a fusion of genre and decoration. Murillo had already seen 'nature to advantage dress'd'; Grimou probably preferred nature to come to him through the art of other painters. He was indeed one of the first painters of the

century to utilize Spanish-style accessories for his portraits. These are usually semi-fancy pieces, charming and faintly mysterious rather than penetrating character studies, but more beguiling than the hard-faced *opéra comique* nymphs of Raoux. Recollections of Rembrandt combined with a certain lively charm make individual such a picture as Grimou's *Girl reading* (Karlsruhe, signed and dated 1731) (Plate 4). It is a minor talent, which easily becomes monotonous. Yet Grimou partly succeeds by not attempting too much; he prefers a brand of 'reality' in which dressing up is not pompous but picturesque. It is even possible to see a relaxed, romantic simplicity about his people when compared with the more florid public personages of Largillierre and Rigaud. In the *Girl reading* the concept, the handling of paint, and the air of spontaneity, all look forward to Fragonard; between Rembrandt and Fragonard, Grimou is a slight yet viable bridge.

A much more ambitious, important, and indeed more competent painter than either Raoux or Grimou was Jean-François Detroy (1679–1752), son and pupil of François de Troy. He was to show himself a master of several categories of picture – painting large religious and mythological compositions and designing two series of Gobelin tapestries – but it was in 'l'imitation juste de la nature' (as one of his early biographers said) that Detroy excelled.[13] He could create the actual prosperous world of upper-class Parisian life, without sentiment or satire; the verisimilitude of the *Reading from Molière* (Marchioness of Cholmondeley) (Plate 5) seems complete, and completely absorbing in its detail of furniture and dress. This civilized 'nature' remains typical not only of France but of the whole eighteenth century; the manners and modes of polite life become a suitable subject for art in themselves, without any of the moral application to be given to them by Hogarth. Detroy establishes a phenomenon to be duplicated later by Pietro Longhi at Venice, and Troost in Holland. Hints probably came to him from Watteau and from Lancret. He was incapable of Watteau's subtle erotic poetry and lacked Lancret's charm; even when he attempts to suggest gallantry, he achieves no vital spark. The appeal of his genre pictures was what it has remained: they are minute records of what the tone of social life was like, convincing just because it is so obviously unenhanced. Perhaps the final touch of convincingness comes from Detroy's own personal fondness for being in the milieu he depicts.

His father was a native of Toulouse, but Detroy was born a Parisian. At first he was not encouraged to be a painter, and he seems early to have revealed his talent for enjoying himself and causing scandal. Through the influence of Mansart he became a pensioner at the French Academy in Rome, though it was his father who had paid for his journey to Italy. Detroy remained pleasantly engaged in Italy from 1699 to 1706, moving from Rome first to Florence, where he found a rich Italian patron, and then to Pisa, where he made love to the young wife of an aged judge. Back in Paris, he was *agréé* at the Académie in 1708 during the period of his father's directorship; presumably because of this, he was exceptionally allowed to present a picture on the spot as his *morceau de réception* (a *Niobe and her Children* now at Montpellier). And long before his father's death in 1730, he had become professor at the Académie. At the Salon of 1725, he exhibited seven pictures of varying sizes and subject matter: from a large *Rinaldo and*

Armida to a small genre scene of a woman repulsing a man attempting to retie her garter.[14] Detroy was not interested in following his father as a portrait painter, though he was more than equal in ability. He seemed perfectly placed to be the great all-round artist, gifted if not inspired, with a good grasp of 'nature' and yet capable of decorative effects. In 1725 he stood as one of the leading painters in France, apparently destined for a great career. Yet this did not in fact follow.

He came into conflict with a younger painter, François Lemoyne, who had also showed his paces at the 1725 Salon. Two years later a royal *concours* revealed them as open rivals; Lemoyne produced a *Continence of Scipio* and Detroy *Diana reposing*, both pictures today hanging close to each other at Nancy. The final decision was that the two painters should share the prize; but it was eventually Lemoyne who became Premier Peintre. In 1738 Detroy accepted the post of director at the French Academy in Rome (the second time it had been offered to him), and there he remained until his death in January 1752. He continued to send to the Salon exhibitions at Paris and received a further important royal commission, for seven tapestry cartoons on the story of *Jason and Medea* (exhibited in 1748). The sketches for these (e.g. Birmingham) (Plate 6) reveal the abilities and limitations of Detroy; and their lively handling is welcome after the rather pasty, heavy treatment of paint which often mars his large-scale work. They remain decorative in concept, suitable for transference into the tapestry medium, robbed of any intensity and horror which – it might be thought – the story could inspire. A set of the Gobelin tapestries was chosen for the pavilion at Strasbourg in 1770 when Marie-Antoinette arrived as dauphine in France. There the young and highly impressionable Goethe saw them; he was horrified at such a choice of story to welcome a bride, exclaiming, 'Is there no one among the architects and decorators who understands that pictures *represent something*...?'[15] The subject was not very happy, it is true, and yet perhaps the decorators of the pavilion instinctively recognized that Detroy's treatment was picturesque. In terms of deep artistic conviction, he had not *represented* anything at all, despite his snorting bulls and flying dragons and poisoned robes. These were properties of a masquerade, of a kind that had virtually ceased to have significance for painters by the time the pavilion at Strasbourg was prepared for Marie-Antoinette.

When Detroy retired from Paris to Rome a new, younger generation of painters, headed by Boucher, had emerged at the Salon.[16] Their style was more flippant, amorous, and more graceful than Detroy's. They seemed closer to Rubens, whereas Detroy recalls Jordaens. Their nymphs and goddesses effortlessly inhabited an enchanted world compared with the solidly prosaic, faintly absurd mythological beings of Detroy – who keeps lapsing into the attitudes of real life. It was in those 'tableaux de modes', as Mariette called them, that Detroy had made his finest contribution to art: pictures which were already preferred by connoisseurs to his history pieces because they were recognized as 'plus soignés'.[17] The century was interested in its own appearance and manners – for their own sake. Moreau le Jeune continues where Detroy stopped; but Detroy is not inferior in response to the sit of a waistcoat, arch of a shoe, or the shape a sacque-dress takes when a woman reclines in a deep armchair. Nor was Detroy as director of the school at Rome without discernment and encouragement for talent in the pensioners.[18]

At the very end of his life, itself made bitter by the premature death of his wife, accompanied by the loss of all his seven children, he was able to detect the ability of Saly as a sculptor, warmly praising him (see further p. 81) and prophesying his future greatness.

Audran and Gillot

Just like other aspects of painting early in the century, the arabesque interior decorations – to be associated particularly with Audran, but executed also by Gillot – claimed a traditional origin even while seeking for more lighthearted and gracefully natural effects. Everyone declared that the taste for painted arabesques and grotesques went back to Antiquity and had been resurrected by Raphael. Nor was it in any way an innovation of the Régence; the elder Bérain practised the style for tapestries and painted rooms throughout the reign of Louis XIV. It was adopted not only for private houses but, where suitable, for rooms also in the royal palaces. Audran was to work successfully at Meudon, Anet, Fontainebleau, and at La Ménagerie at Versailles, as well as – it should be noted – in chapels of the Invalides. He was very fully employed on such work when the century opened, and taste came to prefer his designs to those of Bérain (cf. p. 232). Although the evolution of interior decoration as such is outside the scope of this part of the book, Audran is an artist who requires at least some mention.

Claude III Audran (1658–1734) was the eldest son of Germain Audran, one of a numerous family of engravers and painters who, although of Parisian origin, had established themselves at Lyon.[19] Nowadays Claude III is most usually thought of in connexion with Watteau, but he is a significant phenomenon in his own right. Born at Lyon, he reached Paris at an unknown date but certainly by 1684, when he attended the funeral of his uncle the painter Claude II Audran, with whom he was probably then living. He became a master in 1692 as 'painter, sculptor, engraver and decorator'. Payments document the variety of his talents: designing tapestries, painting on glass, executing a 'feu d'artifice', and gilding gondolas for the canal at Fontainebleau. In 1704 he was appointed Keeper of the Luxembourg, but continued to be much occupied as a general decorator and designer. Among his very last work was that in 1733 for the Duchesse du Maine at Anet, where he had first been employed some time before 1698.

Inevitably, the greater portion of Audran's decorations has been destroyed or obscured by later alterations or repainting. Much of this actual work was probably executed by his pupils and collaborators; it is established that he had a team, of which Watteau was briefly to form part, who followed the designs he prepared. It is his drawings therefore which best represent his style, and fortunately a very large group of these was acquired from his estate in 1734 by a young Swedish architect, Cronstedt (and survives today in the National Museum at Stockholm). In them Audran is revealed as more lyrical and bolder than his obvious counterpart and elder, Bérain, achieving almost dizzy effects of space annihilated in fluttering movement where everything dances and swings. Nature takes over in the shape of monkeys and tumblers, comedians and birds, all rocking or swaying amid exiguous branches like ribbons, and thin trellises festooned with leaves

and slender plants that curve up to support fringed platforms like that where a *Natur-mensch*, a proto-Papageno, kneels surrounded by singing birds (Plate 7). This drawing shows Audran at his least abstract. Indeed, in some ways it is more typical of Gillot than Audran, and there is even a hint of Watteau in it. Not only is it 'natural' in its motifs (the birds at the corners recall that Desportes had collaborated with Audran) but it has the relaxed, undidactic atmosphere of art that is free simply to be art: more bizarre than anything previously seen, deliberately not truthful, stirring neither patriotic nor moral strings, but beating drums for the sheer love of gaiety and noise.

Claude Gillot (1673–1722) is a somewhat comparable phenomenon to Audran, but one less settled, famous, or consistently employed. Yet Watteau's association with him is distinctly more relevant than his work under Audran; and as well as being a draughtsman Gillot does still exist, through a few pictures, as a painter.[20] The best evidence for his stylistic affinities with Watteau comes from drawings – some very difficult to attribute between the two artists. And there were also marked temperamental affinities. One of Watteau's self-portraits is close in mood, and strangely even in physical appearance, to Gillot's portrait of himself.[21] Gersaint records that the two men closely resembled each other in temperament – too closely to get on well together. Gillot was born at Langres, the son of a painter-decorator, Jean Gillot. At an unknown date he arrived in Paris, where he worked in the studio of Jean-Baptiste Corneille (d. 1695). In 1710 he was *agréé* at the Académie –by which time Watteau had probably quarrelled with him. When Watteau came to be received himself in 1717, Gillot voted for him. Meanwhile Lancret had become a pupil of Gillot's, and he too was to be much influenced by his master. Slow to produce his *morceau de réception* – Gillot, like Watteau, took five years – he was officially received into the Académie only in 1715, on presenting the for him somewhat unexpected subject *Christ about to be nailed to the Cross* (Noailles, Corrèze). A chronology is difficult to establish for the few surviving pictures by or attributed to Gillot, but it seems clear that after beginning as a sort of general decorator (executing 'plusieurs idées fantastiques', in the words of Caylus)[22] he turned to the novel subject of the Italian comedy.

It was as a result and while in Gillot's studio that Watteau was to discover this subject matter – or, more accurately perhaps, to realize the full pictorial possibilities of it. Caylus indeed goes on to say that after Watteau left him Gillot never painted again; although not correct, that expresses anyway some aesthetic truth, because Gillot's amusing but basically prosaic scenes of theatrical comedy (Plate 8) hardly exist after Watteau's. And though there is good evidence that Gillot in fact went on painting, he was in the final years of his life more occupied as etcher, and book designer. His last project was to design some plates for an edition of the statutes of the Order of Saint-Michel, but he died before he had executed more than a sketch for the frontispiece. When Gillot's death was reported at the Académie on 30 May 1722, it was taken as an occasion for reinstating the custom of requiem services for deceased members; a general one was to be held for members recently dead, but a special one was planned for Antoine Coypel, Premier Peintre, who had died earlier the same year. Such an honour was unlikely to be accorded to an artist of Gillot's status. His inventory confirms a humble existence. He lodged in one room; his finest possession seems to have been a satin dressing-gown, and there is a

certain pathos in the mention of 'five pictures representing various subjects, not finished, from the Italian comedy'.[23]

With Gillot the Commedia dell'arte remains very much illustrated as a straightforward fact; his harlequins are actual mischievous clowns, and the incidents chosen usually humorous rather than amorous. Although a few of his drawings catch a Watteauesque poetry, a painting like the *Quarrel of the Cabmen* is probably more typical of Gillot's interests. The scene remains patently of the theatre, and humour lies in what is depicted rather than how Gillot depicts it. To some extent he is truer than Watteau to the spirit of the Italian comedians themselves, whose daringly impudent tone had finally led in 1697 to their expulsion from France. Yet, even if not totally consciously, Gillot suggests a climate responsive to the lively, sometimes ridiculous antics of which human nature is capable; monkeys and clowns may amuse us, but may also nudge us into an awareness, amid laughter, that our own behaviour can be not so very different.

Neither Audran nor Gillot would probably have claimed to be more than decorative artists. Their ability lay in pleasing and amusing. No one could foresee that via their studios would come a painter to ally nature and art in a way that was profound as well as decorative: who would turn the wish to please into an entirely serious basis for great art.

Watteau

It is against the background of the early years sketched here that one must see the career of Watteau, an artist so personal, independent, and great that he keeps transcending the context of his period. Yet one of the most remarkable aspects of his career is how rapidly the period responded to his art. The rigid structure of the Académie grew pliant at the sight of his early work; and the sculptor Van Clève, president when Watteau was *agréé* in 1712 (and owner later of two of his paintings), gave him no specific subject for his *morceau de réception* but left it 'à sa volonté'.[24]

Those words accidentally offer the key to Watteau's career, shaped by his own impulses rather than outward circumstance or dominant patronage. Some of his finest work was self-commissioned. It was his own expressed wish, against the feelings of his friend Gersaint, which led to the creation of his largest painting, the *Enseigne de Gersaint* (1721?, Charlottenburg) (Plate 16), an unexpected picture which was to be in more than one sense his last testament, hung in the open street, attracting passers-by, and, in Gersaint's words, 'L'on scait la réussite qu' eut ce morceau.'[25] About this picture even the intensely self-critical creator felt some cause for pride. What Gersaint goes on to say of it hints at the secret of accord between Watteau and the standards of his period: 'le tout étoit fait d'après nature.' Nature may seem obvious enough in the *Enseigne de Gersaint*. It is perhaps not the first thing which would now be thought of in connexion with Watteau's other work. Yet it was on Watteau the student of nature that his close friends and contemporaries always laid emphasis; Watteau's drawings confirm the study; and he himself might perhaps have said that all his endeavour was to follow nature as Pope defined it: 'At once the source, and end, and test of art.'

Jean-Antoine Watteau was born in October 1684 at Valenciennes. Since several of his friends felt a particular urge to write down details of his life and character in a way unparalleled for any other French painter of the century,[26] we know that from his earliest years he showed a passion for drawing – after nature, too, because his very first subjects were the charlatans and quacks selling remedies in the streets of his native town. Watteau's father was a tiler whose drunkenness and brawling are documented facts about which the painter probably, and certainly his early biographers, remained silent, though Gersaint described him as 'naturellement dur'. There seems to have been no objection from the family to Watteau's chosen career, partly perhaps because a painter, Julien Watteau, doubtless related to the family, was already active at Valenciennes. It was not with him but with a much older painter there, Jacques-Albert Gérin, that Watteau studied for a short period. About 1702, his father having failed to pay Gérin's fees, Watteau left Gérin's studio, his home, and Valenciennes. Without money or decent clothes, he sought refuge (the phrase is Gersaint's, perhaps echoing Watteau) in Paris, hoping to enter there the studio of a painter who could properly help him.

Such a progress from the provinces to the capital is a cliché of artists' biographies. It has already appeared here in the careers of Audran and Gillot. With Watteau, where nothing is quite ordinary, there remained a strong attachment to his place of birth – to the place as such, we may suspect, rather than to the family home. Twice, when everything seemed to fail him, he thought of Valenciennes; when he did not win first prize at the Académie in 1709, he retreated there and by chance met the future director of the *Mercure de France*, Antoine de la Roque, who became a close friend. And when he was in fact dying, Watteau became convinced that he would be cured if only he could return to his own countryside; he sold his few effects and lingered through the early months of 1721, hoping to regain sufficient strength for the journey. He was reconciled with Pater, whom as a pupil he had treated harshly and unfairly; and perhaps he sought the reconciliation partly because they were compatriots. But he never saw Valenciennes again, dying at Nogent on 18 July 1721, in the arms of Gersaint, who had been going to accompany him on that return home.

It is more than just fanciful to think that Valenciennes played a great part in forming Watteau. He remained provincial, even rustic, the native of a small country town which was close to the Flemish border and which had become French territory only six years before he was born. When he painted peasant scenes he was not merely following a taste for Brouwer or Teniers; the actuality had been experienced, however much he might care to enhance it, and the same is true of his military pictures – inspired by what he saw in the region when he returned there at the time of Marlborough's campaigns. The very subjects of his earliest drawings at Valenciennes – those 'différentes scènes comiques que donnent ordinairement au public les marchands d'orviétan' – are rightly indicated by Gersaint as probably the origin of his later attraction towards similar sorts of scene, 'malgré le caractère triste qui dominoit en lui'. Clowns, mountebanks, and charlatans, shifting gipsy-like people who live on their wit and their wits, were perhaps already recognized by the artist as his sort of people; just as for Domenico Tiepolo later in the century, they might represent 'nature', indeed truth, almost as a relief from the claims

of traditional high art. Gérin was occupied painting altarpieces for the convents and chapels at Valenciennes. Watteau had already tacitly rejected the traditional category of history painting and was sketching what appealed to him in the streets of Valenciennes.

Nevertheless, he was not a realist nor a painter of nature in any nineteenth-century sense of those words. The centre of his art is a concern with mankind, and mankind within the social framework, stirred by passions. His work is activated by a feeling for drama on the Shakespearean principle that 'all the world's a stage'. His characters are always engaged in acting a scene, seldom in total repose (in this, as in so much, opposed to Chardin), and rarely out of fancy dress. Watteau usually contrives that circumstance should have freed them from the ordinary conventional pressures of society: they seem to owe allegiance to no one but themselves, pay taxes for nothing except being in love, and calmly declare their occupation to be pleasure. The roots of these people are not in peasants or petit-bourgeois citizens of Valenciennes; increasingly they perform no scenes of rustic toil or useful employment. But there remains a clear affinity with the rudimentary theatre devised by travelling quacks, at once colourful, transitory, and deluding even while entertaining. Ambiguity is one characteristic of Watteau's art. And all that Gersaint tries to explain – from the actual comic performances seen at an early age to the dominating 'caractère triste' of Watteau – is summed up by the artist himself in the large-scale, late masterpiece of *Gilles* (Louvre) (Plate 15). That painting alone would justify one in saying that Watteau ended as he had begun.

The hopeful young painter who arrived in Paris about 1702 was to find employment at first only in the lowest form of hackwork, executing copies in a sort of picture factory which paid very badly; however, he told Gersaint, as a charity a daily ration of soup was also provided. All the early biographers mention this period of Watteau's life, which was indeed the worst he ever experienced. It shows the difficulty for an unknown painter arriving in Paris without an introduction and emphasizes the grave step Watteau had taken in leaving Valenciennes. His biographers agree that even during this black period he continued in what spare time he had (by night, as well as day) to draw 'd'après nature'. Probably he had already begun to assemble the nucleus of those figure studies which remain the foundation of his art and which fully justify the contemporary praise of him as 'exact observer of nature'.[27] At this date he was probably still unacquainted with much in the way of old master art, apart from such pictures by painters like Dou which he then so frequently copied. Nor can it have been at all clear what sort of painter he would prove to be. Uncertainty, timidity, and lack of guidance combined to delay him. Although there may be some vaguely Flemish-style peasant pictures by him which can be placed about this period, it was in encountering Gillot that Watteau at last found an artist worthy to help him, one who introduced him also to that significant subject-matter of the Italian comedy.

The chronology of both Watteau's work and life is very vexed. Even the dates for his stay with Gillot and move to Audran are vague, but probably by 1708 he was working for Audran. In 1709 he entered the student competition at the Académie and was placed second. As it happened, no students were sent to Rome that year. Watteau next appears documented in 1712. Although there was no competition, the Académie met on 11

July to decide which student should proceed to Italy. This was the occasion on which Watteau showed paintings which so impressed La Fosse and other senior members that they invited him to join the Académie. All the early biographies make this a significant moment. By this act Watteau, the somewhat old pupil of twenty-eight, became established as a young, highly respected master. Thenceforward he was to be ceaselessly active in the lifetime of nine years – to the very same month of July – which was left to him.

Probably in the period Watteau was working with him, Gillot painted the comic *Quarrel of the Cabmen* (Plate 8). Something very Gillot-like is apparent in Watteau's '*Belles, n'écoutez rien*' (Plate 9) which now exists only in Cochin's engraving. The Commedia dell'arte characters appear in traditional guise. The setting is quite clearly a stage, and there is a stiffness in the grouping of the actor-figures – slenderly proportioned in typically Gillot style. Yet here are all the elements out of which would be fused shortly afterwards the complete creation of Watteau's *fêtes galantes*. Gillot – whose temperamental affinities with his pupil are stressed by Gersaint and Caylus – interpreted nature in quite a different sense, one that may now look artificial but which represented freedom for the artist's imagination. The theatre, tragic as well as comic, interested him as a designer and presumably as a spectator. He sought modernity in fantastic costumes, seeing himself halfway to being a clown when he executed a self-portrait in floppy, falling collar. In effect, Gillot introduced Watteau to the potentialities of art: the make-believe yet real world of theatre, in which passions are always spinning double plots, those of the actors in private behind-scenes existence as well as those on the stage. The crude charlatans of Valenciennes merge with the sophisticated actors of Parisian opera and theatre.

It is significant how rapidly Watteau was to dispense with stage scenery, both compositionally and emotionally. In the picture engraved by Cochin, the clear-cut scenic architecture of wing and floor gives way behind to foliage and melting countryside, yet with a hint of classical Antiquity in the vast carved urn. He quickly dispensed too with the actual characters of the Italian comedy, retaining their clothes for the much more refined people of his acquaintance or fancy. The dialogue of music and love which is here only part of the scene becomes virtually his main subject matter; and the *fête galante* is born.

Of course, it needed Watteau's genius to make of this subject matter something poignantly beautiful and profound. His concentration on it culminates in the *Fêtes Vénitiennes* (Edinburgh) (Plate 14), which is the final summing up of all that lies in embryo in the '*Belles, n'écoutez rien*', transfigured into something so highly personal that it cannot be properly characterized. Jullienne's (*Abrégé de la vie d'Antoine Watteau*) is the most perceptive of the early biographies on this point, emphasizing the dependence on themes which had been Gillot's, yet going on to say: 'il n'est pas moins vrai de dire que, dans la suite, il [Watteau] les a traités d'une manière qui luy étoit propre, et telle que la nature, dont il a toujours été adorateur, les luy faisoit apercevoir'. The lesson that Gillot had to teach Watteau was almost too quickly understood. Something sharper than the usual difficulties between talented master and genius pupil seems to have severed the relationship between them; their very affinities as artists and as personalities perhaps meant the greater antagonism when they separated. This was probably the first manifestation

of that impatience and restlessness which was part of Watteau's illness. He left Gillot, and continued for the rest of his life wandering from lodging to lodging, being somewhat troublesome to his friends and yet capable of retaining their strong devotion. Gillot, as has been mentioned, certainly voted in his favour at the Académie in 1717. Although Watteau seems to have always recognized the merit of Gillot's work, he disliked being questioned about the period of their intimacy and their break.

It is impossible to feel that his study under Audran was so close or so fraught. The two artists had quite different, rightly different, ideas about their gifts. Audran was not a painter of pictures. Watteau, though he executed a few arabesque designs, was not basically a decorator. Audran's chief value to Watteau was his post as keeper of the Luxembourg, thanks to which the Rubens *Marie de' Médicis* cycle became available for him to study. Audran owned two early pictures by Watteau in 1732, but it is not necessary to believe that these Teniers-style paintings – *La Marmotte* (Hermitage) and *La Fileuse* (lost) – had been painted while Watteau worked under him.[28] One would naturally expect to see the impact of Rubens dramatically apparent in Watteau's paintings, but this is not so; and it is patently lacking in these two pictures. Watteau may well have been acquainted with the *Marie de Médicis* cycle before he moved to Audran, though only while staying with him could he have come to daily familiarity with it. Compositionally, its public pageant would have had little influence on him, and his chalk studies of it concentrate on the female nude and cupids; by virtually a symbolic act, his most consistent borrowing from all its rich welter of motifs is the 'natural' one of the curled-up dog in the *Marriage* picture, a motif he became fond of using. Other motifs from other Rubens pictures begin to occur in Watteau's work, but some at least may derive from engravings. The importance of the Luxembourg paintings for him lay in their technique. That was at the heart of *Rubénisme*: a triumph in the handling of paint which in this case did not by any means imply a triumph of colour at the expense of draughtsmanship. Both gifts had been Rubens' own, and both were to be Watteau's. Gillot had shown Watteau the way to personal subject matter for pictures; Rubens showed him how to execute it. The final demonstration that the lesson had been learnt was on a large scale – at least by Watteau's standards – in the bravura, confident handling of the *Enseigne de Gersaint*. Watteau's technique is too large a subject for treatment here, but his exquisite colour and rich, even fatty, oil paint are important aspects of his achievement.

The discovery of Rubens as painter and colourist probably first turned Watteau's eyes to Italy, paradoxical as it may sound. It was in the hope of being selected as a pensioner for the French Academy in Rome that he presented himself at the Académie in 1709 and 1712; and the geographical confusion in Gersaint's mention perhaps reveals what Watteau thought of even while he spoke of Rome: 'Il eut quelque envie d'aller à Rome pour y étudier d'après les grands maîtres, surtout d'après les Vénitiens ...'. Although he never visited Italy, it was later to come to him in the personal shape of Rosalba and Sebastiano Ricci, and in the work of Veronese and Titian – all representatives of the Venetian school whose acquaintance he would owe to Crozat.

Despite his failure in 1709, Watteau emerges that year as no longer a pupil or employee but as an independent painter with his own style and the first of his own themes. At that

date it was not the *fête galante* which interested him but the no less 'modern' subject of military life. Because Watteau is so closely associated with the creation of the *fête galante* category of picture, it is easy to forget the variety of subject matter which he treated. Within the *fête galante* itself there are great varieties of treatment. In addition to military subjects, arabesque decorations, and Flemish-style genre, he painted one or two portraits and some religious and straightforward mythological pictures, as well as a few genre scenes: now in some erotic *Toilette* anticipating Boucher, and now Chardin in the sober *L'Occupation selon l'âge*.[29] The selection of military themes around 1709 seems at first unexpected. It can probably be explained not merely as in a Flemish-Dutch artistic tradition but as directly related to Watteau's own origin in the very countryside which was then the area of Marlborough's victories. In September 1709, by which time Watteau had probably withdrawn to Valenciennes, came the battle of near-by Malplaquet. Such actuality is typical of the natural basis of all Watteau's art; and his soldiers are seen naturally, not engaged in battle but simply marching or resting – no more glorious than might be strolling players – countryfied recruits who scarcely understand the seriousness of war, but try to preserve some touch of domesticity even while encamped.

In a strange way, the apparently incongruous military subject matter is transmuted by Watteau until it seems as personal and typical of him as any *fête galante*. Unfortunately, several of these painted compositions survive only in engravings or in pictures of dubious status, but there is a new graceful mastery apparent – confirmed by some of the existing vivid chalk drawings which were utilized for single figures. Callot had long before shown the miseries of war; artists like Van der Meulen and Joseph Parrocel had made war a more glorious and stirring spectacle.[30] Watteau banishes battle to the past or future; it lies beyond the horizon, and yet its reality is what gives point and poignancy to the temporary bivouacs and the garrisons bravely setting out.

The engraving of Laurent Cars, so responsive to Watteau's subtle effects, catches a great deal of the lost *Escorte d'équipages* (Plate 10), the original of which belonged to Jullienne and was praised by Mariette as 'un merveilleux tableau'. It is indeed the most sophisticated of these military scenes, organized into a microcosm which contains the experience not just of army life but of all life: at the centre of the camp, between flirting soldier and girl, and the cookpot suspended over a makeshift fire, at peace in contrast to the distant soldiers forming up around their commander, lies a sleeping baby. If it seems too fanciful to detect some echo of the theme of the Rest on the Flight, a more mysterious composition of probably the same early date, *La Ruine*, shows a huddled woman on a donkey escorted by a soldier with a staff – and in that there seems a quite conscious echo of the Flight into Egypt. The microcosmic view of life mirrored in society – with children, old people, animals – and society not passive but actively engaged in being social, is carried over by Watteau from scenes of military life into those of people released from all duty except the profoundly human one of seeking happiness. Those people too, however, will find a threat on the horizon: not of war but of time.

Watteau's military pictures enjoyed an immediate vogue. The first picture he sold was one of these, bought by the dealer Sirois, Gersaint's father-in-law. In itself the fact might

not seem remarkable, but it reveals one more of Watteau's quietly revolutionary intentions (the firm intentions of someone who was 'entier dans ses volontés', as Gersaint later wrote). This concerned patronage. Left 'à sa volonté' even by the Académie, Watteau was obviously much happier without commissions to paint specific subjects for specific patrons; but he needed to earn a living. It may fairly be guessed that in general he was more at ease with dealers and *antiquaires* than with upper-class patrons, however well-intentioned. He never sought commissions as such, any more than he sought fame or praise. Caylus (*Vie de Watteau*), by no means an uncritical admirer, vividly records Watteau's indifference, mingled with satire ('il était né caustique'), to flattery and to money, in addition to his tendency to undervalue his own pictures. For all these reasons, a friendly dealer offered him more in the way of freedom than could any patron. Watteau's relations with Sirois remained strong and sympathetic; they continued after Sirois' death in the person of Gersaint, who needs no greater tribute than that it was for his shop that the *Enseigne* was painted. The military picture for Sirois was soon followed by another. And the demand rapidly exceeded Watteau's own interest in the theme; it was to be taken up by the young Pater at a period when Watteau was evolving his concept of the *fête galante*, that category of picture which he may be said to have invented.

Hints for it came from the contemporary French theatre and from engravings by artists like Claude Simpol and Bernard Picart. Scholarly search for previous treatments of comparable subject matter leads back eventually to the Giorgionesque *Concert champêtre* (Louvre), which then hung in the royal collection at Versailles. Here is already stated the theme of a group of fashionable people out in the countryside, themselves idle and relaxed, enjoying conversation and music, indulging a mood of lazy amorousness which seems to defeat time, so slowly does anything move or change in the lulling, afternoon air. This quintessential picture may stand for a whole Venetian cinquecento atmosphere, which was to become actual to Watteau when he was introduced, through La Fosse, to Pierre Crozat and his collection of drawings and paintings. Probably this occurred in 1712, after Watteau's failure and yet success at the Académie; and such artists as Titian and Veronese, who had influenced Rubens, were directly absorbed into Watteau's own stream of *Rubénisme*. In some ways this natural Venetian world, natural in its relaxation and sensuousness as well as in landscape, was almost more valuable to Watteau than had been Rubens; it was more remote, chronologically and geographically. After 1712 he perhaps realized that he himself would never see Italy; it remained a *pays lointain*, familiar only through the medium of art – and doubtless for that reason the more hauntingly vivid.

Between the military scenes and the fully evolved *fêtes galantes* comes such a key picture as *La Mariée de Village* (Charlottenburg) (Plate 11), which at first glance might seem a faintly idealized rustic Flemish scene, but which is much more. A bridal procession is making its way in beautiful weather to a Palladian church of almost dreamlike proportions. This village with its cloudy, feathery trees, sharply prominent pine, and mossy overgrown masonry is the perfect setting for silk-clad country people native to no land except Illyria – and a crystallization of all associations of Italy and the south. It is quite

within the mood of *Twelfth Night* that a carriage is passing through the village, its occupants staring out with mock curiosity at villagers no less refined than themselves. Behind the picture lies a sense of theatre – open-air theatre – with, once again, a panoramic view of human life. There are the suggestions, graceful and unemphasized, of the range of society: from carriage class to the mummer-like village musicians. There are the variations of age which Watteau often introduces, and still makes play with in the *Enseigne de Gersaint;* that is one aspect of time's passage. There is his typical, inevitable sense of movement: here literally expressed in the progress of the bridal pair towards the church porch where the priest waits. Above all, hovering like the tutelary genius of the century, is the most sheerly natural of the emotions: Love – animating the whole scene and binding the couple – at once social, forceful, and unsentimental. Watteau's picture is not *like* any particular village wedding in any particular locality; it is a painted metaphor for a psychological truth. In every way except subject, it is the opposite of Greuze's *L'Accordée de Village* (Plate 153), which is almost sensibility's revenge for Watteau's sense.

Contained within *La Mariée de Village* is the essence of the *fête galante* which Watteau was to develop with increasing freedom: moving out of the village context as he moved closer to concern with groups of people. The setting remains countrified but more like park scenery – as enchanted as the always pleasant weather. There is an increasing freedom too about the content of his pictures, which seldom again show such a specific incident as a wedding or betrothal. The society he depicts is 'free', outside the convention of marriage but actively seeking happiness with the right partners – who by an easily understood metaphor are shown as partners in dance or song. Even while presenting his elegant, beautifully dressed people in surroundings as attractive as themselves, exposed to all the favourable influences of nature, Watteau remains psychologically truthful. This truth is perhaps best revealed in optimum conditions of leisure, pleasant surroundings, charming company. A question seems to lurk at the heart of these scenes of society apparently at play. Perhaps it is an impertinence for an art historian to try to express this in words, yet its presence is what gives depth to Watteau's *fêtes galantes*, in contradistinction to those of even his most talented followers. Can we trust our sensations? Can the sense they give of happiness be sustained? In love there is unity, yet how long does love last?

Such are the sort of questions, it may not unreasonably be thought, that Watteau's pictures are intended to pose; nor would they be surprising in the work of an artist whose health was undermined by tuberculosis and whose character was described by friends as 'inquiet et changeant . . . toujours mécontent de lui-même et des autres . . .'.[31] Besides, Watteau made one supreme statement, explicit in its imagery, when he eventually completed his diploma piece for the Académie, presenting in 1717 the *fête galante* which was first entered in the minutes as representing 'Le pelerinage à l'isle de Cithère' (Louvre) (Plate 12). The deletion of this title and substitution of a mere category, 'une feste galante', probably led to long misunderstanding of Watteau's intention, though it also usefully documents academic acceptance – in every sense of the word – of the new style of picture.[32] Watteau had painted something that was neither modern genre nor a

'history' piece. The title he chose for it gave it a resonance and actuality which, on reflection, may have been felt to be misleading, whereas in fact they were fully justified. The picture had the most official genesis of all Watteau's paintings. It was destined not for the cabinet of some *amateur* but to be scrutinized by his fellow artists. Its personal relevance for him is shown by his willingness to execute a second version – a unique incident in his career – which is even more explicit in its imagery. Yet, allowing for the uncertainty of Watteau's chronology, it is possible that this subject represented the artist's intended last word about the *fête galante*.

The misleadingly called *Fêtes Vénitiennes* (Edinburgh) (Plate 14) must be later and is rather more intimately direct – even to inclusion of the artist's self-portrait.[33] The late *Gilles* (Louvre) (Plate 15) is again unexpectedly a different sort of picture, in mood and scale, and something of its effect is compositionally heralded in *La Danse* (Charlottenburg composition usually accepted).[34] The contrasting day and night scenes of the *French Comedians* and the *Italian Comedians* (both at Berlin-Dahlem) are not *fêtes galantes* but a mature return to the world introduced originally by Gillot. Finally, confirmation of Watteau's deliberate departure into fresh themes, with consequent changes of technique, is shown by the *Enseigne de Gersaint* (Plate 16) – the least foreseeable of all Watteau's pictures but the ultimate testimony to him as 'sempre instancabile' in the study of nature (Orlandi, *Abecedario*).

In the *Pilgrimage on the Island of Cythera* (Louvre) Watteau united allegory and reality in the same way, and for the same purpose, as Rubens had done in his *Garden of Love* pictures. Somewhere, at the end of the world, must be supposed a lovers' paradise. Rubens had devised a garden which could almost be his own splendid one at Antwerp; Watteau prefers an enchanted island, set in a misty sea, less accessible, altogether less physical than Rubens' May-Day-like-festivity – symbolism Rubens had frankly used when he congratulated a young bridegroom on planting the may in his beloved's garden. The *Garden of Love* depicts a cheerful fertility rite, in which the only doubtful note comes from bashfulness. In the *Pèlerinage à Cythère* the mood is poignant. A festive day is over. The statue of Venus has been hung with its tribute of roses and as evening approaches the reluctant pilgrim-lovers must leave the island. The idea of time's passage, the inevitable movement of life, is conveyed by compositional movement: unwinding from the stone impassivity of the statue – fixed pole amid fluidity – through the three pairs of lovers who represent a gradual awakening to reality, down to the cheerful group boarding the boat amid a flutter of guiding cupids. At the exact middle of the composition, movement is checked by the male pilgrim's pose, held between homeward journey and past felicity, poised on the crest of the hill through the action of his partner who has turned back momentarily with a smile which mingles pleasant recollection and regret (Plate 13).

A bitter-sweet reality lies there under all the light-hearted trappings of allegory and fancy dress; yet the picture escapes from the genre category of Detroy's gallant scenes, just as it does from being mythological. Its central concern is with humanity – in which it remains typical of its century. It is typical too in the importance it gives to women – not as slaves or as queens, but man's equal partners; and it is personally typical

of Watteau in the emotional weight placed on a woman, whose impulse of turning round is perhaps the subtlest thing in the picture.

Thus, in this first, official *fête galante* Watteau already transcends the apparent subject matter. Far from suggesting timeless bliss in an Arcadian world, as may still sometimes be carelessly assumed, he conveys the frailty of human happiness. Even the most beautiful day must end; the happiest lovers, deep under Venus' spell, must leave her shrine and return to a more prosaic world. He is as serious as Poussin, and as individual, in requiring the spectator to 'read' his picture; but even at the time its significance was blurred. Later critics like Diderot were to see only surface grace and artifice in such work, and by redefinition of the word 'natural' to stigmatize Watteau's nature. It was the easier to do this amid the flotsam of the *fête galante* as practised by Watteau's followers and imitators, an accumulation of trivia – for the most part – which began as tribute to Watteau's innovatory genius and ended by damaging his reputation. Had Watteau lived, we may guess that his rejection of the theme would have become absolute. Yet it is what he was able to make of it which matters; it attracted him not because it was pleasing and frivolous, but because it allowed him to discuss the implications of love and serious human search for happiness. It is far from Gillot's scenes of Italian comedians to Watteau's metaphorical climate in which we are all comedians, wear masks or cap and bells, and play parts; and there human transience is pointed up by the eternity of monuments, those stone figures who alone seem to survive time, still standing when the music has faded and the singers gone.

<div style="text-align:center">*</div>

Watteau's legacy was not in fact connected with any single category of picture. It was perhaps in his drawings rather that the essence of his genius lay, and these were after his death to become widely known and disseminated in a remarkable way, thanks to the enterprise of Jullienne in having them engraved and published. Ruined by the failure of Law's financial system, Watteau had visited London in 1720 perhaps hoping to consult the famous physician who was also a collector, Dr Mead. It was when he returned to France, more ill than he had set out, that he sold the major portion of his effects and added the resulting sum to such capital as Jullienne had managed to save for him from the Law débâcle. His artistic capital lay in those drawings (Plates 17 and 18) which had seldom been preparatory studies for definite pictures, but which were the fruit of constant study: heads, hands, clothes, bodies – a whole vocabulary from which he selected as he required for the composition of a painting. These were bequeathed by him in equal portions to four devoted friends who between them represent the few firm points in an unsettled, consciously withdrawn life: Gersaint, the young dealer; Hénin, an amateur, acquaintance of Caylus and himself an engraver and draughtsman; the Abbé Haranger, possibly a Fleming and certainly a canon of the Flemish community's church of Saint-Germain l'Auxerrois which Watteau attended; and the sensitive collector Jean de Jullienne, whose great wealth came to him only in 1721.

It has very reasonably been suggested that Watteau's bequest to the quartet was the stimulus for the idea of the *Œuvre gravé*, four superb volumes eventually, produced by a

variety of engravers under Jullienne's direction and at his expense. A set was presented by him to the Académie on 31 December 1739. In them are collected not only a range of Watteau's drawings (sometimes mere sketches, often in brilliant near-facsimile), as well as arabesque designs, but the majority of his finest paintings, sometimes reproduced on double pages. The previous comparative inaccessibility of Watteau's work was thereby changed. No single artist ever before had been the object of such sustained reproduction, or of such sustained posthumous patronage. It revealed not only Watteau's versatility but the extraordinary amount of work achieved by a sick man, slow to find fame and always full of self-doubt. From posterity's point of view it is also an invaluable guide to pictures now lost or destroyed. The artistic influence of the *Recueil Jullienne*, a deserved title which the instigator modestly did not choose, is hard to calculate. In France alone its influence must have been considerable, not least on one young and talented, then un-known, artist who participated in it as an engraver: Boucher. Outside France its in-fluence was perhaps more subtle still; Gainsborough owned a copy of it and is sometimes patently indebted to it; Domenico Tiepolo certainly owned some engravings after Watteau; and, consciously or not, Goya is an inheritor of Watteau's achievement. Such great names are really more interesting than the immediate following of Watteau's French imitators, satellites who, for the most part, were revolving round a vogue rather than round a genius.

The frontispiece to the third volume of the *Œuvre gravé* prints a well-meaning poem by the Abbé de la Mare which in its very commonplaceness is perhaps revelatory of its century. An allegorical fable entitled 'L'Art et La Nature', it was chosen by Jullienne to introduce, in effect, the two volumes of Watteau's paintings. Art and Nature quarrel but are reconciled by the appearance of Watteau; he unites them peacefully, saying:

'Vous estes faits pour estre ensemble.
Je veux vous unir à jamais.'

Feeble as the verses are, they express a truth that is profound.

Lancret, Pater, and Lesser Painters of Fêtes Galantes

Lancret is the one painter who stands out among the Watteauesque artists, and he is also the one who has suffered most perhaps from juxtaposition to Watteau. The dreadful fate of being 'émule de feu M. Vateau' was already his in 1723; yet considered in his own right he is an attractive, competent figure, with a lively eye for topical manners – no poet but a charming essayist. To savour his vivacity, and his talent, it is sufficient to com-pare his pictures with Detroy's similar gallant scenes; that comparison does some justice to Lancret, if not as pioneer at least as the better painter.

Nicolas Lancret was born in Paris in 1690 and there he died in 1743, no more than middle-aged and yet having outlived the majority of the *fêtes galantes* painters like Pater, Bonaventure de Bar, Octavien, and Quillard. The death of Watteau, followed by Gillot's death the subsequent year, left Lancret the outstanding exponent of this type of

picture. He had been an unruly student at the Académie in 1708 and then moved to become a pupil of Gillot during 1712–13; Gillot's influence on him is apparent not only in subject matter but in the slender proportions of his figures, at least in his early pictures: lively marionettes who are often assembled in considerable numbers, dancing or flirting in the open air. *Agréé* in 1718, he was formally received the following year when he presented as his *morceau de réception* a *fête galante*. In 1722 and 1723 he exhibited in the Exposition de la Jeunesse at the Place Dauphine; he appeared at the isolated Salon of 1725 and was a regular exhibitor at the re-established Salon in the last years of his life. Made councillor at the Académie in 1735, he became an established, popular artist whose work was greatly in demand, especially in court circles. He executed pictures to decorate rooms at Versailles, but some were also owned by Jullienne, and many were later to be collected by Frederick the Great. The very collectors so responsive to Watteau seem to have been unaware of obtaining an inferior article with a Lancret; it was left to Mariette to sum up with cold accuracy the trouble about Lancret, that he was basically no more than a 'practicien'.

The range of his art varied little. The mood is more cheerful than even particularly *galante* – and it ends by being rather monotonous *en masse*. He perhaps deliberately modelled himself on Watteau, yet he could not conceal his much more *mondain* interests, skilfully blended with a persistent prettiness. Although the figures in his pictures are sometimes meant for portraits, they lack any real tang of individuality; certain types of wide-eyed, ever-smiling, faintly infantile faces keep recurring and become a hallmark of Lancret's style. In some ways he is nearer Boucher than Watteau.

Lancret's light-hearted charm almost conceals his extreme competence – a competence which is, however, confirmed by his drawings. His ravishing colour sense, with pale pastel-yellows and poppy-reds, never deserted him. Although the graces of the *fête galante* soften all his depictions of would-be real life, it was in such latter scenes that Lancret produced his best work. If in those he was emulating Watteau, it was Watteau the creator of the *Enseigne* who inspired him. Lancret's figures assume a larger, firmer place within the composition, and several of his last pictures – like the *Montreur de Lanterne magique* (Charlottenburg) – achieve a limpid balance between extremes of art and nature. The *Tasse de Chocolat* (Knightshayes Court) (Plate 19) was exhibited at the Salon of 1742, the last in Lancret's lifetime, and is a masterpiece, emancipated from all influences. The family anecdote is charming, just tinged with humour; the figures themselves have a flower-like charm and freshness, anticipating early portraits by Gainsborough. The secluded garden with its graceful sweep of fountain and tall, flower-entwined urn is décor which almost succeeds in convincing the spectator it could exist, and much the same is true of the cluster of hollyhocks amid which a dog chews his bone – fashionable hollyhocks dyed to suit Lancret's palette.

A heavier fate was reserved for Watteau's sole pupil, Jean-Baptiste Pater, in artistry devoted and timid, and the more irritating the more closely he pastiches his master. Born at Valenciennes in 1695, Pater studied there under the painter Jean-Baptiste Guidé before coming to Paris and working for a short time as Watteau's pupil, probably in 1713. Although Watteau treated him badly, no doubt out of moodiness rather than

from any jealousy, his influence on Pater was decisive. When he was dying at Nogent he was reconciled with Pater, who had meanwhile spent a two-year period back in Valenciennes; Pater very briefly became again his pupil, and Gersaint tells of Pater's declared indebtedness to this tragic month's teaching. In 1728 he was accepted as a member of the Académie, presenting a military piece in the style popularized by Watteau, *La Réjouissance des Soldats* (Louvre). Overwork and a miserly temperament – according to Mariette – brought Pater to a premature death; he died in Paris in 1736.

The majority of his pictures are insipid *fêtes galantes* where not merely the theme but most of the figures are directly borrowed from Watteau: an anthology of imitation much closer than anything contrived by Lancret, and executed in rather greyish, powdery colours with a flickering use of line that is the most personal characteristic of Pater's style. His subject matter moves away from Watteau and towards Hogarth in the series of fourteen pictures produced in the last years of his life, illustrating Scarron's *Roman comique*; yet here the basic theme, of a troupe of travelling players in northern France, strangely brings us back almost to the actual world of Valenciennes seen and sketched by the very young Watteau.

Pater's illustrations are humble, hasty, and pedestrian in their attempts to be funny: it is somehow sad, yet not surprising, that they should have ended up in the cabinet of Frederick the Great who owned, as well as pictures by Watteau, an extraordinary amount of Pater's work.[35] Among these, however, are one or two pictures in which Pater successfully, if temporarily, seems to foreshadow Boucher: not only in groups of *baigneuses* but in the pretty, stage-like *Landscape with a Cart* (Charlottenburg) (Plate 20). There the figures are totally subordinated to the fragile buildings and picturesquely twisted trees, and the whole composition has a feathery, calligraphic delicacy which suggests the extreme of evanescent Rococo to be found in Fragonard or even Francesco Guardi. The picture has been dated to the last years of Pater's life; it suggests a distinct shift away from Watteau, perhaps from the *fête galante* world altogether, but Pater was deprived of the opportunity to consolidate such a move.

The other *fête galante* painters are more shadowy figures, artistically slight in surviving work and themselves also doomed often to early death.[36] Some signed pictures establish a basis for the *œuvre* of François Octavien (1682–1740), who emerges from obscurity in 1724, when he was *agréé*; the following year he entered the Académie, presenting the Van der Meulen-style *Foire de Bezons* (Louvre) as his *morceau de réception*. Little is known about him, but he seems to have been influenced only late in life by Watteau. More interesting and promising were the two young contemporaries, Quillard and Bonaventure de Bar. Pierre-Antoine Quillard (c. 1700–1733) twice competed at the Académie *concours* as a student, having the bad luck to lose first place in 1723 to Boucher and the following year to Carle van Loo. In 1726 he travelled to Lisbon with a Swiss doctor who required an artist to execute drawings for a work on natural history, and there he remained for the rest of his brief life. He was well patronized by the Portuguese court and produced lively pictures, usually crowded with small figures, in a style which ultimately perhaps owed more to Gillot than to Watteau. Quillard may rather dubiously represent an aspect of expansion of French art outside France, but he can scarcely be

claimed as carrying Watteau's ethos to Portugal, because in Quillard's work the echo of Watteau is very faint.

Closer to Watteau, but with a marked Flemish flavour, are the few pictures by or attributed to the even more briefly-lived Bonaventure de Bar, who died at Paris in 1729 no older than the century. He attended as a pupil at the Académie, failing to win a prize in 1721 and failing in 1723 to be among those selected by the Duc d'Antin, Surintendant des Bâtiments, for the journey to Rome, although designated by the Académie. He was *agréé* on the same day as Chardin in 1728, when the Netherlandish orientation of his art was underlined by his being approved as an artist 'dans le talent particulier de la figure comme Téniers et Wauwermanns . . .'37. What exists of his art does indeed suggest a response to rustic manners; and he seems the most artistically robust of all the artists who followed Watteau. Far from making even more artificial the *fête galante*, he would probably have brought it back, quite literally, to earth. His career had hardly begun before it was interrupted first by illness and then soon after by death. At that time he was lodging with the Marquis de La Faye, the original owner of Watteau's *Mariée de Village*, which passed to La Faye's mistress, the Comtesse de Verrue, herself possessor of a very choice collection; almost too neat a circle seems traced by the fact that it also included one version of Rubens' *Garden of Love* and no less than four pictures by de Bar.38

The *fête galante* painters mentioned here do not exhaust the influence of Watteau, felt also in such artists as Antoine Pesne (1683–1757) and his pupil Philippe Mercier (1689–1760). But both these lie largely outside the scope of this volume. Pesne spent all his working life at the court of Frederick the Great; Mercier, more truly receptive to Watteau, spent most of his life outside France – chiefly in England, where he was a potent agent in the taste for Watteau, whom he could conceivably have met in London.39

Some other artists have sometimes been linked with Watteau. One or two, like the attractive Jacques-André Portail (1695–1759), are basically draughtsmen.40 Others were perhaps always more drawn to the 'nature' rather than the 'art' in Watteau's unique synthesis; to some extent the two streams are continued by Chardin and by Boucher – the greatest of Watteau's posthumous pupils. The final triumph of the *Œuvre gravé* was probably to affect taste almost without its being consciously noticed; few artists can have escaped from some touch, however remote, of Watteau's genius, and his compositions proved good to steal from, as also for the decoration of porcelain, books, and indeed rooms. Yet in this dilution lay partly the reason for reaction. Lancret might seem to have diluted the style sufficiently in painting, and by the time of his death in 1743 the whole idiom of the *fête galante* was out of date. In 1752 the Marquis d'Argens was positively to attack a taste for artists like – he instanced – Teniers and Watteau:41 good enough to be represented by a few pictures in a small cabinet, but not to be ranked with the glory of French art in the living persons of Carle van Loo, Restout, Boucher, and Natoire. Those were the great names of the mid century, some of them not long after to come under critical fire; while such a painter as Restout represented a tradition which had continued unaffected by the Régence or the *fête galante*.

Oudry and Parrocel – The Coypel, Restout, and Lemoyne

Traditional tendencies which continue across the chronological barrier of 1700, taking little notice of a new century, are apparent in the work of Jean-Baptiste Oudry (1686–1755), the pupil of Largillierre and the continuator of a style of still-life painting practised first in France by François Desportes (1661–1743). Desportes' patrons had been headed by Louis XIV and Louis XV; the latter was to be Oudry's greatest patron, and to some extent the two painters' careers overlap. They both sought their sources in the rather specialized aspect of *Rubénisme* represented by Snyders and Fyt, and also – perhaps stylistically closer still – in the hard, decorative hunting pieces and still lives by two painters of the Dutch School, the Weenix father and son.

Although it is with pictures of similar subject matter that Oudry is most often associated, he was also a portrait painter and a decorative painter, producing arabesque designs and at least one sub-Watteauesque *Italian Comedians* (Paris, A. G. Leventis Collection) [42] and it was as 'peintre d'histoire' that he was received at the Académie in 1719. Oudry was the son of a painter–picture-dealer established on the Pont Notre-Dame. Trained first under his father and Michel Serre, he had an unusual opening to his career, becoming a member of the Académie de Saint-Luc, as well as being a pupil of Largillierre. His portraits clearly derive from Largillierre, who is said to have advised him to take up still-life painting – advice which was probably shrewd rather than rude, and given by a painter who had himself practised it. Although Oudry was to be concerned with Buffon's *Histoire naturelle*, to depict the royal animals alive and slain, and to paint the royal hunts, he remained a consciously decorative artist; however exotic their origin, his animals are contained within the environment of civilized park or garden, often with suggestions of balustrade or wall, usually accompanied by glossy dead game or baskets of unblemished fruits (Plate 21). Even his thistles betray a decorative intention.

Contemporaries might praise him for following the hunts in the forest of Compiègne so as to 'faire des études d'après nature' before designing the cartoons for the Gobelin tapestries of *Chasses royales*. But Oudry's 'nature' was well suited to the conventions of the medium. In 1736, when that set was woven, he became Surintendant of the Gobelin manufactory; ten years earlier he had already been appointed to the comparable Beauvais factory. From one who had studied nature on the spot, the backgrounds to Oudry's pictures are disappointingly perfunctory. It is true that he made drawings and oil sketches of an attractive kind showing the park at Arcueil, [43] but Desportes had preceded him in this *plein-air* type of work. And his animals lack the ultimate animation of nature, studied as they are in an effective but superficial way – in contrast, for example, to the animals painted by Stubbs. Even his occasional, much-praised *tours-de-force* in still life (like the *White Duck*) lack any real sense of the weight and place of objects; against Chardin, the convention looks indeed conventional, cardboard thin despite its effectiveness. In the *White Duck* (Marchioness of Cholmondeley) (Plate 22) Oudry's concern was with the differing whiteness of a variety of materials – from silver to paper – as he had outlined in a lecture delivered at the Académie in 1749, four years before he painted this

demonstration of his point.[44] Something of its academic origin can perhaps be detected, for all its virtuosity of handling. Pleasing enough as his pictures can be, particularly when he is freed from the royal obsession with slaughter and dead game, they do not represent a profoundly new grasp of nature, nor a particularly revolutionary aspect of art. Indeed, rather the opposite. The aura of the *grand siècle* conditioned Oudry, more perhaps than he realized; he is much closer to it than to the nature and natural reactions of a Diderot or Rousseau. There is something faintly mechanical in the vivacity of even his best work; like Burke as described by Paine, he could almost be one of those *ancien régime* figures who 'pities the plumage but forgets the dying bird'.

The *grand siècle* hung quite incontrovertibly around Charles Parrocel (1688–1752), a close contemporary of Oudry. His father Joseph (1648–1704) was himself the third generation of a Provençal family to be active painters; Joseph had worked in Italy with Jacques Courtois and became a famous battle painter after settling in Paris in 1675. Charles was the elder son, formed as a painter not only by his father and also by La Fosse but by a year's service in the cavalry. While Oudry recorded Louis XV's private fights with wild animals, Parrocel recorded the royal victories on the battlefield in the years 1744–5, following the king as Van der Meulen had followed Louis XIV.

Pictures like the *Halte de grenadiers* (c. 1737, Louvre) (Plate 23) are more genre than military in their atmosphere: convincing in detail and with lively colour, they are powered also by the painter's interest less in battle as such than in horses. With perhaps more profound observation than Oudry, he brought an almost scientific eye to the study of horses he specifically conducted to illustrate the *École de Cavalerie*, published at Paris in 1733. Whereas Oudry is constantly concerned with the chase, hounds always barking, if only at an inoffensive gazelle or a caged leopard – postulating man the hunter behind all his pictures of wild life – Parrocel emphasizes man more usefully employed, his commands enhancing the beauty and movement of the horse. Cochin's *Essai de la vie de M. Charles Parrocel* (1760) mentioned this very point. Parrocel becomes virtually an ideal figure beyond the confines of books on equitation, preparing the way for the combination of superb animal and intelligently commanding rider that is David's *Count Potocki* (Plate 196).

Even more impressively linked to the seventeenth century was the dynasty of the Coypel, represented after Antoine's death in 1722 by his son Charles-Antoine (1694–1752) and his always much less famous half-brother, Noël-Nicolas Coypel (1690–1734). Antoine Coypel had himself enjoyed the advantages of a famous father, director of the French Academy at Rome; he had been encouraged by Bernini and patronized by the Grande Mademoiselle long before his success during the Régence. The fame and prestige of the Coypel form really a happier subject of discussion than their art – with the ironic exception of Noël-Nicolas, the least successful at the period but easily the most attractive artist of the family. Antoine Coypel might have seemed to represent a peak of grandeur and power not to be equalled; but it was very much thanks to his position that Charles-Antoine professionally advanced, becoming heir to his father's honours, directeur of the Académie, and finally Premier Peintre in 1747 – a post renewed after a ten-year gap, which in terms of artistic merit should have gone to Boucher.

Trained inevitably under his father, Charles-Antoine was received at the Académie in 1715. He had no opportunity of showing his ability in public until the Salon of 1725; it was then noted in the *Mercure de France* that this was the first time that the painter had exhibited his work 'aux yeux du public'. This isolated Salon was the occasion for the public display of Detroy's talents, and also those of François Lemoyne. The three painters were already perhaps jostling for position as the outstanding artists of a new generation; and even if none of them was in fact startlingly young, they were all youthful by comparison with the over-seventy-year-old Louis de Boullongne, who in 1725 was appointed Premier Peintre. And they were all painters in the tradition of decorative historical painting exemplified by Antoine Coypel and La Fosse – thus more flexible in talent than Oudry or Parrocel – yet each was to show some interest and ability in either genre, portraiture, or even landscape. In 1727 the Duc d'Antin was to organize the *concours* which brought Detroy and Lemoyne into direct rivalry. Then the prize might well have been awarded to Charles Coypel, whose *Perseus delivering Andromeda* (Louvre) was executed for the competition and had its own partisans; it was indeed acquired for the Crown. Something of a *concours* element already enters into the 1725 Salon, when all the painters, possibly by chance, exhibited pictures drawn from the *Orlando Furioso*, specifically from the love-story portion of Rinaldo and Armida. Coypel, the youngest of the trio, showed a *Rinaldo abandoning Armida* which is probably to be identified with Plate 24 (Baron Élie de Rothschild Collection).

But this was a mere sample of his abilities, displayed – surely consciously – on a wide range. There was a group of portraits, executed in pastel as well as oil, including a double portrait of two boys, sounding proto-Chardinesque in its motif, 'dont un fait un château de cartes'. Royal tapestry commissions were represented by both a biblical subject (*Joseph recognized by his Brothers*) and a cartoon for the big series of *Don Quixote* tapestries, a task given to Coypel in 1714 and not completed until 1751.[45] To confirm his ability as decorative painter on an even more ambitious scale, there was his sketch showing the proposed allegorical scheme for a room at Saint-Cloud, where ceiling and wall were interestingly planned to be merged in a single illusionistic effect: 'le plafond et le bas ne devant faire qu'un seul morceau' (*Mercure de France*). To touch the new taste for charming *galant* subjects, tinged with overtones of genre, there was *Cupid as a Chimney-sweep*.

Thus Coypel tacitly declared himself armoured by all-round talent – and he was talented in other directions too, being literate and witty, writer of not only Académie discourses but poems and several Molière-style comedies. Under his directorship the Académie became the scene of discussions and lectures; 'lives', like those of Watteau and Lemoyne composed by Caylus, were read; aesthetic theory was discussed. Coypel took his duties very seriously, acting in support of sculpture as well as painting. In the last year of his life, he is found proposing that a grove at Choisy should be nominated 'le Bosquet de la paix'[46] and adorned with sculpture by five leading sculptors, of whom Michel-Ange Slodtz would receive the major commission. All this was accepted by the future Marigny and approved by the king. The scheme got under way, despite Coypel's death, but other deaths, some reluctance, and the usual lengthy delays prevented it from

ever being completed; in the reign of Louis XVI, and with d'Angiviller as Directeur des Bâtiments, Bridan exhibited a *Vulcan* statue which – though probably no one could then remember the fact – was directly related to Coypel's project.

Most histories of French eighteenth-century art have found it easy to dispense, however, with Charles Coypel the painter, and there are good reasons for this. Some of them are hinted at in the *Rinaldo abandoning Armida*, which is a favourable specimen of his work. If the organized, literary basis of the Académie under him suggests a return to the standards of Le Brun, Coypel's paintings equally suggest a return – to the decorative standards of his father and La Fosse. Rubens and Veronese certainly haunt his art, but in a pastiche mixture that is already familiar particularly from La Fosse's pictures. In Coypel's composition the conventional gestures – faintly silly in Armida's grab at Rinaldo's clothing – and insipid faces reveal a talent which is either not robust enough in itself or else cannot be bothered to take imaginative trouble. Like some other academically respectable French painters of the period, Coypel seems to begin enervated, overshadowed by the example of the past and unable to formulate a fresh style. His own mediocrity was recognized at the time; Mariette used this actual word of him and shrewdly analysed his faults with phrases that cannot be bettered. His failure lay in not recognizing the necessity 'd'étudier d'après nature. Il s'étoit fait une espèce de routine . . .'.

The subject of Rinaldo and Armida is one which was to inspire great eighteenth-century painters, Tiepolo among them, and not only painters – as Handel's *Rinaldo* and Gluck's *Armide* may serve to recall. To Coypel it perhaps seemed merely operatic in a pejorative sense. Unfortunately, he was not to prove a better painter of more elevated subjects; his *Supper at Emmaus* (Plate 25), painted in 1746 for a chapel designed by Boffrand in Saint-Merry at Paris, is pathetically inept. This is one of his last pictures, a strange mixture of Correggio-style angels and dim anticipations of the neo-classical – at once insufficiently pretty and inadequately serious. Its wavering quality can fairly be detected amid other contemporary altarpieces in the church. These are by no means masterpieces, but they show that Coypel could not compete with the competent if perfunctory work of Carle van Loo; and even an early Vien altarpiece (signed and dated 1754) is scarcely worse. Some of Coypel's designs for the *Don Quixote* tapestries are lively in a simple-minded way; his portraits are competent but seldom specially interesting.[47] In his life he had honours enough, and he collected a fine assembly of old masters. For posterity his uncle, the obscure Noël-Nicolas, is much more attractive as an artist.

Noël-Nicolas seems to have been a timid, unbrilliant personality, rising only slowly in the academic hierarchy.[48] Trained under his father, he was *agréé* in 1716 and received the following year but not made *professeur* until 1733, the year before his death. He took part in the *concours* of 1727, executing a *Rape of Europa* which, though not awarded a prize or bought by the Crown, was highly thought of by some connoisseurs. Although he never went to Italy, his art owes a great deal to the example of Correggio and also, it is reasonable to guess, to Rosalba. It is probably his more forward brother, Charles-Antoine, whom she often mentions as the 'figlio Coipel' in her Paris journal for 1720-1; but both Coypel brothers practised as pastellists, almost certainly under her influence. Noël-Nicolas was praised by discerning contemporaries for religious work as well as for

mythologies – but most of the former has been destroyed. The always decorative, effectively decorative, nature of his talent was seen in the dome of Blondel's Chapel of the Virgin in Saint-Sauveur at Paris: there around 1730 he was working with the most painterly of sculptors, Jean-Baptiste Lemoyne (who has left a brilliantly vivid portrait bust of Coypel), in an illusionistic scheme where painted angels merged into sculpted ones – also coloured – as they streamed around the Virgin.

Such a mingling would be commonplace in a German or Austrian church, but it clearly disconcerted some sectors of taste in Paris – though praised by others. The scheme indicated Lemoyne's essentially theatrical flair, increasingly greeted with reserve by classicizing theorists like Caylus. The scheme brought trouble to Coypel, involved in disputes with the church authorities over expense; upset and emotionally distracted, he accidentally injured his head when passing through a doorway, and died from this injury.

Coypel best survives today in a fairly homogeneous group of mythological pictures, not on too vast a scale, which breathe a gentle hedonism and relaxation without insipidity. They form one frail but distinct link between the Régence and Boucher. The *Alliance between Bacchus and Venus* (Geneva, signed and dated 1726) (Plate 26) has welcome gracefulness and spontaneity; although its subject is an alliance of two great powers, emphasis lies on the female one – hostess, as it were, in her own realm, where cupids and nymphs kiss or gather grapes. Perhaps Coypel kindles only a faint erotic spark, but he does at least provide a charming treatment of the female nude, naturally observed amid charming natural scenery. The routine elements so painfully present in his brother's work are replaced not simply by greater confidence in the handling of paint but by delight in painting as such. Great claims cannot be made for the pictures painted by Noël-Nicolas Coypel. His mythological world is enchanted but not very robust: it is just spirited, pleasing and personal in a way that none of his family could achieve, and which was impossible for the prosaic Detroy. The painter who came nearest to Coypel was François Lemoyne; but before turning to him there remains in Restout one *grand siècle* relic rather different in style, mood, and taste from anything conventionally associated with the Régence, still less with Louis XV and his usual pursuits.

Restout's *Death of St Scholastica* (Tours) (Plate 27) comes as a considerable shock after the work of virtually all the painters so far discussed. *Fêtes galantes* and light-hearted mythologies, topical amorous scenes, hunting or battle pieces – all seem abruptly rebuked by a serious Baroque altarpiece strayed, it might be thought, from a Roman seventeenth-century church, not from Paris in 1730. The truth about Restout is, however, a little more complicated.[49] Although always associated with austere religious works, he was a painter also of some portraits and several mythological and classical subjects; his *morceau de réception*, for example, was *Alpheus and Arethusa* (now at Compiègne), and at the Salon of 1725 he showed – along with a vast picture of the *Healing of the Paralytic* (now at Arras) – a small easel painting of *Jupiter and Callisto*. Nevertheless, it is right to sense in him an artist much more serious, both artistically and in personal character, than the two Coypel. His career was tremendously successful and he exercised an influence, through a long life, which links him to the revival of history painting as a school for morals and virtue in the later years of the century.

'It is necessary', Restout stated, 'for the painter to have noble feelings, an elevated mind, an excellent character, to treat his subjects worthily.' This maxim, enshrined in his discourse to the Académie in 1755, he said he had imbibed from his father: an impressive testimony to the seriousness of the young Restout, who was scarcely ten years old when his father died. The Restout family is one more dynasty of painters, though none challenges him in importance. Marguerin Restout was a painter active at Caen in the early seventeenth century. Several of his sons became painters; the elder Jean Restout (1663–1702) married at Rouen Marie-Madeleine Jouvenet (c. 1655–1698), herself a painter and sister of Jouvenet. There the younger Jean Restout was born in 1692. Although early orphaned, he had already received some artistic training from his father, who seems to have combined this with very rigorous, even harsh educational standards; nor were these lessened when Restout came to Paris about 1707 to work under his uncle.

Jouvenet completed the formation of a character universally remarked on for its reserve, integrity, and industry – much the same terms as apply to Restout's pictures, equally indebted to Jouvenet's training. Restout was *agréé* in 1717, the year of Jouvenet's death, and was received at the Académie in 1720. In turn professor, rector, director, he became chancellor in 1761 and died in 1768, after a career of impressive activity. His son Jean-Bernard Restout (1732–97) was also a painter; he executed a portrait of his famous father (Versailles) which shows an austere face, rather grim compared with the usual convention of smiling ease for this sort of portrait. Restout's pupils included Deshays (cf. p. 150), Barbault, and Cochin;[50] but the most significant tribute to his teaching came from Latour, who told Diderot that Restout was the only painter who had given him useful advice.[51]

Restout laid particular emphasis on truth and expression. His few portraits reveal his sober pursuit of natural appearances, catching facial character in a way which indeed has affinities with Latour, while a rare portrait of a small child (1736, Stockholm) possesses a Chardinesque integrity. Restout's serious concern with observing a given subject and conveying its significance made him a painter of religious historical pictures which are more remarkable than the dutiful mythologies closer to the climate of Noël-Nicolas Coypel and Lemoyne. Some of his classical history pictures too, at once emotional in content but severe in style, carry him markedly towards David. Not too much perhaps should be made of his choice of subject matter, but it may be significant that at the *concours* of 1727 – when Detroy produced his mildly erotic *Diana reposing* (Nancy), and the Coypel uncle and nephew respectively a *Rape of Europa* (Philadelphia) and a *Perseus and Andromeda* (Louvre) – Restout offered the more dignified and emotionally charged subject of *Hector bidding Farewell to Andromache* (Vésier Collection, France).

Through Jouvenet he had a link back to the vein of French seventeenth-century religious painting represented by Le Sueur, and also by La Hyre in such pictures as *Nicholas V before the Body of St Francis* (Louvre). The factual realism of Restout's contributions to the series of pictures of the life of Vincent de Paul, beatified in 1729, is indeed close to La Hyre's picture, despite the fact that there is a gap of time between them of a hundred years. But on other occasions Restout, while preserving an austere, concentrated composition, gives literally swooning intensity to his figures. The *Death of St Scholastica*,

signed and dated 1730 (Tours) (Plate 27), was commissioned for a monastery at Bourgueil, not far from Tours, and is the companion picture to an *Ecstasy of St Benedict*. These two pictures represent an expressive extreme not often attempted by French art and best paralleled perhaps in some of Michel-Ange Slodtz' sculpture, for example the *St Bruno* (Plate 72). Combined with the prominent, hypnotically detailed floor boards and observation of the wood grain of the desk, the collapsed figure of St Scholastica dissolves like a dying flame – suggesting the final extinction of consciousness with a psychological perception that is only tautened by the 'hard-edge' detail of the setting with its truly 'nature-morte' of hourglass and skull. To render a subject 'dans toute sa vérité et son expression' was Restout's advice to other painters; and he here follows his own example to create a highly personal masterpiece. The demand for religious pictures had not slackened. Most of Restout's contemporaries had to execute at least some but, apart from Subleyras, none equalled his intense, artistic conviction.

Certainly François Lemoyne did not.[52] Just as Restout produced some mythological pictures which are not truly representative, so Lemoyne painted some church decorations and even religious pictures which are scarcely more than charming and graceful exercises. Lemoyne was born in Paris in 1688 and, unlike so many painters of the period, came from no artistic dynasty. His father was a postilion, an occupation so humble that Caylus could not bring himself to mention it when he eventually read his life of Lemoyne to the Académie. The postilion died early in Lemoyne's childhood and his mother married again, this time the portrait painter Robert Tournières (1667–1752). Tournières gave Lemoyne his earliest training, which was more interestingly supplemented by study under Louis Galloche (1670–1761), a 'chef d'école' largely lost sight of today. A friend of de Piles, Galloche cultivated in his pupils respect for Raphael and enthusiasm for Rubens, Correggio, and Veronese; but he laid special emphasis on the new century's key word of 'nature'. By this Galloche meant not only the living nature of humanity but the countryside as well[53] (thus providing one further piece of evidence that this was not a Romantic discovery). His advice was taken seriously by Lemoyne, whose pictures reveal a considerable response towards the nature of fields and woods – sometimes more directly observed than the Veronese- and Correggio-derived beings he sets among them. At the Salon of 1725 Lemoyne exhibited, amid his typical mythologies, one pure landscape which he had painted 'd'après nature' when travelling in the Apennines.

Lemoyne does not usually figure in histories of landscape painting; nor can it be pretended that it was in this branch of art that he made his major contribution. Yet his interest in it helps to show that a single definition of 'nature' and the natural could, in the early part of the century, activate the same painter to produce without discrepancy such pictures and also subject pictures which later taste was to stigmatize as artificial. Lemoyne's *Baigneuse* (Leningrad) (Plate 28) might well look false and posed after the subject had been painted by Courbet; in 1724 it was itself something of a revolution for its natural effect of the female nude, placed in a natural outdoor setting, without any literary context, and for its excitingly natural motif of a girl – neither Venus nor Bathsheba – testing the water with her toe – in a pose anticipatory of Falconet's famous statuette. Even

Watteau's picture of a very similar subject is seen on examination to show Diana at the bath.[54]

Lemoyne was *agréé* at the Académie in 1715 and received in 1718. Ambitious to carry out large-scale decorative schemes, he hoped to receive the commission to decorate the vast ceiling of the then Banque Royale.[55] He executed sketches for this, but the commission was given in 1719 to Pellegrini, Rosalba's brother-in-law, much to Lemoyne's disgust. His own first major commission was to paint the *Transfiguration* in the choir vault at the church of Saint-Thomas d'Aquin, and the culmination of such work came with the commission for the *Apotheosis of Hercules* ceiling of the Salon de la Paix at Versailles, completed in 1736. In some ways, the church ceiling is the more daring in its use of sheer space, allowing a complete luminous vacancy to shimmer around the ascending Christ at the centre of the composition. However, there is no doubt that to Lemoyne's contemporaries it was his work (Plate 29) in the Salon de la Paix (renamed the Salon d'Hercule) which consecrated his fame and reputation. Approved by Cardinal Fleury and the court, praised by connoisseurs, one of the few modern works favourably mentioned by Voltaire, it gained for Lemoyne the coveted post of Premier Peintre du Roi. He did not long enjoy it. A series of events, perhaps beginning with the strain of work and including the death of his wife and the death of the Duc d'Antin, Surintendant des Bâtiments and his great protector, led to insanity. In a fit of madness he hacked himself horribly to death in 1737.

And in many ways the *Apotheosis of Hercules* ceiling marks an artistic end also. Much more brilliant in colour, and more gracefully organized than anything by Le Brun, the concept nevertheless goes back to the decorative schemes planned under him at Versailles; its luminosity and ease of manner relate it particularly to La Fosse's work, though Lemoyne's Olympus consists of much more subtly planned groups, spiralling gracefully up on two sides to where Jupiter and Juno are seated under an asymmetrical curling drapery more banner than canopy. This drapery in itself might seem to signal Rococo liberation. In Italy, where Lemoyne's ceiling would already have appeared rather out of date – at least in Venice – a fresh generation would achieve more audacious effects. In France there was to be no sequel. This style of large-scale decoration, basically a Baroque inheritance, was replaced by a preference for more intimate canvases often inserted in the cornice area – such as Natoire's *Cupid and Psyche* series at the Hôtel de Soubise. Small rooms were preferred to large rooms, even by the king. Elaborate perspective illusionism is never attempted by Boucher. Olympus is no longer situated on ceilings, and Mariette lived long enough to lament that Lemoyne's once famous ceiling had grown neglected.

From the first, Lemoyne seems to have seen himself as a painter of preferably decorative, mythological pictures. He was not tempted to challenge Detroy's excursion into topical genre or ape the would-be all-round talents of Charles Coypel. At the Salon of 1725 he was represented by a typical group of his usual decorative pictures; apart from the solitary *Landscape*, all were vaguely *galant* in theme, drawn from poetry or mythology, emphasizing in different ways 'les charmes voluptueux' of femininity and the female nude. This quotation comes from the description given by the *Mercure de France*

33

of Lemoyne's picture showing Armida's enchanted island with the warriors searching for Rinaldo beguiled by her spells: the ideal, eternal theme of Lemoyne's art, where prettiness, however, rather than voluptuousness reigns. Femininity strangely extends to the men too in Lemoyne's pictures, so softened by association that there is not much travesty element in his *Hercules and Omphale* (1724, Louvre) (Plate 30). Omphale or Andromeda became much the same pretty blonde, slimmer than Veronese's women but, like his, with some recollections of Parmigianino, adding elegance to their other attractions. Shortly before the 1725 Salon Lemoyne had been travelling in Italy with his patron François Berger, ex-Receveur-général des Finances of the Dauphiné.[56] The *Baigneuse* was actually begun in Italy, but shows no particularly fresh impact of Italian art – probably because Lemoyne's Italian orientation was already established. At Paris in the collections of the regent and Crozat – to name no others – he had seen the work of those cinquecento painters, Veronese above all, who continued to influence him, compositionally as well as in handling of paint. He may have been influenced by Pellegrini, but appears never to have come into contact with Tiepolo. And though the same is largely true of other French painters, such as Boucher, it has definite significance in the case of Lemoyne. His large-scale decorations and his graceful but rather slovenly pictures are the last echo of the climate of *Rubénisme* (not that Lemoyne shared much interest in the robust master himself); in effect they close an epoch which had been presided over by Antoine Coypel and La Fosse. And even the death of the *ancien régime* figure of the Duc d'Antin has symbolic significance.

The Salon of 1737, which opened after Lemoyne's suicide, gave an opportunity for the public exhibition of work by very different painters, the new men who would increasingly occupy attention and patronage throughout the middle years of the century. Some, like Boucher and Natoire, were Lemoyne's own pupils. Others, like Chardin and Latour, stood for completely new styles of art – their own. A certain type of high Italianate art was dropping out of fashion, but no hasty explanation about the middle classes or 'realism' should be offered. These same years were to see Nattier's portraits at their best and most popular, and also the triumphant, official career of Carle van Loo, Premier Peintre before Boucher. All these artists were assiduous exhibitors at the Salon. Its re-establishment first as an annual and then as a biennial event from 1737 onwards is one definite factor, affecting both painters and sculptors. Another is the developing personality of the king, no longer the faithful husband but soon to be settled into a relationship with Madame de Pompadour, whose uncle and brother between them would serve the Bâtiments for nearly thirty years.

Such are a few of the tendencies that are to characterize the middle years of the century. Meanwhile, one must turn back to the beginning of the century to see the development of sculpture in those early years, still haunted by overtones of the Baroque, still partly ruled by concepts formulated by Louis XIV, and remaining to some extent a less adaptable medium – artistically as well as physically. Yet in that art too, 'nature' was to prove the significant keyword.

SCULPTURE: FROM THE COUSTOU TO SLODTZ

Introduction

The place taken by sculpture in the artistic hierarchy was in general below that of painting. It is reflected in the outward circumstances, and even in the personalities perhaps, of the sculptors themselves. They remained consciously craftsmen, occupied with problems of their art and little given to theoretical pronouncements on the arts. This is largely true throughout the century. Apart from Falconet, no great sculptor in France showed any inclination to write about himself, his art, or his attitude to other sculptors.

As a result their personalities remain dim, obscured amid the dust of marble chips and made fainter by a taciturn character shared by such disparate sculptors as Lemoyne and Bouchardon. The craftsman tradition shows itself most strongly in that dynastic tendency which stretches across the whole century, and can be illustrated at its widest extent by the relationship which runs from Coysevox, born in 1640, to his great-nephew, Guillaume II Coustou, who died in 1777. Not only are painter families like the Coypel and Van Loo less numerous than the sculptor families who include the Slodtz, the Adam, the Lemoyne, but they are basically less distinguished in their members. The emphasis on craftsmanship could be inherited and though, for example, it is usual to think of Bouchardon as a solitary figure, his father was a distinguished provincial sculptor and one of his brothers was also a talented sculptor.

Other, more important factors separated the sculptors from the painters throughout the century. The first of these was the problem connected with their medium. It must be remembered that before Clodion no sculptor worked so exclusively in terracotta and on small-scale objects. Until Houdon no sculptor specialized so totally in portraiture alone. Most sought or received large-scale commissions which required large blocks of marble which might or might not be already in the commissioners' possessions. If bronze was the medium, problems of casting arose. Such problems soon became as much financial as artistic, especially when one considers the length of time that could elapse between first model and final large-scale work – often a space of many years. Pigalle received the command for what became the greatest achievement of the century, the Marshal Saxe tomb, in 1752/3; the final monument was unveiled under Louis XVI in 1777. Nor is this an isolated example.

Expense of material, and necessary length of time working on it, meant that few sculptors worked other than to commission. There could be little room, especially in the early years of the century when the Crown commissions were very important, for private fantasy and expression. No sculptor therefore is comparable to Watteau. None could afford to go against the whole accumulated tradition of official patronage and large-scale work. The nearest equivalent is Robert Le Lorrain, himself an individual and 'difficult' character, who significantly received little official encouragement and was not much employed in Paris. Thus royal patronage, exercised through the Directeur

des Bâtiments, was of vital concern to the sculptors. If withheld, it could harm a career – as Houdon learnt.

Since they were very much at the mercy of patrons, not so much forming a public as being subservient to it, sculptors had a status necessarily thought of as lower than that of painters. No sculptor was ever appointed Director of the French Academy at Rome. No sculptor was honoured by the order of Saint-Michel before 1769; nor was there any post comparable to that of Premier Peintre. The prejudice, as old as Leonardo, against the mechanical aspect of sculpture continued to be felt and manifested itself openly in the history of the failure to obtain the Saint-Michel for Michel-Ange Slodtz.[57] One of the chief officials under Marigny at the Bâtiments told Cochin on this occasion 'qu'il y avoit bien des mechanismes dans la sculpture'; and though Cochin made a spirited reply, it remained ineffective as regards Slodtz. The subservience to painters was made quite explicit when they provided the designs from which sculptors must work – and Charles-Antoine Coypel, Boucher, even Cochin, produced drawings to be followed in this way.

Although several collectors specialized in acquiring small-scale models, small bronzes and terracottas, few in the first half of the century directly commissioned such work from the beginning. They were more likely to ask for the model, or the reduction of a larger work executed originally for the Crown, a city, or possibly a church. Success of the original might lead to a demand for versions of it, but success was an essential ingredient. Hence the importance of exhibiting, either at the Salon or in the sculptor's studio. Clodion could afford to dispense with exhibiting at the Salon, but that marks a shift in sculptural aims and patronage. Naturally, portrait busts and portrait-style heads were in a different category; they were commissioned by anyone who could pay. Yet there too one could lose sight of the original commissioned amid the duplicates which followed – just as it often remains hard to tell which is the original piece. Saly's *Bust of a Young Girl* was one of the most popular of such objects, early ceasing to be thought of as a portrait, and was executed in a variety of media (cf. Plate 85).

The popularity of the statuette, preferably naked and preferably feminine, was given tremendous impetus at the mid century by the coincidence of Falconet, Madame de Pompadour, and the material *biscuit de Sèvres*. The result was more than a vogue and resulted in the creation of virtually a new genre. It marked a significant break with the sculptural preoccupations of the seventeenth and early eighteenth centuries. The ideal location was no longer a garden but a boudoir. The way was prepared for a career such as Clodion's; he never bothered to become a full academician and though he received a Crown commission (for the very fine statue of Montesquieu) it is not by that that he is usually remembered. Once the small-scale group or single statuette became popular it was obvious that the range of patrons was increased. The sculptor could recover a sort of freedom, if only from the lengthy struggles connected with work on and payment for large-scale, semi-public monuments. Like Fragonard, Clodion seems to express a release from constraint which is not found in such apparently similar artists of the earlier generation as Falconet and Boucher.

This shift to the private and unofficial is really of more importance and significance than the three major projects of the century which have sometimes been thought to mark changing taste: the early Crown commission for the series of statues of the 'Companions of Diana';[58] the mid-century project of replacing the plaster statues in the Invalides;[59] and the series of 'Great Men', initiated by d'Angiviller under Louis XVI. All were attempts to employ the leading sculptors at the relevant periods, and it is certainly true that the first and third may conveniently mark a change in official policy. Under Louis XIV sculpture was serving a decorative function, chiefly in the royal parks and gardens. It was for Marly that the 'Companions' were originally destined, where Coysevox had already executed his equestrian *Renown* and *Mercury*, which were to be replaced there by his nephew Guillaume I Coustou's famous *Horses*. D'Angiviller's concept was more public, overtly patriotic and even defensive, at a period when acute artistic and political crisis could be sensed in France. What was now needed was history, not mythology or allegory. The statues erected in the gardens at Marly may fairly stand with the contemporary work of Watteau; the 'Great Men' – always destined for a museum – belong naturally in the public world of David.

Nicolas and Guillaume I Coustou

Of all the distinguished sculptors at work in the eighteenth century, none was more profoundly of the *grand siècle* than the team made up by the two Coustou brothers. Sons of Coysevox's sister Claudine and a minor sculptor in wood, François Coustou, of Lyonnais origin, the brothers together and separately carried art over that transitional period which took no account of the year 1700. Although it is a temptation to make them thus appear counterparts of their near contemporaries Largillierre and Rigaud, the Coustou were really quite different in their aims, much bolder, more ambitious and less restricted in their subject matter. The younger, Nicolas, was born in 1658 and was to be commended by Louis XIV. 'Coustou est né grand sculpteur,' the king is recorded to have said.[60] Guillaume, born in 1677, was to achieve his greatest success in 1745, the penultimate year of his life, when his *Horses* were placed beside the abreuvoir at Marly – the last significant addition to the elaborate, ever-shifting scheme of the grounds there. The year that they were installed at Marly saw Madame de Pompadour installed at Versailles.

The Coustou began with the fortune of being trained by a great sculptor, one perhaps greater as portraitist than in decorative work, Coysevox. Both veins were to be developed by them brilliantly, though they never produced any single indubitable masterpiece to eclipse the achievement of the Mazarin tomb. Like their uncle, they were centred on the court, serving Louis XIV, then the regent and his circle, and finally the young Louis XV. This closeness to the court did not, however, lead to a narrow court style. They retained much of Coysevox's bravura combined with instinctive, common-sense grasp on personality – an almost Flemish directness and self-confidence. Amid Baroque concepts they kept a sober tang of actuality, and were capable of producing under the sweeping periwigs portrait faces of pungent realism. At his death in 1720 Coysevox was

said to have been 'le van Dyck de la sculpture'. The Coustou might, in these terms, almost be compared to Rubens. Although they lack the effortless range and sweep of his genius, they possess something of his plastic imagination and vitality. Like him, they instinctively think on a grand scale, and, at their best, with an unforced sense of drama. Both are manifested in one of their few works to survive largely unmutilated and *in situ*, the *Pietà* group with Louis XIII and Louis XIV on the high altar of Notre-Dame, where they collaborated with Coysevox. Something of it can still be felt too in the Place Bellecour at Lyon where replicas of their bronze Rivers, Nicolas' *Saône* and Guillaume's *Rhône* (which were completed by 1720), are placed at the foot of Lemot's *Louis XIV* in the positions occupied by the originals when the equestrian statue of the king was by Desjardins.

In such work there is often no distinction of style between the two brothers, but there is increasingly a distinction in quality which has become quite apparent by the time they received the commission for *Louis XV and Marie Leczinska as Jupiter and Juno*. By then Nicolas was old and he was to die in 1733. From the first he had been the less versatile of the brothers – or, at least, the one less capable of evolution – though this judgement is only apparent after the event. His fame and wealth were considerable; and to Mariette he was far the better sculptor. His portrait (Louvre) (Plate 31) by Guillaume shows him in workman's deshabillé – as the craftsman he was and always remained. The personality expressed here seems shrewd, proud, and fully confident of itself, needing no conventional trappings.[61]

Nicolas' career was of the pattern to be established in the eighteenth century. He won first prize at the Academy School in 1682 (receiving his gold medal from Colbert) and went the following year to Rome. There he studied the antique and dutifully executed the requisite student's copy of an antique original (and also a reduced copy of the Borghese *Gladiator*), but it was really the 'modern' idiom of Baroque Rome which, along with Coysevox, formed his style. Orlandi names him as 'scolaro' of Bernini; and though Bernini was no longer alive, his work was there to be studied. Nicolas did not neglect to do so. Back in France in 1687, he was to present his *morceau de réception* a few years later – one of the last pieces to be a bas relief and not a fully modelled statue – and to rise through the varying grades to become Chancellor of the Academy in the year of his death. Guillaume's career was to be very similar. He had returned from Italy by 1703 and began to share in the commissions given to his elder brother. Some trouble – 'Quelques tracasseries de famille' – had interfered with Guillaume's term at the Academy in Rome, and he seems to have despaired at one point of returning to France. He considered in desperation going to Constantinople, but was prevented by the friendly counsel of Frémin. His ability is revealed in the first established work, his *morceau de réception* of 1704: the *Hercules on the Pyre* (Louvre). This is intensely dramatic and forceful. Years later Cochin was rightly to single it out as one of Coustou's finest works.[62] It shows a talent already formed and very definite in its character.

Between them the brothers produced such statues as the decorative and dynamic pair of *Apollo* (1713–14) (Plate 32) by Nicolas and *Daphne* (1713) (Plate 33) by Guillaume, originally placed at Marly, now in the Tuileries. The *Apollo* especially is a conscious

echo of Bernini. This sculpture is vigorous and robust, fully modelled, with the emphasis on action and space – the space of the open air. The pose must be immediately effective when approached from several angles, glimpsed against a background of trees, or, as in the case of *Apollo*, made the centrepiece of a fountain. Just as Marly itself represented rural freedom in comparison with Versailles, so this garden sculpture escapes from any requirements of state or religion. There was nothing ludicrous in feeling amid alleys of shrubbery, or at a fountain's side, that this was the ideal setting for classical gods and goddesses. Beyond the palace and the church, for those hours when the king lost himself in hunting, there existed a rural environment where it was only fitting to encounter other hunters like Meleager or Diana. For such sculpture, so quickly to grow weathered, a finished surface, in the sense it was conceived by Bouchardon, was not required. A coarser texture is responsible for the animation of surface, with bold, wind-blown draperies and muscular bodies, and with a vigorous drama of expression. A momentary action, in which gestures almost speak, is seized upon with a preference for the natural over the dignified. Guillaume's *Daphne*, with her desperate, gesticulating hands, looks forward to the 'natural' drama of his horses and their tamers, executed many years later.

Nicolas' group (of 1712) of the *Seine and Marne* (Plate 35), also in the Tuileries, so much admired by Mariette, shows his ability to produce straightforward allegory. It is much less wrought and refined than Van Clève's comparable near-by group of the *Loire and Loiret*. But it is much more satisfactorily and subtly composed, with its complementary personifications who are linked into a single whole yet gaze out in opposite directions, encouraging the spectator to walk all round. The putti at two corners serve a similar purpose, as well as being charming and lively in themselves. The work continues to compose at each angle but reveals fresh facets. Above all, it enshrines the grand-scale, yet not florid, world of the Coustou. Public without being pompous, decorative without over-refinement, effortlessly allegorical but never pedantic or cold, their sculpture has a tremendous confidence about it. It touches no particular emotions beyond vaguely stirring the spectator. It is as masculine and as commonsense as Dryden's verse. He indeed might have written a sonorous but not too serious poem to Commerce in a style akin to Nicolas Coustou's illustration of the theme for the pediment of the Custom House at Rouen (Plate 34), executed in 1716. Mercury presides over a lively bas relief where shipping and trade take on memorable images: the nervously handled figure of the seaman with a corded bale, the alert scribbling boy at the far left, and the vivid dog crouched at the right – one of Nicolas' liveliest animals. At the same time all is carefully planned to fill the difficult triangular space, and the final impression is of the seated central god, dominating as symbol and as sculpture.

The work executed by Guillaume alone shows him moving, probably unconsciously, out of *grand siècle* concepts, with increasing emphasis on nature and reality. His ability as a portrait sculptor is proved by other busts as well as that of his brother, with their pungent response to personality and what seems like a delight in ironic expressions amid the official wigs and the thick folds of impressive robes. All this made him the

ideal sculptor of the tomb of Cardinal Dubois – that shrewd, shabby Régence figure who managed to grasp a red hat just a year or two before his death in 1723. His weasel's face was criticized inevitably by Saint-Simon, but it is the culminating irony in Guillaume Coustou's image of him (Plate 36). The rest of the tomb, once in Saint-Honoré, is destroyed. It was executed about 1725 and seems from the first to have been wrongly placed. In Saint-Roch the cardinal now kneels against a wall and faces out at the spectator; what Coustou intended was to break the straightforward axis by having the head inclined towards the high altar of Saint-Honoré, as the cardinal turned to share in worship at the Mass. It is this twist of the head, even while the hands remain stiffly in prayer, which imparts so much vivacity to the statue. Something of the effect had already been obtained in the very remarkable kneeling *Joly de Blaisy* (Musée de Dijon) by the distinguished Dijonnais sculptor Jean Dubois (1625–94). But with Coustou there is an unexpected contrast between the heavy folds of cardinalatial robes, the brilliant fringes of rich lace, the pious pose, and that mask of the face, so *rusé*, smiling, Voltairian, unexpectedly sharp and even malicious. All seems to promise a solemnity and piety which the face dispels. It is almost as if the low-born abbé, witty, dissolute, powerful as he was, is amused by his final achievement – forever kneeling as a Prince of the Church, when so much of his life had been passed in other postures.

After the great tombs of the great cardinals, Girardon's for Richelieu and Coysevox's for Mazarin, Coustou's is suitably of lesser range for the lesser man. It dispenses with allegory, and hardly attempts to impress any more than it is meant to be moving. The effect is of directness and intimacy. Despite the bold broad shape of the cape and the deeply cut folds of drapery, bulk is suggested rather than executed in the marble, aided by the vibrant texture it is given; below the waist, the statue and its robes tend to diminish speedily. It would be an exaggeration to say that it is basically a bust that has been extended – for the biretta and cushion are there for horizontal emphasis – but it is the upper half of the statue that has really absorbed the sculptor. In Coustou's later comparable tomb, for Forbin Janson (at Beauvais, 1738), begun by Nicolas, this is no longer true; but lost there is that concentration on the features which, along with the turn of the head, makes the statue of Cardinal Dubois so spirited and so impressive.[63]

Something of the same directness and honesty is given by Coustou to the full-length of the young *Marie Leczinska as Juno* (Louvre) (Plate 37), begun in 1726 and finally paid for in 1733. Inevitably this invites comparison with Coysevox's *Duchesse de Bourgogne as Diana* (Louvre, 1710), and it is obviously inspired by the earlier statue. But it is in many way a less Rococo piece of work, more solidly handled, more compact in its design, and more static in pose. Despite the squeezed-out clouds – like thick paint pressed from a tube and overflowing the pedestal – the figure is less airborne than Coysevox's breathless, hastening, graceful woman. This unexpected difference between the work of uncle and nephew does not make for neat generalization about increasing Rococo tendencies in eighteenth-century France, yet it is a difference that becomes quite explicit when one examines the two sets of *Horses*. What is, however, equally true is that Guillaume's *Marie Leczinska* does appear 'rococo' when compared with Nicolas' companion piece of Louis XV as Jupiter (executed in the same years). This

is simply a heroically posed, somewhat dull, Baroque statue. Guillaume's is animated by a feeling once again for character: not yet the placid bourgeoise of Nattier's familiar image, the queen is shown youthful, unflattered, with an individual likeness which has its own piquant, unexpected, charm. The flying putto at her thigh gives an otherwise static composition welcome vivacity and softens the mood into playfulness. The putto presses forward with the sceptre; Marie Leczinska half-idly grasps the crown of France, while the shield with the lilies is barely noticeable. All that in Coysevox seems taut grace is here relaxed. The personification as Juno is only partly serious, though it has certainly its apt application for a woman whose husband was so constantly to deceive her.

But Guillaume Coustou remains, above all, the sculptor of the Marly Horses (Plates 38 and 39). To nearly everyone – except Caylus, the champion of Bouchardon, Coustou's pupil – the *Horses* were one of the finest achievements of the century. They originated in a significant discovery, made only after the death of Louis XIV, that the pair designed by Coysevox for the abreuvoir at Marly was not sufficiently large to fill this somewhat difficult position. And with this new aspect of taste went a change in the concept of what might, superficially, seem similar. Coysevox's pair are specific allegories: divine, winged animals, effortlessly bounding skywards, and as effortlessly bearing Mercury and Fame, who do not even sit astride but perch, enchanted, against the horses' flanks. They enshrine the idea of military victory, with a tumble of armour over which they rear. It is they who have a sort of Rococo abandon, symbolized by the essentially decorative twist to the tail of Mercury's horse, which curls round completely to touch its rump. Throughout, they are animated by decorative poetry; they are steeds sprung into existence beside some classical stream and themselves, like Pegasus, capable of making a fountain gush over their hooves. And all this refinement must have seemed more obvious when they stood beside what was literally a horse pond.

That is the starting point for Coustou's conception. His *Horses* are not so much decorative, still less elegant, but romantic and natural. Rough-hewn rocks replace those trophies of arms, and emphasize the natural and untamed spirit of the rearing animals whom their naked attendants can barely control. Man and beast are in conflict now. These horses, for all the savagery of their jagged manes and staring eyeballs, remain earthbound, just as they remain riderless. They break out of the monumental Baroque into a wilder manner and express a desperate urge towards the freedom of being natural. All the formal beauty of the gardens at Marly virtually ended with the horse pond: closed at one end by a terrace where originally Coustou's *Horses* stood, and at the other shallow and open to allow ordinary, real, horses to enter the water.[64] Nor were Coustou's statues placed, as far as one can judge, at anything like the extreme height they are now at the entry to the Champs-Élysées. Their plinths were quite low, keeping some contact between the onlooker and these forces of nature held in stone. Part of their power is in their directness. They are not meant to glorify *La France*, nor were they ever intended for an urban setting. Surrounded by the woods and ponds of Marly, they were, rather, an early expression of the romantic wildness of nature. The men who struggle with them are identified by Dézallier d'Argenville as a Frenchman and an American[65] – and they adumbrate in more ways than one a new world. Only Napoleon

will be able to mount such fiery horses; and only Géricault will do full justice to the battling sense of man versus beast.

The models for Coustou's *Horses* were ready by the Salon of 1740 but could not be exhibited there owing to their size. They are mentioned in the *livret* as available to be seen in the sculptor's studio. And in 1745 the groups themselves, the marble for which had been selected at Carrara by Michel-Ange Slodtz, were set up at Marly, where they remained for fifty years. Their popularity probably dates from 1740 and is attested by numerous small-scale replicas as well as by written testimony. Yet it is doubtful if they exercised any significant influence on any French sculptor of the century – except Falconet. Coustou himself was briefly to train Bouchardon, but this would hardly be guessed from their two styles; and they appear to have retained a natural antipathy to each other. Coustou's son Guillaume II was established as a successful sculptor before his father's death in 1746, but he was another sort of artist who was to achieve his own minor masterpiece in a very different key.

Van Clève – Cayot – Le Pautre, Frémin, Le Lorrain

Much older than Nicolas Coustou was that long-lived sculptor Corneille van Clève,[66] President of the Académie when Watteau was admitted in 1712. Like Watteau, Van Clève was Flemish in origin. The son of a goldsmith, he was born in 1645 and did not die until 1732, only a year before Nicolas Coustou. He was to be employed at Versailles and Marly on very similar decorative work to that of the Coustou. Like them he studied at the French Academy at Rome and, rather unusually, spent a further three years at Venice. He returned to France in 1680, impregnated not only with Bernini but with – one may guess – the work of another Fleming like himself, Duquesnoy. Nor had he failed to study Annibale Carracci's frescoes in the Farnese Gallery; his *morceau de réception* (presented in 1681), the *Polyphemus* (Plate 40), is directly derived in pose from Annibale's composition there, and his inventory at death recorded, among much else, 'la gallerie de Carach, complette gravé'. Nevertheless, despite its derivative nature, the *Polyphemus* is important as the first reception piece to be a completely modelled statue and not a bas relief. Its forceful musculature and robustly confident air initiate a whole series of such pieces; and its influence can be traced as late as Guillaume II Coustou's reception piece, the *Vulcan* of 1742.

Exposed to direct comparison with the work of Nicolas Coustou, as in the two groups of *Rivers* in the Tuileries, Van Clève's appears rather timid and over-finished in its details. Here the scale was perhaps larger than he was quite happy in, but the refined surface, and the tendency to decorate it (for instance in the paddle held by the figure of the Loire, the urn of water, and the cornucopia), were part of his intense obsession with his work. His character was naturally withdrawn and somewhat solitary; even at the Academy gatherings he was inclined to be prickly (the exact term is applied to him by Caylus).[67] There is a certain lack of ease in his work; though it is always competent, it tends to be insipid. Its most attractive aspect is found in the groups of playful putti which were executed for the Parterre d'Eaux at Versailles. Here Van Clève seems to

show an instinctive response to those words of Louis XIV's famous letter of 1699, which are like an unconscious prophecy of a new attitude to decoration: 'Il faut de l'enfance repandue partout.'[68] The presence of putti is hardly in itself sufficient to make the Rococo style; and rioting little cupids go back through Duquesnoy to Titian and to the copyist who placed the mischievous creature at the feet of the Ludovisi *Mars*. But the decorative possibilities of children in sculpture, explored notably by Sarrazin in seventeenth-century French sculpture, are taken up by Van Clève and culminate in something of a masterpiece by his assistant Claude-Augustin Cayot (1667–1722).

Cayot began as a painter, studying under Jouvenet, and then turned to sculpture.[69] He was in Rome at the French Academy and then returned to France to become Van Clève's assistant. The degree of his collaboration is not sure, but possibly he worked on the putti at Versailles. Somewhat similar groups by, or attributed to, him add a significant theme lacking in Van Clève's treatment – a definite flavour of the erotic. The *Cupid and Psyche* (London, Wallace Collection) (Plate 41), signed and dated 1706, has often rightly been singled out for being at once so early and yet so fully eighteenth-century in sentiment and treatment. The group contains in essence the children of Pigalle and the *Cupid* of Falconet, and is more flagrantly pretty than either of those sculptors' work. Its pervasive infantile grace is such that Psyche too has become a child – a very unusual motif – but the play between the two children is hardly innocent.

The piece has an almost Alexandrian sophistication and provocation. Marble is handled until it takes on a butter-like meltingness (with all that 'souplesse ... qui fait le véritable caractère de la chair' which was the exact quality Caylus indicated as lacking in Van Clève's handling); where Psyche's hand clutches at Cupid's arm, the flesh yields slightly under her pressure, giving the faintest tremor to the contour. The children who had decorated fountains or played with animals were rustic but ignorant compared with this interlaced pair so fitted for a boudoir, both stimulating and stimulated. Although the group might well be directly inspired by the embracing winged children in the centre of Titian's *Venus Worship*, it speaks a less frankly sensual language and one more titillating. A very conscious concept of modesty placed that piece of drapery between the thighs of a girl who has hardly ceased to be a baby – concealing the sex of one barely possessing sex. These highly experienced children do not quite kiss but savour the moment of their lips' proximity without actually being in contact. An age-old erotic thrill is given new excitement by being expressed in the youngest possible protagonists.

A definite drama, also inspired by love, is apparent in the even more sophisticated *Death of Dido* (Louvre) (Plate 42), Cayot's *morceau de réception* of 1711. This combines detail of the sort approved by Van Clève with an appropriately writhing Rococo dramatic pose: Dido emerges here as one of the first operatic heroines of the new century, suitably enough when a few years later Metastasio was to produce *Didone abbandonata*. More directly relevant for Cayot were probably the almost contemporary Aeneid decorations by Antoine Coypel for the gallery of the Palais Royal, where the *Death of Dido* was naturally included; that scheme seems to have prompted renewed artistic interest in the whole love story, testified by both paintings and sculpture.[70] Cayot's

Dido is a martyr to love, and the whole statue is imbued with a double *frisson* of *l'amour* and *la mort*. The figure's pose is, especially when seen from the side, an almost violent, ecstatic arabesque, emphasized by the very fluent draperies which manage both to cling and to expose. This woman is dying of love, with a sword thrust deeply into her flesh, eyes upturned, and mouth slackly opened. The carefully executed pyre, with Aeneas's armour about it, not only follows Virgil's text closely but adds its own excitement, tilting the figure and also solving the problem of the base of such a statue – every inch of marble being made to play its dramatic part.

All this becomes tame in the bronze version of *c.* 1711 (in the Hermitage) where the pyre is no longer built up to a crescendo and Dido herself is no longer so perilously posed on it. A conventional helmet is placed on the cushion beside her there, whereas in the original marble the helmet is brilliantly displayed, gaping open towards the spectator – a fishy monster's mouth – and given its own staring life by the trick of a huge eye in the headpiece. Cayot's virtuosity in this – one of the outstanding reception pieces of the whole century – embraces mood and execution: he displays a Rococo gamut of dramatic movement, erotic sentiment, and brilliant accomplishment, managing to do all this without the result being trivial. Presented to the Académie while Louis XIV still reigned, the *Dido* does seem to speak a new language, as markedly new as its feminine subject seems new. But in both these things Cayot was not the innovator; and for both of them he was probably consciously indebted to a greater sculptor, Robert Le Lorrain (1666–1743).

Before considering Le Lorrain's rather obscure life and somewhat private career, it is useful to glance briefly at the public careers of one or two lesser sculptors who were also his contemporaries. At the period they were successful and famous, but their styles are not particularly individualized and their chief tasks were very similar to those of the Coustou: working on a large scale for the royal parks and gardens in a decorative Baroque idiom.

The oldest of them was Pierre Le Pautre (1660–1744), son of the engraver Jean Le Pautre, who created several works for Marly and Versailles and who shared in the commission for the 'Companions of Diana'.[71] It was for Marly in 1716 that he completed probably his best-known work, the powerful group of *Aeneas and Anchises* (now in the Tuileries), the design for which had been provided originally by Girardon. Trained in Rome, Le Pautre was anxious in 1695 to return to Paris but was advised not to because at that moment, to quote Villacerf, then Surintendant des Bâtiments, 'on n'y fait rien'.

The closing years of the seventeenth century saw Crown patronage of the arts at its lowest; Le Lorrain was to return from Rome to find the Académie itself closed, and in fact it had narrowly escaped extinction altogether. Le Pautre prudently did not return to Paris until 1701. In the subsequent years sculpture, especially for Marly, was once again required by the Crown and Le Pautre received several commissions. But his prolonged stay in Rome, where he had first gone in 1685, underlines the patronage difficulties which particularly affected sculptors.

The offer of a tempting commission from abroad was to lure several distinctive

sculptors out of France. In 1721 Philip V of Spain, Louis XIV's grandson, turned in-
evitably to France for a sculptor to work in the gardens of La Granja. Le Lorrain con-
sidered but declined the task, and it was René Frémin (1672–1744) who profited from
Le Lorrain's refusal. Frémin, trained under Girardon and Coysevox, made the custom-
ary stay at the French Academy in Rome and was back in Paris in 1699. With the
resumption of commissions for garden statues at Versailles and Marly, several came his
way, including the attractive *Flora* (Louvre), of 1709, which was originally at Marly,
while what was probably a plaster version of it was placed at La Muette. Frémin too
shared in the 'Companions of Diana' series, and his *Nymph* (signed and dated 1717)
is also now in the Louvre.

Sometimes he worked in collaboration with the slightly older and less distinguished
Philippe Bertrand (1661/4-1724). Bertrand's own groups, though touched with some
Rococo graces, seem to belong in the past, the past not only of Girardon but of Giovanni
Bologna. His three-figure narrative groups, such as the *Rape of Helen* (*c.* 1701, Hermi-
tage), are re-workings of the famous *Rape of the Sabines*, from which is borrowed the
device of making the apex of the groups an outstretched arm with gesticulating hand.
Like Giovanni Bologna's, some of Bertrand's groups were duplicated in bronze
reductions; on that scale their grace is more apparent than their force, and the figures
elegantly pirouette in a balletic atmosphere.

Frémin too, before leaving France, had produced some comparable groups, more
svelte than Bertrand's, but with the same contrast and contact of male and female
bodies, lightly conceived 'rapes' in purely decorative terms. At the Salon of 1704 he
showed two such groups, one of *Hercules with Deianira*, the other a *Mercure qui enlève
Pandore*, which seems quite likely to exist in a bronze in the Hermitage (at present
entitled *Mercury and Psyche* and attributed to Bertrand,[72] but more airborne than would
be usual with Bertrand). At the same Salon Frémin exhibited portrait busts of his
parents-in-law – he had married Cartaud's daughter – and it would be interesting to
see his style for these exceptional works in his *œuvre*. Frémin was prosperous and am-
bitious, but Law's 'System' ruined him as it did so many others, including Watteau.
All the more eagerly did he accept Philip V's invitation to Spain, where the major part
of the rest of his life was spent. For the gardens at La Granja he produced a whole series
of statues and fountain figures, executed in lead.[73] Frémin did not return to France
until 1738, honoured by the Spanish king, prosperous again, and with his family
ennobled.

Such would possibly have been Le Lorrain's career if he had chosen to go to Spain.
The reason for his refusal is recorded as the climate. Doubtless this is true, for he had
already been upset by the climate in Rome. Yet there was something in his character
which made him a very different personality from the courtier-like Frémin. And there
was a distinction and poetry in his art which separated him from all the other sculptors
of the early eighteenth century. Part of the mystery about Robert Le Lorrain comes from
the comparative paucity of his surviving work, though in recent years some pieces have
been re-identified.[74] But the amount of his work in Paris was never great. He was little
patronized by the Crown. Probably his finest achievements were small-scale groups for

private patrons, often also his friends, and the beautiful relief of the *Horses of the Sun* (Plate 43), still *in situ* at the Hôtel de Rohan, which remains a secluded work of art.

Le Lorrain was born at Paris on 15 November 1666 and from his earliest years 'eut un goût décidé pour les arts'.[75] Unlike so many contemporary sculptors he had no family tradition in which to be trained, and his apprenticeship was in fact with a minor painter. He is later mentioned as executing pictures, though nothing by him seems to survive. When at Rome he was in the habit of drawing in the streets, and his best work preserved an almost earthy directness and observation. As a sculptor his training was under Girardon, with whom he is said to have worked on the tomb for Richelieu, and he attracted the notice of Le Brun. He won the *premier prix* for sculpture at the Academy in 1688 and was named for Rome. Thus he seemed assured of a successful career when he returned to France, especially as his *morceau de réception* was immediately appreciated on its presentation in 1701. This was the *Galatea* (Washington) (Plate 44), signed and dated that year, and intended as a pendant to Van Clève's *Polyphemus*. Like that, it takes its inspiration from Annibale Carracci's fresco in the Farnese Gallery, though Le Lorrain has not attempted to duplicate Galatea's flying twist of drapery. But the pose – one of momentary stillness, interpreted gracefully and undramatically – is recognizably Annibale's and only makes full sense when accompanied by the complementary Polyphemus, leaning amorously forward from his rock. Galatea turns her head and pauses in her passage over the sea, a figure of lyrical elegance, delicately and yet keenly modelled in piquant contrast to Van Clève's statue. She is one of the first of those feminine nudes which discriminating collectors sought from Le Lorrain, and which seem often to include similar marine classic associations, like the *Andromeda* for Crozat, and the now lost *Thetis*. The *Galatea* was presented to the Academy when La Fosse was director and de Piles its honorary councillor. De Piles is mentioned as one of Le Lorrain's friends, and there must have been a quick sympathy between the champion of Rubens and the sculptor who preferred his students not to be correct but 'échauffés par la nature'.

Though praised for uniting nature and the antique in the *Galatea*, Le Lorrain was really a partisan of nature. Interpreted by his gifts, nature came to mean sculpture that was more relaxed and personal, and on a much smaller scale, than the typical work of the Coustou brothers. Le Lorrain's ideal setting was not a palace interior nor its gardens but the cabinet of an amateur. Though lost, the two groups that he showed at the Salon of 1737 are described in the *livret* in terms which reveal the original concept and unofficial mood of most of Le Lorrain's art – and even the material, terracotta, points to a warmer, more rapid style of execution: 'Deux petits Groupes de fantaisie en terre cuite, l'un representant une fille qui frise son Amant; l'autre une fille tenant un Lapin qu'un jeune homme veut lui arracher, et l'Amour témoin de leur scene.' These sound like Boucher groups in miniature, anticipating one aspect of Falconet. Nor were their mood, size, and material new to Le Lorrain, for already in the Salon of 1725 he had exhibited two small terracotta genre groups, 'des Jeux'.

It was for such work, which had no connection with the antique, that he was specially prized. The younger d'Argenville was right in finding him 'incorrect' though graceful. Mariette did not allow him so much, criticizing him for insufficient study of nature and

for being mannered in his style.[76] The ultimate character of Le Lorrain's work accords with his own personality, which seems to have been socially difficult outside his own circle of discriminating and highly literate friends. He probably disliked the rigour of royal commissions, and it was suggested by his biographer that his career had been passed in obscurity because of his misanthropy and also 'un amour peut être mal entendu de la liberté'. Whatever incidents are concealed under this general remark, the inference is clear. It was less easy for a sculptor than a painter to preserve individuality of thought and action, and that *fantaisie* which is Le Lorrain's strength. Le Lorrain needed liberty.

Although he worked at Strasbourg and at Saverne for the Cardinal de Rohan, he remained for periods without any employment at Paris. It is remarkable how this fact was remembered. Years later his pupil Jean-Baptiste Lemoyne recalled him as in 1723 'peu occupé', and to lack of work were added increasing fits of illness which must have further hindered him. At a period traditionally winter time and in his old age he executed his masterpiece of the *Horses of the Sun* (Plate 43) for the stables at the Hôtel de Rohan at Paris.[77] This now blackened relief over the doorway cannot have been an important commission; indeed, it is obviously less important than the very weathered and restored *Seasons* for Delamair's façade of the Hôtel de Soubise. But the relief of the *Horses of the Sun*, even if compositionally inspired by Marsy's marble group of the subject at Versailles, remains justly famous.

Its exciting surface is achieved by the delicate transitions from very low relief, where clouds and the horses' necks and flailing hooves are lightly incised in the plaster as if drawn, to the projection of the central portion, where a horse's head protrudes, drinking greedily from the beautiful fluted shell, itself gripped by the fully-modelled arm of a kneeling attendant. All might seem casual, mannered, and incorrect to a pedantic eye, but in fact the relief is carefully planned, and then warmed by poetry. The Horses of the Sun are real horses, nervous, sinewy, as restless as the clouds which curl around them, as fiery as the last rays of sun which shoot at the upper left corner. The whole concept remains intensely linear. It emphasizes Le Lorrain's long training in drawing and design – he was, said Lemoyne, 'bon dessinateur et ses ouvrages de sculpture s'en ressentent'.

Yet it is line with the springing vitality of the Quattrocento, with the wild air of Botticelli or Agostino di Duccio, even if a closer stylistic parallel is with the reliefs of Goujon. Le Lorrain ignores the architectural setting, indeed banishes it by treating the wall merely as the support to a thoroughly pictorial effect whereby the rusticated façade is blotted out by drifting cloud. The subject itself is a perfect allegory of freedom, as here at the imagined rim of the world the sun's horses snort and pant and quench their thirst, now unbridled and released from their hot day's task. The relief breathes sympathy and above all a poetic conviction by which classical mythology regains the intensity it had for the Renaissance. That feeling alone would suffice to make it unique in eighteenth-century France.

The relief of the *Horses of the Sun* was not to exercise any influence on the course of sculpture. It is an isolated masterpiece. But though Le Lorrain himself still remains an elusive artistic figure, something of his qualities is apparent in the testimonies – and the work – of his two greatest pupils. Both Lemoyne and Pigalle remained grateful to their

master. To one of Le Lorrain's sons Lemoyne wrote a letter in 1748, already quoted above, which has rightly been shown to indicate something of his own art while defining that of the older man, as well as expressing affection.[78] In Pigalle the imaginative fire of Le Lorrain, an earthy but inspired vigour, is at work from the *Mercury* onwards. As for Lemoyne, who had praised his old master's observation of physiognomies, he was to become the most brilliant portrait sculptor of his period – perhaps the most brilliant France has ever produced.

The Lemoyne

Among the many dynasties of sculptors the Lemoyne cannot claim to be the most distinguished or multifarious. Their claim lies in the very wide and varied activity of Jean-Baptiste Lemoyne (1704-78), whose name – but hardly his output – can be confused with that of his similarly-named uncle. Always esteemed as a portraitist, but usually denigrated for his religious and monumental sculpture, Jean-Baptiste Lemoyne has been treated by posterity much as he was by connoisseurs of the period. A re-examination of what survives of his non-portrait work (much inevitably destroyed) shows how erroneous is the received idea; his art is really one brilliant, theatrically brilliant, whole.

The career of his father is a shadowy anticipation of his own. Jean-Louis Lemoyne (1665-1755) was the son of a *peintre-ornemaniste*, himself the son of a sculptor who had worked on the façade of the Louvre. A contemporary and presumably friend of Robert Le Lorrain, he was to receive many more official commissions in Paris and for the royal residences. And he was also to show a marked gift for portraiture, suitably enough for someone trained under Coysevox. Like his son, Jean-Louis did not visit Italy. In both cases this failure – not connected with ability, for both were academically successful and eligible – may have prejudiced contemporary opinion. Of Jean-Louis it was unkindly said by Mariette that his chief merit was in begetting his son, but this is more spirited than just.

His *Companion of Diana* (Washington) (Plate 45), of 1724, is one of the outstanding statues in this series, and shows a colourful sense of movement and life, gracefully interpreted. It belongs in the world of Le Lorrain's *Seasons* and indeed seems throughout influenced by him. The nymph and her dog hold a positive dialogue, as she inclines her head and gesticulates with that arm which crosses her body – a gesture effective and yet unrhetorical, in which grace is preferred to force. The treatment of the draperies is in the same vein, falling softly from the bosom as the head leans forward, and wrapping themselves gently about the slanting spear at the left. Lemoyne is not particularly original, because his *Companion* is hard to conceive without the example of Coysevox' *Duchesse de Bourgogne* of fourteen years earlier. Less bold and brilliant, Lemoyne's statue is not however dull. It speaks a softer language and explains how the very old sculptor was able to produce, aided doubtless by his son, the Rococo group of the *Crainte de l'amour* (Paris, Rothschild Collection), finished in 1742.[79]

Coysevox was naturally the dominant influence on the portrait busts by Jean-Louis Lemoyne. When received into the Academy at Bordeaux he presented a bust in wood

of the king (Louis XIV). At Paris equally the Academy made his *morceau de réception* a bust of its protector, Hardouin Mansart, and this imposing marble (Plate 46), of 1703, now in the Louvre, is probably the most successful of Lemoyne's official busts. It is the Coysevox formula for the king utilized for the king's representative. This is not Mansart the architect or planner so much as the seignorial fount of patronage. Though his behaviour as Surintendant was capricious, and often harsh, Mansart set in train various artistic enterprises. In Lemoyne's bust he shines out, heavy, confident, assertive, amid a profusion of lace and curls, one of the last *grand siècle* personalities. Everything seems pushing; the marble rolls grandiloquently, but the characterization is otherwise rather slight, smoothed away in an aura of pomp and dubious benevolence.

There is a more spontaneous feeling, and a greater sense of observation, in Lemoyne's busts of fellow artists such as Louis de Boullongne and his own master Coysevox. The plaster bust of *Coysevox* (Paris, École des Beaux-Arts) has a moving mask of face, with vigorous expression.[80] Its air of tousled negligence, and its simple undress, make a pointed contrast with the bust of Mansart. The sympathetic directness so noticeable in the *Coysevox*, explicable probably by real sympathy existing between sculptor and sitter, anticipates the expressive powers of Jean-Baptiste Lemoyne, who seems to have been able to create a link of comparable sympathy and *rapport* attaching him to almost all his sitters. The surviving busts by the elder Lemoyne are all of men except for a single, unknown woman's portrait of 1712 (recorded in the Pillet-Will Collection, Paris). Character is observed but there remains always a conscious sense, thoroughly seventeenth-century, of posing for the portrait; and the curling amplitude of the periwigs, mingling with a marked virtuoso handling of lace in the marble, adds to their public manner.

Despite his extremely long life Jean-Louis did not enjoy an equally long career, for he had been prevented by blindness from working for some fifteen or so years before his death at the age of ninety. Already in 1728 he had asked for his son to remain in Paris rather than take up the pensioner's post that was his in Rome. From that date onwards it is likely that Jean-Louis' work benefited from his son's assistance. Beside this pair Jean-Louis' brother, Jean-Baptiste Lemoyne the Elder (1679–1731), is a very minor, even short-lived figure. It was he who began the group of the *Baptism of Christ* (Paris, Saint-Roch) (Plate 47), which must however be largely his nephew's work, for at his death in 1731 he had done no more than sketch out the St John. The only other surviving identifiable work by him that we know of is his *morceau de réception*, presented tardily in 1715, of the *Death of Hippolytus* (Louvre).[81] This dramatic, Baroque piece is rather awkwardly handled, but shows something of his nephew's talent for bravura effect. It pays tribute to the significant and pervasive influence of Rubens in the early years of the century. Even if it is not positively derived from a particular Rubens composition, it must be generally indebted to him in its pose. While at the same moment Watteau was making utterly original art out of his study of Rubens, a person like the elder Jean-Baptiste Lemoyne could do no more than borrow.

Painting played an important part in the formation also of his famous nephew. Jean-Baptiste the Younger was born at Paris on 19 February 1704 and seemed to have

every advantage of circumstance, with a father talented and prosperous. The collapse of Law's 'System' abruptly ruined Jean-Louis Lemoyne and precipitated his son into a completely professional role at the age of sixteen. He worked by night as well as day; and he was not to cease working for another sixty years. By the standards of Bouchardon he must have seemed unlearned to the point of illiteracy. He never visited Italy – indeed, he did not need Italy. There was in his art something pictorial that makes it unsurprising that he should polychrome some of his religious sculpture. That feeling for painting must have received encouragement during his training under Robert Le Lorrain, and Lemoyne from his early years sought the advice of François de Troy and Largillierre, while painters like François Lemoyne also helped him. Such men were instinctive *Rubénistes*, belonging to the party of Colour, more 'natural' than intellectual in their art, and uncurbed by concepts of the antique.

The standards these artists adumbrated are those by which Lemoyne must be assessed. His fire and brilliance could not be denied, but they could be disapproved of. He represented, without being part of any conscious programme, the Rococo element that was a sort of 'infâme' to be crushed by connoisseurs and classicists in France. Even had Bouchardon been less contemptuous in general of other sculptors, still he would have had an antipathy to the work of Lemoyne. The two men were doomed to be artistic enemies. Bouchardon's comment on Lemoyne's elaborate altar at Saint-Louis du Louvre is inevitable in its sweepingness and as brutal as Cézanne's dismissal of Van Gogh: 'ce n'est pas là de la sculpture'.[82] But, fortunately for art, it cannot be defined by a single style or a single artist, however great. The consistent refusal in eighteenth-century France to do justice to Lemoyne, or to the Slodtz brothers, is merely part of that country's temperament. In Germany at the same period all these sculptors would have been artistically at home, though their Rococo is tame beside the superb achievements of, say, Günther and other Bavarian sculptors.

It is not surprising that Lemoyne should show equal vivacity and fire in portraiture – and there the century's obsession with the natural made it impossible to deny his greatness. However, the category of portraiture was itself not the highest; once back in France, Bouchardon, the supreme example of the correct and classical, executed only a single portrait bust. Yet Lemoyne's range through all the grades of society made his success irresistible. He was Louis XV's favourite sculptor,[83] and the king's taste is as much to his credit as was George III's preference for Gainsborough to him. Lemoyne executed busts of courtiers, magistrates, scholars, great writers, and – most significant of all – actors. His sitters were almost exclusively from French society; unlike Houdon he did not portray a series of distinguished foreigners, but it is fitting that one of the rare exceptions should have been the greatest European actor of the day, Garrick (the bust is lost).

Perhaps there was something of the actor in Lemoyne himself – not in the conventional sense of being a showy personality, for he was the reverse of that – but in what can only be called empathy, whereby he seems to become the personality he is sculpting, so intense is the vitality that plays around the features. He aims more perhaps at expression than at character, and indeed emphasizes expression almost as if making faces in the

mirror. Though never verging on caricature, this element explains why his male busts tend to be more memorably brilliant than those of his female sitters. He remained more modeller than carver; his terracotta busts are better than his work in marble, as Diderot pointed out. And at times he treated marble as if it were terracotta or plaster, those more rapid media where he was naturally more at ease. He always understood that he was translating into sculpture the mobility of flesh and the sparkle of eyes. Long before Houdon he recognized the importance especially of the eyes to convey life and expression; and in the busts of Louis XV (Plate 48) done over a period of forty years he has caught the declining brilliance, the increasing pouchiness, of the king's one-time *beaux yeux*.

Lemoyne's public career begins in 1731. *Agréé* at the Académie three years before, he was in 1731 to receive by chance two important works. The death of his uncle brought him the then largely unfinished group of the *Baptism of Christ* (Plate 47), destined for Saint-Jean en Grève; Lemoyne must have worked on this with tremendous speed, for it is signed and dated 1731. In contemporary eyes a much more distinguished commission was the bronze equestrian statue of Louis XV for Bordeaux which had been given originally to Guillaume Coustou. But so high was the sum Coustou demanded that Jacques Gabriel, creator of the splendid Place Royale for which the statue was destined (cf. pp. 273ff), turned elsewhere in disgust. The Lemoyne, father and son, received the commission, though one was very old and the other very young.

Thus Lemoyne was launched as sculptor of the king; he began with a bust that pleased and went on to the troublesome task of the whole huge statue which was to cost so much time, labour, and money, only to be pulled down at the Revolution. It was set up in 1743, and its appearance is recorded by an engraving (Plate 49) as well as by several reductions which were executed in Lemoyne's studio. France's obsession with equestrian statues of Louis XV resulted in a series of works which seldom seem to have been of great artistic interest, or even variety, as far as can be judged in the virtually complete absence of the original statues *in situ*. In Lemoyne's may be detected a conflict between the requirements of decorum and the artist's natural verve. It had been stipulated that the horse 'sera marchant' but Lemoyne's horse gives the impression that this action has been recalled only just in time – such is the fiery quality of the head and the *élan* which carries the animal forward. The sense of movement is increased by the king's flying draperies, which make an almost romantic silhouette. Inevitably, the statue invites comparison with Bouchardon's, on which the example of *Marcus Aurelius* has laid its restraining hand and where dignity and nobility are expressed in calmness. Lemoyne's is a bravura concept which looks forward to his pupil Falconet's *Peter the Great*. Nor is this quite accidental, for Falconet was in Lemoyne's studio when the statue was being executed, as he later recorded. What was more immediately important to Lemoyne was the king's publicized delight in the model. Despite the rain, the *Mercure* recorded with awe, the king had actually turned aside on his way to La Muette on 29 March 1735, to visit Lemoyne's studio; he had snubbed a courtier who tried to criticize the work and himself had drawn attention to the beauties of 'this superb monument'.

The *Baptism of Christ* (Plate 47) is something very much more original and striking.

Quite apart from being one of Lemoyne's few large-scale works to survive intact, it has the added importance of being one of the few successful pieces of religious sculpture in the whole period. Part of its success, and doubtless part of the reserve it may have inspired among classicizing connoisseurs, is in its deliberate choice of a moment of action. It is in effect a group of frozen theatre, with the figures consciously placed in attitudes that could be held only for a few seconds. This vivid, instantaneous mood culminates in the water pouring on to Christ's head, but it is apparent equally in the expressive faces – St John's almost palpitating, wide-eyed and open-mouthed. The group makes a single frontal impact. Intended for the high altar of Saint-Jean en Grève, it naturally had to make a bold and arresting effect and to hold its own under a cupola supported by columns, but it is not planned to be seen from a variety of angles. Today it is placed against a wall in Saint-Roch. One would not anyway be encouraged to walk around these figures – that again is part of their *coup de théâtre* effect – and, though they are fully modelled, they have a fluid ectoplasmic grace which minimizes any sense of solidity. The result is a thoroughly pictorial concept. Emotion runs excitedly through it, agitating the draperies into flying, creased folds and giving a lyric swing to the figure especially of the Baptist. He virtually dances forward, with that balletic *élan* Lemoyne was daringly to give the king, somewhat similarly posed, in a projected standing statue for the Place Royale at Rouen.[84]

The year after the *Baptism* Lemoyne was involved in a more elaborate scheme of Parisian church decoration, this time at Saint-Sauveur, already mentioned in connexion with Noël-Nicolas Coypel. Some of the accompanying angels around the Virgin were painted, others carved in low relief and coloured. Although no visual record of the scheme apparently survives, and the church was demolished before the Revolution, it is a further reminder of Lemoyne's essentially pictorial decorative gifts. In 1732 they were appreciated as they deserved; the *Mercure de France* was warm in praise of the whole ensemble at Saint-Sauveur, and in particular of the young sculptor who was already 'homme consommé dans son art'. But 1732 was also the year of Bouchardon's return from Italy. In the subsequent twelve years or so, which saw the disappearance of the generation of the Coustou, Le Lorrain, and the rest, Lemoyne's leadership was challenged most patently by Bouchardon. And taste was in general to side with Bouchardon. The two sculptors met in the competition in 1743 for the tomb of Cardinal Fleury; Bouchardon won the commission, but, ironically, it was Lemoyne who eventually executed the tomb.

The fate of Lemoyne's tombs has been almost as unfortunate as that of the rest of his monumental work. Of the four that he executed, two are completely destroyed. The Crébillon tomb, probably always the least successful, is now in the museum at Dijon.[85] The earliest commissioned – and almost certainly the finest – survives in a mutilated state in Saint-Roch: the monument to Mignard (Plate 50), which was originally set up in the near-by Jacobins' church. This was commissioned in 1735 by the painter's daughter, Madame de Feuquières. Her first project, of long before, had been for a mourning figure of Painting with various trophies, surrounding the bust of Mignard executed by Girardon. By the time she came to commission Lemoyne, she had decided

to substitute herself as the mourning figure; the tomb thus became her monument as well, though its central point remained Girardon's bust of her father. That portion of the ensemble survives. How very different, and how very much more elaborate, was the complete tomb Lemoyne executed is shown by Lépicié's engraving of 1743 (Plate 51), the year in which the tomb was finished. The monument was executed in a variety of media. The shield and garlands are likely to have been in bronze; the high pyramid was probably of coloured marble, while the figure of Time and the drapery he wields are recorded to have been of lead.

In this original concept, inspired perhaps by *pompes funèbres* ceremonies, the tomb became the site of a drama, a clash between the imploring woman at its base and inexorable Time with his prominent scythe. The two were connected compositionally by the tremendous twist of fringed drapery which curled around the obelisk and cascaded right down behind the tomb to touch the floor. With brilliantly dramatic effect Lemoyne seems to anticipate the drama of Slodtz' Languet de Gergy tomb. The fullest theatrical treatment is given to the figure of Time – so cleverly attached to the side of the obelisk – whose outstretched wings increase the sense of urgency and menace. As is so often apparent in other tombs of the century in France, the imagery employed is starkly pagan. Death itself is a threatening, leaden curtain which falls alike over genius and filial piety. Beyond the grave is annihilation. It is that to which the Maréchal de Saxe will come in Pigalle's superb concept.

Time or Death – a figure probably compounded of both – was to play its part in Lemoyne's first ideas for the tomb of Cardinal Fleury. That would have been an innovation in the monument for such a highly-placed religious personage. Lemoyne did not include it in his final and much later sculpture which was put in Saint-Louis du Louvre and inaugurated only in 1768. The monument is destroyed, though two mutilated fragments,[86] a description of it, and also a feeble engraving exist. From these it is clear that the eventual design was strongly indebted to Girardon's Richelieu tomb, probably because that had been the patent inspiration behind Bouchardon's own eventual design. Death has been banished, and the aged cardinal quietly expires surrounded by heavily draped allegories of Religion, Hope, and *La France*. Though the mood here was pathetic rather than dramatic, Lemoyne preserved his virtuosity of working in a variety of media and even, it would seem, of tinting the allegorical figures in monochrome so as to achieve an effective pallor in the marble features of the dying cardinal. Although taste had turned sharply away from the Baroque ideas expressed in the Mignard tomb, Lemoyne, while obedient to the new tearful simplicity in his design, continued to execute his sculpture in literally picturesque terms and with consciously theatrical effects.

By a quite easily understood paradox, Lemoyne was using these effects in the interests of verisimilitude. The drama of Christ's baptism, the cutting off of a life by death, or the paleness of a dying head, all were to make impact on the spectator by an actuality more vivid than in real life but closely connected with it. He sought a psychological truth rather than any abstract idea of 'correctness' or dignity in sculpture, still less any imitation of the ancients. It is significant that when commissioned to execute a statue

of St Theresa, Lemoyne wished to borrow a Carmelite habit – managing to do so, incidentally, only with difficulty.[87] He needed that actual garment to begin with, before he could fill it with the fiery sentiment of the saint. His attention to the clothes of his sitters was to be criticized at the time as lowering their dignity, but in fact this is part of the individual envelope of personality which his finest portrait busts possess; out of the wardobe of cloaks, buttons, shirts, Lemoyne created clothes as animated – almost – as the people he put inside them. It is in this sense that his portraiture too belongs in the world of theatre.

Lemoyne's first exhibited portrait busts were in his favourite medium of terracotta and were shown at the Salon of 1738, one of them being a head of *Madame de Feuquières*. Well before this date, however, he was launched on a successful social career as portrait-ist. News of the first Louis XV bust had reached Vleughels at Rome by January 1733, and he begged for a plaster of it. Lemoyne exhibited for the last time at the Salon of 1771; after it had opened he sent a bust of *Marie-Antoinette as Dauphine* (now Vienna) which by its subject alone reveals the span covered by his activity. At the same Salon Houdon made his first appearance with non-Roman work.

Over the years Lemoyne's technique hardly altered. What altered with each sitter was the concept of the bust, altering apparently effortlessly as the sculptor placed him-self before an unparalleled range of society. It is as if it was he who, almost like a tailor or hairdresser, adapted himself to his subject, allowing each to impress an image upon his receptivity – but always an intimate physical image. In plaster and terracotta his bravura effects seem endlessly varied: symbolized by the *tour de force* at the Salon of 1742, when he showed three heads (perhaps with the same features?) at three different stages of life. At times he reduced the shoulder to being hardly more than a single fold of drapery, as with the Arnaud de la Briffe bust (1754, Paris, Musée des Arts Décoratifs) (Plate 52), where the heavily jowled face seems as a result to take on added ponderous-ness and weight. It may be compared with the very different effect achieved in the long-fronted, official marble of Maupeou (1768, Paris, Musée Jacquemart-André) (Plate 53), an almost deliberately old-fashioned bust which exudes a heavy, legal air. Maupeou is invested with that falsely smiling benevolence that so often accompanies the law's undue assumption of its own majesty. The superficial resemblances between the two men's appearances, and their careers, only help to underline the profoundly different concepts which animate them.

Above all, Lemoyne is the sculptor of expression. It was not surprising that he should succeed with such individual and revealing faces as Voltaire's or Crébillon's, but his skill gives individuality to a whole series of faces – some still anonymous – which ex-press a gamut of emotions, from the simpering *Mademoiselle Clairon* (1761, Comédie Française) to the cold, supercilious *Le Cat* (Rouen). It is this mimicry of features which makes the terracotta bust of Réaumur (1751, Louvre) (Plate 54) one of Lemoyne's most stunning achievements. The expression is seized in a positive rictus, the lower half of the face bitten deep into by a trench of wrinkle running down either side of the nose, while the eyes are wide-open and staring. All has been caught as if by flashlight photo-graphy, but the vitality persists from whatever angle the bust is studied. So intense

indeed is its sense of life that it is a slightly uncanny object, especially if unexpectedly encountered, throwing back at the spectator a beam of *trompe l'œil* realism. It lives, as if a personality were enshrined inside the material. No longer a mask, the face here seems like a lantern lit from within.

Lemoyne could not always carry over such effects into his marble busts. He was basically a modeller rather than a carver. It was true, as Diderot complained, that marble was refractory to Lemoyne's efforts; it was simply the wrong material for him, and even its surface contradicts his striving for a warm, palpitating surface which should resemble skin. It suggested the permanent, whereas he aimed at the fleeting. The fragility of terracotta as handled by him comes to stand for the fragility of human existence; and his people are the more moving for being vulnerable. As an artist his final justification could be that he was natural.

Though the century certainly advocated following nature, it was seldom content with art that had no greater ambitions. Already in 1785 the anonymous author of a *Discours sur l'origine . . . de la peinture en France* accused Lemoyne of being 'un des premiers corrupteurs de l'art';[88] he was disgracefully ignorant of the ancients; he had not attempted the nude; the 'true' sculptor's material of marble did not really suit his work. To all these strictures there existed an almost too perfect answer in Bouchardon.

Bouchardon

In contemporary eyes there could be no doubt who was the greatest French sculptor of the century. Cochin (*Mémoires*) represents enlightened opinion, fair without being over-partial: 'M. Bouchardon a été certainement le plus grand sculpteur et le meilleur dessinateur de son siècle.'[89] From the close friend of Slodtz, from someone who was not blind to the faults of Bouchardon either as man or as artist, this statement is impressive. Yet to posterity Bouchardon's place must be lower; his actual surviving masterpieces are fewer than Falconet's or Pigalle's. When every tribute has been paid to his outstanding technical mastery, and also to his ability as draughtsman, it still remains possible to doubt if there is any sculpture by him that really deserves to be called a masterpiece. The truth is that his period over-estimated Bouchardon.

Not only did he represent the sculpture of reason and intelligence, and of intellect in place of passion, but he was the leader of the return, in Cochin's words, to 'le goust simple et noble de l'antique'. That was his title to esteem naturally in the eyes of Caylus and thus in those also of Mariette. However, Bouchardon cannot be treated as some form of neo-classical artist and explained simply in that way. Because of the period, and his character, the situation is more complex. He was the close contemporary of Chardin and Boucher; he rose to fame in France about the same date as did they, and it is impossible to impose a single epithet on the society which welcomed three such diverse talents. Bouchardon, so conscious of his own genius and so disdainful of the gifts of others, recognized the opposition of his style to the alternatives offered by the Adam, Michel-Ange Slodtz, and of course Lemoyne. All those grow in differing ways out of the sculpture practised at the beginning of the century, the tail-end of the Baroque which

curves on from Coysevox to the Coustou brothers. There was no reason why, as Guillaume Coustou's pupil, Bouchardon should not continue the manner; indeed, he was to study the true Baroque very carefully in Rome and was capable, when required, of producing Baroque work.

That he did not usually do so was due to his own nature, not to antiquarian fashion or the advice of Caylus. His stern, rather disagreeable yet timid character, and his proud isolation, must have increased his intention of excelling in a new way, of stamping his work with completely personal authority. Drama, rhetoric, colour, did not appeal to him. He re-asserted the standards of design with all the confidence of being an accomplished draughtsman. The ancients and the great masters of the past encouraged his concept of what was 'correct' and monumental. It is true he copied Pietro da Cortona, but he really studied Raphael and Domenichino's Santa Cecilia frescoes;[90] and they proved the more potent in his development.

Thus Bouchardon is a sharp break across the general pattern of French sculpture in the early years of the century. He must have felt it his duty to bring the picturesque to heel – and hence the harshness of his criticisms and his hostile attitude to fellow sculptors. Hence also the exaggerated care and extreme finish which he gave to most of his work. It was meant as a rebuke but often resulted in flawing the final sculpture; it became too finished, too chaste, and, at times, icily dull. Intelligence and application have polished the surface until all fire is lost.[91] An almost rancorous rejection of the adventitious, or the merely charming, can make his work artistically displeasing. It is perhaps the tragedy of Bouchardon that such a complex personality never received the commission which would have allowed him to express satisfactorily his greatest gifts. Or perhaps the tragedy was that Bouchardon feared to express himself fully.

Edme Bouchardon was born in 1698, son of a provincial but not negligible sculptor, Jean-Baptiste Bouchardon (1667–1742). Two of his other children also showed some talent for sculpture: a daughter who helped her father, and Jacques-Philippe (1711–53), who worked in Sweden and produced some attractive portraits.[92] The father was active at Chaumont, where he settled, and where his distinguished son was to be born, as well as in other parts of Champagne and Burgundy, including Dijon. He was both sculptor and architect. In a provincial milieu he held an important place and ranked as famous. Under him Bouchardon was to receive not only an apprenticeship but his earliest commission – the bas relief of the *Martyrdom of St Stephen* (1719–20), for the church of the saint at Dijon – which is mentioned by the elder Bouchardon in May 1720 as executed 'sous ma conduite'.[93] Thus, before he ever reached Paris, Bouchardon was technically proficient and experienced. Though he studied for a while with Guillaume Coustou, he probably thought he had little to learn from such a source. In later years he openly expressed disdain for his old master, who had warmly recommended him for the journey to Rome.

By the autumn of 1723 he was a pensioner there at the French Academy. His talent had been publicly revealed when in 1722 he won the first prize for sculpture at the Academy in Paris; the following year the winner was Lambert-Sigisbert Adam, and together the two new pensioners travelled to Italy. It was a significant moment in France:

the year of the death first of Cardinal Dubois and then of the Regent Orléans. Long before either Bouchardon or Adam returned home, Louis XV would have begun to reign in earnest and France would have regained some stability under Fleury.

There was some irony in the proximity of the two young sculptors, both trained in the provinces, both about to experience at first hand 'le goust simple et noble de l'antique' – with very different results. In Rome they were often to be placed in direct artistic rivalry, and though the French seem from the first to have preferred Bouchardon, it was, for instance, Adam who won the Fontana di Trevi competition. In Rome they shared several patrons, and a few years later in Paris they were to share at least one commission; Adam's contribution then was the worst object, according to Bouchardon, that he had ever seen. Adam undoubtedly was the inferior sculptor – posterity, said Cochin, will never understand how he could have been paragoned with Bouchardon – and yet it is possible to see hints of Adam even in Bouchardon's Rue de Grenelle fountain.

Like all pensioners, Bouchardon was set the task of copying an antique statue for the king. His was the Barberini *Faun* (1726–30, Louvre), and the resulting free interpretation, rather than copy, took several years to complete. It did not reach Paris until 1731 and was not seen by d'Antin until the spring of the following year; a few months later Bouchardon himself was back in Paris. His delay on the royal commission was only the first of his delays, but it is easily explicable. What had seemed promise in Paris now blossomed into accomplished fact in the sympathetic artistic climate of Rome. Bouchardon executed and projected a whole range of works which carried him far beyond the status of a student. In Rome he became famous. Well might d'Antin, pressing for the return of him and Adam to France, coldly point out: 'ce n'est pas pour enrichir les paiis étrangers que le Roi fait tant de dépenses à son Académie'.[94] Although Bouchardon did not, as he had hoped, enrich Rome with a fountain, nor execute the tomb of Clement XI, nor even the figures for the Corsini Chapel at St John Lateran (for which he was definitely commissioned), he did carve several remarkable portrait busts.

That of Philipp Stosch (Berlin-Dahlem) (Plate 55) was the earliest and in some ways the most remarkable. It was completed in 1727 and is consciously revolutionary in its cold, pure classicism.[95] Not only the portrait of an antiquarian, albeit a shady one and a spy, it is deliberately antique in concept and execution: indeed, so completely neoclassical is it that one is surprised to realize that Winckelmann was only ten years old when it was executed. Though Bouchardon certainly studied busts like Bernini's of Cardinal Borghese, what he has produced here is a rejection of the Baroque. It is such a perfect pastiche of the late classical style that it might be of some short-lived, decadent emperor – and Stosch would probably have appreciated that analogy. Nor is the concept to be explained entirely by Stosch's own classical interests, for Bouchardon was soon after to conceive a life-size virtually naked statue of the *Prince de Waldeck* (1730), while the sole portrait bust he executed in France was that of the *Marquis de Gouvernet* (1736, Comte Aynar de Chabrillan), where he dispenses with even the formal strip of drapery appearing on the Stosch bust. That represents one extreme of Bouchardon's

Roman style. It was followed by other busts, of women and men, two of which were of English sitters and were despatched from Rome to London.

Bouchardon's Roman patrons were naturally extended to include the French cardinals Rohan and Polignac; he executed busts of both of them.[96] His entry into the circle around Cardinal Albani, facilitated doubtless by the Stosch commission and by his friendship with Ghezzi, was to be useful. And when in 1730 a Corsini pope was elected as Clement XII, the friendship of Vleughels and the art-loving papal nephew Cardinal Neri Corsini brought Bouchardon the important commission for a bust of the new pope. This impressive marble (Florence, Prince Tommaso Corsini) (Plate 57) shows that, while Bernini had not been looked at in vain, Algardi was the more distinct influence. Bouchardon aims here at the natural and actual, with virtuoso treatment of the cape, the cap, and the fur trimmings, all enhancing the dignified portrait likeness itself. The concept had already been fixed, even to the direction of the head, in the Polignac bust; but the papal one is still more highly finished in its details – as in the patterned stole with its knotted cord and tassel – and the whole bust is finished off by the soft line of the fur-edged cape. Attention has been paid particularly to the sitter's eyes, the pupils being only lightly incised: perhaps to suggest the pale colour of them (they were blue) and also the milky gaze of incipient blindness.

The bust of Clement XII thus represents the other extreme of Bouchardon's art from the bust of Stosch. While the latter lifts the sitter out of everyday appearances, and out of time too, the Clement records in exact detail an old man in papal vestments; though it is dignified, it makes no gesture in the direction of rhetoric or flamboyance, and its dignity is the pope's own. The same extremes are everywhere in Bouchardon: from the elevated nobility of the Rue de Grenelle fountain to the common street genre of his 'bas-peuple' in the 'Cries of Paris'. Perhaps it could be said that, rather like Batoni and Mengs, he is better at his more natural, when not attempting too public a statement. Yet in Bouchardon the extremes were really part of the same character, and not discrepant. His art is based in realism, in ruthless study of the natural appearance, and he never generalizes. It is on a basis of the natural, the truthful, that he imposes classical calmness. In the *Marquis de Gouvernet* bust Caylus praised 'le sentiment de la chair, joint à la plus grande simplicité'.[97] For him, as for the sculptor, that is a perfect alliance of the natural and the antique; from that alliance springs the finest art.

However, it was not always easy for Bouchardon to find opportunities to achieve this alliance, itself one that came only after great pains had been taken. When he returned to France, to a career of just thirty more years, he instinctively expected some important royal commission to compensate him for what he had potentially left at Rome.[98] What he first received was the command for a statue to replace Coysevox' *Louis XIV* in the Coustou *Pietà* in Notre-Dame. Bouchardon disliked the task, probably hardly worked on it, and abandoned it a few years later. His imperious ideas were bound to conflict with the civil service attitude of royal servants and with the implications that he too was only a servant. By 1736 d'Antin was warning him, 'si vous voulés que le roi se serve de vous', to be less difficult and to stop his daily demands for money. More aggressive than Le Lorrain, Bouchardon was equally expressing the artist's wish for

independence. Meanwhile, he executed in boldly Baroque style a *Hunter with a Bear* which, with a pendant by Adam, was presented by Louis XV to his Garde de Sceaux, Chauvelin,[99] and entered into arrangements with Languet de Gergy, the curé of Saint-Sulpice, for a series of twenty-four stone statues of which only ten were completed, and then probably with studio assistance.

While the court was always to remain somewhat unenthusiastic about Bouchardon, the party of connoisseurs represented in Paris by Caylus and his familiar Mariette expressed enthusiasm of a type no previous sculptor had enjoyed. Not content with praising Bouchardon, they must denigrate other sculptors; and in the end they had actually contrived to damage his reputation by their ruthless treatment of potential rivals. Mariette was, however, especially useful as the anonymous writer of pamphlets in praise and defence of Bouchardon's two famous achievements,[100] one for the city, the other for the court – and neither left uncriticized: the fountain of the Rue de Grenelle and the *Cupid*. Bouchardon needed some mediator with the public, to explain why neither of these works was like the ordinary presupposed concept of a fountain or the god of love.

In 1737, when the re-established Salon opened after twelve years, he exhibited more pieces than any other sculptor, and displayed the full range of his talents and media, perhaps at the instigation of Caylus. There was his marble bust of Cardinal de Polignac; sanguine drawings which ranged from the learned (*Les Fêtes de Palès, célébrées chez les Romains* . . .) to portrayal of Mariette's children; and the brilliantly dynamic terracotta models connected with the Chauvelin commission which were to enter the cabinet of the discriminating Jullienne. In 1737 these exhibits represented Bouchardon's declaration of his stature as an artist. They seemed also to underline the fact that no single important commission had come his way since he returned five years previously from Italy.

This was quite soon remedied. The first contract for the Rue de Grenelle fountain was signed between the city of Paris and the sculptor on 6 March 1739. And in that year Bouchardon exhibited at the Salon his terracotta first model for the *Cupid*. In Rome not only had he competed for the Fontana di Trevi but, as his drawings record, he had familiarized himself with Bernini's fountains. The combination of water and sculpture must indeed have fascinated him, and he effortlessly fantasized on the theme in many drawings (Plate 58). At Versailles he had contributed to the Bassin de Neptune scheme, though the major part of that decoration had gone to Adam. In the Salon of 1738 Bouchardon showed 'an idea of a public fountain for a city', and perhaps the Rue de Grenelle commission was already under discussion. The civic theme was to be a significant aspect of the final monument, as was Bouchardon's awareness that he was not working for a piazza in a southern country.

But it is reasonable to think that some aspects of the Fontana di Trevi project remained in his mind. The linking of the fountain to an architectural screen may have been partly forced on him by the restricted, awkward terrain of the Rue de Grenelle site. Yet it was, for different reasons, inherent in the Roman plan all along; Salvi's eventual design is more classical than Rococo, and the concept of wedding façade and fountain can be

traced back to Pietro da Cortona. Bouchardon's fountain is the final repercussion of that. He may even have recalled Adam's winning design, which is known to have included in the upper portion a seated statue of Rome flanked by Doric pillars. Or Bouchardon himself may have included such a motif in his submitted Trevi project, and re-worked it for Paris. What he undoubtedly did was to curb any elements of fantasy, suggestions of Baroque jets, rocaille sculpture, or anything that might evoke the garden world of Versailles and Marly. It is sometimes hard to remember that Guillaume Coustou's *Horses* are closely contemporary with the fountain of the Rue de Grenelle.

This was being cleaned at the time of writing, but there has emerged a startling contrast between the white marble figures of Paris, with the reclining Seine and Marne, and the honey-coloured stone against which they are set (Plate 59). Most photographs make the whole scheme look dull and rather pompous, and oddly Second Empire in effect. The urban setting, the narrowness of the sloping street, the public utility of the proposed fountain – all these contributed indeed to the creation less of a fountain than an architectural façade. As a result, the theme of flowing water has been repressed to an almost ludicrous degree – two taps at the base of the central feature. Voltaire and Diderot, and Laugier, shared an astonishment at the absence of this *raison d'être* of the whole monument. It is doubtful too whether the sculpture is bold enough in scale or execution to hold attention, placed so sparingly along the façade, and raised so high above the ground. Only the central group is in marble, so that the statues of the Seasons tend to merge into their niches, and even the famous bas reliefs below (Plate 60) play only a minor part in the scheme as a decorative whole.

It seems likely that Bouchardon miscalculated, for Cochin saw the sculptures in the artist's studio and *in situ*, and found that in the latter they had lost half their original effect. To impose on a very powerful and high façade they needed to be conceived on a much grander scale; and even their actual scale appears diminished by the meticulous finish, which seems to have robbed them of vitality. The seated Paris is a chilly figure of draped rectitude, a Roman matron dwarfed by the huge portico behind her and herself as much a façade, hiding inner emptiness. To Mariette, the richness of the complete scheme was achieved by its extreme simplicity. But looked at without his *parti-pris*, its simplicity hovers dangerously on the borderline of banality.

The figures of the Seasons are individually more *mouvementé* and graceful, and the bas reliefs below are positively playful. Among the Seasons, the pose of Spring seems to show notable anticipations of the statue of Cupid, the *Amour se faisant un arc de la massue d'Hercule* (c. 1750, Louvre), which Caylus said was a subject chosen by Bouchardon himself: 'il préfera celui de l'Amour, adolescent . . .'.[101] Even more than at the Rue de Grenelle does the resulting work (Plate 56) illustrate Bouchardon's dilemma. In his anxiety to follow nature by studying naked adolescents he was led first into an awkward incident on the banks of the Seine and then, more artistically serious, into the awkward problem of how far to reproduce exact nature in a mythological work for the Crown. The result did not seem in court circles to be a successful fusion of the natural and the antique; it looked more like Cupid turned into a street-porter, it was said, while the intended action of the figure was merely puzzling. This cannot be

criticized as too literary to be translated into art, since it is the exact action in a Parmigianino composition, a copy of which probably influenced Bouchardon. But Bouchardon stopped well short of charm and grace; he checked his figure's movement so that it remains either not sufficiently pronounced or disturbing in what might otherwise be complete repose. The head is deliberately stylized and the elaborate hair is flattened with broad bands and then twisted into strange corkscrew curls.

The whole concept is akin – as concept – to Falconet's *Amour menaçant* (Plate 89), completed a few years later. But the results are different in every way. Falconet does not try to resist, instead surrenders to, all the implications of slyness, erotic charm, and decorative effect; the result is a perfect boudoir child. Bouchardon's *Cupid* is at an awkward age, and his awkwardness is emphasized by the action. It is apparent in the dichotomy between winged god and Parisian adolescent which was rightly detected at Versailles. The statue was destined for the Salon d'Hercule, but it was rapidly banished to Choisy. Bouchardon protested that his work was not intended for a garden but a room. He may even have thought that he had made some concessions to court taste, and it might be judged appropriate that the Hercules motif had been introduced into a statue to stand in the Salon d'Hercule. However, in 1752 Marigny was stating the categorical fact that it must go, 'puisque le Roy ne la veut absolument pas dans le salon d'Hercule'.[102] At Choisy it was placed in a miniature temple of its own. Perhaps France was lucky to retain it at all, for despite the fact that it had been a royal commission, Bouchardon stated that he had had a better offer from an Englishman; and as a result the Crown had to pay an unusually high price for the statue.

It was possibly Bouchardon's insistence on being paid at his own valuation that led to the collapse of the royal project for a monument to Cardinal Fleury.[103] Judging from the surviving maquettes, it seems likely that he would there have achieved an indisputable masterpiece. The death of the aged minister in 1743 was quickly followed by the king's expressed desire to build a worthy tomb for him. Among the competitors Bouchardon, Lemoyne, and Adam stood out; it was Bouchardon who received the commission, but for reasons never made explicit he did not execute the tomb. When it was finally carved by Lemoyne, the cardinal's family – not the king – paid.

Bouchardon designed no less than four models, two considerably evolved (both Louvre); the first is a clear recollection of Coysevox's Mazarin tomb and the second equally clearly recalls Girardon's Richelieu tomb. Fleury had achieved great but unspectacular things for France; he had preferred peace to glory, and was by no means unworthy of that analogy with the cardinal ministers of the *grand siècle* at which both Bouchardon's designs hinted. The earlier maquette expresses the public sense of loss at the death of a distinguished statesman; France holds three crowns of laurel, oak, and olive, symbolizing respectively the cardinal's care for his king, his country, and peace; afflicted Virtues mourn over the globe, where Europe figures prominently. This grandiose concept gives way to something more direct and pathetic in the second maquette (Plate 61), whose design was approved by the king. No longer kneeling, Fleury is shown expiring in the arms of Religion. Though France is still present weeping, the crowns have gone, as have the globe and other allegorical trappings. The cardinal's

achievements are hardly referred to, and the whole concept has become not only simpler but more private. This design suited Bouchardon as much as Louis XV; he was artistically much closer to Girardon than to Coysevox, and the refinement of his hand-ling of, for example, Fleury's draperies is apparent even in the small wax maquette. Perhaps in the eventual marble their flowing lines, which seem to symbolize the dis-solving consciousness of a dying man, would have been wrought too carefully to retain this delicate harmony.

Bouchardon's final important commission was to be worked on so long, and with such intense application of detail, that he never lived to complete it. This was the huge equestrian statue of Louis XV, commissioned by Paris formally in 1749 for the Place Louis-Quinze (Plate 62). More than four hundred surviving draw-ings testify to Bouchardon's pains over this project, which cost him so much labour in the very years that he was growing ill.[104] For some time before his death in 1762 he had suffered from 'une main tremblante' – a particularly cruel affliction for one who had been such an accomplished draughtsman. The *Louis XV* must have seemed to him to offer the ideal opportunity to crush the reputation of Lemoyne; and it is reasonable to see it as a 'reply' to the famous statue at Bordeaux. The horse and rider are almost too patently inspired by the *Marcus Aurelius*, but corrected by greater truth to nature. While dressing Louis XV in Roman military style – thus differently from the pacific togaed figure of the emperor – Bouchardon produced a much more profoundly studied and more pensive horse.[105] For the pedestal he conceived something quite novel – neo-classical rather than classical, and perhaps faintly ludicrous as well: four Virtues who effortlessly supported the platform in place of the conventional slaves. Hints towards this concept are provided in the Louis de Brézé tomb at Rouen, with its caryatid figures, and also in the balcony of the ground-floor Salle at the Louvre by Goujon. The idea of praising men by showing around them statues of men they had enslaved was to be criticized by Voltaire, and in turn very consciously rejected by Pigalle. Bouchardon re-jected it too, perhaps more on artistic than enlightenment grounds, but his solution seemed absurd to Grimm. Yet more 'enlightened', Grimm would have liked to see great contemporaries like Saxe, Montesquieu, and Voltaire himself, at the feet of the monarch.

The *Virtues* were Bouchardon's final expression of a preference for the ideal over the actual; they take up that classical interest made patent as early as the bust of Stosch, but the shift is now from Rome to Greece. More slender and more graceful than the Rue de Grenelle *Paris*, they belong in a much more profoundly classical world. Their effect has to be judged largely from engravings and reductions, since the monument was inevitably destroyed at the Revolution. But in addition there remains the mutilated wax maquette (at Besançon) where two headless, armless bodies beautifully animate the corners of the pedestal, seeming to flow into it, so organically do they belong there. Their draperies, hinting at the forms beneath, have an effortless, rhythmic rightness that is classic as well as classical. Though they have come a long way from the caryatid porch of the Erechtheum, these figures are recognizably akin.[106]

The actual full-scale statues were the part of the monument on which Bouchardon had done least. Humbled by illness and by awareness of approaching death, he – who

had scorned so many great fellow-artists – had finally to seek one worthy to complete his work. The Caylus party naturally assumed that their creature Vassé would receive the dying sculptor's voice, but Bouchardon's intelligence triumphed over intrigue. In his solemn letter of 24 June 1762 to the city of Paris he declared his chosen 'cher et illustre confrère', naming the greatest: Pigalle.[107] Little more than a month later, Bouchardon was dead.

The Brothers Adam

Along with Lemoyne, the name and the presence of Lambert-Sigisbert Adam (1700–59) had long haunted Bouchardon. Adam stood not only for a style but for a team practising it, of which he was the business head. In sheer talent he was inferior to his younger brother Nicolas-Sébastien (1705–78), but he asserted himself by a pushing character and an almost desperate determination to receive commissions. Cochin was right to think posterity would be puzzled by contemporary opinion that Adam shared artistic honours with Bouchardon, but in fact opinion was gradually turning all the time against Adam. Nicolas-Sébastien lived to receive Diderot's abuse, and soon after the two sculptors were forgotten. If they were mentioned at all it was because their nephew was Clodion.

Yet no more than the admittedly much greater Lemoyne did the Adam deserve abuse or neglect. Nicolas-Sébastien produced one of the few poignant monuments of the century – but not for Paris. Lambert-Sigisbert reached a decorative peak in the *Bassin de Neptune* statues which justified the choice of him for the task, though admittedly he never again came near equalling that achievement. The Adam were consciously court artists, unassailed by doubts about nature, antiquity, correctness, or morality. They conceived their function to be decoration. To this they were restricted by a lack of ability in portraiture; one of their rare essays – Lambert-Sigisbert's bust of Louis XV – led to a tangled tragi-comedy in which Adam's persistence was defeated only by the king's absolute determination to refuse the object.

The Adam family had a long-established connexion with Nancy and with sculpture. Perhaps Claude Adam, active in Rome in the seventeenth century and sometimes wrongly supposed to have carved the *Ganges* for Bernini's *Four Rivers* fountain, was a relation of that Lambert Adam of Nancy, a *maître fondeur*, whose son was Jacob-Sigisbert (1670–1747). He was a sculptor and the father of three sculptor sons, of whom Lambert-Sigisbert was the eldest. Though he is said to have visited Paris late in life, when his sons were well-known and active there, he was basically a provincial figure, occasionally employed by the court of Lorraine and executing statues in wood, as well as small-scale terracotta pieces. He trained his sons carefully and perhaps exercised some hereditary influence over his daughter Anne, the mother of Clodion.

Lambert-Sigisbert was to break out of this provincial milieu and to start on a career which each of his brothers followed. He left Nancy for Metz at the age of eighteen and then made the long, significant journey to Paris. In 1723, when Boucher won first prize at the Académie for painting, Lambert-Sigisbert won that for sculpture – though

he was the only sculptor competing. That year he accompanied Bouchardon to Rome, where Cardinal de Polignac quickly became his patron. Adam added to and altered the cardinal's antique sculpture and in 1724 produced busts of *Neptune* and *Amphitrite* (Charlottenburg) which the cardinal immediately acquired. Despite their classical subject, these are patently Baroque in feeling, but rather slack in treatment. The orientation to Bernini may already be apparent here and soon becomes the dominant note in Adam's strangely limited style. The starting point for his *Neptune* bust is indeed likely to have been Bernini's *Neptune* group (now Victoria and Albert Museum) at Villa Montalto, and a few years later Adam was producing some quite conscious full-length derivations from that.

Though he presumably satisfied Cardinal de Polignac as a restorer and interpreter of antique statuary, though he dutifully copied the Ludovisi *Mars* and built up his own collection of Greek and Roman sculpture, he was scarcely touched by any classicizing tendencies. He might mention his classical studies when pressed, like Bouchardon, to return to Paris; but he was speaking nearer the truth when he mentioned, as an additional reason for remaining in Rome, his wish to give deeper study to Bernini's style.[108]

Soon the Adam family was re-united in Rome. In 1726 came Nicolas-Sébastien, who was already a speedy and experienced worker, though untrained at the Academy. Finally, the youngest brother and the most mediocre as an artist, François-Gérard (1710–61), arrived. His signature was not put on the joint work of the Adam; and, though he was to become first sculptor to Frederick the Great, he seems to have been summoned to Berlin originally in mistake for Nicolas-Sébastien. Left to himself he produced a series of garden statues for Potsdam, adequate but uninspired.

The basic attraction of Rome for Lambert-Sigisbert was the series of important, attractive commissions he received. It was he who won the competition for the Fontana di Trevi,[109] though machinations saw to it that such a prize did not eventually go to any foreigner but to the native Salvi. This sort of decorative sculpture was perfectly suited to Adam, as he made clear at Saint-Cloud and, most triumphantly, in the *Bassin de Neptune* at Versailles. Meanwhile, at Rome he completed a bas relief for Clement XII's Corsini Chapel in St John Lateran, and on the strength of it was received into the Accademia di San Luca. Given the situation in Rome, and granting that prejudice against foreign artists could be overcome, Adam might well have had a more fortunate career in Italy than in France. Before him Pierre Legros stood as an example of such a transplanted career,[110] while a few years after Adam left Rome Michel-Ange Slodtz was to begin there a whole series of masterpieces, culminating in the Montmorin monument.

Speedy in execution, imaginative rather than intellectual, Adam had not a wide range of ideas but he was capable of effective, if unoriginal, sculpture. His *morceau de réception* of *Neptune calming the Waves* (Louvre) (Plate 63) reveals his ability and his limitations. Back in Paris in 1733, he completed the model the following year and the piece itself in 1737. Its debt to Bernini needs no emphasizing; nor does the piece, for all its bravura, survive too close a scrutiny of its movement and anatomy. But it has a compensating largeness of effect, despite its small scale, and a welcome vigour. It is a piece of illusionism, with its dramatic movement – Neptune now advancing forward

to quell the waves, instead of being balanced in the equilibrium Bernini had devised – and its bold flying swag of drapery which emphasizes the action. It may be only pastiche Bernini, but compared with Bouchardon's reception piece, itself pastiched from Michelangelo's *Christ* in Santa Maria sopra Minerva, it has refreshing authentic vitality. There is even a sense of poetry in the sturdy impressive head. At the Salon of 1737 Adam exhibited a group of busts of the elements. The terracotta model for the head of *Water* is in the Hermitage (Plate 64) and shows that the vein of poetry in Adam's 'fancy pieces' was very real. The limpid treatment of the hair, the ardent yet wistful gaze, reveal an unusual delicacy and response, perhaps more those of a modeller than a carver.

It was probably an aid to the success of the grand group of *Neptune and Amphitrite* (Plate 65), for the Bassin de Neptune, that it should be executed in lead. Thanks to d'Antin the commission had been given to the Adam, and his death in 1735 meant the loss of a powerful patron. While Lemoyne and Bouchardon were given only the subsidiary groups of *Ocean* and *Proteus* respectively, the Adam had the ambitious central theme where amid a riot of marine motifs, curving shells, and fishy heads and tails, the god and goddess of the sea sit enthroned. Such a picturesque pagan world was one the elder Adam instinctively understood. His earliest commission on returning to France had been for the vast reclining figures of the *Seine* and *Marne* to decorate the cascade at Saint-Cloud. In his design for the Trevi fountain there had been a place for Ocean and the Mediterranean, along with sea-horses and tritons; but what was there only one portion of a very elaborate whole has at Versailles become the complete subject. Frustrated in Rome, Bouchardon and he were each to get the opportunity in France to compensate themselves with not irrelevant tasks: the fountain in the Rue de Grenelle, with its conscious, static calm, its deliberate simplicity, and the exuberant, rolling, almost rollicking *Neptune and Amphitrite*, rich, noisy in comparison with Bouchardon's marble silence. The huge lead group is all movement and action – Neptune poised as if about to rise and strike with his trident, and the whole rocky platform with its people and animals about to swing forward over the water. It is the *Seine* and *Marne* group for Saint-Cloud, and his *Neptune* presented to the Académie, which flank Adam in the unusual self-portrait drawing from these years (Oxford) (Plate 66) itself one testimony to his ambitious, pushing nature.

Though Lambert-Sigisbert was to live on for many years after the Bassin de Neptune was completed in 1740, and to be employed on other work for the Crown, he never quite rose again to that level of inspiration; nor did he receive another opportunity to work on that scale. Almost like a detail he had not managed to fit in there was the popular *Boy bitten by a Lobster* – of which the plaster was shown at the Salon of 1740 – intended for a fountain and commissioned by the Comte d'Argenson (bronze, Victoria and Albert Museum). But his terracotta allegories of France and the king seem to have been less successful. That which was intended to celebrate Fontenoy was never executed on a large scale because the project was declined. The allegory he exhibited at the Salon in 1750 was so complicated in its adulation that it required several paragraphs of explanation, accompanied by a somewhat acid note that these appeared at the author's

express wish. The bust of *Louis XV as Apollo* seems to have been executed as one more speculation, and was doomed to royal disapproval.[111] The terracotta version (Victoria and Albert Museum) (Plate 68) is, however, in its way a masterpiece, grandiloquent, faintly absurd, but finally impressive. Its Italianate rhetoric tends to become meaningless in the agitated folds of drapery, but from them rises a bold head, more Apollo than French king.

It shows little apparent advance on the bust of *Neptune* executed almost twenty years earlier for Cardinal de Polignac. Adam's restricted diet of a few motifs went on sustaining him, even if it had begun to pall on his patrons. The *Lyric Poetry* (Louvre) was commissioned by Madame de Pompadour for Bellevue and is signed and dated 1752. Here absurdity is only too apparent, and the statue's faults of windy affectation must have been even more cruelly revealed when it was seen with its pendant at Bellevue, Falconet's *Music*. A new generation of sculptors had arisen and Adam, though not old, was out of date. He was bitterly to witness Pigalle supersede him in the project for the Louis XV monument at Reims. Caylus and Mariette and Cochin were soon to be joined in their strictures by Diderot, though Lambert-Sigisbert did not survive to receive them. At the Salon of 1765 Diderot was to exclaim: 'Abominable, exécrable Adam!' before the work of Nicolas-Sébastien.[112] Almost as if he had heard, the younger Adam never exhibited there again.

Yet it is doubtful if he was at all inferior to his brother in talent. They can be fairly judged by the bronze bas reliefs each contributed to the chapel at Versailles, where the elder's *St Adelaide taking leave of St Odilo* is accomplished but fussy when compared to the clearly organized, highly pictorial *Martyrdom of Sainte Victoire* (Plate 69) by Nicolas-Sébastien. He indeed practised sometimes as a painter, and d'Argenville was not exaggerating in suggesting that his orientation towards painting was apparent from his sculptural work. His bas relief is almost a homage to Pietro da Cortona in composition, but executed in a fluent pastiche manner that is closer to Sebastiano Ricci. The dying heroine, the pagan altar, the dramatic action of the aged priest, and the whole classical atmosphere, are ready to be transmuted into another of the younger Adam's reliefs, that of the *Sacrifice of Iphigenia*. If his brother was best employed in masculine subjects, Nicolas-Sébastien interpreted in equally decorative terms more graceful, feminine themes.[113] His subjects are Clytie, Juno, Iris, or the Virgin; and it seems doubly suitable that he should be one of the few sculptors to have tackled the *Banquet of Cleopatra*, that famous tribute to a woman's power so popular with his century's painters.

He was the ideal choice for the tomb of Queen Catharina Opalinska, set up in 1749 in the church of Notre-Dame de Bon Secours in his native Nancy (Plate 67). Nevertheless, his brother struggled hard to be preferred for the task. But panache was not needed so much as lyricism and a gentle piety, in commemorating the quite unglamorous, humble, religious wife of Stanislas of Lorraine and mother of Marie Leczinska. Bon Secours had been built by Stanislas a few years before with the intention of its containing tombs of himself and his wife, and the church's title might have suggested to Adam the theme he was to illustrate in his touching masterpiece of a soul helped by a vision. The useless royal crown and sceptre, which had proved so barren in life, are deliberately

laid aside at the moment of passing from death into immortality.[114] The queen, made youthful again, kneels in prayer, while an angel points her way to heaven. The eagle of Poland, the incense burners that smoke with the queen's praises, are unimportant in the central depiction of a simple allegory which has the rare merit of also expressing a truth. All the testimony is that Nicolas-Sébastien was himself a simple, pleasant man. A chord seems to have been struck in him by the unhappy story of the woman who had been queen of Poland and duchess of Lorraine. And it must have vibrated the more keenly when the sorrowing widower took his hand and exhorted him: 'Travaillez avec cœur pour votre souveraine.'[115] Adam's emotional response can be detected even in the lines that described the model for the tomb in the Salon *livret* for 1747, with their Bossuet-like threnody: 'Détachée depuis longtemps de tout ce que le Monde a de flatteur, elle a déjà déposé les marques de ses Grandeurs et de son Rang . . .'.

The juxtaposition of the person commemorated and the angel of immortality is not dramatic – as it had been in the Marquis de la Vrillière tomb at Châteauneuf[116] and was to be in Slodtz' Languet de Gergy monument. In that lack of drama lies its whole point. The hand of the Lord, the revelation of eternal happiness, cannot startle someone who has waited so long for them. The queen's face expresses no surprise, only ecstasy. The angel and she are integrated into a single form, in effect a white bas relief set against the coloured marble of the pyramid; its steep lines are broken by the long undulating diagonal that runs up from the lowest fold in the queen's mantle and culminates in the extended forefinger of the angel's upraised hand. In composition the tomb is not original. Rather similar devices can be traced in the *pompes funèbres* for Anne of Austria and Mademoiselle d'Orléans in the previous century: perhaps it is no accident that both examples come from funeral ceremonies for women.[117]

The pyramid and the smoking incense-burners were to be taken over nearly twenty-five years later when Vassé designed the tomb of Stanislas opposite. Superficially it appears to be a pendant to Adam's for the queen, but it is markedly different in mood. The king reclines in an oddly old-fashioned pose, doing nothing; and the Virtues beneath him collapse and gesticulate in unconvincing sentimentality. The failure of Vassé's monument is the sculptor's own artistic failure, but in concept it shows a shift of taste away from the gentle rhetoric of Adam, with its billowing draperies and picturesque cloud, and its affirmation of immortality. While Stanislas calmly reposes, Catharina Opalinska is about to ascend, guided by the angel; everything breathes aspiration upwards and the pair seem softly taking flight for heaven. Just as much as Lambert-Sigisbert's Bassin de Neptune, but more subtly, Nicolas-Sébastien's concept expresses the principle of movement.

Michel-Ange Slodtz

René-Michel Slodtz (1705–64) was his proper name, but it is inevitable to think of him under the nickname he was first given by fellow students in Rome and which he used when signing his work. The close contemporary of Lemoyne and the Adam – born the same year as Nicolas-Sébastien – Michel-Ange Slodtz was easily the most distinguished

exponent of the Italian-inspired Baroque style, with a French accent, which they practised in common. No other great French sculptor of the century remained so long at Rome, but this had disadvantages for his career. He was not always to be fully employed when finally he returned to France, and his last years were clouded by ill-health and various troubles. He exhibited only once – in 1755 – at the Salon. His greatest achievement, the Montmorin tomb, was executed in Rome and was destined to be placed in France far from the capital, at Vienne.

Nor has his reputation ever been consolidated by posterity. Until very recently no monograph existed on him or the family from which he sprang. More like the Adam than Lemoyne in that he rarely executed portrait busts, he displays a brilliance and nervous sensitivity much closer to Lemoyne's – while his invention and execution are far finer. Contemporary opinion was interestingly divided over him, for while Caylus despised him and Bouchardon thought the Languet de Gergy tomb absurd, Cochin was much attached to him and his work. Dézallier d'Argenville praised the Languet de Gergy tomb as 'cette composition poëtique', and Diderot – in reviewing the Salon of 1765 – showed himself fully conscious of the loss to French art through Slodtz' recent death. Marigny thought highly of the Montmorin tomb,[118] yet it was he who withheld the much-striven-for order of Saint-Michel from the sculptor. And by the end of the century Slodtz was a by-word among neo-classicists for his disgraceful style. The strictures of Milizia are almost more moral than aesthetic in their vehemence: 'this artist sinned against the purity of forms'.[119]

René-Michel was one of five sons of the sculptor Sébastien Slodtz (1655–1726), a Fleming by birth, who had moved from Antwerp to Paris; there he became a pupil of Girardon. Employed later in the Menus-Plaisirs du Roi, he remained in a subordinate position and executed ephemeral decorations of the kind afterwards associated with his sons – notably some pompes funèbres. As a sculptor Sébastien Slodtz produced competent but unoriginal work. His Hannibal (Louvre; signed and dated 1722) was, somewhat unexpectedly, praised by Mariette, but says nothing not said better by the Coustou. A sort of dull application seems typical of his style, for portraiture as well, to judge from the Titon du Tillet bust (Wildenstein Collection; signed and dated 1725) with its too careful transcript of appearances. His chief claim to attention really is that he produced five children, all of whom were in one way or another to be connected with the arts. Only two however, apart from René-Michel, require even brief mention: Sébastien-Antoine and the more interesting and more ambitious Paul-Ambroise.

Both were to follow their father in the service of the Menus-Plaisirs and much of their work too – sculpture en carton and feux d'artifice – was by its nature ephemeral. The elder, Sébastien-Antoine, was born about 1695. At Meissonier's death in 1750 he succeeded to the latter's post as Dessinateur de la Chambre du Roi, and at his death in 1754 Paul-Ambroise followed him there. It can hardly be claimed that Sébastien-Antoine is properly a sculptor, and in the joint activity of the two brothers it is probable that in general he designed and Paul-Ambroise executed. Between them they produced some impressive pompes funèbres, as even Cochin – not very sympathetic to them – had to admit. That for the dauphine, Marie-Thérèse of Spain, in 1746 shows the splendour they

extracted from catafalques and weeping putti, yards of ermine and thousands of candles (Plate 70). It was all very well for Cochin to stigmatize this sort of thing as bad taste, but in fact as a young man he engraved the scene reproduced here and only later learnt to condemn such displays. They need to be judged by the standards of masques, and this one is a grand allegory of Time's triumph, seated on the globe of the world, under a baldacchino decorated with sable plumes and skulls.

Paul-Ambroise (1702-58) could be called a neglected figure, but his *morceau de réception* of 1743, the *Dead Icarus* (Louvre) (Plate 71), is sufficient to reveal his very real gifts.[120] The plaster model for this was included in the Salon of 1741, the first at which Slodtz exhibited, and he was to appear on and off there for ten years. His charming bas-relief *Angels* in Boffrand's graceful chapel at Saint-Merry are effective decoration and completely uniform in style – though separated in execution by more than a decade.[121] In the porch at Saint-Sulpice the bas reliefs are more serious and less purely charming. The decorative emphasis of Paul-Ambroise's work ultimately robs it of much individuality or robustness; he might indeed feel some jealousy, as Cochin more than hints, of his younger brother, René-Michel.

Yet the *Icarus* is a brilliant piece of drama, in one way an academically respectable study of the nude, in another highly picturesque. The almost pretty handling of the long feathers of the wings and the loops of ribbon is counteracted by the starkly dramatic pose of the broken body, whose flotsam-like character is conveyed by its being supported on the crest of a wave. It is raised only to be about to fall again; and already the water draws away in foam at the lower right. While remaining elegant, the piece yet manages to convey a sense of shock; in its effect it is not so much Rococo as romantic. One hardly exaggerates in saying that it would serve as a suitable monument to Shelley.

In the joint work of the Slodtz Cochin professed to see a marked difference after the return of Michel-Ange from Italy. And in Michel-Ange's own design for a catafalque at Notre-Dame there was remarkable nobility and simplicity after the 'colifichets' of his brothers. But Cochin's sympathy for the man made him partisan, and the imagery and varied media of the Languet de Gergy tomb suggest very different qualities. It is true, however, that the sculptor was brilliantly various and had the potentiality to follow two quite different styles.

Michel-Ange Slodtz won first prize for sculpture at the Académie in 1726 and two years later went to Rome. Not until 1736 did he cease to be a pensioner. During the next decade he remained at Rome, producing an astonishing range and variety of monuments of increasing importance and authority. He began with the simple monument to Vleughels in San Luigi dei Francesi and culminated with the huge Baroque Montmorin tomb and the *St Bruno* for St Peter's (both finished in 1744), throwing off soon afterwards the delicate, neo-classical, Marchese Capponi tomb (1746). Slodtz' style was like an instrument responding to the player's touch, and his shifts within it are made in accordance with dramatic demands. It is drama – high, emotional drama of an intensity rare in French sculpture of the century – which dictates his effects: his silences as much as his bravura tympani. If he does nothing more, he demonstrates the futility of trying to label eighteenth-century artists with single stylistic adjectives. Whereas

with Bouchardon there is sometimes an assumption of the Baroque for outdoor decorative purposes, with Slodtz there is occasionally, for all the core of Baroque energy, a whitewash coating of the neo-classical. It is because he perfectly understood that the object should dictate the style that one longs to know what was his concept of Cupid – that central presiding personage of the century, a statue of whom was to be commissioned from him by Madame de Pompadour, but never executed. As for the strange polarity which exists between Slodtz and Bouchardon, this almost seems recognized at Rome by the pair of busts they executed of, respectively, Vleughels and his newly-married wife in 1731. And it is symbolically right that, like Bouchardon, Slodtz should copy Michelangelo's *Christ* in Santa Maria sopra Minerva.

From the moment Slodtz arrived in Rome Vleughels seems to have recognized his quality, even though he was timidly conscious of having no positive proof of it. D'Antin sensibly pushed Vleughels on in a letter of 20 December 1728, encouraging him and the young sculptor. His advice was to have Slodtz do some fine figure: 'cela le perfectionnera bien davantage, et lui faire surtout travailler quelque chose d'imagination et de son propre dessein, ce qui avance bien plus que de copier.'[122] This intelligent, pointedly unacademic recipe was fully borne out by the results, but must naturally have startled someone as lacking in imagination – of every kind – as Vleughels. The superiority of Slodtz was to lie in the power of his imagination; and it is pleasing that an early proof of this should be the monument for Vleughels.

Two 'fancy' busts executed at Rome reveal Slodtz' two manners: the *Iphigenia* and *Chryses* (Lyon, Académie).[123] Even if these identifications are not quite sure, the busts are certainly classical in subject matter and are conceived as pendants, in effect of a priestess and priest. The *Chryses* is a fully Baroque head – anticipatory of Tiepolo's Calchas in the Valmarana *Sacrifice of Iphigenia*. That of *Iphigenia*, however, is oblique, retiring, a veiled profile which is a remarkable essay in the recreation of a classical mood; to find its parallel in Italian painting of the time one would have to turn to Batoni. Already here, as again in the Capponi tomb, it is a woman whom Slodtz classicizes. There is an antique Roman distinction in his attitude to the sexes: a woman is a 'gracious silence', concealed by draperies, while men take their place firmly on the public stage of life. Even the idea of bright sun and pale moon is subtly present in the Lyon pair of heads: the priest is robustly of the daylight, with eyes raised to invoke Apollo (whose name is inscribed on his forehead), whereas the ivory-pale priestess shrinks away, obscured under robes decorated with the crescent moon. Superficially recalling the elder Adam's bust of Neptune and Amphitrite, Slodtz' are distinct not merely in their superior handling but in their innate sense of drama.

It is this which distinguishes his Roman masterpiece, the *St Bruno* (Plate 72) in St Peter's, signed and dated 1744, but commissioned a few years before. Rome was to Slodtz not so much the city of the ancients as the home of Bernini – and also, it is worth suggesting, that of Borromini too. Borromini's elegant, emotionally motivated architecture would make the ideal setting for Slodtz' statue, itself so nervously refined, with its ectoplasmic, fluid white draperies. The saint's hands are long and flickering like tongues of flame as he gesticulates his repugnance for the bishopric symbolized by the

mitre and crozier held up to him by the child angel; and his whole body is animated by the swing of this refusal.[124] An expressive serpentine rhythm runs from the polished crown of his head down to the extreme lower right, where the folds of fringed cope bulge out of the niche. And across this there cuts the tautly linear, dead straight, diagonal of the crozier. Within the limited space Slodtz makes use of every dramatic device, recessing the saint on a plane behind the angel, on a rocky eminence that suggests the Chartreux, with beside him a skull and length of chain that form the ascetic answer to episcopal honours. Yet for all its tension, and its huge scale, the statue's final effect is of delicacy and grace. It beautifully suggests the momentary and fleeting, despite the solidity of its medium: in some ways the statue is a Pontormo figure, executed in marble.

The obvious comparison is with Houdon's *St Bruno* (Plate 170), also for a Roman church and done just over twenty years later. It has been customary to see the differences between the two statues as due to a shift in taste, yet in fact after Slodtz' *mouvementé* concept, Houdon had little choice but to conceive an entirely static figure. Slodtz had taken to an extreme the drama to be extracted from a single standing figure destined for a niche. His *St Bruno* is swept and tormented by emotion into an arabesque that is only just contained within the space. It is an instant's vision – for the putto must disappear and the saint regain his placidity. And Houdon's figure might have been conceived to express exactly that recovery of tranquillity. His *St Bruno* is a figure of stone, perfectly still, completely contained within its niche, a statue that is deliberately statuesque: as much an extreme as Slodtz'. But it is a classical and traditional extremity – that tradition so often agreeably thought of as French, by the French. By any standards it is a *reasonable* work of art, in concept and execution; the saint is shown as philosopher and stoic rather than a vessel of divine fire. Slodtz goes to the edge of reason to excite and exalt, to disturb the spectator by the spectacle of the disturbed saint.

Yet Slodtz' *St Bruno* is unique in his work. It is in four sculptured tombs that his art, which thus remains in the family tradition of the *pompes funèbres*, is seen at its most varied, producing some of the finest French funerary monuments of the century. The earliest of these is also the simplest: that for Vleughels (who died in 1737) in San Luigi dei Francesi. It is really no more than an extended bas relief, with the deceased shown in a medallion, and a single child genius with draped head, holding a palette. The inspiration is clearly from Duquesnoy and the putto suggests direct reference to the Van den Eynde tomb. It hardly prepares the way for the grand-scale monument which followed, for which indeed there is really no prototype. This was the combined tomb and monument which was commissioned from Slodtz in 1740 by the Cardinal de la Tour d'Auvergne, completed by 1744 and set up in 1747 in the cathedral at Vienne (Plate 75). The cardinal slowly mounts the steps, his hand held by his old mentor, Montmorin, the earlier archbishop, who seems to have returned to life to indicate that the cardinal shall succeed him. Thus the monument unites those twin eighteenth-century obsessions of the portrait and the tomb. Living and dead are brought into close contact, and the succession to the proud See of Vienne is expressed in terms more actual than allegorical. The whole concept was the cardinal's own, and letters between him

and the sculptor document the various stages in the evolution of the monument; already when the contract was signed in Rome on 1 October 1740, the cardinal had seen Slodtz' preliminary wooden model.[125]

Unlike the majority of French funerary monuments of the century, the Montmorin tomb remains intact and in its original position, in the apse to the right of the high altar. The long harmonious line of the nave remains unbroken by this addition of centuries later which, far from dominating the church, makes sense best from the steps of the altar – itself also by Slodtz. Almost as if to suit the grave, severe beauty of the surrounding architecture, the tempo of the sculpture is more stately and much slower than in the *St Bruno*. And the effect is, of course, much richer, though obscured under cobwebs and dust. Against the pyramid of mottled mauvish-grey marble, Montmorin reclines on a cushion of brownish-red, and the same warm marble is used for the thick surrounding draperies with yellow fringes. His vivid, penetrating face – the pupils of the eyes drilled very deep – is the focal point of the whole monument. Though conventionally reclining to convey that he is dead, Montmorin is throughout invested with keen vitality, with his expressive pointing hand, the sharp folds of his robes, and his foot projecting over the edge of the black marble tomb, suggestive of stepping back into life again (Plate 74). That it is *his* monument is emphasized by the profile figure of the cardinal who might be stepping up, hesitantly, to pay homage, and who seems to come reluctant to accept another's honours.

It is with this figure that Slodtz radically altered what would otherwise be merely a funerary monument. The cardinal is in fact a fully modelled statue of a living person placed on a tomb not as mourner but, as it were, in anticipation of his own death. The uniqueness of the concept must have been emphasized when the cardinal himself officiated at the altar, close to the monument he had had erected. While Montmorin is all sharpness – of personality, it would seem, as much as in sculptural treatment – Cardinal de la Tour d'Auvergne is conceived in more *adagio* rhythm, bulky in his tremendous, swollen robes, and in actual physiognomy a contrast to his patron, fatter-faced, heavily-wigged, a sculptural *tour de force* of brilliantly executed lace and draperies which retain in marble the light creases of silk as they gently balloon out over the steps of the monument. Though the textures are cleverly simulated, it is the expressive lines of the folds themselves that give to the falling train something of that beautiful singing rhythm found in Pilon's treatment of drapery (e.g. *Cardinal Birague*).

In this double monument of two churchmen, set up in their own cathedral, there is a marked absence of religious imagery, and a complete neglect of death. It is conceived in a spirit not of piety but of *pietas*: a monument to fidelity first, and then to power. The sole allegorizing touch is that of the putto who hastens to inscribe the event in the annals of the cardinal's house. And in some ways, for all its Baroque manner and its mingling of materials, it is animated by an extraordinary Renaissance concept, an affirmation of the splendour of being human, and the immortalizing in art of human glory.

After it the Capponi monument in San Giovanni dei Fiorentini, Rome, is tenderness and grief personified, literally, in the graceful, mourning Virtue who contemplates a skull beneath a medallion portrait supported by two putti (Plate 73). With her much

pleated draperies and willowy pose, she is somewhat similar in style to Filippo della Valle's work, but markedly more neo-classical. It is not surprising that the two sculptors worked together in Santa Maria della Scala, but the result was to give a frenchified air to the extremely attractive work of della Valle rather than to affect Slodtz. Yet the Capponi tomb is typical of tendencies in Rome during the 1740s, and it is notably modest in effect when compared with the grandiose Montmorin tomb or the dramatic pageant of that for Languet de Gergy. Slodtz made no attempt to involve Capponi as an actor in his monument, but expressed instead the conventional idea of a female mourning figure, raised out of banality by the delicate treatment of robes that seem positively to rustle, yet posed with un-Rococo tranquillity. Perhaps not too much should be made of Slodtz' nascent neo-classicism, which may here be explicable through haste or some lack of interest in the commission. Certainly the Languet de Gergy tomb is a violent contrast to it.

Slodtz returned to Paris in 1746 and that tomb (Plate 76), completed in 1753, is the most important work he executed during the remainder of his life. It is also the most rhetorical of his tombs and possibly shows some signs of strain – despite, or because of, its virtuoso technical display. He was to receive several commissions for work at Saint-Sulpice, itself a monument to Languet de Gergy, as Slodtz was to indicate in the tomb. The monument is a narrative in allegorical terms, expressing almost the sentiment of Donne's words: 'Death, thou shalt die.' Languet de Gergy represents, as it were, the Christian soul over whom Death has no power, vanquished by the appearance of an angel who thrusts back the curtain of mortality and brings a vision of eternal happiness. The dramatic effect is somewhat overpowering in the small chapel where the monument is placed, and there is a distinct mannerism in, for example, the angel, which was not apparent in Slodtz' earlier work.

The profusion of materials is today less obvious, and the tomb is shorn of several details. On the plinth below the sarcophagus were originally two child genii symbolizing Religion and Charity, along with a festoon, a cornucopia, and the Languet de Gergy arms. The angel held a huge ring, probably of bronze, and also a long fluttering paper bearing the plan of the church. The skeleton of Death is in bronze, the curtain apparently of lead, while a range of coloured marbles – comparable to those at Vienne – serves for sarcophagus, cushion, the angel and the curé, and the pyramid against which the action takes place. Amid all this Slodtz manages, however, to keep attention focused on Languet de Gergy himself, whose expressive outstretched hands and ecstatic face wonderfully suggest the unseen vision. The vividness of the head was praised by La Font de Saint-Yenne and by Diderot, and some credit is due to the young Caffiéri who had carved Languet de Gergy in 1748, and whose bust appears to have been utilized by Slodtz. Nevertheless, it is the conviction of the emotion in the face which makes it remarkable – the more remarkable as Languet de Gergy was by no means above the suspicion of being a charlatan. Slodtz makes him a worthy subject to be fought over by Death and Eternal Life, the centrepiece of an easily-read, effective allegory. The monument is the three-dimensional expression of words inscribed on the plinth below it: 'ses vertus le feront vivre éternellement avec les anges dans le ciel'.

73

Yet the monument also marks an extreme. It does not seem extreme by the standards of German Rococo sculpture, but it is the farthest limit of French art. This type of allegory, especially with the skeleton of Death, increasingly seemed ridiculous. Bouchardon's reported mocking comment on it at the period is intensely rational: 'vous rirés bien'.[126] And though Cochin defended this tomb, he notably avoided such imagery when involved a few years later in the tomb for the dauphin. Pigalle draped Death on the two occasions he carved the figure, and even then did not escape criticism. And there is another dubious aspect of Slodtz' concept: the idea of immortality, at least in the guise of a guardian angel. It too might seem, if not ridiculous, no longer a particularly convincing or interesting belief.

Adam and Bouchardon had both felt indications of new taste and the presence of new sculptors. Bouchardon had finally singled out Pigalle, considerably his junior, to take up the equestrian statue of Louis XV. Perhaps through Slodtz' delays on the *Cupid* for Madame de Pompadour, the commission for such a statue went to Falconet, to result in a masterpiece.[127] In a period of five years Adam, Bouchardon, and Slodtz all died – and all prematurely, by the standard of longevity established by Girardon and Coysevox; of the great sculptors of their generation only Jean-Baptiste Lemoyne was to survive into his and the century's seventies.

It was a new generation which was rising to fame in the middle of the century, to be patronized by Madame de Pompadour, to be praised and blamed (often without their knowing it) by Diderot.

THE MIDDLE YEARS

SCULPTURE: FROM THE GENERATION OF
FALCONET AND PIGALLE TO PAJOU

Introduction

THE middle years of the century saw the emergence of a cluster of talented new sculptors in France and the striking arrival of two closely contemporary geniuses, Pigalle and Falconet. After the burst of talent at the Salon of 1737, there was no comparable revelation in painting for this period until the début of Greuze in 1755, and he was much younger than the group of sculptors born in the second decade of the century; the only remarkable names of new painters from the same period are first Vernet and then Vien.

These sculptors were becoming established in the years when French literature was producing a diversity of revolutionary, and rich, work: from the *Esprit des Lois* (1748) to *Candide* (1759). In 1750 there appeared the prospectus to *L'Encyclopédie*, and in Diderot perhaps of all eighteenth-century literary figures there are most typically assembled the contradictions, frank impulses, emotions, and rationality that make up the complexity of the age. This would remain true no doubt even if he had not shown an interest in the arts which largely separates him from Voltaire, and an interest especially in the *beaux-arts* which separates him from Rousseau. With his reviews of the Salon, and his close friendship with Falconet – and not forgetting his ability to write – Diderot becomes relevant in a new way, quite different from that of a Caylus or Mariette.[1] It is not only his ideas – sometimes, not always, finding expression in the art of his contemporaries – which are important but his central belief in the power of art. At the Salon of 1765 he made a claim specifically for sculpture, conscious of the monuments that have survived from Antiquity: 'Ce sont les ouvrages de sculpture qui transmettent à la posterité le progrès des beaux-arts chez une nation.'[2] In these years art is seen as able to possess a purpose, a moral purpose, which would have baffled the two Coustou and seemed irrelevant to Le Lorrain, as much as it must have done to the middle-aged Boucher. But the way is prepared for David.

Diderot legislated for a moral art, while Rousseau became celebrated by his crushing negative answer to the Dijon Academy's question: 'Si le rétablissement des Sciences et des Arts a contribué à épurer les mœurs?' The famous prosopopoeia of Fabritius, scribbled under a tree and read in a delirium to Diderot,[3] seemed to have its application to Paris rather than Rome: 'brisez ces marbres, brûlez ces tableaux . . .'. Expanded, it was to appear in 1750 as the *Discours sur les sciences et les arts*, revealing Rousseau as opposed to the very civilization on which his century prided itself.

Luxury and refinement were no longer goals to seek but vices to be crushed; and in fact Rousseau was expressing – in a hectic manner – the century's growing preference for the 'natural' (redefined) and the un-artificial, a preference which was to affect the arts. It is already seen where it might not superficially be expected, in the patronage exercised by Madame de Pompadour. This was to touch, sometimes briefly, sometimes significantly, all the leading sculptors of the new generation: Allegrain, Pigalle, Coustou le fils, Vassé, Falconet, and Saly. Some lingering confusion caused by nineteenth-century ideas of rouge, a mistress, and 'douceur de vivre' seems to have given Madame de Pompadour a reputation for artificiality and high solemnity – to which even her name may have accidentally lent some colour. The truth is very different; but the naturalness she sought in art is itself of a thoroughly eighteenth-century type. It was represented by statues of girls engaged on tasks of butter-churning and cheese-making in her dairy at Crécy. Or in being portrayed in dignified surroundings, and yet with devastating frankness, by Drouais (Plate 138). It is symbolized by her action at Bellevue in arranging a mid-winter garden of spring and summer flowers – but all of porcelain.

Porcelain was indeed to play its part in the new dissemination of sculpture which naturally sought more decorative and playful subjects for small-scale execution.[4] There was a growing tendency to prefer other media to the formality and finish of marble; porcelain could be prettier, and terracotta seemed fresher. The interest in terracotta models was not quite new but it developed very much parallel to increased interest in painters' sketches. One was closer to the artist's original inspiration in such work – an idea that would have surprised, or left indifferent, the average *grand siècle* patron. When La Live de Jully published the catalogue of his cabinet in 1764 he explained his preference for the terracotta maquette: 'Ces modèles', he pointed out, 'ont souvent plus d'avantages que les marbres parce que l'on y trouve bien mieux le feu et le véritable talent de l'artiste.'[5] Three years later, in reviewing the 1767 Salon, Diderot was to inquire rhetorically why we prefer a fine sketch to a fine picture and to give the same answer as La Live de Jully, though at greater length.

Yet the middle years of the century, suitably enough for its complex nature, were also to see the construction of three major monuments, all royal commissions though one was from a foreign sovereign, but none set up in Paris: Falconet's *Peter the Great* at St Petersburg, Coustou's tomb of the dauphin at Sens, and Pigalle's tomb of Marshal Saxe at Strasbourg. Two of these sculptors received the order of Saint-Michel, the first of their métier to be so honoured and valuable recognition of the importance of their status in official eyes. In their different ways the three monuments heroicize, or celebrate heroicism. They continue the cult of the great man in an age growing somewhat short of great men – apart, of course, from men of genius in the arts. It was to be a minor revolution when a life-size statue of Voltaire was subscribed for in 1770 by Madame Necker's weekly dinner guests.

Madame de Pompadour did not live to subscribe, though she might well have done so. The art she fostered was quite apart from any previously associated with the court; while she lived there was in effect a double stream of royal patronage, administered by her brother Marigny. Pigalle received, on the one hand, the public commission for the Saxe

monument – enshrining masculine glory and national honour – and on the other, at the same period, commissions personal to the Pompadour: herself as Friendship, allegories of Love's education, and, most personal of all, a tender, graceful monument to her changed relationship with the king, *Love and Friendship*. The resulting statues remained her private property and were destined for her own gardens at Bellevue. The career of Falconet in France was, of all sculptors' careers, that most seriously affected, indeed diverted, by the patronage of Madame de Pompadour – just as Boucher's is the outstanding example among painters. But for some twenty years, up to her death in 1764, she offered new kinds of opportunity to all artists. Thus in sculpture the middle years of the century are, to some extent, hers artistically. She provides a bridge between the *retardataire* Baroque world of the Coustou and the softer, even sentimental climate of Houdon, Chinard, and Chaudet that brought with it a new century.

Allegrain

Of all the new generation of sculptors Christophe-Gabriel Allegrain was the oldest and probably the least exciting.[6] He owed his advancement, such as it was, to his brother-in-law, Pigalle, who also generously helped him in the execution of his work. Son of the painter Gabriel Allegrain (1679–1748), he was born in 1710 and lived on, artistically extinct, until 1795. He seems to have been slow to develop and was slow to be recognized. His first appearance at the Salon was in 1747 with a plaster *Narcissus* of which the marble became his reception piece at the Académie in 1751 (now at the Château de Sagan). Once attributed to Pigalle, the *Narcissus* has the rather sleepy charm which is typical of Allegrain at his best, while the very subject seems to anticipate the narcissistic *Venus at the Bath* (Louvre) (Plate 77), which was probably his most famous work, and certainly his sole royal commission – apart from the lost *Batteuse de beurre* executed in stone, to Boucher's design, for Madame de Pompadour's dairy at Crécy.

 Commissioned in 1756 and completed some ten years later, the *Venus* was mentioned in the Salon *livret* for 1767 as available for inspection in the sculptor's studio. Diderot was eloquent about it, and angry that the artist should have been assigned a defective block of marble. This unpleasant texture of the material is perhaps partly responsible for the statue's displeasing effect, yet it is – like the *Narcissus* – somehow deficient in rhythm. Cochin was to tell Marigny, in answer to an inquiry, that he knew nothing by Allegrain except the *Narcissus* which he found 'figure aimable pour la composition'.[7] Doubtless because derived loosely from Giovanni Bologna, the concept of the *Venus* is much better than the execution, whereby the goddess remains lumpish and her draperies inert and mechanical. The treatment of the flesh is positively ugly, and the final artistic blow is given by comparison with Falconet's *Nymphe qui descend au bain*, admittedly of very different scale from Allegrain's life-size figure with its top-heavy head. It remains strange that Diderot, so sympathetic in his response to Falconet, could also fall into ecstasy before Allegrain's inferior work. This appealed to Madame Du Barry, who obtained the *Venus* and placed it at Louveciennes, and commissioned in 1772 from the sculptor a pendant of virtually the same subject in less languorous mood: a *Diana*

surprised by Actaeon (Louvre), completed five years later and then exhibited in the artist's studio. The obvious contrasts in composition were made, while both statues aimed at the erotic. What in the earlier nude was a sort of contemplative self-love in the act of disrobing (like Handel's Semele: 'Myself I shall adore, if I persist in gazing') becomes excited consciousness of being nakedly exposed to a stranger's gaze – and drama re-places the mood of quiet contemplation.

Allegrain had no original contribution to make to the study of the nude. Apart from the disparate pair of Diderot and Madame Du Barry, few people showed any inclina-tion, even at the period, to esteem him very highly. Even the proximity to Pigalle could hardly raise his work to the level of being interesting. But Allegrain outlived many of his younger and artistically much more attractive contemporaries.

Guillaume II Coustou

The youngest Coustou, Guillaume II, was born in 1716, son of a famous father. He was the exact contemporary of Vassé and Falconet, but appeared at the Salon earlier than either of them, exhibiting first in 1741, on his return from a period at the Academy in Rome. He was to enjoy a prosperous career, much patronized by Madame de Pompa-dour and by Marigny, as well as by the king. When Marigny quitted the Bâtiments in 1773, Louis XV offered him a large-scale statue of his monarch, leaving him free to select the sculptor, and Marigny chose Coustou. That was one of the sculptor's last works; it reached Ménars in 1776, only a year before his death. Among his earliest important work had been the *Apollo* of 1751 for Bellevue, paid for by Madame de Pom-padour, for whom he was also commissioned to do *Une Marchande d'œufs* at Crécy (1753), which accompanied Allegrain's figure there.

The plaster model of *Vulcan* he exhibited in 1741 served for his *morceau de réception* (Plate 78) the following year, and he thus entered the Académie while his father was still alive. The *Vulcan* (Louvre) might indeed be mistaken for the elder Guillaume's work, so completely is its idiom his vigorous 'engaged' Baroque. Except in its rather more nervous treatment of the hair, it shows in fact no advance on Van Clève's *Poly-phemus* (Plate 40), executed more than half a century earlier, and patently the inspiration for the statue. If this suggests some lack of originality in Guillaume II Coustou, that seems correct. His work is not impressed with strong individuality, and is often oddly flavourless for all its steady competence. Although much of his decorative work has been destroyed, it is not unfair to suspect that this was in general trite, however charming and graceful. It is significant that his major achievement, the tomb of the dauphin in the cathedral at Sens, is almost certainly not his in design.

He proved to be the sculptor of the last *ad vivum* image of Louis XV, 'en habits de son sacre, ayant à ses pieds sa couronne', and that is one testimony of traditionalism and court attachment to him. This feeling was to increase when the dauphin's son succeeded to the throne as Louis XVI, anxious to honour the sculptor of what had become a memorial to both his parents. Ill, in fact dying, Coustou was given the Saint-Michel, granted with special permission to wear it before his actual reception into the order, but

he never lived to see the monument set up at Sens. When the Salon opened in 1777 he was dead; the completed monument, finished except for gilding of its bronzes, was available for public inspection in his studio.[8] The result was Coustou's most important work.

This tomb is something quite fresh in sculpture at the date of its commissioning, and indeed in the tradition of funerary sculpture in France. It is a deliberate attempt to create a new type of monument, almost certainly conceived by Cochin but probably influenced to some extent by Diderot. The basic concept of the monument was dictated by the prominent free-standing position it was to occupy in the choir of the cathedral, and by the wishes of the dauphine, Marie-Josephe de Saxe. She required it to serve a double purpose: '... qui éternisât à la fois son attachement pour Mgr. le Dauphin et le souvenir des vertus de ce prince' (letter of Marigny to Louis XV). Louis de France died in 1765 and by his will asked to be buried at Sens.[9] Coustou was chosen as sculptor of the monument – 'le plus magnifique qui ait encore été élevé en France' – and during the summer of 1766 he and Cochin must have planned different interpretations of the theme. Coustou executed at least two models, and the final choice was made by Marigny. At Cochin's request, Diderot threw off several literary projects for the tomb, of which one mentioned two urns with a seated figure of Justice ('Et voilà ce que les anciens auraient appelé un monument', he wrote significantly),[10] and also the mourning wife with one of her children. In the light of that project it is strange to read Diderot's condemnation of Cochin's *Allegory on the Life of the late Dauphin* (a drawing exhibited at the 1767 Salon) for its mingling of real and imaginary people. But two urns remained the central point of the eventual monument, and must have seemed prophetic when the allegory of married fidelity took on reality with the death of the dauphine in 1767.

The monument's novelty is in the absence of any image of the deceased. It is conceived as a catafalque and, in the end, consists entirely of mourning allegorical figures grouped about the two urns (Plate 79). There is no skeleton of Death, no mingling of the real and personified which Diderot said he objected to. It is quite without drama and aims at poignancy. It is conceived within the one convention of the allegorical, and that largely pagan. Indeed, it is the first large-scale neo-classical tomb to be built in France.[11] It rejects the ideas of Lemoyne and Slodtz, substituting a dignity and pathos which aim to imitate the ancients. The mood is resignation, not Christian hope – despite the presence of Religion and Immortality.

The design breaks away from the wall tomb or niche and returns to the all-round concept of, supremely, Pilon's monument for the heart of Henri II. Today, Coustou's monument is banished behind a locked grille in a side chapel at Sens, and a tissue of cobwebs adds to its neglected appearance and general inaccessibility. In fact, the monument hardly makes sense when it can no longer be walked round, and to understand it properly one must turn to a record of it in its original place in the centre of the choir, before Servandoni's high altar replaced it (Plate 81). The single urn of Pilon's reliquary is doubled for husband and wife. While Religion and Immortality are placed closest to the altar, with Religion holding up a crown of stars, at the opposite end Conjugal Love mourns, and Time remorselessly veils the dauphine's urn, having already covered that

of the dauphin. Though from no single point are all four figures properly visible, each group is planned to be complementary – even to the raised left arm of Time and the raised right one of Religion, and the mourning putto at each end. And the focal point is, as it were, quite literally the heart. The imagery is pathetic, but it makes no *coup de théâtre* assault; the spectator is instead invited to meditate and is forced to take time to assimilate each facet of the monument: the urns, the inscriptions, the cypress-decked royal arms, the broken chain of flowers. At each point further imagery is disclosed – too much in fact, and the monument betrays its literary origin.

Yet it remains a daring concept in one of France's finest cathedrals. Entering under the central doorway, with its Christ enthroned in Paradise, the visitor originally approached the tomb, standing between the nave and high altar, to see nothing but the back of Time and the sorrowing figure of Conjugal Love (Plate 80), perhaps carved by Coustou's pupil, Julien, and in itself so strongly anticipatory of Canova. This aspect is the more bitter, the more effective, and the more realistic. There are no assuaging angels, any more than a grimacing Death. Nothing is allowed to prevent Time's action in covering the urns. All the classical feeling at which Diderot had hinted finds full expression here, where grief is seen to be powerless and the promise of immortality faint and chilly. It is a monument of rationality and feeling whose sentiment must conflict with the very building in which it is placed; and its removal to the obscurity of a side chapel during the nineteenth century pays tribute to its disturbing, pagan power.

Perhaps inevitably, Coustou's part in it all is rather mechanical. He has dutifully executed rather than fully responded. Yet he captures the new spirit in the carefully executed, grave folds of the draperies and in the slow, restrained, but noble gestures. The youthful winged Conjugal Love is gracefully classical, with his extinguished torch and his sorrowful gaze – the presiding genius of the tomb. If the result is all rhetoric, it is no longer a rhetoric to stir amazement or fear but to appeal. It asks for the spectator's tears. In this it is one of the most typical, as well as one of the most neglected, monuments of its century.

Vassé and Saly

Although Vassé and Saly both received the opportunity to execute large-scale monuments, neither could produce anything to equal the artistic level of Pigalle or Falconet; and neither was to equal the intellectual interest of Coustou's monument at Sens. In the Paris of that period they could hardly compete unless aided by intrigue, and as protégés of Caylus they were to be involved in intrigue. Saly was the more talented and in every way the better man. Vassé's ability was directed more to intriguing than to executing works of art. Diderot shrewdly hit his weakness, that of so much French art of the century, when he remarked of him '. . . que m'importe que vous soyez supportable, si l'art exige que vous soyez sublime?'[12] Cochin's *Mémoires* tell in sober detail the extraordinary depths to which Caylus and 'son cher Vassé' sank in their efforts to wrest from Pigalle the task of finishing Bouchardon's *Louis XV*; and the pettiness of Vassé's actions seems to have permeated his sculpture too.

Louis-Claude Vassé was born in 1716, son of the sculptor and decorator François-Antoine Vassé (1681–1736) (cf. p. 260 ff.).[13] Having already trained under Bouchardon, he went to Rome as a pensioner in 1740, the same year as Saly, but taking second place. He naturally thought of himself as Bouchardon's successor, and did succeed him as Dessinateur des Médailles du Roy at the Académie des Inscriptions. He was diligent in exhibiting at the Salon; between 1748 and 1771 – the year before his death – he appeared there regularly, and with a great diversity of work: projects for tombs in vaguely neo-classical style ('une Femme qui pleure sur une Urne' was his favourite motif), portrait busts which included one of *Benedict XIV*, and marble medallions, as well as bathing nymphs. Despite all Caylus could do, Vassé failed to be entrusted with either Bouchardon's *Louis XV* or the statue of the king that the city of Reims wished to erect: like the former, the latter went to Pigalle. But Vassé was the obvious choice for the monument to Caylus at his death in 1765, and he finally obtained the commission for the frigid, uninteresting tombs of Marie Leczinska and her father that were put up close to Adam's Catharina Opalinska at Bon Secours.

Vassé's *morceau de réception* of a *Sleeping Shepherd* (Louvre) (Plate 82), presented in 1751, reveals a general indebtedness to Bouchardon accompanied by a sentimental slackness. The pose is too contrived to be convincing – indeed, it is slightly absurd as well as uncomfortable – while the execution lacks all the accomplished handling which helped to make such a success of Saly's *morceau de réception* in the same year, the *Faun holding a Goat* (Paris, Musée Cognac-Jay) (Plate 83). Both statues derive from antique prototypes which they reduce and frankly prettify, but Saly achieves this completely, whereas Vassé remains awkward. He never lost this awkwardness, as the Virtues at the base of the Stanislas of Lorraine monument confirm on a large scale.

Jacques Saly was historically perhaps not much more important than Vassé but he was a genuine, if minor, talent, whose early work showed more promise that was ever to be fulfilled. He was born at Valenciennes in 1717 and outlived Vassé, dying in 1776. In 1753 he left France for Copenhagen, to work on the equestrian statue of Frederick V of Denmark, and the remainder of his active career was passed there.[14] Although recommended by Bouchardon for the task, and though ambitious and academically respectable in Denmark, Saly was not *au fond* a monumental sculptor nor, possibly, even a portrait sculptor, but a graceful, playful, artist who might have enjoyed the vogue of Falconet or Clodion. In his short Parisian career he was well patronized by Madame de Pompadour and, for the sake of glory abroad, and a monumental commission, he gave up the style which had led to such charming neo-Pompeian essays as the Leningrad *Hebe* (Plate 84), shown at the Salon of 1753, the marble of which was destined for Bellevue.

Already, during his years in Rome, Saly had been singled out for high praise by De Troy, then Director of the French Academy. One of his earliest commissions came from De Troy – 'une jolie tête de fille' – which may well have represented one of De Troy's own children. The marble head in the Victoria and Albert Museum is perhaps the original which was duplicated in a variety of media (Plate 85). If the result is charming, the sense is of truthful portraiture: an unsentimentalized, even somewhat sad, rendering of childhood. Here are no roguish graces, no tantalizing hints of the

erotic. It is the portrait of a child in which truth comes before prettiness – and in that it is classical. It combines a feeling for substance and weight with delicacy of handling: the still smooth child's flesh, the carefully plaited hair, and the individually crinkled ears. Houdon's children may be, indeed are, much more sparklingly alive – children as adults like to think of them. Saly sacrifices that effect deliberately, by the downcast eyes and the closed mouth which convey a touching sensation of the withdrawn. Though it has been common to think of the child portrayed as Madame de Pompadour's short-lived daughter, it is more subtle, if less glamorous, to recall that she is quite likely to be the recently widowed De Troy's sole surviving child, who herself never reached adulthood.[15]

Back in France in 1748 Saly was quickly famous. The *Faun holding a Goat* created such a stir that it had to be shown to Louis XV, and though the Duc de Luynes (*Mémoires*) was careless in his spelling, he at least noted the event on 27 June 1751: 'Le Sr. Salvy avait fait porter son chef d'œuvre pour l'Académie, qui est un faune que le Roy a trouvé fort beau...'. The king's taste was shared by Grimm and by Caylus, whose comment on its dignified treatment of a rustic theme is one of those perfect mid-eighteenth-century dicta; Saly had chosen 'un homme de campagne', he wrote in the *Mercure*, 'mais c'est un jeune homme que tous les rapports rendent noble et agréable'. The reassuring 'mais' calms any fear that the rustic might lead to the rude. So little rude was Saly's svelte, and somehow *petite*, concept that some critics felt it was altogether 'trop galant'.[16] The statue is androgynously elegant and makes an effect of being smaller and daintier than it really is: it seems already a product of the Sèvres factory, and was in fact soon to be translated into porcelain. It is Falconet who comes to mind before the statue, for though it is less striking than his nymphs, it inhabits the same Anacreontic world of grace and charm.

Saly's ambitions led him in 1752, even before he left France, to a statue of Louis XV for his native Valenciennes. But basically more relevant to his talent was the final commission from Madame de Pompadour of a small marble *Amour* as a child testing his arrows. Saly's original is lost or destroyed. Slodtz never finished his *Cupid* for her. It was left to Falconet to conceive and execute the quintessential statue of the whole century, in the *Amour menaçant* (Plate 89), done after Saly had settled in Copenhagen. There Saly produced a bust of *Frederick V* (Copenhagen Museum) which is fresher and more impressive than the eventual equestrian statue. Given one of the most attractive urban settings created by his century, Saly could not quite rise to its level. His statue is neither animated nor original enough to hold its own in the centre of Frederick's creation of Amalienborg, with its four handsome façades and intervals of airy space.[17] A genius was needed, and Saly had no more than talent. The average visitor to the Amalienborg hardly bothers to glance at the central statue which, via Girardon, repeats the concept of the *Marcus Aurelius*.

Something of the pains taken by Saly over the statue can be learnt from the contents of the sale held in Paris on 14 June 1776, after his death. The catalogue lists the models, studies, and drawings which it had given rise to; but it evokes also the sculptor's early years in Italy when he was young and promising. Among the pictures he owned were

pairs by Panini and Vernet – the latter noted as done in Rome. There were caricatures by Saly himself and also one by Ghezzi, probably of him; and a drawing of a *feu d'artifice* done in 1746 by Piranesi to celebrate Saly's recovery from an illness.

Falconet

Saly provided a prototype for the export of a French sculptor to a northern capital to execute the statue of a foreign monarch. And altogether his career has some analogies with Falconet's. The creator of small-scale *Baigneuses*, the director of the Sèvres factory, was also to be the creator of the most original and romantic equestrian statue of the century. 'Vous allez', wrote Diderot, 'au milieu des glaces du Nord élever un monument au plus grand des monarques.'[18] Falconet had gone to Russia in 1766 and was not to return to France until 1778, chilled and disillusioned by more than Russian weather. He left behind him the Peter the Great monument, but it was to have no influence in France. That represents Falconet at his most masculine artistically, while in his own country it was his feminine work, feminine in subject and feeling, which brought him fame. His career falls into two distinct portions. There are in effect two sculptors in Falconet, at least two conflicting aspects of an artistic nature in a character recognized at the time as remarkably ferocious, temperamental, and literate. Falconet was individual in the highest degree; he looked it, as is shown by the able, loving bust, now at Nancy (Plate 86), from the hand of his devoted pupil and daughter-in-law, Marie-Anne Collot;[19] and even his library revealed it, for no other French sculptor would have owned a copy of Pope's poems.[20]

Étienne-Maurice Falconet was born of very humble stock in Paris in 1716 and was among the fortunate many – including Pigalle, Pajou, and Caffiéri – who trained under Jean-Baptiste Lemoyne; and Lemoyne retained a special affection for him. The two had much in common as artists, not least the fact that neither made the visit to Italy. It was perhaps through Lemoyne that the young Falconet discovered the sculptor who was to serve instead of Italy in his artistic development and who remained for him 'the greatest sculptor of his century': Puget. They had similar temperaments, though Falconet had the advantage of living in an age without a Colbert or a Louis XIV; Catherine the Great was to prove a more intelligent and sympathetic patron.

Not since Puget had a French sculptor allied such independence of thought with genius. Falconet's discovery of the *Milo of Crotona*, then slowly losing its surface in the open air at Versailles, led to a piece of homage so direct in subject matter as to be stigmatized for supposed plagiarism, the plaster model of *Milo of Crotona* (Louvre) which marked his first Salon appearance in 1745. His devotion to the sculpture of Puget symbolizes his firm belief in the superiority of the moderns over the ancients, a superiority consisting above all in vital realism: life, movement, textures of flesh, and sense of blood beneath the skin. The concentrated drama of Puget's sculpture and its 'engaged' quality set it apart from the majority of work executed for the gardens at Versailles. Puget transmuted his experiences of Italian Baroque art into something highly personal; in turn Falconet was to be inspired by Puget to produce personal art which should

enshrine a clear idea, which should have a very definite purpose. Puget showed him that one need not turn to the ancients, still less to one's contemporaries, to achieve great art; it is in oneself that it should lie. Falconet possessed exactly that self-confidence, and an ability to express his ideas in writing as well as in marble, which Bouchardon lacked.

But it took time for him to be formed. One of the least precocious sculptors of the period, Falconet was slow to be admitted to the ranks of the Académie, found little royal favour, and was never to become chevalier of the order of Saint-Michel. His stormy independence had official disadvantages. During his early years he was too poor, and too preoccupied with getting himself an education, to undertake any major work. To this late start must be added his premature end as an artist, perhaps first through increasing blindness, and then by an abrupt paralytic stroke in 1783. From leaving Russia in 1778 until the end of his life he executed no more sculpture. Although he lived on until 1791 he had nothing to do but put his writings in order and grow daily more cantankerous.

It is typical of Falconet's tendency to be involved in conflicts that his career should start with the Académie's rejection of the *Milo* as a piece of plagiarism. If that made him feel a grudge he was certainly right, to judge by the final, accepted, marble (Louvre) (Plate 87), not finished until 1754 and so totally unlike Puget's composition in every possible way. It is typical too of Falconet's art that he should have succeeded ultimately with this vividly dramatic and forceful subject, whereas he failed with the subject the Académie assigned him in place of the *Milo*, an allegorical *Genius of Sculpture* (1745–6) which was in the end recognized as inferior to Falconet's own original proposal. By the time the marble *Milo* was finished Falconet had already received commissions from Madame de Pompadour, for the elegant marble *Music* (Louvre) destined for Bellevue, and the now lost or destroyed stone statue of a *Jardinière* which accompanied similar statues by Allegrain, Coustou, and Vassé in the dairy at Crécy. Since he never received a major crown commission and seldom executed portrait busts, he certainly needed such patronage. However gruff and rough his actual character, he had to produce work of a very different tenor, giving marble the air of being already *pâte tendre*, replacing drama by a lyrical eroticism.

The *Milo* seems truer to the artist's natural inclinations. It has in miniature something of the unconventional and bravura force that was to set Peter the Great riding dynamically beside the Neva. Milo is seen pinned to the ground in a pose that goes back to Titian's *Prometheus* in the Prado but here is more untidily interpreted – with the desperately flailing leg and mouth expanded in a howl of horror. Less emphasis is placed on the hand caught in the cleft of the tree trunk than with Puget's concept. That is indeed the central point of Puget's drama and composition: the long agonized arc extending through the tree and arm up to the contorted face. It makes an almost expressionistic effect of pain even without the presence of the lion. Falconet is much more concerned with the encounter of beast and man; the two heads are juxtaposed on the same level, mirroring ferocity and suffering. The head of Milo is particularly personal, being a portrait of the sculptor himself. Milo's reversed pose emphasizes the drama of the moment, and this is further enhanced by the splendidly fierce lion, with its shaggy body seen from the back and conceived in Barye-like terms of realism – very different indeed

from Puget's heraldic animal. The opposing forces are balanced, momentarily, on the uneven rocks; a tension is held between them which looks back to Rubens and forward to Delacroix.

It was followed by a series of popular successes in the very opposite vein, that least to be expected from a sculptor characterized as 'cet homme sévère'. Fascination with the problem of conveying flesh in marble was to lead Falconet to the feminine nude, to become a sort of Boucher of sculpture – though rarely on a large scale. The taste for small models and maquettes was easily extended to highly-finished pieces which preserved the proportions of what had once been preparatory work. Not surprisingly, La Live de Jully was one of Falconet's patrons – perhaps one of the very first – and was the owner of the plaster *Milo*. Other rich bourgeois patrons included the Thiroux, for whom the *Baigneuse* and the *Pygmalion* were to be executed. It was this milieu rather than the court which favoured Falconet, and which to some extent was the natural one also of Madame de Pompadour, herself bourgeoise. Falconet thus had virtually a new public which was neither from the court nor from the circle of antiquarians. It was really closer to the milieu from which he himself came. It did not require sculpture to be large and impressive, still less learned and severe, but to charm: by its smallness and by its frank eroticism. When sculpture did not positively depict Love in some guise or other, it postulated him by its treatment of the female body.

Much of the resulting work, sometimes not directly by Falconet but inspired by him, has a strangely Victorian air and a sense of having been carved from white lard. The supposed erotic power of these statuettes was recognized at the time with proto-Victorian prudery when the Thiroux d'Arconville draped the Galatea of Falconet's most famous group with 'une chemise de satin qu'on lève de temps en temps en faveur des curieux', as Diderot recorded.[21]

Falconet's real success came with the Salon of 1757 when he exhibited the *Baigneuse* (Plate 88) and also the *Cupid* (Plate 89) (both Louvre). The *Cupid* was Madame de Pompadour's commission; it became, and has remained, one of the most famous pieces of eighteenth-century sculpture. Falconet tackled a subject which had already been treated notably by Bouchardon and Saly. Madame de Pompadour had asked for the same subject from Slodtz, but he had done no more than execute the drum-shaped pedestal. That *Cupid* had been intended for Bellevue but perhaps with the sale of the house in 1757 and in the light of Slodtz' continual delays, the project was abandoned and replaced by Falconet's comparable work for her Paris house.

This was conceived in very different terms from the standing figures of Bouchardon and Saly. As presiding god and *genius loci*, Cupid is seated, cloud-borne, in deceptive, apparent, repose. He is a boy, a baby, made diminutive by affection. The statue incarnates the attraction, and yet the threat, of love. In one profile Cupid is seen with hand on lip, urging discretion and secrecy – only the extended tip of his quiver hints at more. From the other side, and from the front, it is apparent that his left hand is drawing an arrow from the quiver; an ambiguity is now apparent too in the gesture of finger to lip which becomes less conspiratorial and more threatening. And finally, all Love's ambiguity is summed up in the prominent spray of roses carved at the base of the cloud.

H

The statue is perfectly prepared for entry into Fragonard's pictures, to be the dynamo that sends waves of erotic energy through their every curve and twist of paint. Falconet makes Cupid not only a boy but a toy, consciously charming, mischievous, and yet paradoxically powerful. In one way, it is such an effective piece of sculpture because it is so serious. Other gods and goddesses might continue to be carved as a mere fashionable continuation of mythology, but this god is – as the century fully recognized – real. He really does preside over its art, from Watteau's *Pélèrinage à Cythère* to Mozart's *Nozze di Figaro*. Falconet did not attempt to say anything new about Cupid, nor to present him in any novel guise. His concept is obvious, but with the obviousness of genius. It deserved its instant fame, its reductions, the copies, its transference into paintings. It immediately spoke to the whole century and crystallized – canonized – its strongest belief: 'Qui que tu sois, voici ton maître.' Although Voltaire's distich was not written for Falconet's statue it might well have been, and was quickly inscribed on his pedestal as homage to the god: 'Il l'est, le fut ou le doit être.' The menace is seen also as a promise; love is seldom quiescent. Part of Falconet's success comes from that sense of the youthful god only momentarily poised on his cloud, momentarily still before withdrawing the arrow: with his prominent, finely-feathered wings, he is a 'farfallone amoroso' of marble, about to flutter once more into activity.

After the *Cupid* the *Nymphe qui descend au bain* (Louvre), exhibited at the same Salon, and equally popular, does not deserve her success. Svelte to the point of being meagre, she is a graceful bagatelle which has almost ceased to be sculpture; later French critics have been rather shocked by Gonse's pronouncement that the level of the object is that of an 'agréable dessus d'étagère', but he spoke the truth. A faint chilliness is apparent in the polished limbs of the *Cupid*, but in the *Baigneuse* the marble becomes icy, while the small scale adds to its doll-like insipidity. Apart from the interest of the pleated chemise, the handling is chastely dull, and it is hard to recapture the bather's supposed allure. There was a *frisson* to be shared in the concept of the figure's foot just advancing into contact with the water – but that is not a motif invented by Falconet and had appeared in painting as early as Lemoyne's *Baigneuse* of 1725, itself not perhaps without some influence on him. In Falconet's final result the gracefulness of the pose is too stylized and commonplace with the head seen on the same axis as the advancing leg. The plaster (Hermitage) is less patently graceful but more striking in pose, the head tilted to one side, and the body animated by a greater sense of movement.

The *Baigneuse* of 1757 was only the first of Falconet's variations on the theme. It led to a whole range of figures, now standing, now seated, sometimes accompanied by a Cupid, but of which the main purpose always remains a study of the naked female body – a body which does not vary very much in type, being always youthful and slightly immature. Above all, the purpose and the appeal of such work was in the sense of marble turned to flesh, or warm blood under the stone. The myth of Pygmalion, so popular in eighteenth-century France,[22] was fittingly to be carved by Falconet; the result appeared at the Salon of 1763, to be enthusiastically received by everyone, including Diderot. The *galant* connotations of the theme added to its popularity. Diderot wished for greater physical contact to be shown between sculptor and statue as a woman slowly emerged

from the marble block. Pygmalion must be excited before the sight of his concept assuming living shape; and each spectator of Falconet's group became himself a Pygmalion: 'appuyez-y votre doigt et la matière qui a perdu sa dureté cédera à votre impression', breathed Diderot in ecstasy.[23] This was probably the greatest moment of public success in Falconet's career, though it did not coincide with his finest work. The group's popularity was connected less with its merits than with its subject, which inspired several paintings and Rousseau's *scène lyrique*, among other theatrical pieces, as well as some philosophic interpretation. The myth expressed, above all, the idea of woman coming to life under a man's hands; it had seldom been utilized by sculptors, and Falconet's Pygmalion kneels in rapture before what amounts to a double act of creation.

The group is serious in a way that Boucher seldom was. Indeed, for all the eroticism of the theme, it is notable how severe is Falconet's actual treatment of it, and how little *galant* when compared with the much earlier painted treatments by Raoux and Lemoyne. It has more than a touch of that sensibility which was quite apparent in Falconet's *Douce Mélancolie* of which the completed marble also appeared in the Salon of 1763. By 1765 this was pronounced to a positive degree of sentimentality, in the classically-shaped *Amitié* who offered her heart with both hands in a gesture which offended some critics, but not Diderot. It marked Falconet's last Salon appearance and also the extent to which his sculpture had been moulded by current tastes, moving away from the early vigorous *Milo*, Baroque in style, through the pretty if chilly phase of the *Baigneuses* to the Greuzian rhetoric of *L'Amitié*.

Yet this is only one aspect of Falconet's activity. Admittedly, it is the aspect which had gained him the effective directorship, with Boucher, of the Sèvres factory from 1757 onwards. His Salon exhibits were adaptable, and were immediately adapted, to duplication as figures in *biscuit de Sèvres*. Though this dissemination of his designs, often with minor variations, meant fame, it is significant that he himself never bothered to list what he had executed for the factory, clearly not thinking of it in terms of sculpture. The taste which he had satisfied was to be catered for next by Boizot, who succeeded him, after an interval, at Sèvres; and then, with much greater élan and light-hearted bravura, by Clodion.

While this represents to some extent a new taste, Falconet's other work in the years up to 1766 was more traditional in its scope. His chief opportunities for sculpture on a large scale were given by religious commissions, though the results seldom survive. The evidence at Saint-Roch is difficult to interpret today, but the *Fainting Christ* is a displeasingly theatrical figure and the *Glory* he devised there is dusty and faintly tawdry, a sadly-distant echo of Bernini, and unexpectedly tame in execution. Through it was planned to be seen the artificially lit *Calvary*, which Diderot could not defend – indeed, his strictures on the whole scheme remain apt. Falconet had at Saint-Roch a splendid opportunity, one that occupied him for a considerable time, and yet the eventual decorative scheme was not judged a success by anyone, not even by the sculptor himself. Apparently more dramatic and exciting was the *St Ambrose*, intended to replace a statue of the same saint by Sébastien Slodtz in the Invalides. That statue by Michel-Ange's father showed the saint quietly blessing. Falconet's concept, perhaps inspired by Rubens,

placed him as protagonist in the dramatic moment of refusing the emperor admittance to the cathedral at Milan.[24] All that can be evoked of it (removed from the church and probably destroyed at the Revolution) suggests a return to the dynamism of Falconet's earliest work and a prophecy of his greatest achievement. He made his saint a hero, playing a hero's part, with windswept drapery and a face of noble defiance. The effect was grand and terrible, and was probably Falconet's most successful large-scale work in Paris; but it was not to be placed in position until after he had left for Russia in 1766.

His fame remained that of the sculptor of such work as the *Baigneuse*, and thus he was not among the obvious candidates to create the bronze statue of Peter the Great. The names that first occurred were those who had worked for Russian patrons, as had both Pajou and Vassé, or those who, like Guillaume II Coustou and Saly, were already associated with large-scale monuments. Ultimately, Falconet was chosen because he was the cheapest in his estimate, and was also prepared to reduce that still further.[25] Like so many other great sculptors of the period he wished to raise a monument to himself as well as to an ostensible subject. In his case the wish is particularly interesting as marking a break – a final one – with the bourgeois patronage that had made him famous. No important royal commission had come his way in France. Madame de Pompadour had died in 1764. La Live de Jully was to become mentally disturbed in 1767. Falconet himself was well aware of his position when he wrote to Marigny in 1763: 'j'ai bientôt cinquante ans et je n'ai rien fait encore qui mérite un nom'.[26]

By the time he was in fact fifty he was engaged for Russia, to raise the monument to Peter the Great 'au milieu des glaces du Nord'. This phrase of Diderot's serves as a clue of sorts to Falconet's inspiration. The location of his statue was exotically far from Paris, in a city that was the creation of the person to be commemorated. Peter the Great was an inspiring subject – in contradistinction to Louis XV in the last decade of his reign. At once general and lawgiver, Peter was the greatest ruler of the greatest empire in the world; and the earliest Russian project for the monument emphasized that fact. Though he had died only in 1725, well within Falconet's lifetime, he was already a figure of mythology, the hero of a lengthy but unfinished *Pétréide* by the then famous rhetorical poet, Thomas, who also wrote an *éloge* on the Maréchal de Saxe. The grandeur of the project stirred Diderot as well as Falconet. The commissioner of the statue, Catherine, was herself glorified by it. Everything encouraged an original concept which should do justice to the originality of the project; and it is significant that the preliminary idea came to Falconet before he ever saw St Petersburg. One day in Diderot's study he sketched in a flash the essential elements of his composition: the emperor, 'gravissant ce rocher escarpé, qui lui sert de base, étendant sur sa capitale une main protectrice'.[27] That alone makes clear its break with the Marcus-Aurelian tradition of Girardon, Bouchardon, and Saly; and it is already apparent that it will be more excitingly 'engaged' than Lemoyne's statue for Bordeaux.

A quite different solution to the problem of the equestrian statue had been propounded by Bernini's *Louis XIV*, where the king rode high on the crest of ragged rocks – almost as airborne as Bellerophon on Pegasus in the drawing, but muted in the final statue which had signally failed to please, and was converted by Girardon into Marcus Curtius. This

offers the prototype of uneven ground under the horse's hooves, but unfortunately Falconet thought the statue very bad, perhaps because of Girardon's modifications. For the horse's rearing pose it is usual to cite Tacca's *Philip IV* at Madrid. Falconet's attention was indeed drawn to this by his enemy, the Russian Director of Fine Arts, Betskoi, but once again the sculptor condemned the statue as a poor thing, though he may well have benefited from it. Finally, the Marly *Horses* contain some seeds of Falconet's concept; their installation, and fame, had coincided with the young sculptor's début at the Académie, and they can hardly have failed to impress him.

Their naturalness heralds the naturalness of Falconet's *Peter the Great* (Plate 90). The statue was to express the 'idea' of a hero, and yet without allegorical trappings. Whatever the final mutual disillusionment of the sculptor and the empress, they agreed in this and they achieved it in the eventual monument. The fused concept of ideal, heroic, and yet natural at which Falconet aimed is shown by his modelling the czar naked. Probably he realized he would never be allowed to cast the actual statue with his hero nude, but he avoided both conventional Roman dress and also specifically Russian costume. The czar wears timeless robes, lifting him into an ideal sphere and achieving the same result therefore as nudity. There were to be no allegorical groups round the statue's base; 'mon héros se suffit à lui-même', Falconet pointedly declared.[28] There was to be no rhetoric in the inscription. Catherine not only shared these views but, like posterity, was rather worried by the single allegorical element, the snake crushed by the horse's hooves. Falconet's defence was largely technical; the pose of the whole statue presented problems of casting; the bronze had to be heavier at the back than the front, to preserve its equilibrium, and the snake helped in fixing it to the rock. Perhaps it was Falconet's concern with the ideal aspects of his statue which allowed him to leave the head of Peter the Great to be executed by Marie-Anne Collot. He had little interest in portrait sculpture, while her narrow but genuine talent was for this category alone. Diderot thought her bust of him better than that by Falconet; so did Falconet, who consequently smashed his. And from the first he widely proclaimed her valuable part in the execution of the monument.

What was united in it was ideal and natural, reason and passion, symbolized in the calm rider on his fiery horse. Diderot perceptively apostrophized the result as 'le centaure Czar', and the concept looks forward not only to David's *Count Potocki* (Plate 196) (pp. 192–3) but to the *Napoleon crossing the Alps* (Plate 201), which enshrined a ruler's express wish to be depicted 'calme sur un cheval fougueux'. But unlike that, it emphasizes reason. The czar is more legislator than conqueror. Like Catherine herself, he stands for liberal autocracy, ease in place of pomp, intelligent achievement over mindless show. Whereas the ruler of France must always be bolstered by imaginary glory and high-pitched homage ('Victoriarum Auctor et Ipse Dux' flattery dared to inscribe in praise of Louis XV on the very monument to Marshal Saxe), the two Russian sovereigns could stand by themselves and display a truer pride. Falconet instinctively understood it when he conceived that four-word inscription which Catherine immediately approved: 'Petro Primo/Catharina Secunda'.

Falconet was back in France when the monument was finally unveiled in 1782.

Though he never saw it *in situ*, plenty of French visitors to St Petersburg did, and their disapproval is the best testimony to its originality. The monument's romantic bravura, its naturalness, departed from all the conventions of a royal equestrian statue as conceived in Paris. It is fitting that it should have inspired Pushkin's 'Bronze Horseman', for in many ways it anticipates Romanticism. Yet it remains very much of its own century in its humanism, in its expression of the philosopher-king, not threatening but protecting his city with outstretched hand. Falconet's enshrining of such concepts in sculpture, like his friendship with Diderot and acquaintance with Voltaire, make him a new sort of sculptor in France; he is part of the Enlightenment in a way unparalleled by any other great artist except Pigalle.

Though their rivalry is understandable enough, it is quite different from that of Bouchardon with Adam, or even with Lemoyne. Intelligent taste rightly recognized that, wherever one's own preference might lie, Falconet and Pigalle were both great. Far from representing two extremes of style, their general idiom is remarkably similar, though pronounced in each case in a highly personal accent. They are commanding figures of the mid century. Surveying the Salon of 1765, it was of them that Diderot thought to show posterity 'que nous n'étions pas des enfants, du moins en sculpture'. His own tendency was to prefer Falconet; and yet: 'Au demeurant, ce sont deux grands hommes.'

Pigalle

Perhaps it was only when Pigalle died in 1785 that his greatness could be fully appreciated. Even if no one positively came forward then to claim him as the greatest French sculptor of the century, the testimonies to his ability and achievement were more sustained than for any other sculptor. On the invitation card to his funeral the titles and honours form a miniature biography, evoking a career that runs from the first tremendous success, that of his *morceau de réception*, the *Mercury*, the most successful ever in the Academy's history, to the final solemn inauguration of the Saxe monument. After the *Mercury* came the success of Louis XV's monument at Reims – and that prompted Bouchardon to nominate Pigalle as his successor for the Paris monument to the king; the greatest sculptor of the age, in most people's eyes, singled out the next greatest. But Pigalle's wealth and honours were unparalleled: with Saly, the first sculptor to receive the Saint-Michel, he was one of the very few to become Chancellor of the Academy, being in addition a member of the Académie Royale at Rouen and honorary citizen of Strasbourg. No more indifferent to honours than to money, Pigalle fought hard for the official equality of sculpture with painting. Though the post of Premier Sculpteur du Roi, which he had envisaged, was never created, his impressive career is the triumphant culmination of sculpture's struggle for individuality and respectability within the framework of the arts in France as first devised under Colbert.

Although no one could perhaps fully realize it, a whole tradition died with Pigalle; his death signals the end of the French Baroque style, and with it the end of the system of royal patronage. The great court painters were long since dead. Of comparable sculptors

it is true that Falconet lived on, but completely inactive. Vassé, Saly, Coustou le fils, were all dead, as was Lemoyne. 1785 was an eventful year, politically and artistically; politics and art were soon to be dramatically entwined, and meanwhile in that year France experienced the scandal of the Diamond Necklace and the instant success of the *Oath of the Horatii* (Plate 198). Soon David was to challenge the authority of the Académie whose chancellor Pigalle had been; and not only royal patronage but royalty itself was soon to be overthrown.

A great distance, of more than actual years, separated those events from the world of Pigalle's birth in 1714. Jean-Baptiste Pigalle, born while Louis XIV still reigned, had risen higher than any other sculptor but came from the very humblest rank of society, comparable in origin to that of Falconet. As with Falconet too, there is an unorthodox start to his career. Falconet never visited Italy; Pigalle was to go there under official auspices and yet, it seems, not as a royal pensioner. It was one of the last acts of d'Antin to sign the *brevet* on 7 October 1736 which allowed the young sculptor to work at the Academy in Rome, a considerable privilege, since he had failed to win first prize at the Academy Schools in Paris. Like Falconet, he was a pupil of Lemoyne; but before that he had worked under Le Lorrain, the first individualist among the century's sculptors. Neither of these masters could be claimed as 'correct'. Indeed, it was to be recorded by Pigalle's friend, the Abbé Gougenot, that Le Lorrain preferred pupils who were 'échauffés par la nature'; and that is the keyword for Pigalle's own style. From his earliest success onwards, he made nature his study; even the pictures which he collected in his prosperity proclaim an interest in the natural, and the names of Chardin and Greuze are prominent.

But the 'nature' that he sought needs definition and qualification. Closer to Falconet than to Lemoyne, he was never much attracted to portrait sculpture. His concept of nature had in it something of Rubens' Baroque vigour and warmth, and something also of his preference for the large-scale. It had a ruthless quality of honesty which could lead to the awkward result of the naked *Voltaire* but which gives tremendous symphonic force to the drama of the Saxe monument. Its force and almost rude power were best displayed in masculine subjects, and it is noticeable how free is all Pigalle's work from slyly *galant* or erotic overtones. His male portrait busts are not only more numerous than, but superior to, his female ones. The *Mercury* is rightly famous, while the *Venus*, its pendant, was little esteemed from the first and deserves its obscurity.[29] Even his work for Madame de Pompadour is, not altogether by chance perhaps, concerned with friendship rather than love. Vigour banishes from his style any of the century's tendency towards the pretty, just as – as far as possible – it concentrates on the big scale and avoids the statuette. Every aspect of his art is summed up in the Saxe monument, beginning with the sheer fact that the man commemorated was worthy of a great monument, and ending with the fact that it is concerned with an inescapable law of nature: death. Naturalness leads to the grim skeleton who prepares Saxe's tomb for him; there is no place for the comforting Slodtz concept of Death Overthrown. Thus, for all the panache and the allegorical figures about Saxe, the central moment is intensely, poignantly, natural.

Hardly anything is established about Pigalle's early years in Rome, except that he

seems to have benefited already from the friendship and generosity of Coustou le fils, who many years later was to be a witness at his marriage. His entry for a competition at the Accademia di San Luca resulted in his gaining a second prize, but he had entered against the French ambassador's wishes and had to withdraw. Neither Antiquity nor Bernini – those twin Roman lodestones – seems to have exercised much influence upon him, though he must have been fully aware of both. He was capable of copying the antique directly, as in the *Dice Player* (Wildenstein Collection),[30] which was executed in Rome about 1738, and equally capable of contributing years later to the *mise-en-scène* at Saint-Sulpice with the Virgin and Child in a stucco glory.[31] Yet it is significant that neither of these works is truly typical of the sculptor: he is not of the party either of Bouchardon or Slodtz; and the attempt to see him combating the Baroque by the classical makes him an 'engaged' artist of exactly the type he was not. As easily as Chardin, he sails between these two preoccupations of the century and emerges as attached to a third party – that of nature. He was distinguished by a 'surabondance de vérité' which was at times too pungent for some tastes but which pointed the way, rather like Goya's art, towards the new century.

Traditionally, the *Mercury* was executed or at least conceived in Rome during Pigalle's student years, which ended in 1739. There seems no real reason for this view, and the statue might equally well have originated during the period he spent at Lyon on his return from Italy and before settling in Paris. In 1741 he was back in Paris, and the following year the terracotta *Mercury* (Plate 91), now in New York, destined to be the preparatory model for Pigalle's *morceau de réception*, was exhibited at the Salon. Two years later he presented the marble version (Louvre) (Plate 92) to the Académie and became instantly famous. He received a royal command for large-scale marble versions of this and its pendant, a *Venus*, which the king was to despatch to Frederick the Great. But the *Mercury*'s fame was not connected with that, and indeed the large-scale marble is of diminished power, just as the marble reception piece is itself a less impulsive and dynamic object than the preliminary terracotta.

All Pigalle's art seems concentrated in this. There is a concentration of form, allied with the concentrated pose in which strength is held in potentiality; Mercury is the perfect allegory of speed and power, and though, when Pigalle added *Venus*, he attempted to tell a story, the statue is basically sufficient by itself. It is not a narrative of the kind displayed in the bravura of Falconet's nearly contemporary *Milo*, but the expression of all those qualities associated with Mercury. As has recently been suggested, the brilliant pose – worthy to have derived from Rubens – may well derive from Jordaens;[32] but it was a pose Jordaens had used for Mercury slaying Argus, whereas Pigalle retains the crouching pose and keen gaze as inherent in the concept 'Mercury', illustrating simply his character. The action of tying the sandal hardly matters; what is supremely summed up in the work is a sense of coiled power – the potential to take off which is locked inside the medium but communicates a vibrating sense of energy to the boldly-handled surfaces. The forms seem to relate to each other through a series of exciting, bumpy transitions – where the sculptor's ability as a modeller is felt – which flow together more gracefully in the marble but less forcefully. The rough, uneven contour of the hat brim

in the terracotta version is not only closer to Jordaens' treatment but has a vigour which is smoothed away in the neat outline of the marble hat, under which too the hair has become more prominent, softening the original pulled-down effect which was part of its unconventional power.

Less literate and less pugnaciously a 'character', Pigalle was as much as Falconet unconventional by nature and perhaps *au fond* more stubborn in pursuit of his aims – both in life and art. His own self-portrait bust of 1780 (Louvre) (Plate 93) has a heavy authority along with its pungent self-awareness. It is a face the very opposite of the mercurial mischievous mask of Falconet; what in him was a biting quality of mind was in Pigalle a growling, bear-like tenacity. It is sufficient to instance Pigalle's obstinate refusal to change his Cupid on the Saxe monument into a genius of war; he appeared to yield, but finally left it, as he had always intended, a Cupid. Inevitably, Pigalle and Falconet ask to be compared; like Turner and Constable, or like Dickens and Thackeray, they share similarities for all their individual differences. They remain of their period, and in Madame de Pompadour they shared a patron.

In the years immediately following on the success of the *Mercury* Pigalle was to be very fully employed by the Marquise and by the Crown. No other sculptor received such a rich share of important commissions; they included portrait busts of *Louis XV* and *Madame de Pompadour*, allegorical statues, a white and black marble crucifix for the dauphin, and finally the Saxe monument. It was in the statues for Madame de Pompadour that Pigalle came closest to comparison with Falconet, and it was there also that he came closest to surrendering his own stylistic preferences. Several of the statues included her portrait in allegorical guise and more attractively than in the straightforward bust of her (1748–51, Metropolitan Museum) which is strangely waxen and impersonal. The much weathered but still tender *Love and Friendship embracing* (Louvre, signed and dated 1758) is probably the most ambitious of her commissions to Pigalle – apart from the *Education of Cupid* group, never executed on a large scale in marble. The *Love and Friendship*, for all its allegorical theme, has a naturalness that is maternal rather than anacreontic; it is conceived in terms of realism rather than prettiness. The pose of *Friendship* must always have seemed rather awkward, but the *Love* has still a childlike vivacious appeal, and originally its modelling must have added to the effect.[32a]

Pigalle had already revealed in the marvellously studied, unsentimentalized *Enfant à la Cage* (Louvre) (Plate 94) how brilliantly he could convey not only infant flesh but even infant character. An actual portrait of the one-year old son of Pâris de Montmartel, it appeared at the Salon of 1750, and its popularity was so great that it nearly eclipsed that of the *Mercury*. This was Pigalle's first essay in what was almost a new genre, or rather a return to the antique Roman type of statues of children. Pigalle's statue became in fact a pendant to an antique one presumably already owned by the financier, of a child holding a bird. The statue's success led to its being duplicated and much copied, and Pigalle himself returned once or twice to the theme of children, now sitting, now standing, usually with fruit or a bird. They may be charming, but they seem separated from the first and most famous example by its pronounced, idiosyncratic portrait air. It is resolutely ungraceful and unidealized; indeed, it is, just as much as the *Voltaire nu*, the

result of obsessive truth to nature. Although it has been claimed to possess 'une grâce alexandrine', it is distinguished from so many children and cupids and putti of the century exactly by its lack of that sophisticated air. Pigalle seems to have recognized its worth by buying it back later for much more than he had been paid; it was in his studio at his death and was the most highly valued of all the sculpture he then possessed.

Its public success was due to its having been exhibited at the Salon, but Pigalle was never to exhibit there again after 1753. Although he did execute a few small-scale decorative works, he left to Falconet the vogue for statuettes like the *Baigneuse* and the *Pygmalion*, and turned to the sequence of large-scale monuments by which he is best known. Yet he also found time to execute some busts, chiefly of writers and doctors – significantly not courtiers but people who had thought and worked, and who often were his friends. Technically less dazzling than Lemoyne's busts, or Caffiéri's, they seem the result of profounder sympathies: personalities that had stirred Pigalle by some affinity with his own. There is never any virtuoso display, either in the costume or the sculptor's treatment of it; the neck and shoulders are treated with sobriety and the face too is sober, unsmiling, usually somewhat tense. The terracotta *Desfriches* (Orléans) (Plate 95) is probably the most outstanding achievement in its simplicity and worried lifelikeness. The physiognomy of this *amateur*, friend of Pigalle and Cochin, has a resemblance to Pigalle's own; it gives the same sense too of life's pressure upon the features, and all the working of the clay expresses the tensions which have gone to shape the exposed flesh, marked by lines about the mouth and heavy-lidded eyes. There is something naked about the effect which makes it moving.

But it is, finally, Pigalle's monumental art which raises him above his contemporaries and which illustrates also royal and official confidence in him. In 1750 Madame de Pompadour commissioned from him a full-length statue of the king and, though this was not completed until 1754, it may have combined with his other court work to gain him the Marshal Saxe commission which was confirmed early in 1753. Though Lépicié, secretary of the Académie, had proposed Coustou, it was Pigalle whom the young Vandières (not yet Marquis de Marigny) announced as chosen by the king. The resulting task was to occupy more than twenty years of Pigalle's career and is best considered outside the context of the rest of his work. But, once given, the commission singled out Pigalle as potentially the greatest sculptor in France.

It led to him receiving the commission from the city of Reims for the monument to Louis XV, preferred to the ageing Lambert-Sigisbert Adam and to the Caylus protégé, Vassé. In turn, the success of the Reims monument prompted Bouchardon to select him to finish the monument to Louis XV for Paris. In addition, Pigalle executed the statue of *Voltaire* (Paris, Institut) that had been commissioned by Madame Necker's circle in 1770 and which never found a public site, and also the confusedly sentimental tomb of Claude-Henry d'Harcourt, set up by his widow at Notre-Dame. To these actual works can be added two other monuments projected but never executed, the *Joan of Arc* for Orléans, which was to consist of two figures in bronze, and the grandiose plan for the Place Royale at Montpellier, which was to have four groups of *grand siècle* personages surrounding the equestrian statue of Louis XIV.

In each of these cases Pigalle produced new solutions: shocking people by the novelty of the *Voltaire*, which became, and has remained, something of an embarrassment. In the Harcourt monument, where he was tied by the widow's elaborate programme of conjugal reunion, there is an unexpectedly neo-classical, *larmoyant* tendency. That is his last large-scale monument and in its execution shows no diminution of the high competence which characterized his handling of marble. Even if the programme of the monument was devised by the sorrowing widow, the result remains strikingly novel. It is a completely dramatic illustration of the same sentiment that had been commemorated less effectively in Coustou's monument to the dauphin – that too originally intended to immortalize marital devotion.

The novelty of the monument to Louis XV set up in the Place Royale at Reims was entirely Pigalle's own, and he set his personal seal upon it by including himself on the monument. The concept put forward by Adam was completely rejected – as completely as was Adam's choice of medium; instead of lead statues of the king in coronation robes, with Minerva and Remus (an allusion to the city of Reims), Pigalle executed in bronze the king clad in Roman military costume but with arm benevolently extended – 'pour prendre le peuple sous sa protection', said the sculptor. This theme of benevolence guided him in the figures below, also of bronze: not the conventional slaves signifying a conqueror which, as he pointed out, had been stigmatized by Voltaire, but emblematic figures of mild government and of a contented nation.[33] The latter was symbolized by a citizen (Plate 96) who is a portrait of Pigalle. While the woman who leads a tame lion, symbolizing France, is a rather trite and unconvincing piece of allegory, the *Citizen* is a powerfully modelled figure, admittedly in mood more like Rodin's *Penseur* than a happy man, which suggests the influence not of the antique, nor Bernini, but Michelangelo. The figure has a brooding, timeless, sense which lifts it out of all associations with the allegorical luggage around it, and with the rest of the monument. It is an enlightened reply to the chained slaves at the base of Desjardins' *Louis XIV*; yet, as it gazes out, uneasily posed, it seems to embody not so much exhilaration in liberty but awareness of the responsibilities that liberty brings.

Although the *Citizen* is individually memorable, and perhaps magnificent, the Reims monument must always have failed to make a single, coherent effect. It is doubtful if even the original statue of the king was satisfactory – the position of the feet in Moitte's engraving suggests a penguin rather than a man – and it was singularly detached from the huge allegories at its base. The ideas Pigalle was trying to express were not totally suited to a royal monument, not even one raised to the 'best of kings'.

In both the Reims monument, completed in 1765, and the quite different Harcourt one, of some ten years later, there is a tendency for the parts to be more effective than the whole. One of the achievements of the Saxe monument is that – at last, one is tempted to say – execution is matched by successful invention; the parts cohere into a striking whole, unique in its tremendous power (Plate 97). Yet the concept is in fact the earliest of Pigalle's large-scale monuments. The king had selected and approved the design by 19 March 1753 and the model was completed by 1756, though another twenty years were to pass before the final monument was inaugurated under Louis XVI. Even here the

ultimate coherence of the design – and the effect from which it gains so much – came almost by chance. Pigalle had planned the marshal looking away to the left at the symbols of his defeated enemies; and it was a court suggestion, transmitted by Vandières, which proposed instead his gazing, 'avec la même fierté', at Death.[34]

Maurice de Saxe, bastard of the Elector of Saxony, Marshal of France, brilliant soldier and victor above all of Fontenoy, had died prematurely at his château of Chambord on 30 November 1750. If the death of the aged Cardinal Fleury, seven years previously, had caused little grief except to the king and perhaps some far-sighted pacific spirits, the death of Saxe stirred all those associations of military glory and bellicose France which still continue to haunt that nation. Between Louis XIV and Napoleon there was Saxe; he gave a heroic tone to an essentially unheroic, but intelligent, age; and the widespread grief at his death was sincere, deepened yet further by his repute as lover as well as soldier. It was indeed his boudoir victories which had hastened his death. Although he died comparatively young he was, as well as great in himself, a link with the great past. As a boy he had been present at Mons and Malplaquet; he had served under Peter the Great; for him the title of 'Marshal General' had been revived, not having been used for anyone since Turenne.

All these considerations are relevant to Pigalle's eventual concept; and several of them were to find expression in his monument. He had read Voltaire's *Siècle de Louis XIV* and studied the monument to Turenne (then at Saint-Denis) which he thought a poor tribute to a great soldier. Originally he planned two different designs for the Saxe tomb: one expressed the sense of his country's grief, and showed the hero dying in the arms of France – a clear echo of Girardon's Richelieu tomb – while the other emphasized the heroic rather than the pathetic. It was the latter the king chose. The marshal stands; even at the moment of death he seems invincible, and the proud isolation of the standing figure against the pyramid is the first and literally arresting effect of the monument.

Just as chance played its part in the marshal's pose, so chance governed the site of the tomb. Being Protestant, Saxe could not be buried in Notre-Dame or at Saint-Denis. Saint-Thomas at Strasbourg was chosen as a Protestant church on French soil, and reduced to being in effect a temple around the Saxe shrine, in a way that would not have been possible in either of the more important buildings. Alterations to the choir, re-arrangement of the windows, were made to achieve the concentrated central effect: the main door opens to reveal the well-lit monument filling the space of the apse. It can be approached only frontally – and its impact is increased by the movement of the figures towards the spectator, away from the wall. Pigalle has rejected the proscenium frame concept of Slodtz and Adam, in which the figures tended to be bas-relief-like, however fully modelled, and replaced it by a fully three-dimensional sense of the scene acted out in depth on different levels that descend towards us (Plate 98). This sense is further increased by the powerful cutting of the marble, with its tremendous folds of thick drapery, manifested at its most powerful perhaps in the shrouded figure of Death (Plate 99). Pigalle has conceived this with no gesticulating rhetoric, making it instead a compact and intensely sombre shape – inevitable mirror image of what even the heroic Saxe shall soon be. The weeping Hercules is conventional by comparison; and the

animals symbolic of defeated countries are, like the huge standards, so many rhetorical flourishes which only decorate the main theme – the actual drama – of Death and the Marshal.

For the final stark but superb effect comes from Pigalle's concentration on that encounter, with scarcely any mitigating suggestions of resurrection or immortality.[35] The opened tomb is there before us and cannot be avoided. But Saxe does not deign to glance at it; he steps forward at Death's summons, hardly restrained even momentarily by the imploring figure of France who vainly intercedes for him. He goes to death like Regulus back to Carthage, as calmly as if 'tendens Venafranos in agros', but with the panache of his own century. His bravery consists exactly in facing the reality of death, in gallantly setting forward for a battle that is already lost.

This is only one way in which he anticipates another fighting lover, Mozart's Don Giovanni. Dissoluteness and bravery excite a sort of envy. When carried to the extremes of a Saxe or a Don Giovanni they lead to premature death and the retribution which is almost the same thing: 'Ho fermo il cor in petto/non ho timor, verrò.' Sculptor and composer both turn back to the Baroque for their treatment of the one subject that even the Enlightenment could not wholly rationalize. The honesty which runs throughout Pigalle's work is seen here at its most impressive, in the very place where the subject might tempt an artist to hyperbole. But Pigalle emphasizes *la condition humaine* which controls the hero as much as the ordinary man; the greatest human glory ends in death. Even while recognizing this, Pigalle's Marshal Saxe remains also a character, a definite portrait not in generalized robes but positive armour, and set within a truthful perspective. When d'Angiviller commissioned statues of great men from several sculptors, Pigalle did not apply for a commission. In the monument to Marshal Saxe he had already created his concept of a great man – on an unparalleled scale.

Caffiéri, Lecomte, Defernex, Attiret

The second half of the century was rich in competence as well as genius; indeed, Patte declared in 1765 'les progrès de la sculpture au jugement des connoisseurs, passent pour être supérieurs à ceux de la peinture'.[36] There is a positively embarrassing choice of lesser sculptors who remain basically unoriginal but usually proficient. Few of them, however, were to prove very successful in working on a monumental scale – even when they themselves were anxious to do so. The best that was produced therefore was some graceful, charming, decorative sculpture, often of rather insipid character, and many highly competent portrait busts. Several of these sculptors were outside the established circle of the Académie Royale at Paris; thus Defernex belonged to the Academy of St Luke and was patronized by the Orléans faction, and Attiret, also a member of that academy, was active largely in Burgundy.

The years of such men's activity were those awkward ones marked by a slackening of artistic energy, a dissatisfaction with the energy and *manière* of the first part of the century, and an uncertainty which preceded the more 'engaged' discipline which involved the neo-classical. Meanwhile, an artist was safest in being natural and true, taking

little imaginative risk. It is no accident that the most successful category was 'natural' portraiture, acceptable to all ranks of society, and always saved by being a good likeness even when not very interesting art. Lemoyne went on exhibiting at the Salon up to 1771 and his influence remained potent. But aimlessness and lack of any definite style are most clearly revealed in the best known, if not in fact the best, of these sculptors, Pajou: drifting on the currents now of the Baroque, now the neo-classical, with no more difficulty than he had in serving first the king and then the Revolution.

It was to give sculpture a purpose, to revitalize the country with a tonic both artistic and moral, that d'Angiviller conceived the series of statues of the great men of France, the first group executed in 1777. The scheme is as much conscious reform as were the efforts at fiscal reform under Louis XVI, and no more successful, despite some individual achievements. The best of Pajou's work cannot be said to be his contributions to the series, and the same is yet more strikingly true of Caffiéri. It was genius which counted, and the unexpected success of the series as executed is Clodion's *Montesquieu* – showing also that genius needs no rules. Its energy can triumph when lesser talents are infected with a general lassitude.

Jean-Jacques Caffiéri cannot, however, be accused of any lack of vitality, either in life or art. In neither did he fully succeed in directing the vitality to achieve his ambitions; he never gained the Saint-Michel, never executed the statue of his ancestor Le Brun which he proposed, and in Houdon encountered a rival who has triumphed only too well over him posthumously. Caffiéri's portrait busts can be stunning, but almost too virtuoso in effect. He is virtually a Liszt of sculptors, never quite receiving his due through some inherent suspicion of his sheer brilliance. Perhaps it was because he felt the reserve – which over his *Molière* became open criticism – that he gave so much time to pushing his career, his work, his gifts, his wishes for place and ennoblement, and left posterity an entertaining and sad correspondence which is an undoubted tribute to his persistence. In Caffiéri there was a strong aggressive strain, neatly and eternally sidestepped by d'Angiviller as Directeur des Bâtiments and recipient of the sculptor's letters and memoranda. It is not too much to detect the same aggression in Caffiéri's work, especially the trick of tilting the heads in his portraiture to give a challenging air, investing them with a rather insolent pride very different from his master Lemoyne's busts.

Caffiéri was born in 1725, son of the outstanding *fondeur-ciseleur* Jacques Caffiéri, and thus a member of that famous family who descended from 'one of the most ancient and honourable families in the kingdom of Naples' (in Caffiéri's own words), brought to France by Mazarin.[37] As the sculptor counted it in 1787, it represented one hundred and twenty-seven years zealous service for the arts and the Crown. His grandfather, Philippe, had indeed been Sculpteur du Roi under Louis XIV; his father was much employed by the Bâtiments and also executed some portraits in bronze, and Jean-Jacques was trained first by him. Something of his Rococo audacity passed to the son, who was exclusively a sculptor, chiefly in marble. After training with his father he worked under Lemoyne, for whom he retained affectionate respect, a fact the more noteworthy as in general Caffiéri was openly scornful of fellow sculptors.

From Lemoyne he must have learned a technical dexterity which sharpened his natural

gift for portraiture – and it was there that Caffiéri's talent lay – but it may be doubted if he had, or could acquire, Lemoyne's natural sympathy with his sitters. It is perhaps significant that one of Caffiéri's finest busts is the *Jean de Rotrou* (1783, Comédie Française) (Plate 100), a poet who had died before the sculptor's grandfather reached France; Caffiéri's particular brilliance lay in such animating of the faces of the past. In the case of the Rotrou bust he worked from a painted portrait. He himself had a special interest in collecting the likenesses of great artists, whether painted or carved or modelled, and was constantly offering the Académie engravings, marbles, and especially casts of, among others, Raphael, Rubens, Pietro da Cortona, Watteau, Bernini, ranging as far back as Andrea del Sarto and Dürer.

Even before going to Rome he had revealed his ability in the bust of *Languet de Gergy* (Musée de Dijon) which was executed from life in 1748, the year that Caffiéri won first prize as a pupil at the Académie. From 1749 to 1753 he was in Rome, where he executed the stucco group of the Trinity above the high altar in San Luigi dei Francesi, stigmatized by Natoire as revealing the sculptor's lack of study of the antique but accorded papal approval. In fact, the antique was hardly relevant to what was virtually a modelled 'glory' in Italian Baroque style. Caffiéri was doubtless more interested in modern Rome, and part of his time there must have been spent in taking casts of the busts on various funerary monuments as well as executing some portrait busts of living sitters – including Benedict XIV. Already he was noted as 'entêté et difficile à gouverner'; and already his ambitious projects were collapsing, like the proposal for him to execute statues at Caserta.

Though later to be touched, somewhat unexpectedly, by fashionable sentimentalism, he remained basically a Baroque sculptor and his *morceau de réception*, the almost awkwardly vigorous *River* (Louvre), shows his true character. The terracotta model appeared at the Salon in 1757, the first to which Caffiéri contributed, with a dazzling array of work in all categories. His facility was proclaimed, and in the following thirty years he was to be considerably employed, by the Crown for the Invalides, as well as for the 'grands hommes' series, by Madame du Barry, and – most memorably – by the Comédie Française on busts of dramatists. In the midst of letter-writing, pleas for pensions, complaints about lodgings, Caffiéri continued to press for further commissions from the Crown, itself none too firmly placed after the fall of the Bastille. He remained devoted to this source of patronage and as late as 1791 was wziting directly to the king urging the commissioning of a statue of Le Brun. His persistence was strangely removed from political facts. Within six months of Caffiéri's death in 1792 Louis XVI was tried and condemned to the guillotine. It was almost a double event which ended the Caffiéri and the royal family they had long served.

Caffiéri's finest work was not produced for either Louis XVI or Louis XV. His bravura and panache were better suited to the world of the theatre; his busts are portraits conceived very much as 'characters', and this sense is enhanced by the virtuoso details of costume. Madame du Barry fits into this atmosphere well enough. Caffiéri's marble bust of her (Hermitage) (Plate 101) is much more showy than Pajou's, typically more assertive, and almost the rendering of an actress posing as a courtesan: her breasts

pointing through the silky, lace-bordered, slipping drapery, and a garland of roses cascading over her shoulder. The handling of the lace is brilliant; that of the over-blown peony-like flowers more brilliant still, reminding one that Caffiéri executed a complete marble bouquet (exhibited at the Salon in 1781) which he later offered to Louis XVI. All Caffiéri's sitters seem fully conscious of who they are, and his portraits of great people from the past are especially marked by this – never more impressively than in the *Rotrou* bust, with its 'Three Musketeers' romantic aura, boldly-handled hair, bare throat, and masterly sweep of cloak seeming to echo the sweeping moustaches. Something more personal and more shrewdly realistic is apparent in the portraits of Caffiéri's own contemporaries, like Rameau or Favart, or the memorable *bonhomme* Pingré (Louvre) in his many-pleated surplice. It is in these that he comes closest to Lemoyne; and at bottom it is in a straightforward, no-nonsense world that Caffiéri is artistically most at home. Actors and musicians, and men like Rousseau, Mesmer, Benjamin Franklin – these represent his milieu.

But these were among the very sitters with whom Houdon was to achieve some of his most successful portraits, working with more thought and less instinct. Inevitably Caffiéri and he were rivals, and Caffiéri must certainly have felt the sting of challenge offered by the much younger man, himself capable of virtuoso effects, brilliant lifelikeness, and impressive characterization. Yet the comparison, if a comparison still has to be made, is not all to Caffiéri's disadvantage. His ability to astonish is a thoroughly eighteenth-century gift. If his effects tend to be meretricious, they are dazzlingly fluent at first sight. Indeed, at their best his portraits confront one with the startling sensation of having been abruptly unveiled: they throw back at the spectator a supercharged vital gaze, as impressive as that of the sculptor himself in Wertmüller's sumptuous portrait where Caffiéri stands, very much in *grand tenu*, waiting only to be adorned with the cordon of the Saint-Michel which never came.[38]

Among Caffiéri's decorative work is the group of children symbolizing – just – *Geometry and Architecture* (signed and dated 1776, Waddesdon Manor), which was one of four groups of the arts executed for the Abbé Terray, and probably commissioned during the abbé's brief period as Directeur des Bâtiments.[39] Each group was by a different sculptor, though the resulting pieces are homogeneous in style and indeed represent the culmination of sculpture in a private setting, yet not on a miniature scale, playful, graceful, and decorative. Clodion contributed the *Music and Poetry* (Washington, Kress Collection). The two other groups, *Painting and Sculpture* (Kress Collection) and *Astronomy and Geography* (Waddesdon Manor), were respectively by Tassaert and Lecomte. The elder and less interesting of these was Jean-Pierre-Antoine Tassaert (1727–88), son of the Flemish sculptor Felix Tassaert; he had a cosmopolitan upbringing and training, working partly with Roubiliac in London and then entering the studio of Michel-Ange Slodtz. Only after Slodtz' death in 1764 did he emerge as a sculptor in his own right. His career in France was brief, for in 1775 he left for Berlin, and his later work, often confused and rather old-fashioned in its allegorizing, is represented by such subjects as *Catherine the Great as Minerva* (Hermitage).[40]

Felix Lecomte (1737–1817) was a much more important artist, popular and active,

but of small merit outside his portrait busts. Of these the most familiar and duplicated is that of *Marie-Antoinette* (1783, Versailles) (Plate 102), at once imperious and benevolent, and perhaps a more truthful likeness than any painted portrait; however, the effective animation of the head is distracted from by the busy yet limp and over-emphatic draperies. Lecomte received the commission for *Condé* (of which the model was shown at the Salon of 1733) and also the *Fenélon* (1776–7, Institut) in the 'grands hommes' series, and the result is competent if rather dull; there is not much more vitality in his group for Terray (Waddesdon). He shared at least one other commission with Clodion, that for statues in the cathedral at Rouen. His career was academically respectable; he had been the pupil of Falconet and Vassé, with Vassé's influence preponderating, as was natural with a sculptor who was to execute the tombs at Nancy which Vassé had designed before his death. But Vassé's influence was only guiding him, prophetically, in the direction that fashion was to take in the last quarter of the century, with a sentimentalizing neo-classical style. Lecomte's reception piece, *Phorbas and Oedipus* (signed and dated 1771, Louvre), suggests by its subject alone the new climate, and places the sculptor with such committed figures as Chaudet and Chinard.

It is in a humbler sphere that Jean-Baptiste Defernex (1729–83) takes his place. Though he began his career as a modeller at the Sèvres factory, he is best known for his portrait busts which, as they survive, seem more usually of women.[41] The treatment is very simple, almost uncouthly so in comparison with the flash and dazzle of Caffiéri, and there is little attention to costume. Indeed, the busts are seldom more than of head and neck, with rather heavy features and a somewhat lumpish air. They have not only homogeneity but conviction: honest, unidealized, quite free from gallant flattery, they make something of the straightforward effect of Greuze's portraits. Defernex was sculptor to the Duc d'Orléans, and worked at the Palais Royal on some gilded lead groups of children. He was not a member of the Académie Royale but belonged to that of St Luke, and himself ran a school for sculpture and drawing where Durameau was to study. Naturally, he received no official commissions for sculpture, and he remains a slightly obscure figure whose early training is not clear. It is easy to see how unfashionable his art would be. It shows a dogged attachment to nature, and in a way this becomes Defernex's style, certainly the hallmark of his portrait busts. All the graces and tender amorous atmosphere that floated about Madame Favart seem dispelled by his convincingly truthful bust of her (1762, Louvre) (Plate 103).

Also from the Academy of St Luke and also to be connected, however tenuously, with the Favart, was Claude-François Attiret (1728–1804). He was born and died at Dôle. Some of his religious work is in Saint-Bénigne at Dijon, but he is remembered, if at all, by the bust of *La Chercheuse d'Esprit* (Dijon) (Plate 104), of which the marble was exhibited under this title at the St Luke Salon in 1774. The title comes from a comic opera by Favart, and it has even been suggested that the *Chercheuse* is Madame Favart, though that is most unlikely. There is something deliberately idealized in the bust, which indeed seems hardly to have the air of a portrait.[42] If Defernex represents in sculpture one aspect of Greuze, Attiret suggests another – the more typical one. The bust has a refinement and delicacy of handling, enhanced by the freshness of the terracotta

I

medium, which makes one pardon its sentimentality and somewhat false air of coyness; but there is artfulness, as well as art, in its simplicity. This becomes obvious when it is compared with what must have inspired it, Saly's *Bust of a young Girl* (Plate 85), which was too famous and duplicated to have remained unknown to Attiret. Such a comparison emphasizes the idealizing spirit of *La Chercheuse* which is a clear indication of its date of execution; and in its simplicity and bland maiden purity there is more of neo-classicism than nature.

For all these sculptors, including Caffiéri, the portrait bust offered the most successful results for technical reasons, as well as because of its realistic standard. The problems of organizing a large-scale figure, whether from the Bible or from French history, were considerable; those of a monument even more so. It is significant that Caffiéri's brilliance in bringing to life again faces from the past – in which he was undoubtedly the most gifted of French sculptors – was not sufficient to carry him through the full-length statues of Corneille and Molière. Invention of a pose, execution of it, avoidance of the pitfalls both of rhetoric and of dullness, such were qualities taxed to their utmost, especially by the requirements of the series of 'grands hommes'. Above all, the centralizing of sculptors' commissions on the Crown inevitably led to a weakening of effort when the Crown manifested as little personal interest as it did under Louis XVI, who, though eager to reform the court of his grandfather, chose for the sculptor of the first bust of himself as king the very favourite of Madame du Barry, Pajou.

Pajou

The finest work of art inspired, accidentally, by Louis XVI was the decoration of the opera house at Versailles, executed on the occasion of his marriage as dauphin in 1770, under the direction of Marigny (cf. p. 308). The sculptural portion of the whole elegant blue and gold ensemble, today restored virtually to its original state, was allotted to Pajou and remains the most attractive monument to his basically anaemic talents.

Augustin Pajou was born in Paris in 1730, son of a craftsman sculptor who had married the daughter of a yet more obscure sculptor. Though the milieu might be humble, it offered an early useful grounding for the young artist, who then went on to work under Lemoyne. Five years younger than Caffiéri, he was to follow him closely: first with Lemoyne, then at Rome (where at one point it seemed that Pajou too would execute something for San Luigi dei Francesi), and finally back in Paris, working both for the Crown and for Madame du Barry. But Caffiéri seems never to have sensed a hated rival in Pajou – whom indeed it was probably difficult to dislike. All that is known of Pajou's character suggests a docile, industrious, untemperamental man, who remained on affectionate terms with his children even over involved money matters and who was represented by his son (in the year VIII of the Republic) looking remarkably youthful, amiable, and undisturbed by thoughts of any kind.[43] Even his unusual obstinacy in seeking to be paid what he considered the correct amount for his work at Versailles seems to have been stimulated by his wife, who herself wrote several of the begging letters – not only to d'Angiviller but to the Comtesse d'Angiviller – in an affair which

dragged on for nineteen years. Content to work for Madame du Barry or for Louis XVI, Pajou was equally content to serve new masters when these persons had been dramatically removed from the scene.

He was the sole sculptor on the committee appointed to organize the National Museum during the Directoire and was particularly concerned with the project of creating a museum at Versailles. And though his very late sculpture is rather pathetic, he remained active enough to exhibit a bust of *Caesar* (Paris, Palais du Sénat) at the Salon of 1802 – an official command from the Senate, for whom a year later he also produced a plaster full-length *Demosthenes* (Chambre des Députés), one of the series to which Houdon contributed his *Cicero*. Member of the Institut, chevalier of the Légion d'Honneur, he lived on, though he had ceased to work some years before, until 1809, dying in the same year as Vien. He was the most important surviving sculptor from the high years of the eighteenth century; he had won the first prize at the Academy school in 1748, the year of the treaty of Aix-la-Chapelle, and he died only two months before the Battle of Wagram.[44]

Any excitement engendered by great events is banished in Pajou's work, in which the mood is quiescent, tending to lapse into the sentimental and particularly into the inert. To that extent he was – rather like Vien – born orientated towards neo-classicism rather than the Baroque. His training under Lemoyne did little to affect this preference for stillness over movement, and a preference for the linear over the three-dimensional. After Bouchardon he was probably the sculptor who produced the finest drawings in the period.[45] Nor is it any accident that much of his best sculpture is bas relief; even in fully modelled work his effects are often markedly linear – as, for example, on portrait busts where the pupils of the eye are usually incised very lightly. This aspect of his art was recognized by his appointment as designer to the Académie des Inscriptions on the death of Vassé; for twenty years he was responsible for composing its medals. He was certainly the most suitable sculptor to add figures to Goujon's famous Fontaine des Innocents, and he took particular pains to study Goujon's manner and achieve stylistic harmony.

Drawings are among Pajou's earliest recorded works. Some done at Rome in 1755, while he was still a pensioner at the French Academy, won the approval of Marigny: 'j'y trouve de l'exactitude et de la correction', he wrote with other laudatory phrases. The following year Pajou was back in Paris, with a recommendation from the Abbé Barthélemy to Caylus – a further indication of the direction in which his talent tended. Perhaps the sculptor himself hardly understood this. It is rather typical that his *morceau de réception* of 1760 – with the rare subject of *Pluto holding Cerberus chained* (Louvre) – should be a Baroque essay which suggests direct study of Caffiéri's *River*, though it has greater repose. Much closer to Pajou's nature, however, was the marble relief which he showed at the Salon of 1761 with the somewhat unpromising theme of the *Princess of Hesse-Homburg as Minerva consecrating on the Altar of Immortality the Cordon of the Order of St Catherine* . . . (Hermitage) (Plate 105).[46] Though the subject might be obscure, Pajou's treatment of it effectively avoids both the ridiculous and the fussy. The execution is of great delicacy, with graceful chiselling of the patterned helmet and the folds of

Grecian-style drapery that gently fall about the shoulders. While the bas relief below is a piece of historical narration, the main portion is composed with deliberate calm, aiming at harmony of line, a sense of interval, and a purity of form, which lift it out of direct association with events in Russia and make it a timeless meditation. The result is obvious pastiche of a classical stele, but the concept and its limitations were exactly suited to Pajou. What he had achieved here in elevated vein was to be repeated, with less constraint and solemnity, at the Versailles opera house.

Like nearly all his fellow sculptors, Pajou was also to be employed as a portraitist; like them he showed his most sustained ability in this category of work. Though he had none of the instinctive empathy of Lemoyne, and even less any of Caffiéri's panache, he was capable of being inspired to fine effect by the right sitter. When his old master Lemoyne sat to him the result was a brilliantly direct, unexpectedly forceful bust (Louvre), made the more striking by the sitter's own memorable physiognomy, but remaining a testimony to the young sculptor's skill.[47] The terracotta is dated 1758 and is therefore one of Pajou's earliest busts; it may perhaps have been executed at Lemoyne's instigation for his ex-pupil to display his ability. It speaks of reciprocal sympathy.

Lemoyne remained interested enough in Pajou to sign the register at the latter's wedding, and it was probably through him that Pajou received the commission for a bust of Louis XV. He was to carve both Marie Leczinska and the dauphin (a posthumous portrait), but he remained most successful in portraying those people he really knew. The *Hubert Robert* (Paris, École des Beaux-Arts) (Plate 106) is the result of friendship and knowledge, as well as talent. It was shown at the Salon of 1789 and represents Pajou's art much better than the busts of Madame du Barry so often associated with him and which brought him particular success. Not only does he idealize and refine in those, but his concept remains commonplace beside Caffiéri's voluptuous, recklessly insolent courtesan. The *Robert* is at once direct and delicate. The painter appears negligent, relaxed, and almost breathlessly alive – the mouth very slightly open, the expression a momentary one, rapidly seized. The delicacy of Pajou's handling is well shown in the treatment of the hair and the lines of hair-like slightness at the corners of the eyes which aid the expressiveness of the face. With the delicacy of observation and execution goes a feeling for the bulk of head and shoulders, an effect enhanced by the broad shape of the lapelled coat with its prominent, plain buttons.

But official commands and his own very variable gifts did not often allow Pajou to create something so effectively simple. The more imaginative the effort required, the more Pajou failed. This did not prevent him from attempting the unfortunate marriage of actual and symbolic which produced the full-length *Buffon* (1776). He was chief among the sculptors chosen to contribute to the series of great men, and his *Bossuet* (1778-9, Institut), indebted patently to Rigaud's portrait, is highly accomplished, unforceful yet suave, the lace brilliantly treated like carved and pierced ivory. After this the *Turenne* (1782-3, Versailles), more ambitious in intention, is a disaster. Among all his official work there is no doubt that Pajou himself would have singled out the *Psyche* (Louvre) (Plate 107) as his major contribution, and in many ways this statue remains most typical of his art, as it is certainly typical of its period.

It was a Crown commission, given with the intention of providing a pendant to Bouchardon's *Cupid*. The pose, even the subject, had apparently been left to Pajou's own devising, and in February 1783 he reported to d'Angiviller that he had now conceived a Psyche in the sorrowing attitude of having lost her lover through indiscretion; at her feet would be a dagger and lamp; and he added that the head 'sera susceptible d'expretion [sic]'.[48] What he finally produced was much praised; yet already at least one critic remarked how ill the *Psyche* matched Bouchardon's statue, in concept alone. Not only does it not form a pendant to this in any way, but it is a sentimental and much softer object, over-insistent in such details as the embroidered cushion and decorated plinth, and slack in its consciously graceful pose of distress; Pysche's timid gesture fails to convince, being evocative not so much of heartache as of heartburn. Pajou seems uncertain of the idiom in which he is working. An air of the neo-classical is superimposed on virtually a Greuzian anecdote; the complete nudity and absence of movement are combined with a tearful appeal to the emotions. Yet without its head the statue would not be expressive of anything. It is simply a dutiful but unexciting study of a tranquil, seated nude. The head is made the expressive centre of the statue and bears a weight of intensity which it cannot properly carry; grief is not allowed to disturb the features out of their decorous unity any more than it had stimulated a gesture beyond that of crossing one arm across the body.

The very theme of a grieving, deserted girl – whether genre or derived from classical mythology – was, not surprisingly, to grow less popular in art, because it had enjoyed a long vogue. In the stirring world of the young Napoleon, and in David's art, the place of women is less important. The *Psyche* marks the end, in enervation, of a typically eighteenth-century fiction; and ultimately its weakness is not the heroine's but Pajou's.

In the opera house at Versailles Pajou was working primarily as a decorator of surfaces – within his own powers, that is – but even here he is less successful when the scale is large. The groups of *Venus* and *Apollo* in the foyer are charming but lacking in some essential rhythm; Apollo's arms are awkwardly articulated and the accomplished gracefulness apparent in the preparatory drawings is replaced by wooden execution – the less pardonable as Pajou was positively working in wood and should have managed to preserve a light touch. It is the gilded bas reliefs of 1768–70 (Plates 108 and 109) on the lowest tier of the boxes in the auditorium – also of wood – that best represent his art. There is in these elongated, reclining figures (lapsing into languor, in typical Pajou mood) a hint already of the sculptor's study of sixteenth-century models, notably the achievements of the Fontainebleau School. Delicately incised rocks and trees provide a setting for mannered bodies with rippling draperies and lively companions in the shape of dogs and birds and cupids. Within the regular format Pajou cleverly devises variations, and manages to fill each area satisfactorily but not oppressively; Mars crouches, Diana sleeps, Venus exchanges kisses with a dove, in fluid, thinly modelled, essentially linear designs which perfectly fulfil their purpose. Each panel is separated from the next by blue and gold cameo-style medallions; and the two arcs gracefully curve round the auditorium, with a serpentine line undulating from relief to relief.

It is not great art, but then Pajou is not a great artist. Indeed, he is perhaps most

interesting for the period he lived through, his friendship with the architect de Wailly (cf. pp. 336–7), who built his house, and the artistic problems he embodied. The *élan* and vitality which he did not possess were to enter his life by proxy, as it were, when Clodion became his son-in-law.

PAINTING: UP TO BOUCHER'S DEATH (1770)

Introduction

The middle years of the century are even more complex to characterize for painting than for sculpture. The medium itself offered greater possibilities of variation, with sometimes a more directly personal response by the artist, and the opportunity too to respond easily – and inexpensively – to a particular patron's wishes. Sculpture has never been a medium which the public can appreciate without difficulty, at least since the Renaissance and outside Italy. The growth of public interest in painting in France in the middle years of the century – an interest which was really more literary than visually artistic – introduced a new social factor. Style became less important than subject matter; the way was prepared unwittingly for the basic philistinism of Napoleon's patronage, while an obsession with pictures that tell a story virtually shaped the rise and fall of Greuze (who lived to paint the First Consul). At the same time, the stylistic complications are no less real. It must be for each person to decide whether the strictly contemporaneous and successful careers of Chardin and Boucher represent a paradox, or whether the two painters are basically united despite appearances to the contrary; certainly in handling of paint they could scarcely differ more. Yet both the Swedish court and Louis XV owned work by them. Patrons were not always partisans. The last royal purchaser, within the artist's lifetime, of a pungent study by Chardin was Madame Victoire, Louis XV's daughter, who had once been portrayed lightly allegorized into the element of Water by Nattier's brush.

It is also remarkable how certain distinguished and influential painters of a much earlier generation lived on well into the century, bringing with them an air from the *grand siècle*. Watteau's premature death is the more striking against the longevity of Rigaud and Largillierre, the former dying only in 1743, the latter not until 1746, the year in which died also Guillaume Coustou the Elder, equally an echo of the *grand siècle*. And it was Largillierre who had given praise to the young Chardin's work, supporting his candidature at the Académie as warmly as La Fosse had earlier supported Watteau's.

By 1746 the reign of Madame de Pompadour had begun at Versailles. This was to mean more than a new mistress for the king. Probably for the first time in France since Marie de Médicis, a woman was to take a leading part in patronizing the arts. That passion outlasted any passion for the king, and since Madame de Pompadour held her place at Versailles as royal friend long after she had ceased to be Louis XV's mistress, her reign as patron did not stop until her death in 1764. And in 1746 her brother, later the Marquis de Marigny, was already designated Directeur des Bâtiments to succeed her uncle Lenor-

mant de Tournehem. Marigny retained that post until 1773, the penultimate year of Louis XV's life. Officially and unofficially, brother and sister were – it could be said – the Crown; and they neatly reflect its public and private faces in the ordering of elevated, 'national' work on the one hand and on the other purely pleasurable, decorative pictures.[49] The latter are for ever associated with Boucher, but it must be remembered that he represented only certain aspects of the period.

A much inferior painter, Carle van Loo, was more highly esteemed and remains much more truly typical: the author of history pictures and often vast religious compositions (occasionally royal commands, like the dreadful *Sainte Clotilde*, intended for Louis XV's chapel at Choisy) as well as small *galant* mythologies which were sometimes owned by Marigny. Nor did Van Loo become merely Premier Peintre to the king: he was, as Diderot wrote at his death, 'Premier peintre . . . aussi de la nation'. Mediocre though Van Loo remained, he was yet active in producing pictures in every category – including portraiture. His timid, nerveless style steers a middle course between the gifted extremes of Boucher and Chardin, or those of Nattier and Latour; it is indeed typical of much French painting in the years between Watteau and David. If many practitioners of that style remain little known, there are often good aesthetic reasons for the ignorance.

In many ways these were confident years for France, and for painting. Even if one discounts the Dr Pangloss-like euphoria of Patte, who in 1765 found everything – from painting to agriculture – in perfect state under a king who was 'un vrai héros de l'humanité', still there seemed good cause for contentment. The Peace of Aix-la-Chapelle in 1748 was to be celebrated pictorially by Dandré-Bardon in *Louis XV donne la paix à l'Europe . . .*'.[50] In 1748 too there was established with royal approval the École royale des élèves protégés, of which Van Loo became governor the following year.[51] This institution started better than it finished; and it is not quite clear how definite its effect was on painting and young painters. Its charter, however, is one more symbol of reforming zeal; the pupils selected were to be given not only art instruction but 'une teinture suffisante de l'histoire, de la fable, de la géographie, et autres connoissances . . .'. This is worth emphasizing as the mid century's official aim, another attempt to stop painting from becoming 'errante'.

A further factor was the re-establishment of the Salon, first as an annual and then as a biennial event. Van Loo himself was a considerable exhibitor there. The whole concept of public exhibition – and at first there were also student exhibitions at the École des élèves protégés – introduced a new aspect. Whether works of art were commissioned by the Crown, by the Church, or by rich amateurs, they now underwent also public scrutiny in public exhibitions where they might be praised or blamed. An artist's success thus lay in more than pleasing a single patron. 'Le public', wrote Dézallier d'Argenville in 1745 (*Abrégé de la vie des peintres*), 'est l'arbitre souverain du mérite et des talents.' Without much pleasure Mariette, himself something of a *grand siècle* echo, connoisseur and collector rather than in any sense an art critic, was to say much the same, speaking of 'le gros public' which delighted in Chardin but had less appreciation of high-style Italianate art. With the establishment of the Salon exhibitions as an event where the public could pass its verbal vote on contemporary art (an ordeal which most painters positively sought,

often begging a patron to consent to public exhibition of privately commissioned work), there arose the factor of written criticism of the exhibits, destined for a cultivated public who might however be not collectors or connoisseurs, but simply literate people. The most famous example is, of course, Diderot; but since his criticism was not published at the time its effect was probably very slight compared with what was printed in, for example, the *Mercure de France*. Increasingly, each Salon gave rise to its own cluster of pamphlets, apart from the relevant *livret* itself, which often provided a lengthy explanation of what was depicted. What culminates with Diderot begins with La Font de Saint-Yenne, already criticizing and analysing the current artistic situation in 1747 (*Réflexions sur quelques causes de l'état présent de la peinture en France*). La Font, who published anonymously, created a certain sensation with this brochure; he annoyed several of the artists he criticized (his criticisms being indeed often niggling and unfair) and stimulated some quite sharp replies, e.g. *Lettre sur l'exposition* ... (1747) and *Lettre sur la peinture* ... (1748). His praise was seldom whole-hearted and his writings lack utterly Diderot's response to the phenomenon of art. Obsessed with choice of elevated subject matter and with the primacy of the history-painter ('Le Peintre Historien est seul le Peintre de l'âme, les autres ne peignent que pour les ïeux'), he urged these views yet more strongly in his anonymous *Sentimens sur quelques ouvrages de Peinture, Sculpture et Gravure* (1754), partly also a review of the 1753 Salon. It is, however, not quite true, as is sometimes supposed, that he just complained of degeneracy and languor. The stylistic situation was complex; he himself was perhaps among the last to give extremely high praise to Watteau; and he was warmly appreciative of Vernet and Latour. As some contemporary critics pointed out, he had scarcely complained of decadence in modern French painting than, in praising numerous individuals, he seemed to argue 'qu'elle y est plus florissante que jamais'.

At what may be reasonably claimed as the very latest manifestation of the artistic tendencies of the middle years of the century, the Salon of 1773 (the last to be held under Marigny and Louis XV), there is apparent a mingling and variety of styles which justify one in emphasizing the complex nature of those years. Van Loo and Boucher were of course dead, but Vien – though not yet Premier Peintre – showed a group of commissioned pictures which in themselves suggest diversity: beginning with a large history picture, *St Louis giving the Regency to his Mother, Blanche of Castille*, one of a series destined for the chapel of the École Militaire[52] – a type of national patriotic subject which was to become increasingly common under d'Angiviller's subsequent directorship of the Bâtiments. There were also a couple of essays in Vien's insipidly pretty antique manner (*Two Young Greeks swearing Friendship not Love; Two Greek Girls finding Love asleep*), pseudo-chaste and chicly neo-classical for Madame du Barry, who had rejected Fragonard's work. For the king, Rococo in taste until the last, Vien had painted a *Diana and her Nymphs returning from the Chase* ..., intended for the Trianon, and in subject alone sounding like a last graceful evocation of that mythological kingdom where Boucher had once been sovereign. And at this same Salon of 1773, the aged Chardin exhibited *Une Femme qui tire de l'eau à une fontaine*, noted as a repetition of his picture in Sweden – a composition which dated from exactly forty years earlier.

Boucher

Whatever historical attention is required by Van Loo, and whatever the variety of other contemporary talents – rising to genius with Chardin – yet the middle years of the century rightly belong to Boucher. No other painter was attacked by Diderot with the vehemence he devoted to diatribes on someone about whom he had to admit 'Cet homme a tout, excepté la vérité' (*Salon* of 1761). There are times when one senses an undercurrent of attraction which Diderot feels he must struggle against – anticipating Baudelaire's equally partisan but more intellectual struggles against the spell of Ingres. If Diderot in 1761 could almost yield ('C'est un vice si agréable . . .' he significantly went on to confess), that is perhaps tribute enough to a painter who has remained misunderstood, though no longer perhaps ridiculed, and who is only now beginning slowly to be appreciated for his true merits. Although it is no longer obligatory to judge art by Diderot's standard of 'vérité', it happens that there exists a considerable vein of 'vérité' in Boucher's work which is by no means all frivolous, licentious, and meretricious – adjectives which may anyway prove more profoundly applicable to Greuze.

François Boucher was born at Paris in 1703, the son of an obscure painter who apparently recognized very quickly that his son's talents needed a more gifted master. His choice of Lemoyne was perceptive, though it seems to have been true that Lemoyne gave little attention to his pupils. Boucher was to declare that he had not gained much from the few months of his apprenticeship, though he later professed respect for Lemoyne's work. In this, there is probably no paradox. Many of Lemoyne's most sensuous proto-Boucher paintings, such as the *Hercules and Omphale* (1724, Louvre), date from the period after Boucher had ceased to be his pupil. *Rubénisme* of a kind which included within it Correggio and Veronese was already widespread; Lemoyne was scarcely needed to introduce the style to Boucher.

There was, further, a more significant influence on the young artist – and a more formative activity even than painting. Boucher's speed and dexterity made him early an accomplished draughtsman for book illustrations. He was attracted into the studio-factory organized by the elder Cars, himself an engraver like his better known son. There Boucher learnt to practise engraving as well as drawing. Thus he became a suitable artist to take a major part in Jullienne's publication of the *Œuvre gravé* of Watteau; and perhaps by 1722 he was actively involved in this. 'Sa pointe légère et spirituelle', wrote Mariette, 'sembloit faite pour ce travail.'[53] And in many ways Boucher is Watteau's great posthumous pupil: graceful, lively, already enchanted in his view of life, he yet remains natural. How well his basic affinity with Watteau was recognized, even after he had become a famous, established painter, is shown by the description of him in 1745 (in a 'list of the best painters' drawn up for the Bâtiments): '. . . Excellant aussy aux paysages, aux bambochades, aux grotesques et ornements dans le goût de Watteau . . .'. Indeed, his compositions for, for instance, the beautiful six-volume edition of Molière's work (Plate 110) – which was published in 1734 – show a flickering Watteauesque sensitivity of touch, as well as a serious ability to respond fully

to details of modern costume, furniture, and setting. Other Boucher drawings – whether figure or landscape studies – often unexpectedly confirm the sheer grasp on reality which underlay even the most 'false' of his decorative paintings. One thing which is consistent in his work is an emphasis on design, and indeed on *dessin*; his inventive compositions retained coherence until the last years, and throughout his career he preserved an ability to, as it were, sketch in the medium of paint – a gift to be equalled only by Fragonard.

In estimating Boucher's true talents, it is important to realize how little his early work and interests linked him to the decorative tradition represented by the Coypel and Lemoyne.[54] He was more 'modern'. Even before taste had turned against the large-scale architectural decoration which culminated in the Salon d'Hercule at Versailles, Boucher had tacitly withdrawn into more intimate scale and literally less elevated treatment. Dazzling Italianate decorative *trompe l'œil* was never his; he is much closer to the 'Flemish' School, as interpreted by the eighteenth century. His earliest appearance at the Salon (in 1737) was by 'divers sujets champêtres', and several of the earliest pictures reasonably acceptable as by him confirm this pastoral interest. Thus the influences which conditioned his early work are better represented by such painters as Bloemaert, Berchem,[55] and Castiglione – all influences which, it may be said, continued to condition him. His sober portraits are another indication of the real nature of his talent; the wonderful and varied series of small full-length portraits of Madame de Pompadour – seldom shown without books or music beside her – convey settings as well as the sitter (Plate 111). His graceful transmuting of his childishly pretty wife into goddess or nymph is commonly mentioned; but it needs to be recalled that he also painted an almost satirically pointed portrait of her as she and her untidy ambient really were (1743, New York, Frick Collection) (Plate 112). Guided by such evidence, it is possible to see that Boucher was closer to Detroy than to Lemoyne, and that his artistic world was not always totally alien to that of Chardin.

What may well be true is that from the first Boucher had no inborn respect for facts as such. His vernal woods – like the nymphs and shepherdesses who tripped through them – were never intended to teach 'more of ill and good than all the sages can'. It was this sense of moral 'vérité' which was rightly to be detected as lacking in his work. The wish to find such a quality in art is one that did not, however, become urgent until the second half of the century – and then only gradually. It is unfortunate that it should have coincided with Boucher's own declining powers and ability. By the time of Diderot's attacks he was already ill, his eyesight was impaired, and even his remarkable energy had flagged. He struggled on, the 'aged gladiator' of Diderot's last sneers. Many of his late pictures are frankly, sadly, bad. Yet if by 1760 he was a spent furnace, the previous thirty years or so had witnessed him blazing with talent: creator of ravishing landscape paintings and genuinely enchanted pastorals, as well as tapestry and stage designs, portraits, and the finest of those mythological pictures – at once famous and yet little studied – where he did indeed respond to the female nude, in a way unequalled since Rubens and not to be rivalled again until Renoir.

Only a little of this was apparent in Boucher's early work, which strikes one as

competent but slightly lacking in positive direction or emphasis. There is something ludicrous in the very title of the picture with which he won first prize as a student at the Académie in 1723 – so far was this assigned, obscure, biblical subject from Boucher's later tastes: *Evilmerodach fils et successeur de Nabuchodonosor, délivrant Joachim des chaines dans lesquelles son père le retenait depuis longtemps.* Yet it was his very competence which triumphed, even in a category of picture to which he probably rarely returned. Although technically a student, Boucher was in fact working as a professional artist, continuing among other activities his engravings for the *Œuvre gravé* of Watteau (his plate after Watteau's self-portrait was frontispiece for the first volume, published in 1726). There is a certain obscurity about Boucher's life in these years. Although he went to Italy in 1728, in the company of the young Carle van Loo, he seems not to have been a full pensioner at the Rome Academy despite being accommodated there by Vleughels in 'a little hole of a room'. The description is Vleughels' own, as is that which qualifies the young artist at the same time as 'de beaucoup de mérite'. No facts have come to light about Boucher's stay in Italy, but it is likely that he spent no less than three years there – not necessarily all at Rome – and he was certainly back in Paris by 24 November 1731, when *agréé* at the Académie.

It remains difficult to decide what effect Italy had on Boucher's art, and when the Goncourt wrote, they could speedily glide over the whole problem. There can be little doubt that he must have responded to work by such painters as Pietro da Cortona, though Cortona's work need not have come as a revelation. Although it is sometimes said that Boucher admired Tiepolo, it remains uncertain what Tiepolo paintings he could then have seen, and even more uncertain whether he would have admired Tiepolo's style in the decade 1720–30. Boucher's links with Venetian art remain at best tenuous. It is much more likely that he was affected by the Franco-Italian Rococo style fostered at Rome and especially at Turin,[56] well represented by, for example, Beaumont; that Beaumont was living in Rome during the years 1723–31, and that Carle van Loo was in the same period working under Luti, are probably more significant pointers to the atmosphere in which he moved and worked. In a more allusive way too Italy affected Boucher, whose landscapes often have echoes of an Arcadian Italy, recollected at a distance in tranquillity, with ruined temples and blue mountains. These recollections are not derived from secondary pictorial sources but, sometimes at least, from actual observation on the spot: amid French eighteenth-century sale catalogue references to Roman views by Boucher is one of 1781 (Sireuil sale) where a view of the *Temple of Concord* is noted as painted at Rome.

With Boucher's return to France his public career began. He was never to be idle; and even his death occurred in his studio in front of a fresh, unfinished painting. An echo of Lemoyne is still apparent in the *Rinaldo and Armida* (Louvre) of 1734, his *morceau de réception*, though already the piquant Armida indicates what was to be his main theme. His decorative gifts were quickly made use of – by, among others, Marie Leczinska for her apartments at Versailles, long before Madame de Pompadour had arrived on the scene. Equally he had, before her arrival, worked for the king. He was employed on stage designs for the Opéra, and was associated with Oudry in tapestry design for the

Beauvais factory. It was for Beauvais that he produced his enchanting 'sujets chinois' (sketches at Besançon), decorative, flippant, and deft: presenting a sort of Cloud-Cuckoo China, with palm trees, doll-like people, feathery hats, and a mass of properties such as fans, parasols, guitars – suggesting a generalized, amusing exoticism – all executed with a lively touch. Yet he remained only one of the painters at the period specializing in decorative, lightly erotic subjects. Employed about 1736 on the decorative schemes for Boffrand's newly designed apartments at the Hôtel de Soubise, he shared the commission with such close contemporaries – virtually rivals – as Natoire, Carle van Loo, and Trémolières.[57] Nor can it be pretended that stylistically Boucher's paintings differ drastically from theirs, though the quality is usually notably higher.

In the years that followed there were to be few dramatic changes in either his style or his career. The favour of Madame de Pompadour gave him, it is true, particular opportunities for the exercise of his talent, yet what is certainly one of his very finest pictures, the *Triumph of Venus* (Stockholm) (Frontispiece and Plate 113), dates from 1740 – five years before Madame de Pompadour met the king. That painting is arguably the quintessence of his abilities, perfect in size as well as execution, and seems to have been sent to the Salon as uncommissioned work. If anyone may claim to have been its inspirer, it is Madame Boucher, the ravishingly pretty, slightly shy blonde goddess, so demure at the centre of her marine triumph.

This picture, which could be called Boucher's *Pèlerinage à Cythère*, is even more effective a key to the aspirations and tastes of a whole period. To begin with, its very size is adapted to the small-scale room, essentially for living rather than mere parade, represented by the graceful Boffrand apartments at the Hôtel Soubise and by the Petits Appartements which Louis XV had created amid the grandeur of Versailles. It is no coincidence that both schemes had involved Boucher.[58] The fact that his pictures were so often intended as part of the décor of living does not explain, but at least enhances, their *joie de vivre*. So much are they part of such décor, that it is somewhat unfair that they now have usually to be seen in standard museum conditions; where those happen to be sympathetic, the pictures again come to life. Boucher's basic gift lay perhaps in the ability to express *joie de vivre* in purely visual terms. His standards were not nature's but art's.

Yet there remains a sense in which his work could be called natural – an important, uncommitted sense which starts with the noticeable fact that nearly all his most typical pictures choose an open-air setting, preferably the countryside. The very expanse of sea and sky in the *Triumph of Venus* is part of this nature, interpreted to mean freedom: a freedom culminating in that light, light-hearted twist of salmon-striped silver drapery which is so effortlessly sported with by tumbling amoretti, tossed into the air like a banner of liberty. Another aspect of Boucher's freedom comes in the actual subject matter, treated as the excuse for a spontaneous aquatic frolic – a bathing party along the coast of Cythera – rather than anything seriously connected with the bloody genesis of the goddess. Glassy water and bodies as pale as the pearls which twine about flesh and hair virtually *are* the subject. Boucher is here – as wherever possible he always is – free of drama. He prefers a lulling incantation certainly closer to Correggio than to Rubens,

and very different from Fragonard's erotic energy. In the *Triumph of Venus* the sea nymphs recline indolently, borne up on velvet waves as on couches – free even to be idle, like the clustering doves and the almost sleepy putti around them. This is close to the mood of most of Boucher's pastoral pictures, where nature equals relaxation: how often there is someone reposing, just as Madame de Pompadour usually does in his portraits of her (it was left to Drouais to show her positively at work, embroidering). There is another aspect of this relaxation, making it no longer necessary to deal – as Watteau had done – with love. That is too serious, almost too mature and social a theme for Boucher, whose dream is naturally of pretty girls as such, objects of *grand luxe*, permanently on display in mythological or pastoral shop windows as beautifully arranged as are the girls themselves (Plate 116). There are seldom any men, and nothing masculine, in Boucher's pictures: man is postulated as the spectator, looking into the picture as into a vitrine, wondering what to buy.

Although these would still have been the elements of Boucher's art even in George III's England, they were encouraged – perhaps ultimately abused – by the taste of the age. Boucher's work was the fashion: in meeting it by steady production, the painter helped to destroy first its level and then the fashion. Not even he could avoid monotony and fatigue, and when he had to deal, not for the first time, with the subject of the *Rape of Europa* in 1747, there were sounded some early critical reserves, the more penetrating for their generally admiring estimate of Boucher himself. One of the typical anonymous publications of that year (*Lettre sur l'exposition* . . .) spoke of being irritated that such an accomplished painter had not sought in history 'quelque fait digne de son pinceau'. At the same period there began – and were soon to increase – reproaches about the overall pinkish-purplish tone of his flesh tints. By 1750 even the *Mercure*, most faithful eulogist of Boucher, lightly chided him for the pompoms and furbelows of his latest shepherdess.

Although it would be wrong to accept too literally the criticisms which Boucher increasingly encountered – because taste was changing, regardless of the quality of his work – it is true that most of his finest pictures had been painted by the mid century. Those years saw him achieve pensions and honours – notably the ever-desired privilege of a studio in the Louvre (granted to him at the death of Charles Coypel in 1752, when Carle van Loo became Premier Peintre). Nor must his successes at the Salons be forgotten. His own apogee and decline are heralded by the large pair of pictures, of which one at least was originally intended as cartoon for a Gobelin tapestry, the *Rising* and the *Setting of the Sun* (London, Wallace Collection) (Plates 114 and 115). They excited general admiration at the exhibition of 1753, and even La Font de Saint-Yenne (in his *Sentimens sur quelques ouvrages de peinture* . . .) gave them rather grudging praise, mingled with typical, somewhat petty criticisms. Boucher himself is recorded to have been satisfied by them – and his modest estimate of his abilities was well-known. Both pictures were acquired by Madame de Pompadour for Bellevue; recent study of them has shown that the *Rising Sun* was originally executed in grisaille (confirming its purpose as a tapestry cartoon), but that there is no trace of grisaille under the *Setting Sun*, perhaps directly commissioned by her therefore, having diverted the first composition.[59] And

the whole mythological climate of them seems to belong to her – to the point where one might well identify her directly with the nymph Tethys who so openly welcomes, and is welcomed by, Apollo at evening in a *Coucher du Soleil* at once personal and royal. Whereas in its pendant Apollo prepares for day amid a flock of female courtiers, Tethys is singled out, made prominently central, distinguished by the attention of a still radiant god in whom flattery could easily see symbolized Louis XV.

These two masterpieces, for such they are, in themselves justify Boucher as artist even during the years when he was granted more honours than praise. His constant activity – and indeed his fidelity to royal taste – received full recognition at last when in 1765 he became Premier Peintre; but some irony resides in Marigny's eulogistic letter to him announcing the distinction, with its phrase, 'qu'il semble que Sa Majesté ait consulté le vœu public'. The final five years of Boucher's life began with illness and culminated in widespread public criticism of his declining powers and monotony of artistic expression. He died in 1770 in that long-coveted studio in the Louvre, amid his own canvases and the even more remarkable richness of what he had acquired in the way of porcelain, minerals, shells, lacquer, armour, precious stones, 'et autres productions de l'art et la nature'. The words are Wille's; they might aptly serve to describe not only Boucher's possessions but the style of his own work.[60]

There was one category of picture where his powers best and longest survived: in the marriages of art and nature which are his landscapes. 'Nature to advantage dress'd' was his standard for these, and his brilliance partly consists of the variations he can play on the steady subject-matter of watermills, dovecotes, rustic bridges, and distant ranges of blue-green hills. Yet it is not sufficient to dismiss such 'arrangements' as mere stage scenery – though it is true they are artfully designed and always intended to please. They have a vein of real natural poetry in them, but it is the poetry of Pope's *Pastorals* or *Windsor Forest*, with landscapes devised so that '. . . order in variety we see'. It is probably correct to feel that such landscape pictures represented a certain relief for Boucher from the pressure of demands for his figure painting. He could virtually banish humanity, reduced to Guardi-like specks to activate a scene which seldom strayed from a countryside with some homely human associations, but which often frankly represented a dream landscape, neither Italian nor French, simply Arcadian.

The large *Evening Landscape* (Barnard Castle, Bowes Museum, signed and dated 1743) (Plate 117), though not known to have been commissioned, is one of the most sustained and poetic of such scenes. Evening has already darkened to marvellous blue the heavy foliage of this summer landscape, where the small figures of a girl and young child pause near a ruined temple, while outside a cottage a woman gathers in her washing and doves settle on the thatched roof with its smoking chimney. A few streaks of red on the horizon mark the close of day. Silence seems to be approaching like darkness – conveyed by the still water in the foreground – and a mood of faint melancholy is evoked by the ruined temple and slow atmospheric approach of night. Everything here is certainly contrived – but beautifully so. The influence of Ruisdael, perhaps of Pynacker, probably of Claude, may all be detected; comparison could be made with the early landscapes of Zuccarelli, though they were from the first much weaker. Boucher's

picture absorbs influences into a totally coherent, personal creation – as valid as Gains-borough's view of landscape was to be, a decade or so later – at once artificial and yet natural.

Nevertheless, such landscapes, though they provided more than a hint for Fragonard, must have found increasingly few people to appreciate them. Like the rest of Boucher's work, they were to be judged part of that 'doratisme de la peinture', as Falconet brutally called it, so seductive but so false.[60a] It was finished with. Boucher had been a friendly, popular artist, generous in helping his pupils. Yet in the very artists closest to him fatality intervened. His two sons-in-law Baudoin[61] and Deshays – the latter highly thought of by nearly all contemporaries including Diderot – predeceased him; his own son was a total disappointment. When in 1785 Madame Boucher, still alive, had her pension doubled by d'Angiviller she wrote effusively to thank him for this fresh testi-mony 'to the memory of her husband and his talents'. They were touching words to be recorded in the year when the Salon contained David's Oath of the Horatii (Plate 198) – and when almost certainly few people were left to cherish the memory of Boucher as a talented artist.

The Van Loo, Natoire, Trémolières, Subleyras, Pierre – Vien

Although the Van Loo formed a numerous, somewhat confusing and certainly cosmo-politan family, only one of them is of real significance for the history of painting in eighteenth-century France. Amiable, deeply stupid and uncultivated, Carle van Loo appeared not merely the leading French painter during the middle years of the century but – in the words of Grimm, who frankly called him 'fort bête' as a person – 'le premier peintre de l'Europe'. This astounding judgement was widely shared among patrons and academic circles. La Font de Saint-Yenne, who also esteemed him, thought it however necessary to raise some caveat when a brochure reviewing the Salon declared of Van Loo 'qu'il fait quelquefois mieux que Rubens'. Madame de Pompadour and Marigny patronized him at least as much as they did Boucher; well might Van Loo paint for Marigny an allegorical picture of the arts deploring Madame de Pompadour's death (Salon of 1765). Diderot and Grimm warmly praised him. At the Académie he rose to be Directeur; in 1750 he received the coveted honour of the Saint-Michel, having already been created governor of the newly established École des élèves protégés. In 1762 he was made Premier Peintre and was complimented graciously by the dauphin when he thanked the royal family for this honour.[62] His death in 1765 seemed something of a national disaster.

Yet not even the most chauvinistic historians have been able to estimate Van Loo's work very highly. Adopt the mid century's standards though one may and grant the maximum to his highly efficient drawings, still it is impossible to see in him more than a dutiful but basically uninventive, uninspired artist. Boucher annihilates him, and even Detroy produces livelier sketches. Trémolières is more graceful and Subleyras is far superior in robustness and handling of the actual matière, where Van Loo grew increas-ingly dull and dry. Although the case of Van Loo must remain in part baffling, probably

his very mediocrity, combined with undoubted industry, guaranteed his success. It must have been hard to dislike the style of a painter who so signally lacked anything in the nature of a style. He left little to the imagination, possessing so little of it himself.[63] It might be said of him that he served, for his country and his century, as Sir Edward Poynter, P.R.A.

The Van Loo family was not French in origin but Flemish. Jacob van Loo, its artistic founder, was a Fleming who had lived in Amsterdam before settling in Paris, where he died in 1670. His son Louis-Abraham (d. 1712) had two sons of very disparate ages: Jean-Baptiste (1684–1745) and Charles-André, called Carle, born at Nice in 1705.[64] The death of his father so early in Carle van Loo's life led to his apprenticeship under his much elder brother, who was working in 1712 at the court of Turin. Jean-Baptiste remains most familiar in England as a portraitist. Yet he had in fact trained as a history painter, working under Luti at Rome and later at Genoa, and at Turin he was employed on decorative schemes. His work there for the Prince de Carignan was successful enough for the prince to ensure a continuation of patronage at Paris by his father, the famous Prince de Carignan, when the two Van Loo brothers arrived there under the Régence in 1719. Jean-Baptiste was a typical member of the family in his competence and lack of imagination, but he seems to have been a good if severe teacher. In France he began by executing some pictures for Parisian churches and achieved some fame with an equestrian portrait of the boy King Louis XV (1723). His *morceau de réception*, the *Diana and Endymion* (signed and dated 1731, Louvre), shows the most favourable aspect of his basically unexciting talent, which indeed seems to have increasingly been left under-employed in Paris. In 1737 he decided to come to London and was an immediate, fashionable success as a portrait painter, though his portraits are unremarkable enough. He was quickly patronized by the Prince and Princess of Wales, who the following year visited his studio and, in Vertue's words, 'staid there to see him paint with great satisfaction'. Until 1742 he remained in London, leaving apparently through ill health, which rapidly increased on his return to France. He retired to his birthplace of Aix-en-Provence, where he died.

Van Loo's sons all benefited from their father's teaching. The eldest and most talented, Louis-Michel (1707–71), a far better portrait painter than his father, and perhaps the best artist of the family, is probably the only painter to have produced official full-length portraits of Louis XV and also a portrait of Diderot (1767, Louvre; amusingly reviewed by Diderot himself in his Salon critique of that year). A successful student at the Académie, Louis-Michel accompanied his uncle Carle and Boucher to Rome in 1727. From the first he concentrated on portraiture, and in 1737 was appointed court painter to the Spanish Bourbon court under Philip V, remaining in Madrid until 1752. His portraits executed there seem to have had some influence on Goya, though they scarcely attempt profound characterization. It must also be admitted that the pungent realism of Latour was equally beyond Van Loo's range.

He became a frequent exhibitor at the Salon on his return to Paris, deservedly popular for his vivacious, convincing likenesses, and the smoothly rendered materials worn by his sitters and revealed in their settings. 'Un luxe de vêtement à ruiner le pauvre

littérateur,' was Diderot's comment on the portrait of himself. In painting the king in state robes, Van Loo responded to all the possibilities of sumptuous yards of ermine and vast bronze throne upholstered with patterned brocade, creating a grandiose setting of canopy and towering marble pillars that manages to outdo Rigaud's *Louis XIV* (Plate 1). Even in this formal portrait Van Loo managed as well to retain some sense of humanity, almost a sparkle in the royal features. On other occasions he took every opportunity to suggest the instantaneous, actual moment – in sudden alertness or relaxation – which the century increasingly required from portraiture. The group portrait of the family of his uncle Carle (Musée des Arts Décoratifs) is probably the most familiar and large-scale example. That Van Loo could carry this mood beyond such personal confines is shown in the much smaller and later double portrait of the *Marquis et Marquise de Marigny* (Scotland, private collection) (Plate 118); this is almost as much a genre scene as a portrait. It gives a sense, rare enough in double portraits at any date, of positive dialogue between the two sitters, and evokes a domestic harmony between husband and wife – married only two years previously – which was in reality of short duration. The picture's intimacy is like that of some topical Moreau le Jeune engraving – and is only the more remarkable given the highly-placed personages and the fact that the portrait was publicly exhibited at the Salon in 1769.

Of Louis-Michel's two brothers, the elder, François, was killed in a carriage accident in Italy while still a student; the other, Charles-Amédée-Philippe (1715–95), was an industrious, unremarkable artist, but one who at least kept up the family tradition of international travel. He too received a reckless measure of praise from Diderot, who found in his *Families of Satyrs* 'poetry, passion, flesh, and character'. Amédée rose to be rector at the Académie but was perhaps best known through having served at Berlin as court painter to Frederick the Great – an honour previously declined by Boucher and by Carle van Loo.

In Louis-Michel's group portrait, Carle van Loo is shown in the process of portraying his daughter. Although portraiture was not a main activity of Carle's, he was nevertheless to exhibit at the Salon full-length portraits of the queen and the king, as well as his own self-portrait (respectively Salon of 1747; 1750, Versailles; 1753, Nîmes). Yet it is notable, and perhaps more than coincidence, that he did not show portraits again there after the return of Louis-Michel from Spain. He certainly accepted at least one commission from Frederick the Great; though he would not travel to Berlin, he sent his *Sacrifice of Iphigenia* (1757, Potsdam, Neues Palais), which was highly praised by Caylus.[65] And that too represents an additional triumph for Van Loo – to have united in praise of his work the antagonistic figures of Diderot and Caylus. Even Voltaire mentioned Van Loo favourably.

Carle van Loo certainly began his apprenticeship at an early age. He was only fourteen when he returned to France with his elder brother in 1719, yet already he had studied painting under Luti in Rome and sculpture under Le Gros (who was working for Juvarra's Carmelite church at Turin about 1717). His brother's training had played its part too: its strictness was such that Van Loo was not permitted to paint until he reached the age of eighteen. His drawings are indeed always highly competent and assured,

though no more inspired than his paintings. Academically, his early professionalism and application were, however, well rewarded. He became a pupil at the Académie and proceeded to win first a medal for drawing and then in 1724 the *premier prix* for painting. When he reached the French Academy at Rome in 1727, history repeated itself. He won a special prize for drawing at the Accademia di San Luca and the first prize for painting. While we have to piece together a few hints about Boucher's sojourn in Italy, we know more than enough about Van Loo's activity there. Although, by an irony, his name was much later to be associated with supposed Rococo excesses and to inspire a pejorative verb, 'vanloter', the bias of his nature is revealed by the artists to whom he was attached and whose work he copied – Raphael, the Carracci, Domenichino, Reni, and Maratti. An unfortunate mixture of native stolidity and academic timidity held Van Loo back from creating any true works of art. Timidity might pass as 'correctness', industry as genius – it being easily granted that no one sent *bigger* pictures so constantly to the Salon than did Van Loo – and yet before his death a few criticisms had tentatively been expressed about the tendency of his pictures to heaviness.

This tendency is something which certainly was increasing towards the end of his life. Such vivacity and decorative powers as he had were really seen best in the years 1732 to 1734 when he returned to Turin – no longer a boy in the studio of his brother, but a fully fledged painter who had won honours at Paris and Rome. In buildings like Stupinigi, for example, he was working with other decorative painters, all of them benefiting from the architectural settings. Much the same is true of his work at the Hôtel de Soubise (Plate 119) when he eventually came back to Paris and joined the group of friends and rival decorators active there, including Natoire and Trémolières, as well as Boucher. In 1734, on his return, Van Loo was *agréé*. By an exceptional favour (perhaps unprecedented since Watteau) he was allowed to select his own subject for his *morceau de réception*, choosing the academic, notably unappealing one of *Apollo flaying Marsyas* (1735, École des Beaux-Arts). The rest of his career was exceptionally successful and unimpeded.

At Rome he had frescoed the ceiling of San Isidoro; at Turin he had painted some altarpieces. He was thus equipped by experience, as well as training, to welcome the very type of commission which was so seldom offered to Boucher. Van Loo's nymphs and goddesses have a proto-Victorian quality, and though the same is cruelly true of his large – indeed often enormous – religious pictures, the latter are more banal than absurd. Year after year at the Salon there appeared paintings ten to sixteen foot high, by Van Loo – *The Adoration of the Kings* (1739, Saint-Sulpice), *St Peter curing a Lame Man* (1742, Saint-Eustache), the *Vow of Louis XIII* (1746, Notre-Dame-des-Victoires), *St Augustine disputing with the Donatists* (1753, *ibid.*) – which serve as useful reminders that no more than the sculpture of the period did painting consist entirely of boudoir work and portraiture. A tradition was being kept alive in this way for perfectly serious – would-be serious – history pictures (Plate 121); indeed Van Loo was contemporaneously painting stern, classical subjects like the *Defeat of Porus* and *Augustus closing the Doors of the Temple of Janus*. As a category, such elevated work forms a bridge between the *grand siècle* and the 'engaged' history pictures to be encouraged towards the end of the century:

between, one might say, the *Vow of Louis XIII* as painted by Philippe de Champaigne and by Ingres.

Perhaps one further cause for Van Loo's success lay in his variety of subject matter – he even produced for public exhibition one fairly large landscape.[66] While he could offer history pictures of a kind scarcely attempted by Boucher, and ones more firmly designed and painted than anything comparable by Coypel, he was also the creator of a Falconet-sounding *Amour qui tient négligement son arc et paroît méditer sur l'usage qu'il va faire de ses traits* (1761)[67] and *galant* mythologies, in addition to the faintly exotic, semi-genre Turkish subjects, like the *Grand Turk giving a Concert* (1737, London, Wallace Collection) (Plate 120), the vein in which he started a fashion and in which he is to modern taste most tolerable.

It may also be a factor in the consecration of Carle van Loo as the greatest talent in mid-eighteenth-century France that several possible rivals were gradually removed by fate from the world or from the Parisian scene. The suicide of Lemoyne in 1737 was followed the next year by the retirement to Rome of Detroy, appointed Director of the French Academy. In the subsequent year Trémolières died prematurely. His brother-in-law Subleyras never came back to France. In 1751 Natoire left, to replace Detroy in Rome. Such facts help to explain why the death of Coypel in 1752 must have seemed the culminating disappearance, merely emphasizing the stature of the man who was left alive, active, and soon to be hailed as a national glory.

To some extent, the career of Natoire is that of a slightly less famous and less talented Van Loo. Charles-Joseph Natoire was born at Nîmes in 1700, the son of an architect and sculptor.[68] He came to Paris and studied under Lemoyne, won first prize at the Académie in 1721, and went to Rome two years later. He was certainly one of the most gifted of Lemoyne's pupils, and seemed destined for a more glittering career than he was actually to have. His graceful, facile style was well suited to decorative commissions, but proved monotonous on a large scale and somewhat flimsy when unsupported by its setting. His most familiar work – the *Cupid and Psyche* series of 1737–8 at the Hôtel de Soubise – is also his best (Plate 122). When he returned to Paris from Italy in 1728 he was considerably patronized. He entered the Académie in 1734 with a very typical *morceau de réception* of *Venus begging Arms from Vulcan* (Louvre), and later as teacher at the Académie he was to have among his pupils both Pierre and Vien – in whose work can be detected the last echoes of his own softly-coloured, rather weakly prettified style. Before Natoire began the Soubise series, he had been personally commissioned by Orry, newly appointed Directeur des Bâtiments, to execute a rather different series on the *History of Clovis* (Musée de Troyes) (Plate 123). It is quite likely that Orry, who was to be involved in the national-patriotic scheme for a monument to Fleury, was the first Directeur to turn back to national history for pictorial subjects. The pictures of Frankish battles, etc., which he commissioned from Natoire may not be very good, but their commissioning as early as 1737 is a landmark.

Natoire went on to receive important, official commissions – chiefly for decorative work and tapestry designs – and it was an honour, not banishment, when he was chosen to replace Detroy as head of the Academy in Rome. Nevertheless, it marked the

effective end of his career. Nor was Natoire particularly talented as an administrator, to put it kindly. He never returned to France and, after retiring from his post, lived at Castel Gandolfo, where in 1777 he died. That romantic spot is suitable for an artist who during his last Italian years had manifested a new, unexpected interest, in landscape painting. His own paintings and drawings of Rome (Plate 124) and the Campagna are quite unlike anything he had attempted before. Scarcely had he reached Italy and taken up his new post than he was writing that it might be good to encourage the student hopeless at history painting to study 'celuy de paysage, qui est si agréable et si nécessaire, car nous en mancons'. A year or two later Fragonard and Hubert Robert would arrive in Rome, to satisfy the need indicated by Natoire.

Two close contemporaries of Natoire, the brothers-in-law Pierre-Charles Trémolières (1703–39) and Pierre Subleyras (1699–1749), might have proved a sharp challenge not only to him but to the establishment of Van Loo. Like Natoire, both painters were provincials – though from different regions of France – but unlike him they worked largely away from Paris.[69] They married the daughters of the Italian musician Tibaldi, and for both of them Rome was a more significant location. Indeed, Subleyras became a complete expatriate and may reasonably be thought more relevant to Italian eighteenth-century art than to that of his native country. He was born in southern France and worked for a time in the studio of Antoine Rivalz (1667–1735) at Toulouse.[70] This interesting and individual artist showed no more wish than Subleyras to live in Paris; his independence extended to his style, and both perhaps influenced his pupil. In 1727 Subleyras received the *premier prix*, after three years' study at the Académie in Paris; he left for Italy the following year and never returned. The shorter-lived Trémolières inevitably remains a more shadowy figure. The protégé of Caylus, he was the pupil of Jean-Baptiste van Loo, who taught him competence without damaging his delicate, almost fragile gracefulness. He spent six years at Rome – working not only on expected subject matter but painting landscapes (now lost). He had a much firmer grasp on design than Natoire yet, like him, may be seen at his best in the Hôtel de Soubise (Plate 125). At the Salon of 1737 he exhibited several decorative mythologies destined for different rooms there. His work was well received, and he was given a royal commission for a series of tapestries, *The Four Ages*, which he never lived to complete. In the year of his death, Subleyras married Madame Trémolières' sister at Rome, where he had been living since 1728.

The range of Subleyras' work, and a good deal of its quality, is conveniently conveyed in the artist's picture of his own studio (after 1740, Vienna, Akademie) (Plate 126), situated near SS. Trinità dei Monti. From this painting alone it is apparent that Subleyras was pursuing his own individual manner, in opposition – conscious or otherwise – to the style represented loosely by Lemoyne and his pupils. Of all French painters of the period, Subleyras is closest perhaps to Chardin: he has something of Chardin's gravity, response to density of objects and materials, and subtle use particularly of white as a colour. There is something too of Poussin in him, though in handling paint he is more directly influenced by Italian examples; Sacchi, Mola, and Solimena all seem utilized and assimilated – Solimena quite patently since Subleyras spent some time

in Naples. In contemporary France, only Restout might have claimed to possess Subley-ras' deep seriousness of purpose and sense of sober conviction in treating religious subjects. That category of picture, with portraiture of an equally sober kind, represented Subleyras' preference: both are prominent in the view of his studio, including the portrait of *Pope Benedict XIV* and the sketch for his *Mass of St Basil* – probably his most famous work – commissioned by the pope for St Peter's. The pope, the cardinals, and the religious orders (the latter particularly keen when the canonization of one of their members took place) were Subleyras' major patrons, to whom should be added the French ambassador in Rome, the Duc de Saint-Aignan. The latter is as close as Subleyras came to retaining connections with France. Although his artistic stature entitles him to much more sustained attention than he is here given, Subleyras must pay some penalty for leaving France. It is notable that few of his pictures returned there. He exercised little influence; among his few pupils was Duplessis (cf. p. 185), and perhaps the gap between their styles is sufficient illustration.

A return to the main stream of decorative painting – a stream which was tending to dry up – is represented by the frankly insipid Jean-Baptiste Pierre (1713–89), a Parisian pupil of Natoire who achieved considerable academic success.[71] It is the story of Carle van Loo all over again, even to high praise from Diderot, except that Pierre never quite deceived the public – nor some contemporary painters. Madame Vigée-Lebrun had no cause to like him, it is true, but her epithet of 'mediocre' for his abilities is remarkably controlled.

In fact, Pierre's ability as a painter was increasingly less displayed the more heavily he was involved in administration. From about 1763 until his death in 1789, he scarcely pro-duced any pictures, but his earlier work had attracted a good deal of favourable, quite unmerited attention. The pupil of Detroy and then Natoire, Pierre began as a decorative painter in a sub-Boucher style but even he – typical product of his century – early show-ed marked interest in genre, represented by his *Figures dessinées d'après nature du bas peuple à Rome*, which was published in 1736. He had studied at the French Academy in Rome, and this not totally expected work was the first fruit of his years there. A more obvious bid to be a serious, elevated artist came with his *Medea*, which created considerable interest at the Salon of 1746. Although Pierre does not deserve a great deal of posterity's attention, it is useful to realize how concurrently with Boucher and Carle van Loo he flourished artistically. He received a rare token of esteem in 1750, when Rousseau (in the famous *Discours sur les sciences et les arts*) linked his name favourably with Van Loo's. Two years later Pierre became Premier Peintre to the Duc d'Orléans. He rose high in the hierarchy of the Académie and within a week of Boucher's death had replaced him as Premier Peintre to the king. When d'Angiviller became Directeur des Bâtiments in 1774 under Louis XVI, Pierre served him loyally, somewhat too loyally, becoming the servant of the system rather than daring to stand up for the independence of painting or painters. D'Angiviller must have been amazed to read a letter from the elder Lagrénée which – already in 1781 – coolly informed him: 'On ne commande point aux talents . . . les arts ont toujours été et seront toujours enfants de la Liberté.'[72] Such language could never have been Pierre's. Luckier in some ways than d'Angiviller

himself, Pierre died in the historic year 1789. As Premier Peintre he was succeeded immediately by Vien, who lived to see fierce dissension in the Académie and the collapse of the whole *ancien régime* system of state patronage, but who yet survived to be made a senator and finally a Count of the Empire by Napoleon.

Joseph-Marie Vien (1716–1809) thus enjoyed a career which makes it possible to treat him – the mentor of David – as a figure of the later part of the century; but his own claim for his significant activity stressed the year 1750, when he returned from Rome to Paris. Referring to that period, he wrote in the third person as 'citizen Vien', in 1794/5: 'His astonishment was equalled by his regret when he saw that instead of presenting young people with nature as a model and guide all they were being offered were bizarre examples and bad taste . . .'[73] What Vien first offered them – high-falutin sentiments of forty years later apart – was the *Sleeping Hermit* (1750, Louvre) (Plate 127), which was exhibited and much praised at the Salon of 1753.[74] It is unexpected work by the standards of Vien the neo-classical regenerator, but to some extent that role was one Vien would later claim against the evidence of his paintings. Perhaps that is too harsh a judgement; but certainly the forcefulness of Vien lay more in his claims to be a great and influential figure than in any of the work he produced. At the same time, the *Sleeping Hermit* suggests that he had been studying in Rome the work of Mola, at least as much as the monuments of Antiquity. Nor is Mola an altogether bad prototype for the somewhat unnatural and assumed classicism of Vien – himself an acute case of a painter without pronounced stylistic affiliations and without much individuality of style. Since Diderot has often had to be quoted here praising indifferent painters, it is only fair to quote him characterizing the art of Vien. In 1765 he found the painter's *Marcus Aurelius* (Amiens) 'sans chaleur et sans verve; nulle poésie, nulle imagination'. Two years later he gave measured praise – with some justice – to *St Denis preaching* (Saint-Roch) (Plate 128). However, on *Briseis led from Achilles' Tent* (Salon of 1781, now at Angers) he remarked that the Homeric description provided ideas for two or three pictures 'infiniment mieux ordonnés, infiniment plus intéressans que celui de M. Vien'. And though it is true that in summing up the state of French art in 1767 he had named Vien as taking first place, he had carefully limited that primacy to technique, adding sharply 'Pour l'idéal et la poésie, c'est autre chose.' Finally, while Diderot is commonly quoted à propos Vien with his testimony of 'sapit antiquum', it should also be noted that à propos the same painter he exclaimed 'Oh! que nos peintres ont peu d'esprit! qu'ils connaissent peu la nature!'[75]

Vien is in fact an excellent further piece of evidence for the complex and critical position of French painting in the middle years of the century. He claimed, at least retrospectively, to be following nature. Diderot applied the same criterion: sometimes he found Vien passed the test (in his *Saint Germain* of 1761, 'c'est la vérité'), but probably more often he did not. Vien was born at Montpellier and after some early training arrived in Paris, to become a pupil of Natoire. And, to some extent, he never threw off that influence. He never forgot how to be graceful and decorative, whatever style he practised. His style was increasingly, however, one which by its very lifelessness approximated to what passed for classicism. Less and less action, figures arranged like

bas reliefs, chic references to and depictions of Greek manners and furniture – such were the contributions of Vien to steering art back towards the recovery of noble simplicity. It was less forceful than Boucher, less energetic than Fragonard, less intense than David. The typical *Greek Girl at the Bath* (1767, Ponce) (Plate 129) belonged to Choiseul, who placed it in his bedroom where it hung near two semi-erotic pictures by Greuze and a *Sacrifice to Priapus* by Raoux.[76] The juxtapositions may tell enough about the nature of Vien's 'neo-classicism'. In many ways he is comparable to Pajou, though a good deal older; in both 'neo-classicism' seems no burning doctrine but something of a stylistic accident, encouraged by lack of vigour in their own temperaments.

Vien's first years in Rome were as pensioner at the French Academy. Returning to Paris in 1750, he was *agréé* the following year and received at the Académie in 1754. His *morceau de réception* was a *Daedalus and Icarus* (École des Beaux-Arts) which already showed – in distinction to the *Sleeping Hermit* – a knowledge of how to appear 'antique', inspired by Caylus, whose protégé he had become. Boucher is said to have encouraged him. Madame de Pompadour certainly patronized him, as Madame du Barry was also to do. In 1776 he returned to Rome as director of the Academy there – remarkably enough, taking David with him. Five years later he was back in Paris, and proceeded in semi-old-age to amass honours and prove impressively adapted to survive into the Napoleonic Empire. He outlived Greuze and died in the same year as Pajou.

If Vien was no dynamic innovator but basically a trimmer, he was at least a trimmer who very early realized whence fresh winds were blowing – from Rome and from classical Antiquity, because there seemed the location of 'nature'. Even if no one was quite clear what they would mean in re-defining that keyword, it was clear negatively that the quality was lacking in Boucher's landscapes, and also in Nattier's portraits. When in 1767 the Académie assembled to hear Nattier's daughter, Madame Tocqué, record her father's life and unhappy last years, they had clear hints of the changed world which had gradually grown up around them: 'la guerre, le fléau des arts, l'inconstance du public, le goût de la nouveauté, tout se réunit pour lui faire éprouver le plus triste abandon.' The adept Vien was not caught in any of those ways. That variety of work which he offered at the Salon of 1773 – the last, one may repeat, to be held under Louis XV – takes on an additional significance. The future 'citizen Vien' was the last *ancien régime* appointment as Premier Peintre. He was among the first painters in France to practise an admittedly diluted, somewhat perfumed neo-classicism. He was one of David's masters, but he had much closer affiliations, at least in subject-matter, to Boucher's erotic mythology. He is both epilogue and prologue; for that reason, perhaps, he plays little part as a protagonist.

Portraiture: Nattier and Tocqué – Liotard, Roslin, Aved, Latour, and Perronneau – Drouais

Like Boucher, Nattier is popularly associated with a style of slightly unreal decorative painting – of portraits particularly, in his case – which might seem to stand as representative of Rococo taste as fostered by the court under Louis XV and Madame de

Pompadour. Yet, as with Boucher and the whole central period of the century, the facts are more complicated. To begin with, it is not Nattier but the more pungent Latour and the more prosaic Drouais who have left the most memorable portraits of Madame de Pompadour, apart from Boucher's. It was Nattier who in 1748 produced the relaxed, homely, though still charming image of Louis XV's neglected queen, *Marie Leczinska* (Versailles) (Plate 130). Perhaps this is the less unexpected since the queen herself was a good amateur painter. Other less famous portraits by Nattier confirm his ability to be direct and simple when he – or his sitter – wished it. He could not however help remaining a graceful painter. It is true that he had often lightly allegorized his female sitters into goddesses or nymphs – and taste turned against such mythological trappings. Just as much of a convention, but one paying tribute to a redefinition of 'nature', is apparent in the artifice of Drouais' popular device of depicting royal and princely children as beggar boys, chimneysweeps, or gardeners. Indeed, that prepares the way for the no less conscious simplicity of Madame Vigée-Lebrun's portraits, with drapery arrangements which are not natural but artistic, echoing Domenichino rather than reflecting actual costume as worn.

All these devices to enliven and present a sitter are understandable enough, given the basically prosaic task of the portrait painter. An element of the mechanical in his art was, perhaps unfairly, recognized by the Académie, which always ranked the portraitist in its inferior grades. It must also be recalled that the very popularity of the portrait among patrons of all kinds – a popularity that extended of course to sculpted portraiture – meant that any artist might turn momentarily to this category of work. As well as portraits produced by the portrait painter as such, there were also the isolated but often successful portraits by painters like Boucher and Carle van Loo – pictures very much better usually than the few attempts at subject pictures by the portraitists. Good as Greuze's portraits are, it was not until David that a painter appeared capable of truly sustained great work both as portraitist (e.g. the full-scale *Lavoisier* portrait (Plate 199), of 1788) and as history painter.

Perhaps something of that double aspect haunted Jean-Marc Nattier (1685–1766); he presented himself at the Académie as a history painter, but it was as a portrait painter that he was destined to become famous. The destiny is more than mere cliché, because his father, Marc Nattier (1642–1705), was a Parisian portrait painter of respectable standing, and even his mother had worked as a miniaturist. It is hardly surprising that such parents encouraged the talents of their two sons: Jean-Baptiste (1678–1726), who committed suicide the day after he was expelled by the Académie, and the always much more gifted Jean-Marc. As a boy Nattier already attended the Académie and was soon awarded a prize for drawing. His drawings after Le Brun's battle pictures indeed received the approbation of Mansart; his first drawings after Rubens' *Marie de Médicis* series in the Luxembourg Gallery were shown by Mansart to Louis XIV, and the artist himself appeared before the aged king in 1712 to present his drawing executed after Rigaud's portrait (Plate 1), intended for the engraving. The Nattier family preserved, even if they slightly embellished, the royal encouragement given on that day: 'Monsieur, continuez à travailler ainsi et vous deviendrez un grand homme.'[77] More direct

124

encouragement was provided by Jouvenet, who seems often to have given him generous protection: he urged him towards a vacant place at the French Academy in Rome, but Nattier regretfully declined, finding himself over-occupied with work at Paris.

Although he did once, somewhat unexpectedly, travel to Holland and work there briefly for Peter the Great, Nattier remained a Parisian phenomenon. As for his artistic training, this was probably best summed up by the versifier in the *Mercure* who greeted him as 'l'élève des Grâces' at the time of the 1737 Salon. For the subsequent twenty years that was indeed Nattier's title to interest. Although he occasionally painted portraits of men, these were often strangely emasculated and insipid. His portraits of women were at their best remarkable for more than just graceful painting – though that in itself is welcome against the leaden handling of such a painter as Carle van Loo. Nattier could catch a likeness speedily; without losing it, he could yet make the un-attractive look delightful. If he never aimed to present character seriously, he was yet responsive to vivacity and charm. For all their allegorical properties, his sitters appear relaxed and at ease; there is more 'nature' in such portraits than in Raoux', which are the most obvious prototype. Nattier's succession to Raoux is made quite explicit by the patronage extended to him at Raoux' death by the Grand Prieur de France, the Chevalier d'Orléans.

Over the years Nattier's style evolved scarcely at all. His sitters were drawn equally from Parisian society and from Versailles, but it was his increasing popularity at court which made him famous. His first portrait of one of the Mesdames de France, *Madame Henriette as Flora* (Versailles), was commanded in 1742 by the queen and was also fortunate enough to please the king. Although Louis XV sat to Nattier, and although the portrait of *Marie Leczinska* (Versailles) (Plate 130) is among Nattier's finest work, it was probably through his whole series of portraits of their daughters that he was best known. And while he often portrayed them as goddesses, as the seasons, as the elements, he also portrayed them in a sort of stately intimacy, mingling such Baroque devices as pillars and looped-up curtains with modern truth to nature. Madame Henriette thus appeared in a sumptuous full-length portrait, playing the bass viol (Versailles); she had been a keen musician and the portrait ('un de mes meilleurs ouvrages', wrote the painter) was allowed to be exhibited at the Salon in 1755 after her death. It then belonged to her sister, Madame Adélaïde, who was portrayed the following year in a wonderful coral-red dress powdered with gold stars, engaged in the domestic diversion of knotting (Versailles). Two years later she was painted again by Nattier, in a pendant to the full-length of her dead sister, beating time while practising some music, accompanied by a pet dog which has already torn up a sheet of music on the floor (Louvre) (Plate 131).

Probably the tone for such comparative simplicity had been set by the portrait of Marie Leczinska, where we know that it was the queen's express wish to be shown in ordinary costume. Here there are no mythological trappings. The queen appears in her own setting – her apartments at Versailles – dressed in lace cap and furred red dress, a wintry costume (the sittings were actually in April) which in its resolute un-décolleté is almost a bourgeois reproach to court fashion. Her hand rests on the Bible – but in one version, for the queen's friend, the président Hénault, this was changed to a book

of philosophic essays.[78] Without any diminution of his usual charming manner, and with steady attention to details of dress and setting, Nattier achieved a portrait which was widely praised – and rightly – for its 'noble simplicity'. With dignity, it was also more direct, truthful, and intimate than any royal portrait which had previously been publicly exhibited. It appeared at the Salon of 1748, at the same time as Latour's pastel of Marie Leczinska, which has equal directness but no nobility. Nattier's woman is more than a pious bourgeoise; the setting – and the chair with the fleur-de-lis – are reminders of royal status, and those things make her simple costume and devout occupation only the more remarkable.

Towards the end of Nattier's long life and active career, taste was changing. It is often said that his own work began to reveal signs of fatigue and skimped handling. Yet a portrait such as that of *Manon Balletti* (London, National Gallery), admittedly only a bust length, shows that even as late as 1757 Nattier could respond with enchanting effect to an enchanting sitter. Doubtless he grew tired, as he certainly grew ill and dispirited. The accidental death of his son, intended as a painter, and drowned at Rome in 1754, was a dreadful blow. He had never been careful about money and was in serious difficulties when Marigny reduced the payments for all royal commissions. Words like 'false' began to be used of his art. A witty article in the *Mercure* by Cochin, posing as a future critic in the year 2355, made fun of the extraordinary fashion there must have existed in eighteenth-century France for women to lie about holding pots of water or taming eagles to drink wine out of gold cups. It was Cochin, in fact, who was in 1767 to read to the Académie the sad account of Nattier's last years which had been compiled by his eldest daughter, Madame Tocqué. And it was Cochin who had written interestingly to Marigny some years earlier about Tocqué's singular fatality in never enjoying Nattier's vogue, 'malgré ses rares talents'.[79]

Louis Tocqué (1696–1772), a Parisian, had married Nattier's daughter in 1747. Although he inevitably came under Nattier's influence, he was basically a quite different type of portraitist. If he never had a great vogue, he undoubtedly had considerable success. In some ways he was more sheerly competent than Nattier, but he was also more commonplace. In 1762 the two painters painted each other's portraits (both at Copenhagen), and these reveal their differing attitudes: Nattier is shown very much at work, with a strong sense of verisimilitude; Tocqué is also at work, but something ineradicably graceful haunts his very pose, and he is given what can only be described as an air. In his portraits Tocqué preferred harder, uncompromising effects (Plate 132). Not for nothing was he an admirer of Largillierre and, more pertinently, Rigaud. His portrait of *Marie Leczinska* (dated 1740, Louvre) is intensely formal, for all its smiling good nature, and hard in its outlines, its solid paint surface, its sober recording of rich detail. Indeed, although Tocqué portrayed some other members of the royal family, and worked most successfully at the Russian and Danish courts, he was not at his best with either women or royalty. Nattier might be 'l'élève des Grâces', but Tocqué really responded to a masculine world where sitter and setting proclaimed themselves as very much part of ordinary existence; the soldier with a cuirass or helmet, a gentleman relaxing with his snuff-box, or reading and writing in his study. He had first made a

name at the Salon of 1739 when he had exhibited a large portrait of the youthful dauphin 'dans un Cabinet d'Étude' (Louvre). That style suited his art much better than excursions into pseudo-Nattier compositions, of which *M. Jéliotte, sous la figure d'Apollon* (ex-Wildenstein), shown at the 1755 Salon, was undoubtedly the most high-flown.

In those pictures which portray the setting of a person as well as his features, and in sometimes selecting 'engaged' poses where work or study are suggested, Tocqué touched a nerve of the period. Yet he often retained touches of conventional drapery and poses which recall Rigaud and Largillierre; an echo of the *grand siècle*, more than a hint of stiffness even, is apparent in him. He remains a not very interesting or original painter, despite his competence. Nevertheless, there can be little doubt that to intelligent, would-be advanced taste like Cochin's, his work was much more sympathetic than Nattier's. Again much closer to Tocqué is Drouais' portrait of Madame de Pompadour (Plate 138), no longer graceful but prematurely middle-aged, busy at her embroidery. Portrait painters who were adept at a good likeness and could do sufficient justice to lace and velvet, yet without too luxurious a display, would always find patronage and popularity. Among the embarrassingly rich choice it might seem perverse to single out two technically foreign painters, yet that serves as reminder of the influence exercised by Paris as a centre of culture and the arts. Both Liotard and Roslin worked in France, and Roslin especially became part of the established artistic scene at Paris. High claims should not be made for either as an artist, but they pleased by sheer truth to nature; indeed, Liotard, the better painter anyway, sometimes produced extraordinary *tours de force* of verisimilitude which are in their own restricted way unrivalled.

Jean-Étienne Liotard (1702–89) was born at Geneva and studied there for a time before arriving in Paris in 1723, to work under the painter and engraver Jean-Baptiste Massé, a close friend of Nattier's. Two years older than Latour, Liotard also was probably influenced by the success in Paris in 1720–1 of the Venetian pastellist Rosalba Carriera. Though he executed some oil paintings, he specialized in pastel portraits, and in 1736 set out on a long period of travelling which took him successfully to Constantinople as well as to Rome, Vienna, London, and Holland. Finally he settled at Geneva in 1758, though still travelling elsewhere until late in life. His considerable stay in Constantinople resulted not only in portraits as such but in remarkable genre studies which seem already to have something of J. F. Lewis's romantic response to languorous moods as well as to exotic costume. At the same time Liotard achieved some shadowless, exquisitely uncluttered effects – placing, for instance, a richly dressed Turkish woman against a large area of completely blank, creamily cool wall – which almost anticipate certain Ingres drawings. The summit of his virtuosity as a pastellist is in the *Maid carrying Chocolate* (before 1745, Dresden) (Plate 133). Here the medium challenges the power of oil paint. Smooth as velvet in surface, and with its own bloom, pastel is made to simulate a gamut of textures and dazzling effects – of which the most brilliant is the glass of water on the tray the girl is holding. The tenacious power of observation in this picture is confirmed by Liotard's almost disconcertingly realistic portraits, sharp close-ups of the human face. Just as the *Maid carrying Chocolate* is no pert, ogling chit posing as a servant, so no flattering charm – still less any of Nattier's grace – is

allowed to soften the impact of these candid portraits. They do not have the tempera-
mental conviction of Latour's portraits, nor much exploration of character, but as
sheer likenesses they may well be more powerful.

Competence rather than power marks the portraits of Alexandre Roslin (1718–93).
'Roslin Suédois', as he sometimes signed and was often called, was born at Malmö and
trained in Sweden. After visits to Germany and Italy, he settled in Paris, and from the
1750s onwards was an assiduous exhibitor at the Salon.[80] He was *agréé* at the Académie
in 1753 and received later the same year. He seems to have become something of a
pillar of the Académie, attending its sessions regularly up to his last years, and in him-
self he may stand for several Swedish artists who gravitated to France. His solid, even
stolid portraiture was extremely popular, both at the French court and at the other
Northern European courts to which he was summoned. In 1774 he returned to Sweden
and went thence to Leningrad, coming back to Paris via Warsaw and Vienna; the
Swedish royal family, Catherine the Great, Maria Theresia, were among his sitters,
between whom Roslin catches a common likeness. Slightly heavy and not particularly
animated, his people share a bourgeois strain – even when they are high-born. They
are prosperous bourgeois, however, with gleaming coats and highly polished buttons.
Sometimes the facture of Roslin's portraits, at their best, suggests the manner of Allan
Ramsay, and this may be more than accidental. Both painters had spent significant
periods of time in Italy, Ramsay studying directly under Solimena; Roslin too may have
learnt something from the same source, less directly because he arrived in Italy only in
1747, the year of Solimena's death.

Although it is now difficult to be stirred by Roslin's portraiture, it is easy to see that
his steady competence would remain in demand whatever currents of taste affected
painters of more pronounced style. He survived quite literally too, outliving Tocqué,
the pastellists Latour and Perronneau, and the much younger court-favoured portraitist,
Drouais. Apart from these, there was one other distinctive portrait painter, Aved, of
whom it might be said that he represented Chardin to the Boucher of Nattier. Indeed,
Nattier and Aved were to be contrasted in mid career; this does not mean that taste
necessarily preferred one to the other, but that both seemed to express aspects of the
period. In Nattier there could be found 'tout le faste et l'orgueil de la nation française';
Aved offered 'ses beautés solides et vraies'.[81]

At least one monograph has been written about Aved, and yet he remains a somewhat
unfamiliar painter outside France, perhaps because his official career was not particularly
brilliant, and more probably because his comparatively small output is scattered.
Although Jacques-André-Joseph-Camelot Aved (1702–66) was not a foreigner, he was
to some extent a painter brought up in a foreign style, from the first more concerned
with Dutch realism than with French grace. Born in or near Douai, he was first trained
at Amsterdam; later he was to own pictures by Rembrandt and, though there is scarcely
any *Rembrandtisme* in his style, there may well have been some compositional influence
on him. From Amsterdam, Aved went to Paris, to study under the portraitist Alexis-
Simon Belle (1674–1734). *Agréé* at the Académie in 1731, he was received three years
later on presenting portraits (now at Versailles) of Jean-François Detroy and Cazes, the

128

master of Chardin. It is customary to link Aved and Chardin, rightly, because the two men were friendly. Chardin painted Aved's portrait, and Aved owned some of his still lifes. Yet Aved seems to have been friendly also with Boucher and Carle van Loo at least in these early years. His patrons proved quite often to be royal or at least noble; ambassadors like Count Tessin sat to him, and Louis XV commissioned a portrait which, however, caused Aved trouble and which took long to complete. It may well be that court portraiture as such did not suit him, but he travelled to The Hague in 1750 to paint the Stadhouder William (Amsterdam) – with rather conventional results.

Much more remarkable, and noted at the time as remarkable, was the portrait of *Madame Crozat* (Montpellier) (Plate 134), which he showed at the Salon in 1741. In the nineteenth century this was supposed to be by Chardin. As it happens the picture contains a hint rather towards Nattier's *Marie Leczinska* of seven years later (Plate 130). More than a mere likeness is aimed at. Aved conveys something of the sitter's character – including a lack of vanity – and her ordinary existence. With her tapestry work and a teapot handy in the background, she might stand as representative of the highest bourgeoisie: sensible, comfortable, industrious. It was thought worth commenting on in 1741 that another woman would have suppressed the fact of those spectacles which Madame Crozat has just taken off and still holds; Aved seizes on this very detail to give a sense of momentary pause in a pleasantly busy domestic life. As for the detailed suggestion of environment, this was rightly praised as 'd'un naturel ravissant'. Something similar had been attempted in the portrait of Tessin, certainly seen at ease in his study, but the *Madame Crozat* is more remarkable. Perhaps it owes something to Chardin's large-scale genre studies such as the *Woman sealing a Letter* (1733, Charlottenburg), shown at the Salon of 1738. It represents a tendency which increasingly developed: not only made fashionable by portraits like Drouais' of Madame de Pompadour but apparent in provincial centres. Indeed, in a simplified form, its artistic pendant is *Madame Nonotte* (Besançon, signed and dated 1758), shown reading, deeply absorbed – slumped in a chair – a closed fan clasped idly between two fingers, by the talented local portraitist, Donat Nonotte (1708–85).[82]

The most famous of all portraitists in the middle years of the century was of course Maurice-Quentin de Latour (1704–88). The man, as well as his masterly pastel portraits, made a mark on society – partly by the slightly manufactured 'character' he presented, a sort of homespun Voltaire of portraiture, lively, opinionated, satiric, and sometimes rude. Something of this emerges from his portraits. They retain an astonishing impact of vivacity and vitality, unequalled except by the busts of Lemoyne. They are virtuoso achievements which stole, and still steal, éclat from the portraits of Perronneau which, on a more sober assessment, may well be more sensitive and penetrating likenesses. Latour is full of tricks; Perronneau seems to disdain them. Perronneau spent a good deal of time out of France. Latour, once arrived in Paris from his native Saint-Quentin, passed the rest of his working life there apart from an early stay in London; he became a familiar part of the social scene.

Latour arrived in Paris for the first time probably during Rosalba Carriera's triumphant success there in 1720–1. It may well have been her pastel portraits which encouraged

him to take up that medium where he was easily to eclipse her, despite some loyal protests from Mariette. Latour's early danger was too great facility. After a brief but successful period in London (about which little is known), he returned to Paris, was *agréé* in 1737, and appeared that year at the Salon with portraits of pretty *Madame Boucher* and 'l'autre, celui de l'auteur qui rit' (examples at Geneva, etc.). An anecdote is recorded of how, some years before this, Louis de Boullongne (d. 1733) had warned Latour to concentrate on drawing; Latour himself later more than once paid tribute to the useful advice he had received from Restout. At the Salon of 1737 his work at once attracted attention; thence onwards until 1773 he was a constant exhibitor, and his mastery of the pastel medium led not only to imitation but to fears that he would provoke a distaste for oil paint. His sitters ranged as widely through society as Latour pleased. From the king downwards everyone wished to be portrayed; they paid for the privilege, when Latour granted it. Highly successful and prosperous, he was by turns dramatically generous or stingy, a social delight but a sensational disaster at court, capricious, vain, full of wild schemes yet tenacious about his art, and, in the end, apparently feebleminded. His fascinating character is still not totally clear; it almost stands in the way of the art, but both are convincingly evoked by the Goncourt in probably the best chapter of *L'Art au dix-huitième siècle*.

Despite some ambitious essays in what might be called Aved-style portraiture, culminating in the large-scale *tour de force* of *Madame de Pompadour* (Louvre, signed and dated 1755), Latour was at his best in concentrating on the face alone: the face as an expressive, palpitating mask. Like the people of Lemoyne's busts, his sitters assume the character of actors, and there is an extra mobility of feature about their so often smiling faces, an almost theatrical vivacity greater than any in life. This is what the artist meant when he spoke of the limit of 'un peu d'exagération' that art allows beyond nature. In that way Latour may have flattered his sitters; he could not help, perhaps, letting his delight in their appearance emerge in the pastel – and even that observation is probably made somewhere by the Goncourt. For vivid directness – a sense of being surveyed and quizzed – nothing equals Latour's *préparations* (Plate 135), sometimes much rougher and more patently hatched in their application than the final, smoothly blooming surface of his finished work. Inevitably, Latour could at times be dull, try as he might to avoid commissions which did not inspire him; he was always uneven – in a very difficult and capricious medium – and towards the close of his career he was seized with a mania for re-doing pictures, experimenting with new fixatives, and so on.

Yet the body of his finest work, at once consistent in quality and varied in attitude to the person portrayed, must rank with the best of European portraiture in the century. He carried the pastel medium to a point of sheer technical brilliance not reached before or since. Technical brilliance, intimacy, and vividness combine in the *Abbé Huber reading* (at Geneva; Plate 136), which was shown at the Salon of 1742. Less famous than the full-length *Madame de Pompadour*, it is stamped with a sense of the artist's personal knowledge of the sitter. We seem present beside Huber, who, planted on the arm of his chair (as the Salon *livret* noted), hunches absorbed over a book, unheeding of a just-guttered candle – a detail David was to seize on in *Napoleon in his Study* (Washington).

There are other aspects of Latour too which deserve mention. If he had affinities with Lemoyne as creator of likenesses, he was nearer to Falconet in his dogmatic individual theorizing. Not only did he have general ideas about art, but he – like Falconet – centred them on the concept of natural, unadorned, and unlearned nature. Latour probably saw his own methods as coming between the academic extremes he criticized (as recorded by Diderot); the cold slaves of the antique, on one hand, and on the other the devotees of a false 'libertinage d'imagination'. In that he becomes very much a typical voice of his century, stressing the need to follow nature; and it is typical of the century too that he should interpret the concept entirely as of human nature.

Latour's personality undoubtedly excites more interest than Perronneau's. Yet Jean-Baptiste Perronneau (1715(?)–1783) has several times been esteemed by posterity as highly – if not more highly – as a portraitist. Born in Paris, he became the pupil of Natoire and of the engraver Laurent Cars. He himself worked for a time as an engraver, but abandoned it for painting – in oils as well as pastel. He first exhibited at the Salon in 1746, the year in which he was *agréé* at the Académie, and one of Latour's quietest years as an exhibitor, but his reputation in France remained overshadowed by the older, established man. He began travelling abroad around 1755, visiting Italy and Holland, and, late in life, Russia; he died in Amsterdam, where he had frequently worked.

Perronneau's pastels show less technical virtuosity than Latour's, perhaps quite deliberately. Something of a *préparation* remains in the finished portrait, giving a gritty, unflattering, yet forceful character to his work. He is less concerned with simulating the texture of skin or hair, for example, than with lively drawing in pastel; the strokes remain, and add their vibrancy to Perronneau's sharp observation. His sitters are seldom smiling or exuding a charming vitality: if anything, they often seem rather heavy and disagreeable – but very convincing. Unlike Latour, Perronneau was also an adept at using oil paint, achieving some of his best portraits in this medium. Outstanding is the *Portrait of a Man* (Plate 137) of 1766 at Dublin, as pungent and penetrating as a Goya portrait. The hand is painted almost roughly; the lace is suggested rather than painstakingly detailed; and the clever, challengingly shrewd face twists round with disconcerting abruptness, as if defying the spectator to slip by.

Among the five portraits Perronneau showed at the Salon of 1746 was one of the respectable painter Hubert Drouais (1699–1767). Drouais himself was a good portraitist, but he is chiefly of interest as the father of a highly fashionable court portraitist, François-Hubert Drouais.[83] Born in 1727, the younger Drouais was to inherit in effect the clientèle of Nattier – his senior by forty-two years. Yet he died nine years after Nattier, in 1775, having lived only just long enough to paint one portrait of Marie-Antoinette as queen of France. Had he survived, he might have adversely affected Madame Vigée-Lebrun's rise to court favour. As it is, he remains a phenomenon of Louis XV's reign. As befits such a figure, he is sometimes to be found echoing Nattier in a stilted style (e.g. *Marie-Antoinette as Hebe*, 1772–3, Chantilly), but more often preparing the way for the climate of rustic royalty and rather self-conscious simplicity associated with Louis XVI's court.

Drouais studied not only under his father but also under Nonotte, Carle van Loo

(most markedly), and Boucher. From this training he emerged with a hard, competent, but basically monotonous style, academic in the worst sense. At twenty-eight he was *agréé* at the Académie, and speedily proceeded to establish himself as a popular portrait-ist, particularly of royal and aristocratic children. If he did not positively invent the genre, he made supremely fashionable the device of showing such children temporarily dressed up as well-bred little gardeners and prosperous, healthy beggars. From clothes to foliage, everything in these portraits had its glossy surface and slightly wooden charm. There is a lack of personality which might seem due not to Drouais but to his often very youthful sitters – were it not that the same lack is apparent in his portraits of Marie-Antoinette and Madame du Barry.

More truly remarkable than the children's portraits, for which he became so famous and fashionable, is Drouais' large, full-length portrait of *Madame de Pompadour* (Ment-more) (Plate 138), begun in the last year of her life and still unfinished at her death in 1764. An interior suits him better as a setting; some of his hard, wooden manner is usefully employed in painting furniture, especially the shiny embroidery frame. Even the ever-present lack of characterization is less apparent amid so much detail of the sitter's environment and the triumphant recording of her boldly floral dress. This picture takes its place logically in the progress out of mythological portraiture into the everyday but highly personalized reality which culminates in David's *Lavoisier* portrait (Plate 199). (Nor can one forbear pointing out, historically irrelevant though it doubt-less is, that Drouais' son, Germain, was to be closely, even emotionally, associated with David.) The aspect of daily life had been touched on by Nattier and developed by Aved. Latour had scrutinized his sitters, as Drouais devastatingly does here. Drouais was not really great enough to create a masterpiece, but this portrait comes very near; it is certainly the masterpiece amid his *œuvre*. And something, of course, attaches to it from the sitter – patroness and subject of some of Boucher's most enchanting pictures – about whom as shown here one can only murmur moralistically: 'L'occupation selon l'âge.'

Landscape: Vernet and some Lesser Painters

The middle years of the century showed no rich crop of landscape painters to compare with the crowd of talented portraitists. The Abbé Du Bos had not rated landscape very highly in his *Réflexions . . .* (1719), even when depicted by a Titian or a Carracci.[84] Apart from theoretical disdain, as a category of picture the landscape was not particu-larly in demand. It remained largely a personal, even private concern of any painter at a given moment; thus François Lemoyne, as has already been mentioned, had ex-hibited a rare landscape at the Salon of 1725. Watteau's landscapes were scarcely to be thought of in that category. Only Boucher evolved a highly decorative style of land-scape – and that was the first aspect of his art to come under attack when new definitions of the 'natural' were formulated in the later part of the century. By then there was apparent a marked increase in the number of gifted landscape painters; Fragonard may be a special case, but Robert, the elder Moreau, and Valenciennes are three significant examples, all preluding nineteenth-century achievements.

One outstanding exception to the mid century's dearth exists, however, in Claude-Joseph Vernet, who enjoyed a European reputation and indeed became the most famous landscape painter – though 'marine painter' does better justice to the type of picture he commonly produced. Vernet is not a totally satisfactory phenomenon as an artist, but in his middling talent he is perhaps typical of the period at which he lived. He worked industriously – exhibiting regularly at the Salon from 1746 until 1789, the year of his death. He received much praise from Diderot, who coupled him with Chardin. Although there are some refreshing pure landscapes by him, it was for his seascapes, sometimes calm, sometimes tempestuous, at different times of the day and night, that he became so celebrated. The mixture of two elements in his art – prosaicism mingling with proto-romanticism – is accidentally but well defined in a letter of 1756 to him from Marigny, à propos the important royal commission to paint the ports of France: 'Vos tableaux doivent réunir deux mérites, celui de la beauté pittoresque et celuy [sic] de la res-semblance . . .'. In fact, this extensive commission caused Vernet a certain amount of trouble, as well as travel. The 'pittoresque' played a large part in his art, and when he expressed a wish to avoid painting the port of Sète on the spot ('petite méchante ville', he called it) Marigny firmly reminded him of 'l'intention du Roy, qui est de voir les ports du royaume représentés au naturel'. For this reason, Vernet was obliged to finish, in Marigny's words, 'votre tableau du port de Cette à Cette même'.[85] Vernet was never less than competent (his standard being quite remarkably sustained over a long working life), but the results of this royal and patriotic commission are not among his finest pictures.

Vernet was born at Avignon in 1714, son of a humble journeyman painter, and his formation as an artist was remote not only from Paris but from France. With the patron-age of local nobility around Aix, he was enabled to go to Rome at the age of twenty. There he settled, marrying an English wife in 1745 and being much patronized by English clients. He was recalled to France by Marigny in 1751 but did not settle per-manently in Paris until the early 1760s, by which time he was established and famous. As much as Claude, he was formed by Italy – except that Claude too played some part in the evolution of his subject matter, if not his style. Once found, his style scarcely evolved. He was sensitive to atmospheric effects, but probably responded best to steady, tranquil – Claudian – moods, tending to become somewhat rhetorical in ex-tremes of storm and shipwreck; he lived long enough to paint the sublime and senti-mental shipwreck of *Paul et Virginie* (Leningrad), not quite convincingly.

Italian scenery, especially coastal scenery, had a decisive effect on him; it became his preferred subject matter and continued to haunt his art well after his return to France. Indeed, some of his paintings of the mid 1770s show as vivid if slightly unlocalized a response to the Italian coast as any painted on the spot (Plate 139). And his views are always enlivened by people, often elegant sightseers and tourists, who are completely of the period; they are not to be dismissed as mere *staffage*, because there is in them quite vivid observation of costume and manners – and a liveliness that approximates to wit. For such figures there can be little doubt that Panini proved a significant influence; the stylistic affinity is clear, and the fact of Panini's close personal relations with the

French colony at Rome increases the likelihood of direct influence. One negative effect of Panini's presence in Rome may have been to keep Vernet away from the ruin picture; that aspect of the picturesque was left to Robert to develop, largely away from Italy and after Panini's death. An ultimate tribute to Italian artistic influence is apparent in one of the pictures Vernet exhibited at the Salon in the final year of his life, where in a last extraordinary burst he showed well over a dozen paintings, including 'Un Temps orageux dans un lieu sauvage . . . dans le goût de Salvator-Rosa.'

Vernet's influence is a difficult subject, because in many ways he was a popularizer, not a great innovator. Based on seventeenth-century models, he drew together several threads of his own century's growing interest in natural scenery and phenomena, combined with utterly un-nostalgic tourist concern and a steady emphasis on the decorative. Commonly held beliefs in the 'age of reason' restricting imagination may seem to receive support from Vernet's coolly rational work: his prospects always please, and man is never vile. The potentially most rewarding aspect of his influence lies outside France, in Wilson and Joseph Wright. The closest of Vernet's followers, to the point of copying his compositions extremely carefully, is Charles de Lacroix, a painter from Marseille and presumably Vernet's pupil at Rome in the early 1750s. He conveniently signed many of his Vernet copies; his other pictures are usually seaports, more obviously capricious than Vernet's, in a tradition that goes back again to seventeenth-century Rome. Little else is known about him except that in or around 1782 he died in Berlin.

It is perhaps significant that such other landscape painters as may deserve mention before the decade of Fragonard and Robert were – like Vernet – provincial by birth; unlike him, they seldom arrived, in any sense of the word, on the Parisian scene.[86] Apart from their own individual charm and talent, these figures serve sometimes as useful reminders of the considerable provincial activity and patronage which existed far from the capital. Jean-Baptiste Lallemand (1716–1803) was born at Dijon; though he did visit Paris and exhibit at the Académie de Saint-Luc, he produced his best landscapes after a return to Dijon. He had spent some years in Italy, but recollections of pictures by painters like Weenix mingle with observed fact in his fanciful seaports. More indigenous and interesting are views like those of the *Château de Montmusard* (*c.* 1770, Musée de Dijon) (Plate 140) which combine observation of manners with response to a notable piece of contemporary architecture, even though one never finished.

More patently decorative, with retardataire Rococo touches, is the work of Jean-Baptiste Pillement (1728–1808). Pillement was born at Lyon and died there in poverty after a highly peripatetic career which carried him from Lisbon to London, and included visits to Italy as well as a period in Vienna. Some of Pillement's designs for tapestries are closer to Watteau than to Boucher, yet his final success was as painter to Marie-Antoinette. Too much can be made of the inevitable decorative element in his landscapes, which are by no means all artifice in a pejorative sense. Some views around Lisbon, for example, are notably sensitive in conveying atmospheric effects (Plate 141). Wynants and Berchem certainly influenced him, and perhaps Cuyp too. In some ways

Pillement is more sheerly romantic than any earlier French painter; tall trees and rushing cascades dominate his compositions, reducing mankind's importance and seeming to hint at that triumph of natural scenery in its own right which will culminate in Corot.

Serious and non-accidental anticipations of the next century are apparent in the comparatively few pictures and drawings of the obscure Simon-Mathurin Lantara (1729–78), who never exhibited publicly. Lantara was a peasant born at Oncy (Seine-et-Oise), who received no professional training. His life seems to have been erratic, perhaps through ill health rather than the familiar dissipation beloved of biographers. Simple and atmospheric, his small landscapes are among the most direct transcripts of nature to appear in eighteenth-century France.[87] They are a personal note – which should not be too highly estimated merely for anticipating the future – that could hardly expect to be heard amid the chorus of praise which accompanied Vernet's constant appearances at the Salon.

Chardin

The prominence which Chardin now customarily receives in any history of his century's art would almost certainly have surprised his contemporaries. That is only one of several good reasons for not writing about art entirely through the eyes of period witnesses. It was not Chardin who was named as the leader or the hope of the apparently declining French school in the mid century. It was not his death but Carle van Loo's which seemed a national disaster; nor is this merely because Chardin had lived a long, active life. Certainly he was a well known painter, widely esteemed, and within his small circle warmly liked. He was eloquently praised by Diderot, though not before he was middle-aged; by then he had virtually ceased to paint genre and was associated with still-life pictures. Other talents – often more patently appealing – had risen to attract attention. Above all, there had appeared Greuze. Chardin was probably most praised publicly in the earlier half of his career, when he seemed more of a novelty. By the time d'Angiviller had replaced Marigny at the Bâtiments, it was not only Chardin's age and tendency to exhibit repetitions of his earlier work that might cause reservations, but the fact that he had never practised, in words Pierre drafted for d'Angiviller to use to him, 'les grands genres'.[88] This was something which mattered much more in Louis XVI's reign than at the close of Louis XIV's. But the age of the *grand monarque* may reasonably be evoked when we hear how Chardin's early paintings won the approval of Largillierre, even while deceiving him: '. . . very good pictures. They are surely by some good Flemish painter.' And in this connexion it should be remembered that Largillierre himself, the master of Oudry, had painted some still-life pictures; he was also to own at least one genre picture by Chardin.

Jean-Baptiste-Siméon Chardin was born at Paris in 1699. His father was a respectable, respected carpenter, *maître-menuisier*, and it is tempting to seize on the circumstances of his birth and see reflected in his art – in the still-lifes as much as in the genre scenes – the narrow, typically Parisian household where economy is practised almost with religious devotion. It is as well to be cautious on this point, because Chardin's early

circumstances were probably little different from Boucher's. The rigour and austerity of Chardin's work are more artistic than social. Indeed, it might be said to be the more extraordinary achievement for someone who came from comparatively humble surroundings to show them in a light as flattering, for all its sobriety, as Chardin undoubtedly does. There exists an ideal aspect of Chardin's art, attaching perhaps as much moral value to enjoying austerity as Boucher's does to the duty of enjoying luxury.

Boucher's early working years were hard, laborious at least, and Chardin's were considerably harder. He seems to have had little formal education. Nothing is known of his life before he was apprenticed in 1718 to Pierre-Jacques Cazes (1676–1754), but it is most unlikely that he had been allowed to spend his time up to then in idleness. Possibly he began by assisting his father at carpentry. There is an element of practicality about all we know of him that makes this quite conceivable. Something well made, well built, and even – one might add – inlaid, marks his work. His technique was to be compared by contemporary critics to mosaic or tapestry, because of its slotting-in effect of juxtaposed tones, but a closer analogy is with marquetry. In any event, Cazes proved a quite uninteresting, unimportant teacher for Chardin, who is next recorded about 1720 working as assistant to Noël-Nicolas Coypel (cf.pp. 29–30), collaborating on still-life accessories in his pictures. When finally in 1724 he emerged as a professional painter, it was at the Académie de Saint-Luc. This début, which Chardin was soon to repeat at the socially more prestigious Académie Royale – turning his back totally on the Académie de Saint-Luc – has been ascribed to his father's craftsman-like ambitions and milieu. That may be so, but it should also be noted that Oudry had followed the same route (cf. p. 26), and Oudry's precedence – and presence – certainly affected Chardin's activity. Unlike him, however, Chardin was received at the Académie in 1728 not as a history painter but as a painter 'des animaux et fruits'.

Neither category very satisfactorily covers *La Raie* (Louvre) (Plate 142), which is not Chardin's first still life but is among the first which brought him to public attention. It was one of several pictures he showed on Corpus Christi day, June 1728, in the annual young painters' exhibition in the Place Dauphine. This was the occasion of his being encouraged by several academicians to present himself at the Académie Royale. In September of that year he was *agréé* and, somewhat exceptionally, received on the same day. One of his two *morceaux de réception* was *La Raie*. In this, to a remarkable extent, are already present much of Chardin's attitude to still life and his compositional preferences. The stone ledge and austere interior setting – in marked contrast to the garden settings of such predecessors as Weenix – are typical. The sense of a few plain objects arranged not artistically but practically, not for show but for use, the hinted human activity of the knife projecting out towards the spectator, the frugality of what is displayed combined with sensuous response to textures of metal, earthenware, linen (never silk, and only occasionally porcelain or silver), all remain typical. The slightly anecdotic cat amid the oysters – not, incidentally, a very successful animal – is one of the few indications of the picture's early period; it is the sort of traditional northern still-life episode which seldom reappears in Chardin's work.

His still lifes grow intensely still and are animated only by the sheer application of the paint, requiring no living presences. But the most disconcerting, almost shocking, aspect of *La Raie* lies in the fish itself, bloody and disembowelled and with some horrible sense of grinning, suspended on its hook. This is realism of a kind Chardin did not repeat, at least in such an aggressive manner. It is arresting certainly, and is doubtless intended to be so – perhaps something of a youthful riposte to the highly ornamental, tasteful, and polished still lifes of Desportes and Oudry. All the same, Chardin may well have also consciously emulated, at least for his fishy subject matter, two elaborate still lifes with trout, lobsters, and other fish which had been executed by Oudry, 'à Dieppe d'après nature', and which were shown at the isolated but important Salon of 1725. To seek a precedent for Chardin's powerful effect is not necessary, but it is at least worth mentioning Rembrandt's *Flayed Ox* (Louvre), a picture which was almost certainly not known to Chardin.[89]

Yet although Chardin was active in the 1720s as a still-life painter, and was received at the Académie with this still life and the ostensibly more agreeable, and more artificial, *Le Buffet* (Louvre), he had in fact earlier had experience of painting some genre. It was not therefore a total departure when he began to exhibit genre scenes, and it is difficult to accept as more than legend the story that it was a remark of Aved's which directed him to this new source of subject matter. The earliest recorded work of Chardin is a sign (long lost) painted for the shop of a surgeon-apothecary who was a friend of his father. The composition showed both a shop doorway – with a wounded man being tended after a duel – and the street outside. The inspiration for this picture is most likely to have come from the *Enseigne de Gersaint*, and there are other indications that Chardin at this obscure period of his career was paying attention to Watteau's work. Chardin's sign, on wood, was even longer than that for Gersaint and appears to have been composed of no less than fifteen figures. It remained quite exceptional in his *œuvre*, not merely for its size but for its drama, its social panorama, and its somewhat raw actuality: the duellist stripped to the waist and being bled, the arrival of the police, onlookers peering from windows. It sounds more like Daumier than Chardin's usual, intensely intimate domestic scenes, rarely of more than two people. Perhaps it is not too fanciful to parallel this unexpected genre with the unexpected bloody still life of *La Raie*; both indicate currents which might not be apparent from Chardin's later and more – in all senses – familiar pictures.

A further reason for doubting the story of Aved piquing Chardin into painting genre rather than still life is in the homogeneity not only of Chardin's attitude but of the objects which appear in each kind of picture. It is an obvious extension from the marvellously dignified still life of a copper cistern (*c.* 1733?, Louvre) (Plate 143), with every indication of use, to the appearance of it in the several-times-repeated design of *La Fontaine*, where the implicit has become explicit: it is now located in a cobbled scullery and a maid bends at it, filling the very jug which stands beside it in the pure still life. From kitchen objects, brooms, pans, a few vegetables, Chardin was naturally led to depict their users: and use extends into a subtly moral domestic climate where work and industry are tacitly praised, and where order, duty, even education, focus on

women. There are no fathers in Chardin's domestic interiors, and sons usually require training. It is the mothers who prepare the meals and the children for church or for household tasks. In *La Gouvernante* (1738, Ottawa) (Plate 144) a housekeeper reproves a schoolboy as she pauses in brushing his hat, perhaps in part rebuke for his idle pleasures, symbolized by the litter of playing cards and racquet with shuttlecock on the floor beside him; but beside her is a work basket. The girl child in *La Petite Maîtresse d'École* (London, National Gallery; by 1740) already assumes maternal duty and teaches a younger child to read; and in contradistinction is such a traditional Vanitas subject as that of a boy blowing bubbles, significantly described in the Salon *livret* as 'l'amusement frivole . . .'.

It is indeed in the total gravity of his view – whether of two pots or two people – that Chardin goes so far beyond his Dutch predecessors. Yet it is likely that in many of his best known themes (e.g. *Le Bénédicité*, c. 1740, Louvre, Plate 145) he was affected or influenced by their treatment. Some pictorial devices – a window embrasure, for example, framing the subject – derive directly from Dou and Mieris, both inferior artists who were highly esteemed in eighteenth-century France. Though it might be nice for chauvinism to suppose so, Chardin has actually little artistic root in his own country. Analogies with the Le Nain are not particularly to the point, though at least one picture (*La Récureuse* of 1737; Paris, Musée des Arts Décoratifs) by the obscure André Bouys (1656–1740)[90] has distinct affinities with Chardin; it is not however clear whether Bouys – otherwise largely a portraitist – is a forerunner or rather an early example of Chardin's own influence, as the date of this picture suggests.

Well before the regular establishment of Salon exhibitions in 1737, Chardin was producing both genre and still-life pictures concurrently. He continued to exhibit at the Place Dauphine, being favourably reviewed in the *Mercure de France* in 1732: '. . . une vérité à ne rien laisser désirer . . .'. In 1734 he exhibited sixteen pictures. The following year he had an opportunity to exhibit briefly at the Académie; among his work was mentioned *Petites femmes occupées dans leur ménage*, and again the *Mercure* spoke perceptively well of him: 'On loua beaucoup sa touche sçavante et la grande vérité qui règne partout avec une intelligence peu commune.' Chardin was already assiduous in attending sessions at the Académie, and he became an assiduous exhibitor. With what Mariette deprecatingly called 'le gros public' he grew popular for his genre scenes, a speciality Chardin cultivated probably the more because of Oudry's continued presence as *the* painter of still life. It is surely significant that not until 1753 – only two years before Oudry's death – did Chardin exhibit any still-life paintings at the Salon. The popularity of his genre pictures was increased by engravings after them; popularity and engravings led to copies, and English sales already by 1738 record versions of pictures which – whether by Chardin himself or only after him – testify to the dissemination of his work.[91]

In engraving some of his pictures, but even more in directing towards him the benevolent attention of the Bâtiments under Marigny, Cochin proved a good friend to Chardin. He is only one of a group of artist-admirers of Chardin, several of whose pictures belonged to Aved – which is not surprising; but the sculptors Jean-Baptiste

Lemoyne, Caffiéri, and Pigalle all had choice examples of his work. Although Mariette might condescendingly refer to the taste of the 'gros public' for Chardin's genre scenes, these appealed far beyond such limits. To speak of Chardin's patrons is to mean something different from Watteau's; between them and Chardin there was less personal involvement, but their rank alone is sufficient refutation of any suggestion of Chardin's appealing specifically to a bourgeois or advanced taste. *Le Bénédicité* and *La Mère laborieuse* were in the French royal collection by 1744; other genre subjects were early owned by Frederick the Great and the King of Sweden. Although less interest was probably manifested by these and other highborn collectors in Chardin's humble still lifes, his late decorative pictures – almost a return to the manner of Desportes – were destined for the royal châteaux of Choisy and Bellevue. A version of *Les Attributs des Arts* was acquired by Catherine the Great, and Chardin's public existence ends with the exchange between him and Madame Victoire, Louis XVI's aunt, who had admired *Un Jacquet* (presumed lost) at the Salon of 1779, in the last year of his life. The painter presented it to her and she sent him in return a gold box 'comme témoignage du cas qu'elle faisait de ses talents'.

Chardin's career was thus honourable and successful. Although naturally he never rose to the highest posts at the Académie, he held the treasurership and also for long the more delicate post of *tapissier*, annually responsible for the hanging of the pictures at the Salon. Perhaps it is no accident that one of the very rare disputes he had, while generally applauded for his tact and fairness in the difficult task, should be with Oudry. They were often openly compared, not merely as two painters in what seemed the same category of picture but, to Chardin's detriment, in terms of Oudry's rapid, prolific output against his slowness and, even, laziness. Comparable complaints were heard contemporaneously in Venice against Piazzetta; both painters suffered through living in a century of virtuosi and brilliantly speedy executants, where speed for its own sake was admired.

Although there were no dramatic fluctuations in either his career or his style, Chardin certainly evolved as a painter, and his career falls, in fact, into three fairly marked portions, with an epilogue. His early work basically comprises still life, of a humble sort and usually connected with food, whether a loaf of bread or a dead hare. Whatever kind of meal is adumbrated, it remains no banquet. This restriction is, of course, artistic; Chardin finds enough exercise in the placing of a jug and a game bird against a patch of bare wall. The colour too is usually restricted in these early still lifes, with their grainy texture, soberness, and – a word contemporaries used of the artist himself – probity. What has been sought is not the novel or beautiful object but artistic, geometric novelty and beauty: horizontals, verticals, the cone, the cylinder, which matter much more than eye-deceiving effects. Indeed, despite all that has been said – from Diderot onwards – in praise of Chardin's illusionism, he is not perhaps the greatest master of such effects: at least, that is not his primary aim. The convincing power of his pictures comes first from their scaffolding, not their surface. In the early still lifes – in a picture such as the *Vase of Flowers* (Edinburgh) – there is one homogeneous surface texture, vibrant and yet saturated, which is really shared by the vase and the flower petals and

the ledge. It would be easy to find flowers, by Van Huijsum say, which looked more like real flowers, and this extends to colour as well as texture (the Edinburgh bouquet contains an unrealistic amount of blue, marvellously harmonized with the bluish-white and blue-patterned porcelain).

It was a development, probably from not before 1733 or so, when Chardin began to concentrate on figure compositions; and, even if encouraged by Aved, he certainly turned for inspiration again to seventeenth-century Holland. His early figure pictures tend to present a large, almost close-up, virtually a portrait even when not positively a portrait, like *Le Souffleur* (Salon of 1737, now Louvre), which is presumed to be of Aved. The concept here, even to the three-quarter-length figure, is borrowed from Rembrandt's followers rather than from Rembrandt himself, and close analogies exist with, for example, Bol's *Astronomer* (London, National Gallery). It may not be an accident that Chardin seems to execute these echoes of *Rembrandtisme* just at the time Grimou and Raoux, those two much older supposed exponents of the same style, died. These large-scale pictures – perhaps the least successful of all Chardin's work, as he also may have felt – were soon replaced by the small genre scenes, fully-realized interiors, which proved so successful. In these Chardin established a speciality; he had moved beyond any relevant comparison with either Desportes or Oudry.

Technique separated his pictures totally from those seventeenth-century Dutch painters whose subject matter had prompted some – not all – of his own. To such an extent was his conception blended with execution that he lifted daily genre studies into a world as timeless and grave as Poussin's. His servant maids are as calm and unmoving as statues. Everywhere there is repose, the repose of people and things in their appointed place, and fixed in the heavy medium of the paint which seems physically to weight as well as to shape each object. Chardin had learnt too – from no one unless from Watteau – how to enliven his compositions with passages of unexpected colour. Like the sudden glimpse of sage-green stockings in the woman stepping into the shop of the *Enseigne de Gersaint* are touches such as the bright blue ribbon round the neck of *L'Écureuse* or, more pertinent, the aquamarine stockings surprisingly worn by the strict *Mère laborieuse*.

There is not space here to develop the point, but it is likely that much of the original popularity of Chardin's genre scenes came from their subject matter rather than appreciation of the painter's style. Then, as taste required something more 'literary', they may well have increasingly seemed ineloquent and without sufficient incident. 1755 was the year not only of Oudry's death but of Greuze's first appearance at the Salon. Two years before, Chardin had exhibited his small picture *L'Aveugle* (Fogg Art Museum), a simple, single figure, begging but dignified; if not positively the last it was one of his last genre inventions. In 1755 Greuze exhibited his arch *L'Aveugle trompé*, painted the previous year, when shown at the Académie. Amid his other highly successful Salon pictures, this particular Greuze was not of great significance; but even its title hints at new anecdotic tendencies in genre, a direction in which Chardin could not – or would not – go.

Over the next decade and beyond he returned to still life as his major subject matter. It was in a new mood, however, that he did so. The objects themselves have often

become more elaborate, and are usually collected together in more elaborate array. The life they reflect is less austere; instead of raw beef and copper saucepans, there is now fruit and china. The handling of the paint is less saturated and at times tends to a rather disconcerting scratchiness. It may be wrong to say that something of Chardin's impressive power was gone, yet certain critics complained of diminution already in the 1750s. Along with the elaborate meal tables and fruit and game pieces, Chardin began to paint still lifes of a more sheerly decorative kind, with musical instruments and attributes of the sciences and the arts in the shape of a microscope, books, portfolios, and plaster models (notably Pigalle's *Mercury*; Plate 146); the natural and the physical are replaced by artifacts and the mental. Several of these were first commissioned as overdoors for the royal châteaux, and then repeated; they represent Chardin coming as close as he could to the style of picture in vogue when he was young, when Desportes and Oudry were receiving steady royal patronage.

That might seem a suitable close to Chardin's career; but in addition to sobriety and probity he had tenacity. Failing eyesight and poor health in his last years led him to change his medium to pastel, but he continued to work and exhibit. He first exhibited pastel heads in 1771, and for the rest of his life he continued to produce similar heads, several of which are lost or unidentified. What he could achieve in the medium, however, remains memorably, movingly clear in the well-known portraits of himself (Plate 147) and his wife (Louvre). They owe little to Latour or Perronneau. Instead, pastel is made to conform to Chardin's ever-recognizable technique: hatching, inlaying of colour, tonal sensitivity without illusionistic tricks, marvellous firmness of forms – utter unsentimentality of vision – such are the qualities of the pastel portraits. Chardin had indeed always possessed them, and was triumphantly in his late seventies to prove that he retained them. It is fitting that Chardin should have had no true pupils or imitators; those who attempted to emulate him became, in Diderot's apt term, his victims.

We know very little for certain about Chardin the man. No letters of his exist, no theoretical writings; nor can it be thought that he would have had much to say about his own art. From this it would be wrong to deduce that he was not highly conscious of the effects he obtained, or that he had less to express than Greuze simply because he told no overtly affecting stories in paint. One illuminating anecdote about him was recorded in the year following his death: to another painter who boasted of his own technique for colours Chardin had replied, 'On se sert de couleurs; on peint avec le sentiment.'[92]

Other Genre and Still-Life Painters: Jeaurat, Saint-Aubin, Roland de la Porte, Leprince, and Lépicié

It would probably have seemed disconcerting to Jeaurat that he should be classed with genre painters, for he was the author of numerous history pictures. However, it is his genre work which entitles him to posterity's attention. Étienne Jeaurat (1699–1789), Chardin's exact contemporary, was born in Paris and became the pupil of Vleughels. When appointed director of the French Academy in Rome in 1724, Vleughels took

Jeaurat with him, though no trace of that Italian stay is apparent in Jeaurat's work. He was *agréé* in 1731 and received two years later, with a *Pyramus and Thisbe* (at Roanne). In contradistinction to Chardin, he rose to the highest posts in the Académie, becoming rector and chancellor.

Jeaurat's most interesting genre pictures are a series which illustrate street life in Paris, recording the city's appearance, as well as its inhabitants, with a sub-Hogarthian gusto. Police raids, *filles de joie*, a painter moving house – such are the subjects of these small pictures which he exhibited steadily at the Salon during the 1750s.[93] Although they are not great works of art in themselves, they testify to a steady, vivid interest in daily life, catching at topical, open-air, and urban scenes in a way seldom previously attempted in France. Jeaurat's influence was felt by Gabriel de Saint-Aubin (1724–80), a rarer painter but also the finer artist. Saint-Aubin is most familiar from engravings and drawings, especially his useful sketches in his own Salon *livrets*, but his few surviving paintings have individuality and highly personal charm. *La Parade du Boulevard* (London, National Gallery) (Plate 148), apparently painted in 1760, is full of surprising colour notes, and even the angle of the composition is faintly unexpected. Saint-Aubin seems to possess an instinctive sense of the decorative which eluded Jeaurat; and he is much less constrained by realistic detail. The tall arching trees which frame the street-show, the energetic player-duellists, and the slender spectators have passed beyond the topical into a realm of enchanted genre. The woman with a parasol who leans from a balcony is brushed in with a felicity which reveals the influence of Boucher. If Saint-Aubin were not established as the picture's author, one would be tempted to suggest it was an early Fragonard.

Saint-Aubin, despite the charm of his work, had a largely unsuccessful career, and at his death his elder brother wrote a severe biographical account, deploring his paintings and the confused existence he led. He painfully failed several times to gain first prize at the Académie and eventually became a member of the Académie de Saint-Luc. He exhibited there in 1774 a variety of paintings, including a 'plafond' of the *Triumph of Love over all the Gods*, and appeared again in 1776 at the Colysée with pictures of all sorts, including some in gouache and pastel. These facts alone make it clear that he did not abandon his ambition to be a painter, while becoming known for his amusing, vivacious engravings which presumably helped him to keep alive. It is an irony that one of the most attractive advocates of the century, making the life of his day seem impregnated with *douceur de vivre*, should have been treated rather shabbily by it.

Much more obscure was the career of Henri-Horace Roland de la Porte (*c.* 1724–1793), a still-life painter too quickly characterized by Diderot as one of Chardin's victims. It is true that this was for long his posthumous fate, because his best pictures were mistaken for Chardin's. Roland de la Porte was *agréé* in 1761, and it was at the Salon of 1763 that he exhibited a group of pictures which drew down on him Diderot's comment. Some of his work does sail too near the wind of Chardin, but in, for example, the *Little Orange Tree* (Karlsruhe) (Plate 149) he attempts something distinctly different, in subject and technique. In some ways he is more naturalistic than Chardin; the glossy-leaved plant – recorded with sensitive precision – springs from a convincingly earthy earthenware pot, across which is bent a stalk which cleverly enhances the three-dimensional effect. Perhaps

not too much should be made of a single example, but there are other pictures by Roland de la Porte of growing plants; it is a subject not treated by Chardin and somewhat alien to the pronounced human concern of his still lifes. Yet this picture was bought in Paris within the painter's lifetime for the Margravine Karoline Luise of Baden, and at her death, still within his lifetime, was catalogued as by Chardin. Roland de la Porte was thus early his victim, but modern scholarship has convincingly separated his work from Chardin's. Though he can be austere in design, his paint has none of the gritty, viscous character of the greater artist; indeed, in handling, he comes nearer Desportes.

A more prominent figure, and one more typical in the faintly unreal, fancified genre that he produced, is Jean-Baptiste Leprince (1734–81). Born at Metz, he became Boucher's pupil in Paris; that influence remained paramount, and Leprince emulated his master not only in style but in sheer productivity. About 1758 he travelled to Russia, where he was to be extensively employed on decorative pictures for the palaces of the Empress Elizabeth. Experiences of life in Russia provided the basis for his art when he returned to Paris in 1763. He was ambitious to make a name for himself and launched a virtual campaign for picturesque *russeries*, with paintings and etchings of Russian customs and costumes, views of Russian countryside, and the *Russian Baptism* (Louvre) which was his *morceau de réception*. *Agréé* in 1764, he became a member of the Académie the following year and immediately appeared at the Salon with well over a dozen pictures.

Leprince was able without being particularly interesting, and his increasing ill health perhaps drove him to a fury of productivity which has given a deadly monotony to his pictures. Neither a Boucher nor a Fragonard, he was simply not sufficiently inventive, despite all his efforts. When illness required him to leave Paris for the environs he began to paint landscapes, exhibiting some of these for the first time in 1773. Though some critics felt that here he challenged Vernet, Diderot had never showed himself very favourable to Leprince, and his reserves are fully justified. Even in his Russian genre pictures Leprince remains weakly fanciful and unconvincing for one who had visited the country, partly through an inability to infuse vitality into his figures. Their wooden faces were unkindly contrasted by several critics with the lively handling of their costumes. It is no surprise to find that Leprince owned several Russian costumes and also a collection of small mannequins which were utilized only too patently in his pictures.

Much closer to Jeaurat than to Leprince as a painter is Nicolas-Bernard Lépicié (1735–84), usually associated nowadays with genre pictures but esteemed at the time equally for his history pictures.[94] Trained first under his father, the distinguished engraver and biographer Bernard Lépicié (1698–1755), and then under Carle van Loo, Lépicié was *agréé* in 1764 and quickly came into prominence, exhibiting constantly at the Salon from 1765 onwards. He became a member of the Académie in 1769. His history pictures are sometimes of historical interest (e.g. *William the Conqueror invading England* at the Lycée Malherbes, Caen, an early example of inspiring national subject matter, shown at the 1765 Salon) but of little artistic merit. Nor are his genre pictures always successful, wavering between Chardin – several of whose genre pictures had been engraved by the elder Lépicié – and the sentimental style of Greuze. They tend to exploit – the word is not too cruel – the instinctive charm of children, but Lépicié was probably at his best in

virtually straightforward child portraits, without anecdotic flavour. Although he began by emulating the texture of Chardin's paint, as in *L'Enfant en pénitence* (Lyon), he already there applied the tearful recipe of Greuze to his subject matter. In his later genre, the handling grew lighter and more fluttery.

In the struggle for his allegiance Greuze effectively defeated Chardin, but elements of both painters can still be detected in *Le Lever de Fanchon* (Saint-Omer) (Plate 150), painted in 1773. The picture has charm – a natural gift which deserted Lépicié only in high-flown historical subjects – and it is also a perfect document of taste for its particular period. Boucher's impossible girlish nymphs reclining amid velvet cushions have been replaced by an actual nymphet-girl dressing in bed in a carefully realized humble setting. The still life of broom, pots, and plain wooden table forms a homage to Chardin; the tantalizingly disarranged clothes, with all the elusive suggestiveness of the morning toilet, pay their tribute to Greuze. In one way the girl is a descendant of the *baigneuse* (a theme already hinted at in Santerre's *Susanna* of 1704) but combined now with intense realization of low-life genre – a Rousseau setting of supposedly purer manners and more innocent hearts than would be possible for upper-class people in Paris. Fanchon's attic is indeed vividly conveyed: the large areas of bare wall and coarse wood even hint towards David's use of such devices in *Marat assassiné*.

Lépicié does not teach an overt moral lesson nor depict any dramatic action but 'naturalness' and simplicity, attractively located in the environment of a poor but pretty girl, are none the less urged on the spectator. It is thus a picture which could have appealed almost equally to the aged roué Louis XV and to the virtuous domestic dauphin, so soon to become Louis XVI.

Greuze

Historically, Greuze is the most important painter of mid-eighteenth-century France.[95] If the speedy success of Watteau in the first quarter and David's slower but ultimately greater success in the last decades indicate outstanding *rapport* with their contemporaries, then the huge popular success enjoyed by Greuze reveals how effectively he spoke for the middle years. In that role he is more relevant than Chardin and far more ambitious than other genre painters like Jeaurat and Lépicié. His talent did not, unfortunately, match his historical importance, and it would be wrong to pretend otherwise. At the same time, without defending the worst of his pictures, there remains Greuze the surprisingly tough portraitist – at his best with characterful men (Plate 151) – and Greuze the extremely gifted draughtsman, whose drawings show a remarkable range of styles, as well as sensitive response to things seen, including Madame Greuze (Amsterdam) (Plate 152).

Nevertheless, it was not for those categories of his art that Greuze won his greatest success: it was for genre painting, of a kind which is unprecedented (owing little to Hogarth and not much to Dutch seventeenth-century genre) and which is intended to affect the spectator less by surface realism than by intense psychological truth. Greuze's forerunner is thus Poussin, rather than any genre painter as such. And where Chardin is calming, Greuze is consciously disturbing: he aims at sensations of drama, and in his

most elaborate genre scenes he therefore introduces conflicting emotions which should stir the spectator to enter a similar state. In this he positively anticipates David; one of the first critiques of the *Oath of the Horatii* emphasized the most interesting contrast between the sublime heroes and the sorrowing women, and expressed admiration for the 'magic brush' which knew 'how to awake in the mind such opposing and powerful emotions'. Before David, Greuze realized that the unit of the family is the framework within which most emotional havoc can be caused. The inherent conflict between parent and child provided a theme for most of his large-scale figure compositions; and this is still relevant even for those which depict extreme harmony – for example *La Piété filiale*, *La Mère bien-aimée*, *Le Fruit de la bonne éducation* (the *Paralytic*) – since these examples hint at the alternative – which indeed Greuze often depicted in a deliberate pendant. In such pairs lie opportunities for conflicting emotions: 'look here upon this picture, and on this'.

To stir the emotions became an end in itself for Greuze. For that reason he has rightly been detected as at best an ambiguous moralist. Perhaps the earliest criticism was made by the future Madame Roland, who remarked of *La Cruche cassée* (Louvre) that one doubted if the girl looked sufficiently disturbed not to be tempted to repeat her mistake. Despite Greuze's own claims and all Diderot's assertions – c'est la peinture morale' – Greuze was not a truly moral painter but a sensational painter, in the sense of affecting the spectator. Madame Roland appreciated the girl in *La Cruche cassée* as quite piquant and delightful. Another contemporary, also a woman, found *La Vertu chancelante* (Munich, by 1776) 'very affecting'; praise enough. Whatever praise may now be given to the so-called *Accordée de Village*, it is doubtful if it would be felt that 'le sujet est pathétique et l'on se sent gagné d'une émotion douce en le regardant', though such were Diderot's words when he saw it. The *Journal de Paris* reviewed in verse Greuze's work and urged him on:

> Poursuis, Greuze, poursuis, la faible humanité
> Pour le peintre du cœur te réclame et te nomme.

'Peintre du cœur' was Greuze's title to his period's interest. The heart, so clearly left untouched by Boucher and significantly not appealed to by Chardin, was to be virtually assaulted by Greuze. Although he did not create the taste for emotionalism, he ministered to it. It was an appetite which did not need to feed on contemporary subject matter either, but could find sufficient tearful nourishment in, for example, the *Sacrifice of Iphigenia*. Of Carle van Loo's composition of that subject Caylus had said: 'le spectateur n'en est frappé qu'après avoir versé des pleurs . . .'. If this might be said in praise of Van Loo's banal, unmoving work, it is clear that an audience already existed to enjoy the patent emotionalism of Greuze, so constantly conjuring us to feel – and only secondarily, if at all, concerned with what exactly we feel.

A new emphasis was increasingly placed on the value of feeling, as such. Artistically, this was shown by the century's concern with expressive physiognomy, typified by Hogarth and Lavater, as well as by Latour, and by Caylus' foundation at the Académie of a prize for 'expression'. A sufficient subject for a picture existed in a head which conveyed an emotion – and this did satisfy, to some extent, a new psychological interest. Yet

Greuze betrays his own tendencies by preferring girls' heads as his theme, perhaps believing, wrongly, that sensibility is a female prerogative. What is more, Greuze could convey emotion in a way which particularly appealed to the period, by giving it virtually literary expression: 'd'enchaîner des événements d'après lesquels il serait facile de faire un roman' was one of Diderot's most pertinent comments on Greuze, intended as praise. Some of Greuze's pictures are indeed modern novels in themselves, with every detail meant to be read, and he increasingly supported them by descriptive matter, usually published in the *Journal de Paris*. This literary tinge naturally appealed to a literate public – the readers not only of Rousseau and Voltaire but of Richardson (about whom Diderot wrote in the *Journal étranger* (1762) a glowing *Éloge*, praising his novels as different from those of previous writers because they touch the soul and breathe 'l'amour du bien'). To help the less literate or intelligent, Greuze actually composed his more ambitious pictures like theatrical tableaux.

All this confirms the existence of a wide public – very different from the small amateur circle who had appreciated Watteau. Not only did Greuze make the fullest possible use of the Salon exhibitions, but through engravings of his pictures he ensured that they remained familiar even when the original had passed into private ownership. In this use of engraving for dissemination of his important compositions he once again anticipated David.

There is one final important factor in Greuze's success. The parallel between his work and the novel – even more than the stage – is closest in the concern of each not merely to tell a story but to tell one which had never been told before. No other eighteenth-century French figure painter avoided conventional and familiar subject matter so completely as did Greuze. Chardin often reworks Dutch genre subjects, and the novelty of subject matter as such is never his aim. Apart from one early religious picture, a commissioned work, Greuze painted hardly any religious pictures – unlike Watteau, Boucher, Fragonard, and David. He rarely painted mythology, and his one history picture is of an obscure incident. His elaborate genre scenes are contemporary stories of his own devising; they require to be read the more carefully just because they do not derive from a known literary source, and they could make their effect without any of those odious comparisons likely to arise when what has been described in literature is illustrated by painting (cf. Diderot on Homer and Vien, p. 122). There was astuteness in Greuze's method, reversing the process by writing about what he had previously painted. Above all, he provided the public with what it has always enjoyed: pictures which tell stories simple enough to be deciphered, yet topical and fresh. The expressions, the gestures, the 'telling' detail, all help to make one forget one is confronting art; it becomes as actual and arresting as a street accident.

When a taste for different subject matter – more heroic, closer to the battlefield than the pavement – grew prevalent, Greuze naturally fell from favour. The faults of his actual painting were revealed; age increased them and time confirmed them. He had enjoyed a great measure of popular success, beginning with the burst of fame which came to the previously unknown painter at the Salon of 1755. His last years were like a dreadful lingering revenge taken by the public on its one-time favourite. In 1802 Farington

(*Diary*) glimpsed him in Paris; with unconscious cruelty he qualified the name with the words 'formerly an artist of very great reputation'. That year Greuze still exhibited at the Salon, no longer with éclat and indeed for the last time. Not until 1805 did he die.

Jean-Baptiste Greuze was born at Tournus in 1725. His father was a tiler and dealer in masonry who seems to have hoped at first that Greuze would become an architect. Recognizing however his son's gift for painting, he sent him to study at Lyon under the mediocre Grandon. Ambitious, confident of his talent, always childishly arrogant, Greuze must quickly have realized the need to go to Paris. It is not established exactly when he arrived, but he soon impressed some distinguished confrères, including the royal drawing master, Silvestre, and Pigalle (both of whose portraits he painted; shown at the Salons of 1755 and 1757 respectively). It is possible that he had begun at Lyon the *Père de famille expliquant la Bible* (Salon of 1755) which was bought by the well-known amateur La Live de Jully, who became a considerable collector of Greuze's work and was twice portrayed by him. To these useful acquaintances was soon to be added the Abbé Gougenot, a close friend of Pigalle's.

Greuze's obscurity ceased abruptly in 1755. A month or two after being *agréé*, he showed at the Salon a group of pictures, including the *Père de famille*, which La Live de Jully had already exhibited privately within his own circle. Critics, other artists, the public, all joined in praise of this new talent; it was probably the most brilliant début of the century, and perhaps the century took a first conscious revenge when fourteen years later Greuze's *Septime Sévère* was to be somewhat unfairly attacked, beginning with the Académie's snub in receiving him not as a history but merely as a genre painter. Meanwhile, in 1755, with success doubtless inflating his always abnormal vanity, Greuze went off to Italy with Gougenot, arriving in January 1756 in Rome, where he was welcomed by Natoire. Italy proved in fact to be of little significance in Greuze's art, though he recorded some picturesque costumes and painted one or two Italianate genre scenes. The most useful aspect of Greuze's visit to Italy is that it led to Marigny writing about him to Natoire. Thus we learn how highly regarded he already was by Marigny, who commissioned two pictures from him for Madame de Pompadour's apartment at Versailles; 'they will be seen by all the court', Marigny explained, though Greuze showed no haste to execute them.

In 1757 he returned to Paris and never travelled abroad again. Yet despite exhibiting a great deal, he did not capture public attention as successfully as he had done before, until at the 1761 Salon he showed *Un Mariage* (*l'instant où le père de l'Accordée délivre la dot à son gendre*) (Louvre) (Plate 153). With this he consolidated his fame, both contemporaneously and posthumously, because this picture remains the popular symbol of Greuze. Once again he had achieved success by depicting a family – and though much can and should be said against Greuze's typical numerous girls, it is noticeable how often in his major subject pictures he emphasizes the role of the father (that figure markedly absent from Chardin's genre scenes): a father explains the Bible, a father hands over his daughter's dowry – both duties with moral and social significance. It is of course a father who is involved in *Septime Sévère*. Indeed, the last picture Greuze ever exhibited was a *Père de famille remettant la charrue à son fils devant toute la famille* (Salon of 1802).

L'Accordée de Village, as it is now usually called, is in effect the *Oath of Horatii* for the middle years of the century. Even its ownership is typical; bought by Marigny himself, it was to be acquired at his death on behalf of Louis XVI by d'Angiviller, on the enthusiastic recommendation of Cochin and Pierre. It remains the essence of Greuze, compositionally as well as in other ways. His preferred setting is an interior, a shallow stage-like area, normally with one right-angled wall; the figures are assembled in a loosely-knit frieze across the composition, a tendency increasing in his later work. The emotional variations exploited by the subject are much greater than in the *Père expliquant la Bible*. Watteau had made the subject (cf. p. 18) a symbol of almost cosmic peace, with music and dance gratefully uniting humanity with nature – open-air nature of a tranquil village amid tufted trees. Greuze concentrates on human nature, excluding the natural world and simplifying the setting so as not to distract from the gamut of emotions expressed by the faces. Each figure expresses an individual reaction to the moment. Disunity in the family is prophesied, for the mother tearfully must part with her daughter, whose younger sister is also saddened, while her elder is sullenly envious. The tearful yet ineffective females contrast with the trio of men: the dignified father praising his daughter and exhorting his future son-in-law, a serious young man who receives girl, dowry, and exhortation, and the sly peasant notary who literally documents the occasion and reminds us that it is as much legal as domestic. In the very division between men who act and women who remain passive, it is perhaps not excessive to see some hint of the *Horatii*.

All this makes sense if Greuze, like David, looked back to Poussin for inspiration. Indeed, there can be little doubt that at least instinctively Greuze was painting comparable mixtures of emotion ('choses . . . qui ne déplairont pas à ceux qui les sçauront bien lire', as Poussin had written of his own *Gathering of the Manna*) before he turned to the frankly Poussin-style *Septime Sévère* (1769, Louvre) (Plate 154). What still needs clarification is Greuze's stylistic sources, an inevitably complicated matter since little is yet established about his earliest years. Although Italy played small part in his development, it is probably right to see an influence of Reni in his expressive heads. When he was in Rome he became aware perhaps of new neo-classical tendencies represented by Gavin Hamilton (whose work Natoire was to praise) and conceivably saw something of Subleyras' work. Back in Paris he seems to have come close temporarily to Chardin's handling of paint – seldom closer than in the fine *Écolier qui étudie sa leçon* (Edinburgh) (Plate 155) of 1757, which has the unforced sobriety of his best male portraits. There is considerable variety in Greuze's style, yet with a movement away from Chardinesque vigour towards smoother, even glossy handling of paint – especially when dealing with more upper-class milieux like those of *Le Tendre Ressouvenir* and *Une Jeune Fille qui a cassé son miroir* (London, Wallace Collection), both of 1763. Something of the same oscillation is apparent in Fragonard.

The step which took Greuze from modern family subject matter to the imperial Roman dissension between Septimus Severus and his son Caracalla was almost inevitable.[96] Jeaurat and Lépicié were both accepted as painters of history as well as of genre, and Greuze must have wished to be recognized as at least their equal. He chose an

obscure subject to illustrate, but it may well have seemed ideally chosen: historical and antique, it could also be seen as a variation on *le fils ingrat* or a *malédiction paternelle*. Varied emotions are at work too within it: from Caracalla's angry shame to the surprise of the chamberlain, Castor, at the emperor's recklessly heroic gesture which is at once a challenge and a rebuke. Feebler pictures were painted by Vien, and indeed by a whole generation of later neo-classical painters who escaped the censure given to Greuze by the Académie. The bas-relief composition and the dull colouring could be found in other pictures by Greuze; as he himself fairly remarked, why should he alone be judged by the standard of Poussin? It is difficult not to think that the picture's chief fault was its prematureness; ten years later it might well have sufficed to qualify Greuze as a history painter. Certainly there is some irony in the fact that it should have been so violently criticized in a climate which was imperceptibly changing and would soon warmly encourage this sort of stern, antique, semi-patriotic subject for pictures; and there is further irony in the fact that, when a genre painter took the step so often and widely urged – to ennoble his art – he was rebuffed.

The incident led Greuze to a quite different step, yet one in which he once more anticipates David. He broke with the Académie and never exhibited again at the Salon during the *ancien régime*. As David was to do, he made his studio his place of exhibition; there he received the Emperor Joseph II, Marie-Antoinette's brother, and there he exhibited his portrait of Franklin – both events made much of in the press. Greuze soon proved that press publicity was more valuable than the prestige of the Salon. His highest prices and greatest fame came in the years from 1769 onwards, until the arrival of David. But though his popularity declined, he remained active. He seems positively to have welcomed the Revolution, parading republican sentiments which should not be dismissed as just claptrap; rather, they may cast reflective light on the real similarity of his attitude to Rousseau's. He went on to paint portraits of the revolutionary leaders and stirring scenes of contemporary life – among them the *Death of Marat*. Favoured by the Bonaparte family, he was commissioned in 1804 to execute a portrait of the First Consul; in his long, remarkable career perhaps nothing makes a more suitably remarkable closing incident than that his last portrait should be of Napoleon (1804–5, Versailles), and that he should share the single posing session for it with the youthful Ingres.[97]

Doyen – Lagrénée the Elder – Deshays – Brenet

Not every painter-member of the Académie Royale deserves discussion, even if there were space here to do so. Diderot would pardon the omission of Noël Hallé (1711–81), succinctly characterized by him as 'pauvre homme, artiste médiocre'.[98] But it is useful to remember that, particularly in the middle years, the painters chiefly singled out by posterity lived and exhibited amid rivals and contemporaries who sometimes attracted – if only briefly – greater attention. The problem of dealing with these painters is the more acute because of the lack of stylistic coherence during the middle period of the century. Doyen scored a success in 1767 with *Le Miracle des Ardents* (Plate 156), which is one last robust homage to *Rubénisme*. It has often been pointed out that this commission for

Saint-Roch was painted and exhibited in the same year as Vien's *St Denis preaching* (Plate 128), an effective neo-classical exercise for the same church; it is less often realized that the latter project had originally been given to Deshays. Two years earlier Diderot had praised the elder Lagrénée, admittedly in terms which contain a significant reserve ('... tout, excepté la verve'), and Lagrénée's work now looks half-heartedly neo-classical, stylistically ticking over in a narrow lay-by on the road from Boucher to David. Deshays is something quite different: a painter widely recognized at the time as one of the highest hopes of French art, likely to stir it from its lethargy, but dead before he could establish his leadership. And Brenet was an uncommitted but successful figure of the day – a long day – who encountered hostile criticism only at the end of his career.

François-Gabriel Doyen (1726–1806), a Parisian pupil of Carle van Loo, responded to late Baroque Italian painting when he went to Italy in 1746, having won first prize at the Académie.[99] Unlike Greuze he ventured to visit Venice as well as Rome; his style was indeed formed by colourists – Giordano among them – and an explicit debt to Rubens is shown by his visiting Antwerp before painting *Le Miracle des Ardents*. The result marks the high point in Doyen's career, and the mingled influences bring it close, at least compositionally, to Tiepolo's late altarpieces. It is not quite clear whether Doyen should have proved the highest hope of French painting, a precursor of Romanticism perhaps; on the outbreak of the Revolution he became involved with the national museum project,[100] and in 1791 left France altogether for Russia. Although the effect of the *Miracle des Ardents*, a miracle invoked by St Geneviève, is somewhat confused, it has a sense of real drama otherwise largely lacking in French eighteenth-century religious pictures. The saint herself and the cloudy vision of the Virgin are remarkable enough, but perhaps most admired were the afflicted figures who writhe in the lowest portion of the composition.

Such almost Romantic realism was beyond Doyen's near-contemporary Louis-Jean-François Lagrénée (1725–1805), a more typical pupil of Van Loo, who also travelled to Russia but returned in 1763, after a three-year sojourn. Like Doyen, Lagrénée studied as a prize pupil in Rome, where he was to return in 1781 as Director of the French Academy.[101] Lagrénée's work shows the influence of Domenichino as well as Reni, and also unfortunately a prosaic quality derived directly from Van Loo. Although his subjects were increasingly of high antique virtue (drawn from Quintus Curtius, Valerius Maximus, and Plutarch), the paintings themselves convey no emotion and suggest no emotion. At best they contain competent studies of drapery, elegantly arranged even in situations where elegance is unlikely to have been the first consideration (cf. *La Fidélité d'un satrape de Darius*, Salon of 1787, now at Aurillac). If Doyen once approaches Tiepolo, Lagrénée often comes close – perhaps deliberately – to Batoni.

Jean-Baptiste Deshays (1721–65) was born at Rouen, the birthplace of one of his early masters, Restout.[102] He trained under a variety of painters, being most influenced by Restout and Boucher, whose daughter he married. Although he did not owe his success to Boucher, it is probable that Boucher facilitated his rapid rise to recognition. He won first prize at the Académie in 1751 and went to Italy three years later. His brilliance and vigour had been encouraged; on that foundation he built the elements of Baroque

design, studying the Carracci as well as Rubens, and – it may reasonably be assumed – Pietro da Cortona. In or around 1758 he returned to Paris and was *agréé* in 1759, exhibiting at the Salon for the first time that year.

Although Deshays was talented, it is not altogether easy now to understand why his work created the sensation that it did. By 1761 Diderot was calling him 'le premier peintre de la nation'. Other critics were equally appreciative. It is true that Deshays appeared at a moment of artistic lull, when the older men were growing noticeably older and there seemed a marked diminution of talent. More important was the category of picture which he concentrated on, the grand-scale machine, preferably with a dramatic subject: miracles, deaths, martyrdoms, for which he was perhaps better suited than for more conventional *galant* subjects. Doyen's later success with *Le Miracle des Ardents* shows that traditional religious subject matter, treated in a dramatic way, was widely acceptable. Deshays' *Martyrdom of St Andrew* (Rouen) (Plate 157), destined for a church of that saint at Rouen, achieved a positively sensational success at the Salon of 1759; two years later he exhibited another scene from the saint's life, an altarpiece which led Diderot to hail him with the words quoted above.

Yet it is hard to feel that stylistically Deshays was basically much of an innovator. His sketches may be superior to those of Detroy and Natoire, but they are otherwise very similar. His subject matter is usually different from that preferred by Boucher, yet one may think that in the 1730s Boucher could have produced a dramatically stirring altarpiece that might later have won Diderot's approval – if he had not known the author. Deshays' martyrdoms and deaths do not have the intensity – or the novelty – of Restout's *St Scholastica* (Plate 27). Deshays is perhaps to be classed among the last of Baroque exponents; certainly in handling paint he is nearer to Fragonard than to David. And the supposedly black year of 1765, which saw the death of Carle van Loo followed shortly by that of Deshays, was also to be the year of Fragonard's Salon début, when his vast *Corésus et Callirhoé* proved not only a defiant Baroque gesture but a triumph for the previously unknown painter.

Before Deshays' death there had appeared the apparently promising figure of Nicolas-Guy Brenet (1728–92), immediately praised at his first Salon showing of 1763 for the 'grande manière' revealed by a large-scale *Adoration of the Kings* (lost).[103] He worked hard, especially in his early period, pressed by the need for money ('Annulé par l'indigence', Diderot was to say crisply, if cruelly, four years later). Originally a pupil of Coypel and Boucher, Brenet seems to have been most significantly formed by his years at the École des élèves protégés under Van Loo. His was a style of academic realism, competent, often bold in chiaroscuro, certainly not Baroque but equally not neo-classical. Le Sueur, and perhaps Vouet, meant much more to him than Poussin. In some ways subject matter was more important than style to Brenet who – though he may reasonably be claimed as more robust than, for example, Vien – is basically interesting as a historical phenomenon.

Up to 1775 Brenet was associated particularly with religious pictures. On the appointment of d'Angiviller to the Bâtiments, Brenet largely renounced such subject matter for classical and modern historical themes. This new emphasis on the true history picture

clearly suited him and was encouraged by d'Angiviller to an extent which became publicly clear at the Salon of 1777 (see further on this point pp. 177–8). That year Brenet exhibited the earliest of his versions of the *Homage rendered to Du Guesclin* (Versailles) (Plate 158), one of the first medieval subjects commissioned 'pour le roi' by the new director-general. This deathbed scene, where the hero is honoured by his enemies (the English) and mourned by his own countrymen, combines affecting themes of humanity and patriotism in a way that aims to be historically accurate. Bayard and Henri II were other French historical characters to be painted by Brenet, in a style little different from that he used for Scipio and Roman heroes, but in each case with careful attention to costume and location. His pictures at the Salon of 1789, the last to which he contributed, were tersely criticized ('manque de noblesse') by the *Journal de Paris*, which – like nearly every other newspaper – was warm that year in praise of David. By then David had set an artistic standard which Brenet could not approach. Yet there is an element of stark pathos and grandeur in his concept of the *Du Guesclin* where the great general lies armoured but convincingly dead – a stiff figure with up-turned feet, prone on a high bed under the sombre hangings of his vast tent. It is romantic without being rhetorical, and is the more effective in the original version through the unexpected upright shape which enhances the tall lines of the tent and concentrates the composition on the corpse.

THE LATE YEARS

SCULPTURE: THE PERIOD OF HOUDON'S ANCIEN RÉGIME CAREER

Introduction

HOUDON, born in 1741, exhibited for the first time at the Salon of 1769 – showing there earlier, that is, than some of his senior fellow-sculptors. The last Salon to which he contributed was that of 1814. Thus his active career provides a convenient section of broader study, covering historically the most eventful years of post-Renaissance Europe; in his own sculpture can be traced the end of the *ancien régime*, the rise of new men, new policies, and of course the new, republican, world of America. It is easy to think of him as somehow a parallel to David, but he is perhaps better paralleled in Goya; like Goya, Houdon mirrors an international, not merely national, climate. Since he lived to see the Allies in Paris, it is almost surprising that he, who executed a bust of the Czar Alexander, never sculpted Wellington.

Houdon far outlived all the late-eighteenth-century French sculptors of any importance. His own career subsumes virtually the complete lifetime of Chaudet and the working life of Chinard – the two most robust and interesting sculptors to emerge on the artistic scene towards the end of the century. Well before Houdon's death, Rude (1784–1855) and David d'Angers (1785–1856) were engaged on their reliefs for the Arc de Triomphe; Barye was being employed under Fauconnier, the Duchesse de Berry's goldsmith; and in the year before Houdon died, Carpeaux was born. Indeed, Houdon's lifetime carries French sculpture so deep into the new century, itself born to unprecedented complexity compared with the calm of 1700, that he takes it beyond the scope of this volume.[1] But his own art was formed long before 1800, by which time he had in fact achieved much of his finest work.

The last quarter of the eighteenth century in France is marked by yearly knells of doom for the old political system, dying in public, and only too conscious of needing remedies.[2] Statesmen passed with bewildering speed. Summoned like doctors, they tinkered vainly with the body politic and then disappeared: Turgot, Necker, Calonne, and then Necker again. There was even a shadowy evocation of the great days of cardinal-ministers when the Cardinal de Brienne briefly appeared – with a revolutionary proposal to tax the privileged classes – between Calonne's fall and the return of Necker. The cardinal had to be dismissed by the king, who announced the summoning of the States-General. They met eventually at Versailles in May 1789. Thence onwards the Revolution – which came into existence almost officially with the Oath of the Tennis Court (20 June 1789) – can be charted by monthly, not yearly events. These succeeded

each other with hectic rapidity – as if the century had suddenly to make up for all those years of lethargy and apparent ease. The Republic, so dramatically established before the eyes of Europe, was itself not to survive the century, disappearing with it at the *coup d'état* of November 1799 which made Napoleon the master of France.

All that momentous history had touched sculptors as much as painters. If it did not produce a figure to rival the authority of David, it yet certainly inspired men like Jacques-Edme Dumont (1761–1844), who returned to Paris from Italy in 1793 and was soon active in giving sculptural expression to the new Republican ethos. Some of his work remained merely projected, but his plaster statue of *Liberty* (1795) was executed and set up.[3] Events could divide families in almost Roman fashion; the Deseine brothers were temperamentally split in their allegiance, and while the younger brother Claude-André offered his bust of Marat to the Convention in 1793, Louis-Pierre had proclaimed his sympathies by offering Marie-Antoinette in 1790 a bust done after nature of the dauphin. The steps in the rise of Napoleon are positively charted by the busts executed by Boizot, of him as General, as First Consul, and finally as Emperor. Napoleon's patronage lies outside this volume's scope, and in sculpture – with his preference for Canova – virtually outside France; but probably no one more effectively and economically depicted him as naturally divine and naturally imperial than Houdon (Plate 173). This arrogantly simple, classic mask of terracotta is of a man – but one who is master of the world. For all its positive execution in the nineteenth century, it marks an end rather than a beginning, both politically and artistically. It may legitimately find its place as the epilogue to a century which had opened with a different monarch and a different artistic style: the Coustou brothers' Baroque, which had been specifically approved by Louis XIV.

The problem years of the century, artistically, lay in the period which immediately preceded the Revolution: that rather fatigued *ancien régime* conducted during the reign of Louis XVI. During that period the greatest new sculptural talent was clearly Houdon's, but official patronage of him was very slight. His visit to America was made in much the same circumstances as Falconet's to Russia; he believed he would get the opportunity to create an equestrian statue – a monument of the type he was not commissioned to produce in France. Even in that he was, unlike Falconet, disappointed. No doubt his career in Paris was checked through the presence of Pajou, who retained under Louis XVI the favour shown him by Madame du Barry. But the lack of interest in Houdon is itself an indication of the somewhat insipid nature of patronage during Louis XVI's reign and of the resulting insipidity and uncertainty of style – so well conveyed by the work of Pajou himself. This is not entirely, and perhaps not at all, a question of the rise of neo-classicism. Before Chaudet there was no French neo-classical sculptor – unless Bouchardon during the first half of the century.

Apart from Houdon, and leaving aside Clodion, the sculptors emerging in Louis XVI's reign were largely lacking in artistic vitality and in clear-cut adherence to any particular style. Their strongest trait was itself negative: an avoidance of the Baroque. The masterpiece in this 'styleless style', where repose and grace were the most positive qualities, was created not by Pajou but by Julien, whose seated *Girl tending a Goat*

(Plate 165) perfectly expresses the aims of a basically aimless period. It was an official royal commission, an immediate popular success, decorative as well as decorous (an important point in a prudish climate which excluded Houdon's naked *Diana* from the Salon),[4] the sculptural equivalent to a picture by Vien.

A sort of lassitude lay over the arts, at least in sculpture and painting. New idioms and new inspirations were needed – and hence, incidentally, the sense almost of relief at the arrival of David. But in sculpture there was to be nothing comparable to the *Oath of the Horatii*, and of course no sculptor to assume the prestige and power of David. Houdon is not in any way David's equivalent: he had nothing of the rebel and little even of the innovator in his nature. Although his career was to confirm that a sculptor – as Clodion's career suggested – need not depend for fame or commissions on the official and established forces of patronage, Houdon himself had no urge to opt out of the *ancien régime* system. It must always be remembered that his ambition was not at all to become a *bustier*; circumstances made him one, and in doing so they uncovered the real nature of his unimaginative, essentially uninventive, talent. In that lack of imagination perhaps Houdon shared something of the enervating atmosphere of the arts under Louis XVI.

The king himself is hardly to blame, although it is true that he had virtually no interest in the arts. The enervating mood originated in the last years of Louis XV's reign; Diderot, reporting on the state of painting at the Salon of 1767, had already prophesied gloomily 'Je crois que l'École a beaucoup déchu, et qu'elle déchéra davantage.'[5] It was to combat such a general feeling, and to stir France out of political as well as artistic decrepitude, that the scheme of the 'grands hommes' was conceived under d'Angiviller, appointed Directeur Général des Bâtiments in 1774, the years of Louis XVI's accession. The basis of d'Angiviller's scheme was historical, rational, and patriotic.[6] The Louvre should become a huge public museum – a notion that had long been aired – and among the objects in it would be a series of lifesize statues of the great men of France: writers, astronomers, philosophers, and artists, as well as the inevitable soldiers and statesmen. It is only one of several ironies surrounding the late years of the century that the Revolution should have precipitated the museum's existence. Under Napoleon and Louis-Philippe the scheme was in fact to continue. Yet the 'grands hommes' have never been assembled together anywhere, and are today divided into three major portions, two of them located somewhat inaccessibly for the public.

The individual statues are naturally very varied in quality, though not always in the way that might be expected. Houdon's windblown *Tourville* (1780–1, Versailles) is faintly absurd and undoubtedly his least successful large-scale work,[7] while Clodion's *Montesquieu* (1778–83, Versailles) is a surprisingly accomplished and impressive monumental achievement. The stylistic shifts in the series are not connected just with individual sculptors' merits but reveal the same oscillation apparent elsewhere in work produced during Louis XVI's reign and the basic lack of a dominant sculptural idom. But the overall significance of d'Angiviller's scheme is unmistakable. First it substitutes interior for exterior location – and an interior neither religious nor royal but public and fully national. The sculptors were employed not on decoration, nor on subjects of mythology, but on those of national history, 'propres à ranimer la vertu et les sentiments

patriotiques'. This is a tacit admission that such feelings have sunk to a state requiring re-animation. There is a subtle avoidance of too patently monarchical themes: no evocation of the misty past of Clovis and the Frankish kings. And even when a soldier was selected, it was not simply his military achievement which gained him his place. Writing to Pierre in 1779 about the choice of subjects for statues to be ready for the Salon of 1781, d'Angiviller stated that he had the king's approval for four new figures, including the Maréchal de Catinat: 'un général de terre non moins recommandable par ses talents militaires que par son désintéressement, son humanité et son esprit philoso-phique'.[8] In that phrase there is a Voltairian echo, an optimistic belief in reasonable standards which events were soon ruthlessly to destroy. France was not going to be saved by d'Angiviller's scheme for its 'grands hommes' to be sculpted in marble, and what humane and philosophic sentiments had not achieved was to be gained by force.

The 'grands hommes' scheme was the last, the most elaborate, and perhaps the most intelligent act of *ancien régime* patronage. It made explicit ideas which may reasonably be said to be detectable, however faintly, in the mid 1730s under Orry. Its fault lay in being too consciously an effort made against an existing climate and standards; and as a result it became somewhat boring, for the sculptors one may guess as well as for the ordinary public. The most percipient comment on it came as its epitaph, provided by d'Angiviller himself, who wrote in 1790 that he had attempted to give purpose and direction to the arts, of both painting and sculpture, at a period when the category of historical work was being replaced by the inferior genres of portraiture and landscape, and when there were few decorative commissions available to artists. To some extent d'Angiviller recognized that he had failed – at least that he had not totally succeeded; and one may sympathize with his position, between a largely apathetic court and artists who were not always as eager as he thought they should be to execute his elevated com-missions. Clodion, Pajou, Houdon, Julien, were basically much better employed in other directions; after all, they were artists not moral regenerators. When the Revolution came it would have its own heroes, before it learnt that there was only one hero, a single living 'grand homme' who was enshrined in the public museum when – swollen with his spoils – it became the Musée Napoléon.

Clodion

Artistically the most attractive sculptor of the later years was not the officially approved Pajou, nor Houdon, but the much more elusive Clodion. And although it is necessary not to exaggerate Clodion's role – for he received full academic training in Paris and at Rome, several large-scale commissions, and a great deal of praise – it remains true that he stands for private art and triumphant liberation of the artist in the same way as does Fragonard. They have more than that in common, but historically it is this emancipa-tion – a last grace-note of *douceur de vivre* – that gives them their importance; aestheti-cally, of course, they have it by sheer stature. The very fact that neither fits into any postulated artistic pattern is an indication of originality. About both their lives remark-ably little is known; their personalities remain quite obscure, and gradually the two

artists retreat from the official stage of the Salon into private commissions and un-exhibited work – which deepens their obscurity. By an irony, it is during the Revolution and the years immediately following that their careers emerge into the open again. But their best work was done; it seems no more relevant that Clodion contributed to the decoration of the Vendôme Column than that Fragonard became a sort of republican party official.

Clodion's emancipation is in marked contrast to the Adam milieu from which he came, with its anxiety for respectable, royal commissions and its eagerness to execute large-scale fountains and monuments. Yet it is reasonable to think that he had an innate affinity with the decorative principles of their work, sharing the same emphasis on excitement and movement, and the same preference for not too serious, mythological subject matter. Even less than the Adam did he concern himself with portrait busts; and, like them, his decorative powers were best expressed in a medium other than marble. Although the life-size *Montesquieu* is by itself sufficient indication of Clodion's ability to handle marble, his name is rightly associated forever with terracotta – the medium whose potentialities for small-scale decorative works had first been fully revealed by Le Lorrain. Nothing helps more to make apparent how different was Clodion's aim from Falconet's than their different media: the chilled white figurines of Falconet inhabit an arctic climate of frozen gesture and northern pudicity compared with the warm-coloured, sun-baked, dancing fauns and delirious nymphs whom Clodion sets in recklessly erotic motion.

Claude Michel, always to be known as Clodion, was born at Nancy in 1738, tenth child of a family that was to produce several other sculptor sons. His father was some sort of humble trader, and it proved of more significance that his mother, Anne Adam, was the sister of the Adam brothers; under Lambert-Sigisbert Clodion received his first training, leaving Nancy for Paris and entering his uncle's studio about 1755. These were not very fortunate years for the elder Adam, who had ceased to exhibit at the Salon and was anxious only to receive the sums due to him for several works, including the *Abundance* which may well have been completed by Clodion after his death. At Adam's death Clodion entered Pigalle's studio for a brief period in 1759; he won first prize for sculpture at the Académie in the same year and then entered the École des élèves protégés. After three years there he received his *brevet* as a pensioner at the French Academy in Rome (a document which is, perhaps significantly, silent about his training before Pigalle). He reached Rome on Christmas Day 1762 and did not return to France until the spring of 1771.

As for so many other French sculptors, Rome proved the decisive experience for Clodion – not only the Rome of ancient and modern monuments but that of connoisseurs and collectors. It was there that his uncle Lambert-Sigisbert had won the competition for the Trevi fountain. Clodion sought no public work but was himself sought out. His biographer and friend Dingé was to write of these Roman years that 'his products were bought even before they were finished'.[9] Success brought commissions and offers from beyond Rome; by 1767 Jullienne owned at least two terracotta statuettes by him, and other French collectors – including Boucher – acquired work by him during these

years. Catherine the Great tried to draw him to Russia, probably about 1766 and perhaps before Falconet's arrival at St Petersburg. Whether or not Clodion was tempted, he did not yield. Always somewhat apart from his fellows, whether pupils or mature artists, he was ideally placed in Rome: almost like another Poussin, 'en quelque petits coings . . . à son aise', with a supply of patrons and close to the sources of his art. A comparison with Poussin may seem shockingly ludicrous, but only if the gaiety of some of Poussin's paintings, and the severity of some of Clodion's statues, is missed. And whatever Clodion made of his inspiration, there can be no doubt that it sprang from a vision of classical Antiquity.

This was not in general the accepted academic concept of nobility and dignity – though Clodion could achieve both when required – but a sense of countrified, quite literally *pagan* manners: closer to the Campagna than to the city, expressing a golden age of liberty when wine and love were mankind's only concerns. With him this becomes a single theme, symbolized by the rhythm of the dance, sometimes graceful and enchanted, sometimes rude to the point of rape. Throughout there is a mood of escape which deepens to romantic intensity:

> What maidens loth?
> What mad pursuit? What struggle to escape?
> What pipes and timbrels? what wild ecstasy?

Keats's 'Grecian Urn' was probably conflated from more than one work of art, including Claude's paintings, as well as engravings of vases; and Clodion's classical world was probably derived equally from similarly multiple sources, with some glances at the nymphs and satyrs of, for example, Lauri's pictures. His dancing, chasing, usually Bacchic, people are probably directly inspired by antique vases rather than by figurative sculpture. As for the material of terracotta, it is tempting to see more than coincidence in his being in Rome – as was the young Nollekens – at a period when groups of antique terracottas were being discovered there. We know how much these struck Nollekens, who essayed some terracotta models of his own;[10] and the mention of Cipriani admiring the original antique terracottas is a further hint, sentimental though his nymphs and children are in comparison with those of Clodion.

Clodion's golden age is naturally when the world was young; not only do his subjects tend again and again to treat, or include, children, but a childish air is part of the charm of his nymphs, so much fresher and yet more truly abandoned than the girls of the *Parc aux Cerfs*. His vision is one more testimony to humanity's belief in the rejuvenating, liberating property of the countryside. A tambourine and a bunch of grapes are all we need, apart from a companion in love. And perhaps the final effectiveness of his work comes from the basic truth of his vision; as much as Watteau he speaks quite seriously, for all his gaiety, of passion.

It is probable that his first essays at Rome were terracotta figures, on the miniature scale he was to make so much his own, but single ones. Some were reductions or pastiches of classical statues: vestals, veiled priestesses at their rites, which were in antique taste, with conscious classical purity of line. His vases were similar in style; that in the Mariette

sale of 1775 typically showed children playing, and the commendation given to the sculptor neatly sums up what appealed to the period: 'Il règne dans les ouvrages de ce jeune artiste une correction de dessin supérieure et une touche pleine de feu et d'esprit.'[11] Just so might someone have greeted the early work of the young Bouchardon. But where Bouchardon was to sacrifice fire for correctness, Clodion was to preserve, and even intensify, the energy which was soon animating not merely single figures but complete groups.

Once he had established his style it was to evolve very little in the years of his popularity extending up to the Revolution. Immediately recognizable and immediately appealing, his work managed to remain marvellously inventive. Whatever variations of scale and treatment he was capable of, it is in the small terracotta groups that his energy and delicacy and variety are best displayed. Sometimes chasing each other, sometimes embracing, often accompanied – if not positively urged on – by a mischievous child, these groups of men and women, or satyrs and nymphs, seem like graceful opposing forces from whom a spark is always struck. Even when not actually in contact, their bodies seem to betray on their sensuous surfaces awareness of each other's sex. Man is often the satyr, a little grotesque, a little clumsy, but only to set off the piquant contrast of some slim, naked nymph (Plate 159), herself by no means repelled by a rustic lover. Clodion can hardly help putting them in action; and it is here that the groups have an advantage over even his most attractive single figures. Sometimes it is violent impetuosity that hurls the bodies along, with flying hair and breathless faces; but at other times the tempo is gentle, even wistful (Plate 160): the figures are an enchanted, eternally youthful, family moving amid the scattered grapes, coming as if from some *vendange*, sated with autumnal fullness.

When the sculptor left Rome in 1771 he returned to Paris already successful and well-known. He had established his own category of sculpture and had no need to fear or envy Caffiéri or Pajou or Houdon (who had been in Rome for part of the same period). Clodion settled down to become almost a factory, his work being duplicated in porcelain and bronze, and his studio busy with the sedulous ape activities of his brothers.[12] He exhibited at the Salon for the first time only in 1773, having been *agréé* earlier that year. Neither then nor at his rare later appearances did he, however, show any of his most brilliant terracotta groups. It seems that, at least in 1773, he was eager to emphasize the range of his talents; there was a small marble of a child satyr with an owl, vases, and graceful bas reliefs, but also a *Hercules*, a *Rhine*, and a *Jupiter* in plaster which was presumably the model for Clodion's never produced *morceau de réception*. These indicate the sculptor's ambition to be serious, even severe, proclaiming that he was not only the master of graceful, miniature groups but capable of tackling a large-scale, elevated commission.

That one of these now came his way was owing partly to changing circumstances. When the Salon of 1773 opened, Marigny (become Marquis de Ménars) had resigned and been replaced as Directeur des Bâtiments by Terray – who commissioned the group of *Music and Poetry* (Washington) from Clodion. If that was close in concept to Clodion's previous work, the commission from the cathedral authorities at Rouen for a *St Cecilia*

(1775-7) was more unexpected and the result not particularly remarkable except as showing that Clodion had studied Bernini and Algardi (notably the *St Mary Magdalen* in San Silvestro al Quirinale). In late 1773-1774 Clodion was briefly back in Italy[13] – officially occupied with selecting the marble for this statue at Carrara and also some blocks for the Bâtiments – and it is likely that he looked with care at the achievements of the great Roman Baroque sculptors, already engaged as he was to Rouen to execute his first large-scale religious figure.

When he returned to Paris it was to a new king and a new Directeur des Bâtiments. The immediate result of d'Angiviller's appointment was of course the initiation of the scheme of the great men of France – nearly all chosen from the seventeenth century. It was perhaps Clodion's fortune that when one of these commands was assigned to him in 1778, he received that for the most recent personage in the series, Montesquieu (d. 1755). Modern costume must have seemed wrong for an image of the philosopher, and Clodion seems to have sought the solution attempted by Pigalle's *Voltaire*, absolute or virtual nudity. The plaster model appeared at the Salon of 1779, the same year as Houdon showed his bronze of *Voltaire seated* and his bust of Voltaire 'drapé à la manière des Anciens'. It would be easy to say how typical of the late years of the century were the solutions of Clodion and Houdon – but, if so, they were undoubtedly precipitate. Truth was valued, somewhat naively valued, before any homage to classicizing ideals.[14] Both sculptors were at once strongly criticized in almost identical terms. Houdon seems to have been unaffected, but Clodion was working for the Crown; he took the critics' advice and for the final statue of 1783 produced the *Montesquieu* (Plate 162), clad in the dignified, faintly ecclesiastical costume of *président à mortier* in the *parlement* of Bordeaux.

For some reason, the seated statues in the great men series are more successful than the standing figures, but among them all Clodion's is the finest achievement. It is not so much rivalled by Houdon's *Voltaire* (Plate 174) as conceived in absolutely opposite terms: as patent as the opposition of Slodtz' *St Bruno* to Houdon's – and *Montesquieu* has indeed some Slodtzian echoes. In the *Voltaire* Houdon concentrates mobility on the face and for the rest gives permanence to the seated figure with its few simple folds of heavy drapery: a literally statuesque pose which expresses pride and senility – for there is a sense of Voltaire impotent to move, physically petrified for all the marvellous mental alertness.

Clodion had to be content with recording Montesquieu's features in a rather fixed mask of shrewd thought, abstracted and far-gazing. But for the pose he chose an animated, cross-legged position which, in conjunction with the multifarious folds of drapery, gives a swinging instantaneous effect and a positively Caffiéri-like sparkle to the creased surfaces of the costume. With Houdon, everything is compact. The statue is still haunted by the dimensions of the cube from which it was carved, and it remains very consciously a cube. It is static, timeless, its power held within it as essentially as the will-power which kept its sitter alive. Clodion, with no living sitter to inspire him, gave his own artistic vitality to the challenging figure, seized at a moment, with hands – and even the foot – as if in action. All this is accompanied by tremendous surface animation,

which yet manages not to be distracting despite the details of unbuttoned gown, creased and folded-up cape, fringed tablecloth, and so on. The robes cascade over the chair and nothing seems to keep a completely contained shape: the tablecloth is disarranged, the leaves of the book bent. All the proportions seem emotionally dictated, fluid, elongated, spilling out of one plane into the next; but the final effect is commanding, largely owing to the proud pose of the head. There is nothing intimate in the statue. Julien seems to have directly borrowed its cross-legged pose for his statue of *La Fontaine* in the same series (the plaster model appearing at the Salon of 1783, where Clodion exhibited his finished marble), but he used it to suggest a relaxed mood. The *Montesquieu* is much sharper and more formal; as well as of the philosopher, we are reminded of the patrician.

It was a deserved success, and the only surprising thing is that Clodion did not receive the commission for another great man; he had to wait until in 1810 Denon requested from him a statue of General Lacoste which was never executed. The *Montesquieu* remains the most obvious proof of Clodion's abilities as a sculptor in marble and on a large scale. Further indications of his moving beyond the restrictions of the small terracotta group are the bas reliefs and other decorations which he contributed to several interiors and exteriors: from the caryatids supporting the chimneypiece in Madame de Sérilly's boudoir (Victoria and Albert Museum) to the bas reliefs originally on the façade of the Capucin Convent (Metropolitan Museum) designed by Brongniart in the Rue Saint-Honoré, and the complete bathroom décor for Besenval's hôtel. He thought it worth while to submit two models to the competition which d'Angiviller devised, and then lost interest in, for a monument to the famous balloon ascent from the Tuileries Gardens in 1783. One of these (1784–5, Metropolitan Museum) (Plate 161) might well have been designed by Fragonard and represents the last, light-hearted extreme of an enchanted world: countless rioting putti toil and play about the balloon itself, tumble around the plinth from which it rises, decorate and distract from it, blinding science by their presence. The Montgolfier brothers are forgotten (though recalled by a medallion on Clodion's other design) and it is love that fires the balloon – as it had fired so much eighteenth-century art.[15]

Perhaps not surprisingly, Clodion was not among the four sculptors d'Angiviller singled out to submit further models. Like Fragonard, and in some ways like the Guardi, Clodion represents the extreme dissolution of a style. Beyond him there was only imitation or reaction. It is not just Goncourt-ism to see the *Balloon Monument* as a farewell to the graces of the century, disappearing from the scene in a confused flutter of wings and ribbons and babies' bottoms. After the Salon of 1783 Clodion did not exhibit there again until 1800 – and then with a group in a new manner. Clear warning had been issued by an anonymous critic at the Salon of 1793: 'En effet, les allégories de l'amour, les portraits des courtisans . . . nous intéresseront fort peu désormais.'[16] Clodion, who had retired for part of the Revolution to his native Nancy, returned to Paris and amazed everyone by the heroic, grim, and pathetic group of *The Deluge*, which showed a Géricault-like tableau of a dead woman and a struggling father carrying the exhausted body of his son. Thus, unlike Fragonard or Greuze, Clodion was able to adapt to the new

climate of ideas;[17] *The Deluge* was an instant success and led to several state commissions. He took his place with such sculptors as Chaudet, twenty-five years his junior.

Clodion died on 28 March 1814, less than a month before Napoleon's abdication. He had outlived his brothers, who had continued for so long to pastiche his style; one of them had even borrowed his name. One pupil survived to carry his style further into the nineteenth century: Joseph Marin (1759–1834), whose terracottas at their best come very close to Clodion.[18] Marin had embittered his master's life by carrying off his illegitimate daughter and increasing the isolation of the sculptor – long divorced from Flore Pajou. But Marin figures as one of the beneficiaries in Clodion's will.

The inventory of possessions at Clodion's death reminds one of where his real affinities and achievements lay: with pictures by Boucher, a drawing by Fragonard, plaster models of Pigalle's *Venus* and the famous *Mercury*. It is not that he was a typically boudoir artist, serving fashion and being just decorative. His god was nature, encountered in gardens and fields, figured often as Priapus or Pan. This naturalism shows perhaps most clearly in his terracotta models of animals (Plate 163),[19] but he is aware too of how much man remains an animal – with no sense of shame in it. Clodion is as indifferent to topicality as to costume. His interest in Antiquity is *au fond* liberty of spirit; his religion is the need for love. Though so little is known of his life and personality, he expresses the artist's freedom in abstention from the Académie (never becoming a full member), in his delight in the imagination, and even in his apparently confused amours. Certainly he belongs in the eighteenth century – if only through his grace and wit – but in many ways he anticipates the following one.

Julien

Apart from the obvious exceptions, a cluster of not very dazzling talents represents the new generation of sculptors active largely in Louis XVI's reign and destined to survive the century. Probably the least significant, though he would have been surprised to hear it, was Mouchy, who barely reached the new age, dying in 1801. Several other sculptors are remarkable for some single piece rather than for profoundly important or interesting careers; thus Jean-Baptiste Stouf (1742–1826) lingers in the memory for the *Abel mort* (Louvre), suitably etiolated and collapsed, his *morceau de réception*, dated 1785, which is perhaps the last piece to be presented under the *ancien régime* to the Académie.

The oldest and most talented of these men was Pierre Julien (1731–1804), for various reasons slow to appear on the official Parisian scene, but the one who best embodies the chaste insipidity of the Louis XVI style. Julien was born in provincial obscurity in the small town of Saint-Paulien in the environs of Le Puy. There he is said to have been employed as a boy watching flocks, and that certainly provides a satisfactory background for the sculptor of the *Girl tending a Goat*, though she has long been removed from any rustic reality. One of Julien's uncles, a Jesuit, remarked his ability and had him apprenticed to a sculptor-gilder at Le Puy, in a studio concerned with the production of wooden religious statues for local consumption. From that he moved to Lyon, where he worked

under Antoine-Michel Perrache (1726–79). Probably in 1758 Perrache sent him to Paris, with a recommendation to the younger Guillaume Coustou. In 1765 Julien won first prize at the Académie and then spent three years at the École des élèves protégés before setting out for Rome in 1768.

For the formation of Julien, and for his presumed orientation towards classical Antiquity, some claim has been made about the influence of Dandré-Bardon, professor of history at the École. It is true that Dandré-Bardon lectured on classical subject matter and had views on the uses of mythology and allegory, but, like his paintings, his written works show him quite uncommitted, able to praise Pietro da Cortona or Bernini as fairly as some antique artist. Like Dandré-Bardon, Julien was to be unengaged, affected more by the pressure of fashion than his own instinct. When he executed his first statue for the series of 'grands hommes', the *La Fontaine*, he showed the writer in complete seventeenth-century costume; the plaster model for that statue was executed in 1783. By the time he came to execute his second commission for this series, the *Poussin* (Louvre), of which the model was done in 1789, classical-style costume and poses had grown much more fashionable. Julien managed to drape the painter in a sort of nightgown-toga, with folds falling to expose one bare knee: a conscious piece of antique homage which the figure's statuesque pose emphasized. It was Clodion, much more truly in touch with the sources of Antiquity, who had envisaged classical costume when first trying to depict Montesquieu as a Roman philosopher – only to be severely criticized for so doing. No adverse criticism, however, seems to have been made of Moitte's semi-classically costumed, Roman-style, *Cassini*, the model of which was shown at the Salon of 1789; in ten years taste had come to accept what had earlier seemed an affectation – though there was a precedent for it in Pajou's classically draped *Buffon*. The distinctly different climate at the end of the century was best, if most ludicrously, summed up in Stouf's nearly naked *Montaigne*: 'depouillé des habits de son siècle', as the Salon *livret* of 1800 explained, going on to emphasize that nudity was a state that had been consecrated by the Greeks and Romans in their masterpieces.

There is no evidence of Julien being markedly orientated towards neo-classicism of this programmatic kind. However, it is likely that a tendency to simplicity was implanted in him by his work under Coustou – himself already tending to the 'correct' and flavourless. Coustou is the more likely to have given direction to Julien, since Julien returned from Rome in 1773 to work further under him for the next few years. At this date Coustou was engaged on the major task of the monument to the dauphin, on which Julien probably assisted him. It has even been suggested that Julien was the actual sculptor of the figure of Conjugal Love, the most striking portion of the monument. There are similarities between this figure and Julien's *Ganymede* (Louvre), the model for which was presented to the Académie in 1776, the year before the Sens monument was completed. But the position is complicated by the existence of a *Ganymede* by Coustou (Victoria and Albert Museum), a much more truly classical piece than Julien's, though less delicate, now somewhat weathered, and probably always less highly finished. Indeed, it is partly the picturesque elaboration of Julien's statue – with its obtrusively detailed Wedgwood-style jug, its pudgy cloud and huge eagle – that makes it so clearly

of its period. Coustou's is closer to antique prototypes, in pose and execution (the treatment of the hair in both statues is worth comparing).

It is conceivable that the existence of Coustou's statue was the explanation of why Julien met with an unexpected rebuff from the Académie. Sculptor and model were both rejected in 1776, for reasons not made explicit.[20] But it is worth noting that Coustou was at that date rector of the Académie. Julien seems to have been utterly disheartened by his rejection: he contemplated retiring in dudgeon to Rochefort, where there was a demand for carvers of ships' prows. This extreme step was avoided. Julien recovered his spirits and was soon successfully set on his career. He became *agréé* on presenting the *Dying Gladiator* in 1779 (Louvre) and also received the commission to execute his *Ganymede* in marble for the Baron de Juis, a Lyonnais who became his staunch patron and supporter. At the Salon of 1779 the *Gladiator*, so much more brusque and tough a subject than the *Ganymede*, was highly praised; exception was taken only to the gladiator's hands, which were shrewdly noticed to be sculpted with perhaps 'trop de délicatesse'.[21] And that quality – of sentiment and handling – remained typical of Julien.

He seems never to have executed any portrait busts or monumental groups. Even in the *La Fontaine* (Plate 164) he scarcely attempted to produce accurate portraiture but concentrated on a lively, perhaps suitably anecdotal, effect, with a generalized shrewdness and vivacity in the subject's features. Julien's delicacy of handling is apparent not only in the somewhat over-detailed treatment of the hair but also in the frieze of bas reliefs, illustrating scenes from the fables, which decorate the pedestal. The fables are yet more patently present in the slightly porcine fox, with one paw on a book, which creeps out from La Fontaine's cloak and peers up at him.

D'Angiviller constantly wrote of wanting the subjects chosen for the 'grands hommes' to suit, as far as possible, the nature of each sculptor's talents. Julien's certainly made him a more suitable sculptor of La Fontaine than of, for example, Turenne. In the Salon of 1783 Julien's model was found the best of the four exhibited, the others being Pajou's *Turenne*, Caffiéri's *Molière*, and *Vauban* by Charles-Antoine Bridan (1730–1805), creator of the exuberantly Baroque decoration unexpectedly located in the choir at Chartres.[22]

Perhaps the subject offered Julien the necessary excuse; altogether his statue is the first, and probably the last, of the whole series that is relaxed and even playful in its effect. A writer's life seldom has many of those significant moments of decisive action that could be grasped in depicting a great general; nor could La Fontaine be given the authoritative pose justified for a writer such as Descartes. Julien's 'moment of action' is not, significantly, a moment at all (despite the Salon *livret*'s mention of his seizing 'ce moment'), for it depicts La Fontaine dreaming in an attitude he had held throughout a day's work and thought. The statue's mood is disarming, charming, and natural. Its mood is carried over, even to the inclusion of a pet animal, in what was probably always the sculptor's most famous work: the *Girl tending a Goat* (1786–7, Louvre) (Plate 165), originally the centrepiece of a decorative scheme in Marie-Antoinette's dairy at Rambouillet.

This pavilion was planned by the king as a present for the queen, and designed by Thévenin, on the ideas of Hubert Robert (cf. p. 335). The finished building and its interior decoration seen by the court in July 1787, when it was warmly approved.[23] Although the arrangement is not entirely clear, the scheme was simple enough: the decoration, with two bas reliefs and four medallions, of a room shaped at one end into a rocky grotto, where Julien's girl or nymph was seated with her goat. The two large bas reliefs do not apparently survive, but their subjects alone hint at a changed climate since Madame de Pompadour had commissioned statues for her dairy at Crécy. For her Boucher had designed gracefully natural girls, occupied not too seriously with churns and eggs. That particular note, a mingling almost of rouge and rusticity, would have sounded too heartless and even flippant to the ears of d'Angiviller. The Rambouillet dairy was spiced instead with classical learning: to their country themes the bas reliefs added Antiquity, illustrating the *Nurture of Jupiter* and *Apollo with the Herds of Admetus*. The pedestal of the La Fontaine statue already offered evidence of Julien's ability to handle the bas relief, but at Rambouillet he was assisted on the one pair by Louis Foucou (1739–1815), whose intervention there was sufficient for him to beg the commission for a 'grand homme'; and in the same year, 1787, he received the command to sculpt a *Du Guesclin* (Versailles), producing a romantic, fully troubadour-style image. Foucou was not Julien's only assistant at Rambouillet, for he seems to have also sought the services of Claude Dejoux (1732–1816), probably on the other bas relief.

The reason for this assistance lay probably in Julien's uncertain state of health. He had received the Rambouillet commission while resting at Lyon in 1785, recovering from illness, and though he returned to Paris the following year to start work on the task, he may well have been pressed to complete it by a stipulated time. Having placed subsidiary portions of the scheme in the hands of Foucou and Dejoux, Julien would have been free to concentrate on the major centrepiece, the lifesize *Girl*, which is a fully modelled statue. Along with Pajou's *Psyche*, she presides over the Louis XVI style in sculpture. More decorous than the *Psyche*, she is altogether a more successful piece of work by her very limpidity and lack of drama; she simply sits on a rock, holding her goat's tether in one hand and clasping drapery to her bosom with the other. The modelling of face and hair, the texture of the goat's coat, and the flat, leather-like reins that hold it, are all delicately observed without too obtrusive effect. The statue is natural by the standards of the new style: it is consciously simple, quite un-Baroque, and quite unerotic (far removed from Clodion's contemporary terracottas). Chastity, stillness, a grace of drapery and purity of profile: such are its qualities, none of them carried to an extreme and all governed by the overall wish to charm. It may be doubted if this can be called true neo-classicism, but it might be accepted as neo-Pompeian. Nor need one be surprised that Julien was unable to stamp his work with any very dominant stylistic traits. Even a much more vital and inspiring figure like Chinard was to oscillate between nature and the antique, never quite settling to practise permanently the neo-classicism expected of him. Julien's artistic world was not one of glory, military necessity, patriotism, and duty; it was the last sigh of the *ancien régime*, and, rather like Marie-Antoinette's plain white dresses, very much a matter of fashionable simplicity.

Mouchy, Boizot, the Deseine – Moitte

Oscillation between a training which emphasized nature and an environment increasingly preoccupied by the antique is the typical movement of lesser sculptors towards the end of the century. More than one had been the pupil of Pigalle, but no other was quite such a sedulous ape as Louis-Philippe Mouchy (1734–1801), Pigalle's nephew by marriage.[24] His career was really one long homage to the great man's style. *Agréé* in 1766, he became an academician two years later with his reception piece, *Un berger qui se repose* (Louvre) – itself noted at the time as being close in style to Pigalle's *Mercury*. Only Pajou received more commands than Mouchy for the 'grands hommes' series, and he seems to have had the special favour of d'Angiviller. Costume of the seventeenth century and a general air of realism suited him better than any pretensions to classical style, and his closest essay in a neo-classical manner was in fact to execute a copy of Bouchardon's *Cupid*.

Mouchy's own antique deity, *Harpocrates* (Luxembourg), was significantly to be criticized as being designed on Pigalle's system 'sans oser rien rectifier à la nature'. This rather feeble seated figure was a commission pressed on d'Angiviller by the sculptor himself, 'maintenant peu occupé', in 1782. He had already shown d'Angiviller his model for the statue, but four years later d'Angiviller was still hesitating over whether to order the marble life-size work. His reserves were expressed in a letter to Pierre, then Premier Peintre, explaining that the statue's head had not seemed noble to him.[25] Finally he allowed the statue to be executed in marble, but the figure remained – in Cochin's word – spindly. Not notably talented, and quite markedly uninventive, Mouchy seems equally to have been lacking in concern for Antiquity – and the capital letter is here justified to symbolize the importance it was again coming to have.

Mouchy had been engaged in collaboration on statues for Saint-Sulpice with Simon-Louis Boizot (1743–1809), a sculptor almost as much as Mouchy untouched by classical currents. Despite the fact that his official career began during Louis XVI's reign, Boizot belonged by temperament to the middle years of the century. He was a good choice as director of the sculpture studio at Sèvres, and his most attractive work was probably always on a small scale. A miniature terracotta group by him was already in Jullienne's collection by 1767, and Boucher too owned some of his work; it was probably hard to distinguish these from Clodion's contemporary terracottas.

The son of the painter Antoine Boizot, he became a pupil of Michel-Ange Slodtz before winning first prize for sculpture at the Académie in 1762.[26] He may also have had some training under Pigalle, who certainly knew his family well enough and sculpted Boizot's mother in a bust shown at the Salon of 1745. After three years at the École des élèves protégés, he went to Rome in 1765, the year of Slodtz' death, and returned to Paris in 1770. The following year he was *agréé*, and the rest of his career followed the pattern of success. In 1774 he was appointed director at the Sèvres factory. In 1777 he was chosen to execute busts of *Louis XVI* and *Joseph II of Austria* for Marie-Antoinette. He became an academician in 1778, on presentation of the *Meleager* (Louvre; signed and

dated that year). In 1783 he solicited and obtained a commission for the *Racine* (Comé-
die Française) from d'Angiviller, who in giving it him privately mentioned his success
at Sèvres.

Hints from Bernini and from Bouchardon combine in Boizot's typical statuette of
Cupid (Louvre) (Plate 166), dated 1772, the commission for which is not known. Cer-
tainly it looks backward rather than into the climate of Chaudet's *Cupid* (Plate 167),
against which it is quite patently Baroque. Perhaps it is not too fanciful to see in it some
echo of Slodtz' projected *Cupid* for Madame de Pompadour. The sly baby of Falconet's
imagining has become an adolescent, but though Boizot preserves the device of an arrow
being withdrawn from Cupid's quiver there is no serious suggestion of menace. This is
just a charming figurine, sexless, rather soft, posed in a way that ultimately goes back to
Bernini's *David* – though even a passing mention of that is cruel to Boizot's piece of what
might almost be table decoration. Nevertheless, it is the pose of the *Cupid* which possesses
some sweep and vitality; with pretty eagerness, he still dashes forward into a period
which would soon expect more sober deportment from its classical gods.

Some sculptors hardly younger than Boizot were to aim consciously to create that
climate. Although Jean-Guillaume Moitte (1746–1810) had been the pupil of Pigalle
and Lemoyne, it was as the disciple of Antiquity that he was specifically praised by
Quatremère de Quincy in his *Éloge* at Moitte's funeral.[27] And although Louis-Pierre
Deseine (1749–1822) was to note daily life in the streets of Rome during his stay at the
French Academy, it was his study of the antiquities in the city that proved more
significant. The elder Deseine, Claude-André (1740–1823), is a rather shadowy figure:
deaf-mute from birth, he never won a prize and appeared first at the Salon de la Corres-
pondance in 1782. He worked chiefly as a *bustier* in plaster or terracotta, executing a
tinted plaster bust of *Mirabeau* in 1791 (Rennes). Like other surviving work by him, this
shows an almost grotesque sense of character and animation. His strongly republican
sympathies contrast with those of his younger brother, who was as patently royalist as
he was classically orientated.

Louis-Pierre Deseine trained under several sculptors, including Pajou – of whom he
executed a bust (Salon of 1785) – and won first prize at the Académie in 1780. That year
he received his *brevet* for Rome, where he studied from 1781 to 1784. An album of his
Roman sketches and drawings (now in the Louvre) fortunately survived in his family
and testifies to his concern with classical art, interpreted to include the Carracci and
Poussin as well as antique sculpture. It was perhaps already a mark of his interests that he
left the faces unexpressive in his drawn copies of classical statues and concentrated on
study of their drapery. On his return to Paris he became *agréé* in 1785 and an academician
in 1791, presenting the rather dull *Mucius Scaevola* (Louvre) as his reception piece. Be-
tween those years he received no important Crown commission, though he was em-
ployed by the Prince de Condé on statues for the dining room at Chantilly. He was
chosen by Vien in the hectic days of 1792, at the time d'Angiviller had emigrated, to
contribute a *Puget* to the scheme of the 'grands hommes'; but nothing seems to have
come of Vien's proposal.[28]

Deseine's royalist principles kept him faithful to the Prince de Condé, and with the

restoration of the Bourbons he was to receive several important commissions. He, who had executed busts of Louis XVI and Louis XVII, was indeed the proper sculptor to produce a bust of the new monarch, Louis XVIII (1817, Chantilly, Musée Condé) – though the commission was not in itself very inspiring. Deseine's principles seemed naturally to attract him to religious, legitimist subjects. He was responsible in 1819 for the monument to Cardinal de Belloy in Notre-Dame, and was interested in projecting a monument for Bossuet. His bust of *Pope Pius VII* (Salon of 1806) – another inevitable subject – is impressive, if eclipsed by Canova's of the same sitter. With the return of the Bourbons, Deseine had resumed his old title of 'premier statuaire du Prince de Condé', and to him was given the highly charged, emotional commission of a monument commemorating what the Restoration regarded as the legal murder of the Duc d'Enghien. He produced several drawings and models, the latter exhibited at the Salon of 1819, but the monument itself (at Vincennes; 1816–22) was finished by his nephew after his death. Throughout the development of the concept there existed a rather uneasy mingling of modern dress and allegory, as well as some confusion between classicizing and romantic tendencies in style. Although French taste seems always somewhat suspicious of Canova and his achievements, the Duc d'Enghien monument is the type of work which Canova could have carried out impressively; Deseine, probably not without side glances at the Italian sculptor, achieved what now looks like pedestrian pastiche.

Moitte is yet one more instance of a sculptor receiving his first training under Pigalle. His father, the engraver Pierre-Étienne Moitte, had produced the engraving of Pigalle's Louis XV monument at Reims, and the young Jean-Guillaume entered Pigalle's studio as a boy. Unfortunately his health was already weak, and because of this he rarely embarked on large-scale sculpture. Perhaps his poor health affected his character; his serious, taciturn nature made him very unpopular with his fellow students, and when, in 1768, he won first prize for sculpture there were extraordinary scenes in which Moitte was publicly humiliated. Although he received a *brevet* for Rome in 1771, he was forced back to Paris after illness in 1773. Yet his stay had been long enough to confirm his passion for Antiquity – manifested particularly by his bas reliefs and his frieze-like drawings in pen and ink. Indeed, it was for these drawings, of which he executed over a thousand, that Moitte became most famous. Their decorative basis is shown by the fact that they were often to be utilized by Louis XVI's goldsmith, Auguste, and that their severity and novelty in disseminating a good knowledge of Antiquity were praised by Quatremère de Quincy. They have a linear delicacy and even filigree refinement which makes the three-dimensional achievement of Moitte's *Cassini* (Plate 169) the more unexpected. Although the marble full-size statue was completed only posthumously, the plaster model had been shown, and praised, at the Salon of 1789: in style as fully 'engaged' a piece of neo-classicism as David's *Brutus* of the same year. Moitte himself was no less than David politically engaged as well; his wife was an early patriot, one of the women depositing their jewels at the Bar of the National Assembly in 1789.

In Moitte's *Cassini*, the seventeenth-century astronomer is treated as a Roman philosopher: his hair deliberately stylized, his feet bare, posed like another Cicero as he ponders a mathematical problem. Whereas Julien, exhibiting his model of Poussin in the same

year, still thought it necessary to explain the classical costume as really nightwear in seventeenth-century Rome (as if to check any criticism), Moitte offered no explanation and, indeed, patently intended to evoke Antiquity by every available device. The visitor to the Salon that year could choose his preferred style: from Moitte's tenacious classicizing, via Julien's watered-down compromise, to the troubadour romanticism of Foucou's *Du Guesclin*. Perhaps no trio of statues could better convey the uncommitted, wavering nature of official style in what was to be the last Salon under the full *ancien régime*.

Chinard and Chaudet

To couple these two figures in this way, especially given the alliteration of their names, may suggest that they were somehow a team. Though in fact they never worked together, they do have a certain amount in common – including patronage by Napoleon. And though they both lived into the nineteenth century, each is really symptomatic of the closing years of the eighteenth: it is to its standards that they basically conform. By the time the Romantic movement was under way Chaudet's style would look very posed and chilly, even silly; and for many years Chinard remained totally ignored.[29]

The career of Louis-Pierre Deseine is sufficient warning against equating neo-classicism with revolutionary political ideas. Although Chaudet and, especially, Chinard were sympathizers with the new republican world which abruptly became Napoleonic, their styles were not formed in that climate. Indeed, the direct effect of the Revolution on French sculpture was not great. Temporarily it may have encouraged some patriotic efforts like Boizot's contribution to the Salon of 1793: 'A Republican maintaining Union and Equality'. Yet it is remarkable how quickly these disappeared when Napoleon became the patron-dictator as well as the subject of most sculpture. The Revolution's chief contribution had been unfortunately to destroy royal monuments in Paris and elsewhere; little was executed to replace them, apart from the inevitable statues of Liberty, often of plaster and thus nearly as ephemeral as the political ideal they represented. The turning of the church of Sainte-Geneviève into the Panthéon gave employment to Moitte, for instance, but he was afterwards to be employed on the new-style propaganda represented by subjects like his bas relief for the Louvre: 'La Muse de l'histoire inscrivant le nom de Napoléon sur les tables de mémoire.' And soon Napoleon was taking more drastic steps, even in sculpture, to ensure that the muse of history did not forget him. By an irony, the emergence again of a strong ruler returned conditions of patronage nearly to their old *ancien régime* state under Louis XIV.

Both Chinard and Chaudet were naturally caught up in the Napoleonic machine, Chaudet the more directly. Yet even Chaudet is more remarkable for his essays in a quite unengaged, consciously charming mood, nearer to Proud'hon than to David, which is well represented by the *Cupid presenting a Rose to a Butterfly* (Louvre) (Plate 167) – of which the very title has a graceful, Alexandrian echo.

Denis-Antoine Chaudet (1763–1810) was born at Paris and entered Stouf's studio. He won the second prize for sculpture in 1781 and first prize three years later with the *Joseph sold by his Brothers* (Louvre). The same year he received his *brevet* for Rome and

set off for the city where shortly before Canova had definitely settled. In Rome he was troubled by ill health and returned to Paris in 1789, becoming *agréé* at the Académie but never an academician; that year he exhibited *La Sensibilité* at the Salon.[30] Like other sculptors of the period, Chaudet showed his concern for design by an interest in drawing;[31] unlike most of them, he was also a painter – as was his wife. As well as receiving important Imperial commissions, summed up – quite literally, one might say – by the statue of Napoleon for the top of the Place Vendôme column, he contributed to the illustration of Didot's edition of Racine (published in 1801) and provided designs for bronze decorations on Jacob's furniture. The advent of the new empress, Marie-Louise, unfortunately coincided with Chaudet's death; otherwise he would almost certainly have been commissioned to execute something in connexion with the marriage, and it is exactly the type of commission to have inspired him.

Chaudet's classicism is essentially decorative and delicate. It is no accident that the *Cupid* (Plate 167) should be one of his best known sculptures, and its base is no less typical of his style, even if its execution is not his, with its playful, graceful frieze showing on one side amoretti who have fired their arrows at a beehive and are alarmed at the result.[32] That the theme goes back eventually to an idyll by Theocritus provides a hint of Chaudet's preferred climate. Some of his drawings take the theme of Love versus Reason, with Love triumphing; Love weighs the heavier when put in the scales against Reason, or Love overturns a statue of Minerva. The *Cupid* resumes all the eighteenth-century concepts of this presiding god, but in style is particularly suited to preside in some pavilion at Malmaison. Unarmed and quite naked, Cupid crouches, occupied with a blameless task; no longer is he mischievous or menacing but a pretty accomplice of nature's. His own gracefulness is just a touch exaggerated; the pose, with one delicate foot barely in contact with the ground, is almost too suave, while the extended fingers of the hand which holds the butterfly suggest genteel deportment. Yet, without dullness, Chaudet has achieved stillness, just as he has achieved a delicacy of effect which really is more refined than Julien's or Pajou's. His statue is classical, lyrically so; it holds a balance between art and nature which the eighteenth century would have recognized and approved. Although the marble statue was completed only after Chaudet's death, and not until 1817, the plaster model had been shown at the Salon of 1802. It is typical of that brief Empire period (in 1802 Napoleon was emperor in all but name) which makes perhaps a more fitting epilogue to the eighteenth century than prologue to the century of which it was actually a part.

If that is largely true of Chaudet, it is even more true of the older sculptor, Joseph Chinard (1756–1813). Chinard was born at Lyon, where he was to spend a good part of his working life and where he died. He is easily the most distinguished sculptor working outside the capital, and Lyon provided him with many of his sitters, including Madame Récamier. Although Chinard produced some attractive, Clodion-style terra-cottas, and also more patently neo-classical, sternly republican sculpture, he remains most remarkable for his portrait busts. At their finest these rival Houdon's in realistic vitality, and in addition have a poetic refinement which is Chinard's own. He could respond to a wide range of character, but he was at his best with female sitters, where,

without flattery, he could suggest a certain mystery, even reserve, beneath a charming exterior. His *Madame Récamier* (Lyon) (Plate 168) is certainly the masterpiece of those, but his other busts, often of unknown women, have much of the same unforced freshness combined with a faintly pensive air. The costume styles of the Consulat and Empire, with their somewhat contrived simplicity, suited Chinard perfectly; he paid tribute to their delicacy by the delicacy of his handling which could beautifully suggest the curl straying from a high comb or the creasing over shoulder and bosom of a light gauze dress. Such suggestions harden into the virtuosity of the marble *Madame Récamier*, where the piled coiffure is a triumph of artful negligence, and yet more eloquent vitality is given by inclusion of the sitter's hands clasping pleated drapery which falls about her shoulders to expose one perfect breast.

Perhaps Chinard was fortunate not to be born in Paris and not to undergo full Academic training. He certainly retained an individuality and independence which were basically artistic but also personal. Recently it has been questioned whether Chinard was a neo-classical sculptor at all – though it is a fact that he could produce work in a neo-classical vein – and the question raises a larger one of terminology. To some extent there is a stylistic division in Chinard's work outside portraiture; it is symbolized already in his small terracotta *Perseus and Andromeda* which won first prize in 1786 at the Accademia di San Luca (in that collection) at Rome.[33] Into the arms of a Perseus with classical profile and heroic air of Antiquity there slips a pouting, Clodion-style nymph who seems almost to defy her rescuer to remain indifferent to the proximity of her body. Perseus becomes a Pygmalion embarrassed by what he has achieved; and Chinard conveys spontaneously all the effect for which Falconet had vainly striven in his *Galatea* group.

Chinard arrived in Rome in 1784. Originally he had been destined for a career in the Church, but he early showed promise as a sculptor and, after a period at the École Royale at Lyon, went to work under Barthélemy Blaise (1738–1819). His training must have encouraged a Baroque vigour, intended to be curbed perhaps by his patron, the friend also of Julien, the Baron de Juis. It was at his expense that Chinard travelled to Rome, where he is recorded as working to commission, employed on making many copies of famous antique statues. Back in Lyon in 1787, he was commissioned to execute a marble version of his prize-winning *Perseus and Andromeda* (Lyon) which remains unfinished but betrays a chilling of the verve so apparent in the terracotta group. It has grown more formal, and perhaps for that reason the sculptor himself lost interest in it. Certainly he returned to the theme, but significantly in terracotta again, and produced a version of the group for himself when in Rome once more during the years 1791–2. This is elaborated from the first model but is yet more deeply *dix-huitième* in sentiment: Andromeda retains her very youthful piquancy, while greater sense of movement in the pose of Perseus makes him more animated. As a treatment of the subject it might have seemed very flippant in the Rome that was soon to see the pseudo-heroic posturing *Perseus* of Canova.

It was, however, for different reasons that Chinard found himself condemned. Two groups of *Apollo treading Superstition underfoot* and *Jupiter treading Aristocracy underfoot*

(1791, Paris, Musée Carnavalet) resulted in his being imprisoned in Castel Sant'Angelo, from which he was released on French representation. It is part of the eddying, complex tide of events at the period that Chinard, after returning to Lyon, should have been arrested again, this time accused of being too moderate a republican. He was acquitted and released in 1794, not before he had presented the judges with a highly pertinent group of *Innocence seeking Refuge in the Bosom of Justice*. The style of this was probably resolutely neo-classical – for Chinard seems to have supposed that this style guaranteed political engagement – but Chinard's neo-classicism was never less than delicate and seldom dull. There is strong vitality in his bas-relief model of *Honneur et Patrie* (Lyon) which was intended to decorate the Arc de Triomphe that Bordeaux planned to set up in Napoleon's honour. Individualized faces of the citizens contrast with their Roman and Greek helmets, and the whole bas relief is alive and boldly tingling – strangely more Renaissance than neo-classical in its romantic use of Antiquity. The bas-relief form suited Chinard very well; the pedestal of his own version of the *Perseus and Andromeda* is decorated with a lively frieze of figures with graceful limbs and flying folds of expressive drapery; and he produced a series of vigorous portrait medallions before concentrating on portrait busts.

The years of the Consulat and Empire brought him several times to Paris. As well as working on the Arc du Carrousel, along with sculptors like Deseine, he executed busts of both Napoleon and Josephine's relations. His bust of Josephine herself (Stockholm, Nationalmuseum) is good but suffers from the sitter's personality being more sympathetically interpreted by paint than by sculpture. With Madame Récamier he succeeded where most paintings – even David's – fail. The ever-smiling, eternally gracious, but seldom yielding sitter was probably a sphinx without a secret. Chinard's bust hints at inner vacuousness but conveys the surface mixture of modesty and voluptuousness which fascinated and tormented so many men – Madame de Staël among them, one inclines to say. Indeed, the action of the hands that play with such teasing effect recalls the description of Juliette Récamier in *Delphine* when the character who is she draped herself in an Indian shawl which outlined her figure. In a moment or two, it seems, the woman of Chinard's bust will untie the bandeau in her hair and let it wave about her in the final climactic moment of her dance. This portrait is the total expression of that frigid personality, lost in smiling self-esteem and wrapped in self-admiration, which led Madame de Staël to ask: 'Why, whether in love or in friendship, is one never necessary to you?'[34] Even to that apparently simple question Chinard's Madame Récamier is too absorbed by her own beauty to give an answer.

Houdon

Not singled out for special treatment during the *ancien régime*, Houdon did not enjoy any particularly outstanding success under Napoleon. Although his was perhaps the finest bust to be produced of the emperor (Plate 173) it is rivalled by the sharply observant bust of General Bonaparte (1799, Lille) by Charles-Louis Corbet (1753–1808),[35] a sculptor whom Boilly painted among the assembled artists in his picture of

Houdon's studio. It is posterity that has given Houdon pride of place, not without some concomitant unfairness to other great sculptors and some slight over-estimation of Houdon's own abilities.

The very realism of his portrait busts – which has helped to make him famous and popular – was sometimes disturbing to the eyes of his contemporaries. Quatremère de Quincy, for example, spoke of truth pushed 'à l'outrance' in busts like those of Gluck and Mirabeau (1791, Louvre).[36] This truthfulness is certainly the most positive mark of Houdon's thoroughly scientific observation. He obeys the century's dictum to follow nature until that obedience becomes his style. Although the results have astonishing virtuosity and effectiveness, they do not encourage us to investigate the character of their creator; personally Houdon remains an uninteresting figure, somewhat unimaginative, and in one way perhaps too dependent on the canon of realism.

Even the eighteenth century did not mean its dictum about following nature to be taken quite as literally as Houdon took it. But Houdon shows how uncertain other standards had become by the time he was first active – in the late sixties. The Baroque was out of date; neo-classicism was not – was never? – firmly established as the distinctive, fashionable style. The safest convention lay between these two: simply to be realistic. Houdon early showed his preference for that stylistic alternative not only in the scientific *Écorché*, of which he remained so proud, but in the contemporary *St Bruno* in Santa Maria degli Angeli in Rome (1767) (Plate 170). Despite that statue's colossal scale, it is not a heroic or extraordinary figure. What distinguishes it is sober realism: it is the portrayal of any monk rather than of a fervent saint.[37] When Réau described the *St Bruno* as having the head of the *Écorché* planted on a cowl, he presumably meant to praise;[38] yet he also indicated some limitation in the statue and its sculptor. Houdon's whole career reveals him tacking about stylistically, veering between extremes of Rococo and neo-classicism, displaying even romantic *style troubadour* tendencies, as in the *Tourville*, but ultimately making his criterion nature's. Problems of imagination which afflicted him in non-portrait work disappeared when he was face to face with a sitter; here was the standard which he effortlessly understood. Art must be made to seem more natural than nature itself.

Jean-Antoine Houdon (1741–1828) was trained under Michel-Ange Slodtz, but was significantly influenced by Lemoyne and also by Pigalle. Most significant of all was his attachment to his profession. Born the son of the concierge at the École des élèves protégés, where he was later a pupil himself, Houdon might well claim to have been, as he stated in an autobiographical notice, 'Né pour ainsi dire au pied de l'Académie.' He went on to say that he had worked as a sculptor since the age of nine. Even if that is something of an exaggeration, it expresses Houdon's lifetime absorption in his work. Without social or literary ambitions, barely educated, and interested outside sculpture only in his family and the theatre, he is the typical eighteenth-century worker-artist. He has no claims as a great draughtsman. His activity and his attitude were not made to soften the court prejudice which Cochin had recorded as expressed in the comment: 'il y a bien de la mécanique dans la sculpture.' The status of the sculptor in France was not altered by Houdon's career. He played no outstanding part in the Revolution, and

perhaps was at heart a royalist. Despite some complaints by Pajou, he seems to have been largely unambitious. It is true that he put forward a request in 1803 for the Légion d'Honneur – which was granted – but in his letter of application he stressed his scientific application rather than the nobility of his art. 'Above all,' he wrote, 'the constant occupation of my whole life has been the study of anatomy applied to the fine arts.'[39]

Houdon's *Écorché* (1767, Gotha), which was of course mentioned in his letter to illustrate that preoccupation, had been conceived and executed while he was still a student at the French Academy in Rome. Already at fifteen he had won a prize at the Academy school in Paris; in 1761 he won first prize, and after the customary three years at the École des élèves protégés, received his *brevet* for Rome in 1764. He returned to France in 1768, was *agréé* in 1769, and immediately took advantage of his new position to exhibit that year at the Salon. The pieces he showed not merely reflected, but were the positive fruits of, his Roman stay. They were much praised and indeed revealed a fresh artistic talent; varied in subject, scale, and style though they were, there was one conspicuous lack in the light of Houdon's later career: no male portrait bust.

Houdon's work in Rome had prepared him for a career quite different from that of *bustier*. But the fundamental realism of his art was already patently declared in the origin of the *Écorché*, intended at first to be just a model for the *St John the Baptist* which had been commissioned along with *St Bruno* for the same church. The model eclipsed the final statue in importance; already Natoire, director of the French Academy at Rome, is found urging Marigny to allow a cast of the *Écorché* to be placed in the Academy. And it is worth noting that when Houdon was pressing for the commission, which never came, to execute an equestrian statue of Washington,[40] he prepared an *écorché* of the horse to convince Congress. To some extent he sought to combine his natural abilities with ambition to produce a monument comparable to those of Bouchardon, Lemoyne, and Falconet. Such projects were to be floated before him, but never to resolve into hard accomplished facts: an elaborate monument to Louis XVI at Brest, a simpler one to Gessner at Zürich – both were carefully planned in model but not finally executed.

Yet it is difficult to regret this. Although some of the reserves felt about Houdon were perhaps no more than intrigue, and the jealous reaction of fellow-sculptors like Caffiéri, there can be little doubt that he was not best suited to the creation of large-scale allegorical monuments. As long as taste required veils of gracious mythologizing to overlay reality, Houdon was working to some extent in an unsympathetic climate. That this was not more noticeable is owing to his virtuosity and his ability to produce sculpture in almost pastiche style. Even in his portrait busts the stylistic shifts are patent and often quite surprising; this is less a matter of conscious essays *à l'antique* than of changes in mood between sober and Rococo realism which are like nods in the direction now of Pigalle and now of Lemoyne. In non-portrait sculpture there is yet more patent variety. *La Frileuse* (1785, Montpellier, Musée Fabre) is an essay in imitating Falconet; the Comte d'Ennery tomb (1781, Louvre) is sentimentally neo-classical; the *Diana* looks back to the School of Fontainebleau. Yet throughout there is that stamp of realism which becomes most obvious when Houdon's work is compared to Pajou's and Julien's. Julien's seated *Nymph*, or Pajou's *Psyche*, are like whitewashed plaster, cold and inert beside the springing,

insolent vitality of the marble *Diana* of 1780, poised so unexpectedly today in the museum at Lisbon (Plate 171). She is a woman before she is a goddess, but her superiority consists above all in having existence. Had she been placed in the dairy at Rambouillet it would have been an almost brutal naturalism which would have confronted Marie-Antoinette and the court. Even Catherine the Great, who became its owner without having commissioned the work, seemed to recognize its grasp of realism and positive lack of divinity when she wrote: 'La Diane est depuis ce printemps à Tsarsko-Sélo. Ce Tsarsko-Sélo renferme bien des diableries.'[41]

If mythology and allegory were not best suited to be illustrated by Houdon this was not because he lived in an age of reason, but because his working methods largely dispensed with imagination altogether. Increasingly driven to be a sculptor of portrait busts, he first publicly revealed his abilities with the *Diderot* (New Haven, Mr and Mrs C. Seymour, Jr.) (Plate 172) – shown at the Salon of 1771 – the first of his own personal series of 'grands hommes'. The breathing, almost indeed breathless, quality of this is more exciting and immediate than in many of Houdon's later busts. Regardless of its likeness to Diderot, it remains lifelike. The pupils of the eyes are deeply cut, dark, and extraordinarily impressive, and the mouth is open – an effect Houdon did not often use again for busts of adults but sometimes for children. The inquiring twist of the head emphasizes another of Houdon's gifts of observation: that character can be conveyed by the way the head is held on the neck. The neck itself, in the *Diderot* just wrinkled as the head turns, becomes an object of study to the sculptor. Voltaire's bare skeletal throat suggests age more terribly than his still animated face (Plate 174); Benjamin Franklin's thick dewlap sags slightly on to his neckcloth (an example of 1778 is in the Metropolitan Museum, New York). Part of the power of the *Diderot* comes from its simple directness and lack of accessories. Its nobleness has a naked quality, a candour, that perfectly suits the sitter. Perceptive and yet childishly enthusiastic, marked by life and yet still innocent, Diderot seems here the very image of his writings. There is an imaginative sympathy, or so it appears, between the comparatively young sculptor and the ageing writer; but the talents of Houdon are hardly similar to genius as defined by Diderot (*Encyclopédie*, VII, *Génie*): 'Je ne sais quelle rudesse, l'irrégularité, le sublime, le pathétique, voilà dans les arts le caractère du *génie*.'

Just as he had studied in a Roman hospital to produce the *Écorché*, so Houdon brought an almost medical attitude to the heads of his sitters. His use of life and death masks, his measurements of the subject's head – and, in the case of Washington, all the subject's dimensions – point to an attitude paralleled perhaps only by Stubbs' concern with accurate anatomical depictions of the horse. Houdon is professional in a way that cannot be claimed for Lemoyne. Lemoyne seems to work by instinct; the result is uneven, occasionally dull, but often brilliant. Houdon is not uneven, never less than lifelike, careful of detail (even to the patterning of a coat, as in the bust of Turgot), and 'natural' by a re-definition so sober and exact that Lemoyne's busts by comparison may seem theatrical and over-expressive. Some of Houdon's contemporaries found his work limited, and it remains possibly always too dependent on the physiognomy of a sitter: 'des portraits', said the *Journal de Paris* (19 September 1789) reviewing the Salon of that

year, 'plus recommandables par les personnes qu'ils représentent que par leur exécution qui, en général, est froide et maigre'.

Houdon never goes to an extreme. In that sense he is a classical artist, moving serenely between those poles represented in his early years by Slodtz and at the end of his career by Canova. It may be that for many people he represents the finest achievement of eighteenth-century sculpture; but it must always be remembered that his achievement did not altogether coincide with the century's aims in sculpture. Houdon is not above his century: he is part of a complex stylistic pattern which contained within it other great sculptors.

PAINTING: UP TO THE SALON OF 1789

Introduction

'I have no great knowledge of painting, but you make me fond of it.' [42] With these typically unassuming words, the highest source of artistic patronage in France – Louis XVI – approved the work of Madame Vigée-Lebrun in 1788, the last year of unchallenged *ancien régime* rule. The artistic taste of Louis XVI would scarcely sustain a thesis; more can be said of Marie-Antoinette's, for hers not only had its individual aspects but was the source of Louis XVI's own slight stirring of interest. Apart, however, from the inevitable royal concern with portraiture, neither of them displayed much specific interest in painting.[43]

This withdrawal, accidental though it may be, conforms with the final shift of patronage from the monarch to the state, and from the palace-eye view of art to the emerging concept of the public museum. In Louis XIV and his demands, all these strands had been united; his palace virtually was his museum, and the king was the state. The regent, Louis XV, and Madame de Pompadour had played up the personal, even private, uses of art for themselves and the décor in which they lived at leisure. But already under Louis XVI, and much more patently under Napoleon, art was being directed towards a public end, to reanimate 'les sentiments patriotiques', in the words of d'Angiviller, the newly-appointed and last Directeur des Bâtiments. It was for the national museum which d'Angiviller planned to make out of a royal palace, the Louvre, that the statues of the 'grands hommes de la France' were destined, as were the large history pictures annually commissioned – including David's *Oath of the Horatii* and *The Lictors bringing Brutus the Bodies of his Sons* (Plates 198 and 200). It is quite wrong to argue that such paintings could not have any concealed revolutionary or republican message *because* they were executed for the king. They may well not have had a message of this nature – the point is to be discussed – but they were already destined for public display, to stir not the monarch but the nation. Nor did the Revolution or Napoleon alter the course of David's art; his subject matter merely evolved from the historical to the actual, from the heroes of Antiquity to the heroes of the present.

David's is the dominating personality among painters in the late years of the century. Yet he had had to struggle for the mastery, to assert himself at first amid indifference or

the preference for other painters. The enormous success of the *Oath of the Horatii* came when he was already thirty-seven – the age at which Watteau had died. It is more than phrase-making to call David the child of the eighteenth century; he was formed in it and by it, and perhaps was basically unable to understand the world which he faced when his heroic god Napoleon fell. Like Goya, he came virtually to prefer exile to attempting a return to his own country. Like Goya too, if not so movingly or effectively, he evolved a personal late style, scarcely foreseeable from his early work.

It would be convenient if the last years of the eighteenth century in France showed a stylistic homogeneity in painting which could be labelled 'neo-classical'. However, this is no more true of painting than of sculpture.[44] 'Neo-classicism' is a term that not only fails to do justice to Prud'hon; it is often something of a hindrance to understanding David. A blanket use of it conceals the strong rising interest in nature redefined which manifested itself by marked concern with landscape painting – a European as well as French phenomenon. If some of Madame Vigée-Lebrun's portraits can – just – be called neo-classical, the term is irrelevant to other contemporary portraitists. It is meaningless in relation to Hubert Robert and positively mocked by the sparkling existence of the greatest painter of the period apart from David, the one who escapes labelling of any kind, as he escaped academic trammels and most official commissions: Fragonard.

Nevertheless, there was a significant change in the category of picture being encouraged in these years in France, specifically at Paris. The phenomenon is connected not with Antiquity as such but with history: a turning back to the country's past to gain inspiration for the present, a moral regeneration which art should achieve and which was already in 1777 called a 'revolution'. It was associated rightly with d'Angiviller but answered a general feeling, as well as giving official employment to painters who specialized in large-scale work. Subject matter was more important therefore than style; and far from the typical, popular productions being neo-Poussinesque essays, some of the most successful include Brenet's *Du Guesclin* (Plate 158), Vincent's *President Molé stopped by Insurgents* (Plate 193), and Ménageot's *Leonardo da Vinci dying in the Arms of François I* (Plate 194) – all would-be realistic, boldly handled, positively proto-romantic works in style. In more wildly romantic and troubadour style were Foucou's *Du Guesclin* and Pajou's *Turenne*. Henri IV proved more popular than the Horatii, and in 1783 Vincent was commissioned to produce a series of six compositions dealing with his life, to be woven at the Gobelins.

This vein of historicism was increasingly apparent at the Salon exhibitions. Comparing that of 1787 with the Royal Academy exhibitions, Arthur Young wrote, 'For one history piece in our exhibitions at London here are ten' (*Travels . . .*). Yet at the same time, it must be remembered that not only were d'Angiviller's efforts being made against general inertia but that those very Salons which contained large-scale history pictures also contained still lifes by Anne Vallayer-Coster (1744–1818) and flower pieces by the Parisian-Dutchman Gerardus van Spaendonck (1746–1822), both artists highly esteemed for their specialized work. Indeed, it is no paradox to presume that a flower piece by Spaendonck, considerably employed for the Crown, would have pleased Louis XVI or Marie-Antoinette at least as much as the *Lictors bringing Brutus the Bodies of his Sons*.

It would be wrong to make an arbitrary pattern – as is so often done – out of something as spontaneous as artistic genius and as changeable as taste. Yet a broad view of the period, extending beyond France, shows that Fragonard, for instance, is not a figure strayed from the Régence beginning of the century. He has affinities with other European painters of approximately his own date – with Guardi and at times with Goya. In his own country he is reasonably to be paralleled with Clodion. Like Clodion's nymphs and satyrs, Fragonard's cupids stand for more than just erotic decoration; by an easily sensed metaphor, they represent nature and natural forces. They are a reaction against artifice and a protest against languor. Nature is redefined yet once again, and released by Fragonard in a sheer jet of individual energy.

For the more conscious effort of the period, perhaps no better written evidence was published than a passage in *L'Année littéraire* of 1777, in an anonymous review of that year's Salon, addressed by one cultivated amateur to another.[45] This perfectly sets the mood of an intentionally altered world: 'For a long time, Monsieur, you along with the true amateurs have sighed to see the category of the history picture forgotten, even annihilated to some extent. Indeed, when one reflected that this category, the highest of all, which requires the greatest genius, demanding constant and profound study of the human heart, of the passions of the soul, of nature and its varying effects, which presumes an exact knowledge of mythology, of historians, of poets, which puts the palette on a level with the lyre – when one reflected, as I say, that this category, like the epic, seemed to exist no longer among us . . . one could have wept Nevertheless, I think you have noticed that this neglect ought to be ascribed not to the artists but to the frivolity of the century. That distinction, honours, wisely diffused encouragement, with taste and discernment, would make the flame of genius burn brightly, such is the revolution now achieved by Count d'Angiviller, in accordance with the king's benevolent intentions.' This passage preludes, significantly, references to a portion of the Louvre being set aside for the newly commissioned history pictures and statues of the 'grands hommes'.

Fragonard

Jean-Honoré Fragonard was born at Grasse in 1732, the son of a tradesman who came to Paris when Fragonard was still a child. After a brief, apparently disastrous, apprenticeship to Chardin, he became a pupil of Boucher in 1751; the following year he won first prize at the Académie, defeating Saint-Aubin among others. After three years under Van Loo at the École des élèves protégés, he went in 1756 to the French Academy at Rome, where at first he failed to display the ability with which he had early been credited. The Académie had speedily recognized his great technical facility – but it was disconcerted by some of the work he sent back for inspection from Rome, preferring his drawings to his paintings (with some acuteness, it must be agreed).

Already it was difficult to categorize Fragonard. While it is true that he had learnt much from Boucher, he later showed himself not indifferent to the subject matter of Chardin and Greuze. Later still he certainly studied seventeenth-century Dutch masters.

We may guess, yet cannot say for certain, that he early came under the influence of Watteau. Italy to him artistically meant a highly personal selection of painters, including Pietro da Cortona, Giordano, Solimena, and Tiepolo; but it also provided a landscape to which he responded with an intensity romantic in its fervour, far removed from the sober picturesqueness of Vernet. By 1760 Natoire (so quick to recommend landscape as a suitable category, on being appointed director; cf. p.120) was reporting that Fragonard (whom he went on calling 'Flagonard') had spent a month at Tivoli, with the Abbé de Saint-Non, doing admirable studies.[46] Although Fragonard was to produce other wonderful landscape drawings – in both red chalk and bistre – nothing perhaps equals his response to the gardens of the Villa d'Este. The sheer enchantment of such compositions (Plate 175) makes it easy to forget their application and their novelty. They are not just casual sketches but highly elaborated, totally serious works of art, concerned with contrasts of foliage as well as effects of light and shade, catching a sense of heavy, almost fragrant heat. Fragonard's response to natural phenomena is at once instinctive and excited. As seen by him, the gardens of the Villa d'Este shimmer impressionistically, reducing the human element to a few ant-like figures, utterly dominated by the giant cypresses which shoot up to fill virtually the whole height of the composition. Again and again he makes his dominant motif that of nature. His trees are seldom content merely to crowd into a shade but are invested with the vitality of perfect phallic symbols, asserting their primeval virility either over mankind or as a suitable setting for an erotic adventure.

After a century of so much slack painting and competent yet dull drawing, Fragonard's great gift of energy – communicated to everything he touched – was certainly revitalizing. How spontaneous it was is best seen perhaps in what is otherwise not a major aspect of his art, though an interesting one: his copies in red chalk of paintings which he recorded either for himself or for his constant patrons, Saint-Non and Bergeret. There is nothing tame or timid about these copies; not only inspired, they are often inventive, variations on a theme provided by another painter, positive *capricci* which interpret with something of the same freedom found in the Guardi brothers' treatment of other painters' compositions. They tell something else about Fragonard, which time made only the clearer. The basis of his art is draughtsmanship, more patently even than is Boucher's. Although capable of a high polish on certain pictures, he was at his best when positively drawing with the paint, sketching boldly, and thus obtaining a 'quality of lightness of manner and effect', in the words Reynolds used to characterize Gainsborough's handling. It is indeed hard to believe that Gainsborough and Fragonard did not know each other's work.

The discovery of Villa d'Este as a theme was in many ways a discovery by Fragonard of his own talents. He owed much to the encouragement of the young diletantte Saint-Non (very much an abbé in *dix-huitième* style) and something doubtless to Hubert Robert, also working at Tivoli under the abbé's patronage. It seems likely that Rome had previously disturbed rather than confirmed Fragonard's ability. He was an individual artist who needed individual subject matter. His concept of the natural was to extend beyond subject matter to style, and indeed to his personal life. He was, and remained, a private figure. His best patrons became his close friends. He obviously worked most

satisfactorily without too specific a commission (for all its fame and charm, *The Swing* (1768/9, Wallace Collection) is not Fragonard at his very finest) and in an atmosphere of friendly encouragement, vivacity, and perhaps wit. Another aspect of the natural in his art is its element of humour; this is apparent not only in the deliberately amusing erotic subjects but in his treatment of Boucher-style themes, in which any mood too voluptuous or highflown is punctured by rapid, amused strokes of the brush, pen, or chalk. Fragonard's natural and instinctive urge – and his most significant – was to express his own reactions. He did not imitate or simulate nature. His nudes have none of the saturated, pearl-flesh texture of Boucher's; instead of density they possess a linear vitality which is less sheerly illusionistic but at least as artistically satisfying. His portraits share this linear vitality, though sometimes they may not be of real people, and even as likenesses are intentionally capricious.

Fragonard's revolution is in brief this: he dethrones subject matter and sets up a fresh concept of a work of art as a piece of the artist's style. Any competent topographer could have produced an accurate view of the gardens of the Villa d'Este; that is, in effect, merely the starting point for Fragonard's vision, where the villa recedes and the trees like fountains foam higher and higher. Indeed, in most of his paintings and drawings of gardens, foliage like foam overgrows the balustrades and statues, arches up into a huge bower, or is flecked rapidly across the sky. It is no exaggeration to say that the gardens of the Villa d'Este haunt all Fragonard's later landscapes – at least the freedom of interpretation is still there, even in the apparently French setting of the *Fête at Saint-Cloud* (*c.* 1775, Banque de France) (Plate 176), one of the masterpieces of eighteenth-century landscape painting, no 'tame delineation of a given spot' but an enchanted as well as intensely vigorous view of nature. It may be paralleled in literature by the excited praise given to Saint-Cloud in Delille's *Les Jardins* (1780): 'Aux eaux qui sur les eaux retombent et bondissent/Les bassins, les bosquets, les grottes applaudissent.' That Fragonard set some store on his Villa d'Este drawings is shown by the fact that he chose two of them for exhibition at his first Salon appearance in 1765. At the time the success of *Corésus and Callirhoé* probably prevented their receiving the attention they deserved, but their exhibition confirms the seriousness of such work; and suitably enough, the two drawings of that Salon were identified as belonging to Saint-Non.

After travelling widely in Italy with Saint-Non, Fragonard returned in 1761 to Paris. His public career was about to begin. He was *agréé* by the Académie in 1765, and at the Salon that year the large *Corésus* (Louvre) (Plate 177), which had been praised at first sight even by the sober Wille ('très grand tableau d'histoire ... très beau': *Mémoires*), was a great, if misleading success. It seemed to be a bid by its author to offer himself as the exponent of grand manner to replace his one-time master, Van Loo, and his fellow pupil in Boucher's studio, Deshays, both of whom had died earlier in the year. That the picture is not a success now seems obvious enough. According to Diderot, the public began to have reserves after the first enthusiastic reception. Still, it was bought by Marigny for the royal collection and was intended to be copied in Gobelin tapestry. Nor should the picture's artistic failure be too much emphasized. Although its subject now seems more than faintly absurd, it marks a change of mood when compared with, for

example, Boucher. It is intended to be serious as profane history, with a moral clash of duties. It is a sacrifice-of-Iphigenia-style subject – a girl fainting at the altar amid horrified spectators – to which has been added the additional frisson of suicide as the high priest plunges the sacrificial knife into his own breast. Pietro da Cortona and Solimena are drawn on stylistically, as they were to be in David's early pictures. The swooping, glaring figure rushing down from the clouds is rhetorical – but with something of the rhetoric afterwards to be found in Prud'hon's *La Justice et la Vengeance divine poursuivant le Crime*. For its date the *Corésus* is extremely up to the moment. Its black mood is so exaggerated as to border on the unintentionally funny; that is rare in Fragonard's work, but only too typical of the grim deluge that was to follow (among the better-known, the work of Guérin (1774–1833), e.g. *Clytemnèstre;* Louvre) provides a good example).

What was unexpected, and remains largely unexplained, is that Fragonard did not go on to establish a public career. After appearing at the Salon of 1767 he never showed there again. Like Clodion, he never bothered to become a full member of the Académie. While he remained highly active, he nearly disappears from art history. As with Clodion, we know little of his private life or his personality. The chronology of his work also becomes difficult to trace. His style does not evolve neatly, despite an enlarging of the northern influences on him and probably a visit to the Netherlands. The most important semi-official commission he received was from Madame du Barry, for the panels to decorate Louveciennes which she then rejected, preferring Vien. This awful error of taste – due conceivably to misunderstood ideas of the neo-classical as likely to be more chic – was bad enough in itself. What she rejected may justly be called Fragonard's masterpieces, the four large *Progress of Love* paintings (1771–3, New York, Frick Collection) (Plates 178 and 179), decoration which is more than decoration and yet pictures whose first felicity is their decorative effect as an ensemble in a room. Madame du Barry's reasons for rejecting the series are not known for certain, but Louveciennes was designed by Ledoux (cf. p. 315), and it must indeed be admitted that the consciously classical ethos of Vien's series was better suited there than Fragonard's garden charades – light-hearted, scarcely allegorical, and certainly not antique lovers' games, at once lively and tender yet unsentimental.[47] More dominant than the actors is their natural setting, where a riot of flowers and foliage engulfs both human figures and statuary. There is indeed contrivance in this ordering of nature, but the study and beautiful use of natural motifs are unmistakable. Suggestions of a wilder, always burgeoning, nature beyond the bounds of private park or garden – all massed sparkling leaves and jagged branches of moss-grown trunks or graceful bending saplings – hint at new freedom both for artist and ordinary people. Like Corot, Fragonard might have said, in his own way, 'Je me suis lancé sur la nature.'

His experiences with Madame du Barry perhaps completed his disillusionment with court and official patronage. He made Greuze's discovery that such support was no longer necessary for the successful painter. Fragonard was indeed successful and tremendously active up to 1789. He gained middle-class clients and a few particular patrons and was in demand as designer of amusing, often erotic engravings (himself active also

as engraver and etcher) which, far from damaging his reputation, pay tribute to his wonderful inventiveness. Amorous mishaps and girls' nightgowns inevitably on fire alternate with straightforward scenes of country life and unexpectedly sentimental, almost keepsake-style subjects like *Le Chiffre d'Amour* (Wallace Collection). In the same way Fragonard varied his manner and subject matter as a painter. Nature meant also happy mothers and demure school-teachers – indeed, an interesting concern with family life – beginning to appear in his pictures. He retained his fluent brushwork for such sketches, yet also produced carefully executed genre pictures, whose enamel surface is more typical of Boilly. One other development was graceful, proto-Prud'hon allegory, expressing the unity of love not by genre but by faintly classical figures – yet, typically, active not passive – as in *La Fontaine d'Amour* (c. 1785, Wallace Collection).

At the patriotic ceremony of 7 September 1789, when leading artists' wives came to offer their jewellery to the National Assembly, Fragonard's wife joined the wives of Vien, Moitte, Suvée, David, and others. Though David remained his friend, Fragonard's life and activity were fatally damaged by the Revolution. He held a few posts in the artistic administration, yet without much success. As a painter, even Greuze contrived to be better employed. Fragonard's death in 1806 was not quite so completely ignored as the Goncourt supposed, but it made little stir. In some ways consideration of Fragonard has remained coloured by his sad late years. It is too easy to make him the final representative of all Rococo eighteenth-century tendencies, the late bright spark of love and frivolity extinguished in a stern Republican climate. The truth is probably more complicated. Though he was a responsive pupil of Boucher, he appears partly in reaction against Boucher; his very palette – with little use of blue – is distinct. Far from being a painter of the artificial, he was a painter of the instinctive, the impulsive, the natural.

Although it is convenient to speak of him as a painter, it is significant how in his work the categories of drawing, sketch, painting, virtually merge and interchange; there are highly finished drawings and very hasty incomplete sketches in oil. A few of his masterpieces are on a fairly large scale, but as a presumed decorative artist he produced an unusually high number of no less fine small works (Plate 180). Watteau apart, no other painter in France during the century achieved such consistently high quality in all that he executed in all media.[48] It is clear that he wished always to be actively employed but not tied down too specifically by the terms of a commission. Left 'à sa volonté' – free from the Bâtiments, Madame du Barry, or the Gobelins – he was in effect working for himself. If that was not a total revolution, it consolidated Watteau's revolution at the beginning of the century and would have its relevance for artists in the subsequent one. It is pleasantly apt that when Fragonard fled from Paris to Grasse in 1790, he should have installed the series of the *Progress of Love* in the house where he lived.

Robert, Moreau, and Other Landscape Painters

It is beside rather than after Fragonard that Hubert Robert (1733–1808) should ideally be placed, so closely contemporary were they and so closely did they work together in their early Italian years. Some drawings even pose problems of attribution between

them. And, like Fragonard, Robert may be claimed as in one way the last exponent of a certain type of decorative art – in his case the caprice ruin picture – and yet also as a forerunner of romantic responses to nature. This indeed was the aspect of his style instinctively seized on by Diderot when Robert first exhibited in Paris in 1767.

What is often rather slickly defined in histories of the century as 'the rediscovery of nature', something credited largely to Rousseau, was a complicated but not abrupt phenomenon. In painting alone it is obvious that Watteau early 'discovered' nature; and in the sense of release in natural surroundings from city ways, he not only expressed his awareness in painting but retreated there to die. Although Rousseau's response to nature and scenery was intensely important, his didactic moral fervour is more typical of the eighteenth century than of purely romantic sensations for their own sake. In such a complex matter, so deeply connected with the whole century's concern with nature, generalization is dangerous.[49] Still, it may be said that Diderot's delighted response to Robert and Vernet (and even to Poussin's landscapes) is more aesthetic than moral. And, in passing, that is intensely true of such proto-Romantic responses like that where (in a letter of 1760 to Sophie Volland) he speaks of listening to the beating rain while 'je m'enfonce dans mon lit'. Diderot's famous passage about the melancholy pleasure of ruins ('Tout s'anéantit, tout périt, tout passe . . .') was not only specifically evoked by Robert (Salon of 1767) but seems true to the pleasurable, if not particularly melancholy, intentions of Robert's pictures. By the standards of the landscape painters who followed, Robert may even seem too frankly governed by the desire to please, his 'nature' too contrived and decorative. It must certainly be admitted that he painted too much and often worked to a rather obvious formula; but as well as Fragonard-like gardens and Panini-like ruins, he produced some views of Paris and Versailles which are direct and vividly atmospheric. It is for its wonderfully atmospheric sky of drifting sunset cloud that the *Pont du Gard* (by 1787, Louvre) (Plate 181) remains most memorable. Robert was officially commissioned to depict this famous Provençal monument; what he produced combines the grandeur of man's construction with nature's grandeur in a poignant manner to which Diderot – dead three years before it was executed – would have done eloquent justice.

Hubert Robert was born in Paris but his parents came from Lorraine. His father was valet-de-chambre to the Marquis de Stainville, whose son – the future Duc de Choiseul – carried the young Robert to Rome as his protégé when appointed ambassador there in 1754. Although not officially a pensioner of the French Academy, Robert gained a place there, with Marigny's approval, due to his distinguished patron. Natoire reported that he had 'du goût pour peindre l'architecture', and the example of Panini – for long associated with the French colony in Rome – influenced Robert to the end of his career. If to some extent he was never to be as sheerly competent as Panini, he was also never to be so prosaic. His own lively temperament, itself no doubt part of the reason why he became friendly with Fragonard and Saint-Non, led him to airier, lighter-coloured, and more light-hearted effects than those of the much older Italian. Steeply-rising, silvery trees, sunny skies, sweeps of staircase and balustrade suggest rather than positively depict identifiable settings in Robert's most delightful pictures (Plate 182). Something

sketch-like and spontaneous is preserved in them. Like Guardi, he could paint with topographical accuracy but clearly enjoyed indulging his inventive gifts in caprice views. As Guardi's are more spontaneous than Canaletto's, so Robert's are more spontaneous than Vernet's.

Not until 1765 did Robert return to Paris. He was *agréé* and received in a single session at the Académie the following year and became highly fashionable – even over-employed. That he was also a social success is testified to by Madame Vigée-Lebrun, whose *Memoirs* give a good idea of his vitality and popularity. He was involved with several schemes for re-designing gardens, was involved in the Laiterie at Rambouillet, was d'Angiviller's choice as curator for the new national museum, and – probably inspired by the Parisian views of Pierre-Antoine de Machy (1723–1807) – turned to record the late *ancien régime* construction and destruction of Paris in a fascinating series (Paris, Carnavalet) which could easily be mistaken for nineteenth-century work. Although imprisoned at the Revolution, Robert was eventually released and was as fortunate in death, Madame Vigée-Lebrun remarked, as he had been in life.

Directly a pupil of de Machy was the more obscure Louis-Gabriel Moreau (1740–1806), a member of the Académie de Saint-Luc and painter to Louis XVI's brother, the Comte d'Artois. His glowing, simple landscapes, often of the environs of Paris, form a bridge between Desportes and Corot. While his slightly younger brother, Jean-Michel Moreau (1741–1814), produced vividly detailed, brilliantly composed plates of urban upper-class life in the *Monument du Costume* (1783) (Plate 183), Louis-Gabriel responded with no less sensitivity – in etchings as well as paintings and gouaches – to the country-side, scarcely peopled at all. Some of his pictures, like the *View of Vincennes from Montreuil* (Louvre) (Plate 184), are virtual cloudscapes. They suggest study of Ruisdael, combined with fresh observation of the shifting atmosphere of light and shade; such a basis is close to Constable's, and the *View of Vincennes* is indeed not unworthy of him.

Directness of vision also lies behind the more classically composed, and classically peopled, landscapes of Pierre-Henri Valenciennes (1750–1829), a pupil of Doyen and a recognized precursor of Corot, who should perhaps yield in precedence and talent to Moreau. Yet Valenciennes, for all the classical theme of, for instance, *Mercury and Argus* (1793(?), Barnard Castle, Bowes Museum), is interested in the landscape elements for their own sake; without the foreground group his transformed Io would seem no more than the study of a cow close to some shady trees. Valenciennes' Italian sketches (Louvre) confirm this spontaneous reaction to natural scenery which became deliberately formalized, with homage to Poussin, only in his worked-up pictures.

More than one other landscape painter could probably be cited to show the century's late tendency to enjoy and encourage straightforward depictions of nature – and nature interpreted in the simplest terms of French skies and fields without cataclysms or precipices. Jean-Laurent Houël (1735–1813), born at Rouen but active in and around Paris, seems an apt example. Another protégé of Choiseul, he painted – among other landscapes – enchanting views around Chanteloup, the property to which Choiseul was banished in 1770. Rustic château life seems idyllic in these *plein-air* scenes, where a few people may stroll in the sun, gardeners garden, and cultivated nature merges into

meadows extending gently towards the low horizon. Such is the *Vue de Paradis* (dated 1769, Musée de Tours)(Plate 185); nothing disturbs the wide expanse of clear sky except a swarm of homing-pigeons, flying and clustering round a pointed tower of the old country house. As an image of security and contentment it has now become hackneyed. In Houël's picture – itself so freshly painted – it is seen as if for the first time. The whole view speaks of nature in terms which make Watteau's countryside remote and Boucher's artificial. Houël must not be pushed out of his century – any more than his patron should be – but his vision is certainly very close to 'nature' as Europe would interpret it in the subsequent period.

Portraiture: Duplessis – Ducreux – Labille-Guiard – Vigée-Lebrun

Inevitably, the demand for portraiture did not slacken in the last few years of the *ancien régime*. The prime requirement was for a competent good likeness, of the kind that Roslin continued to provide. There were no innovations of style or even composition – before the vogue associated with Madame Vigée-Lebrun, itself partly a matter of costume more than of artistic style. Few or none of the portraits produced attempted profound study of the sitter's character. Attention continued however to be paid – and was perhaps paid more keenly than ever before – to details of costume and setting. It does not have the obsessive quality of Ingres' observation, but there are hints which lead towards the extraordinary intensity of his response to his sitters' clothes and jewellery. It is typical that Duplessis, charged to execute the official full-length of Louis XVI in the costume of the Sacre, should ask to borrow the actual robes, chains, and sword, so as to paint them accurately. Such determined truth to nature anticipates David's borrowing of Napoleon's clothes, and even his saddle, when painting *Bonaparte crossing the Alps* (Plate 201).

The most forthright portraitist of these years was probably Madame Labille-Guiard, who had a boldness of handling and a tendency towards unidealized portraiture both in contradistinction to her rival, Vigée-Lebrun, who has triumphed with posterity. Labille-Guiard was, perhaps significantly, never employed by Marie-Antoinette. But all four portrait painters discussed here sought and received royal and court patronage; although that did not compel them to any uniformity of style, it was an important aspect of their careers. And in judging their work, the often crippling and confusing amount of replicas they had to produce must not be forgotten.

Joseph-Siffred Duplessis (1725–1802) after a slow start was to become Louis XVI's official painter. Born at Carpentras, in Provence, he studied for about four years at Rome under Subleyras until the latter's death in 1749. Little of this training could be guessed from his highly accomplished but often painfully hard portraits, where a show of shiny materials often competes for attention with the sitter's face. After some years working at Carpentras, he came to Paris in 1752, but was not *agréé* until 1769. In 1774, the year of Louis XVI's accession, he was finally received at the Académie. The following year he exhibited the *Gluck composing* (Vienna) (Plate 186), where an almost Romantic sense of inspiration combines with sober portraiture in what remains probably his best known

work.[50] Allegrain and Vien were among the colleagues he painted. D'Angiviller sat to him for a benevolent official portrait (John Sheffield Collection), shown at the Salon of 1779; this may be compared with Tocqué's portrait of the young Marigny (Versailles), also seen as Directeur des Bâtiments, painted almost a quarter of a century before.[51] There is something stultifying in Duplessis' blandly academic approach, despite his ability. A cruel epigram which greeted the full-length *Louis XVI* (now at Versailles) at the Salon of 1777 – 'very like except for the head' – sums up one's nagging feeling of lifelessness amid surface veracity in the majority of his portraits.

Against those pictures, the work of Joseph Ducreux (1735–1802) is less competent but more personal. The pupil of Latour, and influenced also by Greuze, Ducreux worked in both pastel and oil. He was fortunate enough to succeed in 1769 with a portrait, executed at Vienna, of the young Archduchess Maria-Antoinetta. When she became queen of France, Ducreux was appointed painter to her, and he remained faithful to the royal family. Although he escaped to London in 1791 (exhibiting once, not very successfully, at the Royal Academy), he returned to France in time to draw the last portrait of Louis XVI (Musée Carnavalet), either in prison or during his trial. This has particular documentary interest, yet Ducreux's most vivid work is probably in expressive self-portraits – a welcome echo of Latour – of which he produced a great many.

At the Salon of 1787 the rival women portraitists, Adélaïde Labille-Guiard (1749–1803) and Élizabeth-Louise Vigée-Lebrun (1755–1842), had their work hung so close together that it was virtually intermingled. Each appeared that year with – among other pictures – one full-length royal portrait which well represented not so much their styles as their individual sources of patronage. It was inevitable that the two painters should be compared. Both were received by the Académie on the same day in 1783. Even in their private lives there was some similarity, for despite their hyphenated married names neither was very happy with her husband. The Revolution divided their loyalties. Madame Labille-Guiard sided with it; Madame Vigée-Lebrun fled from France, began a fresh European career, and, towards the end of a long life, was able to write her *Memoirs* without naming the one-time rival whom she had signally eclipsed and outlived. More than seventy years ago Madame Labille-Guiard's biographer claimed it was time to do her justice, but her reputation has been slow in re-establishing itself.[52] For Madame Vigée-Lebrun posterity has had a weakness rather than any real appreciation. It is tempting to redress the balance drastically, yet it must be admitted that in the very real success Madame Vigée-Lebrun enjoyed there is significance. She was to employ – if not positively exploit – her own femininity, throwing it over her female sitters with almost exaggerated effect. It was for painting with masculine vigour that Madame Labille-Guiard was praised; and pre-1789 she was probably the more widely and highly estimated artist.

Pajou was a friend of her father's, and it was with an excellent portrait of him (Louvre, Salon of 1783) that she was received at the Académie, on the distinguished recommendation of Roslin. She had trained under François-Élie Vincent (1708–90), father of the better-known François-André whom she eventually married as her second husband. She worked in pastel and oil, doggedly anxious to be more than a charming pastellist or

miniaturist. Clearly well thought of by many professional colleagues, she was patronized by the Duc d'Orléans and especially by Mesdames, Louis XV's daughters, to whom she was officially appointed Premier Peintre. Her full-length of *Madame Adélaïde* (Versailles) (Plate 187) was, it has been suggested, something of a moral and political 'answer' at the 1787 Salon to Vigée-Lebrun's *Marie-Antoinette and her Children* (Versailles).[53] The plain spinster princess – many years earlier gracefully transformed into the element of Air by Nattier – is soberly depicted, standing before an easel on which are profile heads supposedly painted by her, of Louis XV, Marie Leczinska, and their son the dauphin. This impressively dignified portrait, rich, solidly painted, faintly sad, is one aspect of Madame Labille-Guiard's talent. No less rich, but gay and brilliant as well, is her full-length of *Madame Infante with her Daughter* (1788, Versailles), where strong sunlight and Rubensian costume bring back to life the dead duchess who had never posed to the painter. Madame Guiard (she dropped the Labille) kept up some royal connections even in the changed, strange climate between the king's acceptance of a constitution and his execution. In March 1792 the *Petites Affiches de Paris* announced that Louis XVI had given her the commission for a portrait of himself, but events overtook the sitter and the picture.

Madame Vigée-Lebrun's *Marie-Antoinette and her Children* (Plate 188) was the artist's most official, dynastic image of the queen. Even while depicting the mother, it emphasized the continuity of the French Crown, showing the healthy present rather than the moribund past evoked by Madame Adélaïde. 'More of a historical document than a portrait' was in fact d'Angiviller's description of the picture.[54] It is an effective, and probably quite conscious, attempt by the painter to rival the work of Madame Labille-Guiard. The gamut of textures, the elaborately realized setting, the combination of dignity with intimacy – all seem to mark its ambitious nature. There is also perhaps a deliberate retreat from Madame Vigée-Lebrun's too intimate portrait of Marie-Antoinette 'en Gaulle' – in light dress, simple hat, and holding a rose – which had been considerably criticized for lack of decorum at the Salon of 1783.

It is inevitable to connect Madame Vigée-Lebrun with the queen, yet in many ways this, as such, is the least interesting aspect of her career. Her own *Memoirs* give some account of her early years and artistic training, at first under her father, Louis Vigée. Vernet, she records, advised her to study the Italian and Flemish masters but above all to follow nature. This she did, with many a glance back not only at Rubens and Van Dyck, as well as Greuze, but at Domenichino and perhaps also Reni. Although she proved capable of surprisingly competent male portraits (e.g. *Calonne*, dated 1784, Royal Collection), it was portraits of women which brought her greatest fame. She may not have initiated the new fashion for simplicity in dress, but she followed it for herself and other female sitters. She encouraged a concept of nature which dispensed with wigs and formal clothes, and which emphasized feeling rather than thought. There is an increasing tendency towards sentimentality, but also an effort to achieve something spontaneous-seeming in pose, now liable to strike the spectator as merely arch yet meant to be natural. Her women are usually idle or maternal – but certainly never intellectual (no wonder her *Madame de Staël* (1808, Geneva) is so ludicrous). For d'Angiviller she

painted herself about 1789 in a Greuzian transport of maternity with her own daughter (Louvre), and with a more marked neo-classical flavour than had appeared before in French portraiture (Plate 189). It is a mood quite foreign even to David's portraits before the Revolution.

Vigée-Lebrun is probably to be credited with having mixed a wide variety of sources – including possibly English mezzotints – to produce a new style of portrait in France. In her handling of paint there are indications also of novelty – at least, a breakaway from the Roslin–Duplessis facture – with touches of sketch-like spontaneity, which do perhaps derive from David. In one way it is a pity that she left France at the Revolution; the Empress Joséphine would have been an admirable subject for her brush, and the result might have been something of a masterpiece.

Genre: Aubry and Boilly

Too sweeping a generalization about a pervasive neo-classical or even 'historic' artistic climate in the later years of the century remains unjustified – from the point of view both of the period and of individual patrons. Even d'Angiviller's undoubted eagerness to encourage noble history pictures was partly *against* the general climate, as he came to recognize. In 1787 Pierre reported to him about the prospects of that year's Salon, 'les portraits et les genres étoufferont un peu l'histoire'. And he added, 'cela est la marche de toutes les écoles; l'on prétend qu'il y a plus de cent Français à Rome, tous paysagistes'. When the following year d'Angiviller explained to Pierre his distribution of commissions, he tacitly recognized the situation; he wished to give history painters the specific opportunity to produce work – otherwise, 'il est à craindre que, vû nos mœurs actuelles, les expositions prochaines ne nous présentent plus que des tableaux de chevalet'.[55]

D'Angiviller, it could be argued, had not only a hopeless task but one at times even harmful. His protégé, Aubry, a gifted genre painter (whose work of that kind was in d'Angiviller's own collection), was encouraged by him to attempt history pictures, and failed dismally. Outside Paris, genre and portraiture remained the chief categories of picture in demand. Even if masterpieces were seldom produced, the results were often more agreeable than any except the finest history pictures (Vernet had once told d'Angiviller, 'avec la superiorité et la franchise d'un grand homme', that his pictures were better than most history pictures; the source for this is a letter of d'Angiviller's to Vien, in 1790.) Unexpected minor works of delightful art could be painted, like the *Atelier des Couturières* (1760?, Musée d'Arles) (Plate 190) by the arlésien Antoine Raspal (1738–1811), which has quite Sunday-painter intimacy and charm.

Perhaps down in Arles Étienne Aubry (1745–81) would have lived longer and more happily.[56] He was trained in Paris under Vien, and d'Angiviller early showed a special interest in his career. Although Greuze is usually claimed as the prototype for his studies of single heads and small genre scenes (he also executed some portraits), Aubry had more in common with Lépicié. His delicate talent was at its best in unexaggerated, unaffected, family scenes such as *L'Amour paternel* (Barber Institute) (Plate 191), lent by d'Angiviller himself to the Salon of 1775. If there is sentimentality in that picture, it is so slight as not

to matter. The tone is unforced. There is no weight of anecdote, but instead a delicacy which extends from deft observation to the actual handling of the paint. Two years after it was painted, Aubry was sent to the French Academy at Rome, but he seems to have been unhappy there, and d'Angiviller's ambitions for him were doomed to disappointment. His wife had died; his health was not good; his talent was forced towards subjects for which it was not suited. In place of a simple modern family scene he now attempted the antique one of *Coriolanus taking leave of his Wife* (lost?). This apparently unsatisfactory effort appeared at the Salon in 1781, the year of Aubry's premature death.

As mere postscript, to carry genre successfully into the following century, Louis-Léopold Boilly (1761–1845) should be mentioned if not seen. His countless over-polished little pictures – whose handling suggests study of Terborch and Metsu – can be appreciated in much the same way as Baudelaire appreciated the fashion plates of the Revolution and the Consulat. Boilly was indeed better attuned probably to costume and décor than to people. Born near Lille, he arrived in Paris in 1785 but did not exhibit at the Salon until 1791. Under suspicion during the Revolution, he hastily painted a *Triumph of Marat* (Lille). Iconographically more interesting pictures are his views of two artists' ateliers: *Houdon modelling the Bust of Laplace* (1804, Musée des Arts Décoratifs) and the *Studio of Isabey* (Louvre, Salon of 1798). His most typical genre scenes sometimes catch an echo of Greuze but are more trivial and insipid than the eighteenth century ever encouraged. He seems ready – even before it came – for the world of Louis-Philippe.

Suvée, Peyron, Vincent, Ménageot – David

'Enfin David vint,' one is tempted to write, in an attempt to clarify the pattern of painting – especially history painting – in the last years of the *ancien régime*. That is certainly how it strikes posterity – but in pre-1789 Paris the issue was not yet so clear-cut. Apart from the older generation, represented at its oldest and most distinguished by David's own master, Vien, there were those close contemporaries of David who also received official, 'national' commissions and who no less prominently appeared biennially at the Salons. Although their work has – unlike their reputations – survived, it has been little discussed and not much reproduced. Yet at the Salon of 1789, the spectator would have seen large subject pictures by not only David but the Flemish born Joseph-Benoît Suvée (1743–1807), Jean-François-Pierre Peyron (1744–1814), and François-André Vincent (1746–1816) – probably the best, as well as the best-known, of this trio.[57]

In 1771 Suvée had gained first prize at the Académie, in competition with David. From 1772 to 1778 he was in Italy, developing his rather chilly, insipidly gracious style, with probably a good many side-glances at Mengs as well as at Raphael and Antiquity. Religious pictures remain his most typical productions; no less than four were shown by him at the 1789 Salon, as well as some portraits. Peyron too had defeated David at the Académie *concours* in 1773. He was indeed a much more serious rival than Suvée, being altogether a better painter. He was also much more seriously concerned with Antiquity

and severe antique subject matter. When Vien was appointed Director of the French Academy at Rome in 1775 he took Peyron with him, along with David. D'Angiviller, like Vien, thought highly of him, and David himself confessed a debt to his pioneering interests in Antiquity and Poussin. Peyron's *Alceste mourante* (Louvre) (Plate 192) was much admired at the Salon of 1785, two years after his return from Rome. 'Je me plais, je l'avoue,' wrote d'Angiviller in a letter to Cochin after the Salon had closed that year, 'à voir en lui [Peyron] un homme réellement fait pour être distingué.' This was warmer reaction than he displayed in the same letter towards David, about whom he hoped merely that he would not be harmed by either small-minded criticisms or 'les éloges, peutêtre exagérés,' which he had received.[58] In 1789 Peyron exhibited another death-bed, that of Socrates, 'pour le roi', but the end of the *ancien régime* marked the end of his own career. He lived on, yet remained apparently inactive.

Only two years older than David, Vincent enjoyed much earlier successes. In 1768 he was acclaimed as winner of the *premier prix* at the Académie. Little is known of his student years at Rome, but in 1777 his first appearance at the Salon led critics to speak of him as an artist 'qui vise aux grands effets . . .'. The *Mercure* prophesied: 'Il ira loin.' At the Salon of 1779 his *Président Molé stopped by Insurgents during the Fronde* (Chambre des Députés) (Plate 193) rightly caused a stir. It is a history picture of unexpected veracity and vigour, showing marked ability by the painter to project himself imaginatively back into French history. As much as any antique subject, it shows too a brave hero, aged, unarmed, fearless, and morally indignant before mob rule.[59] It seems one of the best products of d'Angiviller's national programme, so much more effective than Vincent's neo-classical *Zeuxis choosing Models from the Most Beautiful Girls of Crotona* (Louvre), a similar official commission, exhibited at the Salon of 1789.[60] This abrupt return to the world of his master, Vien, is almost a confession of vacillation. Vincent's vigour and nearly brutal realism had grown emasculated in the very year that David showed the harsh drama of *Brutus* (Plate 200). Accidentally or not, it was the latter which better suited the mood of the period. And Vincent's great promise faded away; his few later pictures are tame.

One final possible rival to David did not exhibit at the 1789 Salon partly because he was away in Rome, having been appointed two years previously director of the French Academy: François Ménageot (1744–1816). The pupil of Boucher and Deshays, Ménageot is remembered – if at all – for the *Death of Leonardo da Vinci* (Amboise) (Plate 194), which was a great success at the Salon of 1781. As a subject from French history, and indeed as a deathbed, it had been preceded by Brenet's *Du Guesclin* (Plate 158), but it is an early example of that category of artists' last moments which was to become so popular for pictures in the following century. It is more intimate and touching than Brenet's medieval scene; the French Renaissance and François I, being better documented, are also better evoked. It too, of course, was part of d'Angiviller's scheme – and it may serve as yet another testimony to the patriotic–historical basis of that scheme. In both subject and style Ménageot's picture is very different from David's 'hard-edge' neo-classicism. At the Salon of 1785 he was indeed to be eclipsed by David, but his professional career seemed unaffected. D'Angiviller continued to give him official

commissions and Ménageot was poised to astonish and touch the Parisian art-world with a new painting, a *Meleager*, when the Revolution broke out. The hectic last years of the century he prudently spent in Italy, thus leaving the stage yet clearer for David's domination. With the establishment of the Revolution David was established.

Jacques-Louis David was born in Paris in 1748. He did not die until 1825, by which time he could have seen Géricault's *Radeau de la Méduse*, Delacroix's *Massacre de Scio*, and Constable's *Haywain*, had he not been living in Brussels in virtually self-imposed exile since 1816. David's career is a complicated story in several chapters – *ancien régime* painter, republican official, court artist to Napoleon – with an epilogue of being left working 'à sa volonté'. Of this fluctuating narrative, still in need of being scrutinized and set down at length, only the *ancien régime* chapter can be touched on here. Unfortunately these are the very years about which least is clear, notably about David the man. In many ways he remains an elusive personality; yet in that very elusiveness there is perhaps something significant: something waxlike and highly susceptible to widely different impressions until stamped with the seal of Napoleon. Although later to be hailed constantly as the reformer of the French school, the restorer of correct principles, David was to grasp this role only slowly. He never achieved total artistic consistency – and in that perhaps lay his best proof of talent, as painter and as teacher. Lack of coherence of a similar kind probably accounts for the slow and uncertain steps of David's early career. He is not always an easy artist to understand, and it may be doubted if he ever quite understood himself.

As a boy he was passionately interested in drawing and in little else. His widowed mother took him to Boucher, a relation of hers, who recommended Vien as a good teacher. This was perceptive advice. Vien became David's master and, it is not too slick to say, a second father to him. Ambitious but hot-rather than clear-headed, David needed someone to control what Vien called his 'trop grande sensibilité'. From 1769 to 1774 he was competing for prizes at the Académie. His *Combat of Mars and Minerva* (Louvre) lost to Suvée's version in 1771; his *Death of Seneca* (Petit Palais) to Peyron's in 1773, though in that year he received the Caylus prize for an expressive head (*La Douleur*; École des Beaux-Arts).

Not until 1774 did he at last gain the *premier prix*, for *Antiochus and Stratonice* (École des Beaux-Arts). It is fortunate that these three early paintings have survived, because they reveal affinities that might not be expected. All are much more forceful than anything by Vien. They show no interest in developing the bas-relief composition and neo-Poussinesque air of Greuze's *Septime Sévère*. Among contemporary French painters, Doyen and Deshays seem much more potent influences and, rather than Vien, it is Boucher – the vigorous Boucher of work like *Neptune and Amyone* (Versailles) – who is recalled by passages in all three pictures. Compositionally, that actual picture seems to lie behind the *Combat of Mars and Minerva*. The *Death of Seneca* (Plate 195), the best picture of the three, suggests even closer Baroque connexions, especially with Solimena, a painter whom Doyen is recorded as having particularly admired, and Doyen early took a personal interest in the young David. The *Death of Seneca* – for all its Baroque properties of braziers and looped curtains – belongs to the ethos of David's mature work. Its

grimly noble masculine subject suits him, to begin with. A thundery sense of drama smoulders behind it – and even the device of concealing the hero's torso in shadow anticipates the figure of Brutus in the Salon composition of 1789. Indeed, the whole picture is much bolder than the possibly more 'correct' *Antiochus and Stratonice*, where as an influence Solimena seems receding, to be exchanged for Le Sueur. This does not mean that David had become converted to neo-classicism, but it establishes his growing awareness of another pole – which may be called *Poussinisme*, idealism, rationalism, neo-classicism – between which and contrary elements of *Rubénisme*, naturalism, emotionalism, Baroque verve, he would never quite cease oscillating.

By temperament, we may guess, he was instinctively attracted to the latter qualities. Too much ardour in the man, too much red tonality in the work: such were typical early official criticisms recorded in the exchanges between Rome and Paris during Vien's directorship of the French Academy in Italy.[61] In his work, at least, David soon recognized the need for control. We cannot call it an explicit programme, for there is no direct evidence, yet he may have felt it was his destiny to unite *Rubénisme* and *Poussinisme*, to produce an art which would bring together conflicting tendencies of the century: to be at once intensely natural and supremely elevated, passionate in content, yet meticulous in form, a lesson in morality but also great purely as painting.

The year after David had won first prize for the *Antiochus*, Vien was appointed Director of the French Academy at Rome. David travelled there with him, and in the subsequent five years spent at Rome 'discovered' classical Antiquity. Although this is true on the surface, there was more to David's discoveries. Appeased partly by his eventual student success, he was now eager to undergo discipline by constant drawing and by studying anatomy. It was not only Trajan's Column that he drew but compositions by Ribera, Caravaggio, and Veronese. He was still seeking, in effect, a style. Later he was to pay tribute to the antiquarian theorist, Quatremère de Quincy, for revealing Antiquity to him, but Peyron's neo-Poussinist tendencies seem more apparent in the first classical pictures which resulted from these Rome years. In fact, other painters probably meant more to him than Antiquity as such. Certainly the influence of Gavin Hamilton (whose work had earlier been specifically reported about in France)[62] was very real, in composition as well as subject matter. Batoni's handling of paint – smooth and quite free of any tendencies towards 'trop de rouge' – also affected his technique. These were still apprentice years for David, when he was forging not so much a single style as a dogged competence, in itself greater than any his rivals would achieve.

When he exhibited at the Salon in 1781, having been *agréé* earlier that year, it was in a variety of styles, with varied subject matter. This was the last exhibition to be reviewed by Diderot, and the occasion is one when history fully lives up to romantic expectations. Unfair to Boucher, too optimistic about Greuze, somewhat reserved over Vien, Diderot deserved to see the last high hope of the French school make his début – and to greet with perceptive enthusiasm *Belisarius receiving Alms*, *St Roch interceding with the Virgin* (Marseille), *The Obsequies of Patroclus*, *A Woman suckling her Child*, and *Count Potocki* (Warsaw) (Plate 196). 'Superbe . . . beau . . . bien dessiné . . . nobles et naturelles' (important conjunction): with such adjectives Diderot praised each picture, whether

sketch, large-scale history, or portrait.[63] He did not, it is true, go on to prophesy David's future greatness, but it was already inherent in this group of paintings – of which *Potocki* alone is a masterpiece. That shows David's rapid response to a glamorous sitter, and his ability to respond with Rubensian *fougue* to the implicit *fougue* of the subject. Richly coloured and richly painted, it contrives to suggest sparkling eye-witness spontaneity, in piquant contrast to the measured gravity of the *Belisarius*, itself so much more deeply serious – and better painted – than most previous French history pictures in the century.

In its very restraint *Belisarius* (Lille) (Plate 197) may be claimed to be more effective than some of David's own later pictures, being considerably closer to Poussin than the oddly fussy *Andromache mourning Hector* (his *morceau de réception*) of 1783 (École des Beaux-Arts). The emotional repercussion of the incident across the composition, the scale of figures to the architecture – and the use of this too to gravely weight the picture emotionally – all look forward to the achievement of the *Serment des Horaces*. This is David the creator of an ideal world of stern but poignant Antiquity, intensely realized (as in the almost hallucinatory clarity of the steep pavement in *Belisarius*) and conveyed as intensely important. Some moral lesson seems intended by *Belisarius* – perhaps several. What is undoubtedly mingled is the sense of state and individual: here personal charity, however kindly, will not remove the shocking wrong done to the great soldier, what Lemprière (1788) was to call 'the trial of royal ingratitude', which had already been popularized by Marmontel. ('Ah, mon ami, le beau sujet manqué,' sighed Diderot in a letter to Falconet, when Marmontel's *Bélisaire* first appeared.) David persuades us that he is taking the story seriously, probably in more than artistic terms. Certainly he establishes a reality artistically no less 'real' than the actual living fact of Count Potocki. Thus he is equipped to serve both as the history painter long desired by the century and as one of its greatest portraitists. From *Potocki* descend the *Leroy* (1782–3, Montpellier) and *Lavoisier* portraits (New York, Rockefeller University) (Plate 199) and eventually *Napoleon in his Study* (1810, Washington); from *Belisarius*, not only the *Horace* and *Brutus* but the peculiar state and personal concerns which mingle at the very centre of that reconstructed history, the *Crowning of Josephine* (the so-called *Sacre*; 1805–7, Louvre) and give it memorable intensity.

Although the period between *Belisarius* and the *Horaces* (exhibited at the Salon of 1785 and now in the Louvre) was quiet compared with the agonies and ambitions which had made David literally ill in Rome, it was marked by almost yearly increases of confidence. He married, became a full member of the Académie, started to acquire the first of his vast number of pupils, and received from d'Angiviller an official commission for a picture, 'pour le roi'. After some uncertainty about which incident in the story of the Horatii to select, David chose that where the three brothers unite to swear to die if necessary in defence of their country.[64] He returned to Rome to finish the picture, on which his favourite pupil, Jean-Germain Drouais (1763–88), collaborated to a slight degree, and it was finished and enjoying celebrity there in the summer of 1785. Much has been written recently about this famous picture which consolidates David's artistic revolution and which is perhaps touched also with hints of the Revolution (Plate 198).

The programme into which it fitted was a national patriotic one, focused neither on ancient nor on modern royalty but on the concept of the fatherland. To speak of a republican air about the picture is not to be anachronistic or to suggest that David was in 1785 secretly plotting the overthrow of the monarchy. It may be pedantically inaccurate, because the Horatii had lived in the time of kings at Rome, but the inaccuracy is one first perpetrated by French critics in 1785: 'l'on se voit transporté aux premiers tems de la République Romaine', was the comment of the *Journal de Paris* (17 September 1785). Since the government of Louis XVI was in warm alliance with the American Republic (and in 1785 Mouchy exhibited at the Salon his project for a Statue of Liberty, flanked by Franklin and Washington with drawn sword), David would be sustaining no very dangerous analogy if he intended the *res publica* of France to be understood by his Roman subject matter. He merely urges unity, brotherhood, and inequality for women (reduced to swooning grief). It may be said that nothing has been discovered to prove David was a revolutionary *avant la Bastille*. However, nothing suggests that he was ever pro-royal, and it would be astonishing if, at the age of forty-one, he became the committed revolutionary which he undoubtedly did without having ever previously reflected on events in the uneasy years which preceded the Revolution itself.[65] Indeed, we have Madame Vigée-Lebrun's testimony that David much disliked court people[66] and Drouais' scoffing references in letters to him about the conservative element they called 'les perruques'. Though David himself was writing particularly about his own decision to paint the *Horatii* on a scale larger than customary for official royal commissions, there is a ring of independence in his declaration (in 1785): 'j'ai abandonné de faire un tableau pour le Roi, et je l'ai fait pour moi'.[67]

What cannot be doubted are David's revolutionary views about the Académie Royale – perhaps more pertinent in the long run than his purely political opinions. Fragonard and Clodion had quietly removed themselves from the academic structure, just as had Greuze for a different reason. David actively challenged it; and only to the obstinately naïve will it appear an accident that his rebellion was supported by Pajou and Madame Labille-Guiard, themselves proving warm supporters also of the Revolution. Like the régime, the Académie hesitated, proving neither truly firm nor truly flexible. David's subsequent success, after being ejected by it, confirmed its loss of value. Academic attitudes to teaching, restrictive concepts of nature, the regulations governing admittance to the Salon: these are just tokens of David's active dissatisfaction with the idea of art being codified and regulated. The evidence of Delécluze provides a convincing view of David as a teacher with the widest possible artistic sympathies – not at all a figure forcing neo-classical doctrines on his extremely heterogeneous assortment of pupils.[68] It should not be forgotten that Gros was among them, as well as Ingres.

It is worth emphasizing the violent and revolutionary – if not doctrinaire Revolutionary – aspect of David not only because this aspect links him to the artistic rebels of the subsequent century but because his increasing intransigence before the whole *ancien régime* system proclaimed its unsuitability for dealing with artistic genius. Not since Puget had an artist confronted the system so aggressively.[69] The eighteenth century had regularly called for artistic reforms, but before David no one had welded personal,

artistic – and possibly social – reformatory zeal into a positive weapon. Something intransigent and agate-hard burnishes the steely tableau of the *Oath of the Horatii* and gives it that edge of 'difference' which so excited the earliest spectators of it. The neo-classicism in which this difference is clothed is probably largely an accident: it happens to symbolize the extreme to which David was driven at that moment of historical taste. At another period, when neo-classicism was the established current style, he might well have expressed *his* revolution by an equal insistence on the natural and actual – by painting, one might say, his own *Radeau de la 'Méduse'*. The 'realism' of the *Horatii* is indeed more marked than its classicism: it is forcefully primitive and almost brutally clear in composition and application of paint – and less mannered than the later *Brutus*. David never had an artistic programme which went further than that quoted at the beginning of this book and formulated at the beginning of the century by Antoine Coypel: 'il faut joindre aux solides et sublimes beautez de l'Antique, les recherches, la variété, la naiveté et l'âme de la nature'. But he had the ability to redefine this in moral terms, and to paint with an intensity beside which the pictures of Coypel must shrivel.

David's proposed showing at the Salon of 1789 – itself a vexed point of scholarly discussion – reveals the continuing twin current of his mind: 'l'âme de la nature' in the Lavoisier double portrait (New York, Rockefeller University) (Plate 199) and 'sublimes beautez de l'Antique' in the *Lictors bringing Brutus the Bodies of his Sons* (Louvre) (Plate 200). As it happened, the Salon opened without either of these pictures, and at first David was represented only by the insipid *Paris and Helen* (Louvre), specifically commissioned by the determinedly libertine, royal Comte d'Artois. Despite at least one recent attempt to prove the opposite, it is a fact that the pictures for the Salon which opened after the fall of the Bastille were censored so as to avoid exhibiting anything likely to disturb the public.[70] The name of the Comte d'Artois was thought best suppressed. Lavoisier, in his role as Fermier-Général not as chemist, was also thought a provocative subject and his portrait did not appear. Since it had been finished and paid for in 1788, it is obviously not the picture under discussion in August 1789, when an underling of d'Angiviller's expressed to Vien his relief that the 'tableau de M. David' was 'loin d'être achevé'. This latter was the *Brutus*. Its grim subject was patently thought disturbing,[71] though it did eventually enter the Salon and achieved a success.

The Lavoisier portrait was probably commissioned through Madame Lavoisier, herself a painter and an ex-pupil of David. She is of at least equal importance with her husband in the composition, which celebrates the marriage of their minds – not in some sentimental pose *à la* Vigée-Lebrun, but through careful natural gestures and the recording of the chemical apparatus in which both were deeply interested. A drawing by Madame Lavoisier shows her taking notes during one of Lavoisier's experiments;[72] in David's picture, it is Lavoisier who seems almost taking dictation from her. The picture is imbued with unaffected rationality, optimistic about human nature, affection, and scientific knowledge. Its detailed depiction of a shared life – being at once genre and portraiture – makes it a quintessential product of its century. From its contented, intelligent domesticity to the domestic tragedy of the *Brutus* is an abrupt shift of mood,

yet the *Brutus* too is quintessential to the century's demand for pictures to affect people.[73]
It is indeed among the very subjects La Font de Saint-Yenne had recommended to
painters in 1754 (*Sentimens* . . .): Brutus condemning his sons 'à périr pour avoir appuyé
la tirannie de leurs Rois, et les immole à la liberté de sa patrie'. It offers no optimistic
solutions. It suggests that reasons of state can destroy a family, that mercy is weakness,
and it asks us, by implication, to admire the stoic patriot who had his sons killed for
siding with the expelled tyrant, Tarquinius. Extreme to the point of irrationality, it is
the century's own revenge on itself for having once been civilized with Watteau and
titillated by Boucher. The small private virtues tacitly praised by Chardin are replaced
by a grand public piece of heroic fortitude. It was David who once again selected the
theme, having rejected Coriolanus and Regulus, subjects elevated yet insufficiently
bloody, for Coriolanus' resolve weakened at the pleading of his family and Regulus
sent no one but himself to death.

The ethos adumbrated by the *Brutus* is connected less with the Revolution than with
Napoleon. *Marat assassiné* (1793, Brussels) is a masterpiece, a shock which is the cen-
tury's shock at humanity betrayed, but the hero is dead. Not until he painted Napoleon
in 1800, 'calme sur un cheval fougueux' (Versailles) (Plate 201), did David synthesize
actuality and dream, rational portraiture and an idealized all-conquering aura – in an icy
climate and on a peak raised far above any even Louis XIV had scaled. This portrait has
figured in at least one romantic exhibition; in its idealism, its conscious re-arrangement
of the natural, it might be admitted to a neo-classical exhibition, despite its hero's contem-
porary costume. And its message is 'into battle'. Patriotism is defined as aggression. As
stoic as Brutus, Napoleon orders death for those who oppose him. The fatherland de-
mands blood, as the *Horatii* and the *Brutus* prophesied it would.

With David, painting is passing out of any recognizable eighteenth-century world.
His later career belongs in other books on other periods of art history. Just as his early
years were spent amid talents once thought as promising as his, so in maturity he was
increasingly not alone. Although not perhaps estimated as much of a challenge for most
of the period, the existence of Pierre-Paul Prud'hon (1758–1823) certainly causes posterity
to reflect. He is more than a decorative alternative to David: wayward, poetic, capable
of memorably sensitive portraits (e.g. *Georges Anthony*, c. 1796, Dijon), he refuses to be
neatly categorized. Among the many shrewd acts of Napoleon, not least was his selec-
tion of Prud'hon to serve his two empresses – and well were they both served by his
portraits and decorative schemes. David's most gifted pupils too were beginning to show
their own individual abilities. In 1789 Anne-Louis Girodet-Trioson (1767–1824)was the
winner of the first prize at the Académie and reached Rome that year. Soon he was to
be joined there by the precocious François Gérard (1770–1837), of whom Brenet re-
ported already in Paris 'né pour faire quelque chose, mais donnant dans la mode de
David et n'écoutant pas son maître'.[74] Jean-Antoine Gros (1771–1835) too would soon
be there, a great if flawed painter, whose genius was instinctively understood by Géri-
cault and Delacroix. That none of these three leading pupils of David can properly be
described as 'neo-classical' is a last reminder that that word is no torch to guide us
through the darkening complex wood of late-eighteenth-century France. Yet that is a

wrongly emotive description of what at first sight seemed the final reform, and the final revolution, in a century which had made such constant efforts to relate art and life.

In the Salon *livret* of 1791 the Assemblée Nationale had replaced the Comte d'Angiviller on the title page. It was not the occasion for printing a Cochin-style preface about the 'puissante protection d'un monarque'. No longer did the strict regulations of the Académie prescribe which artists might be allowed to exhibit; the Salon was open to all. A strange summing-up it may well seem, too optimistic about the future and too biased in its rejection of the past, when we read the words which introduced that year's vast Salon, an epilogue on the old and would-be prophecy for a bright new world: 'Les Arts reçoivent un grand bienfait; l'empire de la Liberté s'étend enfin sur eux; elle brise leurs chaines; le génie n'est plus condamné à l'obscurité.' What was ushered in proved not quite so straightforward. But with this new 'liberty', the arts under *ancien régime* conditions had certainly come to an end.

PART TWO

ARCHITECTURE

BY WEND GRAF KALNEIN

THE END OF THE STYLE LOUIS XIV

Introduction

FOR France, the start of the eighteenth century coincided with the end of an epoch. The Sun King's reign had passed its zenith. After unparalleled military and political successes the edifice created by the ambition of Louis XIV and the skill of his statesmen began to crumble. The War of the Spanish Succession shook the country to its very foundations. The change in the intellectual climate and the increasing criticism of abuses in the Church and at the court began to undermine the social order too. While a small body of military contractors made huge sums and ostentatiously displayed their wealth, the lower orders, who had to suffer most under the burdens of war, began to grumble openly. 'On ne vit plus que par miracle', wrote Fénelon – who, as tutor to the Duc de Bourgogne, was close to the throne – at the beginning of the new century. The elation of the period under the young Louis XIV was followed by deep depression under the ageing king.

At the court itself the change only made itself felt, it is true, in Louis XIV's last few years. After the Treaty of Ryswick in 1697, when a short period of peace allowed the country to breathe again, a gay life had once more begun with the young Duchesse de Bourgogne. The king's passion for building had flared up again too. The current, temporarily suspended building programmes in Paris – the Place Vendôme and the Dôme des Invalides – and at Versailles were completed, and a start was made on the new château of Meudon and the remodelling of the choir of Notre-Dame in Paris. It was only under the increasing burdens of the War of the Spanish Succession, and especially after the years 1711 and 1712, when a series of deaths carried off the dauphin, the Dukes of Burgundy and Berry, and the Duchess of Burgundy herself,[1] that life at Versailles lost its splendour. Then certainly a general exodus did begin. All those who could manage it tried to get away from the huge palace, now desolate, and from its oppressive ceremonial, to the intimate circles round the Duc d'Orléans and the Duchesse du Maine, but above all to Paris, where new intellectual and artistic centres were forming.

The new taste which came to prevail in the Parisian salons had been making its way into court circles since the end of the seventeenth century. People had grown tired of pomp and of continually behaving as figureheads. The king himself preferred the more intimate life at the Trianon and Marly to the marble halls of Versailles. With the rise of the younger generation, whose leading representative was the dauphin, a new spirit entered art. Lighter, more graceful forms ousted the classical, academic ones in architecture; more attractive themes borrowed from Italian comedy, from the grotesques, and from the huntsman's and the shepherd's life replaced mythological imagery. The

gods came down from Olympus and assumed human features. In a public speech the court painter Coypel demanded that the 'grand goût' should be made more flexible by 'grâce'.[2] This was the catch-phrase that was to govern future developments – 'la grâce'. In accordance with the pattern set by Jules Hardouin Mansart in the Trianon, at Marly, and at Meudon, comfort, elegance, and grace moved into architecture. The heavy apparatus of forms of the Louis XIV style was dismantled; 'grandeur' and 'magnificence' were succeeded by 'simplicité' and 'variété', by which was meant simplicity outside and nicely balanced variety inside.

Contemporaries were perfectly conscious of this change in style. The description 'goût moderne' was already in use in the first few years of the eighteenth century,[3] and this phrase was intended to imply a disparagement of the previously prevailing style, even though the royal garden châteaux of Trianon and Marly long remained the admired models. At first 'moderne' meant a less formal interior, light wall decoration predominantly in white and gold, and a practical arrangement of the plan. Greater freedom in the treatment of the façade was only the secondary phase. However, this development did not take place in opposition to the Académie and prevailing theory; it was universally welcomed as an innovation in the best of taste and regarded as a sign of progress. The ideals of the *grand siècle* paled with increasing speed as the centre of gravity gradually shifted from Versailles to Paris. By the time Louis XIV died the style of the Régence was already firmly moulded; there was no clear break. On the contrary, the *style moderne* runs in a straight, slowly ascending line from its beginnings round the turn of the century to the Rococo. However, since just about the time of the change of government the arrival on the scene of a new generation of architects brought a noticeable enrichment of the ground-plan and a new use of ornament, we are justified in treating separately the period from 1700 to about 1715, which was particularly keen on systematizing the plan and making interior decoration less formal. In spite of the unhappy political circumstances which plunged France from the summit of her power, this was artistically one of the most creative periods of the eighteenth century, a period which saw not only Boffrand celebrating his triumphs in Lorraine, and Paris discovering a new domestic style, but also the creation of a new style of decoration which can be reckoned among France's finest and most characteristic achievements.

The Art of the Court up to the Death of Louis XIV

Up to the beginning of the eighteenth century the court had been the leading influence on French architecture. The royal Office of Works, the 'Service des Bâtiments du Roi', was responsible for official building enterprises and trained the architects who pioneered new developments. With the economic decline of France all this changed. Exhaustion of finances had already led once before, during the War of the League of Augsburg, to the temporary suspension of building. The destructive course of the War of the Spanish Succession forced the king once again to renounce any building operations. Nevertheless, work in progress, in particular the Dôme des Invalides and the chapel of Versailles, was completed and a start was made on the Château Neuf of Meudon. After

that, however, the activity of the Bâtiments gradually declined. It was confined to decorative tasks, the most important of which was the remodelling of the choir of Notre-Dame. The royal architects, no longer fully occupied, devoted themselves more and more to private practice, so that in the end, while work at Versailles was suspended, in Paris there was an unexpected upsurge of private building. The centre of gravity moved away from the court to the aristocratic and bourgeois world, and for nearly forty years the Crown gave up its leadership in architecture.

Jules Hardouin Mansart did not live to see this decline in energy. When he died in 1708 the Château Neuf (Figure 1) at Meudon (1706–9) was just being built.[4] This last work of his, which was designed as a guest-house for the dauphin, showed once again his modernity and that wonderful feeling for contemporary requirements which had made him great. The façades – different in height and differently articulated as a result of the difference in levels – were distinguished, in accordance with the new taste for the decorative, by elegant and richly adorned balconies, brackets, and keystones, while on the garden side the articulation was concentrated in a giant order in the middle section, beside which the walls were kept noticeably light and without any division into storeys. The motif of the giant order had been employed several times by Mansart in his later work, on the last occasion as a picturesque backcloth in the Royal Pavilion of Marly.[5] Meudon was probably based on the façades of the Place Vendôme – I am thinking of the cut-off corners and the middles of the long sides – which have the same mouldings, bases, and window entablatures, even if there the giant order rests on a ground floor treated as a podium. A little earlier the château of Lunéville had been built, where Boffrand had used the same order. Even though, in view of the master-pupil relationship between Mansart and Boffrand, a transmission of ideas is perfectly possible, the Lunéville portico, with its free-standing columns, differed radically from the attached three-quarter columns at Meudon, and the intellectual background of the two architects was also quite different. Thus if we are confronted here with a common feature it can only be understood as the result of a general tendency.

The plan likewise displayed some very modern features. The long corridors gave access to a series of uniformly planned guest suites, each consisting of three rooms: bedroom, *cabinet*, and dressing room. These 'living units', which took account of the individuality of their occupants and allowed each of them a personal, secluded sphere of his own, had already been employed by Mansart at Trianon-sous-Bois, the wing of the Grand Trianon intended for the princesses and ladies-in-waiting, though less systematically, it is true, and on a smaller scale. They all had, as an innovation, a bed-alcove, as introduced for himself by the dauphin as early as 1699 in the alterations to the château itself; this brought a great saving of space. The Appartement du Roi, the only show apartment in the château, with its grandiose, two-storeyed vestibule and its stair-case, certainly stuck completely to tradition, but the gallery, at Versailles and Saint-Cloud still the most important display room, had become a rectangular hall inserted crosswise near the end of the wing between *chambre de parade* and *cabinet*, and the two last studies were even provided with low ceilings and entresols. This departure from 'magnificence' in favour of 'commodité', this tendency to habitability and intimacy,

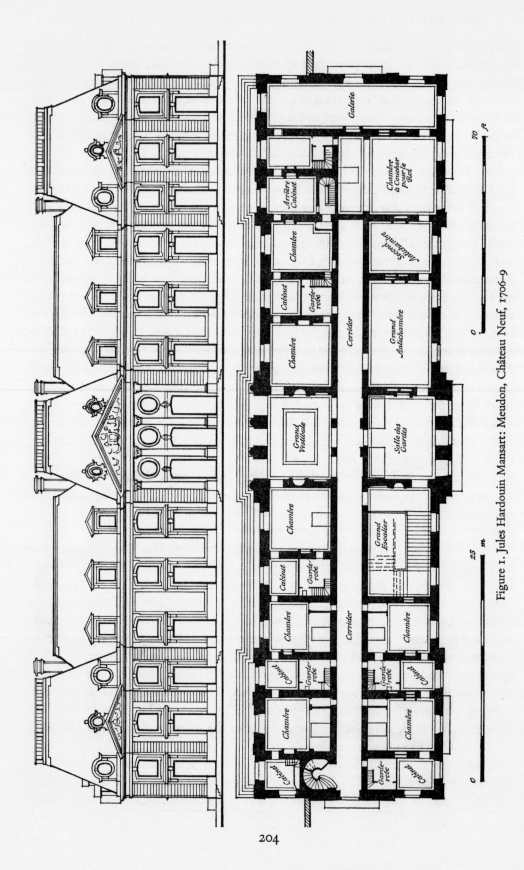

Figure 1. Jules Hardouin Mansart: Meudon, Château Neuf, 1706–9

was characteristic of Meudon. The dauphin had already demonstrated his modern views, which differed from those of the king, during the rebuilding of the château itself and during the construction of the wing known as the Aile des Maronniers in 1702, with its 'petit appartement de Monseigneur'. His influence is also unmistakably present in the Château Neuf, even though the old king himself had commented on and approved the plans.

Mansart's last big church, which was built in the same years, was not commissioned by the Crown. The cathedral chapter of the primatial see of Lorraine at Nancy, which was planning a big new building, turned to Mansart with the request that he should complete the plans.[6] The work had already been started in 1699 by Giovanni Betto,[7] an Italian who had settled in Lorraine, and Mansart had to stick in principle to his plan, a basilica of nave and aisles with a dome over the crossing and a façade with two towers. However, Mansart altered this plan to the extent that the frontal towers and the ends of the transepts were drawn into the rectangular block by the addition of a series of chapels, so that a unified outline was created (Figure 2) and the interior, through a reduction of the nave and choir bays (though the total length was preserved), gained in unity, width, and size. Building was continued in accordance with this design, which was delivered to the chapter in 1706 by Lassurance, with Betto directing the operations until his death. By 1719 the church was complete except for the dome and the upper part of the façade; but then a tragedy began to unfold which ruined Mansart's plan.[8]

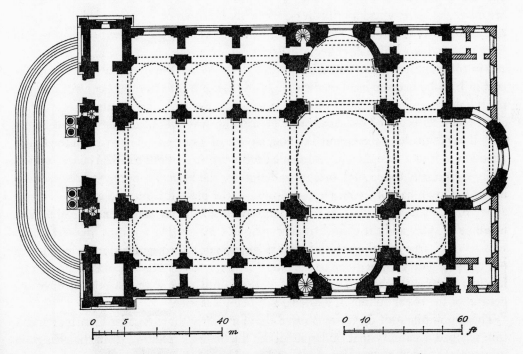

Figure 2. Jules Hardouin Mansart: Nancy, Primatiale, 1699–1736, plan

The interior ranks among the most splendid examples of French classical church architecture and far excels contemporary Parisian churches. The crossing and the drum recall those of the Invalides; it was precisely the centralizing tendency that was strongly emphasized by the enlargement of the circular chapels already planned by Betto between the nave and transepts and by the curved ends of the latter. The façade (Plate 202), in accordance with Mansart's design, was a development of Notre-Dame at Versailles, with substantially stronger Baroque features than the Invalides. The columns, which at Versailles are still spread out across the whole façade, are gathered together in a heavy concentration in the middle, so that this, as the special display piece, provides the dominating accent, much as at Meudon, while the towers, in spite of their rich articulation, are only an accompanying echo. As at Meudon, the delicate, naturalistic garlands over the arches of the windows and niches, the elegant shape of the tops of the towers, and the lightness of the mouldings are clear signs of the movement in style towards the light and elegant.

The real effect of the façade resided in the harmony between the slender towers and the dome in the middle, a fundamentally un-French motif that formed part of Betto's original Italian conception. The later omission of the dome – in spite of Boffrand's objections – ruined Mansart's notion of the façade. The two towers alone could give it no cohesion; the three-storeyed giant façade eventually utilized was an emergency solution which upset the proportions and completely falsified the original idea.[9]

When Mansart died, Robert de Cotte (1656–1735), his brother-in-law and for many years his *chef de bureau*, took over his position.[10] The transition was a smooth and natural one. De Cotte had had a long training for this post. Cultured, sociable, and a gifted organizer, he already had a brilliant career behind him when he succeeded to the position of Premier Architecte. He had been in the service of the Crown since 1674 and since 1685 had worked as Architecte du Roi under his brother-in-law, who protected him and in 1689 sent him on an educational trip to Italy. When the Bâtiments were reorganized in 1699 he became head of the design office, the most important control point in the whole complex, and head of the Manufacture des Gobelins; in the same year he also became director of the Académie. In 1702 he was ennobled. His rise had begun with the colonnade of the Grand Trianon, a piece of work which had drawn the king's attention to him. Since then he had made decisive contributions to all Mansart's undertakings, especially the second, octagonal design for the Place Vendôme and the rebuilding of the town hall of Lyon. He also produced the plans for the reconstruction of the abbey of Saint-Denis (1700), in which he showed that he was a master at the grandiose handling of space and the confident articulation of masses. He was thus Mansart's born successor. It is true that the post of Surintendant was not filled again immediately; it was not until 1716 that it was given to the Duc d'Antin, a son of Madame de Maintenon by her first marriage, who had to content himself until then with the post of director-general of the royal buildings, gardens, and manufactories.[11]

The appointment of de Cotte ensured that for nearly three decades French architecture retained a stability that outlasted all the fluctuations resulting from the change in government and the alterations in taste bound up with it and on the whole put its

stamp on the face of France in the first half of the eighteenth century. Backed up by the extremely efficient Service des Bâtiments du Roi, de Cotte accomplished, like his predecessor, a huge mass of work over a wide area of activity; indeed his own share in the field of design certainly exceeded that of Mansart. His historical importance lay not so much in the invention of new forms as in the refinement and modernization of those taken over from his predecessor. By his feeling for practical necessities, his complete mastery of emphasis and proportion, and the nobility and elegance inherent in all his buildings he fulfilled perfectly the demands of the society of his time. Thus he became the great authority whose advice princes and bishops strove to obtain and who set the standards of courtly architecture not only for France but for the whole of Europe.

De Cotte's effectiveness was displayed mainly in the service of foreign princes. The official tasks remaining to him under Louis XIV were limited. Essentially they consisted in the completion of work already in progress. The only project in which he acted independently was the rebuilding of the choir of Notre-Dame (completed in 1714), where Mansart's plans had not secured the approval of the king. This rebuilding, which had begun in 1699 with the solemn laying of a foundation stone, owed its inception to a vow of Louis XIII, which Louis XIV only decided to fulfil at the end of his life. The original vow called simply for the erection of a new high altar, but Louis XIV made use of the opportunity to display his power and glory in the metropolitan cathedral of his capital as well. He caused the leading artists of Versailles – Degoullons, Coustou, Lepautre, Vassé, La Fosse, Coypel – to create a decorative ensemble of great splendour which was unexcelled in its day and with which even the chapel of Versailles and the Dôme des Invalides could not compete.[12]

At Versailles, where until 1710 the decoration of the chapel absorbed all energies, the last task to be executed was the conversion of the former palace chapel into the room known as the Salon d'Hercule. This room's structure, the only one still belonging to the time before the change of government, dates from 1712, and we shall see later how it continued the development begun in the Hall of Mirrors. No further new work was commissioned by the Crown. There was to be a pause of over thirty years between the building activities of Louis XIV and those of his successor.

Germain Boffrand and the Architecture of Lorraine

Among the pupils and successors of Jules Hardouin Mansart whose talents were displayed while their master was still alive a special place is occupied by Germain Boffrand (1667–1754), a native of Nantes. His architectural ideas had nothing in common with the court style of Mansart and de Cotte. From the latter, with his style of building based on the reconciliation and toning-down of opposites, he was divided by a deep gulf, in spite of superficial collaboration and the general agreement in questions of building 'appropriately' which emerges from the plans for the Residenz at Würzburg. Boffrand was the most versatile of the French architects. In his youth he wrote plays – his uncle was the poet Quinault – and he was interested in theatrical scenery, bridge-building,

and technical problems of every kind. Since 1685 he had worked under Mansart as a draughtsman and had produced the sketch for the first, rectangular design (dropped in 1698) for the Place Vendôme. But in contrast to his teacher he embodied a tendency in French architecture which came from François Mansart and Le Vau and since the appearance of academicism had gone underground. He was preoccupied to a greater extent than any of his contemporaries by giant orders, the opposition of masses, and the expressive power of unclad architecture as a solid body. Even though he was never himself in Italy he often came close to the Italian way of seeing things. He was always open to foreign stimuli; Palladio in particular had a profound influence on him. He could almost be described as a forerunner of English Palladianism, were it not that in the last analysis his French training always kept the upper hand.

His work falls into two periods. The first, which followed his apprenticeship with Jules Hardouin Mansart and was devoted to the design of both palaces and private houses, occupied the first quarter of the century; the second, which was concerned primarily with town-planning and work of a technical and theoretical character, filled the rest of his life.[13] As with de Cotte, however, his most important commissions consisted of the construction of palaces for foreign princes. About 1702 he entered the service of the Duc de Lorraine and in 1711 became his Premier Architecte. In 1705 followed the connexion with the Elector Max Emanuel of Bavaria. As a result of the eternal financial troubles of this exiled prince this link was not in the event a very fruitful one, but it did lead to the construction of the hunting pavilion of Bouchefort. In 1723 he competed with de Cotte in furnishing the Prince-Bishop of Würzburg with a design for the Würzburg Residenz, and in 1724 he provided the Archbishop of Mainz with a plan for the Favorite, near Mainz. In the same year he made a journey to Germany, where at the invitation of the Prince-Bishop of Würzburg he viewed the palaces of the Schönborn family. In spite of this activity abroad he continued to live in Paris, where from 1709 onwards he once again occupied the post of architect in the Bâtiments and from 1712 also the post of architect at the Arsenal. He only left the capital when his presence was urgently required at one of the big building sites.

He began his career in Lorraine as the emissary of Mansart, whom he had accompanied in 1700 on a journey to the court of Nancy. This journey, which the Surintendant had undertaken at the express wish of Louis XIV, had a decidedly political character. The king was trying to win over for France the Duc de Lorraine, who had been re-established in his lands in 1698 and to whom Louis had given his niece in marriage.[14] It was at the same time Lorraine's first contact with modern French art. While Mansart devoted himself mainly to rebuilding the old ducal palace at Nancy, Boffrand's first task was the construction of the new château of Lunéville (1702–6).[15] We are not informed when he took over the work there, but it is certain that from 1702 onwards, when Jules Hardouin Mansart's original plans for rebuilding the old château were abandoned, he directed the construction of the new building in accordance with his own ideas.[16] A departure from the Mansart scheme is already to be observed here. It is true that he modelled the general layout (Figure 3) on Versailles, but he opened up the corps de logis on the central axis with a mighty portico on giant columns (Plate 203),

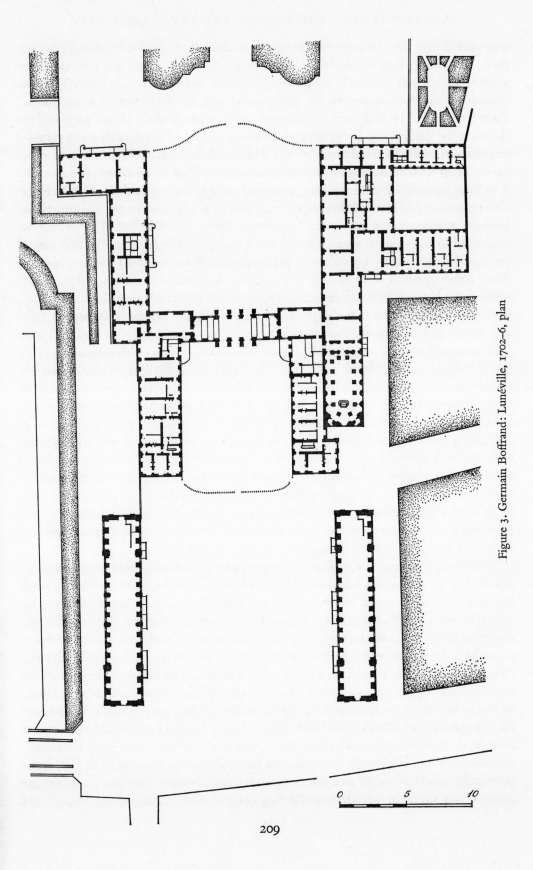

Figure 3. Germain Boffrand: Lunéville, 1702–6, plan

thus providing a view through into the gardens. Behind, on both sides of a third court-yard, long, low wings containing the apartments of the duke and the princely guests were to stretch away towards the gardens, but only one of these was built. The duke attached special importance to the enlargement and beautification of the gardens.[17] Thus the aim at Lunéville was a combination of palace in the style of Versailles and 'house in the gardens' on the pattern of the much-admired Grand Trianon. In carrying out this aim Boffrand could appeal to the tradition deriving from Mannerism of wings curving round on each side of a cour d'honneur and joined by an arcade, a conception which had fascinated French architects again and again ever since the time of Ducerceau.[18] The execution still shows many of the crudities of a youthful work; the opposition between one-storey and two-storey sections, between flat and pitched roofs was not reconciled in the original form adhered to in the *Livre d'architecture*. But the idea of emphasizing the middle by means of the portico with its pediment and the tent-like dome above was new and splendid. It concentrated all attention on the middle, which justified the bareness of the façades by its sheer architectonic weight. The architectonic sense that speaks here was the opposite of Jules Hardouin Mansart's decorative style, and there can be no doubt that in designing the façade of Lunéville Boffrand went back to models by Le Vau, especially his south front of the Louvre. It is true that in the free-standing columns placed before the front wall and in the lack of decoration one might also recognize a Palladian influence which had already appeared two years earlier in the Hôtel Lebrun in Paris. Without this influence the treatment of the wall as a smooth, undecorated expanse is also unthinkable. This treatment is peculiar to all Boffrand's buildings and makes them differ fundamentally from all other French architecture. The wall area at Lunéville is not articulated by vertical accents but drawn together into horizontal zones by continuous cornices linking the window-arches. These cornices bind the building together and give it a heaviness unknown in the work of de Cotte. This exclusively horizontal articulation also occurs in the early works of Jules Hardouin Mansart – in the Château du Val, for example – and in the work of Le Vau at Versailles, but it disappears in Mansart's later works.

The chapel, built only in 1720–3 after the great fire of 1719, which destroyed the whole first version of the garden wing, occupies a special place not only in Boffrand's work but in French ecclesiastical architecture as a whole (Plate 204). It is modelled on the chapel at Versailles. The first design represented only a variation on Versailles, but the chapel as finally built displays considerable differences. In contrast to the three-storey elevation at Versailles, which dissolves the roof-line, we have here a balanced, primarily two-storey elevation; instead of a basilica-like building, a hall-church; instead of the swift rhythm of pillars and columns, a tranquil flow; instead of a wealth of decoration, an almost bare space. In 1706 the Abbé de Cordemoy, a canon of Soissons, had published his *Nouveau traité de toute l'architecture* in which, basing himself on Perrault and a critical attitude to Vitruvius and his orders, he expressed completely new ideas on church architecture.[19] In his view the repertoire of forms should be reduced to simple, clear, quite independent elements and not possess merely decorative functions. To him the bearer of the structure was the free-standing column with horizontal entablature, not

the pier, which, like pilasters and moulded cornices, he rejected. This brought him remarkably close to the Greek method of building and made him an opponent of the prevailing system of Vignola's Gesù, which was based on the orders and their decorative function. Yet this classical mode of thought was tinged with a new admiration for Gothic. It was the lightness of the Gothic structure, the reduction of the architectural mass to a minimum, and the tension of the structural system that fascinated him, as it had Perrault. In his eyes, Greek temples and Gothic cathedrals embodied the same constructional principle – a rhythmical succession of tall, slender supports, between which unconstricted, unconcealed open space extended. His ideal church, modelled on Perrault's design of about 1680 for Sainte-Geneviève,[20] was a building using classical forms but planned on Gothic principles of construction, with light, widely spaced rows of columns for supports, a smoothly continuous entablature without a frieze, and two orders, one on top of the other, in the case of rostra or galleries. The chapel of the palace at Lunéville is the purest example of this system and thus fundamental to an evaluation of Gothic and classical principles of architecture.[21]

The building of the hunting pavilion of Bouchefort (1705) for the Elector of Bavaria meant competing with Marly.[22] The point of departure for both buildings was formally Palladio's Villa Rotonda at Vicenza, but conceptually the central pavilion is a symbol of princely power and display, whence derives the meaning of the subordinate subsidiary buildings radiating out to the sides (Figure 4).[23] There was also a significant difference

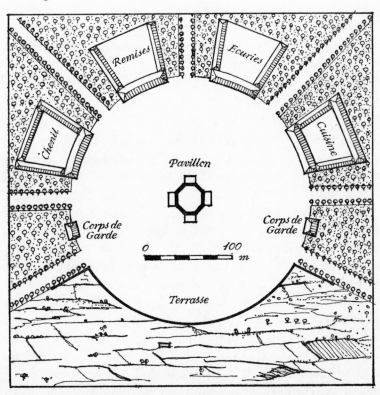

Figure 4. Germain Boffrand: Bouchefort, 1705, general plan

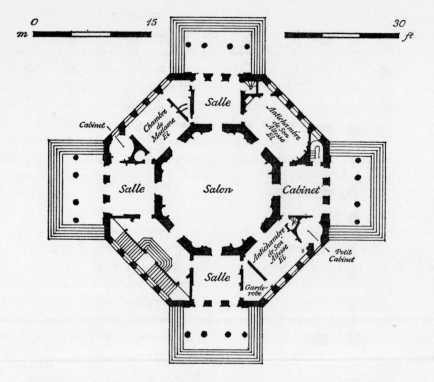

Figure 5. Germain Boffrand: Bouchefort, 1705, plan of the hunting pavilion

in the execution. While the Pavillon Royal at Marly was a square block with an octagonal central room and four apartments on the ground floor arranged radially between the spokes of the vestibules, Bouchefort was an octagon with a vivaciously articulated outline and a central rotunda rising high (Plate 205), the apartments encircling the central room in a ring. While at Marly long enfilades and rooms largely uniform in shape and size were the order of the day, at Bouchefort spatial variety was the aim: lines of movement were broken up and the shapes of the rooms were richly varied (Figure 5). Rectangular rooms alternated with octagonal and round ones; the dressing rooms lay in wedge-shaped spandrels and the big double staircase well in a polygon with pointed angles. In his joy in spatial variation, in his mathematical capacity to conceive complicated spaces, Boffrand was the legitimate heir of Le Vau. Another example of this dependence on Le Vau is the octagonal central salon of Bouchefort, with the caryatids supporting the ceiling, after the pattern of the central salon at Vaux-le-Vicomte, where, above smooth pilasters on the ground floor, caryatids in the same position and arrangement on the upper storey symbolized the constellations. This spirit can be sensed even in the vases and slim buttresses of the rotunda. Bouchefort was a sort of Baroque version of Marly. It lacked Marly's cool elegance and wealth of decoration but was full of a dynamism alien to Mansart's work. It had taken over the central dome and the four porticoes with columns from the Villa Rotonda, but all these parts were contrasted with each other. Even the relationship of the narrow porticoes to the

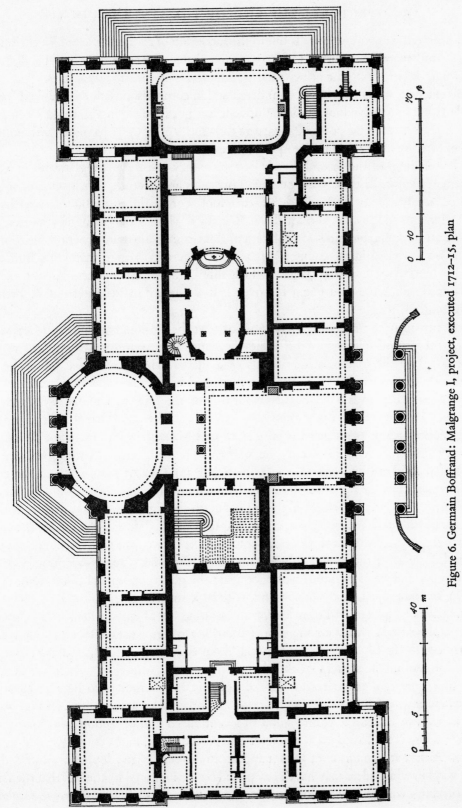

Figure 6. Germain Boffrand: Malgrange I, project, executed 1712–15, plan

213

obliquely retreating outside walls and to the succession of rooms inside fluidly encircling the central space contributed to the Baroque character of the building. Finally, the crowning lantern with the prince's hat put the finishing bizarre touch to it.

Bouchefort, which was never completed and in comparison with the polished forms of de Cotte must have looked old-fashioned, was not imitated in France. In Germany, however, it became the point of departure for a series of summer pavilions and hunting boxes based precisely on the Baroque liveliness of its plan and elevation.[24]

The buildings of the second decade of the century constitute a high-water mark in Boffrand's work. In these years he gave Lorraine's architecture, which until then had turned largely to Italy for guidance, a French look. For the duke he built the two palaces of Malgrange and Nancy, and for the aristocracy a whole series of country houses. He produced innumerable ideas for palace and domestic architecture which took root in the town as well as in the country.[25] It is no exaggeration to say that with Boffrand a new period of building began which lifted this frontier territory out of its provincial remoteness and put it for over half a century in the forefront of French architecture.

The first plans to materialize were those of 1711 for the country house of Malgrange (1712–15), just outside Nancy.[26] If Lunéville can still be regarded as a youthful work, here we have the mature achievements of a master which reveal the full scope of Boffrand's genius. Both sets of plans are published in the *Livre d'architecture*. The first project (Figure 6) was a further development of the type represented by Vaux-le-Vicomte, enlarged along a new transverse axis by a staircase and chapel with adjoining inner courtyards as envisaged by Jules Hardouin Mansart in his design for Rivoli (*c.* 1700).[27] Inside, the cruciform complex of two-storeyed rooms – guard room, central salon and staircase, and chapel – was the dominating feature, from which the two *appartements de parade* ran out symmetrically. An innovation in comparison with Vaux-le-Vicomte was the two-storeyed dining room on the right-hand narrow side, with a small *appartement de commodité* corresponding to it on the left. For the exterior, which gained dignity and size through the six-columned portico on the courtyard side and the central dome over the line of columns on the garden side, Vaux-le-Vicomte with its giant order and angle pavilions was once again the governing model (Plate 206).

The second project, on the other hand, with its X-shaped plan, was based on different assumptions (Figure 7).[28] From a centre consisting, as at Bouchefort, of a circular three-storeyed hall with a colonnade ran four long wings, each containing a complete apartment, while the acute angles between them contained vestibule, staircase, and an elliptical room. The sources of this design, no other examples of which can be adduced in France, though it was utilized again in Italy almost two decades later by Juvarra in the palazzina of Stupinigi, lay on the other side of the Rhine. In the work of Fischer von Erlach the combination of a centralized middle section with long projecting wings is the basic idea at the heart of several designs; in the country residence of Count Althan at Vienna about 1690 it appears in the very form adopted by Boffrand.[29] The ways in which ideas may have been passed on are indicated by the fact that the Duc de Lorraine – who had always looked very much to Vienna – drew closer to the emperor

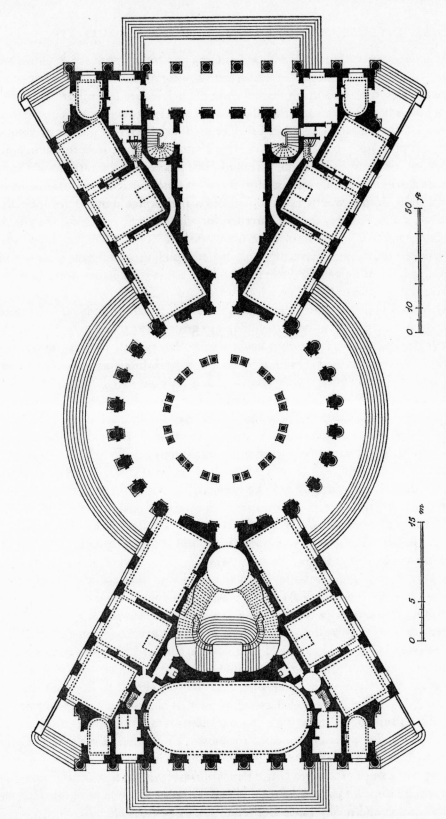

Figure 7. Germain Boffrand: Malgrange II, project, plan

precisely in these years of France's military failures, and by the presence of Bibiena in Nancy in 1708–9 to build an opera house on the Viennese model.[30] The actual structure (Plate 207), which took over from Fischer only the heightened central drum, utilized once again ideas from Le Vau and Palladio, but was in every way more Baroque than Malgrange I. The central rotunda, still slender at Bouchefort, had gained in volume and was held up by powerful, inward-curving flying buttresses; obviously Bernini's first design for the Louvre played the part of godfather here, and the surrounding giant columns are also inconceivable but for him. But what raised Malgrange II far above the level of the Palais Althan was its axiality. Unlike Fischer, Boffrand orientated his building on its short side. Here lay the real entrance, for which precise reason the ends of the wings, oblique in the Viennese model, were equipped with concluding pavilions. From here a grandiose central axis ran through the whole building, uniting the guard room of Malgrange I, the rotunda of Bouchefort, and the staircase of Saint-Cloud in an incomparable suite of rooms.[31]

The Malgrange projects were milestones in the development of French architecture. The first gave a new turn to château-building, especially in the eastern part of the country. It brought into fashion once again the Le Vau type of château, which had never found favour with the French Crown.[32] The second, though it had no descendants, showed the possibilities which French architecture possessed outside the court style but could not exploit because of the latter's claim to exclusiveness.

Four years later came the splendid design for the duke's palace, the Louvre of Nancy (Plate 208). Here, without paying any regard to the existing sections of the old ducal palace, which Mansart had at first wished to enlarge and modernize,[33] Boffrand applied the concept of the Louvre – four wings round an enclosed inner courtyard. But he gave the building a façade echoing both his own original design for the Place Vendôme (abandoned in 1698) and Bernini's second design for the Louvre and a courtyard which, with its orders of columns, was full of reminiscences of Palladio.[34] Both Malgrange and Nancy were ill-fated. Malgrange was begun in 1712 in accordance with the first plan, but after three years of intensive work it was abandoned when nearly complete, allegedly after unfavourable criticism from the Elector of Bavaria, and in 1738 was pulled down by King Stanislas.[35] At Nancy, where building started in 1717, only the façade and the ground floor of the east wing had been erected when in 1722 work was halted here too because of lack of money. In 1745 the not even half-completed palace, which would have exceeded in size and splendour anything else in Lorraine, was torn down and replaced by the building for the Intendance.

In the Place de la Carrière, between the palace and the city wall, Boffrand built in 1712–13 the Hôtel de Beauveau or de Craon, the finest of Nancy's aristocratic mansions, which in the articulation of its façade – giant pilasters over a rusticated ground floor, balustrades crowned with vases round the roof – was a reflection of the side pavilions of the new Louvre. Opposite this building King Stanislas had a similar palace erected in 1752 as a stock exchange. Thus a standard was set for the square; and although it did not acquire its new form until the middle of the century it kept alive the memory of the great project and finally made Boffrand's aims victorious after all.

Among the châteaux commissioned by the nobility of Lorraine alongside the ducal projects, Commercy and Haroué stood out particularly. Commercy (1708–17), the residence of the Prince de Vaudémont – a relative of the duke's – and later of the dowager duchess, on the plans of which Boffrand almost certainly co-operated,[36] was an extensive establishment enthroned on high terraces and looking down on a huge canal axis. On the approach side there were two courtyards in front of it, as at Versailles: an inner rectangular one and an outer one surrounded by quadrant-shaped domestic offices. The central section, which arises above the wings, displays the features of a Palladian villa, as they appear already in a preliminary sketch for Lunéville. At Haroué (1712–13) Palladianism entered into an alliance with the French country house (Plate 209). In order to make use of the existing foundations, Boffrand placed the wings close up to the corps de logis and preserved both the medieval towers at each end and the moats. But in front of the wings he put galleries of Ionic columns borrowed from the Palladian villa, while the elegant double line of columns on the courtyard façade recalls Le Vau – the Hôtel Tambonneau, for example – or the early Jules Hardouin Mansart; the garden side, on the other hand, has affinities with François Mansart's façade at Blois.[37] Even in this, the most charming of his châteaux, built by Boffrand for the lovely Marquise de Beauveau, the duke's favourite, and the only one of them still able today to give some idea of the splendid châteaux of the age of Leopold, the antitheses springing from these two totally different lines of influence and pervading all Boffrand's work are not completely reconciled.

Boffrand was a unique phenomenon in French architecture. His plans for Bouchefort, Malgrange, and Nancy represent the high-water mark of the Baroque stream flowing from early classicism, yet at the same time he also sought to emulate Palladio. But unlike the English Palladian architects, who took over Palladio's system as a whole, Boffrand borrowed only the individual idea which he needed to enhance or tone down the effect, according to his aim.[38] What also distinguished him from his contemporaries was his use of the column. To him, columns were not articulating accents subordinate to the general rhythm but isolated individual members which always retained their classical function of support. The disproportion between column and wall frequently resulting from this approach struck Balthasar Neumann when he visited the palace of Nancy.[39] These contradictions between Baroque tradition and classical, Palladian aims characterized his early period in particular and sometimes lent his buildings crudities which Jules Hardouin Mansart and de Cotte carefully avoided. They also mark the essential difference between Boffrand's work and English Palladianism of the twenties. To this extent there can be no question of Boffrand's being influenced by English architecture, especially as *Vitruvius Britannicus*, the main source for a knowledge of contemporary English architecture, appeared only from 1715 onwards. The inner affinity indubitably existing between the two, an affinity which comes to the surface in much of Wren's work – the designs for Whitehall, for example – proceeds rather from a parallel process of development. Both Boffrand and Wren went back to the architecture of François Mansart and Le Vau respectively without taking much notice of the turn towards the decorative and pleasing introduced by Jules Hardouin Mansart.

Church architecture in Lorraine took no account of this new development. Here the hall-churches (i.e. with nave and aisles of equal height) native to Lorraine since the Middle Ages and characteristic of the province continued to prevail. We also meet these churches in the other border territories of France – Flanders, Artois, and Franche Comté. It was on this pattern, which differed fundamentally from those developed in the interior of France and which also has no parallels in the neighbouring German provinces – the Palatinate and Alsace – that the great monastery churches of the beginning of the century – Saint-Mihiel, Autrey, and Pont-à-Mousson – were erected. The starting-point was Saint-Clement at Metz (1680–93), with which the post-medieval hall-church came into fashion again in Lorraine.[40] The posthumous Gothic style which distinguishes this church was also the governing factor at Saint-Mihiel (1698–1710) and Autrey (1711–14). At these churches new sections in the Late Gothic style were built on to existing cores and only the classical disguise of the piers betrays, just as at Metz, the change of epoch. It is true that the Premonstratensian church of Pont-à-Mousson (1705–16) transposed the Gothic forms for the first time completely into the language of the eighteenth century, but even here verticalism remained dominant. The architect, Nicolas Pierson or Poirson (b. 1692), showed in his façade and in his later works, especially the bishop's palace at Toul, that he was perfectly familiar with the classical forms. The huge interior of Pont-à-Mousson, however, one of the major achievements of church architecture in eastern France, which because of its date cannot be regarded as Pierson's own work, remained firmly traditional. This tenacious devotion to a deeply rooted principle felt to be a national one is even reflected in the chapel at Lunéville, which, with its nave and aisles of equal height, gives the clear impression, in contrast to Versailles, of a hall-church. This reveals the dichotomy inherent in Lorraine architecture of this epoch, during which the tendency imported from central France and fostered by the court ran parallel to the national tradition. It was only the loss of political independence in the second half of the century that gradually effected a reconciliation.

Architecture in and around Paris

It has already been shown that from the beginning of the new century onwards public building in Paris gradually came to a stop. Even church-building had no particular achievements to display. The only façade erected in these years was that of the Église de la Merci by Boffrand (after 1709), and even here it was only a question of putting an upper storey on an already existing ground floor.[41] Instead, private house-building now came to the fore. The age of royal building was succeeded by that of aristo-cratic building. One cannot say, it is true, that the seventeenth century had been poor in town houses for the nobility; the Marais and the Île Saint-Louis are indebted to it for their present appearance. However, with the eighteenth century came an unparalleled inten-sification of mansion-building. The crumbling of the Versailles court, the growth of a new, independent stratum of society in Paris, and the amassing of large fortunes in the country's wars all played a part in this. The town-planning activities of the Crown – the Place Vendôme, the opening up of the area on the left bank of the Seine by the Pont

Royal, the Hôtel des Invalides, and the new quais along the Seine – encouraged the development of new residential quarters, the most important of which were the Faubourg Saint-Germain and the Faubourg Saint-Honoré, the latter dating from about 1715 onwards. Here a wide field of activity for private architecture opened up, for in these quarters was concentrated the new society which in its artistic ambitions replaced the court of Versailles.

The Faubourg Saint-Germain, about which much has been said and written,[42] is one of the most remarkable districts of Paris. At the end of the seventeenth century it contained few houses of importance, apart from the establishments of some religious orders. By 1730, after being radically rebuilt from the Rue du Bac to the Invalides and from the Rue de Babylone to the Seine, and planted with gardens, it had become one of the most handsome and high-class residential quarters of the city. The inner districts of Paris, even the Marais, started to become more and more built up, to be crammed with blocks of flats and tenement houses which deprived the inhabitants of air and choked the traffic in the narrow streets. Therefore not only members of the nobility and of the upper classes but also those who had recently made money in the wars settled in the new quarters, where there was still greenery and fresh air and one was also sure of an exclusive environment. Although the real rise of the quarter started only after the beginning of the new reign, even in the last few years of Louis XIV it had become a centre of social distinction whose aristocratic town houses were to play a leading role in the working out of a new and different kind of life.

The development of a new style of living and of the sort of architecture appropriate to it was one of the great achievements of the eighteenth century. This development had already been set in motion by the high and mighty demands of the court, but it swiftly spread to aristocratic and bourgeois circles. People began to organize their houses for their own comfort, not just to display their rank. Alongside the *appartement de parade* the *appartement de commodité* began to assume growing importance. The decisive innovations in the new type of *hôtel particulier* were that the relationship of the rooms to one another was determined on rhythmical grounds and that the public sphere was separated from the private.[43] In the new edition of Daviler's *Cours d'architecture*, the most popular manual of the period and the book that firmly established the new building habits, Le Blond gave directions about the proper form and size of an apartment and illustrated them with examples from his own buildings. According to Le Blond, who was writing in 1710, an *appartement de parade* should embrace a vestibule, anteroom, salon, bedroom (or *chambre de parade* respectively), and study, to which other rooms, especially *cabinets* and dressing rooms, could be added according to the rank of the owner. The one-storey salon replaced the old two-storey *salle à l'italienne* and the gallery, if it still appeared at all, was inserted as a centrepiece. While the ground floor was increasingly reserved for the *appartement de parade*, the *appartement de commodité* spread more and more into the better-heated upper storeys, even into the entresols and attics. Interior communications were facilitated by additional staircases and corridors, and the positioning of the various rooms was determined more by practical considerations and less by symmetry.

The reduction of pomp and a more intimate mode of life were favoured by the

maisons à l'italienne – modelled on the Grand Trianon and the Château du Val – which had come very much into fashion since the turn of the century. In these flat-roofed, one-storey buildings topped by a balustrade the Italianizing tendencies of the late Louis XIV found expression, but their interior layout had nothing to do with Italian modes of building. Their single-storey nature corresponded to the striving after comfort and closer links with the garden – a striving apparent everywhere in this period, even in its country houses.

In the façades the formal apparatus of classicism was systematically dismantled. Orders of columns, still in full bloom on the early town houses of Lassurance and Delamair, gradually disappeared. Window openings became larger, proportions slimmer and lighter. The busts and statues on façades yielded to a delicate relief decoration, derived from the Grand Trianon and Meudon, which spread in the form of garlands of blossoms and festoons of flowers on to keystones and the arches of doors and windows. The tendency towards the elegant and decorative became one of the marks of the new style.

The revolution had already been heralded in discussions which had been going on at the Académie, parallel to those of the Académie de Peinture on the comparative importance of colour and draughtmanship (cf. p. 4), since the end of the seventeenth century.[44] Le Blond was only formulating changes that were already complete when he set them out in his new edition of the *Cours d'architecture* in 1710, as opposed to the building usages of 1691, the date of the first edition. Alongside this there was certainly one attempt – the only one – at a return to Antiquity, in the shape of the *Nouveau traité de toute l'architecture* by the Abbé de Cordemoy (1706), who in his discussion of Vitruvius' orders turned against all Baroque effects in architecture and preached a Greco-orientated classicism. The abbé demanded not only consideration for 'bienséance', i.e. the adjustment of the character of a building to local and social circumstances, but also symmetry in the plan and, together with unity of design, the independent treatment of the individual architectural components. To him, the free-standing column was the primary member of a building, and the colonnade, even in the shape of a Gothic church, the most perfect manifestation of architecture. He condemned all the decorative accessories used on façades – pilasters, reliefs, pediments, and especially giant orders – because they gave the building a decayed and degenerate character.[45] In all this the influence of Perrault can be traced, but Cordemoy was the first to do more than merely comment on Vitruvius. His unconventional ideas did not at first have much effect, it is true: only later on in the century were they to gain a hold.

Sébastien Le Clerc's *Traité d'architecture* (1714) remained more conventional; it provided a contribution to the everlasting debate about good taste. But since the days of Perrault good taste was no longer decided by reference to the exemplary works of Antiquity; it was based on the judgement of enlightened contemporaries, and the theory of orders of columns and proportions had lost much of its credit. The new requirements of domestic architecture were governed by different considerations.

Numerous architects were concerned in the boom in private building in Paris. Pierre Bullet and his son Bullet de Chamblain erected the houses in the new Place Vendôme

behind Jules Hardouin Mansart's façades; Lassurance, de Cotte, Boffrand, and Le Blond were mainly active in the Faubourg Saint-Germain, and Delamair in the Marais. The great service performed by Lassurance (*c.* 1660–1724), who from 1684 to 1700 had worked as a designer under Jules Hardouin Mansart, was the rhythmical co-ordination of the plan.[46] In the Hôtel de Rothelin (1700), his first independent building (Figure 8), the rooms were divided into two symmetrical apartments looking out on to the garden and leading in strict axiality out of the central *salle*, the biggest room in the house. In front, as a parallel axis, lay the shallow vestibule with the staircase on the right and two rooms on the left. The vestibule and *salle* also formed a transverse axis emphasizing the middle and linking the courtyard conceptually and optically with the garden.

The next step, the Hôtel Desmarets (1704), brought a further tautening (Figure 9) and a balancing of the proportions. The corps de logis had become shorter but deeper. The garden side now consisted of only five rooms, which were more strongly varied and accentuated and formed just one single apartment. The courtyard side, too, now contained only three rooms, and the former *antichambre* had become the dining room. In return a bedroom and a servants' hall had been transferred to the wings. The vestibule,

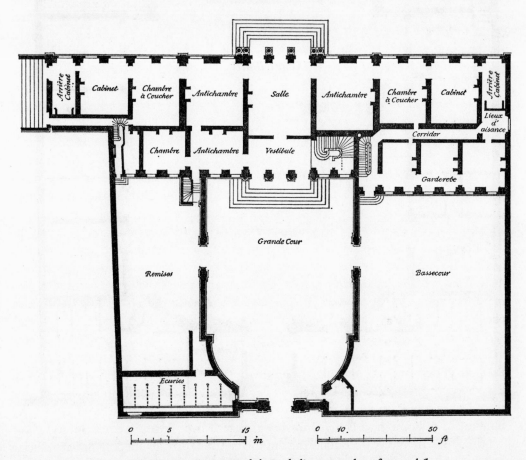

Figure 8. Lassurance: Paris, Hôtel de Rothelin, 1700, plan of ground floor

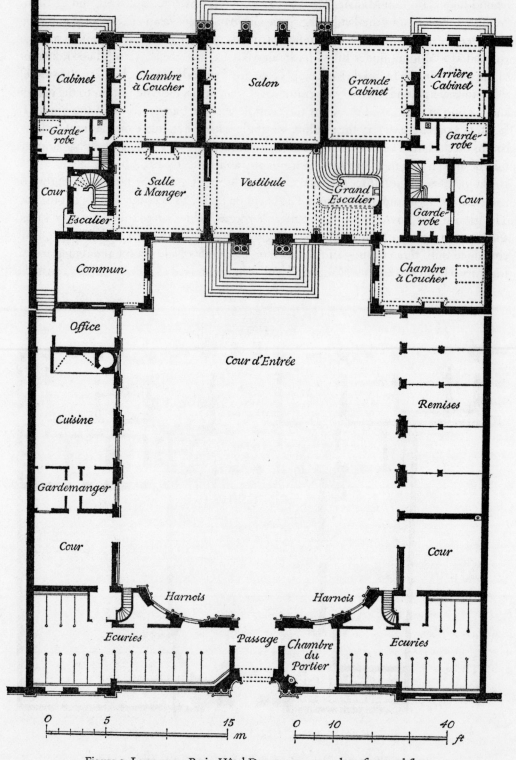

Figure 9. Lassurance: Paris, Hôtel Desmarets, 1704, plan of ground floor

222

now bigger, had been assimilated to the 'salon', which had succeeded the *salle*; in this way the contrast in size between the rooms had been toned down. The unity of vestibule and staircase, the interior communications in the shape of corridors and subsidiary exits, and the more numerous dressing rooms betray the proximity to Jules Hardouin Mansart. Particularly in his upper storeys, in those where, as in the Hôtel d'Auvergne (1708), several *appartements de commodité* were united by three or four rooms ranged along corridors, did Lassurance show himself as the continuer of the 'living units' of Trianon and Meudon. The close collaboration between him and Jules Hardouin Mansart in the domain of interior decoration is well known;[47] in the design of town houses it can only be suspected, owing to the absence of more precise evidence.

In his façades, too, Lassurance translated the Versailles court style into the smaller dimensions of the aristocratic style. To articulate these façades he used coupled columns and pilasters, pediments richly adorned with figures, groups of arched doorways, in short, the whole repertoire of forms familiar from court architecture; and as a speciality the closely spaced, compressed-looking windows and the broken pediments which aroused the fury of his critics (Plate 210). His early Parisian houses are a direct continuation of Mansart's buildings for the court. Behind the Hôtel de Rothelin lurks the Hôtel de Noailles at Saint-Germain, behind the Hôtel Desmarets the central pavilion at Clagny, and behind the Hôtel de Béthune of 1708 the Grand Trianon.

Robert de Cotte worked along the same lines, if not as a front-rank figure. His numerous official tasks left him little time for private work. Nevertheless, there was scarcely one important building in Paris in which he was not involved, at any rate in an advisory capacity.[48] As Premier Architecte du Roi he built the court nobility's town houses, including in particular the Hôtel de Conti (begun in 1716), which was acquired in 1718 by the Duc du Maine, the eldest son of the king and Madame de Montespan, and the Hôtel de Toulouse (1713–19), which he rebuilt for the king's second son, the Comte de Toulouse, out of the old Hôtel de Vrillière. In these houses he, too, transferred courtly usages to the town – stately double staircases, modelled on Saint-Cloud, with double vestibules, long enfilades with a private chapel at one end, and what was known as the *appartement double*, which stretched across the front and back of the corps de logis in two parallel suites of rooms. This large-scale treatment certainly gave his buildings a royal splendour, but basically it was not very appropriate for a town house. As a result the new gains made by 'commodité', namely dressing-rooms and side rooms, are not at all strongly developed. Of his façades, only that of the Hôtel d'Estrées (1713) has been preserved, and even this is in a much disfigured condition (Plate 211). It already reflects the new plainness and reserve in the use of sculptural form. Columns have disappeared on the ground floor, and on the upper storey simple pilasters are now the only form of articulation. The surface is given weight by the use of smooth, rusticated blocks. The profiles, too, have become more slender and elegant. In the distribution of accents and in its perfect proportions this façade (unfortunately given a second storey in modern times) has the carefully weighed assurance and unpretentious nobility that distinguish all de Cotte's work.

In Parisian house-building, too, the man who represented the opposite pole to de

Cotte was Boffrand. He worked mainly for Parisian officials, but sometimes also for the aristocrats whom de Cotte counted among his clients. Both architects were therefore frequently at work on the same building, especially as from 1709 onwards Boffrand was an architect in the Bâtiments and thus also had an official relationship with the Premier Architecte. His career[49] began in the same year – 1700 – as that of Lassurance, with the Hôtel Le Brun. It embraced not only firm commissions but also the erection of speculative buildings, such as the Hôtel Amelot de Gournay or the Hôtel de Torcy, and large-scale conversions like that of the Petit Luxembourg, the Arsenal, or the Hôtel de Soubise. It extended into the thirties, but most of his buildings were crowded into the first fifteen years of the century, so that they did not fall into the Régence proper.

In planning, Boffrand was superior to de Cotte. His richly varied suites, in which the individual rooms frequently had rounded corners, attained a subtleness hitherto unknown. His great innovation was the 'annular' plan, which he used for the first time in the Hôtel d'Argenson (1704-5) and which also formed the essential feature of Bouchefort. In contrast to Lassurance he renounced the transverse axis of vestibule and central salon linking courtyard and garden, and also long vistas of living rooms. Instead, he laid his apartment in various different directions all round the core of the house, thus producing, without any regard for the size or irregularity of the plot, a practical series of rooms offering every possible variation. This was a decisive break with the past and a step towards the intimacy of the Rococo plan, a step which at once found imitators[50] but was never taken by de Cotte. His greatest achievements in this direction were the Petit Luxembourg (1709-16), where the much broken-up apartment on the first floor starts out from the grandiose staircase modelled on that of Saint-Cloud, and the Hôtel Amelot or de Montmorency (1712) (Figure 10). In this building, first erected on a speculative basis, i.e. without any firm order for it, Boffrand was able to put into practice his own personal ideas about interior planning. These ideas are a continuation of what had been started at Bouchefort. Here it was the oval of the courtyard that determined the plan as a whole and led to the succession of rooms in the shape of the pentagon, the trapeze, the rectangle, and the ellipse which, unique as they are in Parisian architecture, give the Hôtel Amelot its special importance.[51] The climax of the apartments on both floors was the central salon projecting into the garden. One could only reach this salon after walking through the whole suite of rooms, since direct access from the vestibule was blocked. This was certainly not very practical, but here Boffrand had sacrificed the principle of practicality to his grandiose conception of space, which came from works like the Hôtel Lambert or the Château du Val.

In the façades of his town houses Boffrand followed the same principle as he did in building country houses: predominance of smooth, unarticulated expanses delimiting clearly contrasted cubes of masonry; intensification of the decoration towards the middle without any subsidiary accents; and division of the wall into horizontal zones by drawing the door and window arches into the line of the cornice. For all the lightness of their proportions, his façades did not really produce the same impression of elegance as those of de Cotte; there were constant echoes of the block-like effect which enjoyed a revival

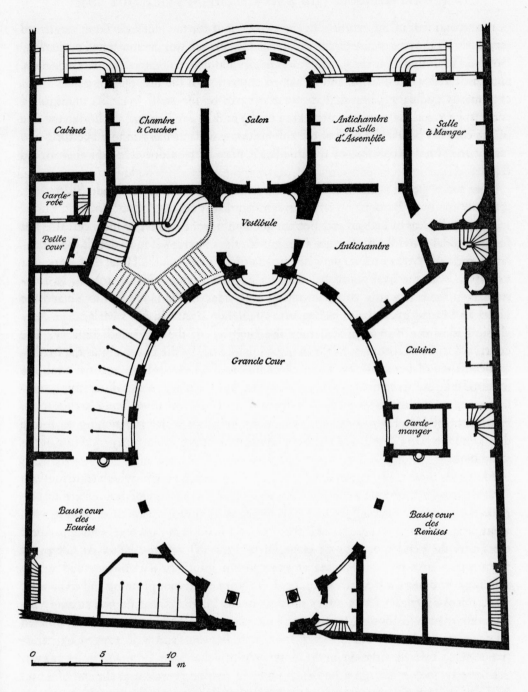

Cabinet

Chambre
à Coucher

Salon

Antichambre
ou Salle
d'Assemblée

Salle
à Manger

Garde-
robe

Vestibule

Petite
cour

Antichambre

Grande Cour

Cuisine

Garde-
manger

Basse cour
des
Écuries

Basse cour
des
Remises

0 5 10
 m

Figure 10. Germain Boffrand: Paris, Hôtel Amelot de Gournay, 1712, plan of
ground floor

225

in the second half of the century. In the two designs for the Hôtel de Torcy produced separately by the two architects the difference in approach was demonstrated perfectly.[52] Boffrand's solution (Plate 212), which was finally adopted, renounced pilasters, columns, and rusticated vertical strips, and remained content with the interplay of planes and a continuous undulating line underneath the eaves of the roof. With its undisguised contrast between the emphatic verticality of the middle pavilion and the horizontal line of the cornices below the roof of the side sections, with its big window apertures and scanty sculptural decoration of the middle, it may be regarded as a typical Boffrand façade.

Here too a special position is occupied by the Hôtel Amelot. Its façade (Plate 213), certainly the most Baroque on any Parisian mansion, does not follow Boffrand's usual scheme. In it ideas of Le Vau and Bernini are combined. It would be inconceivable but for the model provided by Bernini's designs for the Louvre; yet in its details the articulation certainly harks back to the giant orders of Le Vau – on the Hôtel de Lionne, for example. Even the oval courtyard with its staggered wings (Figure 10) has its forerunners in the courtyards, rounded-out on both sides, of the Hôtel de Lionne and the Hôtel de Sainte-Foy, and also in Lepautre's Hôtel de Beauvais. As at Malgrange, early classical ideas are here translated into the language of the eighteenth century. The courtyard owes its form not to the cramped nature of the site but solely to the mathematical fancy of the architect. The perfect fusion of all the sections into the oval, the pyramid-like ascent of the masses in the façade, and the magnificent, distinctive articulation are among the most masterly achievements of French town-house architecture. However, the Hôtel Amelot did not exert any influence worth mentioning on future developments. De Cotte's Schloss Poppelsdorf, near Bonn, was its only successor of the same rank.

Alongside these main figures there was a group of younger men whose contributions to the Parisian architecture of these years were also important, though limited in number. J.-B.-Alexandre Le Blond[53] (1679–1719), the theorist already mentioned, who in 1716 went off to the court of the Czar of Russia, built two houses in Paris before his departure: the Hôtel de Vendôme (1705–6; enlarged in 1714–16) and the Hôtel de Clermont (1708–14), which he incorporated as examples in his *Cours d'architecture* and which skilfully combined the new advances, namely clarity of interior planning and an annular plan. Nicolas Dulin[54] (1675–1751) showed in his buildings that he was strongly influenced by Jules Hardouin Mansart and Lassurance. His Hôtel Dunoyer (1708), situated on the edge of the city like a sort of folly, with flat roofs and walls topped by balustrades, was a refined variation on the Hôtel de Noailles at Saint-Germain; its length was deliberately accentuated, in accordance with the fashion prevalent at the end of Louis XIV's reign. Jean-Silvain Cartaud (1675–1758) began his career with the very remarkable house (Figure 11) for the banker and art collector Pierre Crozat (1704), known as Crozat le jeune to distinguish him from his brother. Here, round a central inner courtyard, were grouped two series of apartments, one on each side, and two galleries, one of which, the bigger, formed the common terminus on the garden side, while the other, smaller one, situated on the first floor, formed the terminus on the courtyard side, so that the house

had room enough both for the reception of artists and for Crozat's famous art collection.[55] The general layout, which translated the Italian palazzo form into French terms, reflected the impression made on Cartaud by a period of study in Rome in 1695. But the interior planning was purely French, and in its rational, completely functional approach very modern. Le Blond incorporated it with a few alterations in his *Cours d'architecture* – which finally gave rise to the Hôtel de Clermont – and Desgots adopted it for the château of Perrigny in Burgundy.[56]

In conclusion we ought to mention Pierre-Alexis Delamair (1676–1745), who gained important commissions early in his career and was ruined by his own conservatism. His Hôtel de Soubise (1705–9) is still one of the sights of the Marais today. The façade, with its cour d'honneur in front (Plate 214), is modelled on Delisle's Hôtel de Souvré (1667), but far surpasses it. As in the early work of Lassurance, the main feature in the articulation consists of coupled Corinthian columns with statues standing on them. These coupled columns also run round the courtyard in a colonnade originally intended to support a terrace, so that façade and courtyard fuse together into a splendid whole. This show side of the house, decked out with all the pomp of Louis XIV's declining years, aroused the admiration even of contemporaries. The staircase behind it did not

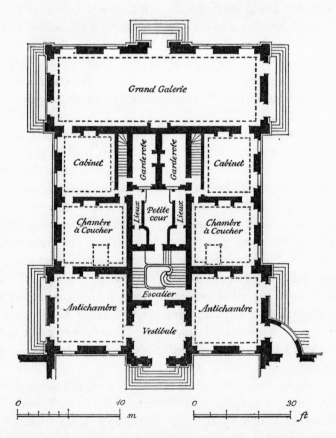

Figure 11. Jean-Silvain Cartaud: Paris, Maison de M. Crozat le jeune, 1704, plan of ground floor

lack splendour either, but the plan drawn up by Delamair for the corps de logis beyond – a monstrous succession of rooms with their doors in the middle – was so old-fashioned that it was not accepted. At the instigation of the Prince de Soubise's eldest son, Hercule-Mériadec, Delamair was relieved of his job as chief architect and replaced by Boffrand, who took over the direction of operations from 1707 onwards.[57] Delamair did not have any better luck with the Hôtel de Rohan or de Strasbourg (1705–8),[58] which was situated on the other side of the extensive plot of land and had been conceived as the counterpart to the garden façade of the Hôtel de Soubise. Its façade and plan were grandiose but also old-fashioned. Against the competition of Boffrand and de Cotte, who had been called in to furnish designs for the connecting buildings, he was unable to secure the adoption of his plans.

His acceptance of a commission from the Elector of Bavaria in 1704 to extend the country palace of Schleissheim, outside Munich, also came to nothing, first because of the impossibility of making the journey to Munich in the middle of the War of the Spanish Succession and then through the interposition of the person of de Cotte, whom the elector, long since informed about Delamair's merits and demerits, had called in when the war came to an end.[59] A big work on town-planning, *Le Songe et le réveil d'Alexis Delamair, architecte à Paris*, which he dedicated to the king in 1731 and which showed him as an architect rich in ideas, probably went up in flames in 1871 when the royal library was burnt down. In his theoretical writings, *Procuration curieuse du Sieur Alexis Delamair* (1731) and *La pure vérité* (1737), he made his whole circle of acquaintance, especially Boffrand and de Cotte, responsible for his continual failure. In reality the fault lay in his own backwardness and obstinacy, which rendered him blind to the requirements of the age.

In these years of intensive building activity in the city, the environs of Paris also began to be dotted with country houses. The château was gradually replaced by the *maison de plaisance*, which corresponded to the new striving for refined simplicity and greater comfort.[60] It combined the design of the town house with the needs of country life; particular attention was paid to drawing the garden into the sphere of the house. Le Vau had already taken the first step at Turny and Vaux-le-Vicomte by breaking up the outline and linking house and garden closely together. The eighteenth century went further along this path by converting the 'representational' layout into a more intimate, comfortable one. The earliest of these country houses were almost all based on Le Vau's system: a vestibule and big, oval, projecting salon on a short central axis, with suites of rooms opening out symmetrically to right and left. The nearest approach to this model was the country house built in 1706–9 by Cartaud for Crozat at Montmorency; its central room was a transverse oval still modelled on Le Vau's concept of the *salle à l'italienne*.[61]

The pilasters with caryatids below the ceiling were an indubitably intentional reminiscence of the central room at Vaux-le-Vicomte, and the façade too was articulated by giant pilasters like those used by Le Vau. However, Italian influences as they emerge so clearly in Crozat's town house have also to be taken into consideration in this façade.

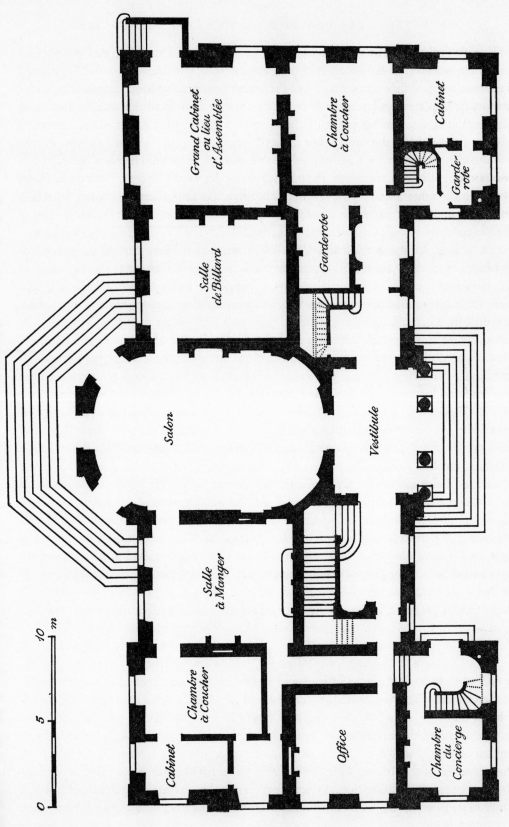

Salon

Salle
de Billard

Grand Cabinet
ou lieu
d'Assemblée

Chambre
à Coucher

Cabinet

Garderobe

Garde-
robe

Vestibule

Salle
à Manger

Chambre
à Coucher

Cabinet

Office

Chambre
du
Concierge

Figure 12. J. Bullet de Chamblain: Champs, 1703–7, plan of ground floor

0 5 10 m

Champs (1703–7), on the other hand, by J. Bullet de Chamblain, who in 1706–8 built a big mansion in the Place Vendôme for the same owner, Poisson de Bourvalais, is more modern.[62] In spite of many old-fashioned features, its garden façade (Plate 215) has lost its heaviness and as a result of the projecting middle section is full of life and tension.[63] It is the starting point of the type of façade which governed the country houses of the eighteenth century, but through Pierre Bullet's collaboration in its design it is also closely tied to the traditions of the seventeenth century. The older man's collaboration can also be perceived in the courtyard façade, which links up with the château of Issy, built some twenty years earlier. The plan, on the other hand, except for the somewhat inorganic vestibule which is probably also the work of Pierre Bullet, is already completely eighteenth-century (Figure 12). At Champs the *appartement de parade*, which at both Montmorency and Vaux-le-Vicomte runs along the garden side only and has no subsidiary rooms, is continued round the wing of the house on one side and on the other is even lengthened by a small *appartement de commodité*, while the side rooms and communicating spaces are easy of access and the problem of interior planning is brilliantly solved.

Similar features were also displayed by the country house of Regnault at Châtillon-sous-Bagneux, by Le Blond.[64] An exception to the series, however, was formed by Boffrand's country house for the Prince de Rohan at Saint-Ouen (c. 1710), where Boffrand was for once forced to take account of the courtly components of architecture as well (Figure 13). Long, flat-roofed wings built on to the domestic courtyard and stretching out into the garden recalled the Grand Trianon, while an isolated central pavilion (Plate 216), raised on several steps and serving the prince and princess as living quarters, recalled Marly. The wings here assumed the function of the twelve guest pavilions of the royal country residence. In comparison with Marly, everything at Saint-Ouen was lighter and more graceful. All the buildings are of one storey and have big doors and windows opening on to the garden. The plan is more polished and refined; in the central pavilion it harks back clearly to the Château du Val. With this light architecture, thrown off like a festive decoration, which aimed at being no more than a summer residence for a small unconstrained circle of privileged people, Boffrand had met the requirements of his period perfectly. The age of grand display was over; that of *fêtes champêtres*, of easy, somewhat frivolous sociability, had dawned.

Decoration

If one were to look at the architecture of the eighteenth century only from the angle of façades and plans, the resulting picture would be lopsided, for an essential feature – interior decoration – would be missing. It was only with interior decoration that architecture acquired the breath of life which linked it to the social life of the Age of Enlightenment and which brings home to us the discrepancy between 'simplicité' and the splendour of the Rococo style. An eighteenth-century building was more dependent than any other on its decoration. As façades grew simpler, so interiors grew more refined. Only in them could the social position and taste of the owner be expressed. Here, too,

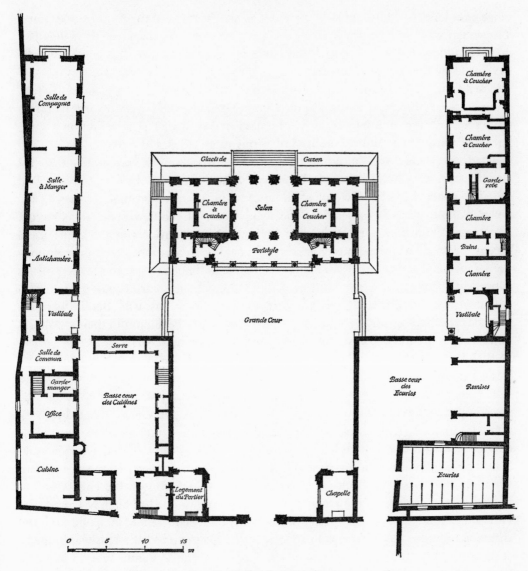

Figure 13. Germain Boffrand: Saint-Ouen, *c.* 1710, plan

it is possible to discern the stylistic cesuras that one seeks in vain in the architecture of the period. In the domain of interior decoration both the threshold of the eighteenth century and the beginning of the Régence are fairly clear turning points, even if they cannot be dated to the precise year.

The great change in interior decoration was already beginning at the end of the seventeenth century. Since the eighties the influence of Le Brun had been on the wane, and with it disappeared the Italianizing tendencies and the abundance of sculptural decoration. At the court the deterioration in the financial position and a change in taste caused a decline in the use of gold and marble. The panelling of walls, with its simple, geometrical division of the surface, the use of mirrors, and the reduction of the

range of colours to white and gold were not an achievement of the eighteenth century. The system which had begun with the redecoration of the royal apartment at Versailles in 1684, and which is linked with the name of Lassurance, was already almost fully developed by the end of the century.

The new impulses sprang from the arabesques and ribbonwork of which Jean Bérain, a pupil of Le Brun, was the undisputed master.[65] In Bérain's style of decoration Le Brun's motifs lived on but underwent a fundamental change. The composition became light and transparent, and the individual forms more slender and lively. Figures and vegetation yielded to geometrically linear ribbonwork. Individual motifs that had already appeared here and there in Le Brun's work – angularly broken ribbons, gold mosaic, feathered masks of women – now came into the foreground. Above all, the fleshy acanthus tendrils turned into the main theme of the new style, the C-scroll. Although Bérain was not involved in the decoration of rooms at the court itself, except for Meudon, numerous engravings for chimneypieces and decorative compositions, in which a large number of engravers shared, did much to spread the fame of this extremely fertile artist, whose influence none of his contemporaries could escape. This influence lasted even when, from the turn of the century onwards, Bérain was outstripped by Claude Audran – a process which was clearly beginning in their collaboration on the redecoration of Meudon (1699) (cf. p. 10). In his *Cours d'architecture* (1710), Le Blond published a series of chimneypiece designs clearly based on patterns devised by Bérain.

The interest stimulated by Bérain's system of decoration now also led to one of the most important innovations in French art, namely the conversion of painted ribbonwork into relief and its combination with the rigid panel-structure of the wall. This development was very much in the air at the time, as is shown by the varying and almost contemporaneous forms in which it was embodied. However, its most important exponent was Pierre Le Pautre (*c.* 1648–1716) (cf. p. 44), son of the engraver Jean Le Pautre, and nephew of the architect Antoine Le Pautre. He had already worked for Perrault, Daviler, and Bérain among others when Jules Hardouin Mansart noticed him and took him into the Bâtiments in 1699 as 'dessinateur et graveur'. This was immediately after Mansart's own appointment as Surintendant. Le Pautre was no longer a young man when he moved into this post, held for the previous fifteen years by Lassurance. Nevertheless, he guided the existing system of decoration into entirely new paths. His very first designs for a series of chimneypieces at Marly (1699), and his redecoration of the royal apartments at Versailles (1701) and Trianon (1702–3), aroused the admiration of contemporaries and were at once copied.[66] In the Marly chimneypieces (Plate 217) we find the C-scrolls, the volute-like curves, and the accompanying delicate tendrils in the top panels over the big mirrors, the rolled-in ribbonwork growing upward in the shape of palmettes in the pilasters at the sides, the rosettes in the middle, and even the mosaic background on the empty area, just as we know them from Bérain. But while the latter filled the various flat areas purely with paint, Le Pautre linked them with the three-dimensional framing of the panels and thus set the stiff system of lines in motion. At Versailles the king's bedroom, the Salon de l'Œil de

Bœuf (Plate 218), and parts of the Cabinet du Conseil are all still as they were after the alterations of 1701.[67] In these rooms the arabesque and ribbonwork decoration had already spread to the leaves of the doors, to the wall panels under the big pictures, and to the window arches; and the upper, gracefully curving corners of the mirrors over the fireplaces were echoed by the wide-spanned arcades of the flat chimney-pieces below. Only in the window niches did plain white panels still hold their ground.

The new forms also made their appearance in church decoration. The choir stalls of Orléans Cathedral (1702–6), executed by Degoullons but certainly designed by Le Pautre, contain the same outward-curving wall panels, and the same oval medallions below semicircular cornices resting on consoles, as the new rooms at Versailles and in the Trianon.[68]

At the Trianon and in the Hôtel de Pontchartrain ('Chancellerie'), the residence of the Chancellor of France, Le Pautre was able to design an integrated scheme of decoration without being tied by existing items like fireplaces, pilasters, and pictures. By means of long vertical panels which rose, accented only by rosettes in the middle, from the base area of the wall to the cornice of the ceiling, and by fitting in big concave-edged mirrors below oval-shaped picture frames, as in the designs for the Buen Retiro wing of the Bonn palace of 1717, he created here for the first time the main lines of a new, splendid, and yet light method of articulating walls which was a clear and undoubted improvement on Lassurance's rather small panels.

For thirteen years Le Pautre was the leading decorator at the court. Jules Hardouin Mansart, and after him de Cotte, who both recognized Le Pautre's outstanding talents, entrusted to him all the important interior decoration carried out in these years, including above all the chapel at Versailles and the choir of Notre-Dame in Paris (cf. p. 207),[69] so that he, much more than de Cotte, must be regarded as the real creator of the 'modern' style in decoration. At Versailles his last piece of work was the alteration, begun in 1711, of the Salon d'Hercule, where big, unbroken arcading between coupled pilasters right round the room, binding together door, fireplace, and windows in the same rhythm; this was the last expression of a development originating in Le Brun's Hall of Mirrors, a development that had already achieved complete unity of room design in Le Pautre's mirror closet in the Trianon (1706).

While the Versailles decorations, in view of their representational aims, always remained relatively gross and powerful – good examples are the chapel with its carved door panels (Plate 219) and its organ flanked by palm trees (1709–10), a clear forerunner of Rococo – away from Versailles there came into existence, especially in the choir stalls of Notre-Dame (1711–12) and the rooms of the château de Bercy (1712–15),[70] decorative ensembles of great delicacy and elegance. The various surfaces, enlivened by semicircular curves and concavely curved corners, were covered with a delicate play of lines which did not halt even at the pilasters. The interlacing ribbonwork became delicate tendrils which encroached more and more on the panels of the walls. The frames of the panels gained greater weight through thin parallel bars which ran right round them, defining the ornament zone proper and providing a soft transition to the various

relief planes. The deepest plane was the border zone inside the outer panel frame; from here the panel rose in steps, marked at the edge only by a shallow ledge,[71] up to the inmost rosette or to the medallion frame which in Notre-Dame enclosed the relief scenes. It was in these layers of increasing relief and in the tension between three-dimensional ornament and empty expanse that the fundamental difference from anything Italian lay. Comparable stylistic manifestations are not the Italian Baroque, with its sculptural, plastic wall-mass, but French ornamentation of the Late Gothic period, the Renaissance, and Mannerism.[72] The structure of the wall was for the time being preserved, but through the letting-in and decoration of the surfaces of the pilasters it had already become thin and fictitious. The concluding cornice also lost its functional meaning. At Bercy the coving of the ceiling was only a zone adorned by continuous friezes of cherubs, interrupted no longer by brackets but by female masks.[73]

The transposition of Bérain's style of decoration into three dimensions was carried out not just by Le Pautre but by the whole generation of Mansart's pupils, though none of them achieved similar importance. The only exception was Boffrand, whose style of decoration differed considerably from that of Le Pautre and his imitators. Proceeding from the notion of the simple flat expanse as the thing that defines the limits of an architectural mass, he divided the interior walls as well into just a few big panels. Below the cornice broad horizontal zones ran continuously round the room and embraced it like a broad ribbon (Plate 220). The inclusion of the door and window arches in these zones produced, as in his façades, a flowing line that lent the room an airy lightness but one devoid of accents. In the Petit Luxembourg (1710) there runs along above this a loose, lacy frieze which comes – like the stars scattered across the ceiling – not from Bérain's repertoire but already from that of Audran.

Boffrand's masterpiece in this domain was Malgrange, the biggest decorative ensemble of its period. The designs, which after the loss of the Recueil Piroux in the First World War are preserved only in tracings,[74] are distinguished by great formal inventiveness and a strong naturalistic streak. In detail they are more compact than those of Le Pautre; the profiles are stronger, the accents are concentrated on just a few zones. As at Bercy, the hollow mouldings have become continuous friezes of arabesques. From the point of view of form, Boffrand looked back in many ways in his approach to decoration, too, to early classicism. The heavy profiles, the termini pilasters of the mirrors, and the heavy garlands in the central salon at Malgrange also occur in the work of Le Vau and Le Pautre; for example, in the vestibule of the Hôtel de Beauvais. The seated atlantes that support the balconies of the upper windows in the central salon are the direct descendants of Le Brun's atlantes on the ceiling of the Galerie d'Apollon in the Louvre, just as the whole motif of figures holding cartouches appears frequently in Le Brun's repertoire of forms.

However, the system as such was completely new. In the central salon at Malgrange Boffrand renounced any architectonic or functional articulation (Plate 221). Only at the foot did the walls still bear panels; above, the wall was a smooth surface across which spread the rhythm of the atlantes and the festoons of trophies. The moment had come

when decoration needed neither pilasters nor panels to support it. Both here and in the salon of the Petit Luxembourg, where a continuous strip of ornamentation cancels out all functional accents, it had become independent. With the a-tectonic system of decoration, which freed the wall from any functional articulation and subjected it entirely to the sway of ornament, Boffrand had laid one of the most important foundations for the Rococo style.[75]

CHAPTER 5

THE RÉGENCE

Introduction

THE death of Louis XIV in 1715 was followed by a general sigh of relief. People were thoroughly tired of his authoritarian mode of government and of the pathos of Versailles. However, the legacy which the five-year-old Louis XV inherited was by no means rosy. The great buildings erected by the Sun King stood out curiously enough against the economic chaos towards which the country was drifting. The results of decades of militaristic policies based on the bayonet were there as a frightening example for all to see.[1]

In Paris a typical post-war mood prevailed, a mixture of licence and greed for money. The Duc d'Orléans, the nephew of Louis XIV entrusted with the regency during the minority of the young king, was a pleasant but weak man who did not understand how to use the power given to him – contrary to the provisions of the royal will – by parliament. He was dependent in all things on the good will of the innumerable governmental committees and of the dukes who presided over them. In a very short space of time ordered government had declined into a state of anarchy, in which everyone did what he pleased, and there was no visible sign of any unified leadership.

The years of the Régence were overshadowed by the financial operations of the Scotsman John Law,[2] which, based on the state taxation system, the East India Company, and the French colonies on the Mississippi, were supposed to restore the shattered national finances, but after initial successes ended in a spectacular crash. This certainly relieved the state of its debts but it ruined innumerable private citizens, while others made huge sums of money by their speculations. As a consequence, the structure of society, already severely shaken by the wars of the past, was loosened still further. Rich speculators penetrated the highest strata of society, married into the aristocracy, and did not shrink from displaying their wealth quite openly. This was certainly very convenient for architecture. The possession of a private mansion in the Faubourg Saint-Germain or the Faubourg Saint-Honoré ranked as a kind of status symbol which seemed to the newly rich the most enviable of all goals. Many of the most beautiful façades and interiors of the Régence and Rococo periods – including the Hôtel de Biron, the Hôtel d'Évreux, and the Hôtel Samuel-Jacques Bernard – would never have been built but for the *nouveaux riches*.

On his very first day in power the regent had moved the seat of government to Paris. Here he resided in the old seat of the Orléans family, the Palais Royal, while the young king had the Tuileries assigned to him as his residence. From now onward the Palais Royal became the centre of the new tendencies in art which the regent, as a connoisseur and collector, furthered to the best of his ability. This was the circle that produced

Oppenordt and Watteau, and here Toro's series of engravings, which came out in 1716, were greeted with enthusiasm as signs of a renunciation of the old days. With the return of the court to Versailles in 1722 and the king's coming-of-age in the next year, the political centre of gravity did shift away from Paris, it is true, but artistic leadership remained with the capital.

Like that of the other arts, the aspect of architecture in this period was determined by the nobility and bourgeoisie. For a start, Louis XV showed no sign of any enthusiasm for building. It was not so much, as is often asserted, the advice of his dying great-grandfather that held him back from building, as a lack of interest, about which Jacques-François Blondel was still complaining in 1736. As a result of the king's youth the Crown commissioned no buildings for the time being, and architects worked primarily for private patrons. Consequently even the return of the court to Versailles and the death of the regent in 1723 caused no break in stylistic development. While in painting the years of Watteau's activity coincided almost exactly with those of the Régence proper, nothing of the sort was the case anywhere in architecture. The architects who came into the foreground with the change of government continued to dominate the scene until this particular stylistic phase exhausted itself of its own accord. They developed further the forms taken over from the last years of Louis XIV and created out of them a transitional style which gradually led into Rococo. The intensive building activity in Paris provoked by the presence of the court and the speculative gains of the Law period favoured the establishment of this style on a broad base, but it also favoured the swift development of continually richer and more differentiated forms. Thus Rococo gradually came to be accepted in the course of the whole third decade of the century. However, it was only about 1730, when the conservative influence of de Cotte was waning and Meissonnier's appointment to the court had introduced a new style of decoration, that the development was completed. About the same time the Parisian passion for building, which had raged for almost three decades, also subsided. The Palais Bourbon and the Hôtel de Biron are the last great examples of an unparalleled efflorescence. It is only here that we come to the dividing line between Régence and Rococo.[3]

The theorizing of these years displays a growing interest in the connexion between building and space and in the perfecting of the plan. These aims were served both by the theoretical works – Courtonne's *Traité de la perspective pratique* (1725) and Briseux's *Architecture moderne* (published by the editor Jombert under his own name in 1728) – and by Mariette's practical manual, *Architecture Française* (1727 onwards), in which his most famous collaborator was the young Jacques-François Blondel.[4] Courtonne, whose theoretical discussion of the subject best formulated the new ideas, demanded a 'rapport parfait' between the inside and the outside of the building.[5] The exterior thus became a duplicate of the interior, an envelope which had lost its own function.

This clarity of design, which was meant to be grasped by the imagination as well as by the eye, naturally impelled architects to adopt lucid ground-plans. The round, oval, and other geometrical shapes which the school of Mansart and particularly Boffrand liked to employ for rooms did not fit in with this. They were therefore categorically rejected in theory, though they by no means disappeared in practice. In general,

however, the plans of this period are distinguished by great clarity. A loose symmetry was certainly the aim, but rigid adherence to it was not demanded. The buildings of the beginning of the century, especially those in Paris, had laid the foundations for this. On the outside, plainness, 'simplicité', was the order of the day. The use of columns, pilasters, and other elements of the classical orders was only permitted in the case of public buildings and princely palaces, which were governed by what was known as the *grand goût*. In any other building outward ostentations would have been an offence against good taste.

The sovereignty of taste, which succeeded the observance, hitherto obligatory, of the rules laid down by Vitruvius and Palladio, became a mark of the new age. In no other country was so much importance attached to taste. It found expression particularly in the concepts, cited by all the theorists, of 'convenance' and 'bienséance'. 'Convenance', the right relation of the parts to one another and to their purpose,[6] became in the work of the architects of the Régence a magic word. It governed the size and character of a building, its plan, and even its decoration, which was supposed to run right through from the hall to the salon, growing slowly but steadily richer all the time, without any surprise effects.[7] 'Bienséance', on the other hand, was concerned with the building's purpose, which had to determine the form. For example, the social position of the house-owner had to be taken into account. If he was a highly placed personage, then it was appropriate for him to have a different kind of house from that of an ordinary private individual. This idea of gradation became important because now theory no longer stopped short at simple constructional tasks but included every form of building in its reflections.[8] However, even the strictest observation of these requirements did not make a building perfect if no account was taken of 'commodité', a traditional concern of French architecture. Within the framework of 'bienséance' and 'convenance' the floor space had to be fully utilized and its planning adapted to all the demands of a sophisticated mode of life.[9]

It would thus be a serious mistake to see in the style of the Régence a relaxation of the strict discipline to which French architects of the seventeenth century had been subject, and to infer from the freedom of ornament which was becoming more and more prevalent that the same freedom existed in architecture. On the contrary, the rules of taste widely disseminated not least by Jombert and Mariette demanded of the architect strict discipline and readiness to restrict himself to what was recognized and generally approved. Experiments and bold innovations were not very highly regarded and usually encountered bitter mockery from the theorists. In this world, drilled as it was to obey the demands of good taste, there was no room for geniuses. Even a man like Oppenordt remained in the last analysis an outsider. Within these limits, it is true, especially in the fields of planning and habitability, the period produced masterpieces of which contemporaries were rightly proud and which formed a substantial contribution by France to the architecture of the eighteenth century.

Even the Académie did not stand aloof from the concentration on contemporary tasks. Desgodets, professor since 1719, combined in his *Cours d'architecture*, which consisted of his collected lectures, the discussion of current architectural tasks – several kinds of

churches, town halls, a hospital – with clear allusions to buildings already existing or in the course of construction.[10] However, the teachings of this important theorist, which were largely based on Cordemoy and contained many neo-classical ideas, especially in church-building, were to become influential only in the next generation.

Private Architecture in and outside Paris

Although the Régence did not usher in any new phase in architecture, the Duc d'Orléans' assumption of power did bring into the foreground personalities who had previously stood outside official art. Thus the name of Oppenordt is closely linked to the rebuilding of the seat of government, the Palais Royal, an operation that was undertaken at once. Gilles-Marie Oppenordt (1672–1742) was one of the circle round the rich banker and art collector Crozat, who was opposed to the academic view of art; Watteau too belonged to this circle.[11] Oppenordt was the son of a Dutch cabinet-maker;[12] in his youth he spent several years in Rome with Silvain Cartaud and subsequently succeeded the latter as Crozat's architect. When he entered the regent's service he was already forty-three and had still not produced any work worthy of mention. In the lifetime of Jules Hardouin Mansart he had always stood in the shadows; now he moved at one blow into the front rank of French architects.[13] The regent had also taken Cartaud into his service. In 1715 he entrusted him with the task of directing the reconstruction of the outside of the Palais Royal, a great deal of which still dated from Lemercier's time. But his work was of no artistic importance; Oppenordt's contribution was far more significant. Thanks to him the Palais Royal became the starting point of a new stylistic tendency which was to determine the outward aspect of the Régence, and which is at the same time typical of the 'Style Orléans', a style very different from that of the court.

Oppenordt had first developed his style in Rome, where he lived from 1692 to 1699 on the proceeds of a pension from the Académie de France. However, it was not Antiquity but Borromini that came to exert a decisive influence on him in Rome. He was also affected by northern Italian architects of the Late Renaissance – by Tibaldi and Alessi as well as Palladio – whose work he had come to know on a fairly long trip through northern Italy. When he returned to France he fused these elements with the French tradition. The result was an individual style of his own which was a curious mixture of French and Italian elements.[14] Basically he did not come from an architectural environment, as most of his contemporaries did, but from the world of craftsmen and decorators, as his father's calling would lead one to expect. Thus what interested him in Borromini and Roman Baroque was not so much the architectural, static element as the decorative, three-dimensional one; and what he liked about North Italian architecture was above all the layers of relief planes, the play of the three-dimensional form against the background of the surface, and the angular, block-like quality which, in his drawings and in many of his buildings, is so reminiscent of the *style rustique*. He was a genius at drawing; Blondel calls him 'un de nos plus grands dessinateurs'. The number of his designs runs into thousands,[15] but in most of them architecture proper got the

worst of it. His strength lay in decoration and arrangement, as is shown by the festivities at Villers-Cotterets when Louis XV returned from his coronation in Reims and by the accompanying restoration of the château there.

Even at the Palais Royal his task consisted only of rebuilding parts of the interior, though this was certainly of great importance for the development of the decoration. The most important pieces of work here were the addition in 1716–17 of two rooms to the regent's apartment – the Rotonde as a study and the Galerie en Lanterne, with its glazed skylight, for the picture collection; the remodelling at the same time of Jules Hardouin Mansart's big gallery, to which he gave a splendid rounded end (Plate 233), with a huge, richly draped mirror *trumeau* over a marble chimneypiece and two flanking obelisks hung with trophies; and in 1719–20 the insertion of the famous corner salon (Plate 222). This two-storeyed salon, known to contemporaries as the 'lanternon' or 'Salon d'Oppenordt', formed the hinge between the state rooms, the Grands Appartements, and the gallery at right angles to them. In it, as in Le Vau's Salon Ovale in the Louvre, two spatial axes met. For this reason Oppenordt had laid it out elliptically and made it jut out over the line of the wall, so that one of the ends stuck out on a bracket over the Rue de Richelieu – a daredevil mode of construction that attracted general attention.[16] For reasons of statics the ellipse had to be flattened and the upper storey had to be abandoned in favour of ordinary straight walls. Nevertheless, such a shape for a room was quite unusual; it was contrary to all the academic rules and would probably have been inconceivable but for the influence of Borromini's rooms. The arched shape for the tops of windows, first employed by Oppenordt – in the 'corner salon' it appears in the upper window – was also revolutionary and against the rules. It occurs in Borromini and in northern Italy, but it had not been seen in France since the days of François Mansart, who had used it in the façade of the Chapelle des Minimes and in his design for the château of Blois.

A design made in the same years for the regent's stables, in the façade of which the lack of harmony between the different elements is particularly striking, was never carried out. The numerous designs for garden architecture, of which those intended for the Elector of Cologne were the most important,[17] suffered the same fate. They are all distinguished by the contrast between French elegance and Italian monumentality, by a partiality for columns, pilasters, coffered ceilings, domes, and rambling roof-lines that gives them a remarkably hybrid appearance.

In spite of his brilliant position Oppenordt did not have a happy touch with his buildings. A fairly large addition which he made to the Hôtel Crozat in 1720 caved in. Further work on Saint-Sulpice, a task entrusted to him in 1719, was brought to an end prematurely, since the tower which he erected over the crossing had to be removed again in 1731 because it put too much weight on the arches. Even in the case of the 'corner salon' in the Palais Royal he had had to pocket his plans again. Statical calculations were not his strong point. What was finally built in the twenties was not of much significance and came nowhere near the work of other architects.[18] In spite of his undeniable wealth of ideas Oppenordt was not in tune with the demands of the age so far as architecture was concerned. It was a different matter with decoration, as we shall see.

A further consequence of the Régence was the intensification in Paris of private build-
ing, which now passed all bounds. The proximity of the court, now in residence in
the Tuileries, enhanced uncommonly the attractions of the western suburbs, especially
those on the left bank of the Seine. The new quarters filled up so quickly that in 1722
the Faubourg du Roule, which adjoined the Faubourg Saint-Honoré to the west, could
be incorporated in the city, and that by 1730 the Faubourg Saint-Germain had already
reached the newly established city boundary on the left bank – the Esplanade des In-
valides – beyond which building was not allowed.

These years were particularly important for the building of hôtels, since it was this
period that saw the development of those features which became classical for the French
mode of living in the eighteenth century and which gave it its specific character in
comparison with other countries.[19] In the first decade of the century the plan had become
lucid and rational; now convenience and flexibility entered into it. A comfortable

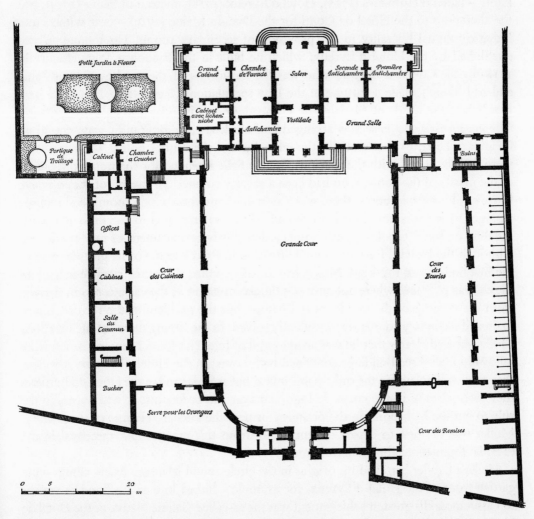

Figure 14. Armand-Claude Mollet: Paris, Hôtel d'Évreux, 1718, plan of ground floor

residence became the first requirement of life. Façades, on the other hand, grew plainer. Structural elements yielded to the optical factor, and especially to rusticated pilaster strips; articulation was frequently replaced by mere decoration.

Among the architects of the older generation Lassurance still enjoyed a high reputation. In the Faubourg Saint-Germain he built the important Hôtels de Rohan-Montbazon (1719) and de Roquelaure (1722); he collaborated in the Palais Bourbon (1722–4); and in the Faubourg Saint-Honoré he converted the old Hôtel Pussort into the Hôtel de Noailles. But further development fell to the younger men. The most important of these were Mollet, Courtonne, Gabriel, Aubert, and Jean-François Blondel, though a far greater number shared in the general opportunities for building.

The leader in the field of designing plans was at first Armand-Claude Mollet (c. 1670–1742), the descendant of an old family of gardeners.[20] The buildings of his that we know – Hôtel d'Humières (1715), Hôtel d'Évreux (1718), château of Stains (1714), and the alterations to the Hôtel de Conti for the Duc du Maine (1719) – bear witness to a hitherto unusual liberality in the provision of secondary rooms. His reputation was established by the Hôtel d'Évreux, which he built in the Faubourg Saint-Honoré in 1718 for the Comte d'Évreux, who was the son-in-law of the wealthy Crozat l'aîné and had himself made a fortune in the Law speculations (Figure 14). This hôtel later passed into the hands of Madame de Pompadour and is today the Palais de l'Élysée. The *appartement de parade* was arranged anti-clockwise, in Boffrand's way, round an imaginary heart, so that spatially the salon formed the central point. The anterooms were doubly linked with the spacious Grande Salle intended for the numerous clients of the master of the house, who had been a cavalry colonel. To the left of the entrance, however, by the bedrooms, there was a system of anterooms, side rooms, and interior passages which was new in this form and which was repeated in the little additional building on the left looking out on the garden, a private apartment of modern design. Although the Hôtel d'Évreux aroused attention in Paris because of its plan, it was not the first building of this kind. Mollet had already applied the same principle in 1714 to the château of Stains, where not only was the accentuation of the various rooms derived from the verticals of the façade, as at Champs, but the problem of the relationship of main and secondary rooms was excellently solved. In the 'living units' of the first floor Mollet showed clearly that he was an apt pupil of Jules Hardouin Mansart. As a further innovation, all three buildings contained bathrooms; in the Hôtel d'Évreux, it is true, they were still isolated in the right-hand annex, but at Stains and in the Hôtel d'Humières they were already in the corps de logis and near the bedrooms. It was normally the rule to put the bathrooms in the orangery or near the kitchen, because of the heating. Mollet was the first to depart systematically from this practice and thereby laid the essential foundations for modern hygiene.

Mollet's façades betrayed his origins in the circle round Mansart. Many things – the garden front of the Hôtel d'Évreux, for example – linked him to Boffrand as well as to Lassurance. His greatest achievement was the so-called Galerie Neuve of the Hôtel de Nevers – now the rear wing of the Bibliothèque Nationale – which he built in 1719

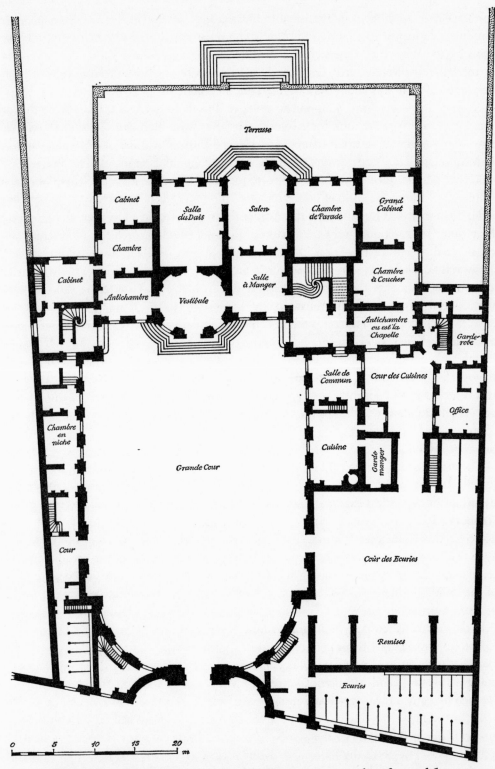

Figure 15. Jean Courtonne: Paris, Hôtel de Matignon, 1722–4, plan of ground floor

243

for Law and his bank, but was unable to complete owing to Law's bankruptcy. It combines dignity with grace and is one of the most beautiful buildings bequeathed to Paris by the Régence.[21] The rich and confidently distributed decoration appears again in the Hôtel du Maine – formerly the Hôtel de Conti – which Mollet completed and decorated after it was taken over by the Duc du Maine in 1719.[22]

Among his most important innovations in this field were the flush semicircular window surrounds. He took these over from the royal buildings at Versailles and Trianon and put them into town houses. The Hôtel d'Évreux was the first private mansion to have them. They became one of the Rococo style's chief means of articulation.

Unlike Mollet, Jean Courtonne (1671–1739) came from the theoretical side of architecture. We know but little of his personality. Blondel calls him 'architecte du roi' and from 1730 onwards he taught at the Académie as a professor. However, the Hôtel de Matignon (1722–4), one of the few works of his own which he mentions in his theoretical manual, is one of the finest in the 'noble Faubourg'.[23] The most striking feature about it is the close harmony between the plan and the façade (Figure 15). In order to be able to accommodate the roomy stables on the limited plot, Courtonne had to move the courtyard away from the central axis and as a result to transpose the front and back façades of the corps de logis. It is this enforced irregularity which produces the remarkable and also very richly decorated suite of rooms. The two enfilades are unequal in length and so displaced in relation to each other that an alternating rhythm arises, with the oval vestibule and the octagonal salon each forming the centre of a group of rooms. It is true that Blondel rightly criticizes the size of the Grande Antechambre, also known as the Salle du Dais, which robs the central salon of its function of dominating. But this room was intended as a dining room for big parties and had therefore to be kept as big as possible.[24]

The articulation of the façade corresponds to this arrangement of rooms, so that the interior layout can already be recognized from outside. Courtonne here demonstrated by means of a practical example his theory of the transparence of a building and of the 'rapport parfait' between interior and exterior. However, Mollet's innovations were not echoed in Courtonne's work. The main staircase is a long way from the vestibule. Secondary rooms are almost completely absent and those that exist are difficult to reach from the living rooms. This was probably why Courtonne was replaced as director of the building operations when in 1723 the Comte de Matignon took over the house in a still unfinished state.[25]

In the façades (Plate 223), whose rhythm corresponds on the court and garden sides, Courtonne transferred from country-house architecture a motif that Bullet de Chamblain had already used successfully at Champs, namely the central pavilion jutting out polygonally. Boffrand had demonstrated the same sort of thing in the Hôtel Amelot. He thereby gained for town-house architecture an important form of articulation which brought the façade to life and created a strong accent without calling on columns or pilasters. The breaking up of the planes, in place of Boffrand's continuous oval, corresponded perfectly with the tendency to slur forms. Here it is still only like a sort of breath passing through the building. The slenderness and lightness of these broken

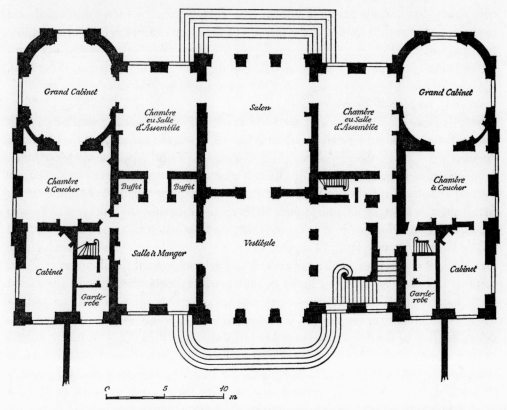

Figure 16. Jacques Gabriel and Jean Aubert: Paris, Hôtel de Biron, 1728–31, plan of
ground floor

pavilions is intensified still further by the very small, open central pediment with the
cartouche containing the coat of arms and by the low roofs. Finally, an important means
of decoration is provided by the wrought-iron balconies on their richly sculptured
brackets. Meudon already had these, but it was Mollet who had first introduced them
on town houses in the Hôtel d'Humières (1715). They are one of the clearest signs of
the way in which structural thinking henceforth gave way to mere delight in decora-
tion, joy in ornament.

The Hôtel Peyrenc de Moras (1728–31), later to become the Hôtel de Biron, must be
regarded as a logical development of the Hôtel Matignon. It is one of the most important
and most beautiful hôtels in the Faubourg – not least because of its garden, which has
been preserved.[26] To what extent it is the work of Jacques Gabriel (1667–1742),[27] who
was another pupil of Mansart and to whom it is usually attributed, cannot be ascertained
with certainty.[28] Gabriel, whose town-planning activities are discussed elsewhere, was
not one of the leading spirits in Paris hôtel-building. It is unlikely that he achieved such
a mature solution here on his own initiative. It is more probable that the decisive influ-
ence was provided by Jean Aubert (d. 1741), the court architect of the Duc de Bourbon-
Condé, who is mentioned as director of the works and whom we often find occupying
a prominent position. In the plan (Figure 16), the aesthetic ideas of the period have been

S

completely fused with practical needs. The correspondence between interior and exterior, between the façade and the shaping of the space inside, has been brought to a final stage of development. The garden façade (Plate 224) duplicates the pavilion motif of the Hôtel Matignon. In the soft rounding of the corners, the varied line of the roof, and the luxuriant ornamentation under the central balcony, the threshold of the Style Louis XV has already been crossed.[29]

Shortly before this the two architects had finished another building which enjoyed a certain fame, namely the Palais Bourbon (1722–9). It was the residence of the Duchesse de Bourbon-Condé, the proud daughter of Louis XIV and Madame de Montespan, who owned a large and splendidly situated plot of land on the bank of the Seine.[30] Several architects had already tried their hands at designing a suitable building for it: first Robert de Cotte, whose plans were never carried out, then the otherwise unknown Italian Giardini, who died in the year in which the foundation stone was laid, 1722, and finally Lassurance, who from all appearances was responsible for the façade but likewise died while it was being erected. Aubert and Gabriel took over the building in 1724 and completed it in 1729. This first Palais Bourbon, which bequeathed only its site to the present seat of the French Parliament, was an uncommonly splendid building and remarkable in more than one respect. Giardini had been expressly instructed to model his design on that of the most modern palaces of Rome and Florence – hence the restless outline of the plan, which is unparalleled in French eighteenth-century architecture (Figure 17). Originally, too, he had planned a building of several storeys, possibly after the style of the two gatehouses, which, with their orders of pilasters above a ground floor, formed a complete contrast to the main building. But after his death this plan was dropped and the building was restricted to a single storey, thus repeating the type of the *maison à l'italienne*. The elevation now followed that of the Grand Trianon, with which the duchess had been familiar since her youth. This is the explanation of the old-fashioned conglomeration of columns and pilasters, which corresponded precisely to the façades of the Trianon.[31] Aubert's contribution, which certainly exceeded Gabriel's in this case too, where a building of the Bourbon family was concerned, cannot be defined with any certainty. The façade (Plate 225), which would have to be regarded as a product of Lassurance's old age, was certainly not by Aubert, except for the big lunette over the courtyard side, which already occurs in a similar form in the stables at Chantilly. But the arrangement of the plan can certainly be regarded as largely his work. Two principles were here brilliantly combined: that of an imposing, courtly, representational effect and that of the greatest possible comfort. The former made itself felt in the double entrances to the two side wings,[32] in the splendid *appartement de parade* consisting of square, octagonal, and oval spaces with its gallery at the end, and in the position of the duchess's bedchamber – recalling Versailles – in the middle of the front. From the point of view of comfort, on the other hand, the palace was a masterpiece in Mollet's terms. The whole left half of the building was reserved for the *appartements de commodité* and was a mosaic, so to speak, of bedrooms, *cabinets*, dressing rooms, and corridors, not to mention bathrooms. Above these there was a mezzanine floor, which increased the living area considerably. This part of the building could be reached from the *appartement*

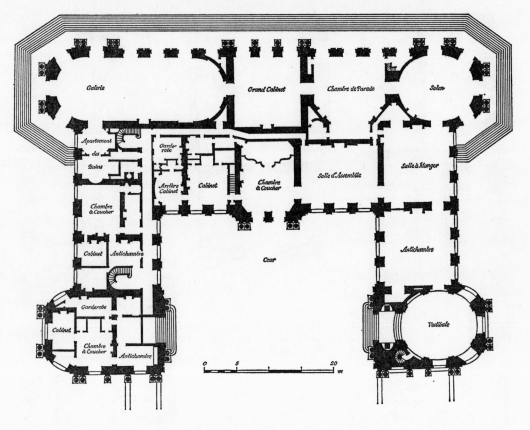

Figure 17. Paris, Palais Bourbon, 1722–9, plan

de parade by a special corridor which was lit from above and skirted round the duchess's bedchamber. Every inch was utilized: even in the triangular spaces alongside the salon and the *chambre de parade* there were staircases and dressing rooms. It was these advantages that caused Blondel and Patte to regard the Palais Bourbon as the starting point of the modern residence,[33] although this is not quite correct if we take into account the earlier buildings by Mollet already mentioned.

Concurrently with the Palais Bourbon, Aubert took over the construction of the neighbouring Hôtel de Lassay (later the Petit Bourbon, today the Présidence de la Chambre des Députés), which belonged to a friend of the duchess and had likewise been started by Lassurance in 1724.[34] This small, aristocratic hôtel snuggled close to the neighbouring palace but was in every way plainer and more modest. Here the façade itself, with its rusticated surfaces, is probably the work of Aubert, and the interior planning certainly is: in spite of the smaller scale, it matches that of the Palais Bourbon in confidence and elegance.

Aubert had begun his career in the Bâtiments, where he worked from 1703 to 1708 as a draughtsman under Jules Hardouin Mansart. However, he had moved quite early to the court of the Bourbon-Condé, with whom his activities remained thenceforth

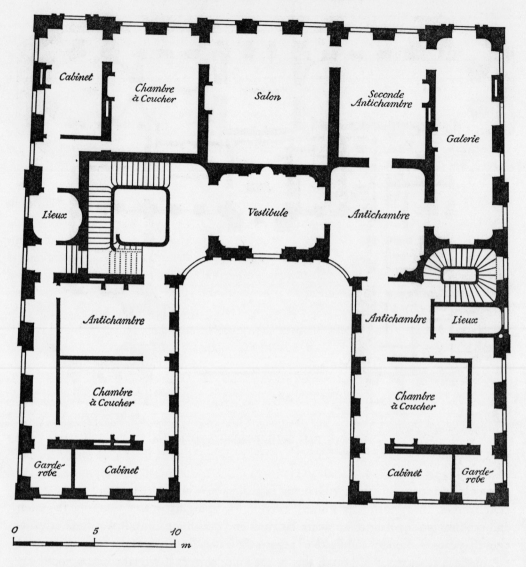

Figure 18. Jean-François Blondel: Geneva, Maison Mollet, *c.* 1722, plan of first floor

connected.[35] His masterpiece here was the stables at Chantilly (1721–33; planned since 1719), which he had begun a few years before the Palais Bourbon. They are the most monumental buildings left behind by the Régence and at the same time a symbol of the rise of the great nobles to the position of the Crown in architecture. They were modelled on Versailles, but the model was far surpassed.[36] These stables were among the extensive new buildings erected by the duke, who had made a lot of money out of Law's speculative schemes, at his family seat. They were closely related to the château, which was built at the same time but pulled down after the Revolution. The plan is a combination of rectangle and trapezium. It is arranged in such a way that the central axis of the three consecutive courtyards forming the rectangle of the whole layout originally ran towards

the Grand Cabinet of the duke, just as at Versailles the central axes of the two stables, the Grandes et Petites Écuries, also ran towards the Chambre du Roi in the palace. The trapezium in which the huge rectangle ends on the side facing the château also goes back to Versailles.[37] It provides the occasion, as it does at Versailles, for an open, circular riding track, which here, it is true, is pulled outwards on the far side and swings out in a convex curve. By means of the splendid arcading, with its figured decoration, Aubert created a monumental exterior to face the château, mightier and richer than the one at Versailles. In the main façade on the meadow side (Plate 226), Aubert took over the motif of rustication with continuous window-arcading familiar from the Orangerie at Versailles. Through this visually effective articulation and the high roofs, he gave it a weight that goes far beyond mere utility architecture. At Versailles, Jules Hardouin Mansart had employed as the centrepiece of the back a slightly projecting space with a shallow dome. Aubert turned this into a huge domed pavilion, thus articulating his façade like the garden side of a château. The three-dimensional volume of this central pavilion, which originally bore, after the pattern of the Tuileries, the lead figure of a horse, the 'Cheval de la Renommée', is adjusted to the scale of the long wings. It gives the façade so much relief that any risk of monotony is avoided. The sculptural decoration too, mainly groups of horses and hunting trophies, executed in 1734–6 by Bridault but certainly designed by Aubert, is distributed among the few accented points – the central pavilion, the arcades of the riding circuit, and the western gateway. It is quite outstanding.[38]

Another architect who must be counted as one of the Parisian circle is Jean-François Blondel (1683–1756), a native of Rouen who was employed in the Bâtiments from 1707 onwards. He was not very active in Paris, but the buildings he erected in Geneva reflect the Parisian type so perfectly that Mariette included him in his *Architecture française*.[39] It was in 1721 that he was called to Geneva, which had been strongly influencd by Paris since the turn of the century. In the three years which he spent there he built three houses – one in the centre and two more in the surrounding area – in which he showed himself influenced by Boffrand and Le Blond. One of the testimonies to this is the plan of the Maison Mollet (Figure 18), a plan which was developed from that of the Hôtel Amelot. The siting of the staircase to the left of the hall made it possible to lay out the *appartement de parade* on the first floor in a circular form, though there still remained room to insert a gallery in the right-hand corner. An important innovation in the articulation of the façade was provided by the brackets which appear on Monsieur Lullin's country house at Genthod near Geneva; they link the corner pilaster strips with the cornice (Plate 227). Until then this position had been occupied by capitals, i.e. structural not decorative elements. The supporting function of these pilaster strips was also weakened by the bands of rustication, which stood out more strongly to the eye and lent more weight to the recessed area. With this the functional system of the structure, the concept of burden and support, which at Marly is still emphasized by architecture painted on a cubic mass, is mutually cancelled out. In this weightlessness, this equilibrium between the structural and decorative functions of the various parts of the building, Blondel's work marks the zenith of the architecture of the Régence.

So far as country houses away from Paris are concerned, not very many were built during these years. The charming little château of Beaumont-sur-Vingeanne in Burgundy is as good an example as any (Plate 228). It was erected in 1724 by an unknown architect for Abbé Jolyot and shows the dominating influence exerted by Paris over the provinces, especially when the architect concerned was one who had spent some years at the court. The most striking thing about the plan is the skilful distribution of the secondary rooms, which use up every corner of the not very extensive ground space and ensure the highest degree of comfort. Both outside and inside, the little building reflects all the Parisian advances of the twenties.[40]

Robert de Cotte (1656–1735) and French Château Architecture

In spite of the emergence of so many younger talents, Robert de Cotte played the dominant role in the architecture of the Régence. His authority was undisputed. Even Boffrand, who in Lorraine had the biggest commissions available in French-speaking lands, came second to him.[41] But since the Crown did not make full use of his services he was able to devote himself largely to private practice. His activity was not confined to Paris alone. He worked for both French and foreign patrons. The expansion of the French court style, which had already begun under his predecessor, Jules Hardouin Mansart, now gathered impetus. Under de Cotte France began successfully to dispute Italy's position in architecture.

De Cotte's official activity in Paris was confined to all intents and purposes during the Régence to the Château d'Eau (1719), whose practical purpose – as a reservoir and distribution point for water – was very skilfully concealed behind a palace-like façade of squared slabs with bosses and a pediment in the middle. It also had the task of providing a stately background to the irregular and unsightly square in front of the Palais Royal.[42] Plans made in the same years for royal stables in the Rue Saint-Honoré were never carried out. Of his numerous private buildings, the Hôtel de Toulouse, with its famous Galerie Dorée, and the already mentioned Hôtel de Conti or du Maine were the most important, since his plans for the Palais Bourbon were not put into effect. But as fashionable architect to court society he was called in to give advice in many other undertakings, with the result that plans and designs in his hand are extant for almost all important buildings.[43] He was even busier outside the capital than in it. In Besançon he produced the plans for the mansion of the Marquis de Grammont (1713–14), in Strasbourg those for the Grand Doyenné, and in Aix-en-Provence those for the Hôtel de Caumont. At Lyon he erected between 1717 and 1724 the regular façades of the Place Bellecour, where the statue of Louis XIV had already been put up in 1713 (cf. p. 38).

However, his fame abroad was based on his châteaux. His importance in this field far exceeded that of his predecessor and is comparable only with that of François Mansart and Le Vau. Like them, he created an accepted type which set the style for a long time. Without giving up representational stateliness, de Cotte used as his starting point the improvements and lighter approach that had appeared in the ground-plans

of the late Louis XIV period. The difference from Jules Hardouin Mansart can be traced all along the line. De Cotte's architecture was lighter, more elegant, and less laden with sculpture. His plans were distinguished by nobility, modern arrangement, and practical convenience for living. This gave them an advantage over the traditional Italian scheme, which still clung to continuous suites of large rooms without any secondary smaller rooms and made de Cotte seem the great renewer of European château-building.

His earliest châteaux lay in the south-west of France, at Thouars (1707) and Chanteloup (begun in 1711). The latter became famous later through the Duc de Choiseul. Cotte built it for Princess Orsini, the French adviser of Philip V of Spain.[44] It was a modern two-storey building after the style of Clagny, with a shallow centre, articulated by three projecting sections adorned with balconies, and two long wings, one of which contained a gallery. All the rooms in the house except for the large central ones were accompanied by corridors or small secondary rooms.

But the big commissions only came in the years after the Treaty of Utrecht, when the German rulers who had fought on the French side in the War of the Spanish Succession and had spent several years in exile in France returned to their countries full of enthusiasm for French art, when the whole of Europe sought contact with France again and palaces were planned everywhere. In the tremendous competition that developed as a result of all this, de Cotte was by far the most active architect. He produced plans for the Electors of Bavaria and Cologne, for the King of Spain and Prince William, later Landgrave, of Hesse-Kassel, for the Prince-Bishop of Würzburg, the Count of Zinzendorf, and the Prince of Thurn and Taxis. In many cases he also provided them with architects to supervise the execution of his plans and the progress of the work on the spot. Numerous letters, still extant, and a huge number of designs and copies of plans show how close the link was and how precisely the central office in Paris was informed about everything. Although Cotte never left France, he kept firm hold of the reins, and it was his genius which inspired the many concurrent architectural enterprises. The extension of such a network of building operations right across Europe as far as Turkey[45] from one single central office was remarkable: it was unparalleled in the eighteenth century. De Cotte's château designs, for the execution of which, it is true, the money was usually lacking in the end, were based systematically on the scheme of the three-wing building exemplified by Versailles. But now, in contrast to the gradual growth of that royal residence, everything was ordered, firmly articulated, and accented according to a unified plan. The sovereign's living rooms were sited in the central block, and the staircases, chapel, and theatre in the wings, a loose symmetry being preserved. As at Versailles, the first floor was meant to be the real living and representational floor. The cour d'honneur was frequently surrounded by covered galleries which protected visitors from the rain; the corridors running along above them were used as interior links between the long wings.

The designs for the first three big palaces – Schleissheim, Bonn, and Buenretiro – are almost contemporaneous. All three are directly connected with the end of the War of the Spanish Succession. Schleissheim and Bonn were intended for the Electors of Bavaria and Cologne, returning to their lands from exile in France, and Buenretiro for

the newly established King of Spain, Philip V, the grandson of Louis XIV. What is common to them all is that through lack of money they were either only partly finished or even not built at all. Thus they could set no example; nevertheless their historical importance is great.

The first design for Schleissheim (1714) (Figure 19) was an ideal one which took no account of the already existing but unfinished building by Zuccali, the Bavarian court architect.[46] It was based unmistakably on Versailles, both in its general design – in the accentuation of the broad side wings divided by intervening courtyards and in the narrow central section – and in such details as the long gallery in the right wing flanked by two big salons. Even the stepping of the ends of the wings – caused at Versailles by successive additions – was repeated here, though in a very skilfully arranged, symmetrical form. The great staircase, sited in an unusual and moreover inconvenient spot, was probably meant to be a reminiscence of the prototype at Saint-Cloud so much admired by the Elector Max Emanuel.

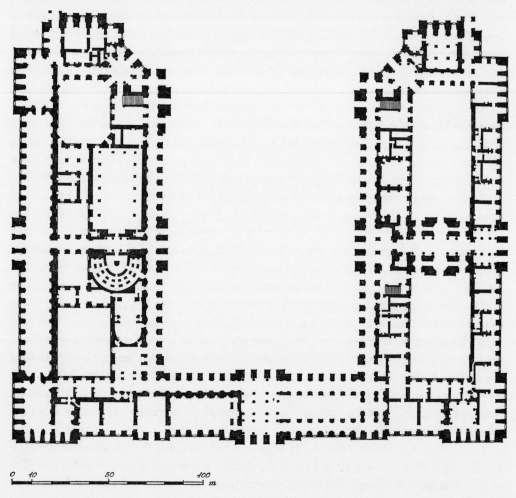

Figure 19. Robert de Cotte: Schleissheim, first design, 1714, plan of ground floor

The second design linked up with Zuccali's building by siting in front of it a deep cour d'honneur, the wings of which bent round in a right angle at their front ends and thus formed a counterpoise to Zuccali's side pavilions. Here the principles of de Cotte's mode of building were already to be recognized: in the wings, reduced in size, comfortable living apartments with corridors running all the way through and the chapel and theatre right at the end; in the middle section, on the other hand, two big apartments for the ruling couple, with central vestibule, staircase wells, and anterooms. Here the modern conception had triumphed.

At Bonn, in spite of all the Elector Josef Clemens' good intentions, de Cotte had to be content with low additional buildings jutting out at right angles from the existing, seventeenth-century château, and with touching up Zuccali's monotonous façade.[47] The plans, it is true (after 1714), were much more grandiose. They provided for the incorporation of Zuccali's château in a big, four-winged layout with a short but wide-sweeping cour d'honneur in front (Figure 20). The heart of this design was the residential wing proper of the elector-archbishop, which lay parallel to Zuccali's building: plan and façade were here knit together, as in Le Vau's châteaux, by a two-storey central room swinging out in an oval. The elector's apartment was clearly articulated with rhythmical accents which also found expression in the façade. The interior planning, with its series of dressing rooms, passageways, and stairs behind the reception rooms, was considerably more progressive and variegated than that of Schleissheim and marked a complete departure from Zuccali's type of château. The resistance of the Rhenish Estates to this building prevented its erection. The elector had perforce to content himself with the little 'Buenretiro' wing, built on the lines of a private mansion at the west end of the palace, as a reminder of his stay in France.

The design for Buenretiro I (1715) combined the ideas of Schleissheim and Bonn (Figure 21). Here the Spanish court had expressed precise wishes with which de Cotte had to comply.[48] The corps de logis contained a double apartment, looking out on the courtyard and the garden, with, in the middle, secondary rooms that could be used from either side and, running up to them at right angles, a central axis which acquired its depth and importance, as at Champs or Turny, through the oval room. A comparison with de Cotte's design for the similar central axis of Malgrange (c. 1712) shows the swift development of concepts of space during these years, especially the striving for a harmonious succession of dissimilar rooms.

However, side by side with the concept of the three-wing building there ran another, derived from the Louvre: that of the square building with four wings grouped round a courtyard. De Cotte used this scheme in the second plan for Buenretiro and, on a smaller scale, in the contemporaneous country house of the Elector of Cologne, Poppelsdorf (1715). In their symmetry, both possess the character of the ideal architecture particularly dear to Mannerism. At Buenretiro (Figure 22) there were four similar apartments on each floor, one in each angle of the square – for summer and winter use by the royal couple – while the inner cross-wings served as a stately entrance and as a link between the apartments. A whole chain of dressing rooms and secondary staircases ran round the courtyard as accompaniment to the living rooms. To increase the depth

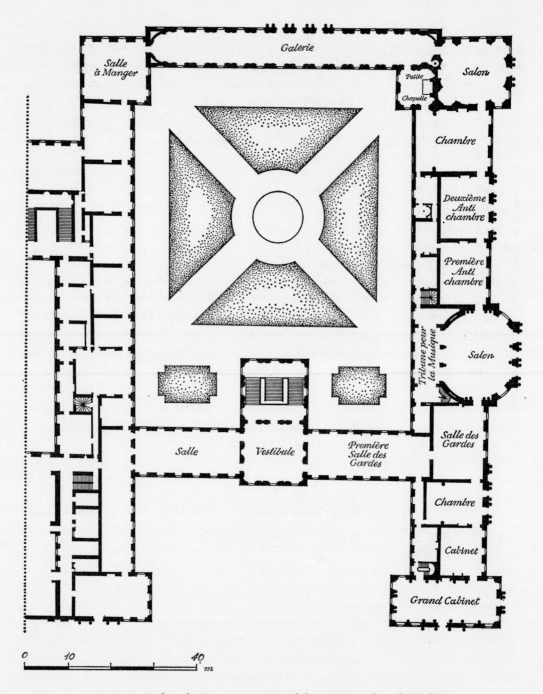

Figure 20. Robert de Cotte: Bonn, second design, 1715, plan of first floor

The labels within the plan, reading approximately by position:

Galerie

Salle à Manger

Salon

Petite Chapelle

Chambre

Deuxième Anti chambre

Première Anti chambre

Tribune pour la Musique

Salon

Salle des Gardes

Salle

Vestibule

Première Salle des Gardes

Chambre

Cabinet

Grand Cabinet

0 10 40
m

254

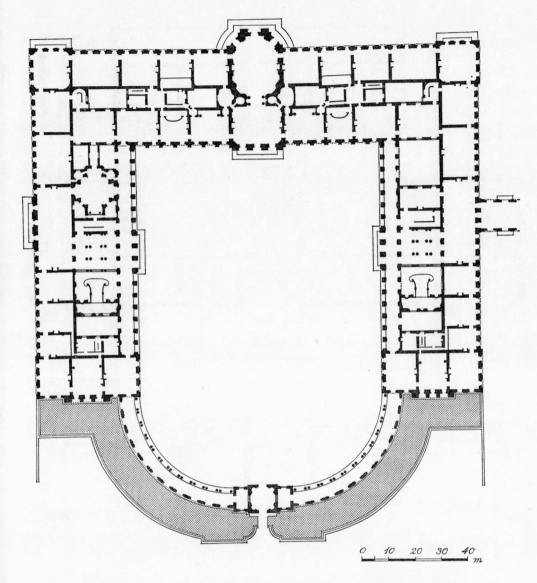

Figure 21. Robert de Cotte: Buenretiro, first design, 1715, plan of ground floor

0 10 20 30 40
 m

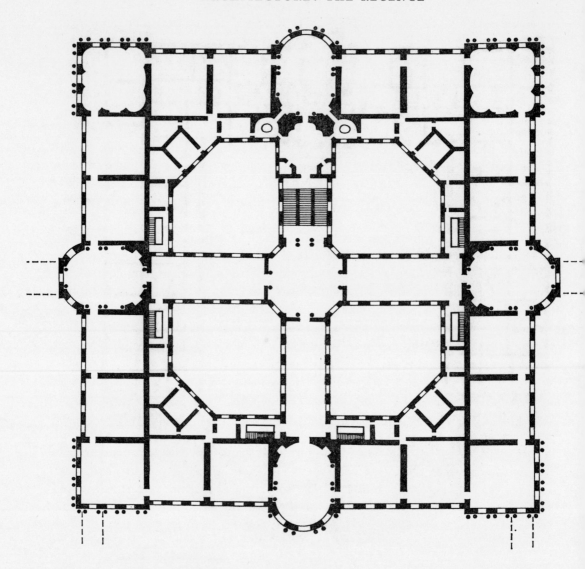

Figure 22. Robert de Cotte: Buenretiro, second design, plan of ground floor

of the axes in the cross-wings de Cotte here again used oval rooms of the sort that recur in the same place at Würzburg.

At Poppelsdorf (Plate 229), the only project of these years actually carried out (after 1715), which was closely linked with Bonn and was sited so as to look towards the Buenretiro wing of the château,[49] the cross-wings in the middle are replaced by a circular court with a gallery running round it, the secondary rooms being shifted to the triangular wedges at the corners and to the entresols. The chapel was also incorporated here in the rhythmical circle of pavilions. As the kitchen and stables could not be sited outside, but had to be accommodated in the building itself, de Cotte here brought off

the master-stroke of combining in the narrowest space and a mathematically ideal form the requirements of a princely *maison de plaisance* with the limited possibilities of a private mansion.

Another building loosely related to this four-wing scheme is Tilburg in Holland, the property of Prince William of Hesse-Kassel, at that time governor of Breda. De Cotte's plans for this moated castle, which almost certainly reckoned with the existing foundations – whether the plans were ever actually executed is questionable – were also probably produced about 1715.[50] They envisaged a massive square building with four corner pavilions, which was divided up by a cross-axis of four big rooms in the middle of each wing and which, in spite of its old-fashioned form, acquired a comfortable and habitable character through the apartments in the corners and a refined system of built-in entresols.

De Cotte's façades were at first based on those of Jules Hardouin Mansart. The system of articulation into middle and side pavilions, with clear central emphasis through a dome, as developed at Clagny, Rivoli, and Boufflers, was obligatory for him too. In the sketches for Schleissheim, however, there often appears a giant order of pilasters for the pavilions, familiar from Le Vau, side by side with another scheme, once envisaged for Versailles: a big two-storey system of arcades and a centre, stepped in plan, with big pediment and dome. This design of Mansart's, which had not been approved by the king, also appears again in the Würzburg façade.[51] From Bonn onwards, however, de Cotte began to hark back to Le Vau's façades – at Vaux-le-Vicomte, for example – and to make the central pavilion curve outwards in an oval, with an order of columns in front of it. Probably at the same time, but in any case at Buenretiro at the latest, he also stretched the central dome. Instead of the square plan, the *dôme à l'impériale*, he gave it an octagonal, round, or, as later in Frankfurt, oval shape, with superimposed ribs and frequently some kind of crown at the apex. Through these new elements the façade acquired three-dimensional accents quite different from those it had hitherto possessed and a vertical stretching which corresponded with contemporary developments in hôtel architecture and with the trend also to be observed in the latter towards the slender and elegant. The most splendid of these façades is undoubtedly Buenretiro (Plate 230). It was more tranquil than Bonn, three-storeyed and articulated by giant pilasters on the pattern of the Place Vendôme. But here too de Cotte based his work on the designs for the south façade of the Louvre, in order to emphasize the royal status of the building.[52] He accordingly placed in front of the central pavilion a giant triumphal arch motif, which may be regarded as a scaled-down version of the former central pediment by Le Vau on the Louvre.

While the work for the Austrian Count Zinzendorf is almost contemporaneous with these palaces,[53] the designs for the Residenz at Würzburg, the Thurn and Taxis Palace in Frankfurt (destroyed in 1944), and some bishops' palaces in France fall into the third decade of the century.

At Würzburg, where plans by Maximilian von Welsch already existed and building had already begun, de Cotte could do no more than impart rhythm to the plan (1723). His revisions, which arrived alongside those of Boffrand and were only followed to a

very small extent, therefore aimed above all at enlarging the cour d'honneur, changing the proportions of the rooms, creating accents by placing oval rooms transversely across the wings – and thus building up spatial axes at right angles to the main direction – inserting sufficient secondary rooms, and creating a dominant central accent consisting of vestibule, staircase, and chapel – in short, a system which, while retaining the existing outline, clearly expressed the modern French manner of building.[54]

Of the bishops' palaces at Châlons-sur-Marne (1719) and Verdun (1724), only the latter was completed. It does not exceed the size of a private mansion, but acquires its own individuality through the inward-curving wings of the courtyard façade, which are tailored exactly to the big, splendidly articulated cour d'honneur and are continued in walls concealing stables and an orangery. De Cotte was busy for a particularly long time on work for the Prince-Bishop of Strasbourg, Cardinal Armand Gaston de Rohan. First he rebuilt (from *c.* 1720 onwards) his residence outside Strasbourg, the château of Saverne (Zabern), which had been destroyed by a fire in 1709.[55] Here it was certainly a case mainly of repairs and modernization – except for the bath house, built about 1730 or a little earlier, a charming little building that displays de Cotte's style, conservative to the end, during this period. But de Cotte's real task was the town residence of the prince-bishop, the so-called Château des Rohan in Strasbourg.[56] This jewel of modern Strasbourg has its counterpart, however, on the other side of the Rhine. At roughly the same time, Prince Anselm of Thurn and Taxis, Postmaster General of the Holy Roman Empire, commissioned de Cotte to build a town residence in Frankfurt, the Palais Thurn and Taxis.[57] Both buildings have much in common, not only the contemporaneous planning (Strasbourg 1727–8, Frankfurt 1727) and execution (Strasbourg 1731–42, Frankfurt 1731–6) but also the general shape: behind a peristyle flanked by pavilions stretched a cour d'honneur, surrounded at Frankfurt by arcades. Behind this lay the corps de logis and on each side the domestic offices. The interior arrangements of the two mansions, however, differed considerably. At Strasbourg the corps de logis contains, on the ground floor only, two separate apartments: a smaller one for the cardinal, looking out on the courtyard, and a bigger one for royal visits, looking out on the river. The entrances lie correspondingly in the right-hand and left-hand corners of the courtyard, as in the Palais Bourbon; courtyard front and garden front are reversed. At Frankfurt, on the other hand, each storey had a double apartment, with a central axis consisting of an octagonal vestibule and an oval central room. The entrance was consequently situated in the middle of the corps de logis. At Frankfurt, to correspond with the oval room, a pedimented central pavilion with an oval dome curved out on the garden side. At Strasbourg, on the other hand, the dominating accent on the river side is a columned portico, which lends the palace dignity and importance (Plate 231). It is a counterpart to Boffrand's columned portico at Lunéville and a reminder that the cardinal was also Landgrave of Lower Alsace and a prince of the Holy Roman Empire. The interior decoration and sculptural ornamentation are excellent; at Strasbourg they are for the most part the work of Robert Le Lorrain and his assistants. At Frankfurt the craftsmen were the Italian stucco-workers Morsegno and Castelli, already known from Bonn and Poppelsdorf. The men who directed the work were Joseph Massol at Stras-

bourg and Guillaume Hauberat at Frankfurt, both pupils of de Cotte. Massol was important for further stylistic developments in Strasbourg; Hauberat had already made a name for himself at Bonn, Poppelsdorf, and Mannheim. He was one of those who did most for the extension of the French style in Germany.[58]

Now that almost all de Cotte's buildings have either perished or been largely disfigured, the Château des Rohan at Strasbourg is the last remaining example of what the *Mercure de France* called in 1735, in its obituary notice for the great architect, 'aristocratic boldness and elegance, combined with the precision and purity of the ancient rules ... and not least that happy interior planning desirable for the pleasantness and perfection of public and private buildings'.

Besides Robert de Cotte and Boffrand yet another Frenchman was called to carry the style of Versailles abroad. In 1716 J.-B.-A. Le Blond, Mansart's pupil, had accepted an invitation from Peter the Great and gone to St Petersburg as First Architect of the czar. Besides him, Peter had also engaged Nicolas Pineau and a whole band of French painters and craftsmen. Le Blond was to direct the building of Petersburg.[59] However, his design, which encountered the opposition of the all-powerful Menshikov and, as a result of his long preoccupation with garden planning, looked like the layout for a garden, was not executed. Nor were his plans for Peterhof and Strjelna put into effect to any great extent: only the terrace garden of Peterhof has been preserved. In these buildings the Mansart school of the late Louis XIV period had been prolonged, with its terrace roofs, sculptured ornamentation, and dominating central dome. The premature death of Le Blond in 1719 prevented the extension of this style to Russia as well

Boffrand's pupil Pineau, who became Le Blond's successor and remained at the czar's court until 1727 as director of all the decorative work, already belonged to the new generation. It is true that in his design for a church in St Petersburg[60] he followed the scheme of the Primatiale of Nancy, but its structural character was here completely transformed into a decorative one, the expanses of wall in comparison with openings being reduced to a minimum. Pineau's real strength lay in ornamentation. In the decoration of Peterhof, especially Peter the Great's study (*c.* 1719), and in the virtuoso carving of the trophies and ornaments, he gave Russia an example of Régence decoration which was the equal of any similar work in France itself.[61]

Decoration

The difference between the late Louis XIV style and the Régence comes out more clearly in decoration than in architecture. On top of the progressive relaxation of the system of geometrical lines came the growing influence of the grotesques of Audran and other painters and a stronger Mediterranean flavour, which made itself felt particularly in the second decade of the century and, with its emphasis on bolder relief, engendered the swing to figured motifs. The two leading artists of this period were Oppenordt and Vassé; the former worked for the regent and his circle, the latter for the Bâtiments. Oppenordt came, as we have already mentioned, from the Roman

atmosphere of Borromini; François-Antoine Vassé (1681–1736) (cf. p. 81) from the south of France. He had worked on Bérain's designs for the decoration of the arsenal at Toulon, the home town of Pierre Puget.[62] Another factor in the trend towards the three-dimensional was the publication in Paris in 1716 of a series of engravings by the wood-carver Bernard Toro (1672–1731), who also had a Provençal background.[63] The renunciation by these three of the prevailing two-dimensional approach and of Le Pautre's abstract play of lines met unanimous agreement, not only from the modern-minded regent and his collector friends but also at the tradition-bound Bâtiments, which Vassé entered in 1708, working first under Le Pautre and then, after his death in 1716, taking over the direction of the decorative work. It is to Oppenordt and Vassé that the Régence is indebted for its most important ensembles. They exerted a powerful influence that continued – in two different directions – into the beginning of the Rococo period.[64]

Oppenordt's first decorative work – altar designs for the choir of Notre-Dame (1699) and Saint-Germain des Prés (1704) – was still completely governed by Roman models. But in the public competition his designs for Saint-Germain des Prés were preferred to the contemporary, somewhat bloodless designs of Robert de Cotte and the very Baroque, Berninesque ones of Bullet.[65] Later, it is true, Oppenordt turned back into French paths – the altars at Amiens (1709) and at Saint-Jacques de la Boucherie in Paris illustrate this phase of his career – but Le Pautre's schemes always remained alien to him. In the Hôtel de Pomponne (1714), his first big commission, he filled the wall panels with hunting and nature scenes rather like still-life subjects and built up on purely artistic principles. They were very different from de Cotte's contemporary conventional decorations in the Hôtel de Grammont at Besançon or the Hôtel de Toulouse in Paris, and were in fact nothing other than relief versions of the arabesques and paintings of Audran, Gillot, and Watteau. The usual panel frames here became quite subsidiary, with their elements – staves, C-scrolls, palmettes – used quite freely in various different combinations. There can be no doubt that it was precisely this apparently magical freedom and his Roman training, highly esteemed at the time, that gained Oppenordt the regent's favour.

The first pieces of work in the Palais Royal – and it was these that put Oppenordt centrally before the public eye – contained clear traces of Italian influence, Roman as well as North Italian, not only in many individual elements – the strong profiles, the varying relief planes of the background, the boldly outward-curving and sharply contoured cartouches,[66] and the plentiful figured sculpture – but also in the monumental scale of the work as a whole. A good example was the oval end of the Galerie d'Énée (1717), in which fluted pilasters divided the panels, a heavy canopy under the huge heraldic cartouche supported by genii framed the giant mirror over the chimneypiece, and in the side panels big obelisks with trophies and cherubs rose up (Plate 232). But the same thing found expression in the designs for the Galerie en Lanterne with its crowned cartouches, its figures, and its trophies. Toro's designs for cartouches may well have played a part here. On the other hand, the new decoration of the Grands Appartements, carried out a few years later (1720), was much more reserved and French in design. The

ornamentation was more delicate and shallow, the contours livelier and more nervous (Plate 233). The influence of Audran's and Gillot's grotesques was here very much in evidence. It was they who provided the essentially new motifs: the outspread bat's wings, the naturalistic plant fillings, the figured medallions in the wall panels and spandrels of the arches, and in general the predominance of naturalistic elements, which here were not combined with the ribbonwork of Le Pautre but created a system of articulation that was quite their own. Among the motifs which flowed from this source and which were to form an important contribution to the Rococo style were the a-tectonic frames, both those consisting of festoons of tendrils and blossoms and those pinched in the shape of irregular waves. Two further elements mark this phase of decoration: the *têtes en espagnolette*, as they were called, in the frames of mirrors and mantelpieces[67] and shells used as an articulating element. The stylized shell of the Style Louis XIV was loosened up and hollowed out in a naturalistically Baroque way, and in addition the edges of the frames of mirrors and ornaments were scalloped like those of shells, after the style of Audran's grotesques. This careless freedom of the form from all academic conventions and the markedly three-dimensional volume of the ornamentation made Oppenordt a central figure in the artistic development of the Régence and the clear herald of the Rococo style. The only thing still absent from his work is asymmetry, and even this does appear in the big sconces of the mantelpiece mirrors, without affecting the relationship of the groups to one another.

While Oppenordt was thus laying the foundations for a new style in the Palais Royal, Vassé was occupied with a similar task in the redecoration of the Galerie Dorée (1718–19). This gallery was the final step in the rebuilding operations which de Cotte had been carrying out since 1713 at the Hôtel de Toulouse for the Comte de Toulouse, the son of Louis XIV (Plate 234). It formed the counterpart to the Palais Royal. Still extant, it is the second masterpiece of Régence decoration in Paris, and one that made famous not so much the name of its original owner as that of Robert de Cotte.[68] Vassé, who was responsible for the design as well as the execution, here showed himself as the great rival of Oppenordt, though at the same time not free from his influence. Even in his first independent work, the altar in the choir of Notre-Dame (1712), which stood out from Le Pautre's ensemble through its three-dimensional fullness and the lively movement of its forms, the two figures of angels on the narrow side were imitations of Oppenordt's adoring angels in Saint-Germain des Prés. In the Galerie Dorée Vassé was directly influenced by the Galerie d'Énée in the Palais Royal.[69] He gave Mansart's originally rectangular gallery the same oval end divided into three by pilasters, the central section of which today consists of a Baroquely curving marble mantelpiece with, above it, a big mirror, multi-branched candelabra supported by Tritons, and a fully three-dimensional ship projecting into the room. In the original conception, in which over the mirror a huge group of trophies framed the Bourbon lilies and the side panels were filled with big, three-dimensional festoons of trophies, with figured cartouches in them, the similarity was even greater. The entrance side, opposite the fireplace side, carries the other main accent. The leaves of the door and the fanlight above are filled with rich ornamentation in relief. In the fanlight two free-standing three-dimensional hunting

hounds leap up at a likewise three-dimensional basket of flowers on a big shell base; over the entrance are huge antlers and Diana with her maidens. Four big figures on either side of these central groups, two in each recess, symbolize the four quarters of the world. The thematic programme of the gallery thus plays on the prince's office of admiral of the fleet and his favourite occupation, hunting. Along the sides of the room, in contrast to the Galerie d'Énée, the order of pilasters at the mantelpiece end was continued along the whole length of the wall. The paintings there – works by Pietro da Cortona, Veronese, and Maratta among others – were given vigorous, richly carved frames, and the shallow niches, originally intended for statues, were filled with mirrors, so that the gallery looked brighter and more cheerful. In this part of the decoration, too, the dominant tone is set by the bold relief, the rich, strongly three-dimensional cartouches, the shell shapes present everywhere, and the rich, figured sculptural work. Scalloped shell-edges already appear here too. However, Le Pautre's system is in principle retained, not only in the two-dimensional decoration of the wall pilasters but also in the cornice and picture frames, where the C-scroll predominates, now, however, bringing the upper and lower edges to life. Though akin to Oppenordt in the wealth of his ideas, Vassé was more firmly rooted in the French tradition, and in the long run this gave him the greater influence on its development. He came into the limelight again at the end of the third decade of the century, when work began once more at Versailles.[70]

However, at first Oppenordt was given the bigger commissions because of his position. For the Elector of Cologne he produced schemes of decoration for the palace at Bonn (1716) and for the hunting box of Falkenlust near Brühl (1728), and for the King of Spain designs for the château of La Granja.[71] Of his Parisian work, apart from the transept and sacristy of Saint-Sulpice, only the Hôtel d'Assy (1719) – today part of the Hôtel de Soubise – has been preserved; here all Roman heaviness has been eliminated and a new mode of articulation appears. The top of the wall panels is curved downward, in the opposite direction to the door and window arcades, so that a wave-like undulation is produced which enriches the whole room and creates a unified upper zone. This articulation and the clover-leaf-shaped frames of the overdoors with their palm branches bring this scheme of decoration close to Boffrand's work – at Malgrange, for example, or in the Petit Luxembourg – which was based on similar ideas.[72] However, the direct influence of Oppenordt can also be recognized in the decoration of the Hôtel de Villeroy, built in 1720–4 by Claude Gillot, where the scheme of the Hôtel d'Assy is literally imitated, and in the Hôtel d'Évreux, where some of the tops of the doorways and mirrors are shaped exactly in Oppenordt's 'grotesque' style and the edges of the wall panels run in quite unconventional sharp convex and concave curves.[73]

In comparison with the products of Oppenordt's overflowing imagination, the schemes of decoration of the Bâtiments, produced under the supervision of de Cotte, were more tranquil and classical. They developed Le Pautre's system further: the top and bottom ends of the wall panels and the frames of the mirrors acquired S-shaped and double C-shaped curves, and the palmette motifs pushed out from the central rosette and from the two ends further into the wall panels. One of the first examples of

this enrichment is the Hôtel de Bourvallais (c. 1717) – today the Ministry of Justice – which in many respects already points to the Galerie Dorée. Important innovations here are the winged corner cartouches, which climb up from the hollow mouldings on to the ceiling, forcing the cornice to bend upwards – a means of emphasizing the corners of a room and of strengthening the continuity of the decoration.

The masterpiece of the twenties is what is known as the Cabinet du Roi in the present Bibliothèque Nationale, begun in 1721 and only completed in 1741 by Jules-Robert de Cotte, the son of the Premier Architecte (Plate 235). The scheme of the Hôtel d'Assy, with its undulating cornice, was here used to articulate the long sides; the division into individual panels was abandoned in favour of large areas filled partly with trophies and partly with paintings. The shapes of the picture frames, with their vigorous, acanthus-filled C-scrolls, and the vigorous staves, cartouches, and shell shapes are characteristic of the court style of these years, a style which found no employment at Versailles. The room acquired a particular unity through its specially designed furniture, which still distinguishes it today from all similar rooms.[74] Outside Paris, the decoration which de Cotte carried out in the château of Saverne (Zabern) (1721-2) was the most important and also the most advanced, while the designs for the palace at Bonn, especially the Buenretiro wing (1717), remained very conservative and reticent; fundamentally they did not go beyond Le Pautre's ideas.

Alongside these two great streams, almost all the personalities known to us from architecture also worked on decoration. In spite of the losses inflicted by time a surprisingly large number of examples have been preserved in Paris, especially in the Place Vendôme and the Faubourg Saint-Germain, and it would be impossible to deal with them all adequately in the space of a short survey. Among the finest and most important are the Hôtels de Villars (c. 1715) and de Parabère (c. 1720) by Boffrand[75] (Plate 236), the Hôtel de Roquelaure (completed in 1726) by Jean-Baptiste Leroux, the Hôtel Dodun (c. 1720-2) by Jean-Baptiste Bullet de Chamblain,[76] and the Hôtel de Lassay (after 1725) by Aubert. They all share the tendency to dissolve the simple curve into a wave-like, broken, irregular undulation, the division of the main ornamental motifs into numerous repetitions and ramifications, the multiplication of the framing staves and thus of the relief planes, and finally the replacement of the geometrical line by the naturalistic tendril. Now began, too, the separation of the ornamented zones from the top and bottom edges of the wall panels, and the concentration of all the ornamentation in the middle.

Of particular importance here was Jean Aubert, indubitably one of the most gifted decorators of his age. His decorations in the Petit Château at Chantilly (finished in 1722) form the most complete ensemble preserved outside Paris (Plate 237). In spite of echoes of the court style, they reflect a free, individual mind which finds expression in many innovations: for example, in the concave corner bends of the curved door frames – an important Rococo motif – in the wall fillings of net-like gold mosaic, and in the luxuriant freedom of the big rosettes in the wall panels. In all the rooms the ornamentation climbs over the hollow moulding on to the ceiling, whether as light lace-work in the Galerie or as fantastic grotesques in the Salon de Musique and the Chambre de M.

le Prince. Finally, in the Hôtel de Lassay (Plate 238) Aubert gave the hollow moulding its own centre of gravity, either by making big figured cartouches break through the upper ceiling cornice and thus dissolve its continuity, or else by bending the cornice past the corners of the room in an oval curve and thus creating a new zone between the two cornices, which was filled with broadly stretched asymmetrical motifs as already adumbrated at Chantilly. In the wall panels the reticulated gold mosaic of Chantilly has melted into big golden fields and cartouches bearing figured pictures and enriched by a maze of ribbons and tendrils. A clear line can hardly still be traced here; one's impression is governed by the general effect of the extraordinarily rich vegetation which it is impossible to follow rationally. With these decorative schemes and those of the Palais Bourbon, only known to us from Mariette's engravings, where naturalistic, grotesque forms predominate, the different spatial zones run into each other – either through cartouches or rich brackets – and asymmetry makes its appearance, we have reached the end of the Style Régence. Like architecture, decoration stands on the threshold of the Rococo period.

CHAPTER 6

THE STYLE LOUIS XV

Introduction

THE death of Robert de Cotte in 1735 did not really mark any break in development. During the last few years of his life the old master had been almost blind and had largely retired. At the end of the twenties, without any contribution from him, architecture had entered a new stylistic phase which was developed by younger men. However, the school of Mansart had not died with him. One of the Surintendant's keenest pupils, Jacques Gabriel (1667–1742), succeeded de Cotte as Premier Architecte. In addition, Aubert, Boffrand, Jean-François Blondel, and others worked on into the fifties. Thus the tradition remained alive. The official style, it is true, fell victim to a certain shallowness. The models of the great period, especially the façades of the Place Vendôme, were copied again and again. The repertoire of forms turned into a set of clichés. Even Boffrand was unable to influence developments decisively, in spite of his unbroken creative power, as revealed in the foundlings' hospital or the designs for the Place Royale in Paris. After the death of Duke Leopold and the end of building activity in Lorraine he devoted himself more and more to technical and theoretical tasks, among them his *Livre d'architecture*. However, the great town-planning operations carried out at this very time all over the country show that the customary orders of pilasters, blind arcades, and terrace roofs with their balustrades and statues still had plenty of life in them and still seemed appropriate to the aesthetic notions and representational needs of the age. In this last phase of the *goût moderne* the real creative forces had shifted from the outside to the inside. Here, in the interiors of the aristocratic mansions of Paris, the century's finest flower, the 'style rocaille', the Rococo, blossomed. The idea that Rococo was only a final phase of Baroque, always inherent in it, or an Italian invention, has long been refuted.[1] The preceding survey has shown how an unbroken line stretches from the late phase of the Style Louis XIV, resulting in a new style which is an independent French invention, in spite of occasional Italian injections. The last decisive phase, too, began in Paris. The theory of the 'last effervescence of Baroque', which has only a limited validity for Germany and Italy, is certainly not applicable to France, where there was always a fundamental antithesis between architecture and decoration. The style for official architecture developed in the late phase of Louis Quatorze was retained in all its dignity and severity as the *grand goût*. Alongside it there grew up as the contemporary style a softer and more flexible language of forms which, though tied to the observation of the accepted proportions, preferred the undulating line and the curved surface. This style, too, was distinguished by rational ground-plans and economy of means, but here, for the first time since the Late Gothic period, decoration, challenged the pre-eminence of pure architecture.

It was in interior decoration, however, that French Rococo celebrated its real triumphs. For some thirty years the whole of France was gripped by a mania for curves and naturalism. Looking back in his old age, Blondel spoke of a time that had made most architects' heads spin.[2] In comparison with the Italian and German brands, French Rococo remained relatively moderate, yet the very contrast between the 'noble simplicité' of the façades and the wealth of the interiors constitutes one of its most fundamental characteristics.[3] The increased interest in interior decoration also helps to explain why in the years 1730–50 nothing of much importance was built in Paris, so that in comparison with the early years of the century the appearance of the city hardly changed.[4]

The great master of the period, and one whose authority reigned supreme until the end of Louis XV's reign, was Jacques-François Blondel (1705–74). As theorist and chronicler of stylistic development for almost half a century, he exerted a wide influence on the taste of his own and the following generation.[5] He was a nephew of Jean-François Blondel and in his youth had collaborated in Mariette's great series of engravings, L'Architecture française. In 1743, against initial opposition from the Académie, he founded the École des Arts. The teaching there, quite unlike that of the Académie, was based on modern principles. It included architectural theory and practical drawing, and also made allowance – a sensational innovation – for instruction on modern buildings in and outside Paris.[6] A whole series of famous men, among them Ledoux and de Wailly, passed through this school.

Blondel's theoretical works not only served to disseminate architectural knowledge among laymen but also contributed to the discussion of the stylistic problems of the age. The earliest of them, Distribution des maisons de plaisance, which appeared in 1737 and still reflected the influence of Robert de Cotte and Jean-François Blondel, was a compendium of the early phase of Rococo. The Architecture française of 1752, which was a new edition of Mariette's engravings with a full accompanying text, was a comparison of contemporary architecture with that of the seventeenth century. It granted superiority to the latter. The influence of Boffrand's Livre d'architecture of 1745 is here quite evident. Boffrand's conception of architecture as comparable in character with music, his rejection of fashion as the arbiter of taste, and his warnings against the excessive use of decoration all find numerous echoes in Blondel.[7] It was the Distribution des maisons de plaisance, together with the Art de bâtir des maisons de campagne of Ch.-E. Briseux, published six years later, that moulded the private architecture of the Style Louis XV. These two practical manuals ran, with the help of numerous examples, through every architectural and decorative possibility, thus providing something suitable for every purse. The repertoire of forms of the Régence was in all essentials retained in these two books. The decisive difference lay in the slurring of all transitions. This made itself noticeable not only in the rounding of corners and angles and in the recessing of porches, but also in the restlessness of the roof zone through the imposition of sculptural ornamentation and in a further differentiation of the plan, with the curving-out of vestibule and central salon becoming almost the rule.

At the same time the theoretical argument about rules and taste in architecture went on unabated. The most substantial contribution to the discussion was provided by Père

André in his important *Essai sur le Beau* of 1741.[8] The compromise formula devised here by distinguishing between the unalterable principles of architecture, the 'beau essentiel', and those based on proportion, the 'beau arbitraire', was very welcome to an age that was far removed from all the classical models. This formula was not seriously endangered even by the opposition of the academician Briseux and his *Traité du Beau essentiel* (1752). The definition of the style of the first half of Louis XV's reign has always run up against difficulties. Proceeding from the concept of 'rocaille', which governed decoration[9] from the time of Pineau and Meissonnier, that is, from about 1730 onwards, and which caused even J.-F. Blondel to speak of the 'siècle des rocailles', sober classicism invented the contemptuously intended term 'rococo'.[10] In spite of the rehabilitation of the word and the style in the nineteenth century,[11] in France the concept still refers even today only to decoration, with a slight hint of its excesses, while in other countries it is applied to architecture as a whole and even embraces certain varieties of Late Baroque. In France, on the other hand, for architecture the generally happier description 'Style Louis Quinze' has gained acceptance – not without a certain historical justification; for even if the style is not by any means conterminous with the whole reign of Louis XV, it does cover the years of the young king's growing independence, the years of the happy start of his reign and of the fascination which the 'most handsome man in the kingdom' exerted on his contemporaries.

Private Building

With the beginning of the thirties the big names gradually disappeared from Parisian architecture. Gabriel succeeded Robert de Cotte and consequently withdrew from private practice. Aubert was busy building the abbey of Châalis (from 1736 onwards) and Jean-François Blondel was occupied with the Maison des Consuls in Rouen (1733–9). On the other hand, after the king's marriage in 1725 the court at Versailles had once again become a powerful magnet which made residence in Paris seem less important. The building of big town houses consequently came to a halt. Jean-François Blondel's Hôtel de Rouillé (1732) and Cartaud's Hôtel de Janvry (1732–3) were the last achievements in this field. In comparison with the Hôtel de Biron, which had set the standard for the whole Louis Quinze period, they had nothing new to show. Boffrand was once again called in to remodel the Hôtel de Soubise, where he had formerly succeeded Delamair. Here, about 1735, he added, on the garden side, the oval pavilion which, like the oval pavilion of the Louvre, made an elegant right-angled break in the inner suites of rooms and, with its rounded corners, linked up with prevailing fashion. Finally, in 1734, Oppenordt produced yet another important design, for the Hôtel de Gaudion. This design, with its rooms full of undulating curves, the picturesque perspectives of the staircase and its rich sculptural ornamentation, was still governed by Late Baroque conceptions reminiscent of Borromini; but it was probably only executed in part.[12]

The bourgeois residence, as opposed to the aristocratic hôtel, now moved into the foreground. The architects of this period, whom Michel Gallet has brought to light again,[13] at any rate for Paris, fell victims for the most part to Blondel's enthusiastic

purism and to neo-classicism, so that their names were forgotten.[14] The most important of them, as far as can be seen today, were Michel Tannevot (1685–1762), Jean-Baptiste Leroux (c. 1677–1746), and Pierre de Vigny (1690–1772). Tannevot's work has not yet been adequately investigated. Mariette mentions two hôtels in Paris and the hermitage in the park of Bagnolet; Blondel on the other hand speaks mainly of middle-class houses, in which his main strength seems to have lain.[15] He also took part in the competition for the Place Louis XV. Of Leroux we know more.[16] He was responsible for remodelling numerous existing hôtels – the most important of these being the Hôtels de Villars (1732–3), de Roquelaure (1733), de Mazarin (1735), and de Villeroy (1746) – but apparently for no new building of any significance. De Vigny on the other hand, a pupil of de Cotte and admirer of Oppenordt, and certainly the most cultivated and versatile of the three, was highly praised by contemporaries.[17] Rich bankers like Crozat and aristocrats as well were among his patrons. Even the enmity of Mansart de Sagonne and his resignation from the Académie did not harm his reputation. Of his buildings, the Hôtel Chenizot (1726) and the recently demolished Cour du Dragon (1730), with its deeply inset portal crowned by a dragon, most deserve mention.

Bourgeois houses, which were a long way from having any classical ambitions, went far beyond the aristocratic hôtels in their decoration. On the façades, distinguished from those of the Régence by the smaller height of their storeys, three-dimensional decoration created a realm of its own. Repeatedly broken brackets and dragons' and lions' heads supported curving balconies, rocaille work and lush cartouches crowned windows and portals (Plate 239). The great decorators of the period – especially Pineau – worked closely with the architects. Many façades – those of the Hôtel de Marcilly (1728), the convent of the Dames de Saint-Chaumont (1734), and the château at Asnières-sur-Seine (1751), for example – bore his stamp, while de Vigny's own decorative work, especially on the Hôtel Chenizot, is very much influenced by Oppenordt. It was precisely this overlaying of the architecture by the decoration that provided subsequent periods with one of the main bases of their criticism.

Ground-plans, already highly developed in the Régence, attained with the help of geometrical shapes of every kind – circles, octagons, ellipses, and trapeziums – an unsurpassable flexibility. Planning was able to cope with the most difficult terrains and the most unpromising sites. François Franque's plans for the Hôtel de Villefranche at Avignon (c.1740) (Figure 23) and the abbot's palace at Villers-Cotterets (1765) will serve as examples. From about 1730 onwards it became usual to round off or cut off obliquely the corners of a room. Blondel says this was done to give more effectiveness to the decoration, which could be continued right round without a break as a unified system; for the sake of symmetry; and to make better use of 'dead' corners for dressing-rooms. But the same attitude had also led, since Pineau's time, indeed basically even since Oppenordt's time, to the setting of doors and mirrors in shallow, ovally-rounded niches. What found expression here was the delight of the age in the curve, in the fluid line that avoided any break. The way had been led in this by the garden houses and hermitages round Paris, one of the earliest of which was the Ménagerie de la Guêpière at Sceaux (c. 1720).

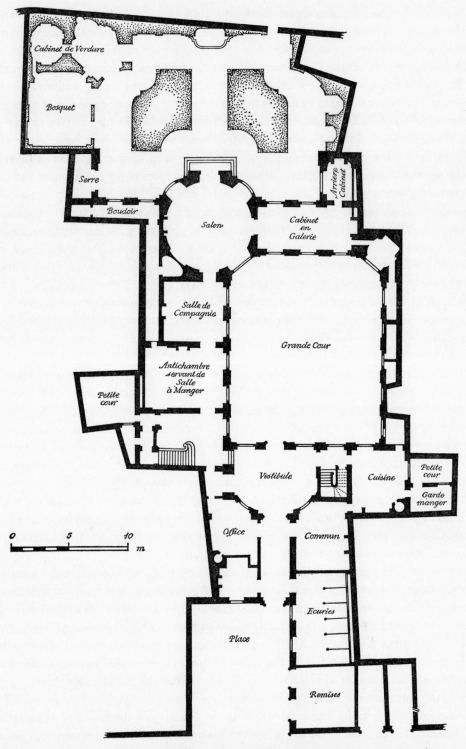

Figure 23. François Franque: Avignon, Hôtel de Villefranche, *c.* 1740, plan of ground floor

269

If the Style Louis XV was not particularly productive in Paris, there was all the more activity in the country and in the provinces. The rising class of officials and the rich merchants competed with the aristocracy in erecting châteaux and country houses, which in the neighbourhood of the towns took the modern form of the *maison de plaisance*, the *pavillon*, or the folly. Members of court society were motivated by the wish to create a refuge for themselves far from Versailles, where they could escape the gossip and cramped living conditions of this monster palace and pursue their hobbies or their love affairs. Thus round Paris the number of these country houses was particularly large. But even far from the capital there arose such graceful creations as Bagatelle, near Abbeville (1754), or La Mosson, near Montpellier (1723–9), as centres of gay sociability and the cultivated enjoyment of life. These country houses were not inferior to the town houses in comfort and surpassed them in spaciousness and the richer architectural possibilities indicated by Blondel and Briseux in their manuals. Some of the most important examples of this category in the neighbourhood of Paris are Champlâtreux (Plate 240), built by Jean-Michel Chevotet (1698–1772) in 1733 for Molé, the president of the Paris 'Parlement'; Jossigny (1743), which was influenced by the Hôtel de Biron; and Asnières-sur-Seine, built in 1751 in the elegant court style by Jacques Hardouin-Mansart de Sagonne.[18] The garden façade of Champlâtreux was still modelled on that of Champs, which was some thirty years earlier in date.

In the provinces the Paris fashion was adopted swiftly and with very few local variations. The unity of the style is here noteworthy. Rouen, Nantes, Bordeaux, Orléans, Dijon, and Strasbourg all adorned themselves with the same façades, with their curving grilles on the windows, their rocaille work, and their homely, low storeys. In Strasbourg, it is true, as a result of the tremendous impression made by de Cotte's late creation, the Hôtel de Rohan, elements of the Régence were preserved for a long time. The great retarding influence here for another three decades was de Cotte's pupil and colleague Massol, who did a great deal of work for the nobility and clergy.[19]

Even Provence, always very much open to Italian influence, gradually adopted Parisian building habits. Jules Hardouin Mansart had already employed motifs from Le Vau's garden façade at Versailles in his design for the town hall of Arles (1675–84). Robert de Cotte produced the plans for the Hôtel de Caumont in Aix (1715 – c. 1720), the stateliest private building in the town.[20] Thomas Lainée (1682–1739), who came from Mansart's and de Cotte's team, spread Parisian influence still further in Aix and Avignon. His town houses and decorative work, the theatre (1732) and the Chapelle des Pénitents Noirs (1739) at Avignon, influenced in particular Jean-Baptiste Franque (1689–1758), who was not much younger than Lainée himself. Franque and his son François were among the leading architects of the south.[21] In the work of the former at Avignon – the Hôtel de Caumont (1720–1) and the Hôtel de Villeneuve-Matignan (1741), now the Musée Calvet, this mixture of local Italianate forms – triangular pediments, balustrades, vigorous cornices – and Parisian articulation or planning is particularly noticeable. François Franque (1710–86), on the other hand, a member of the Académie and Architecte du Roi, far outgrew the scope offered by his native region. He worked a great deal for the clergy, building the abbeys of Corbie (c. 1740), Saint-Benoît-sur-Loire (1746),

and Villers-Cotterets (1765), and also the seminary at Bourges (c. 1740). He was re-
garded as the very model of good taste by Blondel, who consequently devoted several
plates in the *Encyclopédie* to his work. In Paris he was entrusted with the important task
of rebuilding the aristocratic Abbaye Royale de Penthémont. His designs for this owed
much both in plan and elevation to Mansart's Invalides and adjoining soldiers' church.
However, the execution of the plans fell not to him but to the much harder and more
sober Contant d'Ivry (1749), who did not leave much intact of the harmonious design,
which aimed at great spatial effect and nicely graduated façades. François Franque is one
of the important personalities of the Louis Quinze period. He was distinguished not
only by the mastery of his plans, which Blondel could not praise enough,[22] but also by
the confidence with which he maintained the principles of articulation of the school of
Mansart, without falling into the merely decorative or giving these principles a neo-
classical hardness. This must be borne in mind in judging the numerous buildings attri-
buted to him.[23]

Another architect from the south, who founded a whole dynasty, was Jean Giral
(1679–1753).[24] He came from Montpellier, which had already been affected by Parisian
ideas at the end of the seventeenth century, thanks to Daviler. His brother Jacques was a
pupil of the Académie de Peinture in Paris and won the Prix de Rome. He himself intro-
duced the *style moderne* in Montpellier. The once richly furnished Château de la Mosson
(1723–9) and the still-standing Hôtel de Cambacérès, to name only the most important
buildings, were not inferior to contemporary achievements in the capital. His nephew
Jean-Antoine Giral, equally gifted and entrusted with larger tasks, created for the ana-
tomy faculty of the university the masterpiece of the Hôtel de Saint-Come, the anatomy
lecture theatre. In this building, in order to comply with the special provisions of the
foundation, he produced a tauter variation of the Parisian Hôtel de Saint-Cosme, a
circular building with a domed roof (built in 1744 by Barbier de Blinière). He turned the
cylinder of the model into an octagon, made the surfaces of the walls between the corners
of the building curve inward, and brought the dome, semicircular in Paris, to life by
stretching it and inserting ribs. In the sixties other nephews of Jean Giral, Antoine and
Étienne, gave Montpellier its landmark, the Peyrou.

Outside France, François Cuvilliés (1695–1768) was the most important exponent of
the *style moderne* in Germany.[25] A Walloon by birth and at first court dwarf to the
Elector Max Emanuel of Bavaria, he was sent by the latter in 1720–4 to Jean-François
Blondel in Paris. From then onwards he lived as court architect at the court of the Bavar-
ian elector in Munich, but throughout his life he retained close links with Paris. His
numerous buildings and decorative schemes at Munich, Brühl, Falkenlust, Wilhelmstal,
and other places are at first in a very individual Régence style, which changes impercep-
tibly into a Rococo dominated by plant motifs. In the Amalienburg, near Munich
(1734–9), a *rendez-vous de chasse* in the park of the Nymphenburg palace, he created, not
uninfluenced by Boffrand's Hôtel de Soubise, the most perfect embodiment of courtly
Rococo achieved on German soil.

Town Architecture and Public Buildings

One of the great merits of the age of Louis XV was the way in which it opened up the country by building a large number of roads and bridges. There was also a great upsurge in urban architecture. The modernization of the towns, which until then looked more or less medieval, was one of the achievements of this century that quickly won it the praise of posterity. Louis XIV had already started the process. In his reign Paris, Dijon, and Lyon had acquired their great squares, and the frontier cities their regular fortress-like layouts. But under Louis XV, so Patte reports, Lyon, Bordeaux, Nancy, Lunéville, Besançon, Metz, Rennes, Tours, Dijon, Nîmes, and many other towns changed their appearance completely. The peace and security reigning in France made the old town walls superfluous and these were replaced by public parks and promenades. Long, straight streets began to cut through the tangle of medieval lanes. Regularly shaped squares gave cities a more open look and public monuments embellished them. The happy years of prosperity between the Peace of Aix-la-Chapelle in 1748 and the outbreak of the Seven Years' War in 1756 contributed to this activity, but essentially it was the work of the provincial governors, who, in complete accord with the spirit of the Enlightenment, prided themselves on giving the cities in their own areas a friendly, modern appearance. So far as Paris was concerned, it was the 'Plan Général' (1759) of the city architect Moreau that was to release the capital from its medieval compression and chaotic traffic conditions.[26] This plan provided not only for the demolition of the houses on the Seine bridges but also for the construction of continuous quais along the river and of numerous squares, including one in front of Notre-Dame that was to serve as the starting point for all the main roads of France. This same striving for hygiene, for pure water and clean air – in short, for the physical well-being of man – not only pervaded private building but also led to the reform of hospitals and monastic buildings.[27]

Town-planning considerations also governed the theoretical work of architects. Delamair's *Le Songe et le réveil d'Alexis Delamair* (1731), Patte's *Monuments érigés à la gloire de Louis XV* (1765) and *Mémoires sur les objets les plus importants de l'architecture* (1769), and Blondel's *Cours d'architecture* (1771-7) created completely new categories. They saw architecture not 'en maçon', as Blondel puts it, but 'en philosophe', that is, they elevated it into a subject of public interest. The purely practical aims of building were joined by an ideal one – that of beautifying the city. This approach now made France, which in the sixteenth and seventeenth centuries had lagged behind Italy, into one of the most modern countries in the world in the field of town-planning.[28]

The new principles found expression above all in the reconstruction of towns destroyed by fires, for example Châteaudun (1723-7) and Rennes (1721-44), and in the laying out of the various Places Royales. The Bâtiments played a leading part in all this. It was therefore its director, Jacques Gabriel,[29] the close colleague and successor of de Cotte, who was the decisive influence on the official architecture of these years. On the whole conservative in attitude, he introduced a suppleness and a tendency to ostentation that classical French architecture had not known until then. This is most clearly apparent in

the loosely outward-curving group of the present town hall – formerly town hall and law court – at Rennes (1736–44) (Plate 241), and in the magnificent staircase of the Palais des États at Dijon (Plate 242). At Rennes, by means of soft roundings and gradations of the planes, Gabriel gave the town hall a maximum of modelling and loosening, a connexion between the separate parts that was almost only visual. However, more decisive than de Cotte, he picked out the centre quite clearly by means of an elegant tower section perfectly attuned to the symmetrical wings. At Dijon he made the stairs ascend in one single free-standing flight accompanied by brightly lit balconies, and thus achieved the impression of increasing width and light to be found in the great Italian and South German Rococo staircases.[30]

In the domain of town-planning Gabriel's name is linked above all with Rennes and Bordeaux. At Rennes he directed the rebuilding of the old town, completely destroyed in 1720,[31] in accordance with a generous modern plan which in the end also caused the citizens of Nantes to modernize their own city, always a great rival of Rennes. At Bordeaux he was responsible for laying out the Place Royale on the bank of the Garonne; this is one of the finest squares in France. He carried out both tasks with great skill and clear insight into the functions of a modern city. His place in history is thereby assured.

These 'Places Royales' are one of the curiosities of French town-planning. In them the last Bourbons created a perpetual monument to themselves.[32] The prototypes – the Place des Victoires and the Place Vendôme in Paris, the Place d'Armes in Dijon, and the Place Bellecour in Lyon – had come into existence in the reign of Louis XIV. Under Louis XV they were given numerous and splendid successors. They were in effect a new kind of square intended not only to beautify the town but also – and this is where they differ from the first, early squares of France, the present Place des Vosges and the Place Dauphine in Paris – to symbolize the power of the state and of the monarch himself, the former through the accumulation of public buildings, the latter through the erection of a statue. It was thus not so much the needs of commerce and traffic as aesthetic and political considerations that helped to create them.[33] Their importance from the point of view of town-planning lay above all in their connexion with the remodelling or clearing-up of a whole district and in their function as the centre of a new network of streets. They were laid out on an axis that ended with a view – of a church, a town hall, or some other public building. Here lay an essential difference from the seventeenth century, which had still looked on these squares as isolated features. The two squares which Gabriel laid out in Rennes still belong to the older type. These are the Place Louis le Grand in front of Salomon de Brosse's huge Palais de Justice, spared by the fire, and the Place Louis XV not far away. The former has façades modelled on those of the Place Vendôme and a statue of Louis XIV; the latter was to be surrounded by the town hall, law courts, and governor's palace, though the last of these was never built, and is adorned with a statue of Louis XV (Figure 24). The new type of square begins with Bordeaux's Place Royale, which is sited between the old town and the river bank and wide open on the Garonne side.[34] As a variation on the plan for a semicircular area already produced by the local architect Héricé – corrected and revised by de Cotte in 1728 – Gabriel, who went to Bordeaux for the first time in 1729, designed a rectangle with the corners cut off, i.e.

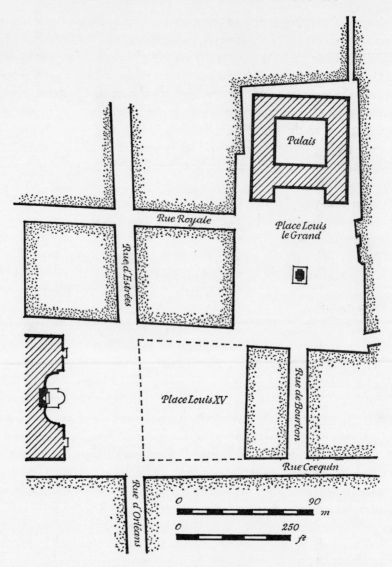

Figure 24. Jacques Gabriel: Rennes, Place Louis le Grand and Place Louis XV, layout

half an octagon, which in principle followed the Place Vendôme not only in plan but also in the elevation of its façades. At the back, where the square met the old city wall, he linked it by two fan-shaped streets with the old city (Figure 25). The authoritative design dates from 1730 (Plate 243). The execution, however, which lay in the hands of the local architect André Portier,[35] took a long time. The customs building on the south side was erected in 1735–7, but the exchange on the north side was only built in 1744–9, under Gabriel's son and successor, Ange-Jacques. The last building to go up (in 1750–5) was the central pavilion, which was set back a little in order to respect the line of the old city wall; it stood at the point where the two new streets met. But the statue of the

Figure 25. Jacques Gabriel: Bordeaux, Place Royale, 1735–55, plan

king had already been put up in 1745. Thus the starting point was provided for that splendid remodelling of the city which was to be carried out in the years 1743–57 under the energetic governor Tourny and which made Bordeaux, with its long Cours, the famous Allées de Tourny, and its uniform façades into one of the finest Baroque cities in France.

The next big piece of planning outside Paris was carried out in Nancy. The Place Royale, which Emmanuel Héré (1705–63) laid out at the instigation of King Stanislas – successor since 1737 of the Dukes of Lorraine – was the ideal of a concept that took equal account of aesthetic and town-planning considerations.[36] Héré had been trained in the school of Boffrand, but from his father, who came from the Tirol and had moved to Lorraine with Leopold – his name was really Herre – he had also inherited an Austrian temperament. His career under Stanislas was a brilliant one. At first only an assistant to the court architect, Jennesson,[37] he swiftly moved into the latter's post; in 1740 he became Premier Architecte, in 1751 he was ennobled, and in 1753, as a special honour, he was permitted to hand over to the King of France at Versailles the plans of the numerous new buildings erected by his master.[38] The town-planning work of the Polish king and his architect in Nancy is one of the greatest achievements of the eighteenth century. It is equalled only by the Baroque squares of Rome. Through the rhythmical succession of three squares – the Hémicycle, the Place de la Carrière, and the Place Royale (now the Place Stanislas) – an axis was created which linked together the previously separated old and new cities and provided the framework for the whole future development of the city (Figure 26). For this Héré had to break through the old forts, the demolition of which France had long opposed for military reasons. In their place he erected a triumphal arch in the style of the Arch of Severus in Rome, as a sort of link between the two parts of the city.[39] The Place Royale became the centre of the new city. Its shape and size were dictated by the forts. Héré therefore shifted the centre of gravity to the side of the new city and here erected the town hall (Plate 244), which dominates the square with its mighty, richly decorated façade,[40] while on the other side he masked the old fortifications and the moat with the low gallery-like buildings known as the 'Basses Faces'. The short sides of the square were intersected by a continuous transverse axis with a triumphal arch at each end, and were meant to contain theatre, exchange, governor's residence, and financial and legal offices. They continued the line of the town hall façade, borrowed from Boffrand's Louvre. For the Basses Faces a reading room and café were planned – a touch very typical of the Age of Enlightenment. Gilded wrought-iron gates barred the ends of the many streets running into the square and big fountains richly adorned with figures filled the corners opening on to the moat, so that the square became a complete spatial unity. The statue of Louis XV by Lemoyne gave it quite the character of a Place Royale, even though this mark of honour to the King of France was not at all appropriate so long as Lorraine was independent.

On the other, 'old city' side of the triumphal arch, Héré unified the façades of the old Place de la Carrière, originally intended for tournaments and already included by Boffrand in his plans for the palace, gave the Hôtel de Craon its counterpart in the Bourse de Commerce (1752–3), and laid along the middle of the avenue-like square a long strip

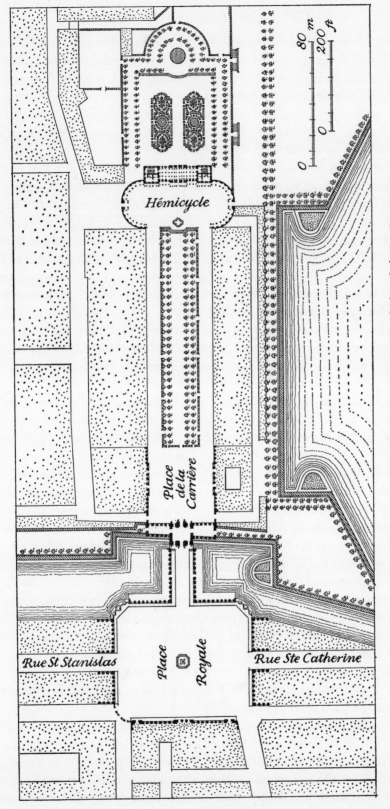

Figure 26. Emmanuel Héré: Nancy, Place Stanislas (Royale) and Place de la Carrière, 1752–5

of grass edged by balustrades and groups of cherubs. The elliptical Hémicycle joins on to this. The Hôtel de l'Intendance, put up in 1751–3 in place of the demolished Louvre and linked to the Place de la Carrière by semicircular colonnades, provides the end of the axis on this side, with its columned portico.[41]

All this came into being with amazing speed in the space of only four years (1752–5). Nevertheless, for all the splendour of the town-planning, which makes Nancy a show-piece of Louis XV architecture, it was precisely here that the dangers of a late phase threatened by rigidity became apparent. Héré's façades repeated in every detail Boff-rand's façades, especially those of the demolished Louvre. They contain no new element; the only difference is that, in accordance with the taste of the period, a dominant place is given to sculptural decoration. In spite of the outward magnificence one cannot quite resist the impression that we are confronted here with an imitator, who has certainly preserved the legacy of Boffrand with great care, but has also made it shallow and merely decorative. The real surprise of the town hall lies rather in its staircase, which, with its raised central landing and two flights of stairs curving up to the upper storey, is a master-piece of the Baroque enhancement of space.

The Place Royale in Reims was closely based on the one at Nancy. Here too the square is incorporated in an axial system that originally included two other squares, the corn market and the cloth market (today the Place du Forum).[42] The main axis runs, accom-panied by two small parallel axes, from the Hôtel des Fermes, which dominates the south side of the square, like the town hall at Nancy, along the Rue Royale to the old Louis XIII town hall. A transverse axis, the former road from Paris to the Ardennes, intersects the ends. In the middle stood the statue of the king (by Pigalle, 1761; cf. p. 95). In Legendre's first design of 1755, which provided only for a central axis on the north side, like the Basses Faces, the similarity to Nancy was still greater. Legendre, engineer to the Ministry of Roads, also produced in 1758 the final, enlarged design, when one by Soufflot, in the shape of a stretched rectangle with the corners cut off and colonnades running all round, had been rejected by the city council. The execution, begun by Legendre in 1758, dragged on for a long time as a result of financial difficulties, and the square was not finally completed until 1910. The façades of the square, like its general proportions, are based on Nancy, though certainly in a simplified and quieter form. The sculptural decoration on the balustrades has disappeared, and the Corinthian pilasters have been replaced by continuous vertical bands on the walls. A classical cornice with triglyphs binds the individual buildings together. The accents are provided by the strong shadow of Tuscan columns and a triangular pediment on the Hôtel des Fermes, and by engaged columns running straight down on the fronts of the transverse axis. In com-parison with the rocaille exuberance of Nancy, a cool dignity that heralds the Style Gabriel already prevails here.

A scheme no less grandiose was planned for Rouen. Antoine-Mathieu le Carpentier (1709–73), a pupil of Jacques Gabriel, wanted here, too, to lay out a big axis between the cathedral and the Hôtel-Dieu. It was to embrace a new city hall as well as a succession of squares and gardens. The design which he produced in 1750, and revised in 1756, for a city hall with three wings was an important example of the *grand goût* as it is found in the

designs for the Place Louis XV in Paris, with strong reminiscences of Le Vau.[43] However, although the foundation stone was laid in 1758, the already approved plans were never carried out. But Patte incorporated them in his series of engravings, *Monuments érigés à la gloire de Louis XV*, a work which provides a complete survey of all Places Royales.

In Paris it was a relatively long time before the decision was finally taken to create a monument to the monarch, and by then the capital was able to learn from the provinces instead of acting as leader. Since the death of Louis XIV almost nothing had happened in the field of public architecture. Praiseworthy exceptions were the Fontaine de Grenelle by Bouchardon (1739–45), which was not so much architecture as a vehicle for sculpture (cf. p. 59), and the north wing of the Bibliothèque du Roi, built by Jules-Robert de Cotte in 1736 and closely based on Mollet's Galerie Neuve. The general indignation, which had already been cautiously expressed in Blondel, was vented in 1749 in a piece of writing called *L'Ombre du Grand Colbert et la ville de Paris*, in which the author, La Font de Saint-Yenne, by way of a dialogue between the spirit of Colbert and an allegorical figure representing the Louvre, reproached the Crown bitterly for not having done anything for the capital, and called on the age of Louis XIV in support of the accusation. It was therefore a striking event when in 1748, at a time when the king's popularity was at its zenith after the Peace of Aix-la-Chapelle, the merchants of Paris decided to show their own loyalty to the monarch by putting up an equestrian statue of him.[44] While Bouchardon was entrusted with the statue (cf. p. 62), Tournehem, the director-general of the royal buildings, requested the members of the Académie to send in suggestions for a Place Royale. The response was overwhelming. Not only the Académie but also other architects, engineers, and amateurs of every kind took part, and a stream of proposals – well over a hundred – poured into the Bâtiments. It was certainly the biggest architectural competition of all time. It became apparent that in spite of all the enthusiasm for rocaille the *grand goût* was not dead, indeed that people had obviously only been waiting to try their hand on some big project after such a long period of enforced idleness. Most of the designs were variations on the old patterns of the Place Vendôme and the Louvre colonnade, the standard types of classical French architecture. There was no lack of triumphal arches either. Almost all the competitors strove to combine with the layout of the square the clearance of one of the dilapidated and choked quarters of the old city.

The most important designs came from Aubry, who proposed a show-wall leading off the Louvre colonnade with a big triumphal arch motif at the end of the Pont Royal; from Contant d'Ivry, who wanted to build on the left bank of the Seine, opposite the Grande Galerie of the Louvre, a huge city hall influenced by Le Vau with an oval central room, columned galleries on each side, and outer wings curving round in a quadrant; and above all from Boffrand. The three designs which he handed in show him, in spite of his age – he was eighty-one – at the height of his creative powers. They were not only superbly sited from the point of view of town-planning – at the Carrousel, at the Halles, and in the Place Dauphine – but also convincingly articulated. The big verticals of the pilasters and free-standing columns were the dominant element; on these lay continuous attics of Roman heaviness, broken up by sparingly distributed sculpture. In each case the

middle was accented by a huge triumphal arch. With his plan for the Place Dauphine, where the old triangular shape was to be replaced by a new town hall curving forward in two huge wings to form the background to a 'Colonne Ludovise' modelled on Trajan's Column, Boffrand reached the heights of Bernini (Plate 245).[45] But, in spite of all the effort expended, the competition led to nothing.[46] Since the king shrank from the enormous expense of tearing down so many houses, in 1750 he made available the open space in front of the Tuileries gardens opposite the Palais Bourbon, a space already incorporated by Lassurance and d'Argenson in their own designs, and in 1753 caused his new Directeur des Bâtiments, Marigny, to announce a fresh competition. This time only nineteen architects took part, all of them members of the Académie; they included Blondel, Soufflot, Mollet, Boffrand, and A.-J. Gabriel. One of the conditions was that the view of the Champs Élysées, the Tuileries gardens, and the Palais Bourbon, of which the king was particularly fond, should not be spoilt, a requirement which shows the profound difference between the French and Italian conceptions of a square. Boffrand and Gabriel came closest to fulfilling the demands of the task. Both planned for buildings on the north side of the square only; Boffrand had in mind a rectangular block, but Gabriel proposed – as at Bordeaux – a semicircular frame, so to speak, with the Rue Royale as the central axis. As Marigny was unable to decide in favour of any of the designs,[47] the king finally gave the commission to A.-J. Gabriel, who was also to utilize as far as possible the ideas of the unsuccessful competitors. Gabriel's final design, which after several alterations was at last approved in 1755 and carried out in 1757–75, was thus a compilation in which it is difficult to isolate the individual contributions. However, there can be no doubt that Boffrand's ideas played an important part in it. The site was similar to the one in Bordeaux. In both cases a river formed one side of the square, while the other, built-up side was intersected by a central axis, the end of which was filled at Paris, much more effectively than at Bordeaux, by the imposing backcloth of the Madeleine, as designed by Contant d'Ivry (Plate 246). Unlike the other squares in France, however, the Place Louis XV was not so much a traffic junction or a centre of administration as a quiet, somewhat remote promenade leading over from the Tuileries gardens to the Champs Élysées and including nature in its spatiality.[48] In order to emphasize the self-contained character of the square, Gabriel marked off on its spacious area a smaller rectangle, with the corners cut off obliquely; and this rectangle he surrounded with ditches ten feet deep, balustrades, and little sentry-boxes for the gardeners. This gave the right proportions to the equestrian statue of the king in the centre of the vast expanse (the statue was put up in 1763 by Pigalle, working to a design by Bouchardon; cf. p. 62). Thus the filling of the ditches in the nineteenth century did a great deal of harm to the square. In particular it made the sentry-boxes meaningless; today they bear outsize female figures symbolizing the cities of France.

Of the other squares laid out in Paris during this period, those round the Île de la Cité are particularly noteworthy. As early as 1730 Delamair had considered regularizing the cramped and overflowing old city and linking it with the Île Saint-Louis. In Le Songe et le réveil d'Alexis Delamair he had proposed big squares with colonnades all round them in place of the old Hôtel-Dieu, which was ripe for demolition, and at the

eastern tip of the Île Saint-Louis. Meissonnier, following the example of Delamair, had planned a very Baroque, trapezium-shaped town hall in the Place Dauphine.[49] Finally Boffrand was instructed to pull down the old Hôtel-Dieu, of which he was one of the governors, and to rebuild it in combination with an orphanage.[50] He also wanted to take this opportunity of opening up the square in front of Notre-Dame. Of his whole plan, which provided for a street running up to the middle of the cathedral façade, with the orphanage on one side, the Hôtel-Dieu on the other, and an open space like a square before the façade itself, only the orphanage was actually built (started in 1746; demolished in 1874). The L-shaped building acquired its accent from a corner pavilion articulated on the side facing the street with giant pilasters – like the Hôtel Amelot – and on the side facing the cathedral with a free-standing columned portico; there was to be another corresponding one on the other side of the street. These powerful accents, drawn from Boffrand's familiar arsenal of forms and almost certainly influenced scarcely at all by English Palladianism, were calculated in advance to fit in with the mass of the cathedral and to form a counterpoise to it.

Finally, public architecture was given a completely fresh impetus by the personality of Germain Soufflot (1713–80). Soufflot did not come from any of the Parisian architectural dynasties, but from Burgundy. His father was a lawyer who had settled in Paris. Young Soufflot, against his father's wishes at first, had spent the years 1731 to 1738 in Rome, where he had attracted the attention of the French ambassador by studying and measuring ancient buildings and had been given a scholarship by the Académie de France. On the recommendation of the Académie he moved in 1738 to Lyon; there he built first the Hôtel-Dieu (Plate 247), then the Loge au Change, i.e. the exchange.[51] His appearance on the scene marked an important turning point in French architecture. Completely untouched by the traditions of the school of Mansart and tied neither by relationship nor by patronage, he brought with him a strong feeling for monumentality, for Italian concepts of mass and regularity. The façade of his Hôtel-Dieu (planned in 1740, built in 1741–8) is devoid of any system of pavilions. Behind its contrasting combination of smooth expanses and accentuated bays adorned by pilasters stand buildings like the Palazzo Chigi, not the continually repeated façades of the Place Vendôme and the Louvre colonnade. In the first design, the dome even bore a lantern after the pattern of San Carlo al Corso in Rome.[52] Right from the start, and in spite of the big cartouche containing a coat of arms originally planned for the dome, the whole building aimed at being unadorned, at achieving its effect purely as architecture, without any assistance from sculpture. The soft flow of lines of Mansart's school was here replaced by a style in which everything was regular, cubic, and dignified. This was something completely new. In spite of Soufflot's fondness for Antiquity, his early style does not imitate classical architecture; fundamentally it is Baroque, but the sort of Baroque that measured itself on Antiquity and to which Bernini, Schlüter, and Wren belonged.[53] It is not surprising that the adherents of academicism, headed by La Font de Saint-Yenne, were triumphant over this maiden work. The Loge au Change (1747–50) is built along the same lines, though on the whole it is more Italian and represents a type of building in the style of North Italian town halls.

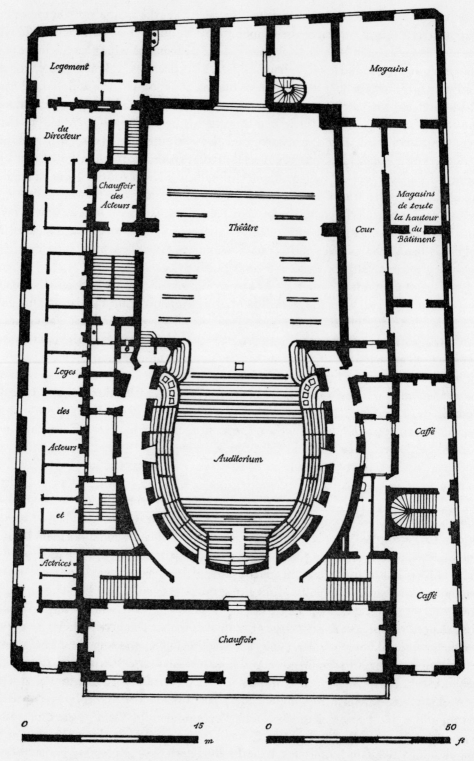

Logement

Magasins

du
Directeur

Chauffoir
des
Acteurs

Théâtre

Cour

Magasins
de toute
la hauteur
du
Bâtiment

Loges

des

Acteurs

Auditorium

Caffé

et

Actrices

Caffé

Chauffoir

0 15 0 50
 m ft

Figure 27. Germain Soufflot: Lyon, theatre, after 1753, plan of first floor

282

With his Hôtel-Dieu Soufflot attracted the attention of Madame de Pompadour. In 1749 she chose him as travelling companion for her brother, the young Vandières, who was to acquaint himself with the great buildings of Italy in preparation for his future post. The result of this two-year journey was not only the friendship of the future Directeur des Bâtiments but also the construction of the theatre in Lyon (designed in 1753, built by Morand and Munet). Soufflot adopted here the modern Italian pattern with a horse-shoe-shaped auditorium (Figure 27), as introduced shortly before by Alfieri at Turin (1738–40). With its smooth expanses, in which the windows seemed to be incised, and heavy pediments, the façade was reminiscent of the Palazzo della Consulta in Rome. This theatre was a great success. Like the somewhat earlier one at Metz, it was one of the first modern theatres in France and in many points anticipated Gabriel's opera house at Versailles. The rest of Soufflot's career was spent in Paris, where he had already intro-duced himself with his design for the Place Louis XV and where great tasks awaited him.

Of the many public parks and gardens, the 'promenades', that came into being all over the country in these decades and contributed considerably to the pleasant appear-ance of the towns – e.g. in Amiens, Châlons, Bordeaux, and Nîmes – there is room here to mention only one, which certainly outshines all the others. This is the Jardin de la Fontaine at Nîmes.[54] Here, starting with a spring sacred in Roman times, Esprit Dardal-hion and Jean-Philippe Mareschal created between 1745 and 1760 a kind of water garden, in which nature and architecture have combined in an ideal union. The balustrades of the restored and re-laid canals, and the rich sculpture brought over from La Mosson, suggest a comparison with the Villa Lante near Orvieto. But here everything is incorpor-ated in a grand system of axes, at the end of which, over the Roman baths, broad stone steps and terraces ascend a tower-crowned hillside, forming a monumental conclusion to the whole.

The Art of the Court and the Early Work of Ange-Jacques Gabriel

Under the young Louis XV the court was slow to regain its leading role and did not emerge into the artistic limelight until the forties. It was only the influence of Madame de Pompadour which managed to ensure that the arts were fostered again as in the time of the Sun King.[55] It was also only under her that the Bâtiments, which had long been in the shadows, began to advance into the foreground again. The part played here by the favourite, who moved into the court as *maîtresse déclarée* in 1745, cannot be valued highly enough. The châteaux and country houses which she owned in great but ever-changing number combined unpretentious exteriors with refined luxury inside. They disseminated the atmosphere of intimate and cultivated sociability which embodied the ideal of the age and for many years also governed the taste of the king. However, contrary to the view of the Brothers Goncourt, and in spite of her preference for grace and charm, the Marquise was no friend of Rococo exuberance. It would be quite wrong to connect her in any way with the origin of the style and even to make her responsible for it. Her influence only began to count when basically the zenith of the Rococo style was already past and all that was left of the riot of forms was the harmony of the soft, curving line.

Through the appointment in 1745 of her uncle, Le Normand de Tournehem, as Direc-
teur des Bâtiments – to be succeeded six years later by her brother Abel Poisson, later M.
de Vandières and Marquis de Marigny – she was able to secure for herself the decisive
influence on the Bâtiments and the Académie. However, her favourite architect was not
Gabriel but Jean Cailleteau, known as Lassurance the Younger. He had to remodel and
furnish the houses which she was given by the king, herself inherited, or – as with
Champs, for example – only rented. Lassurance's chief work for the Marquise was Belle-
vue (1748–50), a big two-storey pavilion on the plateau of Meudon, overlooking the
Seine. It stood on its own between two low wings containing the domestic offices. Pedi-
ment-crowned central projections gave a uniform accent to all four sides. Here and at
Crécy-Couvé, the biggest of these country houses, the gardens were laid out by Garnier
de l'Isle, the grand-nephew of Lenôtre.[56]

The king himself, continually driven on by inner unrest and filled with an unrestrained
passion for hunting, was – unlike his great-grandfather – erratic and uncertain in his
attitude to building. He was more interested in improving his hunting lodges and accom-
modating his numerous family than in winning artistic fame from posterity. Recon-
struction never stopped with him, whether it was at Versailles, Choisy, or La Muette,
so that he spent huge sums without creating anything really lasting.[57]

At Versailles, only decorative work – in particular the completion of the Salon
d'Hercule (1729–36) – and interior alterations were carried out at first. The latter were
intended to produce a more comfortable apartment for the king on the north side of the
Cour de Marbre (1738). It was only in 1752 that it came to deeper inroads into the fabric
of the château, when the king decided to create a new apartment for his daughter,
Madame Adélaïde, beside his own, and for this purpose sacrificed Louis XIV's Petite
Galerie, his Cabinet des Médailles, and above all the Escalier des Ambassadeurs, which
was the main staircase of the château and Le Brun's masterpiece. With this a central part
of Louis XIV's creation vanished.[58]

But the first big commission from the court was the reconstruction of Fontainebleau.
Here in 1739–40 Jacques Gabriel put up on the south side of the Cour des Adieux a new
wing intended for the retinue of the court, the 'Aile Gabriel', in which he followed
closely the style of the François I façades opposite.[59] He had also already made the draw-
ings for the enlargement of the Cour de la Fontaine. However, when he died suddenly
in 1742 and his son Ange-Jacques took over the direction of the work, a decisive change
occurred.

One is inclined to compare the relationship between Gabriel *père* and Gabriel *fils* with
that between Jules Hardouin Mansart and Robert de Cotte, even if talents were more
evenly distributed between the last two. Ange-Jacques Gabriel (1698–1782), later to
become Chevalier de Mézières et de Bernay, had been his father's pupil and first col-
league. He had swiftly climbed the ladder of promotion in the Bâtiments and enjoyed
quite early the favour of the king, who was accustomed to consulting him about his
private building plans.[60] On the death of his father, therefore, he not only succeeded him
automatically as Premier Architecte du Roi but was also entrusted with all current opera-
tions, so that continuity seemed assured. However, very soon a new style asserted itself.

Jacques Gabriel's plans for the so-called Gros Pavillon, by which the king wished to con-nect the west wing of the Cour de la Fontaine to the adjacent Aile Gabriel, had provided for a rusticated ground floor with two orders of pilasters on top of each other above, the middle group of which was to be accentuated by means of a wrought-iron balcony and a sculptured central pediment. Ange-Jacques Gabriel altered this design. In the middle of the pavilion he replaced the pilasters with a portico of Doric columns, the wrought-iron balcony with a stone balustrade, and the segment-headed windows of the upper storey by windows with horizontal architraves (Plate 248). Instead of a pediment he used a continuous balustrade. In this pavilion, built between 1750 and 1754, the basic change of conception was clearly evident. The horizontal line was introduced again in place of the curving line, and the pyramidal form of building replaced by the uniform façade. The tendency to height characteristic of the school of Mansart was succeeded by a tendency to breadth. The column came into its own again in place of the pilaster and, lastly, sculpture disappeared from architecture. All this did not occur under the influence of Antiquity but through Gabriel's own efforts. In the Gros Pavillon Ange-Jacques Gabriel based his treatment of the building on Le Vau's garden façade at Versailles. The first step away from Rococo had been taken. The inclusion of the Cour des Adieux in a general re-building project, for which Gabriel had planned, never came to pass in the end owing to lack of money.

About the same time – 1749 – Gabriel built a little refuge, known as the Ermitage, for Madame de Pompadour at Fontainebleau. The Ermitage also illustrates this change of direction. It was the first of the pavilions characteristic of architecture at the court of Louis XV – a cube of modest size, articulated only sparingly, but of exceptional delicacy of taste and proportion.[61] Here too Gabriel had put all the emphasis – indubitably alter-ing Lassurance's original plans – on the horizontal line and the simplicity of the façades, renouncing any three-dimensional ornamentation. There is an unmistakable return here to the early Style Louis XIV as exemplified in, say, the Hôtel de Noailles at Saint-Germain.

It was in the Pavillon Français (1749) (Plate 249), intended as the centre of a menagerie for Madame de Pompadour – opposite the present Petit Trianon – and in the little château of Choisy (1754–6) that Gabriel came closest to Rococo.[62] The Pavillon Fran-çais consists of an octagonal room, which, like the Salle des Colonnes in the Grand Trianon, is made circular by the insertion of columns and from which four *cabinets* jut out in the shape of a cross. Thanks to the roof balustrades, with their groups of cupids, which were originally accompanied by big lattice vases of flowers, and the cutting-off of the corners, the charming little building acquires a touch of perfect lightness appro-priate to its purpose. Like Choisy, however, it differs from Rococo proper – such as the pavilion at Bosquet du Dauphin (1736) by Jacques Gabriel, for example[63] – in the al-most total absence of curves and bends and the systematic predominance of horizontals, even in the lintels of the windows. The new preference for block-like buildings which finds expression here is even more evident in the contemporaneous Pavillon du Butard, a 'rendezvous de chasse' in the forest of Saint-Cloud (1750). Here it is expressed in the plan as well as in the silhouette (Figure 28).[64] In addition to the central room, which juts

out a long way and, as at Choisy, is a circle inscribed in an octagon, there is only a shallow, cube-like corps de logis of very moderate width. Apart from the sculpture on the central pediment and two stags' heads, which have now disappeared, over the side entrances, the decoration is confined to simple bands of rustication. Not only this pavilion, the originally-planned roofs of which were later struck out by Gabriel, but the whole group was a clear renunciation by Gabriel of the 'faire pyramider' of the classical tradition.

The court of Versailles was mirrored in the court of King Stanislas of Lorraine, which must be mentioned in this context. Politically powerless, a sort of pensioner of the King of France, Stanislas tried at any rate to give his court splendour by the encouragement of art and science, and to allow himself in his newly won position the luxury of building, which for so long he had had to renounce. He had the good fortune to find in Héré a man capable of satisfying quickly and ingeniously his often abstruse wishes. The work done by Héré for the king was extensive but not very permanent.[65] It all had something of the theatrical decoration about it. Lunéville and Nancy became regular Baroque

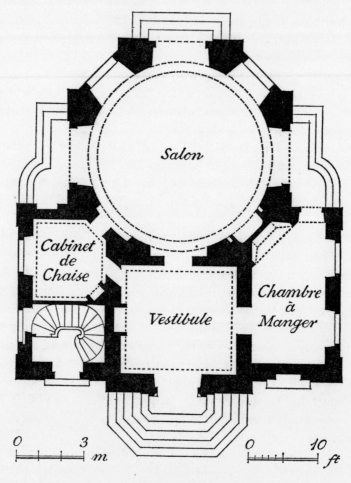

Figure 28. Jacques Gabriel: Pavillon du Butard, 1750, plan

286

residences, thoroughly permeated by the French spirit but with a touch of Austrian light-
ness – in every way more exuberant, more playful, and delighting more in decoration
than similar buildings in France proper. Examples of this tendency were the step-shaped
pavilion of Chanteheux (1739), with its two-storey, somewhat overloaded salon on the
first floor – an imitation of Marly in Polish – the cliff with the automatic water display
in the park of Lunéville, the Pavillon Royal at Commercy (c. 1745) – a stone backcloth
for fountains – and the kiosks at Lunéville and Commercy, reminders of the king's cap-
tivity in Turkey. The château of Lunéville itself acquired, in place of Boffrand's charac-
teristic dome over the columned portico, an octagonal pyramid, as well as continuous
balustrades adorned with trophies along the roof and a clock-cartouche that turned the
whole roof area – as in the somewhat later town hall of Nancy – into a sea of unrest.
Stanislas had Malgrange, Boffrand's other creation, pulled down and rebuilt in the style
of a *maison de plaisance*, clad all over with Delft tiles (1739–40). In theory this was an
attempt to put into practice ideas from Blondel's *Distribution des maisons de plaisance*, but
the building was totally unrelated to the garden and surrounding country, overloaded
outside with colonnades, which ran along in front of both façades and out on each side
to the separate pavilions, and inconvenient and cramped inside.

The radiance of this court was of short duration. It was extinguished with the death of
Stanislas in 1766, which led, as a result of agreements about the succession, to the in-
corporation of Lorraine in France and to the country's final loss of its independence.

Church Architecture

There was more activity in church-building in France in the age of Louis XV than is
generally assumed. Almost all the architects of the period were involved in ecclesiastical
as well as secular work. Brice reported in 1752 that since about 1716 several millions had
been spent on ecclesiastical buildings in Paris alone. The same may be regarded as true of
the provinces, where churches and abbeys did not neglect to accommodate themselves to
changed habits of life and to introduce modern hygiene and comfort in place of medi-
eval simplicity and austerity.[66] The abbots' palaces of Saint-Ouen in Rouen (1753–9),
of Châalis (1736 onwards), Saint-Just-en-Chaussée (1758), Clairvaux, Remiremont
(1750), and Prémontré (c. 1740), to name a few examples, hardly differed on the outside
from laymen's châteaux. However, rigid devotion to seventeenth-century plans and
elevations, and distaste – springing from the intellectual, unsensuous character of French
piety – for pictorial or three-dimensional room decoration, led French ecclesiastical
architecture in large areas of the country into a sterility and lack of imagination con-
demned by both Cordemoy and, after the middle of the century, Laugier.[67] Only in the
peripheral provinces – Lorraine, Franche Comté, Provence – were any independent
solutions based on local traditions achieved.

As most of the big churches, both in Paris and in the country, had been begun in the
seventeenth century, the only room for manoeuvre left to architects was often the
façade. Here a growing restlessness made itself apparent, both in articulation and decora-
tion. The best example in Paris is Saint-Roch, a building of Lemercier's completed, after

long interruptions, by Robert de Cotte in the years following 1719. The façade, erected in 1736 by Jules-Robert de Cotte in accordance with plans drawn up by his father, shows a clear increase of the Baroque element already present in the Primatiale of Nancy (Plate 250). It is hollowed out, as though by the hand of a sculptor, and split up into a series of shadowy depths. The outermost plane, that of the cornice jutting out over the columns, is succeeded by that of the free-standing columns, then by that of the engaged columns, until the back wall proper is reached. Niches are hollowed out even in this. The impression given by the wall that it is a sort of kneadable mass is further heightened by arched door lintels in concave niches. This play of forms would have been intensified even more by the sculpture intended to adorn the cornices. The drawings preserved in Paris and Stockholm show what a contrast there was between de Cotte's designs and Bullet de Chamblain's more old-fashioned, almost High Baroque plan, which had provided for a broad-based, two-storey façade with a flat roof and statues standing on it,[68] very much after the style of Boffrand's intentions for the Église de la Merci.[69]

The extreme in this direction is represented by the church of Saint-Louis at Versailles, built in 1743–54 by Jacques Hardouin-Mansart de Sagonne (Plate 251).[70] Here the tower over the crossing, the towers of the façade, and even the ends of the transepts are made to curve. This is the most Baroque church in France, with vaulting and keystones decorated by Pineau; it may have been affected, as tradition has it, by the queen's recollection of her native Poland. In France at any rate it was exceptional.

The biggest piece of church-building in Paris was Saint-Sulpice, and its history is also the most complicated. Oppenordt had carried on the work here since 1719 in accordance with Gittard's old plans. After the completion of the nave and aisles, he had started on a central tower which had to be removed again owing to statical deficiencies. After this, in 1732, he was relieved of his post as director of the works and replaced by Servandoni. In the same year a competition was announced for the façade, although several designs, including ones by Bullet de Chamblain and Meissonnier, were already in existence.[71] Oppenordt proposed an Italian two-tower façade with porch, elliptically curved balconies, a central pediment, and much ornamental statuary; Meissonnier produced an imaginative but impractical design clearly indebted to the circle of Guarini and Borromini. To both of these Servandoni's design was preferred. Jean-Nicolas Servandoni (1695–1766), the child of a French father and an Italian mother, was born in Florence. A pupil of Panini and Rossi, he was not so much an architect as a painter, decorator, and stage designer. Diderot calls him 'grand machiniste, grand architecte, bon peintre, sublime décorateur'. In Paris, where he arrived in 1726 and quickly made a name for himself with his designs for the theatre and court entertainments, he held from 1728 onwards the post of a director of stage design at the Opéra,[72] but he was also a welcome visitor at the courts of London, Lisbon, Stuttgart, Dresden, and Vienna as a designer of celebrations of every kind. He had already produced designs for the decoration of the Chapelle de la Vierge in Saint-Sulpice in 1729, but it was the façade of this church that made him famous as an architect.[73] Of course, its present appearance is the result of so many alterations that the original aim is hardly recognizable any longer. The first

design (Plate 252), which provided for an entrance hall of nave and aisles in the middle of the ground floor and on top of this, behind three great arcades of windows, the parish library, bears a striking resemblance to Bullet de Chamblain's designs both for Saint-Sulpice and Saint-Roch, and thus also to Boffrand's Stockholm design for the Église de la Merci. The rhythm of the façade, the two-storey style, the accumulation of columns, and the triglyph frieze occur here as they do there, indicating Servandoni's familiarity with the French church architecture of his time and the models which he followed. The second design, produced soon after building operations began (1733) and assigned by Patte to 1736, had become considerably more tranquil and unified.[74] It took the lower portico, which had to incorporate the steps owing to the narrowness of the street, across five bays, put over it a loggia of the same size, and broadened the pediment so that it extended to below the roots of the towers of the façade (Plate 253). It also simplified the outlines of the towers themselves. Finally, in the third design, of about 1750, Servandoni had to delete the big central pediment again at the request of the building commission; he replaced it a few years later with a portico of four columns, set back a little, acting as a third storey.[75] The subsequent alterations by Oudot de Maclaurin, who removed the top storey again (1768), the destruction of the newly erected pediment by lightning (1770), and the revision of the now crippled façade by Chalgrin, who fluted all the columns and put up the heavy north tower – even J.-F. Blondel found it unbearable – gave it a cool, classical character quite unrelated to the original conception.[76] Blondel and Laugier were of the opinion that with this façade Servandoni had taken the first step towards classicism. This was certainly not the case. Neither in his work for entertainments nor in his theatrical designing was Servandoni a classicist. On the contrary, in both these sides of his work a thoroughly Baroque spirit prevailed. In Saint-Sulpice, too, the depth of the columned porches, the heaviness of the entablature between the two storeys, and the combination of columns and arcades are all Baroque features. But in its large-scale articulation and exclusive use of columns the façade does show a tendency to move in the opposite direction to Baroque, a direction that harks back to Perrault, Desgodets, and Cordemoy. The system it employs was already adumbrated in Desgodets' *Traité des ordres d'architecture* (1711) (Figure 29).[77] It can be regarded as certain that Servandoni was closely familiar with Desgodets' ideas, which dominated the instruction given by the Académie in the twenties. But in addition one must also take into account the model provided by St Paul's in London, a church which Servandoni naturally knew and from which he presumably borrowed the pepper-pot towers and the unusual breadth of façade. This latter affinity is particularly apparent in the façade of Saint-Eustache, which Mansart de Jouy built in 1756 on the model of Saint-Sulpice and where the old pedimented form of the model is still extant.

The big square in front of Saint-Sulpice, planned by Servandoni since 1752 as the crowning touch to his work – he wanted to close it off with a triumphal arch – was begun in 1754 but soon abandoned through lack of money. Only one single house was actually built.

Of the smaller Parisian churches, which have almost all vanished, Saint-Louis du Louvre (1738–44), by the goldsmith Thomas Germain, and the Chapelle de la

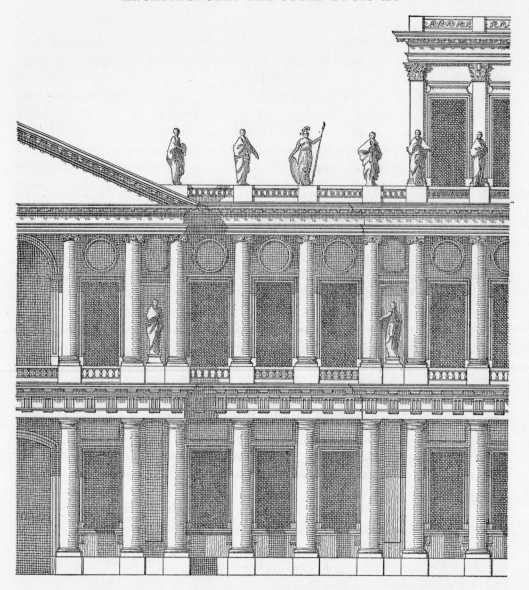

Figure 29. Desgodets: design for a façade, *c.* 1710, from the *Traité des ordres d'architecture*

Communion (1735), built on to Saint-Jean en Grève by Jean-François Blondel, were the most important. Even the latter, a paraphrase of Perrault's 'Salle égyptienne', is unthinkable without the influence of Cordemoy.[78] In spite of all the individual stylistic slurs, it was not the shape but the decoration that related these buildings to the style of the period.[79] Parisian church architecture of the Style Louis XV did not find forms of its own.

Outside Paris the greatest achievements in this field belong to Lorraine and Franche Comté. With their hall-churches, both provinces had taken a path that differed markedly from that of the interior of France.[80] In Lorraine, even the Primatiale at Nancy had been

unable to break through this tradition. Before it was completed, Boffrand's pupil Jennesson built (1720–31) Saint-Sébastien at Nancy, another hall-church. Here, both in the strongly massed columns of the interior and in the curving, somewhat overloaded, and on the whole not happily proportioned façade, a Baroque tone strikingly different from that of the Primatiale made itself evident. By far the most important of these late hall-churches is Saint-Jacques at Lunéville (Plate 254).[81] It is supposed to have been designed by Boffrand. In plan, it is true, it resembles the Primatiale at Nancy (Figure 2) – the transepts end in apses – but in elevation it is a direct descendant of Saint-Sébastien. The similarity is so great that it is tempting to suppose that Boffrand also worked on Saint-Sébastien, perhaps checking and correcting the design. At any rate the collaboration between teacher and pupil was here very close.[82] Most of the extant, unsigned drawings of the façade of Saint-Jacques are probably the work of Nicolas Pierson, the builder of Pont-à Mousson, and betray clearly the somewhat dry, Italianate style of the Lorraine school. However, one circular design, with two towers over the choir added to it, is obviously from the hand of Boffrand, to whom must also be ascribed the idea of the actual façade, with its huge coupled columns and the towers reminiscent of Sant'Agnese in Rome. The execution, probably begun by Boffrand himself, involved the whole school of Boffrand in Lorraine – first Nicholas Jadot (1710–61), who erected the façade from the niches onward and certainly parts of the nave, but quite soon (1737) followed his duke to Florence,[83] then Héré, Romain, and probably also Jennesson. In 1745–7 Héré put the big clock-cartouche over the pediment and set on the towers, in place of the planned onion caps, the lantern-shaped caps so strongly reminiscent of the tops of Boffrand's towers on the Primatiale. The fanciful shape and restlessly curling contours of these additions were further manifestations of Héré's Austrian inheritance, giving Saint-Jacques a special position in Lorraine and bringing it close to the Austrian Late Baroque abbeys.

Notre-Dame de Bon Secours in Nancy, too, in the façade of which the columns of the dismantled portico of Malgrange were employed again, is alien to French taste. Built by Héré in 1738–41 as a burial church for Stanislas (cf. p. 67), it is the only church which, with its vigorous fresco and stucco decoration, continued the king's native habits in this field, his links with Central European and South German Baroque. We must also mention briefly one special group of churches in Lorraine distinguished by their uniform design. These are the Jesuit churches of Épinal (1724–5), Verdun (1731–5), and Langres (1746–60). The features common to them all are arcades of columns as supports, broad pilasters as special emphasis for the corners between choir and nave, the absence of transepts, and finally a one-storey façade with a big segmental pediment. The whole group, which originally included further buildings, is the work of the Jesuit priest René Maugrain, who modelled his designs on Flemish hall-churches. The former Jesuit church at Hesdin (1714–15) may be regarded as a connecting link, but the type had been foreshadowed almost a hundred years earlier in buildings of Huyssens such as the Jesuit church at Namur.[84]

In Franche Comté, whose hall-churches differ from those of Lorraine in the exclusive use of square pillars instead of columns, the two leading architects were Galezot and

Nicole.[85] Galezot, hitherto very little known, brought to perfection in his churches, especially Scey-sur-Saône (1738–61), the local type of hall-church, which had only established itself since the end of the seventeenth century. His buildings are distinguished by the slenderness of their pillars and the stilting of the arcades, features which give them all an exceptional lightness. Alongside Galezot there was Nicolas Nicole (1702–84), as the link with the Paris school. Nicole had spent two years, from 1737 to 1739, in Paris as the pupil of Jacques-François Blondel, whom he knew from the latter's stay in Besançon and from the building of the Hôtel Marivat (1736). The first result of these studies was the Chapelle du Refuge – now the Chapelle de l'Hôpital – at Besançon (1739–45), in which he took as his model the curved façade and transverse oval of the Collège des Quatre Nations (now the Institut de France).[86] Shortly afterwards he started on the Madeleine (planned from 1742 onwards, built in 1746–66), in which he created his masterpiece. It became not only the chief work of ecclesiastical architecture in Franche Comté but also one of the most important churches in France (Plate 255). The plan, like that of the Primatiale in Nancy, is a cross inscribed in a rectangle, though one with shallow cross-pieces. In the elevation the influence of Blondel is very much in evidence.[87] Fluted coupled columns or pilasters, a vigorous entablature, and moulded arches in arcades are here combined with the usages of the local hall tradition, especially Galezot's arches on stilts and the shallow dome. The result is a striking contrast between the weight of the classical components of the building and the airy lightness of the space. Soufflot's idea of a combination of the constructional lightness of Gothic churches with the dignity of the classical orders was here anticipated by fifteen years as a development of local tradition. The two-tower façade, likewise taken over from Paris, though not erected by Nicole, exerted a wide influence, being the first in the region.[88] The façades of Saint-Christophe at Belfort and Notre-Dame at Guebwiller (Gebweiler), among others, were modelled on it.

The south of France, unlike the east, lacked prominent personalities, except for Ferdinand Delamonce (1678–1753), who had settled in Lyon, and Franque, mentioned already, in Avignon. Delamonce[89] was responsible for the design of the Oratoire at Avignon (1730), a building inspired by Bernini and built entirely on the oval, and also for the Baroque crossing of the Carthusian church of Saint-Bruno in Lyon (1733–7), for which Servandoni produced the baldacchino over the altar and Soufflot the altar frames. A church that is similar to the Oratoire, but more intimate, is the oval Chapelle des Pénitents Noirs at Nice (1736). Here, however, as in the whole of Provence, Italian influence was already very much in evidence.

The Gothic style had never completely died out in French church architecture either. Interest in Gothic architecture was kept alive in particular by the Benedictine congregation of St Maur, which systematically produced histories of all its abbeys. But the most obvious sign of the continuance of Gothic was Orléans Cathedral. Severely damaged by the Huguenots in the sixteenth century, the building had been restored bit by bit in the Late Gothic style of those parts of the nave which had been preserved; and by the beginning of the eighteenth century the work had reached the façade. At this point the question of style arose. A 'classical' design from the circle of Jules Hardouin

Mansart was at first envisaged, but this was rejected in 1707 as unfitting by Louis XIV himself and replaced by a design of Robert de Cotte's 'dans l'ordre gothique'. The Gothic of this design, it is true, could not properly be compared with medieval Gothic. In spite of the 'correctness' of the individual components, the design as a whole was a curious mixture of reminiscences of Notre-Dame, the *style flamboyant*, balustrades, and classical panels, only held together by de Cotte's noble and confident proportioning. In spite of the efforts of Jacques Gabriel, who was in charge of the work until his death and in 1736–9 had an impressive wooden model made (it is still in existence), the foundation stone of the new façade was not laid until 1742. In 1765, when Trouard took over the direction of the work, it had only reached the height of the doors.[90] Orléans is the most important evidence of the continuing appreciation of Gothic in France. At the same time it forms the bridge to its rediscovery at the end of the century, a rediscovery which of course no longer proceeded from ecclesiastical assumptions but from literary and philosophical ones.

Decoration

The character of Rococo decoration was governed by two things – rocaille and asymmetry. Both elements were fully developed by 1730. Rocaille already appears in fits and starts in the twenties, indeed even in the Galerie Dorée, but it was only now that it began to enjoy unrivalled predominance. Decoration freed itself from the shackles of architecture and started on a remarkable life of its own which led to the negation of the architectural framework. Wall panels, hitherto rectangular, began to incline towards each other or to interlock with each other. Cartouches and masks were arranged slantwise, and ceiling coves were given friezes of children at play, animals, or tendrils. The curve became the dominating element. It ran round the whole room in a continuous undulation. Even the ornamental panels proper, covering wide expanses, were formed of a succession of curves and counter-curves; in these the flow of the lines was halted and turned aside by opposing rocaille swings, but never interrupted. In addition to this, an unbounded passion for natural forms made its appearance. Garlands and festoons of flowers covered doors and wall panels, delicate tendrils wound round the frames of mirrors and the edges of walls. Exuberant life ruled the ceiling area.

This style, which during the second quarter of the century turned everyone's heads and to succeeding generations was unendurable, sprang from two main sources – the engravings of Meissonnier and Lajoue and their successors on the one hand, and the decorative schemes of Pineau on the other. J.-A. Meissonnier (1695–1750) was a native of Provence actually born in Turin, full of Italian Late Baroque conceptions of form.[91] By profession he was a goldsmith, and it was in this field that he first developed his new style based on the idea of the spiral.[92] In 1726 he was given a court appointment as 'Dessinateur de la Chambre et du Cabinet du Roi', that is, as ornament designer – a post that Jean Bérain had occupied before him. Even though he did not do a great deal for the court, in this position he was able to exert a wide influence. It was he who popularized rocaille, the cleft, scalloped shell work in grottoes and grotesques[93] – not to be

confused with the strictly symmetrical 'coquille' that was a legacy of the Louis XIV style. Proliferating, richly moulded shell shapes began to go round in whirls, as it were, to form spirals, and to split into ridges. They ousted the hitherto dominant palmette and led to completely irrational creations of distorted curves. Meissonnier's notions of architecture were just as irrational. In his engravings the tectonics and independence of architecture were completely disregarded. Unreal buildings, staircases, and landscape backgrounds, consisting entirely of curves, merged with abstract rocaille ornament. Different spheres of reality flowed into each other and merged. The fanciful appearance of these compositions was heightened yet further by swiftly flowing water, a characteristic element of Rococo iconography that broke out of the architecture in the form of springs or rushing waterfalls. The merging of the natural and organic with the abstract and inorganic produced what was known as the *genre pittoresque*; this is what the style was called by contemporaries.[94]

The other main characteristic of Rococo, asymmetry – called at the time 'contraste' – was also a basic feature of Meissonnier's art. It was still unknown in the Régence, except for a few small beginnings in Oppenordt.[95] The appearance of Toro with his asymmetrical cartouches had remained an isolated episode. Meissonnier turned it into a principle that permeated not only his goldsmith work but also his decoration. Although his style was already fully developed by 1728, it was not until 1734 that he published his series of engravings, *morceaux de fantaisie* or *morceaux de caprice*, which made him famous overnight.

Almost simultaneously the engravings of Jacques de Lajoue (1686–1761) appeared. Unlike Meissonnier, Lajoue came from the world of painting and had worked with Watteau, Lancret, and Boucher.[96] Lajoue was primarily a painter of architecture and well known for his illusionistic paintings – those of the library of Sainte-Geneviève (1731), for example, and of Bonnier de la Mosson's collection of natural curiosities (1734). The architecture in his paintings was real enough, whether the subject was a room or a building set in a landscape, though it was affected by a certain softening in the statics and a preference for curved compositions. Here he still belonged to the generation of the Régence. In his ornamental engravings, however (from 1734 onwards), he became a follower of Meissonnier. These engravings display the same fusion of architecture, landscape, and rocaille, with the same waterfalls cascading over them. The only difference is that Lajoue surpassed his model in wealth of invention and converted Meissonnier's often rather violent fancies into something more delicate and French.

The work carried out by Meissonnier – the Maison Brethous at Bayonne (1733) and the decorations for the Polish Marshal Bielinski (1734) and his sister, Baroness Bezenval (after 1736) – and his architectural designs – for example, Saint-Sulpice, the palace and church of the Ordre du Saint-Esprit, and the town hall on the Île de la Cité[97] – were too full of Baroque exuberance and formal restlessness to have a lasting influence in France.[98] So far as influence on interior decoration is concerned, Meissonnier, like Lajoue, was far outstripped in importance by Pineau.

After his return to Paris in 1727, Nicolas Pineau (1684–1754) had devoted himself completely to ornament. In this field he achieved an unrivalled mastery. The erstwhile

artist of the Russian court, rooted in late Louis XIV ideas, became the leader of the Rococo style. In the numerous remodellings and redecorations of the thirties and forties, Pineau was in the forefront as Leroux's closest collaborator. But he was also called in to help with big commissions by Briseux, Le Carpentier, and Jacques Hardouin-Mansart de Sagonne. Of the many decorative schemes he carried out in Paris, only a few have been preserved – the Hôtel de Roquelaure (parts of which date from about 1733), the Hôtel de Marcilly (c. 1738), the Hôtel de Maisons (c. 1750) (Plate 256), and Tannevot's house (c. 1740). Further examples – the Hôtels de Rouillé (towards 1732) and de Mazarin (1735), the gallery of the Hôtel de Villars (1732–3), the château of Asnières – are partly dispersed outside France.[99] However, they have come down to us in Mariette's engravings and a great many of them are also known to us through Pineau's drawings.[100] Pineau's decoration is distinguished not only by its omnipresent asymmetry but also by wealth of imagination and the exceptional grace of the form. The tendrils and borders of the wall panels, the cartouches and consoles, and the mouldings of the door and mirror frames attained in his work a delicacy and lightness unknown during the Regénce and never achieved even by Boffrand. A particularly noteworthy point about it is that all the forms are transformed into vegetation of one sort or another. Pineau's wall systems – like the decoration in the Fourth Pompeiian Style – sometimes only keep themselves upright like pieces of ephemeral garden architecture; the wall panels are enclosed by reeds with tendrils winding round them, the mirrors by palm trees, and everywhere the transition from plant to ornament is fluid. The heads in medallions, which appear for the first time in the Hôtel de Rouillé, contribute to this unreal character of the decoration, in which the influence of Watteau's grotesques can frequently be traced.

In many ways Pineau continued along the path already taken by Aubert and Boffrand – for example, in concentrating towards the middle the actual fillings of the panels, that is, the central rosette and the upper and lower palmette motifs.[101] The decoration of the flat areas thereby acquired more and more the character of a picture, a character which was heightened still further by the figurative scenes and the more vigorous central mouldings. But his creations are animated by a hitherto unknown delicacy and freedom, which bring them close to the painted grotesques of the period.

Boffrand himself appears upon the scene once more with a splendid work which did more than all his other achievements to assure his fame in succeeding ages – the Hôtel de Soubise (now the Archives de France). It is one of the few examples in Paris of a Rococo in which the Baroque tradition is still alive (this is not the case with Pineau) and all the arts are called in to enhance the total impression. Prince Hercule-Mériadec de Soubise, on the occasion of his second marriage – to the young and beautiful Sophie de Noailles – had commissioned Boffrand to redecorate his town house. In order to create the extra space required, Boffrand built on to the end of the Hôtel de Soubise's garden façade round about 1735 a two-storey oval pavilion, from which the suites of rooms opened out at right angles, as in the Pavillon Ovale of the Louvre. The decorative work was carried out immediately afterwards, in 1736–9. It embraced two complete apartments, one for the prince on the ground floor and one for the princess on the first floor. In these two apartments Boffrand is in his most charming and fanciful mood, occasionally

influenced by Pineau, but more powerful and conservative. Big figured cartouches, fully three-dimensional groups on the cornices and ceiling, and vigorous mouldings on the frames of the pictures and mirrors provide strong spatial accents, as one would expect with Boffrand. The climax is formed by the two oval salons, one on top of the other (Plate 257). Both of them are articulated on the system of the big salon at Malgrange. Between the arcades of the windows and doors there are rounded spandrels, filled on the ground floor with figured medallions in relief and partly even with free-standing sculpture – allegories of the prince's virtues – and in the princess's salon above with paintings – scenes from the story of Eros and Psyche. Their curved frames create a zone of continuous undulation which goes right round the room and provides the pictorial and three-dimensional accents in the decorative scheme. Over this rises, in the princess's salon, a light, airy, pergola-like dome on openwork balustrades, forming the end to this intoxicating riot of forms. It was evident in this unique ensemble that the hand of an architect, not that of a decorator, was at work.[102]

At the court, where conservative tendencies always remained influential, Rococo could not flower to the same degree. There everything was much more firmly tied to tradition. When decorative work started again at Versailles in 1725 after the king's wedding, old Vassé was still in command, with the well-tried team of Degoullons, Le Goupil, and Taupin, who were thoroughly familiar with the needs of royal ceremonial. They were responsible for the chimneypiece and the two huge picture-frames in the Salon d'Hercule and also for the big *trumeaux* with mirrors in the queen's bedchamber (1730). Everything here still recalled the forms of the Régence, especially those of the Galerie Dorée. The only innovation, and one that was to be important for the future, was the use of palm trees with olive branches winding round them to frame the mirrors and sopraporti.

It was not until 1735 that a new spirit began to make itself felt. Vassé and his now dead colleagues were replaced by the young A.-J. Gabriel and Jacques Verberckt (1704–71). The former, unlike his father, was a talented draughtsman; the latter, on the other hand – like Oppenordt, of Flemish origin – was an outstanding carver.[103] From now on these two dictated the style of decoration employed at the court. Their first joint piece of work was the cladding of the walls in the queen's bedchamber (1735), where one senses that the Hôtel de Lassay is being closely, conservatively followed. The light, elegant wall panels here form a clear contrast to the heavy doors and mirrors of Vassé. Then came the reconstruction of the so-called Petits Appartements du Roi, which filled all the floors of the north wing and reached their climax in the royal living rooms in the first storey.[104] This well preserved suite, recently refurnished in part as it was originally, which occupies the space once taken up by Louis XIV's billiard room and art collections, dates mainly from two periods. The Chambre de Louis XV, the Cabinet de la Pendule (Plate 258), and the Antichambre des Chiens acquired their decoration in 1738–9; the Cabinet Intérieur, the Arrière Cabinet, and the Cabinet de Madame Adélaïde (now the Salon de Musique) received theirs in 1753–5.[105] Immediately after this came the remodelling of the Cabinet du Conseil in the central wing (1755–6) (Plate 259).[106] The splendours of these rooms, the richly carved figured medallions and

trophies, the delicate garlands and festoons of flowers, are among the most brilliant products of the Style Louis Quinze, but they cannot conceal the conventional character of the decoration. The regular division of the fields, the vigorous mouldings, the gold mosaic in the spandrels are the signs of an unshakable tradition that always drew fresh nourishment from the continual re-employment of older parts of itself. It is only in the greater restlessness of the border-lines, the rosette-like gathering of the narrow wall panels, and the vertical contraction of the broad ones, particularly in the Cabinet du Conseil, that the contemporaneity of this work with other work of the same date finds expression. The combination of several phases of decoration in one and the same room is here almost the rule. Nevertheless, unity is preserved; the differences between the stylistic phases and the hands carrying out the work are relatively slight. Only in the frames of the mirrors and the ceiling mouldings do genuine rocaille forms occur; otherwise they are carefully avoided. Cherubs and animals, too, disport themselves here in unembarrassed play. In what was known as the Cabinet à Pans, which formed part of the Cabinet Intérieur and was dismantled in 1759, there even appeared the profile busts in medallions invented by Pineau.

In comparison with the royal suite, the decoration in the other parts of the palace lagged behind the times, with the exceptions of the rooms of the dauphin and dauphine on the ground floor. Here, in a less official area, it attained a freedom and lightness unparalleled at Versailles. Here, too, a room has been preserved with painted and brightly lacquered wooden panelling – what is known as Vernis Martin – whose delicate carving passes over into pure flower-painting. This is one of the few examples left of an almost vanished mode of decoration.[107]

Fontainebleau, the other great Bourbon residence, was also given a facelift by Gabriel and Verberckt. Here, too, the decoration is distributed over the whole château. The stucco-work reaches its peak in the coves of the Gros Pavillon (*c.* 1752) in the Cour de la Fontaine, where the *style pittoresque* unfolds freely. The most noteworthy carving is to be found in the Petits Appartements of the ground floor and in the rooms of the dauphin and dauphine at the east end. Here all the ornamentation has been transformed into sprouting vegetation. But the absolute climax is the Chambre du Roi and the Cabinet du Conseil on the first floor (1751–4).[108] Gabriel's splendid wall panels in the Chambre du Roi, forerunners of those in the Cabinet du Conseil at Versailles, and the delicate and airy grotesque paintings in the Cabinet du Conseil, by Van Loo, Pierre, and Peyrotte, which are among the finest examples of their kind, are in no way inferior to Versailles. The only difference is that here, owing to the contrast with the heavy coffered ceilings, chimneypieces, and proportions of the Louis XIII and Louis XIV styles, the unity of Versailles is not achieved.

A special position in the art of the court is occupied by the decorations of Rambouillet (between 1730 and 1735).[109] No names are attached by tradition to them, but they are undoubtedly the work of Verberckt, or at any rate the later sections of them are. They demonstrate how far people were prepared to go in the relaxation of form and in covering the flat surfaces with a web of ornamentation. In the Comtesse de Toulouse's boudoir (Plate 260), Verberckt, certainly not uninfluenced by Pineau, attained the

ultimate in Rococo. Here the wall panels are no longer framed by straight lines but by reed stems, which branch out like roots at the top and bottom, and on the inside are accompanied by an uninterrupted chain of irregular curves and counter-curves. In the ceiling moulding, where gods and cherubs disport themselves unconfined amid waves and rocaille work, the same grotesque-like unreality prevails. It is one of the finest examples of the *genre pittoresque*, which dominated even court art in the less official residences such as Rambouillet. A similar freedom is also to be found, for the same reason, at Champs (*c.* 1747), the only example preserved from the environment of Madame de Pompadour.[110] But the creations of this circle all maintain a discreet reserve which hardly allows the appearance of asymmetry. Finally, we must also mention, as an example of the last phase of Rococo, the decorations in the Palais Royal. They are the work of Contant d'Ivry and were carried out in 1755–60 in connexion with the reconstruction of the duchess's apartment, the wing known as the Aile de Valois.[111] They possess a certain aridity, which is only partly due to the exhaustion of Rococo; it is connected much more closely with the temperament of Contant. It is true that in the magnificent Chambre de Parade (Plate 261), modelled on the bedchamber of Louis XIV, free, and also asymmetrical, Rococo forms do appear in the leaves of the doors and in the wall panels, but they are confined in a strict, tectonic framework with quiet, somewhat heavy borders. The three-dimensional form is more strongly emphasized than it is usually; the tradition of Oppenordt is still perceptible. But one has the impression that Contant is inserting his rocaille decoration into a basically Louis XIV scheme. The elliptical dining room, with its half-columns running all round, its classical cornices, painted niches, and festooned reliefs and medallions, returns completely to the style of Le Brun – the first sign of any tendency to look backward at the glorious past.

In spite of all these considerations, it must not be forgotten that alongside carved and painted decoration, to which the painted plasterwork of Clerici and Chevallier also belongs,[112] painting was just as important – whether in the form of genre painting or of the tricks of illusionism. Here time has taken a particularly heavy toll. Only a vanishing fraction of the former splendour has been preserved. The best known examples are the *cabinets des singes* of Chantilly (before 1740), Champs (1748), and the Palais Rohan in Paris (*c.* 1750). In them scenes from comedy, illusion, and ornament mingle to form the fairytale world of the grotesques. Stage effects, only on a larger scale, were also preserved by illusionistic painting. In this the brothers Brunetti were the undisputed masters. They opened up rooms with views of indefinite distances and provided views of porticoes and gardens; good examples were the staircases of the Hotel de Soubise and the Hôtel de Luynes.[113] They even transformed the interior of Boffrand's orphanage into a pile of ruins, past which the shepherds wandered to the altar and to the Holy Family gathered there.[114] These paintings, already known to the Style Louis XIV, were just as much a part of the interiors of houses as any other kind of decoration. It was the interplay of painting, stucco, and carving that brought to life the refined interior decoration that is an indissoluble part of Louis XV architecture.

CHAPTER 7

THE SWING TO NEO-CLASSICISM

Introduction

ABOUT the middle of the century the period of peaceful development which marked the beginning of Louis XV's reign came to an end. After the French victory at Fontenoy and the Peace of Aix-la-Chapelle, which brought the War of the Austrian Succession to a conclusion in 1748, the monarchy had reached the summit of its popularity. Then, however, came political and ecclesiastical crises which threatened to endanger the state. The long-smouldering conflict between the Crown and the parliaments finally erupted and led to the temporary banishment of the Paris parliament from the capital, and the provincial parliaments made no attempt to conceal their pretensions or their hostility.

By clinging to their privileges and resisting tax reforms, the clergy roused public opinion against them and thus put welcome material into the hands of the 'philosophes', who had been attacking the Church since the time of Bayle. The general irritation was directed particularly against the Jesuits, whose influence was suspected behind everything the court did. This mood finally led in 1764 to the dissolution of the Order, the confiscation of its property, and the closing of its schools, which had been among the best educational establishments of their time.[1] In these circumstances the reputation of the monarchy was bound to suffer. The king and the court were not only held responsible for the absence of any will to reform; they also had to bear the odium generated by the unsuccessful issue of the Seven Years' War. The ovations given to the Duc de Choiseul when he was exiled in 1770 could be regarded as open demonstrations against the king. In addition, as a result of the war and the defective taxation system, the country was gradually overtaken by a financial crisis from which it never emerged again because of the general corruption and hostility to reform. The coffers of the state were already empty in the sixties, and work on public buildings had to stop because the workmen could no longer be paid.

But the crisis was even more acute in the intellectual field than in the political. Voltaire's *Essai sur les Mœurs* and *Dictionnaire philosophique*, Montesquieu's *Esprit des lois*, and Diderot's *Encyclopédie*, for which d'Alembert had written the famous 'Discours préliminaire' by way of a preface, represented the first systematic criticism of the Catholic religion, the administration of justice, and the absolute monarchy – the three main pillars of the old France – criticism which either awoke or stoked up discontent in the country. Stimulated by the example of England, Voltaire confronted a long-standing tradition, now hollow, with sound human reason, while Diderot started the process of incorporating every department of human life into one rational system governed by knowledge alone. These were ideas which questioned everything that had gone before; they heralded a new age.

The change of ideas was accompanied by a change in taste. The influence of the Enlightenment made itself felt in architecture too. The principle of the beautiful gave way to the concept of the useful and necessary,[2] as exemplified in the École Militaire and the Halle au Blé (1763–9) in Paris; the play of curves and the proliferation of ornament gave way to the classical ideal with its clear and simple forms, an ideal which had gained a new lease of life through the excavation of Pompeii (1738 onwards) and Herculaneum (1748), and through the discovery of the temples of Greece. There was also the nostalgia, never quite stilled, for France's own past, for the grandeur of the age of Louis XIV. Admiration for the achievements of the Sun King in the domain of architecture was tinged with a sense of the period's own insignificance and of the general decline in taste.

So began a reaction against Rococo which drew its strength from various different quarters. On one side there were the 'antiquaires', headed by the Comte de Caylus, a man well known for his collections of antiquities and his multifarious artistic interests, the Grey Eminence of neo-classicism.[3] His circle included the influential Abbé Leblanc, who had already spoken out against asymmetry and the agglomeration of ornament in his *Letters from England*, published in 1745; Abbé Barthélemy, keeper of the Cabinet des Médailles; and the famous collector Pierre-Jean Mariette, whose pen was responsible for the cutting obituary of Meissonnier in the *Mercure de France* of 1750.[4] On the other side there were the 'philosophes', the supporters of the French tradition and the 'bon goût du siècle précédent'. Their spokesmen were J.-F. Blondel, Diderot, and La Font de Saint-Yenne.[5] In the speech which he made at the opening of his newly founded École d'Architecture in 1747, Blondel had already taken up his stand against the *style rocaille*; he demanded the separation of architecture and sculpture on buildings,[6] and in his *Architecture française* (1752–6) he finally declared his loyalty to the great models Perrault, François Mansart, and Le Vau. In his *Cours d'architecture* (1771–3), a six-volume collection of his lectures,[7] he tried to restore the logic of architecture by reducing buildings, in accordance with the ideas of the Enlightenment, exclusively to their functions, to solidity, fitness for use, and symmetry, and by rejecting all superfluous ornamentation. In his buildings in Metz (1762–75) – town hall, guard-house, bishop's palace, parliament building, cathedral façade[8] – he put his principles into practice. With their well-proportioned but unadorned façades, they recall the classical models of the seventeenth century. As the most important theorist of his age and a collaborator in the *Encyclopédie*, Blondel could count on evoking a wide response.[9]

In addition, a profound influence was exerted in the conflict of opinions by Abbé Laugier's witty *Essai sur l'architecture* (1753). In the view of Laugier, a Jesuit and typical man of letters who soon afterwards turned his back on the Order,[10] architecture was an art derived from building with wood and had reached its zenith in Greece. His fundamental principle was that no part of a building should possess only an ornamental function: that, on the contrary, functional significance must be perceptible always and everywhere. In accordance with the basic elements of the primitive hut, which he saw as the prototype of architecture, he allowed only columns, architrave, pediment, and wall as components of a building; he rejected pilasters, niches, and the whole system of

articulating walls with designs in relief which characterized the French architecture of his time. He was, however, far from preaching the strict sobriety favoured by the next generation. He did indeed demand from architecture solidity, simplicity, and purity of form, but what he wanted above all was elegance and lightness, after the style of Greek architecture as he himself conceived it. The less wall the better; this was his conviction.

The appearance of his essay provoked a storm. Lightly and arrogantly written, brilliantly formulated, if also often provokingly subjective and not always unassailable in its logic, it was welcomed with enthusiasm by the young and the intellectuals and bitterly criticized by the older architects.[11] What Laugier demanded – purity of form, elegance, lightness, and variety – was precisely what was to mark architecture for the next twenty years. Even Blondel, who recommended his pupils to read the essay,[12] showed in his designs for churches that he had been influenced by him.

For the official attitude, however, Marigny's trip to Italy in 1749–51 was decisive. Madame de Pompadour's brother, created by the king first Marquis de Vandières, then Marquis de Marigny, was to succeed his uncle Tournehem, at his sister's instigation, as Directeur des Bâtiments. To prepare himself for this post, he spent two years in the company of Abbé Leblanc, Soufflot, and the draughtsman and engraver Cochin, who was employed at the Menus Plaisirs, touring Rome, Naples, and northern Italy and visiting the excavations at Herculaneum. He returned an admirer of Antiquity and a convinced opponent of Baroque.[13] With that, the official line was settled. A few years later Soufflot acquired control of all the work of the Bâtiments in Paris, and Cochin published in the *Mercure de France* biting attacks seasoned with wit and irony on the Rococo style. The most famous of these articles was the 'Supplication aux orfèvres', in which he made fun of the play of curves, octagonal rooms, cornices covered with vegetation, and the *style rocaille* in general.[14] In 1756 Marigny instructed the Académie, probably at the suggestion of his two friends, to make a particular point of giving its pupils the task of decorating the interiors of châteaux, 'pour corriger le mauvais goût d'ornement qui subsiste aujourd'hui'.

Against this background, the reception of ideas from Antiquity proceeded in two waves. The first wave of classical influence had in fact begun as early as the forties in Rome, in a circle of young Frenchmen who had met at the Académie de France. It was here, under the influence of the ancient buildings and the vogue for painting ruins, that a new vision of Antiquity first arose.[15] The engravings of Jean-Laurent Legeay, the most gifted of all these artists,[16] who came to Rome in 1738, show buildings that are oppressive in their monumentality, especially in comparison with the human figures (Plate 262). They also reveal an archaeological interest in reconstruction and a real enthusiasm for ancient settings, coupled with a dramatic mode of depiction that makes use of the effects of light and shadow. Legeay's fantastic architectural designs also display a particular preference for the column. There can be no doubt that these ideas also exerted a profound influence on the young Piranesi, who in 1740 came to Rome from Venice and in 1743 published his *Prima parte di architetture e prospettive*. But they were adopted and developed above all by the other young French artists of this circle – Le

Lorrain, Challe, Jardin, Potain, and Dumont among others. Le Lorrain's decorations for the Festa della Chinea at Rome,[17] with their columned porticoes, relief friezes, and laurel garlands encircling the whole building, were the first full-scale manifestation of neo-classicism (Plate 263). However, these young innovators drew their inspiration not only from Antiquity but also from the Cinquecento. They seized without any hesitation upon Michelangelo's Logge of the Capitoline palaces with their set-in columns, Ammanati's window profiles, and Palladio's columned porticoes and statues on attics,[18] just as Piranesi made use of ideas from North Italian Baroque, Juvarra, and Bibiena.

When these young men returned to France they brought their ideas back with them.[19] The first result of this was to be seen at the Académie, where in 1742 Legeay was appointed as a professor for some years.[20] With him a new spirit entered the venerable institution. Legeay's lively method of teaching, coupled with his mode of drawing in strongly contrasted perspective, attracted numerous pupils. His influence on the younger generation, which included Peyre, de Wailly, Moreau, and Boullée, was profound. Within a short space of time nothing but columns was to be seen anywhere and designs became gigantic.

The first examples of neo-classical architecture and decoration also came from this circle. About 1756 the Parisian collector La Live de Jully had his study furnished and decorated in the new style by Barreau de Chefdeville, Le Lorrain, Caffiéri, and Leroy. The ebony furniture (still extant) displays straight lines, deep fluting, undulating ribbons, meanders, and the rope-like garlands known as 'cordes à puits'. It became one of the cradles of neo-classicism.[21] Although its heaviness still gave it a considerable resemblance to the Boulle furniture of the seventeenth century, it produced a sensational effect. Both the components of the decorative scheme and the way in which they were combined were absolutely new. Within a very short time the whole of Paris was inundated by the goût grec, which, according to Cochin and La Live de Jully, originated here and was constantly nourished by accounts of the excavations at Pompeii and Herculaneum (1754) and of the temples of Greece (1758) and Paestum (1764).[22] In the sixties, as Grimm, Horace Walpole, and La Live de Jully himself ironically noted,[23] it was the fashion to have everything à la grecque, from hair-styles and crockery to shop-signs. In 1758, about the same time as this furniture was made, Moreau-Desproux, back from Rome, put up the first neo-classical façade on the now vanished Hôtel de Chavannes (Figure 30).[24] Here, too, there were meander ribbons and fluted brackets, and in addition olive branches in the spandrels of the windows; the two pavilions that framed the centrepiece were articulated with giant Ionic pilasters. The still extant Hôtel de Tessé (1765), by Noël Rousset, is similar.

The second, archaeological wave began in the sixties. It was released by the publication of Peyre's engravings and by the return of Clérisseau and Lhuillier from Rome. Awarded the Grand Prix in 1751, Marie-Joseph Peyre (1730–85)[25] had gone to Rome in 1753 and there, under the influence of Piranesi, and in company with his friends de Wailly and Moreau, he had taken all the measurements of the baths of Caracalla and Diocletian. His presentation piece, produced in the same year for the Accademia di

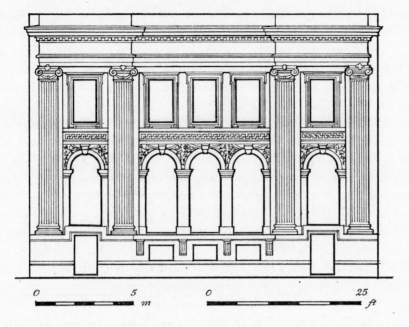

Figure 30. Moreau-Desproux: Paris, Hôtel de Chavannes, 1758, elevation

San Luca, a design for a circular cathedral with archbishop's palace and canons' residence, was still a compilation of Legeay's orgies of columns and motifs from Michelangelo and Bernini, the Pantheon and St Peter's – the whole thing on a scale that clearly revealed the influence of Legeay and Piranesi (Plate 264). In his later designs, however, which were published together in 1765 as *Œuvres d'architecture*, he strove to fuse Antiquity with native building habits.[26] Ancient architectural forms and shapes – the baths of Diocletian and the Pantheon, for example – columned porticoes, triumphal arches, and Palladian staircases were combined with French enfilades.[27] Churches and chapels were given the fronts of ancient temples. The *Œuvres d'architecture* became a manual of French neo-classicism. Gabriel, Ledoux, Victor Louis, and Chalgrin – to name only the most important – were among the many architects whom they influenced. The château de Neubourg, erected in 1762, was the first building in France in which an Italian villa in the style of Palladio was imitated and in which unframed windows were cut out of the surface of the wall.

Charles-Louis Clérisseau (1722–1820), who won the Prix de Rome in 1746, came to Paris in 1768.[28] He too was an unconditional admirer of Antiquity. In Rome he had made friends with Piranesi and Winckelmann. He had introduced Erdmannsdorf and Robert and James Adam to the ruins of Rome. In 1757, in company with Robert Adam, he had measured Diocletian's palace at Split. His architectural achievements in France were of no great significance. The Palais de Justice at Metz (1776) is a heavy, cold building, far removed from the harmony of Blondel. His designs for Russia, too, were ponderous and impracticable.[29] In interior decoration, however, his influence was revolutionary. With him ancient grotesque entered France. Under his influence and

that of his pupil Lhuillier, Bélanger erected in 1769 in the Hôtel de Brancas the Pavillon de Lauraguais, which may be regarded as the first strictly neo-classical work in architecture and decoration.[30] These pioneers smoothed the way for the new style. Buildings like the Halle au Blé (1763–9) and the Colisée, erected in 1769 by Le Camus in the Champs Élysées as a giant amusement palace in the style of the Colosseum, served to popularize it.

The most important theoretical work of this period, a work that fused Antiquity with the French academic tradition, was the eight-volume *Recueil élémentaire d'architecture* (1757–68), a collection of engravings by François de Neufforge, a native of Liège. The author, of whom so far we know little, was in close contact with Le Lorrain before the latter went off to Russia in 1758.[31] In his *Recueil* we meet again all the features that distinguished the designs of the Roman circle of the forties – columned porticoes, reliefs and garlands used for decoration, the preference for square and circular forms, and especially the eclecticism that drew both on Antiquity and on the High Renaissance, on Serlio and Palladio. Here a new direction was taken, both in plans and in forms of articulation. The final outcome was the cube-shaped house, the emphatic longitudinal axis with the staircase in the middle, the façade articulated by giant pilasters and a columned portico in front, and unframed windows cut in the wall. The influence of English Palladianism, alongside that of Antiquity and the High Renaissance, is unmistakable. The cubic house, the smooth wall without relief, the columned portico in front, and the Renaissance decoration had all been employed in England, too, since the time of Lord Burlington, and were accessible to everyone through *Vitruvius Britannicus* and Sir William Chambers' *Treatise on Civil Architecture* (1759).[32] The cube itself, which recurs continually in Neufforge, is also the basic shape in Robert Morris' *Lectures on Architecture* (1734–6).[33] That there was direct English influence on the architecture of the Louis XV period has been demonstrated more than once. It found expression particularly in garden furnishings – the first examples of direct borrowing are the two round temples in the park of Louveciennes (1770) – and in decoration.[34] In all other cases it is sufficient to point to the role of Neufforge as a middleman.

The usual title of 'Louis Seize' for the first phase of neo-classicism is not justified historically, for while 'Louis Quinze' coincided at any rate with part of Louis XV's reign, the 'Louis Seize' style was almost over when Louis XVI came to the throne. For the realm of public architecture the description 'Style Gabriel' would therefore be more appropriate. For decoration, the name 'Style de Transition' has in any case already gained acceptance. No doubt Madame de Pompadour, whose taste we have come to know, played an important part in the formation of the style.[35] The earlier conception of the 'Style Pompadour', which was still championed by the Goncourt brothers, has long been proved false. It was she who set her face against the excesses of Rococo and it was under her influence that Marigny put himself at the head of the new tendency. Nevertheless, it was a long time before neo-classicism established itself.[36] Not only the Seven Years' War but also the admiration of scholarship-holders in Rome for the Renaissance and the Baroque, as they came to know them there, exerted a retarding influence. De Wailly's Baroque decoration in the Palazzo Serra at Genoa (1772) and in

the Chapelle de la Vierge in Saint-Sulpice (1774), and Pierre-Louis Hélin's Carthusian church at Bourbon-lès-Gaillon (1769–75), inspired by Roman Baroque models, were produced at a time when the fashion for the *style grec* had long since triumphed in Paris.[37]

The Style Gabriel and Public Building

The second half of Louis XV's reign saw an upsurge of public building unparalleled earlier in the century. The echoes of the victory of Fontenoy stimulated a whole series of important projects – the École Militaire, Sainte-Geneviève, the completion of the Louvre, and the Place Louis XV. It seemed as if the age of Louis XIV was to return. There was plenty of activity in the provinces as well. The notions of enlightened society about the proper appearance and the requirements of a modern town led everywhere to the creation of new, regularly planned quarters – examples are to be seen in Lyon and Nantes – of unified street-lines, such as the Rue Royale at Orléans or the Cours at Bordeaux, and of public buildings, particularly town halls. As there was a lack of expertise in the provinces, it was generally Parisian architects who were called in, at any rate in an advisory capacity, to attend to these tasks.

The leadership was provided by the Bâtiments. In spite of his youth, the new Director-General, Marigny, was a competent man, who took his job seriously and did not let things simply take their course, as his predecessors had done.[38] As brother of the favourite, he was close enough to the king to be able to use the necessary authority. The Academies came to know his will often enough. Paris in particular had much to thank him for. Of all that was done here under his direction the Louvre gained him the greatest fame. The huge palace had been standing uncompleted since the days of Perrault and was threatening to become a ruin. Overgrown by buildings of every sort, it had only just escaped being demolished. Its condition had been publicly criticized both by Voltaire and La Font de Saint-Yenne.[39] When Marigny had Le Vau's façades on the east and north wings completed, the colonnade restored, and the inner courtyard cleared of all subsidiary buildings (1756–9) by Soufflot, he was the hero of the day. It was not his fault that the undertaking finally came to a halt and that the planned square in front of the colonnade was not actually laid out.[40] Even Marigny could not prevent one after another of his plans from being cut down or even halted.[41]

The leading personalities of this period were Soufflot and Ange-Jacques Gabriel. While Soufflot was at least a lover of Italy and an admirer of Antiquity, Gabriel, who had never been to Italy and knew Antiquity only through engravings, belonged exclusively to the French tradition. Owing to the financial crisis, Soufflot's great plan for the staircase in the Louvre (1768), a mixture of the Escalier des Ambassadeurs and reminiscences of Italian Baroque staircases,[42] never got beyond the paper on which it was drawn. It was only in the new building for Sainte-Geneviève that he was able to demonstrate his capabilities. Gabriel, on the other hand, as Premier Architecte, had every opportunity to display his talents. Not only did he build for the king the Petit Château at Choisy, the hunting box of Saint-Hubert, and the Petit Trianon, he also

decided – like his predecessors Jules Hardouin Mansart and Robert de Cotte – the style of official architecture under Louis XV.

The Style Gabriel, which was distinguished by its elegance and was close to the classical architecture of the Augustan age, became the first phase of neo-classicism in France. However, several stages can be distinguished in Gabriel's development after 1750.[43] The first stage, stimulated by his investigations in 1750 into the completion of the Louvre and by the design for a third storey, was governed by French classicism. It embraces the buildings in the Place Louis XV, where Gabriel took the Louvre colonnade as his model (Plate 265).[44] Not only the giant engaged columns, the continuous entablature, and the pediments at the sides, but also the oval medallions with their garlands and the classicizing dog-tooth, egg and dart, and other friezes are taken over, sometimes with the original proportions. The only difference is that in the Place Louis XV everything has become lighter. With the two façades framing the Rue Royale, i.e. the view towards the Madeleine – on the west side the Hôtel de Coislin, later to become the Hôtel de Crillon (1757–75), and on the east the Gardemeuble, later the Ministry of Marine (1758–66) – Gabriel created a monumental conclusion to the square which not only dominated its vast area but also, thanks to the light and shade produced by its columns and the articulation by pavilions, avoided any trace of monotony. This architecture, inimitably described by Viollet-le-Duc,[45] is still Baroque in its general planning, but its simple, straight-lined clarity and its sparing use of sculptural ornamentation also make it the first great example of the change of taste in Paris and of the renunciation of the liberal ornamentation and abundance of curves dear to the successors of Mansart.

The second phase of the Style Gabriel was governed by Palladianism. It embraces the École Militaire, the courtyard front of the château of Compiègne, the Petit Trianon, the Opéra, and the 'Grand Projet' of Versailles – all of them works characteristic of the *goût grec* and comprising a mixture of Antique and Palladian forms. The École Militaire,[46] a military academy for young noblemen, was conceived as a counterpart to the Hôtel des Invalides – hence the site outside the city near the road to Versailles, where the two buildings could be compared with each other. Gabriel's design of 1751, which had been preceded by another of 1750 now no longer extant, far outshone the Invalides. The Cour Royale alone, the wings of which were to accommodate the headquarters, the instructors' offices, and the classrooms, was almost as big as the whole of Louis XIV's foundation. At the end of a second courtyard rose the church, in front of which Gabriel had placed quadrant-shaped colonnades, just as Jules Hardouin Mansart had done in his design of 1702 for the church of the Invalides. Building began in 1753, but in 1765, after a long pause during the Seven Years' War, the plan was drastically curtailed. Its intended scope was reduced by a half. Gabriel replaced the side wings of the Cour Royale with one-storey columned porticoes and the church with a chapel in the main building. In the façade facing the Champ de Mars (1768–73) (Plate 266) he combined the French tradition, embodied in the dominating central dome, with Palladian features, as expressed in the alternating window pediments and the contrast between free-standing columned porticoes and smooth expanses of wall.[47] In the huge,

temple-like central portico, however, Antiquity predominated, as it did everywhere in the building. The models here were not the Louvre colonnade but the ancient buildings familiar from engravings and Perrault's translation of Vitruvius. The double loggia of the courtyard façade is modelled on the two-storey façade of Vitruvius' market basilica, and the one-storey wings have become ancient columned halls.[48] The chapel, too, one of the grandest and richest interiors of this period, points to Vitruvius' basilica (Plate 267).[49] As there, giant columns run round the space, eight on the long sides, four on the short. The intervening walls look more like a light membrane than real walls enclosing space. The segmental tunnel-vault is also used. Taken as a whole, the interior of this chapel was exactly what Laugier had in mind when he pleaded for a new architecture.

At Compiègne, which Gabriel had begun in 1751 in the plain style of his early work,[50] we find a Palladian pilaster articulation with alternating window pediments on the corner pavilions at the sides of the cour d'honneur. These were begun immediately after the end of the Seven Years' War, in 1763 and 1764 respectively. We also meet again here, on the windows of the ground floor, rustication encroaching on the surrounds. This rustication was typical of Colen Campbell and the English Palladian style; it had been employed by Gabriel shortly before on the sentry-boxes of the Place Louis XV.[51]

But the ripest expression of Gabriel's Palladianism is the Petit Trianon (Plate 268). It was built in the years 1762–8, as a sort of garden house for Madame de Pompadour in the middle of the king's botanical garden at Versailles.[52] In it the development towards isolation and the block shape, a development which we have been able to observe in Gabriel since the Ermitage at Fontainebleau, reached its climax. The outside is a cubic block, each side of which is five bays wide, with the three middle bays emphasized by means of an unpedimented articulation of columns or pilasters. The outer window bays take the place of wings. This block shape, not seen in France since Marly, is derived from the Palladian villa. In England it had already been used in Campbell's buildings – Stourhead and Newby, for example – and by Robert Morris.[53] In France Neufforge, who enjoyed the special protection of Marigny and Madame de Pompadour, had already published a very similar design in his Recueil (Figure 31). However, the special quality of the Petit Trianon lies not only in the new concept of the completely isolated building designed symmetrically with a view to variety, certainly, but not to achieving any kind of climax, but also in the exceptionally elegant articulation, which reaches its zenith on the south side, the one facing the Pavillon Français. The sparing decoration is also attuned to this articulation. Its 'Greek' character, which differs strikingly from the Roman exuberance of the Place Louis XV and the École Militaire, corresponds with the more intimate function of the building and probably also with the taste of the lady for whom it was intended.[54]

With the construction of the opera house at Versailles (1748–70) and the associated completion of the north wing of the palace, Gabriel took up an old plan of Jules Hardouin Mansart which had been dropped at the time as a result of the War of the Spanish Succession.[55] In the façades he based himself closely on his great predecessor, so

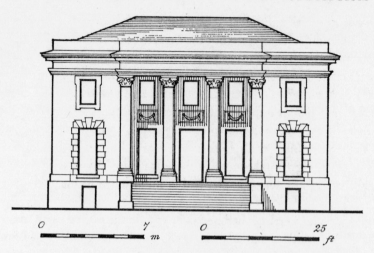

Figure 31. François de Neufforge: Design for a country house from the
Recueil d'architecture

that the difference of more than eighty years is perceptible only in the individual forms
and not in the general character of the buildings. Inside, especially in the oval audi-
torium, he took as his model the royal theatre at Turin, reckoned to be the most modern
in Europe.[56] However, he gradually reduced the traditional arrangement of four tiers
of boxes with rich rocaille decoration, which figures in his first design, to two con-
tinuous balconies with smooth balustrades in his final design of 1765. Over these he
put, on the pattern of Palladio's Teatro Olimpico at Vicenza, a continuous colonnade,
the entablature of which embraced the proscenium. Pajou's rich but cool relief decora-
tion (cf. p. 105) and the colour scheme of blue and gold are in complete harmony with
the rest.[57] The opera house was inaugurated in 1770 with the three days of wedding
celebrations for the dauphin, the future Louis XVI, during which Versailles once more
shone with a splendour not inferior to that of the Sun King.

The 'Grand Projet', which was to give Versailles a uniform appearance and which
had been under discussion since 1742 but again and again postponed, extends through
both this and the following period of Gabriel's career. The splendid design of the early
sixties (Plate 269) combined French and Palladian forms even more consistently than
the École Militaire. It provided for a giant order on a rusticated basement, as in the
Place Vendôme, but the articulation of the corps de logis was determined not by pil-
asters but by half-columns, while the wings had smooth walls with alternating window
pediments. At the ends of the wings appeared the old loggia motif of Le Vau.[58] The new
design of about 1772 already looked different. The corps de logis had acquired a
continuous, one-storey colonnade, but the giant order had disappeared. The wings
on each side had lost any trace of articulation or adornment; only the bare walls were
left. In both cases Gabriel had sacrificed the venerable Cour de Marbre and extended
the corps de logis to the back end of the Cour Royale. On the ground floor it contained
a broad vestibule, with the suite of royal rooms above this, while depth was created

by a big staircase leading through the anterooms straight to the Hall of Mirrors.[59] Of this second design, only the right-hand wing was actually built (1772–83). It was to hold the new show staircase. This wing, known as the 'Aile Gabriel', opposite which a similar one was erected on the other side of the courtyard in the reign of Louis-Philippe, stands, isolated as it is, in no sort of relationship to the other parts of the building. With its severe and arid appearance, it differs strikingly from the warm tone of the façades and the play of the relief planes.

This last period, which began about 1770, was governed by the strict, unadorned style of Peyre. It is represented by the garden façade of Compiègne (completed in 1786). In other designs, never carried out, especially in the conclusion of the Cour des Adieux for Fontainebleau, Gabriel harked back to the severe military architecture of Vauban, in order to achieve the monumental effect of ancient buildings.[60]

With the death of Louis XV Gabriel's task, too, was complete. A year later, in 1775, half blind and covered with honours, he retired from the royal service.

Gabriel's style was widely imitated. His most important disciples were Potain, Chalgrin, Antoine, and Barré, but the young Ledoux also made extensive use of his ideas. Nicolas-Marie Potain (1738–91), the head of his office, had directed the work on the Place Louis XV. He continued the façades eastwards on the same lines with the Hôtel Saint-Florentin, the courtyard side of which was built by Chalgrin. Of his numerous schemes – for example, Rennes Cathedral (1762; not executed until 1786–1844, and then in an altered form) and the Nantes Exchange (never actually built) – a design for a theatre, dating from 1763 and published by Cochin in 1769,[61] is the most interesting. In front of two of the façades of the square building, porticoes of Ionic columns without pediments are placed obliquely, up to the corners.[62] The plan is correspondingly diagonal, with an elliptical auditorium, the main stairs in the corner, and a stage in three sections, after the pattern devised by Bibiena, so that the performance could be properly seen by everyone, even the people sitting at the sides.

More important was Jacques-Denis Antoine (1733–1800), one of Paris's favourite architects because of his precision and confidence. His numerous public and private buildings – which include the Hôtel de Fleury (1768), the mint (1768–75), the château of Herces (begun in 1772), the façade of the Feuillant monastery (1776), the Palais de Justice (1776–85), the Hôtel de Ville at Cambrai (1786), and the mint at Bern (1787–92) – have the same block-like, cubic appearance and vigorous articulation as those of Gabriel, though they lack the elegance of the latter's general style. His most famous work is the mint,[63] which stands on a superb site and is one of the most important public buildings erected in the capital during the reign of Louis XV (Plate 270). It has been denied its final effect, it is true, by the elimination of the river-bank wall, conceived as a sort of visual base, with its steps and rustication. The façade has a box-like appearance, like a Roman palazzo, but the middle of it is strongly emphasized, as in Gabriel's work. The vertical accent is provided by giant columns, continued by an attic storey with figures in front of it. In the design the strict horizontals were brought to life by rhythmically arranged window pediments and balconies.[64] The horseshoe-shaped inner courtyard is closely connected with Gabriel's designs of 1773 for closing up the courtyard at

Fontainebleau. The dome, absent from the façade, appears here and on the side wing in a reduced form. In the strictly classical staircase, the gateway, and the two-storey central room, something of Soufflot's spirit is also perceptible. Structure and decoration are here more vigorous and direct than in, say, the École Militaire, and decoration plays a minor role.

The main work of Nicolas Barré (c. 1730–after 1788) was Le Marais. The various elements in Gabriel's architecture are summed up more fully in this splendid château to the south of Paris than in all Barré's other buildings. His success here and with his other châteaux won him the job of laying out a great square in Brussels between the ducal palace and the church of Saint-Jacques de Coudenberg, the only Place Royale outside France (1774–9). Chalgrin will be discussed in the next chapter.

Outside Paris, building activity was concentrated in Champagne, Nantes, and Bordeaux. In Champagne Nicolas Durand operated as the representative of a late academicism,[65] building the town halls at Châlons and Langres, theatres at Châlons and Reims, and the Hôtel de l'Intendance and Porte Sainte-Croix at Châlons. At Nantes, a splendid new layout was created under the direction of Ceineray, a pupil of Blondel.[66] Montpellier deserves special mention. In collaboration with his son-in-law, Donnat, Étienne Giral constructed here, as the end of a big aqueduct which was to supply the city with water, the Peyrou terraces (begun in 1767).[67] He combined the designs of François Franque and several local architects, rather as Gabriel had done in the Place Louis XV in Paris. The hexagonal temple on the upper terrace (Plate 271), open on all sides and known as the Château d'Eau, which forms the end point of an axis starting from Daviler's triumphal arch, is the most successful example of a type of building that occurs frequently in contemporary series of engravings – Dumont and Neufforge, for example. Academicism and neo-classicism have here entered into an unusually happy alliance. The fresh stream of Antiquity that bathes the relief decoration on the smooth sides and the columned porticoes comes less from theoretical engravings than from the near-by Roman buildings of Provence.

Finally, we must mention the French architects working abroad, whose influence increased continually at this time. The Lorrainer Jadot[68] was active in Vienna, whither he had gone from Florence with the Emperor Francis I. Nicolas-Henri Jardin[69] went to Denmark. In Russia, the operations of Vallin de la Mothe, a pupil of Blondel, formed a French interlude between those of the Italians Rastrelli and Quarenghi.[70] But it was in Germany that the French exerted their greatest influence; there they were largely responsible for the appearance of the small princely courts. Legeay's activity in Berlin was too short-lived to influence the style of Frederick the Great's court decisively; nevertheless, he was responsible for the designs for the church of St Hedwig (1747) and what is known as the 'Communs' opposite the Neues Palais at Sanssouci. These buildings were the first to incorporate neo-classical ideas, but they were too far ahead of their time to provoke new developments in Prussia.[71] Philippe de la Guêpière was more successful in Württemberg, where in 1752 he succeeded the Italian Retti as court architect.[72] He completed the palace begun by Retti in Stuttgart and built the country houses of Monrepos (1760–6) and Solitude (1763–7) for the duke. He also influenced

the building of the palace at Karlsruhe (in progress since 1750). In the Palatinate, Nicolas de Pigage (1723–96) had been at work since 1749. Pigage, a native of Lorraine, was the most gifted of all the French architects working abroad. His main achievements were the garden of Schwetzingen, with its numerous 'fabriques' (1753–95), and the château at Benrath near Düsseldorf, a perfect example of French design and interior planning at the moment when Rococo was turning into Louis Seize. He also built the charming little palace theatre at Schwetzingen (1752), decorated the library in the palace at Mannheim (1755–7), and worked for Heidelberg and Frankfurt. In addition, he revised the plans for the 'Jägerhof' in Düsseldorf, Jean-Joseph Couven's main work on the Rhine. For nearly four decades he dominated architecture in the various Palatinate possessions scattered up and down the Rhine. Finally, in the extreme south-west, Michel d'Ixnard, a southerner who had settled in Strasbourg, introduced French neo-classicism.[73] Ixnard was not untalented, but had little previous experience; he worked for the Upper Swabian nobility and clergy, between the Black Forest and Lake Constance. He was responsible for the abbey of Buchau, the decoration of the choir of Constance Cathedral (c. 1770), the church at Hechingen (1780–3), and other churches that look curiously foreign in the Rococo surroundings of Swabia. However, in the splendid new abbey church of St Blasien in the Black Forest (1768–83), his main work, in which he combined ideas from the Invalides with Contant d'Ivry's design for the Madeleine, he came up against the limits of his own capacity, and Pigage had to intervene. The palace at Coblenz (1777–86) is only partly his work. Here, too, the task exceeded his powers.

Private Building and the Early Work of Ledoux

There was a time-lag before the change of style in public buildings was followed in private building. In numerous country houses, even in the neighbourhood of Paris, Rococo lived on into the sixties – for example, in the stately Bourg-Saint-Léonard (1763–7), in the Château Borély at Marseille, and in the Château d'Enghien at Chantilly (c. 1770). It was only here and there that neo-classical ideas put in an early appearance: at Pignerolles (Marne-et-Loire), for example, an imitation of the Petit Trianon, and at Chanteloup, the splendid residence of the fallen minister Choiseul, where Le Camus de Mézières, the architect of the Halle au Blé in Paris, added in 1762 to de Cotte's three-wing building Ionic colonnades after the style of a Palladian villa. The colonnades ended in square pavilions.[74]

In Paris, the great authorities Gabriel and Soufflot were much too heavily occupied with public commissions to be able to give any lasting attention to private building. However, Soufflot's work for Marigny is interesting because of the light it throws on his artistic attitude. Marigny's Parisian house, which Soufflot had to modernize in 1768–71, was characterized by Roman windows modelled on those of the Villa Farnesina, by a Venetian window in the middle of the façade, and by a gateway from the street described as 'mâle et carré à la Michelange'.[75] Ménars, which he inherited after the death of his sister, acquired, besides other garden buildings, a grotto – 'piccola mia

garbata', as Marigny called it – whose façade could have been modelled on Ammanati's nymphaeum at the Villa Giulia (1770).[76] It was not Antiquity that held sway here, but the Roman Late Renaissance, to which both Soufflot and Marigny were indebted.

The biggest private patron of building in Paris was, as once before, during the Régence, the Duc d'Orléans, the grandson of the regent. In 1752, for the reconstruction of the Palais Royal, which he had just inherited from his father, he called in, as Cartaud's successor, Pierre Contant d'Ivry (1698–1777), who was over fifty and had already made a name for himself with the rebuilding of the aristocratic abbey of Penthémont, besides working on the duke's behalf several times in the park of Saint-Cloud.[77] Contant's alterations were extensive. They began inside Cartaud's Cour des Fontaines with the new apartment for the duchess (1752–6) – the polygonal, projecting central pavilion of its façade has been preserved – and continued, after the fire at the Opéra (1763), with the adjacent corps de logis. Contrary to the prevailing trend, a Baroque feeling still permeates this, especially in the dramatic staircase, strikingly lit from above (Plate 272). But reminiscences of Le Vau and Mansart can also be detected. The façade over-looking the garden (1764–70) is derived from the garden front at Versailles. The Orléans always had their own style, as opposed to the court art of Versailles, and Contant, too, fell outside the normal run of architects: he was an eclectic, who stood between the styles and belonged to the academic tradition, but never achieved Blondel's synthesis.

Neo-classicism in private mansions expressed itself in general in the plain cubic shape of the building itself, in the preference for giant orders, in the relief slabs over the windows, and in the finely shaded relief of the wall surface. The best examples of this aristocratic, still completely traditional type, which also occurs outside Paris, are prob-ably the Hôtel de la Vaupalière by Colignon (1768), the Hôtel du Châtelet by Cherpitel (1770), and the Hôtel de Montesson, now demolished, by Brongniart (1771).[78]

But the really creative spirit in the field of house-building was the young Claude-Nicolas Ledoux (1736–1806). One is tempted to see still in this bold innovator only the creator of the architecture of the Revolution, especially as he himself did all he could to strengthen this impression.[79] In reality, however, there were two sides to him. For nearly two decades he was the fashionable and pampered architect of Parisian society, a man with an inimitable talent for combining contemporary innovation with tradition. Ledoux came from Champagne and was at first a pupil of Blondel.[80] However, his very earliest commission, the decoration of the much frequented Café Militaire (1762), where he put up, between big mirrors on the walls, laurel-entwined bundles of pikes crowned with plumed helmets, as if returning warriors had laid up their victorious weapons there, was a spectacular success that drew attention to him.[81]

The first hôtels he built – the Château d'Eaubonne (1762–3), the Hôtel d'Hallwyl (c. 1764–6), the Hôtel d'Uzès (1764–7) – still show clearly his dependence on Blondel: the finely graduated relief of the façades, the alternation between smooth and jointed wall, the tendency to the perpendicular, the round-arched windows set deep in rectangu-lar fields, the decoration of garlands and keystones. Even the occasional reminiscences of the seventeenth century are due to Blondel: for example, the gateway of the Hôtel d'Uzès was modelled on the Porte Saint-Denis, which the younger Blondel calls 'la

première merveille de notre architecture'. The two obelisks on each side of the latter were paralleled by two columns hung with trophies of war.

Apart from Blondel, it was Gabriel above all whom Ledoux admired and imitated. He regarded Gabriel's buildings in the Place Louis XV as the embodiment of the true spirit of French architecture.[82] The courtyard façade of the Hôtel d'Hallwyl, with its alternating window pediments, mirrors the courtyard wing of Compiègne; the portico of the château of Bénouville (1768–77), with its four free-standing columns, echoes the contemporary portico of the École Militaire. This influence was expressed in numerous details, such as the fluted columns and pilasters, the delicate profiles and dentil friezes, and the window balustrades, but also in the relationship between the vigorously emphasized individual elements and the smooth wall. It was in the Hôtel de Montmorency (1769–70), whose columned pavilions are derived from the corner pavilions of Gabriel's buildings in the Place Louis XV and the system employed on the Petit Trianon, that it reached its climax (Plate 273). Yet from the start these borrowings were slanted in a direction determined by Neufforge's neo-classicism. This was the source in particular of the Palladian elements, the giant orders,[83] which had disappeared from private building since the Régence, the windows cut straight out of the wall without any surrounds, the columned porticoes without pediments,[84] and the figures on the attic. This, too, is the explanation of the somewhat hard and draughtsmanlike treatment.

Ledoux's own style was displayed clearly for the first time in the Hôtel d'Uzès (1767). On the courtyard front he placed four giant fluted Corinthian columns with a smooth entablature (Plate 274); the garden front he articulated with giant Ionic pilasters, topped by life-size figures in front of the attic storey. These façades were the result of several preliminary designs which clearly reveal the gradual swing away from Blondel to Neufforge.[85] How gravely Ledoux offended here against all the conventions is clear from Blondel's condemnation of the façades in the *Cours d'architecture*. But he immediately employed the idea a second time in the huge, block-like château of Bénouville (1768–77), which looks like an enlarged version of the Hôtel d'Uzès: on the courtyard side we find a free-standing portico of four giant columns carrying a balcony, and on the garden side giant pilasters with trophies in front of the attic storey. The monumental three-storey staircase is the biggest ever built by Ledoux; in its cool severity it is comparable not so much with Gabriel as with Trouard.

In Ledoux's hôtels the interior planning merits special attention. It is a mixture of Blondel's flexibility and Neufforge's somewhat stiff symmetry and centralization. Its dominant features, except where it was a question of alterations to existing houses, as in the case of the Hôtels d'Hallwyl and d'Uzès, are two-storeyed central rooms lit from above, marked transverse axes, and an inexhaustible variation in the shapes of rooms – a feature derived from the Rococo. The Hôtel Hocquart (1765–7) was the first perfect example of the application of the new scheme. Inside, the almost square building centred round a circular dining room, which lay between the hall and the salon and was roofed by a heightened dome with a coffered ceiling. This central longitudinal axis was accompanied by parallel side axes, along which the apartments of the master and mistress of the house were arranged. In the salon it intersected the transverse axis of the

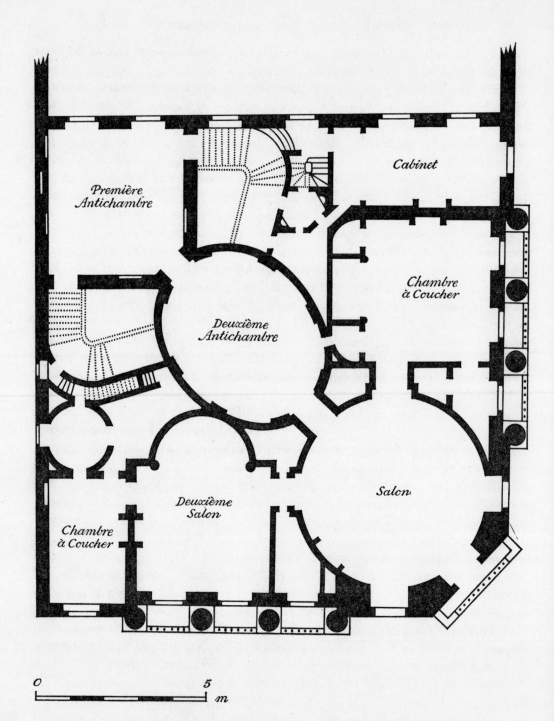

Première
Antichambre

Cabinet

Chambre
à Coucher

Deuxième
Antichambre

Deuxième
Salon

Chambre
à Coucher

Salon

0 5
 m

Figure 32. Claude-Nicolas Ledoux: Paris, Hôtel de Montmorency, 1769–70, plan
of first floor

reception rooms facing the garden. The two-storey central room also dominated the elevation of the house. As at Marly, there ran round it on the upper storey a circular corridor giving access to the rooms for the guests and the servants. This centralized plan, which was not native to France but was certainly one of Palladio's characteristic features, was a revolutionary innovation. By adopting it, Ledoux introduced a decisive change into French building habits, stabilized since the days of Robert de Cotte and Lassurance. The Hôtel de Montmorency, in which, as in Potain's design for a theatre, the entrance was placed across the corner and the main axis ran diagonally (Figure 32), shows how flexibly Ledoux was able to handle the new concept and how he retained the basic principle even in complicated situations.

When in 1770 Ledoux entered the service of Madame du Barry he moved into the ranks of the highest architects in the country. The favourite became his greatest patron. His first and most important piece of work for her was the pavilion of Louveciennes (1770–1) (Plate 275), in which he entered into competition with Gabriel, the creator of the Petit Trianon. He carried out his task, for all the outward imitation, in a completely independent way. In contrast to Gabriel, he made the central section of the rectangular, flat-roofed pavilion jut out like a block and opened it up with a deep, semicircular niche, which was encircled inside by a continuous frieze in relief and marked off outside by fluted Ionic columns.[86] It was roofed with a coffered semi-dome. Portals of this sort – with the niches for statues and the relief in the same places – were to be found in Neufforge,[87] but it seems more plausible to see here the influence of Peyre, who had borrowed these semicircular niches from Roman baths. In comparison with the Petit Trianon the pavilion of Louveciennes was in every way more angular and richer in contrast. The columns stood out against the empty expanses of their setting; the windows without surrounds sat unlinked and isolated in the wall. Relief panels adorned the walls at the points occupied in the Trianon by the mezzanine windows. The individual components were separated from each other as if a free space had formed round them. In general, it was possible to trace here a first step towards the block-like treatment which distinguished Ledoux's later style.

In contrast to the cubic exterior, the plan was a richly articulated one. Its outstanding feature was the extremely varied succession of rooms. Between the semicircular vestibule suite and the Salon du Roi lay, crosswise, an elliptical dining room, with little boxes for the musicians. This change of direction lent a special charm. It was emphasized still further by the rich adornment of this room with pilasters and reliefs, and also with a big painted ceiling.[88]

Ledoux produced a variation on this pavilion in the Hôtel Guimard (1770–2) in Paris. Here, too, the façade was dominated by a projecting middle section with a semi-circular niched portal and four free-standing columns. But this middle section was carried on up far above the cornice, so that it stood over the façade like a rectangular block. Even the portal reached above the columns and opened outwards in a big coffered niche, in which stood a piece of free-standing sculpture – Apollo crowning Terpsichore as the muse of dancing, an allusion to the mistress of the house, the dancer Guimard.[89] The smooth walls of the pavilion were thus provided with a contrast in the

form of the niche's effect of great depth.[90] As the 'Temple of Terpsichore', the Hôtel Guimard was no less famous than the pavilion of Louveciennes, not only because of its theatre, in which Ledoux had borrowed Potain's divided stage and the continuous colonnade of the Versailles opera house, but also because of the fame of its owner and the lavish parties she gave.[91]

In his other designs for the favourite, Ledoux worked on the large scale demanded by the tasks. At Versailles in 1773, in the Avenue de Paris, leading up to the château, he built her stables, which corresponded in magnitude to Mansart's Grandes and Petites Écuries. A big quadrangle, with a lower, wider courtyard attached to it behind, formed, together with the house itself opposite and a semicircular menagerie situated at the back, a cour d'honneur. The façade facing the street was given a monumental look by the huge gateway, the arch of which rested on two separate columns standing away from the wall. All the life and all the sculptural ornamentation are concentrated on this arch. The entrance to the Hôtel d'Hallwyl and the portal of the Hôtel d'Uzès are here magnified to monumental proportions, almost certainly not without renewed borrowing from Peyre, who had been the first to incorporate in his designs a gateway arch with reliefs in the spandrels.[92]

Still more important was the design, begun in 1773, for a château at Louveciennes. This was to be a long, low, two-storey building, articulated by means of three prominently projecting pavilions connected by wings lying back and celebrating the triumph of the giant orders. The original pavilion was to be incorporated in the building; at the back, with its columned pavilions, it determined the articulation and rhythm of the garden front. On the courtyard side, the columns not only marked off the open vestibules of the pavilions but also ran along in front of the recessed connecting wings. Giant orders of this sort had not been seen since Le Vau's time. These, however, were based on the columned halls of Palladio. The elegance of the detail, the elaborately articulated, gilded mansard roofs, and the trophy-adorned dormer windows were concessions to the atmosphere of the court.[93] To this extent the design for Louveciennes was more conservative than Gabriel's 'Grand Projet' for the palace. The principle of the pavilion as a mode of articulation was here used, without damaging the proportions, on the grand scale. This type of château as such already occurs in Neufforge, but Ledoux's design differs from the model in the more vigorous articulation of the building itself, the sharper contrast between bright and shadowy areas, and the greater depth of the colonnades. As a result of the king's death, construction was halted in 1774, which saved the pavilion of Louveciennes. The favourite's Parisian town house, distinguished by long columned porticoes, colonnades, and inner courtyards, also remained a paper project.

Equally important, if less well supplied with commissions, was Étienne-Louis Boullée (1728–99), Ledoux's senior by just a few years.[94] He had originally wanted to be a painter but had later changed over to architecture at his father's wish and had become the pupil of Blondel, Boffrand, and Legeay. The last of these in particular had exerted a strong influence on him. Even Boullée's early works were distinguished by picturesque effects and a touch of megalomania, features which prevented him from being successful in the competitions for the mint and the rebuilding of the Palais Bourbon.[95] In his

hôtels, the most striking of which were the Hôtel Alexandre (1766–8), the Hôtel de Monville (c. 1770), and the Hôtel de Brunoy (1772–9), the Palladian element predominated at first. In the Hôtel de Brunoy (Plate 276) there were also reflections of Antiquity. The stepped roof over the columned portico was the throne for a statue of Flora, a gallant allusion to the owner. The contrast between the over-dimensioned portico and the rows of low arcades shows how strongly Legeay's ideas were still at work here, but the suggestion of a temple of Flora already points forward to Boullée's symbolistic architecture of the following age.[96]

Neo-classical Churches

The critical attitude adopted by the 'philosophes' towards the Church had little effect on the faith of the masses. Church-building went on with undiminished intensity right up to the end of the *ancien régime*, with Paris and the border regions in the north and east of the country continuing to occupy the foreground.

In the design of façades, the traditional scheme of piling one order on top of the other lived on into the late sixties. In Paris, this scheme runs in a straight line from Saint-Roch via the Oratoire (1745) and the Temple des Billettes (1756) to Saint-Thomas d'Aquin (1769–70), though the three-dimensional modelling grows progressively shallower. The last two buildings were designed by the Dominican Claude Navan. His design for Saint-Thomas d'Aquin[97] still bears the stamp, even in the details, of the Style Louis XV.

The Baroque restlessness which distinguishes Saint-Roch also continued in a few big buildings outside Paris. The chief examples of this are the cathedral of Langres (1761–8; architect, Claude-Louis Daviler) and Saint-Vincent at Metz (1768–86; architects, Barlet, Louis, and Lhuillier). The façades of both buildings are marked by the accumulation of columns and three-dimensional decoration, by the in-and-out line of the cornice, and by the contrast between areas of light and shade. The Metz façade in particular, as a result of the play of its coupled columns and niches for figures, gives the effect of being cleft into separate parts. The exceptional height of three orders, a feature which links the church with Saint-Gervais in Paris, sprang from the combination of the new façade with an already existing Gothic nave.[98]

The call for a change in this sort of design came first, significantly, from the rationalist camp. Pierre Patte (1723–1812), a pupil of Boffrand and a supporter of Blondel, was the first to criticize Italianate façades, on the grounds that through their division into storeys they were appropriate for secular buildings but not logical for churches. He demanded instead the giant order as used in Antiquity and by the old masters.[99] His design for a six-column portico with a pediment for Saint-Eustache in Paris (c. 1754), a design which still contains many Baroque features, is the first to introduce the principle of the neo-classical church façade. It is only a little later than the portico of Geneva Cathedral (1752–6), by Benedetto Alfieri, and the similarity between the two rather suggests that Geneva inspired Saint-Eustache.[100] The antiquarians soon took over the motif. In Rome in the fifties Peyre designed churches whose façades were modelled on ancient temples, with giant columns standing before a bare wall adorned only by niches for statues and

a continuous frieze in relief. He published these designs in 1765, a year after Soufflot had erected the ephemeral portico of Sainte-Geneviève on the occasion of the laying of this church's foundation stone. With these two events the signal was given: from now onwards the temple pediment became the predominant motif for façades. It was only in 1780, with Antoine's Chapelle de la Visitation in Nancy, that the process entered its last stage: the bare, windowless wall articulated only with bands of rustication, against which the portico or portal was placed. Among the Parisian churches belonging to this phase were the Chapelle des Filles de Saint-Chaumont by Convers (1781), the Chapelle Saint-Nicolas by Girardin, and Saint-Louis d'Antin by Brongniart (1781). Only the last of these survives.

But the decisive change in church-building concerned the interior. The demand for greater lightness and transparency, already raised by Cordemoy and repeated by Desgodets in his teaching at the Académie, coincided with a new attitude to the Gothic style.[101] Soufflot, Boffrand, and Delamonce among others had declared themselves firmly in favour of Gothic methods of building. Laugier's essay, which demanded for churches not only a return to the purity of form of Antiquity but also the height and transparency of Gothic churches, fell here on ground that had already been prepared. Laugier's ideal church, which he contrasted with those of his own time, had a tall nave, carried on columns and approaching Gothic proportions, and a Gothic feeling for space. But just as he put a second order on top of his rows of columns, after the pattern of Greek temples, so he replaced the arcades with the classical entablature, giving the nave a barrel-vault and the aisles flat ceilings corresponding to the intervals between the columns. In the side chapels and the clerestory he replaced the walls with big windows.[102] This gave the interior a completely new orientation, which was certainly based on Cordemoy's ideas but was here for the first time formulated clearly and systematically. The whole concept sought to combine Gothic construction with classical form, employing the full light of day as a means of creating an impression of space.

Contant d'Ivry and Soufflot were the first to put these ideas into practice. Saint-Vasnon at Condé-sur-l'Escaut (1751-6) and Saint-Vaast at Arras (begun c. 1755), both by Contant, display for the first time rows of columns and continuous entablatures. The columns accorded, it is true, with the local tradition of the hall-church,[103] but the entablatures did not. Unlike Condé, which still contains individual Baroque features, Saint-Vaast is a completely unified concept (Plate 277). Huge columns flank the nave and run round the choir, as in a Gothic church; above is a smooth architrave with widely projecting entablature and big choir windows. The proximity of the hall-churches of Flanders still makes itself felt strongly here.

Contant's designs for the Madeleine in Paris (1757), which were linked with the planning of the Place Louis XV,[104] followed Laugier so far as the plan was concerned, in that the aisles were led round the transepts and the choir was given a flat end. Although the decoration possessed a uniformly neo-classical character and was confined to altars, stone figures, and relief sculpture in the ancient style, there was a certain dichotomy in the bold Baroque projections of the cornice and the galleries over the side chapels. Nor did the solution of the dome problem, for all its ingenuity, help to

produce any feeling of spatial unity. The provision of a broad, octagonal ambulatory, which separated the crossing proper from the nave and aisles, and the elevation of the crossing arches on stilts produced a kind of baldacchino of extraordinary lightness which hovered, so to speak, over the high altar (Plate 278). This baldacchino idea, which also appears in Desgodets,[105] Cordemoy, and Laugier, had already been adumbrated at Arras, where Contant had planned to put a second order over the free-standing columns in the corners of the crossing. The actual model may have been the crossing of Saint-Géry (now Saint-Aubert) at Cambrai, which was built in 1738 in the pure hall-church tradition and which Contant indubitably knew from Arras.[106] But obviously in the Madeleine Contant did not succeed in linking this baldacchino with the nave and aisles of the church.

The authentic realization of Laugier's ideal, the fusion of classical and Gothic, was achieved by Soufflot in Sainte-Geneviève, the biggest and most important neo-classical building in France.[107] Sainte-Geneviève (1757–90), now the Panthéon, is the final result of decades of thinking and striving by the best minds in France to effect a reform in church-building. In 1744, during his illness at Metz, Louis XV had made a vow to rebuild the famous old abbey church. In 1755 Marigny, who had previously eliminated all competition, invited Soufflot, his friend and travelling companion, to come to Paris to take over the building operations.[108] These dragged on for a long time. They were continually delayed by adverse circumstances – difficulties in the terrain, the Seven Years' War, and finally growing financial difficulties, which almost brought work to a stop. After Soufflot's death, building went on under his pupils Brebion and Rondelet and his nephew Soufflot-le-Romain, so that by the outbreak of the Revolution the shell was just complete. Soufflot's basic conception was a Greek cross resting on a crypt-like lower church, with a separate bell-tower and a six-column portico (Figure 33). The wide crossing, which was spanned by a hemispherical dome with a low drum – again after the fashion of a baldacchino – was to contain the shrine of St Genevieve. The arms of the cross were four domed compartments, with shallow domes on pendentives, each of which was surrounded by four narrow barrel-vaults and rested at the corners on squares of four columns – in principle, therefore, a plan similar to that of St Mark's in Venice. Round this Greek cross ran flat-roofed passages separated from the main spaces by columns with entablatures. The arcades of the dome over the crossing rested on narrow piers stretching between four triangles of columns. The large number of columns, their advance and retreat, and the succession of domed spaces produced an exceptionally lively and transparent feeling of space, which combined the monumentality of Piranesi's visions of temples with the light-flooded breadth of Gothic churches (Plate 279). The main spaces of all four arms of the cross was lowered by five steps, so that inside the general cruciform shape a concentric cross was produced, which was surrounded by a kind of gallery. From here it was possible to follow what was going on at the shrine, which was encompassed by three altars and a balustrade. This basic concept of Soufflot's, devised in 1757 and described by Laugier as the 'premier modèle de la parfaite architecture', suffered a series of radical modifications as a result of the wishes of the clergy and of the public criticism which accompanied the building from

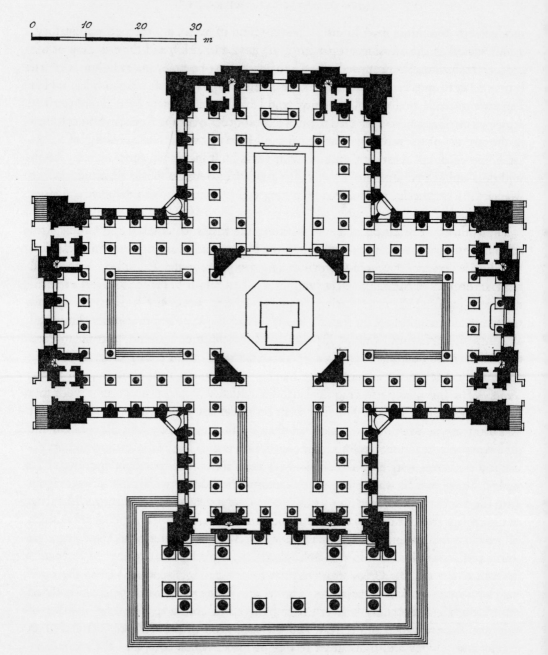

Figure 33. Germain Soufflot: Paris, Sainte-Geneviève (Panthéon), plan, 1757

320

the start.[109] The most important of these modifications were the abandonment of the symmetrical cruciform shape in favour of a lengthening of the choir and entrance arm and the insertion of barrel-vaulted intermediate bays in both the west and east ends (1758). The dome, which seemed too small in relation to the new proportions and whose support system led to a violent controversy with Patte, was stretched and built with three skins instead of two (1770 onwards). Instead of the originally planned half-columns, the drum was given first an octagonal and finally a circular peristyle of free-standing columns, with a corresponding ring of columns inside (1776).

Like Gabriel's buildings in the Place Louis XV, Sainte-Geneviève signifies a return to Perrault and the celebrated Louvre colonnade. Not only did Soufflot take over from this the system of iron anchors and the pattern for his Corinthian capitals; it is also behind the rows of columns of the interior and the first version of the drum of the dome. Perrault's circular peristyle round the dome of the chapel which he planned for the Louvre,[110] together with St Paul's Cathedral in London, probably provided the model for the final form of the dome of Sainte-Geneviève. Yet at the same time Soufflot also finally came to terms with the Gothic style. From the start he worked with a subtly calculated distribution of pressure and thrust, though without letting the Gothic buttress system become visible. Patte's attack of 1769, which was aimed precisely against the static system and the carrying capacity of the piers of the dome, compelled him to check his calculations and provoked a general discussion. Gauthey, who was the firmest defender of Soufflot's theories,[111] demonstrated at this same time in his church at Givry – an octagonal centralized building with short cross-arms and galleries in the spandrels of the vault – how far one could go with the reduction of the wall mass. In the same way Soufflot, too, hollowed out the piers of his chapels into galleries, so that only the buttress system of the arches was left, and widened the upper windows in the aisles. The whole building had become a complex of lines of force in which no stone was superfluous. That in spite of all calculations cracks appeared in the piers of the domes, later forcing Rondelet to strengthen them, so that the original idea was watered down, in no way diminishes Soufflot's achievement. In the eyes of contemporaries, especially the circle round Marigny, his work was the fulfilment of everyone's dreams and the start of a new era in church-building.[112]

The Revolution, by decreeing in 1791 that the building should be converted into the Panthéon, did considerable harm to it. Through the walling-up of the side windows it lost its flood of light, through the destruction of the reliefs and ornamentation on the vaults and the portico it lost its air of gay festivity, and through the strengthening and widening of the crossing piers (1801) it lost its transparent effect of space.[113] Also the east towers, erected only in 1769, were removed. The present cold and gloomy Panthéon, crowded with funerary monuments, still gives only a very imperfect idea of what Soufflot had intended and accomplished.

The square planned by Soufflot outside the church was only begun – with the École de Droit (1771–83), which was supposed to be faced by the École de Théologie.[114]

These great examples ensured the triumph of the column, even though Blondel stuck to arcades on piers in the designs in his *Cours d'architecture*.[115] However, the logical

continuation of Laugier's and Soufflot's ideas also produced, alongside the cruciform plan, the basilica without transepts, already recommended by Desgodets and Cordemoy as the starting point of Christian ecclesiastical architecture. This form of building possessed in addition the timely advantages of economy in materials and great lightness of construction, thus satisfying the supporters of the Gothic style. With the ground prepared by Potain's design for Rennes (1763),[116] which was probably inspired by Soufflot, the return to the Early Christian basilica thus took place soon after Sainte-Geneviève was started. The return was exemplified in three buildings which were all designed in the same year, 1764, and were very similar to each other: Saint-Louis at Saint-Germain-en-Laye, by Potain (started in 1787 and completed, after a long break, in 1823); Saint-Philippe du Roule in Paris, by Chalgrin (built in 1774–84); and Saint-Symphorien at Versailles, by Trouard (built in 1767–70).[117] This phase also included the first design for the chapel of the Couvent de la Reine at Versailles, by Richard Mique (1767), and the Holy Souls' Chapel in Sainte-Marguerite, where in 1764 Victor Louis had a basilican system painted on the walls and ceiling by Brunetti.[118] The main features differentiating these buildings from the Early Christian basilica were the uninterrupted coffered barrel-vault and the continuation of the lines of columns round the apse in the form of engaged columns. Saint-Philippe du Roule (Plate 280) may be regarded as the perfect example of this group; it is equally distinguished for the elegance of its construction and the wealth of its decoration. The best examples of the design outside Paris are Saint-Symphorien at Gy (1769–c. 1785), by Frignet and Colombot; the Capuchin church in Strasbourg (1774–84) and the church at Chivremont (1784–7), both by Chalgrin's pupil, Kleber; and Saint-Louis in Toulon (1782–8).[119]

These ideas took a special form in Franche Comté.[120] 1747 saw the construction of the centralized church of Traves-sur-Saône, in which columns alone were employed. The design of Traves, a Greek cross with arms two bays long and rounded corner rooms with domes, was adopted by Nicole at Voray-sur-l'Ognon (1770) (Figure 34). Instead of the arcades, however, he put a classical entablature all round the interior. This entablature continued over the ends of the transepts, which were one bay shorter than those of Traves. Here Nicole showed that he was an adherent of Soufflot and Parisian neo-classicism.[121] Voray became the starting-point for a number of particularly beautiful centralized buildings, the most important of which are Saint-Pierre in Besançon (1782–6), by Bertrand, and the little country church at Cirey-lès-Bellevaux.

Finally, a word must be said about the 'resurrection' of Gothic. Where this was tried on the originals, that is, Gothic churches, it becomes clear that the point of view of this generation was very one-sided. The neo-classicists – headed by Laugier – certainly wanted to bring out the transparency of Gothic interiors and the beauty of the constructional system, but they had no feeling for the atmosphere of Gothic churches, for the muted light, the colours in the windows, and the wealth of decoration.[122] The result was a wave of purification that swept over all the cathedrals of France – the foremost example of this in Paris is Saint-Germain l'Auxerrois (1756) – carrying away altars, rood screens, and choir stalls. In many cases even the medieval stained glass windows were sacrificed in order to let in more light, but at the very least the churches

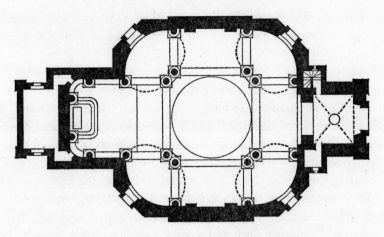

Figure 34. Nicolas Nicole: Voray-sur-l'Ognon, church, 1770, plan

were whitewashed from top to bottom to give them more dignity and grandeur. One of the crassest cases was Amiens Cathedral, where from 1755 onwards, at Laugier's suggestion, the chapter auctioned off the furnishings and only shrank back when it came to selling the famous choir stalls.

The well-intentioned idea of making everything simpler and more elegant, and thus more appropriate, by giving the bases and capitals of pillars a classical look and removing the 'hideous' Gothic ornament, also had its effect on the exterior decoration. Trouard, and after him Adrien Pâris, travelled round all the cathedrals of France in the course of preparing the design of the towers for Orléans Cathedral. In 1793 the façade was complete.[123] The naïve illusion that it was possible to improve in an enlightened way on the original models and thus to become 'more Gothic than the Gothic period itself', had here produced the first example of what came to be known as the *style troubadour*.

Decoration

In the change of style from Rococo to neo-classicism, architecture led the way. In the field of decoration, Rococo lived on, in spite of Cochin's attacks and the death of Pineau. Asymmetry disappeared, it is true, and the curves quietened down, but the undulating rhythm, the delicacy of the relief work, and the vocabulary of forms remained. Cuvilliés' engravings, which show Rococo at its zenith, only began to appear in Paris in 1755. They continued into the late sixties.[124] However, increasing academicism produced a kind of stylistic development in reverse, which led back to the Régence and Louis XIV phases. This made itself apparent not only in the shape of the wall panels but also in the ornamentation. The general attitude is indicated by the fact that in 1761 Blondel, the official spokesman of the Académie, included Contant's moderately Rococo decoration in the Palais Royal in the first volume of plates of the *Encyclopédie*, and as late as 1771 incorporated the Galerie Dorée, which dated from 1719,

in the *Cours d'architecture*. Hence also the survival of Rococo forms in the provinces until about 1770; an excellent example of this is the Hôtel de l'Intendance at Châlons-sur-Marne (1759–70).[125]

The court was particularly conservative. The personal taste of the king and the indecisive attitude of Marigny resulted in the survival of a restrained *style rocaille* at Versailles, Choisy, and Fontainebleau until the late sixties, when the *goût grec* had already begun its triumphal progress through Paris.[126] Verberckt (1704–71) and Antoine Rousseau, congenial collaborators of Gabriel as ornament-carvers, remained to the end the most brilliant exponents of this style. As late as 1767 Gabriel designed the wall panelling and the festoons of trophies in the alcove of Madame Adélaïde's Salon de Musique at Versailles, features which were hardly inferior to the sparkling Rococo of the earlier sections of the decoration, dating from 1752; and in 1769 Chevallier gave Madame Sophie's library on the ground floor of the palace a scheme of decoration in coloured stucco almost in the style of Peyrotte and Huet. In addition, the continual alterations to existing rooms and the increasing scarcity of money led again and again to the necessity, when it came to the question of redecoration, of fitting in with what existed already. This was the case, for example, with the first apartment of Marie-Antoinette at Versailles (1770) and also with the Appartement de Monsieur at Fontainebleau (up to 1784).[127]

The first signs of a change in taste appeared in the Petit Trianon, which as a new building was not subject to any limitations (Plate 281). The interior was completed in all essentials in the years 1765–8. It is noteworthy in several respects. Straight lines and right angles predominate; the rooms are rectangular again for the first time. The curve has disappeared from both the corners and the ceiling area.[128] The walls are articulated with rectangular panels again and continuous undulation has given way to self-contained individual panels. Rococo motifs – C-scrolls and shells – occur only here and there – in the dining room, for example, and in the room known as Marie-Antoinette's Bedchamber – and they are firmly enclosed in rectangular frames. The bare wall surface appears again.

The ornamentation has changed, too. On the ceiling the gambolling children and birds have been replaced by a bracketed cornice or acanthus tendrils, and in the wall panels the shell-shaped palmettes have given way to vases and medallions. Door and wall panels are no longer framed with olive branches or palm stems but with fine palmette friezes and egg-and-dart mouldings. The whole character of the decoration has become cooler and more academic. All the gold has disappeared; the dominant colours in the rooms are delicate whites and greys. The beautifully carved trophies and festoons of flowers and fruit by Honoré Guibert (in the royal service since 1760), which are accompanied by the characteristic motif of big round medallions containing three lilies, are interspersed with the first classical motifs, among which the motif of griffins holding vases also makes an appearance. But here, as in architecture, Antiquity is only imitated at one remove. There is no link with the group of young neo-classicists round Legeay; the link is with Piranesi and English models, which had been known since 1759 through Chambers' *Treatise on Civil Architecture*.[129] The late Louis XIV period, as

exemplified by Lassurance or the Grand Trianon, is not far away either.[130] This mixture of motifs characterizes what is called the Style de Transition, which corresponds in date to the Style Gabriel in architecture. It dominates in just the same way the furniture of the sixties, in which curved and straight forms, C-scrolls and oval medallions are to be found on the same piece.[131] The last example of this style at Versailles is the Cabinet des Bains, dating from 1770, with its four-colour gilded décor of rush-entwined medallions with bathing scenes and figured reliefs by Rousseau, in a delicate frame of architecture in the classical manner, in which the C-scrolls have been transformed into water-spouting dolphins. On the other hand, Marie-Antoinette's first library of 1772, which has now vanished – its doors are in the municipal library of Versailles – and Louis XVI's library of 1774, both the work of Gabriel and Rousseau, already represent a near-return to the Style Louis XIV. The wall panels framed by narrow moulded lines of the Style Louis XV have been replaced by grotesques after the style of Le Brun and broad plaited bands of laurel branches twined like garlands – another motif of Le Brun's.[132] Ledoux's decoration of the Pavillon Du Barry at Louveciennes (1771), with its rich gold mosaic, also bears this somewhat stiff, retrospective stamp.

While in private houses this discreet classical style, with its egg-and-dart mouldings and reliefs over doors and mirrors, gained more and more ground, in official schemes of decoration the return to the Style Louis XIV predominated. It is evident, for example, in the Gardemeuble de la Couronne, now the Ministry of Marine (interior decoration 1768–72), e.g. in the heavy geometrical panels on the leaves of the doors and the ceiling of the Galerie Dorée (Plate 282), where the interlaced laurel wreaths also appear again, while Marie-Antoinette's Bedchamber sticks in all essentials, especially in the mirrors, to the *style rocaille*. The reception rooms of the École Militaire, not decorated until 1775 – the work was carried out by Boulanger in accordance with Gabriel's plans – are more uniform. Here, too, the somewhat stiff splendour of the gilded wall panels, mirrors, and pictures, the bracketed cornice and the big coving entirely covered with gold mosaic show a complete return to the Style Louis XIV.

This academic, retrospective tendency also occurs in other works of the sixties and early seventies; among other places, in the Hôtel de Fleury, the Grand Salon of the mint by Antoine, and the château of Belbeuf (1764–79). Even Ledoux followed the Style Louis XIV in the Café Militaire and his early hôtels (Hôtel d'Hallwyl and Hôtel d'Uzès). His large-scale festoons of trophies and arabesques are among the most power-ful and original things produced by the school of Blondel. De Wailly was the man who came closest to the *grand siècle*. His schemes of decoration for the Palazzo Spinola at Genoa (1772), the Chapelle de la Vierge in Saint-Sulpice (1774), and the Chancellerie d'Orléans (1784) testify, with their columns and pilasters, their agitated relief work, their rich gilding, and their interplay of light and shadow, to a Baroque spirit which wanted to conjure up once more the glory of the preceding century.

On the other hand, the return to Antiquity continued among the Parisian intellec-tuals, outside the realm of the Bâtiments. Here, too, the Comte de Caylus was at work in the background. In 1754, on his recommendation, Le Lorrain designed for the dining room of the castle of Åkerö in Sweden a scheme of decoration that may be regarded

as the first neo-classical interior decoration of the century (Plate 283).[133] The wall was here articulated all round by a continuous line of columns, with niches for fountains and statues, all in painted illusionistic architecture. This had nothing to do with Brunetti's illusionistic painting. Here the room was no longer opened up in the Baroque fashion, but closed in. It was not living people that stood in front of the wall, but marble statues. The ornamentation was restricted to rope-like laurel garlands, as found in Le Lorrain's Roman sketches. Two years later came the redecoration and refurnishing of La Live de Jully's famous *cabinet*, for which Le Lorrain designed the furniture. Although the effect of this *cabinet* was so strong that it gave rise to a whole fashion, the new style was nevertheless far from securing general acceptance. At first only individual forms were taken over – fluting, laurel garlands, coffered arches, niches as a form of decoration, bucrania; these fitted in with the previous system of decoration and slowly ousted the curves and scrolls. The best examples of the resulting transitional style, which was often somewhat heavy and overladen, as far removed from Rococo as it was from neo-classicism, are the schemes of decoration designed by Victor Louis and Jean-Louis Prieur (*c.* 1765–6) for Warsaw.[134]

One thing in particular was of great importance in the development of ornament towards neo-classical forms: the activity of Charles Delafosse (1734–89).[135] Delafosse was really an architect, one who in the colossal scale and symbolic content of his designs can be numbered among the architects of the Revolution,[136] but we possess a comprehensive series of engravings by him, the *Nouvelle iconologie historique*, which appeared in 1768 and was followed by a supplementary volume in the early seventies.[137] This book was the first fully illustrated collection of classical ornament ever to be published.[138] Like Neufforge, Delafosse must have had direct contact with the Roman circle round Legeay and Le Lorrain. With Delafosse, as with this group, the heavy, rope-like garland is the favourite motif. But, not surprisingly in view of his architectural turn of mind, all his designs – whether they are for furniture, vases, brackets, or candelabra – have something very heavy about them which hindered their technical execution.[139] They also contained, again like the architecture of the Revolution, a hitherto unparalleled amount of symbolism. Delafosse's brackets and trophies were laden with symbols of the sciences and the seasons, of the virtues and occupations of man, and of geography and history. But the book was a striking success; within three years a new edition was required. Through the multitude of the new forms which he illustrated and the wealth of his imagination, Delafosse provided a tremendous stimulus, which set craftsmen off in a new direction. The *Iconologie* made a decisive contribution to the formation of the Style Louis XVI. In the supplementary volume it is already fully developed. To this extent, Delafosse has the same importance for decoration as Neufforge for architecture.

It is true that the wall system as such was not affected by all this. Here the change only came about under the influence of the second wave of archaeologically trained Roman scholarship-holders, primarily Peyre, Clérisseau, and Lhuillier. We have already spoken about Peyre's influence on Gabriel and his school. When the young Bélanger, Architecte des Menus Plaisirs, about whom more will be said later, was entrusted in 1769 with the construction of a *casino* for the Marquis de Lauraguais, he had called in

as his adviser Clérisseau, who had just returned home from Italy and southern France; and on the latter's advice he had also fetched from Rome the young sculptor Lhuillier, who was likewise a disciple of Piranesi and Winckelmann.[140] In the Pavillon de Laura-guais, the exterior of which also displays classical features, these artists produced a completely new form of wall articulation based strictly on ancient models – especially the temple. The principles of exterior architecture – columns, niches, statues – were transferred for the first time to the interior. Coupled Ionic columns bore the ceiling architrave, and the smoothly continuous wall was interrupted only by niches for figures and by reliefs. All panelling and all picturesque ornamentation had disappeared, except on the ceiling, where heavy garlands, depicted in illusionistic painting, hung before the coffered transverse arches. This kind of articulation, which corresponded with the period's increased interest in archaeology, spread with unusual rapidity. Barré employed it in Le Marais in 1770, Cherpitel in the Hôtel du Châtelet in 1771, and Lhuillier in the Petits Appartements of the Palais Bourbon in 1772–3. Ledoux, who represented the modern tendency at the court, surrounded the dining room of his pavilion at Louve-ciennes (1771) with marble pilasters and relief plaques, and gave the two apse-shaped ends coffered ceilings. Even the old Gabriel bowed to the new fashion. In the Cabinet du Conseil of the Grand Projet at Versailles (1771–2) and the rooms of the little château of Bellevue (1773), he too abandoned the traditional division of the walls into panels.[141] In the Cabinet du Conseil a strict Corinthian order of pilasters ran round the sparingly decorated room; and in the dining room at Bellevue the stone walls were enlivened only by Pajou's statues and reliefs.

The real service that Clérisseau performed was the resurrection of 'grotesque' decoration, which had in fact never completely died out in France. He had become familiar with it in Rome, both in the Baths of Titus and in Raphael's Vatican logge.[142] For Clérisseau, as he said in a letter to the Empress of Russia in 1779, 'grotesques' were an inexhaustible source for the decoration of building and furniture – even clothes – whether in marble, wood, stucco, or colour. They occur already in his Roman drawings. His introduction of them to Paris started a new fashion which found acceptance at once. His decoration of the Hôtel Grimod de la Reynière (c. 1775), in which big panels of grotesques alternated with mirrors, was a tremendous success (Plate 284).[143] Painted grotesques, by another hand, it is true, had already appeared about 1771 in the Hôtel du Châtelet, but Clérisseau had probably already painted grotesques for Bélanger in the Pavillon de Lauraguais. His style was lighter and more vivacious than Le Brun's, but more classical than Bérain's. The tendrils rising in strict symmetry from the floor com-bined with sphinxes and fabulous beasts, and supported smoking sacrificial dishes, jugs, and half-moon-shaped shields. Relief plaques and medallions formed the centres of the compositions. Everything was on a very small scale. The same ornamentation, with the addition of Etruscan and Egyptian motifs, also appears in Piranesi's series of engravings *Diverse maniere d'adornare i cammini* (1769), a copy of which Lhuillier had brought with him to Paris. With these two elements – the return to an architectural kind of division of the wall into large areas and the painted grotesques – the neo-classical system of decoration was complete.

CHAPTER 8

BETWEEN CLASSICISM AND ROMANTICISM

Introduction

THE reign of Louis XVI, Louis XV's grandson, who ascended the throne in 1774, was dominated by two main problems: the complete disorganization of the finances and the administration of justice, and the struggle for a new constitution, in which all the educated people of the age took part. The solution of these problems was of crucial importance to the survival of the monarchy. The task would have made heavy demands even on a monarch of the calibre of Louis XIV; Louis XVI was simply not up to it. He possessed all the ruler's virtues except one – the necessary hardness. Amid the dangerous ferment in France at the end of the eighteenth century, this was a weakness that was bound to prove fatal as soon as it became a question of taking stern measures to preserve order. Moreover, Louis XVI had the misfortune to be married to a woman who was not only incapable of recognizing the greatness of her task but also intrigued against him her whole life long.

The Revolution of 1789 had been in the making for a long time. It did not arise among the common people but out of the interplay of the 'philosophes' with the parliaments and the discontented nobility. The greatest and most dangerous of the king's opponents was Philippe, Duc d'Orléans, who was not only richer than his cousin Louis XVI but also had his residence, the Palais Royal, in the heart of Paris, where all the threads of agitation met. From here he spun his web of conspiracy until it embraced the king's immediate associates – his brother, the Comte de Provence, and the queen, who was in constant contact with the banished Choiseul.

The start of the reign was encouraging. Debts diminished and France's prestige rose as a result of her naval victory over England and of her recognition of the United States. Paris was, as ever, the model for Europe and, like all other cities in the kingdom, involved in a continuous process of embellishment and modernization.[1] The king enjoyed great popularity among the people. But the inner decay had gone too far. The ideas of Voltaire, who ridiculed the existing governmental system and the Catholic religion and its adherents, of Diderot, who denied the existence of God and of any moral concepts and measured human conduct solely by its usefulness to the world around, and of Rousseau, who wanted to do away with private property and social inequality, had been exerting their effect for years and had taken a grip on the whole of educated France. The 'philosophes', as a closely knit group, supported each other; they pursued the aim of a new political and social order, with Voltaire as their idol. The supporters of the existing order, disunited and lacking any inner conviction, had scarcely a chance of conducting a successful resistance. In the Parisian salons, where encyclopedists, aristocrats, and foreigners foregathered, one had only to express horror for absolute monarchy and

praise England with its liberal system in order to be welcomed with open arms. At the first performance of Beaumarchais' *Marriage of Figaro* in 1784, when Parisian society enthusiastically applauded the very ideas which spelled its downfall, rejection of the present with its traditions and abuses and hope of a brighter future burst out in a sort of ecstasy.

To save the state, a general economic and political reform would have been required. The king, who was well aware of the gathering danger, was ready for this, but the privileged classes were not. The assembly of notables convened for this purpose in 1787 rejected all proposals for reform. Then came national bankruptcy and general obstruction by the parliaments. There was no other course left to the king but to call a meeting of the States General, but he could no longer avert the course of destiny. On 23 June 1789, three days after the storming of the Bastille, the Third Estate refused to leave the conference hall at Versailles and declared itself the National Assembly with unimpeachable powers. This was the start of a tragedy that ended with the execution of the king in 1793. Contrary to all the expectations raised by talk of loving one's neighbour and a republic of philosophers, the *ancien régime* collapsed in a welter of blood and tears.

The new intellectual atmosphere which pervaded the country could not fail to affect architecture as well. If the appearance of Laugier had already called into question the old criteria, the new philosophical and social ideas which produced the Revolution were bound to lead to a completely new evaluation of the principles of architecture. Orders and proportions lost their validity when architecture became the expression of emotion or an integral part of a new social order. Architects no longer contented themselves with making their buildings representative of the state, the kingdom, or a particular social class: they strove to create memorials, and monuments of sublimity and moral uplift. They thus put themselves at the service of philosophy and morality, that is, non-artistic principles. Architecture's previous terms of reference were cast aside. The end of the century strove to pass beyond recognized models into new dimensions which heralded a new age. Beside Rome and Greece stood Ledoux's city gates of Paris, symbols of a capital of a size never seen before, and the pyramids, the spherical buildings, and the cyclopean walls of a new race that explored the paths of the stars. Architecture became programme architecture and it became subjective, the creation of genius. That put it in touch with Romanticism. Desprez' theatre decorations of the eighties contain motifs that may be regarded as immediate forerunners of Caspar David Friedrich; Lequeu's design for a castle by the sea is the spiritual harbinger of Blechen's Hamburg painting, *Kastell am Meer*. It is the Romantic spirit and the historicism bound up with it, the inclusion of art in the growth and decay of nature, that distinguishes the so-called Revolutionary Architecture of the end of the eighteenth century from the continuing classicism.

But even here, in the imitation of Antiquity, there was a change of emphasis. The early, archaic period replaced the Roman imperial age as the main centre of interest. Trips to Paestum, Segesta, and Agrigentum grew frequent.[2] People took note with amazement of Doric columns without bases and of the heavy, clumsy proportions of the early Greek temples, which by no means corresponded to the teachings of Vitruvius. However, in spite of the enthusiasm for Greece and the lasting effect of Le Roy's engravings

of Greek temples, it was about twenty years before the Doric column was fully accepted.[3] Ledoux was the first to employ it in its archaic form without a base – in 1778, in his theatre at Besançon, the most famous example of the early Doric style in France. Cherpitel had also planned to use columns of this sort as supports in the nave of the new church of Saint-Pierre du Gros Caillou in 1775, but his design was not executed.

But more important for France – as opposed to England and Germany – was the unfluted Tuscan column as advocated by Piranesi. In Piranesi's eyes the Etruscans were the older civilization and the teachers of the Greeks; the huge walls of the period, the heavy vaulting, and even the smooth Tuscan columns without bases all belonged to them. This view, expounded in the *Magnificenza ed architettura de' Romani* (1761), was sharply opposed by Mariette and Le Roy, who were in a position to know the facts; but Piranesi did not abandon his standpoint. In his *Parere sull'architettura* (1765) he rejected Mariette's arguments and made fun of the 'Grecians'' purism and Winckelmann's whole theory.[4] It was due to Piranesi's strong influence on the Académie de France's scholarship-holders in Rome that they, and thus the younger generation in France, continued to regard Etruscan architecture as characteristic of archaic, i.e. republican Rome. And since people considered the Roman Republic the glorious model of all the civic virtues they wanted to see in their own state, it also provided the model for the new architecture. The squat Tuscan column without a base became the fashion, together with cyclopean walls, heavy cornices, and a system of ornamentation based on that of Etruscan funeral vases. After Soufflot had employed it, with a still correct appreciation of its function, in his grotto at Ménars (1770), it was once again Ledoux who introduced it in a public place in 1774 in his gateway for the Saline de Chaux (Arc-et-Senans). He was followed about 1778 by de Wailly, who used it in the interiors of private houses,[5] and in 1780 by Bélanger and Brongniart, who used it in the Comte d'Artois' stables (now the Hôpital Cochin) and the courtyard of the Couvent des Capucins respectively. It even became the expression of a political attitude. In J.-L. David's *Serment des Horaces* (1784) (Plate 198) (cf. p. 193) it signified, together with the oath-scene depicted, a political programme.[6] The Rue des Colonnes in Paris was constructed by Poyet in 1798 under the Roman-Republican-minded Consulat.

But the imitation of Antiquity no longer satisfied the generation of the Revolution. Interest in alien civilizations had already been part and parcel of the Enlightenment. With the awakening of Romanticism, it was given a literary and scientific foundation, especially as knowledge of foreign countries had grown considerably wider during the course of the eighteenth century. China and Egypt took first place. Blondel was already complaining in 1772, in his *Cours d'architecture*, that Chinese fashions were being imitated on the inside of buildings and the heavy forms of Memphis on the outside.[7] Chinoiserie, introduced into France in the seventeenth century – the most important examples are the Trianon de Porcelaine at Versailles and the Trèfle at Lunéville – had been given a powerful impetus by the publications of Chambers, Le Rouge, and the French Jesuits in China, and by the importation from England of the Chinese garden.[8] Until then Chinese forms had been only an exotic disguise; now, with the appearance of regular books of model designs, they came to constitute a clearly defined, independent style which anyone

could learn. At the end of the eighteenth century there was no park of any importance which did not contain Chinese pagodas, pavilions, or bridges.[9]

It was much the same with Egypt. The first wave of the fashion for things Egyptian was concerned primarily with decoration. It started from Rome, where obelisks, sphinxes, and hieroglyphs had long been known.[10] There they came to the notice of the French Académie's scholars, with the result that as early as 1752 Bellicard was able to do an engraving of an Egyptian temple with hieroglyphs for the title page of Blondel's *Architecture française*. In 1769 Piranesi published his *Diverse maniere d'adornare i cammini*, in which he made the public acquainted for the first time with a wide selection of Egyptian sculptural and decorative motifs. Egyptian architecture had already been discovered and described shortly before by Norden and Pococke on their journeys of exploration.[11] Their excellently illustrated accounts were the standard works till the appearance in 1802 of Denon's *Voyages dans la basse et la haute Egypte*. With their publication, sphinxes, obelisks, and pyramids – whether in Baroque or Romantic attire – moved into French parks. On the other hand, the recognition of Egyptian art as a style with its own laws was the meritorious achievement of the Comte de Caylus, already mentioned several times before. To him, the Egyptians were a wise and enlightened people, in comparison with whose stern and massive buildings the temples of the Greeks were bound to seem like finely decked-out houses of cards.[12] This view was reflected in the work of the young Rome scholars, who in any case had already been gripped by the enthusiasm for the colossal. The drawings of Egyptian tombs made in Rome (about 1780)[13] by J.-L. Desprez are the first example we possess of the incorporation of Egyptian concepts of form in Revolutionary Architecture's mode of thinking. It was precisely Egyptian architecture – whether in the specific form of the pyramids or in the more general form of its massive, quite unclassical proportions – that Boullée and Ledoux called upon in their boldest designs, rightly recognizing its monumental and primitive qualities. However in the eighties, when these designs were produced, the most important theoretical work on the subject had already been written; this was the young Quatremère de Quincy's prize essay, *De l'architecture égyptienne, considérée dans son origine, ses principes et son goût, et comparée sous les mêmes rapports à l'architecture grecque*.[14] His observations on the unbroken monotony of the surfaces and the colossal scale and extravagant solidity of Egyptian buildings were illustrated precisely in the architectural fantasies of the period.

Alongside these two main tendencies the most various exotic and historical styles blossomed out. Turkish, Tartar, Gothic, and classical buildings were set beside each other without a second thought.[15] There were even houses, such as the Vauxhall in the Boulevard Saint-Martin, which had a classical façade in front and a Gothic one at the back, and houses with roof gardens sporting pyramids, ancient ruins, and Chinese bridges. Historicism flowered for the first time, even though a strict neo-classicist like Soufflot resisted this fashion.

An ideal background for this indiscriminate mixture of styles was provided by an import from England, the landscape garden, which had made its first appearance in France at Ermenonville (1766–76).[16] The aim of these landscape gardens with their temples of philosophy, their tombs, grottoes, and artificial ruins – they even penetrated

into towns – was education, moral uplift, and the stimulation of emotion.[17] This aim was met by culling features from native and foreign styles and assembling them in one spot. But the decisive factor was not so much archaeological exactitude as emotional value, the link with ever-changing nature, with the past. The symbol of the past was the ruin. The sight of it awoke romantic feelings. The huge, fluted stump of a column in the Désert de Retz (1771), which the anglophile Chevalier Racine de Monville erected as a house in the midst of a sentimentally landscaped park, may be regarded as the most complete combination of classical and romantic feeling.

The obsession with time and transience, the longing for the good and true embodied in nature, constituted the opposite pole to the heroic atmosphere of the Revolutionary age. Both elements, the heaven-storming architectural fantasies as well as the sentimental landscape gardens, are part of the romanticism that disputed the leadership with classicism in France in the last quarter of the century.[18]

The Art of the Court

Under Louis XVI the court once more gave up the leadership in architecture. Even under Louis XV, who enjoyed building, the state's growing debts had already brought building almost completely to a stop. The money was lacking everywhere. At Choisy, the king's favourite creation, the workmen even ran away; the ladders for picking the cherries could no longer be repaired. Under his successor this became the normal state of affairs. The king made no personal demands and had no interest in representation. Marigny had already resignedly said farewell in 1773. Gabriel retired from his post in 1775.[19] With his departure, the great age of the Bâtiments came to an end. His successor as Premier Architecte, Richard Mique (1728–94),[20] who had filled Héré's post at Nancy till the death of King Stanislas and whose gift for decoration had already been displayed in the Couvent de la Reine at Versailles (1768–72), was not of the same stature. In addition, the authoritarian d'Angiviller, who became Director General in 1775 after the brief reign of Abbé Terray, carried out a general reorganization of the Bâtiments (1776) and split Mique's post into three. There were now three Intendants General, of whom Mique was only one, though he took precedence over the other two – the much older Soufflot, annoyed at being passed over, and the insignificant Hazon. Important decisions were now taken by a committee of three, not by one individual. Mique's independence was cut down on every side; even as Premier Architecte de la Reine he was finally (in 1777) made directly subordinate to the Director General. But d'Angiviller came to grief, just as his predecessor had done, on the shortage of money. In 1779 he had finally to abandon his plans to clear the Louvre and install a museum in it. His relations with the Académie, another institution which he tried to reform, also remained tense as a result of his clumsy and arrogant behaviour.

Compiègne was the only one of the royal residences on which work continued up to the end of the monarchy. One must visit this château, the king's favourite, in order to form any accurate idea of the official architecture of the court of Louis XVI.[21] Here Gabriel's ideas lived on. The great orders of fluted pilasters, the delicate classical

profiles, even the swing of the main staircase were the same, but the walls had become bare; they did not achieve the classical elegance of Bélanger or Pâris. Sculpture formed the only decoration – reliefs in the living rooms, and a huge entablature with plumed helmets in place of triglyphs and a big three-dimensional group on top of the entrance door of the Salle des Gardes (1784) – but everything is austere and as though created for a race of heroes. Here the Empire could follow on without a break.

At Versailles itself, however, apart from decoration, the reign of Louis XVI has left few visible traces. The interior alterations which the king and queen made for their own benefit round the inner courtyards of the château – the rooms known as the 'Cabinets' or 'Petits Appartements' – tell us a good deal about the habits and interests of the sovereign but are of no architectural consequence.[22] This gives all the more importance to the plans drawn up in connexion with the Grand Projet. Gabriel's design, on which work was at first continued, though without much enthusiasm, did not get further than the Aile Neuve or Aile Gabriel.[23] A new design produced by Mique in 1776 brought no essential changes.[24] However, d'Angiviller, who wanted to crown his career with the rebuilding of Versailles, and the queen, who did not feel that sufficient attention had been paid to her own wishes in Gabriel's plan, pressed the king to undertake a complete reconstruction, in which only Mansart's garden façade, the north side containing the Grands Appartements, and the chapel were to be left intact. In 1780 a competition was announced, the biggest that Europe could offer at that time.[25] As on the occasion of the competition for the Place Louis XV, the most renowned architects of the age – Boullée, Peyre the Elder, Peyre the Younger, Le Roy, Potain, Heurtier, Huvé, Darnaudin, Pâris – all handed in their proposals. They are among the most splendid château designs of the century, in spite of the Utopian dimensions which they all display. A comparison with Fischer von Erlach's designs for Schönbrunn, for Frederick I of Prussia, and for Nero's house makes clear the surprising parallels between the megalomania of the Baroque at its zenith and that of early classicism, before the latter began to prefer isolated blocks. Behind them, too, still lay the Baroque idea of the architectural group. Some of the designs envisaged a considerable lengthening of the garden façade, with pavilions even jutting out far into the garden (such was Boullée's plan) (Plate 285), while others proposed enclosing the Place d'Armes with barracks or with colonnades like Bernini's (this was Peyre's suggestion, for example). However, they all brought the courtyard façade forward to the line of the Salon d'Hercule and the present Galerie des Batailles, and replaced the Cour de Marbre and the Cour Royale with several big courtyards adjacent to each other. The design finally chosen was that of Adrien Pâris. It had the advantage of leaving the garden façade almost intact and of reserving the central part of the palace for two complete apartments – one for the king on the right and one for the queen on the left. These ran round two courtyards separated by the Grand Staircase. As in the Place Louis XV, the front was dominated by an unbroken giant order of Corinthian columns on a rusticated base. In the middle section this was out-topped by an attic storey, in the projecting wings – Pâris gave the widened Aile Gabriel a counterpart on the left – only by stone figures. The Place d'Armes, framed by semicircular barracks for the guards and enlivened by obelisks and fountains, formed the gigantic

outer courtyard to the columned façades of the palace. The whole design was a brilliant mixture of classical and Baroque, as they were known from the sketches of the Rome scholars.[26] Since the financial position of the state made the execution of this design unthinkable, it was put by for better times, which were never to come. Thus fundamentally it was the Revolution which, contrary to Louis XVI's plans for rebuilding, ensured the survival of Louis XIV's château to our day.

However, the style at the court was determined less by the king than by the queen. It is to her that we owe the development of the Petit Trianon, where she created a kingdom of her own. She was also responsible for the so-called 'Baraques de Versailles', ephemeral wooden structures for balls and theatrical performances which at carnival time disfigured the Cour Royale from 1785 onwards and the façade of the south wing from 1787 onwards.[27] These Baraques, basically a traditional court arrangement for garden parties and functions involving temporary collections of tents, are known to us only from plans and drawings; they were not the work of Mique, but of the royal draughtsman, Pâris. They are interesting in that they reflect the last phase of neo-classicism at the court. Pierre-Adrien Pâris (1745–1819), a pupil of Trouard and a member of the Académie,[28] had spent three years in Italy, although he had not won the Prix de Rome. There he had devoted himself so enthusiastically to the study of Antiquity that in technical circles he was regarded as the best antiquarian in Rome. This focused attention on him when he returned to France in 1774, for the interest in archaeology was general at that time in Paris, and opened the way for him to the highest positions. His decorations for the Duc d'Aumont in the latter's Parisian mansion (now the Hôtel de Crillon) procured him in 1778 the post of royal draughtsman and 'Architecte des Menus Plaisirs', the man responsible not only for the organization of royal funerals but also for theatrical and festival decorations at the court. Here Pâris gave full play to his archaeological knowledge. Both in the Baraques and in the scenery for the theatre there appeared vistas of columns, triumphal arches, coffered ceilings, acanthus friezes, statues, and reliefs, all softened, however, by festoons of flowers, mirrors of unusual size, elaborate chandeliers, bellying expanses of material, and an exceptional elegance of form which had already been noticeable in the Hôtel d'Aumont. The great ballroom of 1787, encircled by Doric columns without bases and illuminated by a tent-shaped skylight in the heavy coffered ceiling and two basket-arch-shaped openings in the ends, was more austere. Its bare walls were broken up only by the boxes of the spectators and by isolated reliefs. This room served both for the assembly of notables in 1787 and also, in a slightly altered form, for the sitting of the States General in 1789. On the latter occasion a throne under a baldacchino was erected in the opening for a stage at one end.

Pâris's designs for the town hall at Neuchâtel (1784–90) are of the same classical severity. The columned pediments and the bare expanses of wall with their window openings are reminiscent of Peyre, while the vestibule with its Doric columns recalls contemporaneous work by Ledoux, who had also been invited to submit designs here.[29]

At the Petit Trianon, where Mique was active on the queen's behalf and the shadow of the past lay less heavily over her, the year 1778 saw the erection of a little theatre, a

miniature version of the Versailles opera in form and colour, and also of some pieces of garden architecture: the Temple de l'Amour, a domed rotunda with a marble statue by Bouchardon (cf. p. 60),[30] and the Salon de Rocher, an octagonal belvedere – suggested by Chambers' Temple of Solitude at Kew – above the rocky bank of an artificial lake (1778–9). Opposite these creations, which are in a delicate Grecian Louis XVI style continuing the best traditions of Gabriel, stands, as a piece of romantic scenery, the 'Hameau' (1783–5), a model village of imitation farmhouses arranged round an artificial lake dominated by the lighthouse-like Tour de Marlborough. Marie-Antoinette was here following the fashion of the age, which preached, under the influence of Rousseau, the return to nature and to the simple life. Instead of the exotic fancies of the society around her – Chinese pavilions,[31] Turkish minarets, or Tartar villages – she chose a Norman village, the picturesque, thatched, timber-framed houses of which both ministered to her own needs and country tastes and also sheltered cattle and genuine farmers. Her models were the Hameau of the Prince de Condé at Chantilly (1774–5) and that of her aunts, Louis XV's daughters, at Bellevue (1779). As there, crumbling roughcast and rustic attire hid refined luxury inside, and, as there, the ballroom was housed in a barn. The charm consisted in the contrast between a real life and one that was a game, between courtly etiquette and personal spontaneity.

This combination of classical antiquity and Rousseauesque enthusiasm for nature, still imperfect at Trianon, was finally achieved in the queen's 'Laiterie' (dairy) at Rambouillet (1785–8).[32] This very remarkable building, which in accordance with the fashion of the period was to serve the queen and her ladies for drinking milk and for making butter and cheese, contains, like the dairies at Trianon, Chantilly, and elsewhere, two rooms – a big, domed rotunda, where the earthenware vessels for the milk stood on marble benches running all round the wall, and a rectangular room behind ending in a huge rocky grotto with water streaming down it. This building combined the bucolic atmosphere of Daphnis and Chloe, the notion of Arcadian pastoral bliss and the virtuous, natural life – as expressed in the rich relief decoration of the walls and niches[33] and by the marble group in the grotto of a nymph, Amalthea, with her goat – with the forms of a strict imitation of Antiquity. The various designs of the architect, Thévenin, a protégé of d'Angiviller, reveal the development of taste from the subtle classicism of the Style Louis XVI to the emphatic, block-like severity and sobriety of the architecture of the Revolution. But the general idea went back – as it did with much of this garden architecture – both here and at the Trianon to a painter, Piranesi's pupil, Hubert Robert (cf. p. 182). Here the influence of Romanticism made itself felt again. It was the painter, not the architect, who determined the site and the appearance of the temple.

Neo-Classicism in Public and Private Buildings

In the last quarter of the eighteenth century the real leadership in civic architecture had been assumed by Paris. The appearance of the capital altered visibly the more it expanded to the north and north-west.[34] Classicism and Palladianism dominated here not only individual façades but whole streets; in the new districts one might have thought that

one had been transported to Vicenza. Triangular pediments resting on heavy brackets, columned portals and windows cut smoothly in the bare walls, as preached by Peyre, appeared on blocks of flats and mansions. The danger of uniformity lay near at hand, but was averted by the multitude of different currents flowing within neo-classicism. The relationship of each architect to Antiquity, to Palladio, to the Style Gabriel or the tradition of Blondel determined the character and style of his work

Gabriel's line was continued most consistently by Chalgrin and Antoine. Jean-François Chalgrin (1739–1811),[35] a pupil of Boullée and Servandoni, had collaborated, as architect of the city of Paris, on the Hôtel Saint-Florentin. He clung fast to Gabriel's terse, accentuated repertoire of forms and polished elegance, though in strict imitation of Antiquity, which he had studied at first hand during his four years (1759–63) as a scholarship-holder in Rome. Chalgrin was active both for lay and ecclesiastical patrons. Apart from Saint-Philippe du Roule, his masterpiece in the field of church architecture, he worked on Servandoni's façade and Maclaurin's north tower for Saint-Sulpice (1777–80), thereby giving this originally Baroque building a neo-classical stamp. Of his secular buildings, the one most worthy of mention is the Collège de France, the main hall of which, the Salle des Actes, comes near to the interior of Saint-Philippe du Roule in its irreproachably classical purity. He was also Premier Architecte to Monsieur. In this capacity he erected, in the midst of a park full of garden pavilions, the captivating Pavillon de Madame at Versailles (1784). The plan of this pavilion lies like a Greek cross round a circular central room painted to look like a garden temple.[36]

Antoine made his reputation with another important building in the Cité – the Palais de Justice (1776–85), the rebuilding of which after a destructive fire was entrusted to him as Couture's successor in 1778. In the alterations and additions to Couture's design – the dome with the attic figures on the columns of the portico, the low wings at each side – the last phase of the Style Gabriel survives unchanged.[37]

Peyre, on the other hand, remained an admirer of ancient Rome. After the collapse of his plans for the Hôtel de Conti, the Théâtre Français, now known as the Odéon, became his chief work (1778–82).[38] The first plans went back to the year 1767, when Soufflot, who was at first meant to receive the commission and had already delivered a design, finally declined it.[39] The rectangular block with its pyramid-shaped roof and ground floor surrounded by galleries (Plate 286), the unframed openings in the bare, rusticated walls, and the eight-column portico with its balustrade, correspond with the *Œuvres d'architecture* and the archaeological approach of its author. Yet a remnant of Baroque feeling was still perceptible in the connecting arches that linked the two blocks of houses across the street at each side with the dominating, pyramid-like central building. Inside, for the first time in Paris, the horseshoe-shaped auditorium[40] is approached by a monumental double staircase, which recalls, in its arrangements of columns and domed central octagon, Antoine's mint.[41]

Charles de Wailly (1730–98), who collaborated with Peyre on the Odéon, was primarily responsible for the interior decoration. Here, as in the rest of his work, a tendency, nourished by the Baroque and late Antiquity, to eclecticism and the decorative formed a contrast to Peyre's stricter approach.[42] His supplementary and often publicized

design of 1786, too, which imposed on Peyre's severe façade a triple group of pediments – with niches for statues, reliefs, and a Palladian arch opening divided into three in the middle – was a compilation of Antique and Renaissance motifs which looked rather odd on the classical portico.

Jacques Gondoin (1737–1818), too, was one of the radical exponents of neo-classicism. The son of a gardener at Choisy, Gondoin had been sent to Rome for five years (1761–6) under the personal protection of the king and was given the post of a court furniture designer ('dessinateur du mobilier de la couronne'). His École de Chirurgie (1771–6) is a landmark.[43] It introduced a new phase of the *style grec* (Plate 287). Gondoin saw this centre of medical learning as a temple of Aesculapius. In front of the heart of the building – the semicircular anatomy lecture theatre, with a coffered vault and an open skylight – he placed a hexastyle temple front with a columned forecourt opening on to the street through a narrow double colonnade. His aim here, apart from harking back to ancient buildings, especially the peristyles of Pompeii and Stabiae, was to make the courtyard, which was too shallow owing to the limitations of the site, look bigger, and to give a better effect to the huge columned portico in the background.[44]

In this building Gondoin wanted to realize his conception of 'Greek architecture', which he saw as contrast, symmetry, and simplicity. The contrasts lay above all in the proportions of the street façade[45] and in the relationship of the temple front in the court-yard to the low columned galleries that ran round it; the symmetry lay in the organiza-tion of the space; and the simplicity in the absence of ornament in the interior. What was novel was the smoothly continuous street front, which did not advance or retreat at all and was free from any mouldings. Not only were previously accepted proportions abandoned here; 'convenance' and 'symmétrie' were replaced by contrast, and natural limits by an endless sequence. The organization of the interior was a triumph of rational-ism. The centre was the semicircular anatomy lecture room. To each side lay special lecture rooms, sick bays for men and women, a chemical laboratory, a chapel, and so on. The library was situated over the entrance, on the first floor. These arrangements were novel and at the same time convincing. For this reason, and in spite of the positively shocking abandonment of every tradition, the École de Chirurgie was accepted at once by all the leading critics, including even Blondel. It is true that it only formed part of a bigger plan, which envisaged, according to Gondoin's design of 1771, a monumental square framed by the massive ashlar wall of the debtors' prison – (a dissolved Franciscan monastery), the severe Doric portico of the shortened church of Saint-Côme, and the colonnade front, already described, of the École de Chirurgie. The refusal of the Fran-ciscans to give up their church frustrated this plan[46] and thus caused the loss of a unique opportunity to create a square in the strict neo-classical style right in the heart of Paris.

The most dazzling careers in the reign of Louis XVI were reserved for two architects who, though differing intrinsically from each other, managed through talent and versa-tility to force their way into the highest circles of society. These two were Victor Louis and François-Joseph Bélanger. Louis put his stamp mainly on public architecture; Bélanger was famed for his folies and his buildings for the nobility. Both, in spite of a difference of thirteen years between their ages, were active at about the same time.

Louis personified the first phase of enthusiasm for Antiquity, the one moulded by Caylus and Neufforge; Bélanger represented the second phase, the one inspired by archaeology. Yet their styles were far removed from any rigid dogmatism and fused so completely with the native French tradition that in Louis one can observe the building habits of the eighteenth century running on without a break right up to the end of the century.

Through his arrogance as a scholarship-holder in Rome, Victor Louis (1731–c. 1795) had forfeited the favour of Marigny and thrown away his chance of entering the Bâtiments. Nevertheless, he showed masterly skill in exploiting all the social possibilities of his time – the Parisian salons, the freemasons, the clergy – for the benefit of his career and in always finding the right patrons. As a result, in the end he far exceeded the court architects in importance.[47] Through the famous salon of Madame Geoffrin he came into contact at the age of twenty-three with Stanislas Poniatowski, the last King of Poland, who at that time had big plans for his palace in Warsaw. At Poniatowski's invitation he spent a short time in Warsaw in 1765 and made a series of designs for the reconstruction of the palace. These designs reflected ideas of Piranesi and Peyre.[48] Although his relations with the king broke down soon after this and none of his plans was carried out, they nevertheless formed an important basis for his later work, especially for Besançon and the theatre at Bordeaux.

His student years in Rome had awoken in Louis a tendency to the grandiose and to Baroque effects that was to accompany him throughout the rest of his life.[49] A taste for the theatrical was also innate in him. In 1763 he had created the decorations for the peace celebrations at the Théâtre Italien, and, as a follow-up, he had built the Vauxhall in the Boulevard Saint-Martin (inaugurated in 1770). This Baroque tendency was perceptible in all his work. It is already apparent in a youthful work, still preserved, the Holy Souls' Chapel of Sainte-Marguerite (c. 1764), in which he had a complete scheme of illusionistic architecture, in the form of an ancient basilica with engaged marble columns and reliefs, painted by Brunetti.[50]

Owing to the collapse of the plans for the palace at Warsaw, plans in which the neoclassical spirit of the new generation emerged clearly – especially in the Salle du Sénat of 1765 – the governor's residence (now the prefecture) at Besançon (1770–8) is the earliest visible evidence of Louis' attitude to Antiquity.[51] A Roman triumphal arch leads into the semicircular cour d'honneur. The courtyard façade is articulated by a giant order extending right across it; the middle section, with its six Ionic half-columns and pediment, resembles a Roman temple front. The giant order continues at the back, with coupled pilasters on the semicircular middle section, which curves out as in the Warsaw designs, and single pilasters on the wings. On the other hand, the big windows in both façades – they are almost a negation of the wall – and the delicately graduated profiles of their surrounds are a clear legacy of the Style Louis XV and the school of Blondel. The interior, too, combines classical components and cool severity of line with a traditional, thoroughly French articulation of the walls.

While Nicolas Nicole supervised the execution of the plans at Besançon, Louis was already busy in Bordeaux on his most famous building, the theatre (1772–88).[52] The Bordeaux theatre is really a group of three units: the concert hall, the staircase, and the

theatre auditorium and stage. Louis linked them together in such a way as to produce a grandiose cumulative effect. The main accent is provided by the staircase, situated at the end of the low vestibule (Plate 288). The broad stairs first run up to a front wall articulated by niches for figures and lead through a caryatid doorway, already pre-figured at Warsaw, straight out into the stalls. Splitting up in front of the doorway, they then lead on in two flights to the upper side galleries, which open, through columns, towards the middle, and form the link between the concert hall and the theatre.[53] Over the staircase hall arches a tent-like dome, behind whose thin-ribbed springers an upper gallery runs and little relieving domes become visible. The auditorium itself is encircled by a giant order of columns. Here, too, the dome rests, in a complicated system of vault-ing, on four shallow crossing arches and is supported by semi-domes treated like tents. This system of domes over the staircase and auditorium was a technical masterpiece, inconceivable without knowledge of Soufflot's vaulting in the Panthéon.[54]

Outside, the building is characterized by the long, unpedimented portico on the entrance side, a feature inspired by the portico of Potain's theatre design of 1763. Neuf-forge had published porticoes of this sort for the first time in 1765.

The theatre at Bordeaux must be considered a conscious rival to Gabriel's opera house at Versailles, built only a few years earlier. In its spatial effects and technical innovations it was far superior to this building. It is no wonder that until Garnier built the Paris Opéra it was accepted as the model for modern theatre-building.

Freemasonry helped Louis to obtain his next big commission. Through the Duc d'Orléans, whose acquaintance he had made at a masonic gathering in Bordeaux, he was called to Paris and entrusted with enclosing the garden behind the Palais Royal (1781-4).[55] His solution of the façade problem there followed the lines of Besançon. It provided in several sketches for a continuous line of giant Corinthian pilasters, behind which the ground floor opens up in arcades. The constant repetition of this stage-like architecture, strengthened by the strong shadow cast by the balustrade that topped it, gives the façade unity; any suggestion of monotony is avoided by the rich decoration based on that of the Roman imperial age.

The continuous giant order, which may be regarded as the most important recurring element in Louis' compositions,[56] also appears in the designs for the semicircular Place Ludovise in Bordeaux (1784), the last Place Royale to be laid out in France, only one of whose fourteen houses linked by triumphal arches was ever actually built – owing to the chronic lack of money.[57] The continuous giant order also occurs in another prominent place, the château of Saverne (Zabern).[58] This splendid building, which is closely related to the garden buildings of the Palais Royal, is the work of Nicolas Salins (1753-1839), then twenty-six years old, who came from Paris but worked in Strasbourg. Later on he called himself Salins de Montfort.[59] Cardinal Rohan, Bishop of Strasbourg, well known for his part in the affair of the diamond necklace, commissioned Salins to build a new palace during the years 1779-89 to replace the old one which had been burnt down. In the wide garden façade (Plate 289) Louis' order of pilasters is fused with Ledoux' design for the façade of the château of Louveciennes – a splendid proof of what could be done with Neufforge's arid patterns.[60]

339

Louis had to scrap his plans when the duke changed his intentions and wanted a radical reconstruction of the Palais Royal itself.[61] This envisaged, in connexion with the enclosure of the garden, a complete reversal of the palace, with a huge columned façade facing the garden and a central dome. Louis contented himself with doubling Contant's courtyard façade and with putting up one-storey galleries round the Cour Royale and an open colonnade to complete the courtyard on the garden side (1786). The theatre adjoining the palace to the west, the present Comédie Francaise (1787–90), which he built for the duke in place of the old Galerie d'Énée, now sacrificed, displays some of the characteristics of the Bordeaux theatre. However, its unfortunate proportions and the narrowness of the street front make the façade look mean. On the other hand, from a technical point of view the construction of the interior shows Louis as a daring innovator. The bold use he made of cast iron was totally novel and became immensely influential. There is not room here to discuss Louis' innumerable other commissions – châteaux, churches, theatres, private houses in Bordeaux, and decoration of all kinds.[62]

In comparison with Louis, François-Joseph Bélanger (1744–1818) appears more modern.[63] It is characteristic of him that when, after studying with Le Roy and Contant d'Ivry, he failed to gain the Prix de Rome, he went to England for two years (1765). In 1767 he became, as Challe's assistant, Dessinateur des Menus Plaisirs, in 1770 Monsieur's building superintendent, and in 1777 Premier Architecte of the Comte d'Artois. His versatility enabled him to express himself in the most varied styles – in the forms of a courtly Style Louis XVI influenced by Gabriel and the early Ledoux, in the Palladian manner, in the strict antique fashion – and made him one of the most popular architects of the last few years of the *ancien régime*. He achieved his first success with the Pavillon de Lauraguais (1769), to which he gave, with the help of Clérisseau, just back from Rome, and of Lhuillier, who had also had an archaeological training, an antique character. In 1773 he designed for the opera singer Sophie Arnould a house in the Palladian style, which, as a temple of Euterpe, was to form a counterpart to Ledoux' mansion for the dancer Guimard – the temple of Terpsichore. For Lord Shelburne's town house in London he built a gallery combining imitation of Antiquity with the pathos of the early Style Louis XIV. He also collaborated on landscape gardens, for example on the group of garden buildings in the classical style at Méréville (now at Jeurre) which were based on designs by Hubert Robert. But he was mostly occupied with work for the Comte d'Artois – with his stables at Versailles and in Paris (*c.* 1780), with alterations to the château of Maisons (1777–84), with the plans for a gigantic rebuilding of the château of Saint-Germain, and also with the spectacular Bagatelle (1777).[64] This graceful pavilion, built – thanks to a bet with Marie-Antoinette – within the space of sixty-four days, is not only an example of Bélanger's incredibly confident approach to both design and execution, but also an example of a princely folly in the late Louis XVI style just outside the very gates of the capital (Plate 290). It is less extravagant than Ledoux' pavilion at Louveciennes, but just as refined in plan and interior organization. On an almost square site – the only projection is the round garden room, an indispensable requisite for a little château of this sort – everything necessary for an elegant week-end house is combined: circular salon, dining room, billiard room – these two are oval – two boudoirs on the

ground floor and two further bedrooms on the upper floor. In accordance with the new fashion the staircase is situated in the centre of the house, between the hall and the garden room. This pavilion formed part of an axis of courtyards, lawns, and domestic buildings, of which the ones opposite the front swung out in a semicircle in the Palladian style. The smooth walls with their niches, the smoothly incised windows, and the attic reliefs were reminiscent of Peyre, while the sphinxes before the door recalled the influence of Piranesi. For the garden, however, the prince called in the Scottish gardener Blaikie, a step which smoothed the way for English influence in Paris.

For a rich and empty-headed neighbour of the prince, rendered sleepless by this *tour de force*, Bélanger erected shortly afterwards the even more luxurious Folie Saint-James.[65] Here, in the veranda-like outbuilding on the garden side, he employed for the first time a row of columns carrying arches, which, being both an ancient Roman and a Renaissance motif, was soon to become common. After the Revolution and the death of his patrons, Bélanger devoted himself to public building and took part in many competitions, without achieving much success. The symbolism and the unadorned heaviness of his forms in the designs for these competitions connect him with the current of revolutionary architecture. His only really important work was the dome of the Halle au Blé, erected in 1808–11 as a replacement for the wooden dome by Legrand and Molinos.[66] This had been destroyed by fire; Bélanger therefore used cast-iron ribs tied by wrought-iron rings. It was the first iron dome ever. This system, admittedly preceded by bridges in England, Germany, and America, marked an epoch in French iron construction. The dome, combining neutralization of pressures, lightness, and transparency, was, as it were, the crowning of Soufflot's and the neo-classicists' efforts to re-establish Gothic vaulting techniques. Fontaine called the dome of the Halle au Blé the most important work of the era of Napoleon. When the Bourbons returned Bélanger assumed his old court offices again, but did not make any further influential contribution to architecture.

Finally, a word must be said about Parisian hôtels. Never since the Régence had the private mansion possessed so much importance as now, when the nobility and the big financiers were spending money liberally and the capital had wrested the intellectual and political leadership from Versailles. The man who set the tone here, together with Bélanger, was Alexandre-Théodore Brongniart (1739–1813), Gabriel's successor as director of building operations at the École Militaire and one of the few fashionable architects who had not been in Rome.[67] At first, therefore, he practised a discreet, somewhat theoretical Palladianism tailored to suit the wishes of his patrons. His buildings, of which the Hôtel de Monaco (1774), the Hôtel de Condé (1781), and the Hôtel de Masseran (1787) are still standing, are distinguished by their strict pilaster articulation both outside and inside. From Palladio he also took over the round and oval staircase wells in the central axis of his buildings, as for example in the Hôtel de Saint-Foix (1775). On the other hand, the lasting influence of his teacher, Blondel, is evident in his plans and in the proportions of his façades.[68] It was only in the new building for the Couvent des Capucins (1780), now the Lycée Hoche, where he did not need to pay any attention to conventional forms, that he finally managed to link up with the fashion for the strict imitation of Antiquity. Here he suddenly appears as the disciple of Boullée, who demanded in his *Essai sur l'art*

that architects should draw inspiration from newly erected buildings and awaken in people's hearts the emotions appropriate to a building's purpose. The novel element in this monastery is the asymmetrical, subordinate position of the church, which, contrary to all tradition, features only as the left-hand pavilion of the façade (Plate 291). The coldness of the forms is new, too. Except for a few niches for figures and the two big reliefs by Clodion (cf. p. 161), the façade is completely bare. The cloister situated in the middle, like an ancient atrium, is surrounded by heavy Tuscan columns without bases. In its severity and uncompromising character, the Couvent des Capucins corresponds with Gondoin's plans for the square in front of the École de Chirurgie.

Something of this sobriety also clings to Brongniart's few later buildings, which centre round the stables of the Comte de Provence in the Rue Monsieur.[69] Even in the Hôtel de Bourbon-Condé, built for a young princess, the monotony is relieved on the courtyard side only by four inset reliefs by Clodion, and on the garden side by a central room that curves out in a semicircle. The block-like appearance which marks these last buildings of Brongniart's is characteristic of town houses in general at this time. The wings enclosing the cour d'honneur, even the little end pavilions, disappeared. Giant orders, at first still correctly regarded as a central accent, began from the late seventies onward to spread more and more across the whole façade. Examples of this development are Cherpitel's Hôtel de Rochechouart (1778) and Legrand's Hôtels de Gallifet (1775–96) and de Jarnac (1783). A long portico without any central accent, without even a heraldic cartouche, contrasted with the uncluttered corner bays of the building. The 'thinking in contrasts' that lay behind these façades, as opposed to the earlier notion of symmetry, found expression not only in the opposition between portico and wall but also in the spatial planes. The columns, at first still engaged, moved away from the wall. In the Hôtel de Gallifet (Plate 292) and later buildings, the portico – rather as in Ledoux' revisions of his early work – is a separate block standing in front of the wall. The same is true of the relationship between smooth wall and ornamentation. Here, too, the effect of contrast is the determining factor; it is intended to make the decorative parts stand out more strongly. In the exceptionally delicately wrought garden front of the Hôtel de Salm, by Rousseau (1784), which, in its proportions, its dome, and the outward-curving central room, forms such a striking contrast with the classical columned courtyard,[70] it is precisely this feature that distinguishes it from a pavilion of the Rococo period (Plate 293).

One decisive change in the design of dwelling houses, including blocks of flats, concerned the plan. Ledoux had already replaced breadth by depth and centralized the plan. De Wailly had followed his example in the group of three houses which he built in the Rue de la Pépinière.[71] With the younger generation which dominated domestic architecture in the eighties and nineties – men like Huvé, Henry, Cellerier, and Soufflot-le-Romain – this scheme became the rule. The circle became the basic shape. It appeared in the hall, in the staircase hall, in the projecting semicircle of the salon, and in the courtyard. The other rooms were accommodated to this axis. What is noteworthy about this is how skilfully these un-French shapes for rooms were adapted to native habits of living. The most striking example of a plan of this sort is the abbot's palace at

Figure 35. Louis Le Masson: Royaumont, abbot's palace, 1785–9, plan

Royaumont (1785–9); here Louis Le Masson (1743–1830) used the experience gained in the construction of town houses to combine the French system of apartments situated round a longitudinal axis with the square shape of the Villa Rotonda (Figure 35).[72]

Contemporaries were fully aware of the complete change which architecture had undergone since the days of Blondel.[73] They greeted it with all the enthusiasm that they had shown for the *style à la grecque*. Antiquity was still the fashion, but now it percolated in a purified form into the last block of flats. The whole of France had made itself at home with it. The Empire only popularized and vulgarized what the *ancien régime* had created on totally different assumptions.

343

Revolutionary Architecture

This relatively uniform outward picture is liable, however, to blind us to a powerful current which forced its way to the surface in the architecture of these years and threatened to sweep away academicism lock, stock, and barrel. Romanticism, generally taken into account only in connexion with the nineteenth century, had already made itself heard in the eighteenth. The writings of Jean-Jacques Rousseau had awoken a new feeling for the relationship of man to nature, and this new feeling spread like a wave over the whole of France. The Romantic conception of nature was combined with a Romantic attitude to history. People enjoyed sinking themselves in the past and no longer made any distinction in their evaluation of different civilizations. The parallel phenomenon in architecture – what is known as 'Romantic Classicism' – displayed a similar indifference to the various different styles. The universal admiration for Antiquity as the undisputed pattern of perfection gave way to a subjective, emotional relationship to the past. Each individual building was seen as a separate entity; the great fabric of the Baroque disintegrated.[74]

The harbingers of this movement appeared as early as the twenties in England. In France, Romantic Classicism gained a foothold in the sixties by way of the 'jardin anglais',[75] but its real significance was only revealed at the end of the century in what is known as 'Revolutionary Architecture'. The moral and social aims of this architecture were the same as those which led to the French Revolution: a new, better society – better because it was founded on philosophical principles – in which oppression would be ended, men would be honoured according to their deserts, and everyone would have the right to happiness and prosperity. Thus the description coined by Emil Kaufmann and often misunderstood is justified, although it must be emphasized that the great ideas behind Revolutionary Architecture arose almost without exception under Louis XVI; the Revolution itself made no contribution to them.[76]

Not only because of its dimensions but also because of its social and moral purpose, Revolutionary Architecture is Utopian in character. Only a fraction of what was planned was ever turned into reality. Thus its real achievements lie in the drawings made at this time, in which the new world of ideas and feelings is clearly revealed. The decisive element is not the tendency to megalomania. This had already made itself noticeable in the middle of the century and gradually spread from the drawings of the Académie students and Rome exhibitioners to all designs for public buildings.[77] The plan to rebuild Versailles, and the designs for a Hôtel-Dieu in Paris and a Place Louis XVI at Bordeaux, are eloquent examples of this.[78]

What is more important is the new conception of solids and surfaces, as embodied particularly in the work of Boullée and Ledoux. The pioneering role of these two was rightly recognized even by contemporaries. Viel de Saint-Maux criticized them sharply in his *Décadence d'architecture à la fin du XVIIIᵉ siècle*, which appeared in 1800.[79] Others who were exponents of the same principles, at any rate from time to time, were Lequeu, Desprez, Poyet, Girardin, and Durand. Boullée was the most inventive of them all.

But after he had retired completely from private practice in 1774 he was confined to his academic teaching activities.[80] This was the sphere in which he was really influential; in comparison with it, the practical building work of his youth pales into insignificance. As a member of the Académie and, after the dissolution of the Académie, of the École Centrale du Panthéon, as the expert on numerous commissions and a highly esteemed teacher, he exerted a wide-ranging influence which, during his lifetime, no one could escape.[81] His ideas are gathered together in the manuscript *Architecture. Essai sur l'art*, which he left behind when he died and which was not published until a short time ago.[82]

In comparison with Boullée, Ledoux was the practical man. The favourite society architect in the reign of Louis XV, he continued to be overwhelmed with private and public commissions during the next reign, too, until the Revolution condemned him to inactivity and forced him to live in hiding.[83] The transition from his early style to Revolutionary Architecture, the change in the models he followed, can be clearly traced in his buildings. The transformation begins with the saltworks of Chaux (1774–9) (Plate 294) and the theatre at Besançon (1778–84), where not only a severe Doric classicism is to be seen for the first time but also a clear exaggeration of the forms.[84] The buildings he designed in the eighties are all distinguished by a tendency to the monumental. Quite often this proved a hindrance to their execution – such was the case with the group of buildings (Palais de Justice, governor's palace, and prison) begun but never completed in Aix-en-Provence (designed in 1784, started in 1786), with the theatre at Marseille (1785–6), and with the bishop's palace at Sisteron (1780–5); and eventually, with the city gates of Paris (1785–9), it led to his coming to grief. Even he pushed his ideas to their logical conclusion only on paper: in the designs for the 'ideal city' of Chaux and the park of Maupertuis, and in his unfinished work, *L'Architecture considérée sous le rapport de l'art, des mœurs et de la législation*, which appeared in 1804.[85] This work, the very title of which reveals the extent of the claims made by Revolutionary Architecture, contains a broadly based survey of the vision of a Utopian architecture.

What particularly distinguishes the late work of Boullée and Ledoux is the simplification of the forms into block-like shapes. Josef Langner and Wolfgang Herrmann have shown how Ledoux, when he came to edit his own early works, made the forms congeal and stiffen into separate blocks.[86] The same is true of Boullée's development.[87] The words 'L'architecture doit se régénérer par la géométrie', uttered in the Convention in 1793, could well have come from him. Diderot had already recognized the aesthetic value of the sheer surface and the undisguised cubic form. Under his influence, Ledoux sought to fathom the basic elements of architectural beauty, and in the same way Boullée, in the effort to go back to the sources of art, developed his famous essay *La Théorie des corps*, in which he investigated the specific qualities of stereometric solids in their effect on the senses and in comparison with the human organism. On the grounds of their innate aesthetic and symbolic qualities, the cube, pyramid, cylinder, and sphere became autonomous forms of architectural expression.[88] Boullée regarded the sphere in particular as the ideal form, not only because all points on its surface are equidistant from its centre, but also because it always presents the same appearance regardless of the angle from which it is viewed.[89] The influence of Diderot is here joined by that of the steadily

growing natural sciences.[90] In particular, the *Cristallographie* of Romé de l'Isle (1783), which deals exhaustively with the qualities of regular solids, must have exerted considerable influence on Boullée and his 'théorie des corps'.

One consequence of the crystalline compactness of the architectural unit was the conversion of the previously vertical articulation into a horizontal one. The building was divided into separate horizontal layers which were no longer tied to any firm system of proportional relationship. Gondoin had been a forerunner here. His École de Chirurgie already displays the same layered structure and a continuous, unbroken cornice. Boullée made this principle into a rule. In his designs it is precisely the endless, uninterrupted cornices that give the impression of horizontality and monumentality.[91] The decisive factor in Revolutionary Architecture was not the articulation but the surface. It acquired its life through the effect of light and shadow, and was contrasted with the colonnades and the sparing ornamentation. Both Boullée and Ledoux assigned special importance to shadow. Deep shadow seemed to provide the only way of lending life to their surfaces and cubes.[92] Boullée described himself as the inventor of this 'shadow architecture'.[93] In reality, his teacher Legeay had already anticipated him in this, though it is true that he did not make a doctrine of it.

With the new appreciation of solid and surface, the relationship to Antiquity was also called into question. Like Diderot, Boullée and Ledoux discovered that the heaviness and severity of ancient buildings were diametrically opposed to the tempered taste of classicism.[94] The Pantheon, the Temple of Fortune at Praeneste, and the temples of Baalbek and Palmyra are certainly the archetypes behind many of Boullée's designs,[95] but the classical components acquired an oppressive, almost cyclopean heaviness. Yet they also became mere bits of scenery, employed whenever the spirit of the building required it. Even the particular style as such was chosen to suit each individual case. It could be Gothic, Turkish, Persian, or Egyptian, according to the mood required. Boullée saw nothing odd about incorporating the pediment of the Parthenon in a huge pyramid – a superb example of the historicism with which the nineteenth century was burdened. The architectural conception no longer proceeded inwards from outside, according to definite, traditional ideas, but outwards from inside; it came from the pure form of the building and its emotional value. The columns of Boullée's cathedral, of his museum, or of his library no longer possess any supporting function. Their task is to enhance the monumental effect by the accumulation of the same motif. To this end, Boullée even shortened the normal interval between columns and reduced the size of the module, to make rooms look bigger. In his design for a Palais Municipal (1792) the rows of columns have become narrow ribbons running round the giant cube like ornaments.

With Ledoux, who had to take account of the wishes of his patrons, the classical models, especially Palladio, maintained their authority longer.[96] Even his city gates of Paris (Plate 295) still formed a perfect catalogue of architectural styles, though what he made out of this ring of toll houses is without parallel in the history of architecture. Under his hand the simple customs offices which punctuated the new city wall[97] – there were forty of them altogether – became fortresses, temples, and palaces, so that those arriving at the capital should be able to see its greatness from afar. Alongside

Giulio Romano and Piranesi, and innumerable columns in every conceivable style, stood basic stereometric forms – the cube, the cylinder, and the half-cylinder – piled like blocks on top of each other. Everything was on an exaggerated scale reminiscent of Piranesi's architectural fantasies and far exceeding that of the original models. Here, in the classical and cubist forms, past and future rubbed shoulders. In his Maison Hosten (1792), however, in the designs for the ideal city of Chaux, which were produced in direct connexion with the saltworks,[98] and in the park of Maupertuis (the two latter projects both dating from about 1785), he resolutely put aside the classical repertoire of forms. Here, with hard cubic blocks, smooth, often windowless, walls, endless lines of pillars and arcades, and a cell-like plan, he developed a style intended to meet the needs of a new society, a classless, mass society. One is tempted to call it functional architecture.[99]

But such a description would be only partly correct, for again and again the form of a building was determined more by symbolic aims than by practical considerations. Revolutionary Architecture, more than any other kind, is programme architecture; it is the embodiment of 'architecture parlante'. Its buildings were to contribute to the education of the new race of men that would be produced, so it was hoped, by a new constitution.[100] This was to be proclaimed in them in a way that spoke not only to the mind, but also – and this was a completely Romantic notion – to the heart. The most important requirement in a building was its 'character', i.e. its meaning. It should move the spirit, in the way described by Rousseau. Thus in Ledoux's ideal city of Chaux, which illustrates one single educational programme, many of the buildings are identified with definite moral values: there is a Temple of Memory, dedicated to the fame of women, a Temple of Reconciliation, the Cenobium or Asylum of Happiness, the phallus-shaped Oikema or Temple of Love, and so on. Other buildings symbolized various handicrafts. The house of the hoop-makers bore concentric hoops on its outside walls, the house of the river authority was shaped like a water pipe, through which the River Loue flowed (Plate 296), the house of the charcoal-burners was a semi-dome resting on untrimmed tree-trunks, and the gunsmith's was a square group of smoking pyramids. Lequeu adorned the entrance to a game preserve with the impaled heads of wild animals. Doubtless there are connexions here with the 'fabriques' of contemporary parks.[101] Ledoux had already linked up with these in the grottoes of the gateways to the saltworks of Chaux and to the Hôtel Thelusson (1778–81), and also in the sepulchral pyramid of Maupertuis.

With Boullée the language of symbols rises to the sublime. His designs are monuments for a race of men who no longer pinned their faith to the immortality of the soul but to survival in the memory of future generations.[102] The aim of his gigantic pyramids, his skittle-shaped lighthouses, his city gates and triumphal arches, was to show posterity the grandeur of the epoch through its buildings. The outside walls of his Palais National bear as their only ornamentation the laws of the new constitution and pedestal figures, with the new code in their hands, symbolizing the number of the newly created départe-ments. His fortress gates bore serried ranks of watchmen on their bases; and his Palais Municipal rests on four pedestal-like guardhouses, to demonstrate how society is built on the state's power to preserve law and order. Similarly, Ledoux had conceived his prison at Aix as a fortress-like square block with sarcophagus roofs and sternly forbidding

entrances. Every individual stylistic component was here drowned, so to speak, by the 'character' of the building. Among Boullée's monuments a special place is occupied by the Tomb of Newton (1784) (Plate 297).[103] It was his tribute to the English scholar who had bequeathed to the eighteenth century one of science's most sensational discoveries – the law of gravity. The basic conception was brilliant. The spherical shape symbolized the stars, and the hollow space inside it the universe. The interior was completely dark, and this darkness was relieved only by the light of the night sky, which penetrated through cracks in the surface of the sphere.[104] Right at the bottom of the sphere, almost lost in the vastness of the space and accessible only via two tunnel-like passages, stood Newton's sarcophagus. This design was suggested not only by the great mausolea of Antiquity – this is shown clearly by the circular terraces of cypress trees outside – but also by the giant globes so popular in the eighteenth century and familiar to Boullée from the Bibliothèque Royale.[105] The idea was taken up at once. Ledoux's cemetery hall for Chaux, Lequeu's Temple of the Highest Wisdom, Vaudoyer's House of a Cosmopolitan all derive, among other buildings, from this original form.[106]

On top of this monumentality came 'romantic' surroundings, a feature which received particular attention through Boullée's gift as a painter, but is also evident in the layout of Chaux and its assimilation of the landscape.[107] Boullée's interiors are illuminated not by windows at the side but by light from above, which falls in a broad stream through the dome, and achieves – in the museum (Plate 298) or the cathedral, for example – magical effects.[108] His tombs are backed by stormy skies, and clouds move across the dome of the cathedral. This poetry in architecture, as demanded by Boullée,[109] is the basis of all Revolutionary Architecture. The notion of an 'architecture ensevelie', which shows only parts of buildings rising above ground and hints at other, mysterious sections still below the surface, is poetic (Plate 299);[110] poetic, too, the cult of the dead, which finds expression in the innumerable tombs and cemeteries of the period, and is most urgently embodied in the stage designs of Desprez.[111] This emphasis on the emotional, to which both Boullée and Ledoux attached great importance in their writings, had already been underlined by Le Camus de Mézières in 1780. His work Le Génie de l'architecture bears the significant sub-title L'Analogie de cet art avec nos sensations.[112] This conception of the architect as a freely creative genius – still unthinkable to Blondel – is another fruit of Rousseau's mode of thought. How far this freedom could go is demonstrated by the example of Lequeu, who with thoughtless eclecticism created a completely irrational 'union of opposites' in which the urge to the picturesque destroys all architectural logic.[113] This was the start of a current of eclecticism which bestowed on the second half of the nineteenth century in particular a series of remarkably tasteless buildings in what is sometimes known as the 'villa style'.

Revolutionary Architecture was largely denied the chance to put its ideas into practice. During the years of the Terror both the money and the organizational capacity were lacking, and under the Directoire the strong will required to convert ideas into reality was absent. The architectural dreams of the period remained confined to drawings and festival structures, in which revolutionary pathos mingled with the Romantic enthusiasm for nature.[114]

348

Not even the National Assembly's palace, designs for which were produced by Legrand, Molinos, Vignon, and Poyet among others, was ever actually built.[115] The gathering had to make do with the Salle des Machines in the Tuileries, as modified by Jacques-Pierre Gisors in 1793 (demolished in 1800).[116] The only building left by the Revolution in Paris is the Salle des Cinq Cents, which later became the Chambre des Députés. The semicircular parliamentary chamber which Gisors and Leconte, assisted by Hurtault and Gisors the Younger, built into the Palais Bourbon in 1795–7 for the newly created Council of Five Hundred, still breathes something of the spirit of Revolutionary Architecture. In form it harks back to Gondoin's amphitheatre in the École de Chirurgie, but the Ionic colonnade along the back wall is completely subordinate to the sober surface of the wall, and the ornamentation of the front wall and of the over-sized proscenium arch in front of it is devoted to symbols of ancient virtues and the texts of laws. The semicircular arrangement of the room, the niche for speaker and president, and the galleries for spectators over the deputies' benches, along the lines of what had already existed in the Salle des Machines, provided the model for numerous later parliamentary chambers.

The reaction of the Napoleonic era checked the impetus of Revolutionary Architecture, and its after-effects are therefore to be found primarily in England and Germany. In France it was Boullée's pupil J.-N.-L. Durand who administered the legacy it left and moulded it into a functional architecture intended for daily use. Entrusted, as a teacher at the École Polytechnique, with the training of young engineers and architects, he transformed Boullée's aristocratic handling of the classical repertoire of forms, Ledoux' cubist mode of building by addition, and pure academic classicism into a rational, eclectic functionalism appropriate to the new architectural needs of a mass society. His *Précis des leçons d'architecture* of 1802–5, which united the opposing tendencies of the end of the eighteenth century, became the manual of Romantic Classicism in the nineteenth century.[117]

Decoration

In the field of decoration the *style antique* spread more and more widely as ancient buildings came to be more generally known. Walls, like façades, were articulated by pilasters or columns, ceilings were coffered – quite often by means of illusionistic painting – and the décor came to consist more of sculpture than of painting. As a result, decoration acquired an architectural character. The rhythm of coupled pilasters, introduced by Barré in Le Marais (*c.* 1770) (Plate 300) and by Cherpitel in the Hôtel du Chatelet (1771–4), was adopted by Brongniart in the Hôtel de Monaco (1776) and the Hôtel de Masseran (1787). It occurs in the Hôtel d'Orsay, in the Pavillon Saint-Vigor at Viroflay, and above all in the rooms of Compiègne (*c.* 1784). Stricter taste preferred the column, which at the same time gave the wall stronger relief. It had been heralded by Gabriel's octagonal rooms in the Pavillon Français in the garden of the Petit Trianon (1749) and in the château de Saint-Hubert near Rambouillet, with their Corinthian columns in the corners supporting a circular entablature. Continuous lines of

free-standing columns with entablature had come to be employed in ecclesiastical architecture – in Saint-Philippe du Roule, for example – and Chalgrin had already introduced them in a secular building, the hall erected for the marriage of the dauphin in 1770. Now they became more common. The Aula in Gondoin's École de Chirurgie (c. 1775), the Salle des Actes in Chalgrin's Collège de France (1780), Victor Louis' ballroom for Richard Lenoir (c. 1780), and many other places all displayed this severe form of decoration, which excluded any other. The last and most thoroughgoing example was the Salle des Menus Plaisirs at Versailles (1787), where behind the lines of columns there were aisles with galleries, so that the room no longer differed in any way from a Roman basilica. The Hôtel Gallifet (1775–92), by Legrand, shows how far it was possible to go in this direction. By leaving out the walls and replacing them with columns, the impression of an ancient hall was achieved.

With this form of decoration went niches for statues or, as in the Collège de France, busts of emperors on pedestals. The fashion for adorning interiors with ancient statues was so universal that it led to the opening in Paris of sculptors' workshops occupied solely with copying classical originals. Quality was not their primary concern. Where real pieces of sculpture would have been too expensive, or would have occupied too much room – in corridors, for example – they were painted on the wall in grisaille.

All this, it is true, was only superficial. Underneath, the love of luxury persisted and people clung to the comforts to which they were accustomed. In complete contrast to the sober classical façade, a feminine sensibility often prevailed inside, a preference for delicate colours, for fabrics and draperies. The starting point of this refined style of decoration was the court art of Versailles, where the queen set the tone. While the king contented himself on the whole with his predecessor's rooms and had only some things modernized, alterations never ceased in the queen's apartments.[118] They began, almost as soon as Marie-Antoinette had moved into Versailles, in the Petits Appartements on the first floor, spread from 1776 onwards to the second floor, and from 1783 onwards engulfed the ground floor as well, where, in the central part of the palace between the Cour de Marbre and the garden, near the royal children, a big apartment with three libraries gradually came into being. They did not halt even at the doors of the state rooms, the 'Grand Appartement'. Marie-Antoinette showed no respect at all for the architecture of Jules Hardouin Mansart and had only one aim, the complete modernization of the venerable Appartement de la Reine, including the Salon de la Paix, which served her as a card-room and occasionally even as a theatre. Heurtier, the inspector of works for the palace, had already produced a plan providing for the stripping of all the marble cladding, the removal of the bronze trophies, and the covering of Le Brun's painted ceiling with a false ceiling. Instead, an arcade of wooden panelling, in continuation of the window arcades, was to encircle the room with a uniform rhythm. Absurdly enough, it was thanks to the Revolution that this plan was thwarted and the Salon de la Paix saved. However, the other rooms, and in particular the Cabinet des Nobles, lost most of their marble cladding and bronzes, and acquired fresh chimneypieces, cloth hangings, and completely new furniture.

The men who were responsible for all these pieces of work, after Gabriel's retirement in 1775, were Richard Mique and the brothers Rousseau.[119] In all essentials, however, the style was determined by the queen herself. This 'Style Marie-Antoinette', un-architectural and decorative but of extreme elegance, was marked by tranquil lines, classical profiles, rich gilding, reliefs over the doors, and a certain transparency. Glass doors (even on the bookcases), tall mirrors, and bright, predominantly white materials determined the atmosphere of the rooms. The alcoves which broke up the straight lines of the walls were mirrored on the back wall and ceiling. According to the testimony of contemporaries, the queen's boudoir on the ground floor was nothing but a cabinet of mirrors making its impression by means of Baroque effects.[120] On top of this came a partiality for draperies, curtains, trimmings, fringes, and tassels which was somewhat reminiscent of the taste of a *modiste*. With this taste, which robbed court neo-classicism of any rigour and basically governed even Pâris' classical festive rooms in the Baraques, went the flowers which formed the motif of the decoration. Flowers swamped everything – carvings, paintings, hangings, clothes, and furniture. Festoons of flowers, still lifes of fruit and flowers, and cherubs playing with flowers, as popularized by the engravings of Cauvet, Ranson, Salembier, and the rest,[121] ousted the heavy, classical trophies of Delafosse's *Iconologie*. It was doubtless due to Marie-Antoinette's influence that the decorations of the Brothers Rousseau were attuned to this flower style. The best examples are to be found in the Méridienne, an octagonal *cabinet* with alcoves fitted out in 1781 behind the Chambre de la Reine on the occasion of the dauphin's birth,[122] in the only partly preserved panelling of the ground floor, in the murals of the Belvedere at the Petit Trianon (1779), and in the 'Chaumière' at Rambouillet (1772–8).[123] Here the naturalism of the Style Louis XVI reached its zenith, even though the delicate, symmetrical carvings on the panels and glass doors do not stand comparison with the exuberant fancy of the Style Louis XV and produce a somewhat schematic effect. On the other hand, the classical element was at first not very prominent. Where it appeared – in the Cabinet Doré (Plate 301), for example, or in the chimneypieces – it was modelled on Piranesi's engravings – sphinxes, incense boats, Roman eagles, caryatids, and so forth.

In the eighties, however, under the influence of Bélanger's work for the Comte d'Artois and of the engravings published by Camporesi and Volpato, Colombani, Pergolesi, Richardson, and others,[124] the court style changed too. Through the engravers just mentioned Raphael's grotesques in the Vatican Logge and the Villa Madama, and the grotesques at Caprarola, which were all based on Antiquity, became known and were imitated. As a result, the previously prevailing mode of composition underwent a change. Wall panels were no longer seen as a framed area but as a pictorial unit. As was already the case with the grotesques of the school of Le Brun, a central axis was formed out of several motifs one on top of the other, and these were framed by thin vases, slender female figures, vine tendrils, or arabesques.[125] The composition consisted of few, but large motifs. Vases of flowers, winged geniuses and sphinxes, and relief medallions with ancient or 'Etruscan' scenes, i.e. scenes from Etruscan vases found in Italy, alternated with each other.[126] The *Antichità d'Ercolano* served as the pattern for many of these relief

scenes. They differed from seventeenth-century grotesques – such as those at Vaux-le-Vicomte – not so much in motif as in the mode of execution, which approached the Pompeiian style in lightness, elegance, and isolation of the individual motifs. This style was already in evidence in the leaves of the doors of the Cabinet Doré at Versailles (1783) but reached full flower at Fontainebleau, in the queen's apartment, which was redecorated in 1785. The Cabinet de Toilette may be regarded as the high-water mark of this neo-Pompeiian style (Plate 302).[127] This room is painted out in mother-of-pearl colour, has stucco reliefs over the doors, and is equipped with choice furniture inlaid with mother-of-pearl. The Rousseau Brothers' last arabesque decoration in this style – it adorned Ledoux' Hôtel Hosten – was dated 1792. It is already clear in this piece of work that the queen's taste is no longer exerting any influence in the background. Meanwhile, however, this form of decoration had won universal popularity. Through improvements in wallpaper-manufacture, which from the seventies onward reached a very high standard under the manufacturer Reveillon,[128] it brought radiant colours, Pompeiian motifs, and delicate festoons of flowers into every house. It was only the isolation and simplification into block-like shapes, a tendency which set in around 1800, that put an end to this play of arabesques, medallions, and ephemeral architecture.

Outside the court, the work done by Chalgrin for the Comte de Provence and Bélanger for the Comte d'Artois, the king's brothers, stood out particularly, the former for its quality, the latter for the boldness of its invention. The Pavillon de Musique de Madame at Versailles (1784), by Gabriel's pupil Chalgrin, looked inside like a continuation of the Petit Trianon. The cool white colour and the absence of any gilding make the structure stand out more strongly than in Mique's work. The doors have tops in the classical style, and the octagonal salon, clad with mirrors up to the height of the lintels of the windows, is lined by arcading with a vigorous entablature. But even here the strictness of the profiles is balanced by a rich and graceful décor of flowers: there are flowers in the delicate relief of the carved doors, there are plaster garlands of flowers on the upper part of the walls, and there are acanthus tendrils in the coving of the ceiling. Like the dining rooms in the Hôtels de Thélusson (c. 1780) and d'Argenson (1784), and the Pavillon Beaujon at Issy, the circular music room in the middle is painted all round with views of landscape (Plate 303). The spectator finds himself in the middle of this, surrounded by the painted columns of a round temple.[129]

Bélanger, like his patrons, was more modern. At Bagatelle (1777–8) he introduced the latest kind of classical decoration – grotesques in coloured plasterwork, linked with painting – and fitted out the master of the house's bedroom, in allusion to his office as a Grand Master of Artillery, as a military tent, with draperies everywhere, even on the tent-like canopy, and gilded edgings.[130] For the plaster grotesques he had called in as his assistant the young ornament designer Jean Dugourc, who, like Clérisseau, had made a thorough study of Antiquity in Rome.[131] They are an exact imitation of Raphael's grotesques in the Vatican Logge. It is questionable how far they were affected by Camporesi and Volpato's book, which appeared in 1776 and influenced all later work, including the decoration at Fontainebleau. This first example at Bagatelle, where Lhuillier was responsible for the plaster modelling and Dusseaux and Hubert Robert for the

painting, including that of the unstuccoed walls, was no whit inferior to its Roman model. It was a much admired masterpiece.[132] Dugourc employed the same technique in the Folie Saint-James (1778) and the château of Brunoy (1780), among other places.

In contrast to this, Bélanger's decoration at Maisons (c. 1780) continued the architectural tendency of the Pavillon de Lauraguais, with its articulation of columns and niches, but did not forfeit elegance and charm in the process. The perfectionism and thorough acquaintance with Antiquity of Lhuillier, who was responsible for nearly all the three-dimensional decoration, were a guarantee of that. The masterpiece here is the summer dining room, with its relief friezes, stucco ceiling panels, the eagle inspired by the church of SS. Apostoli over the chimneypiece, and the big figures in the niches. This neo-classical atmosphere comes remarkably close to the classicism of François Mansart in the other, unchanged rooms of the château.[133]

It was also through Bélanger, who, like the Comte d'Artois, was affected by the anglomania of his time,[134] that the English influence made itself felt in decoration. The question of the effect of this influence on the genesis of the Style Louis XVI has been thoroughly discussed by scholars.[135] In the period before 1780 it plays hardly any part in decoration. Clérisseau and the English Adam Brothers, who each exerted a decisive influence on style in their respective countries, had drawn on the same source. They had all been in Rome at the same time, made friends with Piranesi, and studied the ancient grotesques for many years. But the ways in which they applied what they had learnt when they returned to their native lands were very different. The Adam Style, which is based on a smooth expanse of wall, could only be applied in a limited way to the French panel system. In addition, French ornamentation rested on a naturalism continually fed by painters and engravers; the Adam arabesques, which were not backed by any true painting, were bound in comparison to seem thin and bloodless. The decoration of the seventies therefore shows scarcely any trace of being influenced by *The Works in Architecture of Robert and James Adam*, a collection of engravings which appeared in 1773.

Then, however, in the Folie Saint-James and at Maisons there are signs of borrowings from England, and finally, in the eighties,[136] Bélanger completed the change-over to a new style largely inspired by the Adam Style (Plate 304). The main element in the articulation consisted of thin columns reminiscent of what is known as the Fourth Pompeiian Style. The walls, unlike those of the Vatican grotesques, were painted with separate scenes hovering loosely on the surface in the Pompeiian way and were framed by thin mouldings. The pilasters, painted in delicate colours, acquired fields of ornament in white plaster composed of numerous individual motifs taken from the grotesques. They lost their architectural function and instead gave the articulation of the room new coloured accents.[137] The ceiling decorations were also borrowed from England. Tent roofs, outstretched sails or coffers filled with painted or plasterwork medallions, and arabesques or figured scenes based on ancient models, produced a bright, often somewhat heavy pattern far removed from Gabriel's light plaster ceilings. This style, popularized not only by Bélanger but also by Cellerier, Legrand, Molinos, Henry, and many other members of the younger generation, led straight over into the Style Directoire.[138]

English influence also found its way into France in another field. The apses of the libraries of Syon House and Kenwood, separated by screens of two columns, re-appear in the gallery of the 'Petite Maison' of the Prince de Soubise, by Cellerier (1786), in the gallery of the art dealer Lebrun, and in the château of Saint-Gratien (Somme). The Adam arabesque decoration in plaster occurs in the Hôtel de Jarnac, by Legrand (1783–7).

The Revolution caused no real break. Napoleon's court architects, Percier and Fontaine, built on the same foundations, even though under the Directoire English influence waned and Egyptian motifs became more frequent.[139] Just as a straight line runs from Pâris' Salle des Menus Plaisirs at Versailles to the Salle des Fêtes by Percier and Fontaine at Compiègne, so the same spirit prevails in the Hôtel Récamier (1798) as in Bélanger's Hôtel Dervieux (1786). The Hôtel Récamier, an early work of Fontaine, was the most elegant house of the Consulat and the model for early Empire decoration. It was permeated by a delicate Pompeiian classicism which could hardly be distinguished from the refinement of the *ancien régime*.[140] Those who had survived the horrors of the Revolution were far from wanting to live a heroically socialist life; their efforts were directed to starting again as quickly as possible at the point where the sweet life of days gone by had come to an end.

LIST OF THE PRINCIPAL ABBREVIATIONS

NOTES

BIBLIOGRAPHY

LIST OF THE PRINCIPAL ABBREVIATIONS

A.A.F.	*Archives de l'Art Français*
B.N.Est.	Paris, Bibliothèque Nationale, Cabinet des Estampes
B.S.H.A.F.	*Bulletin de la Société de l'Histoire de l'Art Français*
Burl. Mag.	*Burlington Magazine*
C.d.A.	*Connaissances des Arts*
Correspondance des Directeurs	A. de Montaiglon and J. Guiffrey, *Correspondance des Directeurs de l'Académie de France à Rome* (Paris, 1887–1908)
Dézallier d'Argenville	A. N. Dézallier d'Argenville, *Vies des fameux sculpteurs depuis la Renaissance des arts* (Paris, 1787)
Diderot Salons	J. Seznec and J. Adhémar, *Diderot Salons* (Oxford, 1957–67)
G.B.A	*Gazette des Beaux-Arts*
Hautecœur	L. Hautecœur, *Histoire de l'architecture classique en France*, I–VI (Paris, 1943–55)
J.W.C.I.	*Journal of the Warburg and Courtauld Institutes*
Kimball	F. Kimball, *Le Style Louis XV* (Paris, 1949)
Mariette	Jean Mariette, *L'Architecture française* (Paris, 1727), ed. L. Hautecœur (Paris, 1927)
Mémoires inédits	L. Dussieux a. o., *Mémoires inédits sur la vie et les ouvrages des membres de l'Académie Royale de Peinture et de Sculpture* (Paris, 1854)
N.A.A.F.	*Nouvelles Archives de l'Art Français*
Vies d'artistes	Comte de Caylus, *Vies d'artistes du XVIIIᵉ-siècle* (Paris, 1910)

NOTES TO PART ONE

CHAPTER I

p. 3 1. A. de Montaiglon, *Procès-verbaux de l'Académie Royale de Peinture* (Paris, 1875–92), III, 272; attention is drawn to this particular passage by M. Stuffmann in *G.B.A.* (July–August 1964), 26; see further Note 7 below. It should also be noticed that de Piles, while placing so much emphasis on nature – as is widely known – stated elsewhere that the painter must also have a knowledge of history. For discussion of de Piles' views see A. Fontaine, *Les Doctrines d'art en France . . . de Poussin à Diderot* (Paris, 1909), 120 ff. It cannot be made clear too soon that judgements such as Friedlaender's (*David to Delacroix*) (New York, 1968 ed., 3) that the whole artistic movement of the early part of the century 'became still more strongly opposed to the Academy' are totally misleading and absurdly schematic, though widely disseminated.

2. Watteau's decorations for La Muette were almost certainly executed before 1716, when the regent bought the château for the Duchesse de Berry.

3. See H. Jouin, *Conférences de l'Académie Royale de Peinture et de Sculpture* (Paris, 1882), 313.

4. *Ibid.*, 277–8.

p. 4 5. Cited in connexion with aesthetic attitudes and arguments by R. G. Saisselin, *Taste in Eighteenth Century France* (Syracuse, N.Y., 1965), 10.

p. 5 6. See this volume (Anthony Blunt, *Art and Architecture in France: 1500–1700* (Pelican History of Art), 2nd ed. (Harmondsworth, 1970), 234 ff.) for La Fosse, Jouvenet, Antoine Coypel, the Boullongne, François de Troy, Largillierre, Rigaud, and Desportes.

p. 6 7. The fundamental work on La Fosse is now M. Stuffmann in *G.B.A.* (July–August 1964), with catalogue raisonné.

8. *Mémoires inédits*, II, 300: cited by Lady Dilke, *French Painters of the XVIIIth Century* (London, 1899), 33.

9. *Le Siècle de Louis XIV* (*Œuvres de Voltaire*) (Paris, 1819 ed.), XVII, 181.

10. Further for Raoux, see G. Bataille in L. p. 7 Dimier, *Les Peintres français du XVIII^e siècle* (Paris and Brussels, 1930), II, 267 ff.

11. For that picture, see Blunt, *op. cit.*, plate 163B.

12. On Grimou, see C. Gabillot, *Alexis Grimou, Peintre français* (Paris, 1911); his 'legend' is interestingly discussed by G. Levitine in *Eighteenth Century Studies*, I (University of California, 1968), 58 ff.

13. *Mémoires inédits*, II, 255 ff. for three contribu- p. 8 tions to Detroy's biography, the third by Caffiéri; a posthumous sale of his collection (containing pictures attributed to Tiepolo, as well as a range of French contemporary work, including Detroy's own) at Paris, 9 April ff. 1764 (Lugt, 1372); there is no monograph on him but a chapter by G. Brière in Dimier, *op. cit.*, II, I ff.

14. The picture now in the collection of Mr and p. 9 Mrs Charles B. Wrightsman, New York, lent to the R.A. exhibition *France in the Eighteenth Century* (1968), no. 670.

15. The painter is not identified, but Goethe's reactions are recorded very fully in G. H. Lewes, *The Life of Goethe* (London, 1864 ed.), 67–8.

16. The impact of the Salon of 1737 was intelligently recreated by the exhibition *Les Artistes du Salon de 1737* (Paris, Grand Palais, 1930), which remarkably managed to assemble much of the original painting and even sculpture. For those of us who did not – could not – see it, this exhibition too must be studied through its catalogue.

17. Mariette shrewdly puts his finger on the ability and failure of Detroy, noting that he pleased at Paris 'par ses petits tableaux de modes, qui sont en effet plus soignés que ses grands tableaux d'histoire' (*Abecedario*, ed. Ph. de Chennevières and A. de Montaiglon (Paris, 1853–4), II, 101).

18. His reputation emerges clearly from the fact that his views on the models Slodtz was preparing for the Montmorin monument *c.* 1740 were much sought for by the commissioner; see Note 125.

p. 10 19. An old and not very satisfactory work is G. Duplessis, *Les Audran* (Paris, 1892); see also *Claude Audran*, exhibition catalogue (Paris, Bibliothèque Nationale, 1950), to which several of the Cronstedt Collection drawings were lent.

p. 11 20. A useful biography, with a range of topics wider than its title suggests, is in B. Populus, *Claude Gillot (1673-1722). Catalogue de l'œuvre gravé* (Paris, 1930).

21. The early Watteau self-portrait, in clown-like costume (lost), is reproduced after the engraving, by E. Dacier and A. Vuaflart, *Jean de Jullienne et les graveurs de Watteau*, IV (Paris, 1921), no. 33.

22. *Vie de Watteau* (1748); H. Adhémar, *Watteau* (Paris, 1950), 176.

p. 12 23. Gillot's inventory published by G. Wildenstein in *B.S.H.A.F.* (1923), 114 ff.

24. Montaiglon, *op. cit.* (Note 1), IV, 150 (Gillot's reception was not formally recorded).

25. Gersaint's is the most movingly personal of all the early lives of Watteau and its publication (in the *Catalogue de feu M. Quentin de Lorangère*, Paris, 1744) marks it as very different from the best other life – that by Caylus – which was not published until the nineteenth century and which is partly governed by the circumstances of being read at the Académie.

p. 13 26. The early 'lives' of Watteau are printed conveniently in Adhémar, *op. cit.*, 165 ff.; a previously unremarked one is published by J. Lévy in *B.S.H.A.F.* (1957), 175 ff.

p. 14 27. Antoine de la Roque's obituary notice, *Mercure de France* (August 1721), Adhémar, *op. cit.*, 166.

p. 16 28. Adhémar, *op. cit.*, 203 (nos. 13 and 17), placed both pictures in effect pre-1709, and they had usually been supposed very early work until this view was seriously questioned apropos *La Marmotte* by I. S. Nemilova, *Watteau et ses œuvres à l'Ermitage* (Leningrad, 1964). Watteau's early work is a particularly vexed question, but one should probably be cautious about placing pictures with Flemish-style subject-matter automatically in an early period; thus *La Vraie Gaieté* (London, private collection), which Adhémar, *op. cit.*, 201, dated towards 1702, may well be later, as suggested by Denys Sutton in the exhibition catalogue *France in the Eighteenth Century* (1968), no. 722.

p. 17 29. Adhémar, *op. cit.*, 210 (no. 83).

30. It should also be said that a few of Van der Meulen's drawings, vivid in themselves, show a more direct and human observation: see *Van der Meulen, peintre des conquêtes de Louis XIV*, exhibition catalogue (Musée de Douai, 1967).

p. 1 31. Gersaint (Adhémar, *op. cit.*, 172); the same characterization is given equally personally by Caylus.

32. For the real theme of this famous picture, see M. Levey in *Burl. Mag.*, CIII (1961), 180 ff., an explanation which seems to have won acceptance.

p. 20 33. That the left-hand figure is Vleughels and the central woman possibly Charlotte Desmares, an actress, has long been recognized; I believe the seated bagpipe player to be a portrait of Watteau himself, and that there is a personal significance to be detected – though not easily unravelled – in the composition. For some further comment on this point see *Rococo to Revolution* (London, 1966), 74–8.

34. As hinted in the text, I cannot accept this painting – which I have examined at several intervals of time – as by Watteau, though of course the composition is his. Not too much need be made of the fact that it appears to have no provenance before the nineteenth century, because it is certainly Watteau-esque in handling of paint. Yet there is a Lancret-like touch in the brushwork, and something very saturated in the pigment of the girl's skirt. I suspect it is an early copy.

p. 24 35. Today Charlottenburg well reflects the environment and attitude of Frederick the Great, with Pater and Pesne among his preferred artists, as well as Watteau; further see *La Peinture française du XVIIIᵉ siècle à la cour de Frédéric II*, exhibition catalogue (Paris, Louvre, 1963).

36. The best general study is R. Rey, *Quelques satellites de Watteau* (Paris, 1931).

p. 25 37. Montaiglon, *op. cit.* (Note 1), V, 47.

38. Further for the Comtesse de Verrue and her collection, cf. L. Clément de Ris, *Les Amateurs d'autrefois* (Paris, 1877), 153 ff.

39. The uncertain date of Mercier's arrival in England (set by Vertue 'about 1711') is pertinently discussed in connexion with Watteau by M. Eidelberg, 'Watteau's "La Boudeuse"', in *Burl. Mag.*, CXI (1969), 275 ff.

40. Portail had a successful career and held several official posts, being Dessinateur du Roi and also Garde des Tableaux in the royal collection. The sensitivity of his style, plus his use of the *trois*

crayons technique, make him indeed an heir of Watteau. There is a monograph by A. de Lorme, *J.-A. Portail* (Brest, 1900).

41. Cited by Rey, *op. cit.*, 19.

. 26 42. *Watteau et sa génération*, exhibition catalogue (Paris, Cailleux, 1968), no. 73. For another aspect of Oudry, see the discussion of him as illustrator of Scarron's *Roman comique* by H. N. Opperman in *G.B.A.* (December 1967), 329 ff.

43. Cf. further A. Desguine, *L'Œuvre de J. B. Oudry sur les parc et jardins d'Arcueil* (Paris, 1950).

. 27 44. Jouin, *op. cit.* (Note 3), 378 ff. It was, as Oudry explains, Largillierre who taught him to achieve tonal subtlety by a direct example involving the use of white rather than obviously contrasting colours. How closely Oudry's own words anticipate the *White Duck* may be seen from his mention of silver as well as white: 'Ces différents blancs vous feront évaluer le ton précis du blanc . . .'.

. 28 45. Further see J. Seznec in *G.B.A.* (1948), II, 173 ff.: for wider implications of the subject see C. de Schoutheete de Tervarent, 'Les Tapisseries de Don Quichotte et les raisons de leur faveur au XVIIIe siècle', in *La Tapisserie flamande aux XVIIe et XVIIIe siècles* (Brussels, 1959). Several of the other paintings mentioned here are known through contemporary engravings; cf. the collaborative articles prepared under D. Wildenstein, 'L'Œuvre gravé des Coypel', in *G.B.A.* (May–June 1964), 261–74, and *ibid.* (September 1964), 141–52.

46. Further for Coypel's proposal, see M. Furcy-Raynaud, *Inventaire des sculptures exécutées au XVIIIe siècle pour la Direction des Bâtiments du Roi* (Paris, 1927), 38–83. In the light of this, it seems as if contemporaries like Diderot were a little unfair in complaining that it was 'le petit Coypel' who disliked Slodtz and left him unemployed; Slodtz was the only name specifically put forward when Coypel referred to 'cinq de nos habiles sculpteurs'.

p. 29 47. An exception should be made for such an attractive-seeming portrait as that of his sister-in-law, Madame Philippe Coypel (apparently dated 1732), which is charmingly 'bourgeois' in concept, closer to Aved than to Nattier: *French Masters of the Eighteenth Century*, exhibition catalogue (New York, Finch College Museum, 1963), no. 12; there exists a pendant of Philippe Coypel, exhibited *Watteau et sa génération* (*op. cit.*, Note 42), no. 107, now in the Louvre; cf. I. Compin in *Revue du Louvre* (1969), 2, 93–7.

48. He is the subject of a chapter by J. Messelet in Dimier, *op. cit.* (Note 10), II, 217 ff.

49. Very full discussion of the life and work of p. 30 Restout by J. Messelet in *A.A.F.*, N.P. XIX (1938), 99 ff.

50. Jean Barbault (*c.* 1705–1766) was active as p. 31 painter and engraver; his is a minor talent, but with its own individuality, including a welcome freedom in handling of paint: see further J. Picault in *B.S.H.A.F. 1951* (1952), 27–31. For C.-N. Cochin (1715–90) as an artist, see S. Rocheblave, *Charles-Nicolas Cochin* (Paris, 1927); some survey of Cochin's career is in Lady Dilke, *French Engravers and Draughtsmen of the XVIIIth century* (London, 1902), 37 ff.

51. Latour's comments to Diderot about Restout in *Diderot Salons*, IV, 85.

52. There is no modern monograph (but cf. C. p. 32 Saunier's chapter in Dimier, *op. cit.*, I, 61 ff.) and Lemoyne's work is widely scattered. What must remain uncertain at present is his exact role as a protagonist in decorative painting of the period. It is hard to estimate his easel pictures very highly, despite their charm.

53. See particularly Fontaine, *op. cit.* (Note 1), 237–9.

54. Adhémar, *op. cit.*, no. 137. p. 33

55. The history of this, seen in connexion specifically with Pellegrini, is given by C. Garas, *Bull. Mus. Hongrois des Beaux-Arts* (1962), 75 ff.

56. An interesting reference to Berger travelling p. 34 in Italy with 'un fort habile Peintre François' (obviously Lemoyne) is made in a letter of 28 July 1724 from Vleughels to the Abbé Grassetti at Modena; see G. Campori, *Lettere artistiche inedite* (Modena, 1866), 159.

57. The story is told vividly and at length in C. p. 36 Henry, *Mémoires inédits de Charles-Nicolas Cochin* (Paris, 1880), 115–24, 126.

58. Discussed in Furcy-Raynaud, *op. cit.*, 386 ff. p. 37

59. See C. Dreyfus in *B.S.H.A.F.* (1908), 108–9, and, better, the same author in *A.A.F.* (1908), 260 ff.

60. The anecdote is reported in for example Dézallier d'Argenville, 281.

61. A marble version of the terracotta was p. 38 recently acquired (1969) by the Walker Art Gallery, Liverpool; a reproduction in *The Times*, 31 October 1969.

p. 38 62. Henry, *op. cit.*, 93.

p. 40 63. Nevertheless, these tombs represent a style going out of date, despite which the *Mercure de France* in November 1738 was full of praise for the Forbin Janson tomb; see F. Ingersoll-Smouse, *La Sculpture funéraire en France au XVIII^e siècle* (Paris, 1912), 124–5.

p. 41 64. See for example the engraving reproduced by J. and A. Marie, *Marly* (Paris, 1947), 128. To the previously suggested sources for the *Chevaux de Marly* another one (Primaticcio-designed, destroyed frescoes in the Hôtel de Guise) is proposed by F. Hamilton Hazlehurst, *G.B.A.* (1965), 219–22.

65. *Vies . . .*, 309.

p. 42 66. Further on him see Dézallier d'Argenville, 246 ff. For his inventory at death, cf. L.-H. Collard in *B.S.H.A.F.* (1967), 193–210.

67. *Mémoires inédits*, II, 74.

p. 43 68. The phraseology of this minute is variously quoted; I have followed here that given by F. J. B. Watson, *Wallace Collection Catalogues: Furniture* (London, 1956), xxvi, where it is cited in a valuable discussion of the introduction of new decorative tendencies into French art of all kinds.

69. There is a brief mention of him in Dézallier d'Argenville, 252; he has remained a little-discussed figure, with a very restricted *œuvre*.

70. For some interest in the Dido theme, cf. P. Marcel, *La Peinture française au début du XVIII^e siècle 1690–1721* (Paris, n.d.), 202. For the whole Aeneid subject in French art cf. H. Bardan in *G.B.A.* (July–September 1950), 77 ff.

p. 44 71. Further for Le Pautre, see S. Lami, *Dictionnaire des sculpteurs de l'école française sous le règne de Louis XIV* (Paris, 1906), 322–4.

p. 45 72. Z. Zaretskaya and N. Kosareva, *La Sculpture française des XVII–XX siècles au musée de l'Ermitage* (Leningrad, 1963), plate 4.

73. For his activity in Spain, see Y. Bottineau, *L'Art de cour dans l'Espagne de Philippe V* (Bordeaux, n.d. [1961]).

74. For some additions see M. Beaulieu in *Jardin des Arts* (1956), 486 ff. A *Hebe* (Washington, National Gallery), once attributed to Lemoyne, seems to be the statue commissioned from Le Lorrain for Marly in 1729–31; Le Lorrain executed a tomb, for Joseph Benoît, in Saint-Pierre le Martoi, Orléans (destroyed): the description given by Dézallier

d'Argenville, 299–300, makes clear how different this was in concept from the Coustou-designed tombs. There was most markedly no image of the deceased.

75. The chief sources are the Abbé Gougenot in p. *Mémoires inédits*, II, 210 ff. (from which this quotation is taken), and Dézallier d'Argenville, 289 ff.

76. *Abecedario* (*op. cit.*, Note 17), III, 126. p.

77. It is only a tradition that the *Horses* are late work by Le Lorrain; that the date is likely to be one of two different periods (1713–18 or 1723–35) is shown by M. Beaulieu in *A.A.F.* (1950–7), 142–9.

78. Quoted by L. Réau, *Les Lemoyne* (Paris, p. 1927), 44; the letter is printed in *Mémoires inédits*, II, 228–30.

79. Illustrated in Réau, *op. cit.*, figure 20; a memorandum of July 1742 (Réau, 35) refers to the group as 'faite il y a longtemps'.

80. *Ibid.*, figure 10. p.

81. *Ibid.*, figure 21.

82. Bouchardon's comment is recorded by p. Cochin; cf. Henry, *op. cit.*, 92.

83. The king stood godfather to one of his children, at Lemoyne's wish, and a vivacious anecdote in this connexion is told by Dézallier d'Argenville, 357. It is very doubtful if Louis XV honoured any other sculptor in this way.

84. Réau, *op. cit.*, figure 43 for a bronze reduction; p. the full-scale monument was never executed. For the project in detail, cf. L. Courajod in *G.B.A.* (1875), 44 ff.

85. Réau, *op. cit.*, figure 36.

86. I am grateful to Mr Peter Marlow for in- p. forming me that a few mutilated fragments survive even today in the director's garden at the École des Beaux-Arts, Paris. For what is said further in the text concerning the tinting of the marble by Lemoyne, see Dandré-Bardon's *Mercure de France* article (March 1768), quoted by Réau, *op. cit.*, 66.

87. The incident is recorded by Dézallier p. d'Argenville, 359.

88. Cited by Réau, *op. cit.*, 117. In 1787 Dézallier p. d'Argenville commented darkly 'le brilliant de l'imagination, comme un piège dangereux, a trop souvent couvert le vice de ce qu'on appelle manière' (*Vies . . .*, 364). French sculpture might have benefited from falling into this 'trap' more

often. Lemoyne was still thought worth stigmatizing – 'maître dont le faux gout . . .' – in Chaussard's *Le Pausanias français* (Paris, 1806), 462, in contrast with Pajou.

89. Henry, *op. cit.*, 85.

p. 56 90. His drawn copies are in the Louvre: J. Guiffrey and P. Marcel, *Inventaire général des dessins de l'école française*, I (Paris, 1933), 96–100. Further light on his artistic interests is cast by the posthumous sale of December 1762 (Lugt, 1254), with brief but notable biography: he owned a Velázquez of Philip IV, Domenico Tiepolo's *Flight into Egypt* etchings, and one or more drawings by Piazzetta, in addition to a large quantity of miscellaneous engravings.

91. Cf. Dézallier d'Argenville: 'On souhaiteroit en général plus de feu dans ses sculptures' (*Vies . . .*, 327).

92. A whole series of works in the National Museum, Stockholm, including allegorical sculpture, a good bust of the architect Cronstedt, and the polychromed, charming – if considerably restored – full-length boy, the future Gustave III. The daughter Jacquette Bouchardon (1694–1756) remained a dutiful assistant and housekeeper to her father.

93. See the letter (item 12) quoted in the *Bouchardon* exhibition (Chaumont, 1962). To the older literature cited here should be added two important articles on Bouchardon by G. Weber, in *Revue de l'Art* (1969), 39 ff., discussing drawings and maquettes, and in *Wiener Jahrbuch für Kunstgeschichte*, XXII (1969), 120 ff., on the statues at Saint-Sulpice.

p. 57 94. D'Antin's letter is cited by A. Roserot, *Bouchardon* (Paris, 1910), 45.

95. Further on it see P. Metz and P. O. Rave in *Berliner Museen*, VII (1957), 19 ff. That such a bust is rather than an anticipation, a survival (to be compared with a bust of the fifth Earl of Exeter dated 1701, published in *The Connoisseur* (May 1958), 220), is claimed by H. Honour, *Neo-Classicism* (Harmondsworth, 1968), 193.

p. 58 96. For the Polignac bust (Musée de Meaux) see *Huit siècles de sculpture française, Chefs d'œuvre des musées de France*, exhibition catalogue (Paris, Louvre, 1964), no. 82.

97. *Vies d'artistes*, 90.

98. A letter of 4 September 1732 from Vleughels to the Abbé Grassetti at Modena praises Bouchardon, who carried the letter with him on his way

there, returning to France: 'le plus habile homme sans contredire qui soit au monde . . .'; Campori, *op. cit.* (Note 56), 175. For Bouchardon in Rome, see L. Réau in *A.A.F.* (1950–7), 142–9, and E. M. Vetter, 'Edme Bouchardon in Rom . . .', *Heidelberger Jahrbücher*, VI (1962), 51 ff.

99. Bouchardon probably prepared two models p. 59 for this commission, hoping not to share it with Adam (about whose work at Grosbois he wrote as scathingly as usual); his two terracotta models are in the Hermitage and the commission is usefully discussed by N. K. Kosareva in *Trudy gos. Ermitaža*, VI (Leningrad, 1961), 292–300.

100. *Lettre de M . . . à un ami de province au sujet de la nouvelle fontaine de la rue de Grenelle* (Paris, n.d.); letter on the *Amour* in *Mercure de France* (May 1750).

101. *Vies d'artistes*, 96. p. 60

102. Letter of 30 November 1752, to Gabriel; p. 61 Furcy-Raynaud, *op. cit.* (Note 46), 52–3. That the statue had had 'peu de succès' was to be recalled by Dézallier d'Argenville, 324.

103. Perhaps a more powerful reason was the fall of Orry and the rise of Madame de Pompadour; Orry had been associated with Fleury and was dismissed from the Bâtiments in December 1745. The final payment to Bouchardon for what he had executed (models, etc., see further in the text) was effected only in 1760.

104. More than three hundred of these drawings p. 62 are in the Louvre; Guiffrey-Marcel, *op. cit.* (Note 90), II.

105. But the final effect, as far as it can be judged, should be compared with such a study as the strikingly direct one of man and horse seen frontally (Guiffrey-Marcel, *op. cit.*, II, 924); cf. *Dessins français du XVIIIe siècle* (Paris, 1967), no. 39 and plate XXI, with full bibliography.

106. In this connexion Mr Allan Braham kindly drew my attention to the engravings in J. D. Le Roy, *Les Ruines des plus beaux monuments de la Grèce* (Paris, 1758), where plate XVII of the second part gives an elevation of the Erechtheum and plate XXI gives the caryatid porch in some detail; it is mentioned as 'le seul exemple antique' and as 'ignoré jusqu'ici', 19.

107. Roserot, *op. cit.* (Note 94), 120–1. p. 63

108. H. Thirion, *Les Adam et Clodion* (Paris, p. 64 1885), 62.

p. 64 109. For the history of the Fontana di Trevi, see H. Lester Cooke in *The Art Bulletin*, XXXVIII (1956), 149 ff. Adam's design is most fully discussed in the important article on him by Don Calmet in *Bibliothèque Lorraine* (Nancy, 1751), 8 ff.

110. Since Legros has been something of a casualty in the Pelican History of Art, it may be worth noting the discussion in L. Réau, *Les Sculpteurs français à Rome* (Paris, 1945), 45 ff.

p. 66 111. Further for this bust, and the tangled, not unamusing, circumstances surrounding its origin and refusal, see T. Hodgkinson in *Burl. Mag.*, XCIV (1952), 37–40.

112. Diderot's exclamation about Nicolas-Sébastien in *Diderot Salons*, II, 221.

113. On the other hand, Nicolas-Sébastien's *morceau de réception* was a *Prometheus*; for it and a previously unknown terracotta maquette, see P. Pradel in *Pays lorrain* (1958), 129–32.

p. 67 114. Some old photographs show the figure of the queen wearing a coronet, a mistake in over-zealous restoration which has now been removed.

115. Cited by Thirion, *op. cit.*, 165, derived from Dézallier d'Argenville, 384.

116. Ingersoll-Smouse, *op. cit.* (Note 63), plate VI. It is now generally accepted that this tomb is the work of Guidi.

117. In turn it is probable that Adam's maquette suggested the Slodtz' concept for the *pompe funèbre* of Catharina Opalinska; F. Souchal, *Les Slodtz, sculpteurs et décorateurs du roi* (Paris, 1967), plate 53a.

p. 68 118. That he had seen it, doubtless when travelling to or from Italy, is established by Cochin; Henry, *op. cit.* (Note 57), 116.

119. A curt entry for 'Michelangelo Slode' in the *Dizionario delle belle arti* (Bassano, 1797), II, 243.

p. 69 120. Even Milizia, *op. cit.* (previous Note), II, 242, had to admit of the Icarus 'è stimato', and that Paul-Ambroise's work at Saint-Sulpice was 'di qualche pregio'.

121. Souchal, *op. cit.*, plate 36a and b.

p. 70 122. *Correspondance des Directeurs*, VII, 482.

123. These busts are published and discussed by Souchal in *B.S.H.A.F.* (1961), 85–96.

p. 71 124. Perhaps it is more than accidental that hints towards the concept can be found in the work of Legros; cf. his St Philip Neri in San Girolamo della Carità (Réau, *op. cit.* (Note 110), plate 10), with its swinging draperies and fluid, expressive gestures.

125. The documents were first published by G. p. 7 George in *Réunion des Sociétés des Beaux-Arts*, XX (1896), 325 ff.; they show incidentally how closely involved Detroy was in approval of the scheme.

126. The phrase is recorded by Cochin; Henry, p. 7 *op. cit.* (Note 57), 91.

127. To the assembly of Slodtz' work in Souchal, *op. cit.*, a previously unrecognized marble bust of Detroy (Victoria and Albert Museum) is added by T. Hodgkinson in reviewing that monograph, *Burl. Mag.*, CXI (1969), 159–60.

CHAPTER 2

1. Apart from what is cited elsewhere in this p. 75 book, see also J. Seznec, *Essais sur Diderot et l'antiquité* (Oxford, 1957). It should also be remembered that Diderot's Salon reviews were intended to be read out of France; they were not available in print until the very end of the century (1795) and are likely to have been less influential, or at least less discussed, than brochures printed at the time and articles published in periodicals in Paris. It should also be noted that Grimm sometimes intervened with his own gloss on what Diderot had said, sometimes very effectively, e.g. 'Les Carraches, les Tintorets, les Dominiquins gâtent bien des tableaux français quand on se les rappelle' (Salon of 1763).

2. *Diderot Salons*, II, 224.

3. The circumstances are vividly recalled by Rousseau himself in the *Confessions*, II, 8.

4. See for example E. Bourgeois, *Histoire du* p. 76 *biscuit de Sèvres au XVIIIe siècle* (Paris, 1909).

5. La Live de Jully's remarks cited by L. Réau, *Étienne-Maurice Falconet*, I (Paris, 1922), 75.

6. On Allegrain, see S. Lami, *Dictionnaire des* p. 77 *sculpteurs de l'école française au XVIIIe siècle* (Paris, 1910–11), I, 22–5.

7. In an undated letter of *c.* 1755: Furcy-Raynaud, *op. cit.* (Chapter 1, Note 46), 31.

8. The circumstances of the monument's state at p. 79 the time are revealed by d'Angiviller's letter of 12 August 1777 to Pierre, *N.A.A.F.* (1906), 132.

9. The archbishop of Sens had been his tutor.

10. *Projets de tombeau*: cited by E. F. S. Dilke, 'Les Coustou', *G.B.A.* (1901), I, 210, note 3.

11. Nevertheless, there seem some clear hints towards it to be found in the urn and mourning figures which form part of the Slodtz' design for the *pompe funèbre* at the death of another dauphine, Marie-Thérèse d'Espagne, in 1746 (engraved by Cochin and here Plate 70).

p. 80 12. *Diderot Salons*, I, 137.

p. 81 13. Vassé is discussed by L. Réau in *G.B.A.* (1930), 31 ff.

14. See for example V. Sloman, 'Nogle Medailler og Plaketter efter Saly', in *Kunstmuseets Aarsskrift*, XVI–XVIII (1931), 199 ff.; a portrait of Saly by Juel is reproduced by J. Rubow in *Kunstmuseets Aarsskrift*, XXXIX–XLII (1956), 100. For the Frederick V statue, see H. Friis in *Artes* (Copenhagen), I (1932), 191 ff.

p. 82 15. The identity of the sitter is discussed by M. Levey in *Burl. Mag.*, CVII (1965), 91.

16. Further cf. L. Réau, 'Le Faune au chevreau de Saly', in *B.S.H.A.F.* (1924), 6 ff.

17. It should perhaps be recalled that the Amalienborg was intended to be not a royal palace but houses for noblemen; it is a piece of urban planning comparable to the Praça do Comercio in Lisbon or the Place de la Concorde in Paris.

p. 83 18. Letter of 17 March 1766: Y. Benot, *Diderot et Falconet, le Pour et le Contre* (Paris, 1958), 156.

19. Marie-Anne Collot, though edged out here, was a talented portrait sculptor; in addition to her *Falconet*, she worked on the *Peter the Great* head for the equestrian statue. Her work and career are discussed by L. Réau in *B.S.H.A.F.* (1924), 219 ff. See also H. N. Opperman, 'Marie-Anne Collot in Russia: Two Portraits', in *Burl. Mag.*, CVII (1965), 408 ff.

20. The fact is mentioned by Réau in publishing part of Falconet's inventory at death in *B.S.H.A.F.* (1918/19), 164.

p. 85 21. Cited by Réau, *op. cit.* (Note 5), I, 211.

p. 86 22. The myth is interestingly discussed by J. L. Carr, 'Pygmalion and the *Philosophes*', in *J.W.C.I.*, XXIII (1960), 239 ff.

p. 87 23. *Diderot Salons*, I, 245.

p. 88 24. Given Falconet's distinct admiration for Rubens (for some of his favourable comments on whom see A. B. Weinshenker, *Falconet: His Writings and his Friend Diderot* (Geneva, 1966), 15–16, 85, 108), it is possible that he may have

drawn some general inspiration from Rubens–Van Dyck compositions of the subject (e.g. Vienna and London); Falconet showed a good deal of awareness of works of art he had not actually seen – not hesitating to criticize them.

25. Weinshenker, *op. cit.*, 6, seems wrong in claiming that 'many artists tried to obtain the commission'. Several set estimates so high as to amount to refusals: Pajou, 600,000 Livres; Coustou, 450,000; etc. Catherine was offering only 300,000: see F. Vallon, *Falconet: Falconet et Diderot, Falconet et Cathérine II* (Senlis, 1927), 88. For comparison it may be worth noting that Pigalle was finally paid 98,184 Livres for the Saxe monument.

26. Letter from Falconet to Marigny, quoted by Réau, *op. cit.* (Note 5), I, 79.

27. Benot, *op. cit.*, 157.

28. Quoted by Réau, *op. cit.*, II, 360. p. 89

29. It is discussed and more favourably judged p. 91 by M. Charageat in *La Revue des Arts* (1953), 217 ff.

30. L. Réau, *J. B. Pigalle* (Paris, 1950), plate 15. p. 92

31. *Ibid.*, plate 23.

32. See M. Levey in *Burl. Mag.*, CVI (1964), 462–3.

32a. For an interesting discussion of Pigalle's p. 93 work for Madame de Pompadour, see K. K. Gordon in *The Art Bulletin*, L (1968), 249 ff.

33. The point already published by Patte, *Monu- p. 95 mens érigés en France* (Paris, 1765): there are no slaves at the feet of this monarch, 'dont l'humanité est l'âme de tous les actions'; 174–5.

34. 'Correspondance de M. de Marigny', p. 96 *N.A.A.F.*, XIX (1904), 34; the fullest documentation of the protracted arrangements from 1751 to 1777 in Furcy-Raynaud, *op. cit.*, 272 ff.

35. In fact, immortality is symbolized by the p. 97 pyramid against which the drama takes place; nevertheless, the visual effect is that one concentrates on the action, taking little notice of the background pyramid. What is noticeably lacking is any religious imagery as such.

36. *Op. cit.* (Note 33), 16.

37. On the family, see J. Guiffrey, *Les Caffiéri* p. 98 (Paris, 1887).

38. The portrait (signed and dated 1785) is now p. 100 at Boston.

p. 100 39. Terray succeeded Marigny (Ménars) in July 1773 and was replaced by d'Angiviller in August 1774. For the whole series cf. the exemplary discussion in T. Hodgkinson, *The James A. de Rothschild Collection at Waddesdon Manor: Sculpture* (Fribourg, 1970), 16–19.

40. Further for Tassaert, cf. L. Réau in *Revue Belge d'Archéologie et d'Histoire de l'Art*, IV (1934), 289 ff.

p. 101 41. Defernex is discussed by L. Réau in *G.B.A.* (1931), I, 349 ff.

42. Further for this bust, see *Huit Siècles de sculpture française* (*op. cit.*, Chapter 1, Note 96), no. 81.

p. 102 43. Reproduced by H. Stein, *Augustin Pajou* (Paris, 1912), 389.

p. 103 44. An interesting biography, 'Notice inédite et historique sur la vie et les ouvrages de M. Augustin Pajou', in *Le Pausanias français* (Paris, 1806), 462 ff.

45. His drawings, particularly those at Princeton, are studied by M. Benisovich in *The Art Bulletin*, XXXV (1953), 295 ff., and *Record of the Art Museum, Princeton University*, XIV (1955), 9 ff.

46. The relief appears prominently in Roslin's portrait of *General Ivan Betskoi* (signed and dated 1758), which was in the Count Thure Bonde sale, Sotheby, 25 November 1970 (lot 83).

p. 104 47. The bronze is in the Louvre; a terracotta in the Musée de Nantes.

p. 105 48. Pajou's remarks to d'Angiviller on the Psyche (letter of February 1783) in Stein, *op. cit.*, 350.

p. 107 49. Apart from Marigny's official correspondence, which sometimes includes orders for Madame de Pompadour, a good deal can be learnt about brother and sister from E. Campardon, *Madame de Pompadour et la cour de Louis XV* (Paris, 1867); see also E. Plantet, *La Collection de statues du Marquis de Marigny* (Paris, 1885), which provides a good biography. The mood of these years is well set by the note at the front of the Salon *livret* for 1755 (by Cochin?), saying how happy the arts are when honoured by the 'puissante protection d'un monarque ... dirigés avec lumière & que les graces (sources de l'émulation) sont dispensées avec un choix judicieux'.

50. The painting in the Musée Arbaud, Aix-en-Provence; the drawing in the Louvre, cf. *Dessins français du XVIIIᵉ siècle* (Paris, 1967), no. 45, with full discussion.

51. L. Courajod, *L'École royale des élèves protégés* (Paris, 1874), 32, for the appointment of Van Loo. Courajod prints the statutes of the École, 18 ff.

52. Other pictures for the chapel, exhibited in p. 1 the same year, included 'St Louis carrying the Crown of Thorns' by Hallé; 'The Interview between St Louis and Pope Innocent IV' by Lagrénée; 'St Louis attacked by Illness' by Doyen, for the high altar; and 'St Louis administering Justice under an Oak Tree' by Lépicié.

53. *Abecedario* (*op. cit.*, Chapter 1, Note 17). p. 1

54. Some discussion of his early work, and p. 1 influences on it, by H. Voss in *Burl. Mag.*, XCV (1953), 81 ff., XCVI (1954), 206 ff.

55. A fine Berchem (1005) owned by Boucher is now in the National Gallery, London.

56. The subject is not totally relevant here, but p. 1 see particularly, for emphasis on the French connexions, A. Griseri in *Paragone*, XII (1961), 42 ff.: 'Il Rococó a Torino e Giovan Battista Crosato'.

57. See J.-P. Babelon, *Les Archives nationales,* p. 1 *Notice sur les bâtiments* (Paris, 1958), *passim*.

58. Boucher's work for the Crown (that is, Louis XV, Marie Leczinska, and Marigny in his official capacity) is documented in F. Engerand, *Inventaire des tableaux commandés et achetés par la Direction des Bâtiments du Roi (1709–1792)* (Paris, 1900), 39 ff.

59. On this point see *Wallace Collection Cata-* p. 1 *logues: Pictures and Drawings* (London, 1968), 41.

60. G. Duplessis, *Mémoires et journal de J.-G.* p. 1 *Wille* (Paris, 1857), I, 470; Boucher's treasure house of possessions may best be appreciated from this posthumous sale catalogue, Paris, 18 February ff. 1771: 'Catalogue raisonné des Tableaux, Dessins, Estampes, Bronzes, Terres cuites, Laques, Porcelaines de différentes sortes ... Meubles curieux, Bijoux, Minéraux, Cristallisations, Madrepores, Coquilles et Autres Curiosités ...'.

60a. The reference, comparing Boucher's work p. 1 to 'cette fade poésie galante de Dorat', quoted by P. de Nolhac, *Boucher* (Paris, 1925), 197.

61. Pierre-Antoine Baudoin (1723–69) painted only gouaches. He is not remembered for his *Life of the Virgin* illustrations, or those for the Epistles and Gospels, but for much-engraved compositions like *L'Épouse indiscrète* and *Le Carquois épuisé*, treated as if by Saint-Aubin sharing the obsessions of Fragonard. 'Petit genre lascif ...' was

the priggish verdict on his work in Grimm's *Correspondance littéraire* (15 June 1770), remarking of the dead artist, 'épuisé par le travail et les plaisirs': cited by Lady Dilke, *French Painters of the XVIIIth Century* (London, 1899), 131, note 4.

62. Nougaret, *Anecdotes des Beaux-Arts* (Paris, 1776), II, 227.

p. 116 63. This is not merely a modern judgement. Although Marmontel is sometimes instanced as an example of superior literary attitudes to practitioners of the visual arts, his comments on Van Loo remain pointedly apt: 'l'inspiration lui manquait, et pour y suppléer il avait peu fait de ces études qui élèvent l'âme, et qui remplissent l'imagination de grands objets et de grandes pensées': *Mémoires de Marmontel* (Paris, 1878), 235.

64. The family background, but chiefly Carle himself, dealt with by L. Réau in *A.A.F.* (1938), 9 ff.

p. 117 65. The picture, along with preparatory drawings, is studied by F. H. Dowley in *Master Drawings*, V (1967), 42–7.

p. 119 66. At the Salon of 1750 Van Loo exhibited what may be presumed to be a sub-Boucher style 'Tableau de Paysage orné de Figures et d'Animaux; il a 8 pieds de large sur 3 et demi de haut'.

67. The engraving by Meckel of this composition is reproduced in *Diderot Salons*, I, plate 25.

68. Further for Natoire, see the catalogue raisonné by F. Boyer in *A.A.F.*, XXI (1949), 31 ff., and M. Sérullaz, 'Recherches sur quelques dessins de Charles Natoire', in *Revue des Arts* (1959), 65ff.

p. 120 69. Trémolières and Subleyras are discussed in Dimier, *op. cit.*, respectively I, 267 ff., and II, 49 ff.

70. Rivalz is probably most familiar from the *Self-Portrait* (Toulouse, Musée des Augustins), which conveys a good deal about his style and his personality; further for this picture, with bibliographical references, see *Paris et les ateliers provinciaux au XVIIIe siècle*, exhibition catalogue (Bordeaux, 1958), 103–4.

p. 121 71. For Pierre see further J. Locquin, *La Peinture d'histoire en France de 1747 à 1785* (Paris, 1912), *passim*, and 184–7 especially.

72. The letter (containing some other memorable phrases, 'en vain, par des règlements, on exigera pour l'avancement de la peinture, que l'on se lève à telle heure ... tous ces ordres, fussent-ils émanés du Père Éternel (pardon de la comparaison) tout

cela est rien') is quoted by Locquin, *op. cit.*, 114. It is a pity that Lagrénée's own pictures were not as bold as his words.

73. Vien's extraordinary *Mémoire* (of 22 nivôse, p. 122 An III) is published by G. Vautier in *B.S.H.A.F.* (1915–17), 124 ff. The highest tributes to Vien come, significantly, from the end of his career – e.g. P. Chaussard's *Le Pausanias français* (1806), 39 ff.

74. Locquin, *op. cit.*, 191–3. The arrival of Vien on the artistic scene was warmly welcomed, cf., for example, *Jugement d'un amateur sur l'exposition des tableaux* (Paris, 1753), 53: 'il y a un M. Vien très jeune encore qui donne les plus belles espérances ...'. La Font, *Sentimens ...* (Paris, 1754), 46 ff., was no less complimentary.

75. *Diderot Salons*, I, 119.

76. The evidence is on one of Blarenberghe's p. 123 miniatures showing the interior of the Hôtel Crozat de Châtel, absorbingly discussed by F. J. B. Watson, *The Choiseul Box* (Charlton Lecture on Art) (London, 1963).

77. *Mémoires inédits*, II, 351. p. 124

78. P. de Nolhac, *Nattier* (Paris, 1925), 145. p. 126

79. *Ibid.*, 219.

80. Madame Roslin, née Marie-Suzanne Giroust p. 128 (1734–72), also deserves a mention. She married Roslin in 1759, was active as a portraitist in pastel, and was received at the Académie in 1770, presenting her highly accomplished portrait of Pigalle (Louvre), which was shown at the Salon the following year and praised by Diderot.

81. Cited by G. Wildenstein, *Le Peintre Aved* (Paris, 1922), I, 86–7.

82. Further for this portrait and some others by p. 129 Nonotte, see *Paris et les ateliers provinciaux (op. cit.*, Note 70), 45–6.

83. The family is discussed in C. Gabillot, *Les* p. 131 *trois Drouais* (Paris, 1906). For some portraits by F.-H. Drouais of children dressed as Savoyards, see E. Munhall, 'Savoyards in French Eighteenth-Century Art', *Apollo* (February 1968), 86 ff.

84. 'Le plus beau paysage fût il du Titien et du p. 132 Carrache ne nous émeut pas plus que le ferait la vue d'un canton de pays affreux ou riant: il n'est rien dans un pareil tableau qui nous entretienne, pour ainsi dire': *Réflexions sur la poésie et sur la peinture* (Paris, 1733 ed.), I, 52. Such opinions are the very opposite of Diderot's – in the middle of a presumed prosaic age – but not perhaps so very

far from Baudelaire's, whose reserves on the category of landscape are made plain in his review of the Salon of 1859.

p. 133　85. Marigny's letter of 9 October 1756 is printed by L. Lagrange and A. de Montaiglon in *A.A.F.*, VII (1855–6), 153.

p. 134　86. To those under discussion in the text should be added Jacques Volaire (1729–1812), born either at Nantes or Toulon, active largely in Italy, and dying at Naples. He made something of a speciality of dramatic night scenes with Vesuvius in eruption (a good example is in the Musée de Nantes) which tend to become monotonous on repetition.

p. 135　87. It is interesting to find that two of his landscape drawings were owned by Boucher (1771 sale, lot 1858).

88. G. Wildenstein, *Chardin* (Paris, 1933), 138–9; in fact, d'Angiviller softened this very phrase in the letter he sent Chardin, speaking of 'genres qui sont également difficiles, ou qui le sont même davantage'.

p. 137　89. The artistic affinity between Rembrandt's *Flayed Ox* and Chardin's work is touched on by C. Sterling, *Still-Life Painting* (Paris, 1959), 88.

p. 138　90. For Bouys, see M. Faré in *La Revue des Arts* (1960), 201 ff.

91. Notably sales by Andrew Hay and Geminiani, London, where between 1738 and 1743 are to be found such subjects as *A Girl with Cherries*, *A Boy at his Drawing*, *A Girl at Needlework*, *A Woman with a Frying Pan*, *Savoyards Dancing*, *A Boy playing with a Totum*, and *Dead Game*.

p. 141　92. Reported by Haillet de Couronne, whose *Éloge*, based on recollections by Cochin, was read to the Académie in 1780: *Mémoires inédits*, II, 441.

p. 142　93. Several of these, in the collection of Earl Beauchamp, were lent to the R.A. exhibition, *France in the Eighteenth Century* (1968), nos. 345–9.

p. 143　94. Catalogue raisonné in the posthumous article of P.-G. Dreyfus, *B.S.H.A.F.* (1922), 139 ff.

p. 144　95. He lacks, however, as yet an adequate modern biographer. There are two articles discussing him by A. Brookner in *Burl. Mag.*, XCVIII (1956), 157 ff., 192 ff. Other important recent studies include E. Munhall, 'Greuze and the Protestant Spirit', *Art Quarterly* (1964), 3 ff., and *idem*, 'Quelques Découvertes sur l'œuvre de Greuze', *Revue du Louvre* (1966), 85 ff.; see also W. Sauerländer, 'Pathosfiguren im Œuvre des Jean-Baptiste Greuze', *Festschrift W. Friedlaender* (Berlin, 1965), 146–50.

96. See further particularly E. Munhall, 'Les Dessins de Greuze pour Septime Sévère', *L'Œil* (April 1965), 23 ff., and J. Seznec, 'Diderot et l'affaire Greuze', *G.B.A.* (1966), I, 339 ff. 〔p. 1〕

97. See R. Rosenblum, *Ingres* (New York, n.d.), 60, where the Greuze portrait is reproduced. 〔p. 1〕

98. For Noël and earlier generations of the family, see O. Estournet, *La Famille des Hallé* (Paris, 1905). Although older than Hallé and the painters under discussion, Michel-François Dandré-Bardon (1700–83) may find a place here. He was born at Aix-en-Provence, visited Italy, and was *agréé* at the Académie in 1735; his paintings (several at Aix) are less relevant than his teachings and writings, which may be supposed the more influential for his position as professor of history at the École des élèves protégés. His own practice in dealing with antique classical subject matter may be gauged from the *Tullia* (Musée de Montpellier), which is more 'Baroque' than 'neo-classical': this is not surprising, since he was the author of the *Apologie des allégories de Rubens et de Le Brun* (Paris, 1777), read to the Académie that year and heard 'avec plaisir'.

99. Locquin, *op. cit.* (Note 71), *passim*. His pre-Russian work is studied by M. Sandoz in *B.S.H.A.F.*, *1958* (1959), 75 ff. 〔p. 15〕

100. For his activities then see H. Stein, 'Le Peintre Doyen et l'origine du Musée des Monuments français', in *Réunion des Sociétés des Beaux-Arts* (1888), 238 ff.

101. Aspects of Lagrénée have been studied by M. Sandoz, 'Paintings by Lagrénée the Elder at Stourhead', *Burl. Mag.*, CIII (1961), 392–5, and 'The Drawings of Louis-Jean-François Lagrénée', *Art Quarterly* (1963), 47 ff.

102. Deshays as a history painter is studied by M. Sandoz in *B.S.H.A.F.*, *1958* (1959), 7 ff.

103. Brenet is fully discussed by M. Sandoz in *B.S.H.A.F.* (1961), 33 ff. 〔p. 15〕

CHAPTER 3

1. He has also been dealt with by F. Novotny in the Pelican History of Art volume *Painting and Sculpture in Europe: 1780–1880*, 2nd ed. (Harmondsworth, 1972), 210–11. 〔p. 15〕

2. This point must be borne in mind by those who wish to deny, for example, any political awareness in David before 1789. In the summer of

1787 Arthur Young (*Travels in France and Italy* ... (London, 1927 ed.), 80) found at a Parisian dinner-party that 'One opinion pervaded the whole company, that they are on the eve of some great revolution in the government ... a strong ferment amongst all ranks of men, who are eager for some change: and a strong leaven of liberty, increasing every hour since the American revolution.'

154 3. For Dumont's *Liberty*, see Lami, *op. cit.* (Chapter 2, Note 6), I, 303.

155 4. On which see L. Roger-Milès, *Les Dianes de Houdon et les caprices de la pudeur esthétique à la fin du XVIII*e *siècle* (Paris, 1913).

5. *Diderot Salons*, III, 318.

6. It is discussed at length by F. H. Dowley in *The Art Bulletin*, XXXIX (1957), 259 ff.

7. It and a terracotta maquette reproduced by L. Réau, *Houdon, sa vie et son œuvre* (Paris, 1964), II, plates 34A and B.

156 8. D'Angiviller's letter to Pierre (of 5 October 1779) in *N.A.A.F.*, XXI (1906), 265.

157 9. H. Thirion, *Les Adam et Clodion* (Paris, 1885), 241, 243, 387, for what follows about early collectors of Clodion's work (the date of Boucher's posthumous sale is given wrongly).

158 10. Roman terracottas were purchased for Charles Townley by Nollekens, and brought back to England in 1770: M. Whinney, *Sculpture in Britain: 1530–1830* (Harmondsworth, 1964), 158.

159 11. Thirion, *op. cit.*, 388.

12. The brothers were Sigisbert-François (1728–1811), Sigisbert-Martial (1727–after 1785), Nicolas (b. 1733), and Pierre-Joseph (b. 1737). The considerable problems of connoisseurship connected with work signed 'Clodion' await investigation.

160 13. A relief, signed and dated 'CLODION in Carare 1773', is published in an article, with new letters, by A. Griseri in *The Connoisseur* (April 1961), 164 ff.; a relief related in style and subject (signed and dated 1776) is now in the Fitzwilliam Museum, Cambridge.

14. 'On l'a félicité de ne s'être point asservi au costume, et je crois, au contraire, un reproche qu'on peut lui faire, parcequ'il n'est pas question de draper la statue d'un Français du XVIIIe siècle à la grecque, à la romaine, ou de lui donner un costume idéal, mais de la représenter avec le costume de la nation et du temps où il a vécu'; *L'Année littéraire* (1779), cited by Thirion, *op. cit.*, 311.

15. Further for these two modelli see P. Reming- p. 161 ton in *Metropolitan Museum of Art Bulletin*, N.S. II (1943–4), 241 ff.; for the proposed scheme and competition Furcy-Raynaud, *op. cit.* (Chapter 1, Note 46), 417 ff.

16. *Tableaux de la Révolution* (1793), cited by Thirion, *op. cit.*, 346.

17. Cf. the attitude of *Le Pausanias français* p. 162 (1806), 488, speaking of Clodion's contribution to the Salon of that year: 'dans un âge où l'on ne change guère de manière, a cherché à s'élever jusqu'au style sévère qui s'est introduit dans l'École'.

18. Compare, for example, Marin's *Head of a Bacchante* (signed and dated 1786) in the Victoria and Albert Museum (reproduced in H. D. Molesworth, *Baroque, Rococo and Neo-classical Sculpture* (London, 1954), plate 44) and also there a group of *Bacchante and Cupids* (*sic*) (dated 1793).

19. Published by M. Beaulieu, 'Terre cuites de Clodion', in *Revue du Louvre* (1961), 95-6.

20. Remembering that Falconet's *Milo* was p. 164 criticized at the Académie for supposedly being plagiarized from Puget's very different group, it is by no means unlikely that an implication of plagiarism was made against Julien – and, on the face of it, more reasonably – in connexion with Coustou's *Ganymede*.

21. The comment on Julien's *Gladiator* by the Continuateur de Bachaumont is recorded by A. Pascal in *G.B.A.* (1903), I, 333.

22. Considerably more effective, and somewhat less disconcerting in its environment, than photographs usually suggest. Bridan began the *Assumption of the Virgin* group in Italy in 1768 (Réau, *op. cit.* (Chapter 1, Note 110), 86, gives, by a printing error, 1708) and in a memorandum of c. 1797 (printed by Furcy-Raynaud, *op. cit.*, 68-9) claims that he was commissioned by the Chapter of Chartres that year. As well as the *Vauban*, he executed a *Bayard* for the 'grands hommes' series, finished in 1793 and signed by the sculptor as 'Citoyen Français'. The cathedral at Chartres provides a link between Bridan and his near-contemporary Pierre-François Berruer (1733–97), by whom are two signed reliefs there. Berruer executed *D'Aguesseau* (Salon of 1779) in the 'grands hommes' series; he was also the sculptor of the model (Salon of 1785) of an interesting-sounding cenotaph in honour of those who fell in the American war: 'Patriotism uncovers the monument of their glory ... and shows that these brave

officers died for the freedom of America who, filled with gratitude, holding the emblem of liberty, gives them crowns and the order of Cincinnatus.' Not the least interesting aspect of this is the date at which it was shown, for it is most probable that the American Revolution played its part, even artistically, in stimulating a new sense of French patriotism. In 1784 the Toulouse painter Suau gained first prize at the Academy there with a glorification of *American Independence*: Locquin, *op. cit.* (Chapter 2, Note 71), 282.

p. 165 23. The whole scheme is discussed by J. Langner in *Art de France* (1963), 171 ff.

p. 166 24. Some discussion of Mouchy in L. Réau, *J. B. Pigalle* (Paris, 1950), 133-4.

25. Further for the statue and the correspondence concerning it, cf. Furcy-Raynaud, *op. cit.*, 232-4. Cochin's comment on it cited by Réau, *op. cit.* (1950), 134.

26. For Boizot see Lami, *op. cit.* (Chapter 2, Note 6), I, 85 ff.

p. 167 27. See the quotation from this *Éloge* in *Dessins de sculpteurs de Pajou à Rodin*, exhibition catalogue (Paris, Louvre, 1964), 13; further for Moitte's activity, see H. Thirion, *Le Palais de la Légion d'Honneur* (Versailles, 1883), 83 ff.

28. Furcy-Raynaud, *op. cit.*, 409.

p. 169 29. Chaudet remains an under-studied figure (the days being gone when there was a Salle de Chaudet at the Louvre); Chinard has recently been the subject of several articles by M. Rocher-Jauneau, including a convenient general introduction to his work in *Apollo* (September 1964), 220 ff.

p. 170 30. Noticed and praised, along with the model of Moitte's *Cassini*, and Julien's of *Poussin* (i.e. work by established men), in the *Journal de Paris* (supplement for 16 November 1789).

31. P. Vitry, 'Un Album des dessins du sculpteur Chaudet', *B.S.H.A.F.* (1924), 27, though this is hardly more than a mention of the album's existence; see further *Dessins de sculpteurs* ... (1964), no. 4

32. According to P. Vitry, *La Sculpture française classique* (Paris, 1934), 110, this is the work of P. Cartellier (1757-1831).

p. 171 33. Reproduced by Rocher-Jauneau, *loc. cit.*, figure 1.

p. 172 34. Quoted by J. C. Herold, *Mistress to an Age* (London, 1959), 284.

35. For this bust see further the catalogue *Huit siècles de sculpture française* (Chapter 1, Note 96), no. 87.

36. Quoted by Réau, *op. cit.* (Note 7), I, 492. p.

37. Recent re-appraisal of this statue on the spot inclines me to modify this judgement somewhat. Although what is said in the text seems true to the frontal view of the figure, when seen from the side – as first approached – there is a vivid 'disturbed' quality about the draperies which would probably be still more apparent if the statue did not stand in a niche.

38. L. Réau, *Houdon* (Paris, 1930), 23.

39. Réau, *op. cit.* (Note 7), I, 180. p.

40. There is a passing, previously unremarked English reference to him as 'Heudone' in Desenfans' preface to his sale, London, 8 April ff. 1786, viii: 'A famous sculptor sent by the King of *France* last year to America to make the statue of General *Washington*.'

41. Réau, *op. cit.* (Note 7), I, 230. p.

42. *Souvenirs de Madame Vigée Le Brun* (Paris, p. n.d. [1891]), I, 50.

43. See further M. Jallut, *Marie-Antoinette and her Painters* (Paris, n.d.).

44. It may be pertinent to quote a scholar who p. has very closely studied the period in France: 'In terms of quantity alone, in fact, there is enough Rubensian and Rococo survival, or revival, in classical history painting of the late eighteenth century to warrant considerable modification of prevailing ideas about the hegemony of Neoclassic style at the time': R. Rosenblum, *Transformations in Late Eighteenth Century Art* (Princeton, 1967), 54, note 13.

45. *L'Année littéraire* (Paris, 1777), VI, 313-14. p.

46. *Correspondance des Directeurs* (letter of 27 p. August), XI, 354.

47. For the change from Fragonard to Vien, p. suggesting that new classicizing tastes lay behind Madame du Barry's change, cf. F. M. Biebel in *G.B.A.* (July–December 1960), 207 ff.; also the discussion in *The Frick Collection, Illustrated Catalogue: The Paintings* (New York, 1968), II, 94 ff.; for the iconography cf. W. Sauerländer in Munich *Jahrbuch* (1968), 127 ff.

48. Including etching; see G. Wildenstein, p. *Fragonard aquafortiste* (Paris, 1956).

183 49. It will therefore be avoided here; but those who still suspect that the eighteenth century was indifferent to the charms of 'nature' should begin with Linnaeus; a remarkable passage of his, dating from 1732, is accessibly quoted by P. Hazard, *European Thought in the Eighteenth Century* (Harmondsworth, 1965), 378.

186 50. It may be compared, as a likeness, with Houdon's busts of Gluck which originate with a plaster bust (destroyed), shown at the same Salon of 1775. Gluck's interest in the painting is documented by his letters; cf. H. and E. H. Müller von Asow (eds.), *Collected Correspondence and Papers of Christoph Willibald Gluck* (London, 1962), 61, 71, 195, 202.

51. For Duplessis' *d'Angiviller* see *France in the Eighteenth Century*, exhibition catalogue (London, Royal Academy, 1968), no. 212. For a full biography of the sitter, see J. Silvestre de Sacy, *Le Comte d'Angiviller, dernier directeur des bâtiments du roi* (Paris, 1953); *op. cit.*, 49 ff., for his directorship.

52. See R. Portalis in *G.B.A.*, XXVI (1901), 354.

187 53. See J. Cailleux in *L'Art du dix-huitième siècle*, supplement to *Burl. Mag.*, CXI (March 1969).

54. Jallut, *op. cit.* (Note 43), 54.

188 55. For these exchanges of letters, see *N.A.A.F.*, XXII (1907), 205–6, 225–6.

56. Further see F. Ingersoll-Smouse, 'Quelques tableaux de genre inédits par Étienne Aubry', in *G.B.A.* (1925), I, 77 ff.

189 57. These three, after David, are claimed as the best in a letter of 1787 from Cochin to d'Angiviller: J. J. Guiffrey, *Notes et documents inédits . . .* (Paris, 1873), 97.

190 58. Guiffrey, *op. cit.* (1873), 85; the letter was something of a snub, as Cochin had said how obvious it was that David's picture was the better one.

59. Molé was to reappear in the 'grands hommes' series of statues, a commission given to Étienne Gois (1731–1823), a Parisian pupil of Slodtz; the plaster model was shown at the Salon of 1785, the not-quite-completed marble at that of 1789 (reproduced in Furcy-Raynaud, *op. cit.*, plate VI). Gois received several other official commissions (including a bust of Louis XVI) and was referred to by d'Angiviller in 1776 as 'un des nos artistes les plus distingués'.

60. For a reproduction of it and some discussion, see Rosenblum, *op. cit.*, 22 ff. (and figure 19).

61. The reports of the Académie on inspecting p. 192 David's work sent back from Italy are published in *A.A.F.*, I (1852), 339 ff.

62. In August 1763 the French chargé d'affaires at Rome sent back to Paris fairly detailed reports, for publication in the *Gazette littéraire*, of two pictures just finished by Hamilton, *Achilles dragging Hector's Body round the Walls of Troy* and *The Death of Lucretia*. Of the former he reported 'Ce tableau excite également des mouvemens d'horreur et de compassion'. See *Correspondance des Directeurs*, XI (1901), 475.

63. *Diderot Salons*, IV, 377–8. p. 193

64. See F. Hamilton Hazlehurst, 'The Artistic Evolution of David's Oath', in *The Art Bulletin*, XLII (1960), 59 ff., and A. Calvet, 'Unpublished Studies for "The Oath of the Horatii" by Jacques-Louis David', in *Master Drawings*, VI (1968), 37 ff., where a drawing (Albertina) is published which bears the date *1781* and shows Horatius returning in triumph to Rome, with the spoils of the Curiatii and with Camilla's dead body in the foreground. This is a clumsy mingling of public and private concerns – artistically speaking – but interesting evidence for the date at which David began considering the Horatius story.

65. On this point, attitudes to human nature as p. 194 well as to art history are involved. The strongest case for seeing nothing proto-revolutionary in David's work up to 1789 is made by L. D. Ettlinger, 'Jacques Louis David and Roman Virtue', in *Journal of the Royal Society of Arts* (January 1967), 105 ff. Unfortunately, this is marred by several factual mistakes (e.g. David in the company of Caylus (died 1765!) while in Italy) and by some generalizations which are no more acceptable, e.g. that in 1785 no one had yet in France 'seriously considered the abolition of the monarchy'. Perhaps Rousseau is not sufficiently serious when he writes (*Émile*, 1762) 'Nous approchons de l'état de crise et du siècle des révolutions', adding as a note, 'Je tiens pour impossible que les grandes monarchies de l'Europe aient encore longtemps à durer.'

66. *Souvenirs* (*op. cit.*, Note 42), II, 266.

67. The text of the letter to d'Angiviller is given by J. L. Jules David, *Le Peintre Louis David* (Paris, 1880), 28.

68. See *Louis David, son école et son temps* (Paris, 1855), 53 ff. for vivid characterization of David with his pupils.

p. 194 69. Falconet, it might be said, had been defeated by the system; at least, he retired before it. I have no space here to make the point fully, but David's aggression – if one may call it that – seems based on artistic determination. It is reasonable to see a wide context to his remark recorded via Haydon (*Autobiography* (London, 1926 ed.) II, 578), who concurred: 'When you cease to struggle, you are done for.'

p. 195 70. Clearest evidence in J. G. Wille, *Mémoires*, II, 214 (12 August 1789): 'Comme j'avois été nommé par l'Académie, dans notre dernière assemblée, un des juges pour la révision de tous les ouvrages que les divers membres se proposent d'exposer au Salon prochain . . .' The actual committee of scrutiny was long-established, but under d'Angiviller had already been keen in detecting indecencies (*sic*), and he guided them on politically sensitive points. That grim subjects continued to seem provocative may be gauged from a passage in a letter of 17 May 1790 from d'Angiviller to Vien (*N.A.A.F.*, XXII (1907), 289–90): 'J'ai reçu, M^r, la lettre par laquelle, d'après quelques observations faites par le Roi sur les tableaux de *Maillard* et *l'amiral Coligny*, relativement au sang qui y est répandu, vous avés pensé devoir surseoir à les remettre sur le métier . . .'.

71. The letter of d'Angiviller's assistant, Cuvillier, is of 10 August 1789, printed in *N.A.A.F.*, XXII (1906), 263–5.

72. It is reproduced in E. Grimaux, *Lavoisier* (Paris, 1888), facing 128; David's receipt (of 16 December 1788) for the double portrait is given *op. cit.*, 365. The portrait is virtually evoked by Arthur Young's description (*op. cit.* (Note 2), 78) of his visit to the two Lavoisier in 1787.

73. For it see particularly the excellent discussion p. ⅰ in Rosenblum, *op. cit.* (Note 44), 76 ff.

74. L. Courajod, *L'École royale des élèves protégés* (Paris, 1874), 165 (report of 1786 on Gérard).

CHAPTER 4

201 1. Avec elle 's'éclipsèrent joies, plaisirs, grâces. Les ténèbres couvrirent toute la surface de la cour qui ne subsista plus que pour languir' (R. A. Weigert, *L'Époque Louis XIV* (Paris, 1962), 7).

202 2. 'Discours', given between 1707 and 1714, and printed in 1721. However, the concept of 'grâce' had already been introduced by Claude Perrault.

 3. It was first used by Germain Brice in 1713, in connexion with the redecoration of the Hôtel de Beauvais in 1704: '... le goût moderne, qui est incomparablement plus commode et plus agréable, que celui que l'on suivoit autrefois' (G. Brice, *Description de Paris*, 1713 ed., II, 31). On the *style moderne* cf. also H. Sedlmayr's preface to the section 'Das Gesamtkunstwerk' in the catalogue to the exhibition *Europäisches Rokoko* (Munich, 1958).

203 4. Comte P. Biver, *Histoire du château de Meudon* (Paris, 1923); Kimball, 88; Hautecœur, II, 624, with further literature.

 5. Mansart took it over from Le Vau (portal of the Bibliothèque Mazarine, centre pavilion of the Trianon de Porcelaine), who had borrowed it from Dutch sources, not from Italy (cf. Pieter Post's Mauritshuis at The Hague).

205 6. P. Marot, 'Jules Hardouin Mansart et le plan de la Primatiale de Nancy', *Le Pays lorrain* (Nancy, 1930); Hautecœur, III, 63, with further literature.

 7. P. Marot, 'L'Architecte Jean Betto (1640–1722)', *Le Pays lorrain* (Nancy, 1931).

 8. After the interruption of operations from 1709 to 1717 the arches were completed in 1719. In 1721, however, the idea of a dome was abandoned as a result of misgivings about the statics of the design. The façade was thus robbed of its effect. After the consideration of several alternative plans, in which Boffrand too was concerned, the façade was heightened by one storey in accordance with the design of the watchmaker Barbe and the towers were added by Boffrand. The work was completed in 1736.

 9. The influence exerted by the Primatiale was therefore also remarkably slight. It had no real successors, especially as Lorraine preferred hall-churches. p. 206

 10. P. Marcel, *Inventaire des papiers manuscrits du cabinet de R. de Cotte* (Paris, 1906); Kimball, *passim*; F. Lübbecke, *Das Palais Thurn und Taxis zu Frankfurt am Main* (Frankfurt, 1955), 95 ff.; Hautecœur, III, 47 and 106 ff., with further literature. Most of the papers left by de Cotte are today in the B.N. Est., where the drawings and plans were unfortunately not kept together, but split up and scattered in innumerable adhesive albums. This makes the work of editing them exceptionally difficult. An exhaustive monograph has still to be produced.

 11. With this appointment the Surintendance was separated once more from the job of Premier Architecte and became, as it had been earlier, a court post. The Marquis, later Duc, d'Antin – according to Saint-Simon, 'le plus habile et le plus raffiné courtisan de son temps, comme le plus incompréhensiblement assidu' – was at first ridiculed because of the triviality of his job, but did it so thoroughly that he soon won recognition. In 1727 the Surintendance was abolished for the time being.

 12. In 1699 J. H. Mansart was given the task of producing a model for the high altar. Since it did not meet with the king's approval de Cotte had to furnish a new design, which was accepted in 1708. The furnishing of the choir included, besides the altar, new choir stalls with bishop's throne and a total of eight oil paintings above them, the rood screen, the marble cladding of the choir piers with their bronze reliefs, six life-size bronze angels in front of the piers, choir grille, and marble floor. Apart from the choir stalls, all this disappeared during Viollet-le-Duc's restoration of the cathedral in 1844–64. Detailed contemporary description in Piganiol de la Force, *Description de Paris* (1742). Cf. also M. Vloberg, *Notre Dame de Paris et le vœu de Louis XIII* (Paris, 1926); M. Aubert, 'Les trois jubés de Notre Dame de Paris', *Revue de l'Art Ancien et Moderne*, XLIII (1923), 112. p. 207

p. 208 13. Boffrand's interests were unusually wide. He was a bridge-builder and well-sinker, Inspecteur and Premier Ingénieur (from 1743 onwards Directeur) of the Ponts et Chaussées, and in addition a member of the council of the Hôpital Général. His theoretical work, the *Livre d'architecture*, is written in French and Latin.

14. F. G. Pariset, 'L'Opéra de Nancy de François Bibiena (1708–09)', *Urbanisme et architecture* (Paris, 1954), 277; J. Garms, *Studien zu Boffrand* (dissertation) (Vienna, 1962).

15. P. Boyet, *Les Châteaux du roi Stanislas en Lorraine* (Nancy, 1910); Garms, *op. cit.*, 94, with further literature. Of the two abortive preliminary designs, one, which displays strongly Palladian features departing completely from Jules Hardouin Mansart, is now in the Château Museum at Lunéville. Of another, which may go back to Jules Hardouin Mansart, only the plan of the basement is preserved (Nancy, Mus. Hist. Lorrain, Rec. Morey); in this design the solution adopted for Malgrange I – deep central axis, with portico in front and staircases and small courts on both sides – is already foreshadowed.

16. The plans were not laid before the Académie for approval until 1709.

p. 210 17. Laid out regularly on the French pattern by Yves des Ours and Louis de Nesle, and from 1724 onwards by Louis Gervais, who later designed the gardens of Schönbrunn. The numerous structures in the park were for the most part erected only by Héré for King Stanislas.

18. There is a design of this sort, which might well belong to the circle of Le Vau (a variant of it with a four-column portico in the connecting wall and a staircase in the right-hand inner corner of the courtyard corresponds in almost every detail to the solution adopted at Lunéville), in the Cronstedt Collection in the National Museum at Stockholm, nos. 2186–9 and 2696. Cf. on this H. Junecke, *Montmorency* (Berlin, 1960), 58; *idem*, in *Sitzungsber. d. Kunstgesch. Ges. Berlin* (1952/3), 26. To this group belongs the so-called 'perspective' of Marly. The vestibule as a passageway into the courtyard, with stairs on both sides, was known from Parisian town houses (Hôtel Hesselin, Hôtel de Beauvais, Hôtel Crozat l'Aîné).

19. W. Herrmann, *Laugier and Eighteenth Century French Theory* (London, 1962), 106; R. D. Middleton, 'The Abbé de Cordemoy and the Graeco-Gothic Ideal: a Prelude to Romantic

Classicism', *J.W.C.I.*, XXV (1962), 278 ff., XXVI (1963), 90 ff.

20. N. Petzet, *Soufflots St Geneviève und der* p. 2 *französische Kirchenbau des 18. Jahrhunderts* (Berlin, 1961), 77.

21. For imitations in Germany cf. the court chapel at Würzburg and Balthasar Neumann's churches at Etwashausen and Neresheim.

22. P. Lavedan, with whom Garms, *loc. cit.*, agrees, points in his essay 'Le Pavillon de chasse de Bouchefort dans la forêt de Soignies par Boffrand', *Miscellanea Leo Puyvelde* (Brussels, 1940), to Chambord and Malgrange II as other models. Apart from its woodland situation, Bouchefort has not the slightest affinity with Chambord; and Malgrange II is several years later. On the restlessness of plan and elevation in Bouchefort in comparison with French classicism, cf. E. Kaufmann, 'Three Revolutionary Architects, Boullée, Ledoux and Lequeu', *Transactions of the American Philosophical Society*, XL, part 3 (1952), 440.

23. The same radial arrangement of the stables had already been employed at Versailles, and the open circular space round the symbol of the ruler is to be found in the Place des Victoires in Paris.

24. The most important imitations in Germany p. 21 were the Pagodenburg in the park of Nymphenburg (1716), Waghäusel, near Bruchsal (1724–9), Fürstenried, near Munich (1737), and Schloss Clemenswerth, near Meppen (1736–47); cf. T. Rensing, *Johann Conrad Schlaun* (Deutscher Kunstverlag, n.d.). The semicircular arrangement of the subsidiary buildings in general occurs by the round parterre at Nymphenburg (1723 onwards). The 'Baroque' character of Bouchefort is also emphasized by Kaufmann, *op. cit.*, 446.

25. Of the many town houses in Nancy ascribed to him, only the Hôtel de Ferrari, apart from the Hôtel de Craon, can in fact be claimed as his.

26. Laid before the Académie in Paris for approval in 1712. Plan of the old château, with pencil annotations presumably made by Jules Hardouin Mansart, and plan of the new building with annotations by de Cotte, possibly dating from the discussions in the Académie, in the B.N. Est., Top. Va 114a.

27. The designs, previously unknown and not even mentioned at the Turin exhibition in 1963, are in the B.N. Est., Top. Vb 5, nos. 12–15. They date, in accordance with the political situation,

from the years round 1700, and must therefore have been known to Boffrand, who at that time was still working in Jules Hardouin Mansart's office. What is presumably a copy of the original Italian plan of Rivoli, before the reconstruction, has been found among the papers of Boffrand's pupil, Jadot.

28. L. Hautecœur, 'Le Plan en X à propos d'un projet de Boffrand', *B.S.H.A.F.*, XXII (1959), 166; Garms, *op. cit.*, 146.

29. The hypothesis advanced by A. E. Brinckmann and adopted by Wittkower (*Art and Architecture in Italy 1600–1750*, Pelican History of Art, 2nd ed., Harmondsworth, 1965), that Malgrange II is an imaginary project based on Juvarra's plan for Stupinigi can be regarded as outdated since the comparison with the tracings in the Recueil Piroux. The link with Vienna was first pointed out by Aurenhammer in the catalogue to the Fischer von Erlach exhibition (Vienna, 1956), 68; it is also mentioned by H. Sedlmayr, *Joh. Bernh. Fischer von Erlach* (Vienna, 1956), 92.

216 30. F. G. Pariset, 'L'Opéra de Nancy de François Bibiena (1708–09)', *Urbanisme et architecture* (*Mél. Lavedan*), 227.

31. The preliminary drawings in the Recueil Piroux show that from the start Boffrand conceived project II lengthways, i.e. looking towards the narrow side. The crosswise positioning of the plan in the *Livre d'architecture* gives a false impression.

32. Cf. the bishop's palace at Toul and Jadot's drawings in the Recueil Jadot, Paris, Bibl. Doucet.

33. Detailed plans by Jules Hardouin Mansart for the reconstruction of the old ducal palace known to us from engravings by Callot and Brentel are extant in the B.N. Est. (Top. Va 113, Va 433). In these plans the main façade of the Grande Rue traversing the old town has already been shifted to the south side, i.e. to the Place de la Carrière, and the ground thus cleared for the re-orientation of the new building. There is an instructive drawing, in which Boffrand's new building is superimposed on the still-existing old palace, in the Mus. Hist. Lorr. Cf. J. Garms, 'Les Projets de Mansart et de Boffrand pour le palais ducal de Nancy', *Bulletin Monumental*, CXXV (1967), 231, with bibliography.

34. Cf. especially the courtyard of the Convento della Carità in Venice (*I quattro libri dell'architettura*, II, cap. VI).

35. The elector, when on a visit in March 1715, expressed the view that Malgrange was too far away for a *maison de plaisance* in the vicinity of a city, but too close to Nancy for an independent country house. According to contemporary tradition, this robbed the duke of any desire to carry on with the building; but financial difficulties may well have helped to cause the decline in interest. At this point the carcass was complete and the plastering and painting of the interior had already begun. When the building was demolished in 1738, four of the giant columns from the entry portico were used again by Héré for the façade of Notre-Dame de Bon Secours at Nancy.

36. The architect of Commercy, Nicolas p. 217 d'Orbay, was a colleague of Boffrand, who had himself built a town house for the Prince de Vaudémont in Paris; cf. Garms, *op. cit.*, 160. The central building, which rises like a pyramid and has a portico with columns, bears a strong resemblance to the preliminary sketch for Lunéville now in the museum there.

37. Cf. especially François Mansart's design for the courtyard façade (B.N. Est., Top. Va 82).

38. There are prototypes in Palladio for both the central axis of Malgrange II and the columned porticoes of Malgrange I, Haroué, and the chapel of Lunéville; cf. the designs in the *Quattro libri dell'architettura*, II.

39. *Quellen z. Gesch. d. Barock in Franken*, I, 2nd half-volume, no. 1023.

40. The hall-church of Lorraine has affinities p. 218 with the halls of the Eiffel and the Trier area, but not with Saint-Nicolas du Port, as P. Lavedan thought (lecture at Nancy in 1948). One of the connecting links between Late Gothic and the seventeenth century is formed by the Jesuit church in Luxembourg (1613–21). At Saint-Clément in Metz the influence of the cathedral indubitably played an important part.

41. The façade was only conceived as a view for the Hôtel de Soubise, the reconstruction of which Boffrand was directing at that time. It linked up, from the point of view of form, with the façade designs of Le Pautre and showed Boffrand here too closely tied to Baroque traditions. Cf. E. J. Ciprut, 'Les Architectes de l'ancienne Église de la Merci', *B.S.H.A.F.* (1954), 202; M. Heimburger, *Antikken og Faubourg Saint-Germains Privatarkitektur* (Copenhagen, 1963); J. Garms, 'Boffrand à l'église de la Merci', *B.S.H.A.F.* (1964), 185.

p. 219 42. Hautecœur, III, 34, with further literature. The character and social significance of the Faubourg Saint-Germain is best summed up by Balzac in *La Duchesse de Langeais*.

43. 'La chambre à coucher est plutôt de parade que d'usage, quoy qu'on puisse y coucher en Esté, car pour l'Hyver on se retire dans de petits appartements plus bas, moins aérez et plus faciles à échauffer' (Daviler, *Cours d'architecture*, 185.8). On this and what follows cf. M. J. Ballot, *Le Décor intérieur au XVIIIᵉ siècle à Paris et dans l'Île de France* (Paris, 1930); Hautecœur, III, 197, with further literature; and also the brilliant picture of the *hôtel particulier* in the eighteenth century in Schmarsow, *Barock und Rokoko* (Leipzig, 1897), 328.

p. 220 44. *Procès-Verbaux de l'Académie royale d'Architecture*, published by Lemonnier (Paris, 1911–29).

45. Cordemoy based himself for his part on the little book by Frémin, *Mémoires critiques d'architecture* of 1702, in which for the first time the pre-eminence of the orders is disputed and more practical knowledge and thought are required of architects. On Cordemoy and his controversy with Frézier, cf. R. D. Middleton, *loc. cit.*, with bibliography.

p. 221 46. Lassurance's real name was Pierre Cailleteau. He did not begin to work on his own until 1700, after his appointment as Crown architect. In 1702 he was entrusted with the direction of the building operations at the Invalides and officially stationed in Paris. With that he left Jules Hardouin Mansart's office. His most important works (all illustrated in Mariette) were: the Hôtel d'Argenson, later de Rothelin (1700); the Hôtel Desmarets (1704); the Hôtel de Béthune or de Neufchatel or de Maisons (1708); the Hôtel d'Auvergne (completed in 1708); the Hôtel de Rohan-Montbazon (1719); the Hôtel de Roquelaure (1722); collaboration in the Hôtel de Bourbon (1722–4), and the conversion of the Hôtel de Pussort into the Hôtel de Noailles; and outside paris the château of Petitbourg for the Duc d'Antin. Cf. Hautecœur, III, 116.

p. 223 47. His decorating work under Jules Hardouin Mansart extended from 1684 to 1699, when he was succeeded by Le Pautre. His share in Mansart's official buildings was considerable, to judge from the payments he received, but the scope of his activity cannot be precisely defined. In the building of town houses the correspondence with Mansart's design for a house which Mariette published and which belongs to the early years of the eighteenth century is in many details amazing; one must assume that here, too, he contributed some of the ideas. On his relationship with Mansart, cf. the remark of the malicious and not always objective Duc de Saint-Simon: 'Ils [i.e. Mansart and de Cotte] tiroient leurs plans, leurs desseins, leurs lumières, d'un dessinateur des bâtiments nommé l'Assurance, qu'ils tenoient tant qu'ils pouvoient sous Clef.'

48. De Cotte's first house-building job in Paris was the Chancellerie, i.e. the reconstruction of the former Hôtel de Lionne for the Chancellor de Pontchartrain in 1703. Then came the Hôtels de Lude (1710), d'Estrées (1713), de Toulouse (1713–19), Legendre d'Armini (later the Hôtel de Meulan) (c. 1715), and du Maine (1716). In his 1717 edition Brice also mentions the Hôtel de Vrigny. Further houses, as well as the apartments for letting which he built on a speculative basis and his own house on the Quai d'Orsay, in Hautecœur and in M. Ponsonhail, 'La Maison de R. de Cotte', *Réunion des Sociétés de Beaux Arts des Départements* (1901), 508.

49. List of his work with details of each building in Garms, *loc. cit.* p. 22

50. One of the first was Le Blond in the Hôtel de Vendôme (1705) and the Hôtel de Clermont (1708).

51. Forerunners of the oval dining room were the two circular rooms with free-standing columns which Le Vau had planned in a design of 1669 for the two corners overlooking the park at Versailles. The oval shape beloved of Le Vau, but only seldom employed by Jules Hardouin Mansart (e.g. in the Hôtel de Noailles at Versailles), was taken up again by Boffrand.

52. De Cotte's design is in the B.N. Est., Top. p. 22
Va 273e; Boffrand's design in Mariette, II, plates 255–60.

53. B. Lossky, 'J. B. A. Le Blond, Architecte de Pierre le Grand, son œuvre en France', *Bulletin de l'Association russe pour les recherches scientifiques à Prague*, III (1936); the dates are partly refuted by Kimball, 110.

54. Mariette quotes the following works: Hôtel d'Étampes 1704, Dunoyer (Folie de la Roquette) 1708, Sonning 1711, de Locmaria 1730, as well as M. Galepin's country house at Auteuil about 1715.

55. On the arrangement of the two galleries and p. 22
the disposition of the collection, cf. M. Stuffmann, 'Charles de la Fosse et sa position ... dans la peinture à la fin du XVIIᵉ siècle', *G.B.A.*, LXIV (1964), 1.

56. Le Blond's spaciously planned model design was severely curtailed when it came to building: not only the two wings added by him but also Cartaud's inner courtyard were omitted. Instead of being aligned lengthways the building acquired an alignment in breadth, with the back gallery as the main room. At Perrigny or Périgny, which was probably built towards 1720, the rectangle had turned into a square. The two side wings were accompanied on the courtyard side by dressing rooms, so that here a second series of rooms came into existence.

228 57. A short time after this Boffrand built for the Rohans the façade of the Église de la Merci (after 1712; but the contract was signed in 1709) and the country house at Saint-Ouen. The staircase in the Hôtel de Soubise was claimed by Delamair as his own in his Œuvre d'architecture, but this probably also belongs to Boffrand.

58. It was intended for the fifth son of the Prince de Soubise, Bishop of Strasbourg and later Cardinal de Rohan, and was to house his famous library.

59. The Œuvre d'architecture which Delamair presented to the elector as a sort of testimonial, and which contains a list of his works, is today in the Munich Staatsbibliothek, Cod. icon. 187.

60. Cf. the excellent characterization of the maison de plaisance in Schmarsow, op. cit. (Note 43), 372 ff.

61. Described in J. F. Blondel, Cours d'architecture (Paris, 1771–8), Tome III, 102. The octagonal vestibule was already prefigured in the reconstruction of Le Brun's country house of 1675. These strikingly conservative features of the ground floor were not paralleled on the first floor where Cartaud once again showed himself very modern. As at Meudon, it had a central corridor running through it with 'living units', each of three rooms, arranged on each side. Cf. H. Junecke Montmorency, Das Landhaus Charles Le Bruns (Berlin, 1960), with further literature.

230 62. Cahen d'Anvers, Le Château de Champs (Paris, 1928); R. Strandberg, 'Le Château de Champs', G.B.A. (1963), 81, with further literature.

63. As Strandberg has demonstrated, the idea of the projecting oval of the garden façade probably comes from Pierre Bullet – and so from seventeenth-century tradition. In a drawing in the Cronstedt Collection (no. 2250) in the Stockholm National Museum, Bullet combines it with an old-fashioned pilaster decoration. Stripped of its three-dimensional articulation and endowed with a purely surface tension, this motif was made to serve the aims of the eighteenth century for the first time at Champs. In the first version the middle roof was still windowless and isolated from the other roofs, so that it had the effect of an independent body in the seventeenth-century sense. It was only towards 1720 that it received the oval windows as a decorative embellishment, and in the middle of the eighteenth century the rambling roof.

64. Illustrated in Mariette, plates 332–6. A. Mauban, L'Architecture de Jean Mariette (Paris, 1946), 161.

65. Kimball, 78; R.-A. Weigert, Jean I Bérain p. 232 (Paris, 1937); cf. also L. Baron Döry, Die Stuckaturen der Bandelwerkzeit in Nassau und Hessen (Schriften des Histor. Museums, VII) (Frankfurt, 1954), where the essence of Bérain's style is characterized as 'the last stage, so to speak, of the Renaissance-grotesque'.

66. The mirrors over the chimneypieces at Marly in 1700 (drawings in the B. N. Est., Ha. 19; according to the inscriptions on them they were made for the Princesse de Conti and the Duchesse de Chartres), the Trianon decoration about 1705 (drawings for Champs in the National Museum, Stockholm, Cronstedt Collection).

67. The Salon de l'Œil de Bœuf arose out of the p. 233 combination of the Salon des Bassans (or Seconde Antichambre) and the old Chambre du Roi of 1684. As a result of the heightening of the cornice over the Salon des Bassans the pilasters were placed on bases and the surportes on strips of ornament. The Cabinet du Conseil, which was altered in 1755–6, still preserves, from the original decoration, the big trumeaux with mirrors, the door fillings, and the lowest, horizontal zone of panels.

68. Kimball, 86; G. Chenesseau, Sainte Croix d'Orléans (Paris, 1921), 202.

69. That the sketches for these schemes of decoration are in Le Pautre's own hand has been shown by Kimball, loc. cit. Owing to Jules Hardouin Mansart's lack of talent for drawing and the slender capabilities of Robert de Cotte in this field, the design work fell almost exclusively to Le Pautre, so that his influence on the development of style in these years far exceeded that of his taskmasters.

p. 233 70. L. Deshairs, *Le Château de Bercy* (Paris, 1911); Kimball, 104. The château, begun by F. Le Vau, only acquired its decoration in 1712–15. The house was pulled down in 1860 and the decorations are today scattered over several places in Paris and outside it. They have been re-arranged in different surroundings, unfortunately not always without modern restorations.

p. 234 71. This ledge running parallel to the frames of the panels first appears at the Trianon in 1703.

72. The same view is taken by R. Sedlmair, *Grundlagen der Rokokoornamentik in Frankreich* (Strasbourg, 1917), 46 ff.

73. These relief friezes occur already in Le Blond, in the *trumeaux* with mirrors of the *Cours d'architecture*; they appear for the first time in the sketches for the Ménagerie at Versailles, which date from 1698 and which Kimball was able to attribute to Le Pautre.

74. In the Mus. Hist. Lorr. at Nancy. The Recueil Piroux, as it was called, disappeared completely from the possession of the owner's family about 1918. It also included drawings by other hands, e.g. Bibiena's. Although the value of the tracings may be limited, the general disparagement of them by Kimball (p. 107) is unjustified.

p. 235 75. It was not Oppenordt, as Linfert still thinks (C. Linfert, *Die Grundlagen der Architekturzeichnung*, Berlin, 1931), but Boffrand who was the first to complete this separation. The stimulus came from the native tradition, not from northern Italy.

CHAPTER 5

p. 236 1. Even in 1775 the Abbé de Lubersac could still write in retrospect: 'Tels sont, pour l'ordinaire, les fruits amers d'une grandeur trop longtemps appuyée sur les succès militaires: et quelle leçon pour les rois' (*Discours sur les monuments publics*, 158).

2. On the fever for speculation in Law's time cf. Voltaire's description in his *Précis du siècle de Louis XV* (Dresden, 1769), 163 ff.; also P. Vernet, *La Maison du XVIII^e siècle en France* (Paris, 1966), 18.

p. 237 3. The same view is taken by Kimball, 122 ff.

4. The publication date of 1727 is only valid for the first volume; volumes two and three appeared only several years later, and certainly after the completion of the Hôtel de Janvry, which is illustrated in them. The fourth volume, which appeared under the same title, does not really belong to this series; it is nothing else than a new edition of the 'Grand Marot'. A further volume, published in 1738, with a bigger format and a slightly altered title, contains the royal châteaux, the stables at Chantilly, and other fairly big buildings. Cf. L. Hautecœur's preface to the reprint of *Architecture française* (Paris, 1928), and A. Mauban, *L'Architecture française de Jean Mariette* (Paris, 1946). On J. F. Blondel's collaboration, cf. E. Kaufmann, 'The Contribution of Jacques-François Blondel to Mariette's "Architecture Françoise"', *The Art Bulletin*, XXXI (1949), 58.

5. 'Marier les dehors avec les dedans' – this produces a secret pleasure in the mind of the beholder. Boffrand's comparison of architecture with music in his *Livre d'architecture* is instructive.

6. Desgodets, professor at the Académie, gives p. 23 the following definition in his posthumously published *Cours d'architecture*: 'Le bon goût d'Architecture est une convenance proportionnée du tout avec ses parties, et de toutes les parties entre-elles, et avec leur tout qui plaît dans tous les temps sans variation.' Jacques-François Blondel says in the *Architecture française* (1752): '. . . pour que l'esprit de convenance règne dans un plan, il faut que chaque pièce soit située selon son usage et suivant la nature de l'édifice, et qu'elle ait une forme et une proportion relative à sa destination . . .' *Idem*, in the *Cours d'architecture*, IV (1773): 'La convenance doit être regardée comme la partie la plus essentielle de toutes les productions de l'Architecte.' The concept of *convenance* goes back to the Italian *convenienza*, known since Palladio's time. It was first used in the special sense of taste and practicality by Frémin in the *Mémoires critiques d'architecture* of 1702, as opposed to the hitherto rigid doctrine of the orders and the allied neglect of practical needs; then it was widely diffused by Cordemoy. In Daviler's *Cours d'architecture* of 1691 it is still used in the old conventional way, in the sense of tradition. On this and on what follows cf. J. Schlosser, *La Letteratura artistica*, 2nd ed. (Vienna, 1956), 651; E. Kaufmann, 'Die Architekturtheorie der französischen Klassik und des Klassizismus', *Repertorium für Kunstwissenschaft*, XLIV (1924), 197; W. Braunfels, *François de Cuvilliés* (Bonn dissertation) (Würzburg, 1938), 11 ff.

7. Jacques-François Blondel, *Architecture française*: '. . . C'est une loi de convenance que depuis l'entrée du bâtiment jusques à la galerie l'on

observe une gradation de richesses et de magnificences qui soit relative à la destination et à l'usage de chaque pièce.' *Idem, De la distribution des maisons de plaisance et de la décoration des édifices en général* (Paris, 1738), tome I, 3, and II, 81 ff., where the decoration for each room is prescribed. The same idea is to be found in Briseux, *L'Art de bâtir des maisons de campagne*, II, 154.

8. Briseux expressly remarks in his preface that the interests of private people had hitherto been neglected and architects had only bothered about the great.

9. Jacques-François Blondel, *Architecture française*: 'La distribution doit être le premier objet de l'architecture.' It would be wrong to understand by 'commodité' only comfort. The concept embraces every kind of practical habitability.

10. The manuscript, which breaks off abruptly at the author's death in 1728, is only preserved in the retrospective compilation of an Academy pupil, Jean Pinard, probably put together about 1745. Published in one part in 1748 under the title 'Les Lois du Bâtiment'. Up till now four copies of it have come to light. The first part is based on Desgodets' earlier treatise, *Traité des ordres d'architecture*, of 1711, which for its part goes back to discussions of the Académie around 1701. The second part also contains what are probably earlier ideas; cf. the similarity of Desgodets' plan of a cathedral to Pineau's design for a church in St Petersburg, reproduced in Hautecœur, III, figure 70 (cf. J. Duportal, 'Le Cours d'architecture de Desgodets and the Académie Royale d'Architecture', *The Art Bulletin*, XL (1958), 23; T. H. Lunsing Scheurleer, 'Een exemplar van Antonie Desgodets "Traité de la commodité de l'Architecture" in het Rijksprentenkabinett', *Opus Musivum* (Festschrift Ozinga) (Assen, 1964), 285).

11. On the relationship between Oppenordt and Watteau, cf. Mathey-Nordenfalk, 'Watteau and Oppenordt', *Burl. Mag.* (1955), 132.

12. Jean Oppenordt came originally from Gelderland and became a naturalized Frenchman in 1679. As Ébéniste du Roi he lived in the Louvre. The spelling of the name wavers between Oppenoordt, Oppenordt, and Oppenord.

13. In 1715 he was appointed Premier Architecte of the Duc d'Orléans. Jal's assertion that he already had this post in 1712 is not attested and cannot be proved from buildings. In 1724 he was named Surintendant et Contrôleur des Bâtiments et

Jardins du Duc d'Orléans; cf. F. Kimball, 'Oppenordt au Palais Royal', *G.B.A.* (1936), 112; idem, *Le Style Louis XV*, 100. See also in particular M. Gallet, 'Quelques étapes du Rococo dans l'architecture parisienne', *G.B.A.*, 6th pér., LXVII (1966), 153 ff.

14. Dézallier d'Argenville calls him 'the Borromini of France'. Cf. C. Linfert, 'Die Grundlagen der Architekturzeichnung', in *Kunstwiss. Forschungen*, I (Berlin, 1931), 172.

15. After his death almost 2,000 drawings came into the hands of the publisher Huquier, who had them engraved and before 1748 published about 420 sheets in three series – *Moyen Oppenordt* (1737–8), *Grand Oppenordt* (c. 1748–51), and, in between, the *Petit Oppenordt*. The rest of the drawings were never published. Further big stocks in Paris, Berlin, and Stockholm. Cf. Y. Bruant, 'Gabriel Huquier', *G.B.A.* (1950), 113, note 41.

16. The idea of a corner space projecting over the line of the wall goes back to François Mansart (Galerie Dorée in the Hôtel de Toulouse) and Philibert de l'Orme. In this salon the most famous paintings in the regent's collection were assembled – four Veroneses, six Titians, two Rubens, all from the collection of Queen Christina of Sweden. Cf. Champier-Sandoz, *Le Palais Royal* (Paris, 1900), I, 320; Kimball, 131.

17. Illustrated in the *Grand Oppenordt*, plates XCII–XCIV; they were intended for the garden of the newly built palace at Bonn.

18. Alterations to the Hôtel du Temple (1720–1); new living quarters over the entrance to the Hôtel Crozat (1730), where he himself spent his last years; a semicircular orangery for Montmorency; probably also the château of Bove-en-Laonnois (after 1719), the plans of which are extant; cf. M. G. Huard, in L. Dimier, *Les Peintres français au XVIIIe siècle* (Paris, 1928), I, 311.

19. Courtonne, Jombert, Jacques-François Blondel, and Patte are always proudly emphasizing the superiority to all others of the French mode of living, which they saw embodied in the buildings of the twenties (cited in Braunfels, *op. cit.*).

20. Kimball gives his date of birth as 1660, but this seems too early in relation to his activity. In 1692 he was Maître des Jardins du Louvre and in 1698 Contrôleur des Bâtiments du Roi; cf. Hautecœur, 150.

21. Cf. J. Babelon, *Le Cabinet du Roi ou le Salon Louis XV de la Bibliothèque Nationale* (Paris, 1927);

239

p. 240

p. 241

p. 242

p. 244

J. Porcher, 'Deux projets de construction pour la Bibliothèque du Roi', *B.S.H.A.F.* (1930), 100; Hautecœur, III, 151.

p. 244 22. Cf. F. de Catheu, 'La Décoration des Hôtels du Maine au Faubourg St Germain', *B.S.H.A.F.* (1945–6), 101.

23. Begun for the Marshal Montmorency and sold in 1723 to Jacques Goyon de Matignon. Since 1919 government property. Cf. L. H. Labande, 'L'Hôtel de Matignon à Paris', *G.B.A.*, Vᵉ pér., XIII (1935), I, 257, 347. Further works of Courtonne's are the Hôtel de Noirmoutier (1720–4) and a pyramid in honour of Louis XIV. In 1728 he became a member of the Académie.

24. On this occasion Blondel speaks out sharply against the introduction of the dining room into the main enfilade, not only because of the smell of cooking and the corresponding dampness, but also because of the interruption of the enfilade by the passage of the servants during meal times (*Architecture française*, 218).

25. He defined his own share in the work in the *Traité de la perspective*. According to this he was fully responsible for the shaping of the plan and façade. Only the upper part of the porte-cochère was altered by his successor, Mazin.

p. 245 26. Built for the erstwhile wig-maker Peyrenc, who had made money in the Law speculations, called himself Peyrenc de Moras, and became Chef du Conseil of the Duchesse de Bourbon. In 1737 it became the Hôtel du Maine, in 1753 the Hôtel de Biron; today it is the Musée Rodin.

27. He was a nephew of Jules Hardouin Mansart. He started his career in 1688 as Contrôleur Général in the Bâtiments. Other mansions of his are the Hôtel de la Force (1711–15) and the Maison Blouin (1718). He collaborated on the Palais Bourbon (1724–8). The Hôtel de Varengeville (1704), frequently ascribed to him, is by his cousin, Maurice Gabriel; cf. F. de Catheu, 'La Décoration intérieure des hôtels parisiens au début du XVIIIᵉ siècle', *G.B.A.*, VIᵉ pér., I (1957), 271.

28. Gabriel is named as the designer of the plans and Aubert as director of the building operations, but the latter's role was probably greater. In the literature the attribution to Gabriel is sometimes questioned. Cf. J. Vacquier, *L'ancien Hôtel du Maine et de Biron* (Paris, 1909); Planat, *Encyclopédie de l'architecture et de la construction* (Paris, n.d.), II, 93, and IV, 271; Hautecœur, III, 142.

29. Originally the roofs of the corner pavilions p. 246 bore on the cornice sculptured cartouches with lively outlines, which gave the pavilions more weight but made the roof zone more restless.

30. It had long been the subject of exchange negotiations with the king because of the reconstruction of the musketeer barracks. Cf. H. Contant, *Le Palais Bourbon au XVIIIᵉ siècle* (Paris, 1905); P. Marcel, *Inventaire de papiers manuscrits du cabinet de Robert de Cotte* (Paris, 1906), nos. 100–39; Hautecœur, III, 19.

31. The connexion with Versailles was also underlined by the sun-centred iconography of the lunette decoration over the bedroom: rising of the sun, signs of the zodiac, effect of the sun's rays on the earth. Blondel criticized violently the bedroom's situation, which did not permit a central entrance.

32. These were already foreseen in de Cotte's designs, which Giardini obviously utilized. Here, too, we already find the long forecourt, planted with chestnuts, in front of the *cour d'honneur* proper.

33. '. . . ce bâtiment est le premier en France ou p. 246 l'on ait imaginé ces genres de commodité qui font tant d'honneur à nos Architectes François' (Jacques-François Blondel, *Architecture française*, I, 267). 'Ce fut au palais de Bourbon en 1722, qu'on en fit le premier essai, qui a été imité depuis en tant de manières' (P. Patte, *Monuments érigés en France à la gloire de Louis XV* (Paris, 1767), 6).

34. Robbed today of its character on the outside by the addition of another storey.

35. In 1709/10 he was already working for the p. 246 duke on the château of Saint-Maur; cf. G. Mâcon, *Les Arts dans la Maison de Condé* (Paris, 1903); Hautecœur, III, 15 ff. Aubert also worked on the châteaux of Champrosay and Montfermeil.

36. H. Lemonnier, 'Les Grandes Écuries de Chantilly et le style architectural des écuries au XVIIᵉ et XVIIIᵉ siècles', *B.S.H.A.F.* (1926), 7.

37. Cf. the design in the Musée Condé at p. 247 Chantilly, signed by the Augustinian monk Nicolas Bourgeois, who is also mentioned by Mariette. In this design the two side wings have two storeys and the arcading of the circular courtyard one storey.

38. Inside the middle pavilion there stood originally the drinking trough, a big well richly adorned with sculpture. In the trough stood two life-size lead horses being watered by boys from shell dishes.

39. Blondel was the uncle of the famous theorist and professor of architecture Jacques-François Blondel; he was a member of the Académie from 1728 onwards and, as an engraver, collaborated in the graphic work of Mariette, Briseux, and Boffrand. Between 1719 and 1724 he was entrusted with the high altar and the furnishing of the choir in the Parisian church of Saint-Jean en Grève, and about 1725 with a country house in Grand Charonne. Cf. J. Lejeaux, 'Jean-François Blondel, Architecte', L'Architecture (1927), 395; Hautecœur, III, 98, C.d.A. (October 1955), 42.

250 40. Marquis de Montmort, Le Château de Beaumont-sur-Vingeanne (Dijon, 1950); E. de Ganay, Châteaux de France, Nord et Est (Paris, 1953).

41. Cf. the famous passage in a letter of Balthasar Neumann, according to which the Duke of Lorraine had said to him 'dass der monsieur de beaufrand nicht der beste seye, sondern Monsieur de Coti und sein Herr sohn' (K. Lohmeyer, Die Briefe Balthasar Neumanns von seiner Pariser Studienreise, 1723, Düsseldorf, 1911).

42. Several plans had already been made for this square, but they had all foundered on the difficulty of cost; cf. Champier-Sandoz, op. cit. (Note 16), 288.

43. Most of the numerous designs are in B.N.Est., where they are collected in three big gummed albums. They have yet to be sorted and arranged systematically.

251 44. The Marquis d'Aubigny acted as man of straw. He was the princess's secretary and confidant and inherited the château after her death. Princess Orsini, who hoped for the governorship of Touraine in return for her services in helping to arrange the Treaty of Utrecht, wanted the château as a stepping-stone on the way to Spain. It was remodelled by the Duc de Choiseul from 1761 onwards and in 1823 it was pulled down. Cf. E. Schlumberger, 'Chanteloup, un destin glorieux et cruel', C.d.A. (1962), 72; P. de Cossé Brissac, Châteaux de France disparus (Paris, 1947), 103; E. André, 'Documents inédits sur l'histoire du château et du jardin de Chanteloup', B.S.H.A.F. (1935), 21; Hallays-André-Engerrand, Le Château de Chanteloup (Paris, n.d.).

45. In 1722 the French Embassy in Constantinople was to be replaced by a new building. Cf. Marcel, op. cit. (Note 30), nos. 736-7.

p. 252 46. Cf. M. Hauttmann, 'Die Entwürfe Robert de Cottes für Schloss Schleissheim', Münchener

Jahrbuch, VI (1911), 256. The drawings for Schleissheim are preserved, partly mixed up with those for Bonn, in the Bibliothèque Nationale in Paris. The numerous studies and sketches show de Cotte's solution gradually emerging from a design based on Versailles, which was probably the model desired by the elector. Thus the chapel is at first a simple longitudinal space of nave and aisles, with anteroom and west gallery; the middle building is occupied by a big gallery with two corner salons, etc., etc.

47. He was responsible for the rustication of the p. 253 ground floor, the blind arcading, the roof balustrades, the central niche, and the broad central gallery. The plans are in the B.N. Est. Cf. P. du Colombier, L'Architecture française en Allemagne au XVIIIᵉ siècle (Paris, 1956), with bibliography.

48. In the corps de logis, apartments facing both north and south were to be provided for the royal couple, for alternate use in summer and winter; both de Cotte's plans allowed for this. Cf. W. Graf Kalnein, Das kurfürstliche Schloss Clemensruhe in Poppelsdorf (Düsseldorf, 1956), 100 ff.

49. It was the only one of the Elector of p. 256 Cologne's manifold plans to be realized, after he had had to rest content with adding smaller buildings on to the palace at Bonn. The work was directed by the most capable of de Cotte's architects, Guillaume Hauberat. Cf. Kalnein, op. cit., and du Colombier, op. cit., 137.

50. From 1710 to 1754 the château was in the p. 257 possession of the Prince, later Landgrave, of Hesse; in 1755 it was pulled down. Cf. A. Rauch-Elkan, Acht Pläne und ein Baumémoire Robert de Cotte's für Schloss Tilburg in Brabant (s'Hertogenbosch, 1958) (offprint from Brabantia, 2 February 1958).

51. Boffrand's façade, on the other hand, which was incorporated in the Livre d'architecture, produces, with its tall staircase well, a much heavier and more Italianate effect. Its articulation is based largely on that of the courtyard façade of the Palais Ducal at Nancy.

52. Such a design, probably by Claude Perrault, is illustrated in Kalnein, op. cit., plate III. The designs for Buenretiro were laid before Louis XIV personally for his approval before they were sent off to Madrid.

53. The reconstruction of Schloss Wasserburg in Lower Austria, which in the end was not carried out according to de Cotte's plans, was almost

completed 'about 1718'. Cf. F. Windisch-Grätz, 'Schloss Wasserburg', *Alte und Neue Kunst*, 4th year, no. 1/2, 16.

p. 258 54. Boffrand's contemporary plan on the other hand looks old-fashioned except for the noble double stairs and the chapel incorporated at right angles in the left wing; cf. R. Sedlmaier and M. Pfister, *Die fürstbischofliche Residenz zu Würzburg* (Munich, 1923), I, 28 ff.

55. The façade of Cardinal Fürstenberg's big palace, standing since 1670, had been for the most part preserved. Cf. J. Duportal, 'Les Dessins de R. de Cotte pour le palais de Saverne', *Revue de l'Art Ancien et Moderne* (1921), 126; Hautecœur, III, 74; Marcel, *op. cit.* (Note 30), nos. 551–5.

56. At the time of the planning, the plot of ground was still irregular. The site of the present library and chapel, i.e. the addition to the left of the river façade, which corresponds on the plan to the right-hand side-pavilion, was only acquired in 1735. Cf. H. Haug, 'L'Architecture Régence à Strasbourg', *Arch. Als. d'Hist. de l'Art* (Strasbourg, 1926); *idem*, *Le Château des Rohan et les grands hôtels du XVIIIᵉ siècle à Strasbourg* (Strasbourg, 1953), with bibliography. Cf. also du Colombier, *op. cit.* (Note 47), 145.

p. 259 57. Du Colombier, *op. cit.*, 144; F. Lübbecke, *Das Palais Thurn und Taxis in Frankfurt am Main* (Frankfurt, 1955).

58. Hauberat had been working at the courts of German princes since 1716, but always maintained close contact with de Cotte in Paris; cf. Kalnein, *op. cit.*, 40 ff.; Lübbecke, *op. cit.*, 124.

59. Hautecœur, III, 93; L. Réau, *L'Architecture française en Russie de Leblond à Ricard de Monferrand, Urbanisme et architecture* (Paris, 1954), 320; P. Lavedan, *Histoire de l'urbanisme, Renaissance et temps modernes* (Paris, 1959), 267.

60. Paris, Musée des Arts Décoratifs; illustrated in Hautecœur. Cf. the strikingly similar cathedral design by Desgodets, about 1720; J. Duportal, 'Le Cours d'architecture de Desgodets', *Revue de l'Art Ancien et Moderne*, XXXVI (1914/19), 153.

61. Kimball, 144.

p. 260 62. To this extent he belonged from the start to the French tradition. Vassé had been in Paris since 1698. From 1706 he was engaged on the decorative sculpture at Versailles; in 1713 he became Dessinateur Général de la Marine and in 1723 a member of the Académie. Cf. Kimball, 87 ff.; Hautecœur, *passim*.

63. Toro (really Turreau) came from a Burgundian family of woodcarvers which had settled in Toulon; some members of it also lived in Aix. In 1719 he became *maître sculpteur* at the Arsenal in Toulon. In 1716–17 he was in Paris, where his series of engravings entitled 'Desseins à plusieurs usages', engraved by Honoré Blanc in Aix, aroused attention. In his work he combined ideas of Bérain's with the three-dimensional fullness and the many-layered manner of the south. Cf. Kimball, 145; Hautecœur, III, 232; R. Brun, in Dimier, *op. cit.* (Note 18), 350; J. Boyer, 'Une Famille de sculpteurs bourguignons établie en Provence au XVIIIᵉ siècle, Les Turreau (ou Toro)', *G.B.A.* (1967), Tome LXIX, 201.

64. In a letter of 15 March 1732 from the Swedish architect Hårleman to Carl-Gustaf Tessin, there is still talk of two trends among Parisian woodcarvers, some working in the style of Oppenordt, others in the style of Vassé. In 1743 Briseux still speaks of Vassé with the greatest esteem, as the man who first brought woodcarving out of the darkness into the light. Cf. Briseux, *op. cit.* (Note 7), II, 158.

65. Oppenordt's altar, which is designed on the same lines as the baldacchino altar in the Val de Grâce, was copied in 1710 for Sainte-Trinité in Caen (now in Notre-Dame de la Gloriette). The final design for the altar of Saint-Germain des Prés is now in the National Museum in Stockholm. On Oppenordt's designs, cf. Kimball, 111; F. de Catheu, 'Les Marbres de Leptis Magna dans les monuments français du XVIIIᵉ siècle', *B.S.H.A.F.* (1936), 51. On Bullet's design, cf. R. Strandberg, 'Jean-Baptiste Bullet de Chamblain, Architecte du Roi', in *B.S.H.A.F.* (1962), 193; *idem*, 'Les Projets d'autel conçus par Pierre Bullet pour St Germain des Prés', *G.B.A.*, LXXI (1968), 33. On imitations of the altar of the Val de Grâce, cf. M. Reymond, 'Autel berninesque en France', *G.B.A.* (1913), 209.

66. They are the most conspicuous Italian characteristic; some of them correspond extensively with the cartouches of Borromini, drawn by Oppenordt, in San Giovanni in Laterano.

67. Already introduced as a motif by Le Pautre p. 261 (e.g. on the altars of the chapel of Versailles, 1707–8), and first used in the secular field by de Cotte in the designs for the chimneypieces at Bonn, 1716. Cf. P. Kjellberg, 'Ce qu'il faut regarder pour reconnaître le style Régence', *C.d.A.* (October 1962), 72.

68. The present gallery section of the Banque de France was completely rebuilt in 1870–5, though with careful re-employment of the old decoration. The original pictures were shared out among the French museums and replaced by modern copies. Cf. Kimball, 129; F. Laudet, *L'Hôtel de Toulouse, Siège de la Banque de France* (Paris, 1960).

69. The close agreement of numerous motifs, the use of the stag's head again over the entrance door at the same spot in Crozat's orangery at Montmorency, etc., makes Hautecœur think that Oppenordt may have been directly concerned in the designs; cf. Hautecœur, III, 238.

262 70. Further work by Vassé during the Régence was the decoration in the château of Petitbourg for the Duc d'Antin, probably also carried out under the influence of the Galerie d'Énée, and the Lady Chapel in the south transept of Notre-Dame, 1718–19.

71. Five drawings in the National Museum at Stockholm, Cronström-Tessin Collection, inscribed 'Château de la Grange'. To judge by the wealth of rooms, this can only be La Granja, begun in 1721 and now demolished. Cf. Kimball, 134.

72. For the Hôtel d'Assy, cf. the design utilized for the actual work and reproduced in the *Grand Oppenordt*, plate LXIV. The form of the cartouches for the upper wall panels, which in comparison with the engraving have become delicate and shallow, is significant of the change in Oppenordt's conceptions of form from the Italian manner to the French one. Cf. Kimball, 133; J. Babelon, *Historique et description des bâtiments des Archives Nationales* (Paris, 1958), 62.

73. On the basis of their quality and their similarity to drawings of Oppenordt's, Kimball attributes parts of this decoration to Oppenordt himself and places them in the years after 1729. But the difference in the views given by Mariette is not big enough to justify a division between Mollet and Oppenordt. As both the Comte d'Évreux and Oppenordt belonged to the intimate circle round the regent, it is probable that Oppenordt was called in for all designs, even in cases where Mollet carried them out. This makes an earlier date possible, say about 1720–2. Cf. Kimball, 142, 154.

263 74. The room in which the royal collection of coins and medallions used to be kept, and to some extent still is, originally formed part of an arcade spanning the Rue Colbert and was only moved to its present site in the twentieth century. Cf. Babelon, *op. cit.* (Note 21); Kimball, 154.

75. The decoration of the Hôtel de Parabère has been transferred to the house of Baron Fould-Springer. The overflowing of the corners and the uncommon delicacy and elegance of the motifs are characteristic of Boffrand.

76. Only partly still on their original site; the finest are now in the Hôtel de Breteuil (Irish Embassy) and at Waddesdon Manor. The original appearance is known through six engravings by Mariette, and a drawing in the National Museum in Stockholm. The decoration is among the most progressive of its time. What was particularly novel was the hollowing out of two parallel wall panels each time by a transverse oval field in the Grand Cabinet, and the resultant asymmetry of the top edges, which led Kimball to the erroneous dating 'about 1750'; cf. Strandberg, *op. cit.* (*B.S.H.A.F.*, 1963), 252.

CHAPTER 6

1. Cf. A. E. Brinckmann, *Baukunst des 17. und 18.* p. 265 *Jahrhunderts in den romanischen Ländern* (Handbuch der Kunstwissenschaft) (Wildpark-Potsdam, n.d.), 217, and for greater detail Kimball, with older literature.

2. *Les Amours rivaux* (Amsterdam, 1774). p. 266

3. H. Sedlmayer, 'Das Gesamtkunstwerk', in *Europäisches Rokoko*, exhibition catalogue (Munich, 1958), 26.

4. Boffrand in particular complained about this: 'Les décorations intérieures des appartements font à présent à Paris une partie considérable de l'architecture; elles font négliger la décoration extérieure, non seulement des maisons particulières, mais encore des Palais et des Édifices publics ...' (*Livre d'architecture*, 41).

5. Hautecœur, III, 598, with older literature; E. Kaufmann, *Architecture in the Age of Reason* (Cambridge, 1955), 131; *idem*, 'Three Revolutionary Architects, Boullée, Ledoux, Lequeu', *Transactions of the American Philosophical Society*, XLII, pt 3 (Philadelphia, 1952), 436; E. Schlumberger, 'L'Art de bâtir à la campagne selon Jacques-François Blondel', *C.d.A.* (March 1967), 74.

6. Cf. E. Kaufmann, 'The Contribution of J. F. Blondel to Mariette's Architecture française', *The*

Art Bulletin, XXXI (1949), 58, and J. Lejeaux, 'Jacques-François Blondel, professeur d'architecture', *L'Architecture*, XL (1927), 23.

p. 266 7. The *Livre d'architecture*, written in French and Latin and equipped with parallels with Horace's *Ars Poetica*, is a testimony to Boffrand's universal culture. The book includes all his bigger works, sometimes with later corrections, and contains in addition a detailed discussion of taste; cf. Kaufmann, *op. cit.* (1952), 446; *idem, op. cit.* (1955), 130.

p. 267 8. André's work is based on the *Traité du Beau* (1714) by the Lausanne professor of philosophy J.-P. de Crousaz; there is an extract from it in the preface to the second edition (1759) of the *Essai sur le Beau*. Cf. Hautecœur, III, 463.

9. H. Bauer, *Rocaille* (Berlin, 1862), I, 18 ff.

10. Kimball, 10, 183. The word 'rocaille' is first employed to denote a form of ornamentation, as opposed to its earlier meaning of shell work in grottoes, in 1736, in the title of an engraving by Moudon; 'Rococo' is first used to signify a tendency in taste in 1796–7 in artists' jargon, and in 1828 in literature, by Stendhal.

11. Adopted in 1842 in the supplement to the *Dictionnaire de l'Académie Française*, in 1843 in Jakob Burckhardt, *Über die vorgotischen Kirchen am Niederrhein*, then by Springer, A. von Zahn, and Schmarsow among others. Cf. H. Rose, *Spätbarock* (Munich, 1922), ix.

12. Fifteen signed drawings in the Musée des Arts Décoratifs in Paris, on a sheet dated '34'. Gaudion was Garde du Trésor from 1731 onwards; cf. Hautecœur, III, 255; Kimball, 155; P. Alfassa in *Musées de France* (1914), 59.

13. M. Gallet, 'Quelques étapes du Rococo dans l'architecture parisienne', *G.B.A.*, 6th. pér., LXVII (1966), 145 ff.

p. 268 14. In his old age Blondel pronounced a harsh verdict on this period and its architects, although he had been one of them himself: 'Dans ce temps de ténèbres et de vision, les le Roux, les le Grand, les Tannevot, ne sachant que faire des plans, eurent recours au prestige des embellissements et s'adressèrent aux Pinault, aux Messionnier, aux Lajoux, qui, dans la suite, eurent des imitateurs dans les Mondon, les Cuvillier, et ceux-ci achevèrent d'introduire le mauvais goût dans les ornements, conséquemment dans l'architecture' (*L'Homme du monde éclairé par les arts* (Amsterdam, 1774), I, 102).

15. 'Monsieur Tannevot... est un de nos architectes qui a poussé le plus loin l'art de la distribution. Nous avons de cet habile homme une grande quantité de maisons particulières, bâties avec beaucoup de goût et qui réunissent les commodités possibles. La décoration intérieure lui doit aussi beaucoup' (J.-F. Blondel, *Architecture française* (1752), III, livre V, chap XXIII, p. iii). See also J. Feray, 'L'Hôtel Tannevot et sa décoration attribuée à Nicolas Pineau', *B.S.H.A.F.* (1963), 69.

16. 'Il a été un des hommes les plus occupés de son temps, quoiqu'il fût plus sévère dans ses compositions' (J.-F. Blondel, *L'Homme du monde éclairé par les arts*, II, 295); Hautecœur, 168.

17. C. de Beaumont, 'Pierre Vigné de Vigny, architecte du Roi (1690–1772)', *Réunion des Sociétés de Beaux-Arts des Départements* (1894); 'Nouveaux documents sur P. de Vigny', *ibid.* (1898); Gallet, *op. cit.* (Note 13), 156.

18. F. Lucet-Vivier, 'Asnières et son château', in p. 2 *Urbanisme et Habitation*, N.S. (1955), 15. A good example of the court society 'folie' is the Pavillon de Hanovre, erected in 1757 by Chevotet for the Duc de Richelieu in the Boulevard des Italiens (now transferred to Sceaux); cf. C. Connolly and J. Zerbe, *Les Pavillons* (London, 1962).

19. H. Haug, 'L'Architecture Régence à Strasbourg', *Arch. alsat. d'hist. et d'art* (1926), 135; *idem, Le Château des Rohan et les grands Hôtels du XVIIIe siècle à Strasbourg* (Strasbourg, 1953).

20. J. Boyer, 'Une Œuvre inédite de Robert de Cotte à Aix-en-Provence: L'Hôtel de Caumont', *B.S.H.A.F.* (1964), 55; L. Deshairs, *Aix-en-Provence* (Paris, n.d.), xiv.

21. Hautecœur, III, 177, 325, 326, IV, 142; Kaufmann, *op. cit.* (1955), 133.

22. On the plan of the Hôtel de Villefranche at p. 27 Avignon (given in the *Encyclopédie*, illus., I, plate XXV) he says: '... rien de si bien entendu que ce plan; beauté, proportion, variété, agrément, commodité, symmétrie, relation des dedans aux dehors, tout s'y trouve réuni. En un mot, ce projet nous paraît un chef d'œuvre.'

23. Above all the abbey of Prémontré, one of the most magnificent buildings in northern France. It cannot be reconciled with Franque's classical style, with its repression of all sculptural elements. One is more inclined here to think of Bayeux and of his town hall at Beauvais, which displays the same giant articulation. Cf. on the other hand Hautecœur, III, 325.

24. A. Fliche, *Montpellier* (Paris, 1935), 76 ff.

25. W. Braunfels, *François de Cuvilliés* (Würzburg, 1938); P. du Colombier, *L'Architecture française en Allemagne au XVIII^e siècle* (Paris, 1956), 147.

272 26. Pierre-Louis Moreau, *Plan général des différents projets d'embellissement les plus utiles et les plus convenables à la commodité des citoyens et à la décoration de la ville de Paris* (Paris, 1759). This is the beginning of the transformation of Paris into a modern city, even though the execution of the plan was subject to continual stoppages.

27. Hautecœur, III, 333 ff.

28. Public opinion on this subject was prepared by writings such as Voltaire's *Dialogues sur les embellissements de Cachemire* and *L'Embellissement de Paris* (1749). Cf. P. Lavedan, *Histoire de l'urbanisme, Renaissance et temps modernes*, 2nd ed. (Paris 1959), 193 ff.; *idem, Les Villes françaises* (Paris, 1960), 150 ff.

29. He was a scion of an old dynasty of architects, a nephew of J. H. Mansart, and thanks to this protection had risen surely and steadily in the royal Office of Works, although Mariette observed cuttingly of him: 'Il n'auroit pu dessiner le moindre bout d'ornement. Est-ce là être architecte? Et comment un premier architecte peut-il hasarder de juger sur les ouvrages des artistes qui lui sont soumis, quand il est lui-même dépourvu de connoissances?' In 1689–90 he had accompanied de Cotte on his trip to Italy; in 1699 he was already a first class member of the Académie; and in 1704 he was ennobled as Seigneur de Mézières. Cf. Comte de Fels, *Les Gabriel* (Paris, 1924); Hautecœur, III, 140.

273 30. The first design for the staircase wing, in competition with Oppenordt, dated from 1731, and the final designs for the flight of stairs from 1733 (Paris, Musée des Art Décoratifs). Oppenordt's designs have not been preserved; cf. Hautecœur, III, 145. Fels thought that the stairs must be attributed to A.-J. Gabriel, but the designs in the Musée des Arts Décoratifs are at variance with this view. In addition, Gabriel had already built a similar staircase in the Palais de Justice at Rennes.

31. G. Nitsch, *L'Hôtel de Ville, La Tour de l'Horloge, Le Présidial de Rennes* (Rennes, 1928); P. Banéat, *Le vieux Rennes* (Rennes, n.d.); R. Plouin, 'Documents relatifs à la construction de l'Hôtel de Ville de Rennes', in *B.S.H.A.F.* (1956), 89.

32. P. Patte, *Monuments érigés à la gloire de Louis XV* (Paris, 1765) (with a survey of all the Places Royales of the eighteenth century); P. Courtault, *La Place Royale de Bordeaux* (Paris, 1923); L. Lambeau, 'La Place Royale', in *Procès verbaux du Comité du Vieux Paris* (1925), Annexe 31.1; Lavedan, *op. cit.* (1959), 277; P. Zucker, *Town and Square* (New York, 1959), 174 ff.; J. Thuillier, 'Économie et urbanisme au XVIII^e siècle', in *Art de France*, no. 1 (1961), 311.

33. In the *Traité de la police* (Paris, 1738), de la Mare mentions three kinds of public squares, those for trade and commerce, those for public gatherings and the administration of justice, and finally the Places Royales (IV, 390). Thus these already formed a special category in the consciousness of contemporaries. Both in the present Place des Vosges and in the Place Dauphine the statues of the ruler were erected retrospectively, and were in fact imported from Italy – an important clue to the genesis of the Place Royale.

34. Courtault, *op. cit.*

35. M. L. de Grandmaison, 'André Portier de p. 274 Leugny (1702–70), architecte-inspecteur des travaux de la Place Royale de Bordeaux', *B.S.H.A.F.* (1934), 105.

36. P. Marot, 'La Genèse de la Place Royale de p. 276 Nancy', *Ann. de l'Est* (1954), 3; *idem, La Place Royale de Nancy* (Paris, 1966). Important evidence on the topography is provided by Héré's series of engravings, *Plans et élévations de la Place Royale de Nancy* (Paris, 1753).

37. J.-N. Jennesson (1686–1755), a pupil of Boffrand, was Architecte Ordinaire to the duke from 1721 onwards; he built several churches in Nancy, including Saint-Sébastien (1720–36). In 1737 he was appointed Premier Ingénieur et Architecte to Stanislas, but fell out with him over the kiosk at Lunéville.

38. C. Pfister, *Emmanuel Héré et la Place Stanislas* (Nancy, 1905–6); A. Jacquot, 'Emmanuel Héré, premier architecte de Stanislas, et ses collaborateurs', in *Le Pays lorrain*, 33rd year (1952); P. Marot, *Emmanuel Héré* (Nancy, 1954).

39. Closely akin to the arch is the triumphal arch at Innsbruck, erected in 1765. In Héré's arch at Nancy, Marot sees the influence of Piranesi, while the Arco di San Gallo at Florence is much more Baroque.

p. 276 40. In the first design the town-hall end consisted – like the Place de la Concorde in Paris – of two blocks bisected by a street (Salle de Comédie, Salle de Concert, Collège de Médecine, town hall), while the long sides of the square consisted, in contrast to the present layout, of continuous buildings. The bastions were only demolished in 1753, during the course of the building.

p. 278 41. The colonnades here serve at the same time, as in the Hôtel de Soubise in Paris, to articulate the façade. In the side arcs they were altered, contrary to the original plan, into plain walls, with columns adorned with busts standing in front.

p. 279 42. Hautecœur, III, 499.

43. Cf. Le Carpentier's series of engravings, *Recueil des plans, coupes et élévations du nouvel Hôtel de Ville de Rouen* (Paris, 1758). There is a model in the Musée d'Art Normand at Rouen. P. Chirol, *L'Architecte le Carpentier et le projet du nouvel Hôtel de Ville de Rouen* (Rouen, 1913).

44. Cf. especially, besides the engravings by Patte already mentioned, E. Lambert, 'Un Projet de Place Royale à Paris en honneur de Louis XV', *B.S.H.A.F.* (1938), 85; P. Lavedan, 'Le IIᵉ centenaire de la Place de la Concorde', in *La Vie urbaine* (1956); and S. Granet, 'Images de Paris, La Place de la Concorde', *La Revue géographique et industrielle de France*, 61st year, N.S. no. 26 (Paris, 1963).

p. 280 45. The motif of a 'Trajan's Column' in front of the concave façade of a square already appears in a series of drawings in the National Museum in Stockholm belonging to the seventeenth century and attributed by Josephson to Mignard. Cf. R. Josephson, 'Un Projet de Place Royale à la pointe de la Cité', *B.S.H.A.F.* (1928), 52. There is another design, very close to Boffrand's, probably a product of Mansart's office and thus almost certainly known to Boffrand, in the B.N. Est. Cf. J. Garms, 'Projects for the Pont Neuf and Place Dauphine in the First Half of the Eighteenth Century', *Journal of the Society of Architectural Historians*, XXVI (1967), no. 2, 102.

46. The returned designs are published in *La Vie urbaine* (1962); see also S. Granet, 'Le Livre de vérité de la Place Louis XV', *B.S.H.A.F.* (1961), 107, which includes a survey of the designs not publicized by Patte.

47. In his report to the king, Marigny, who was familiar with the layout of Italian squares, pointed to the irreconcilability of the tasks posed.

48. Laugier called it appropriately 'L'image d'une esplanade embellie au milieu d'une campagne riante et d'où l'on aperçoit divers Palais dans l'éloignement' (*Essai sur l'architecture*, Paris, 1753). Before the construction of the Pont Louis XVI (now the Pont de la Concorde) in 1787–90 there was no north-south axis, but the idea appears already in an anonymous drawing dating from the middle of the eighteenth century; cf. Garms, *op. cit.*

49. Drawing in the B.N. Est., cf. Garms, *loc. cit.* On Mignard's project, cf. R. Strandberg, 'Les Projets d'autel conçus par Pierre Bullet pour St Germain des Prés', *G.B.A.*, LXXI (1968), 33. p. 281

50. J. Garms, 'L'Aménagement du parvis de Notre Dame par Boffrand', *Art de France*, no. 4 (1964), 153.

51. Soufflot was admitted to the Lyon Académie in 1739 at the age of twenty-five. He had already published a study written in Italy, 'Les plans et descriptions de l'église St Pierre de Rome et de la colonnade de la place antérieure'. On Soufflot in general, cf. J. Mondain-Monval, *Soufflot, sa vie, son œuvre, son esthétique* (Paris, 1918); Hautecœur, III, 593.

52. Soufflot had originally planned a higher dome. It was made lower during the course of construction and against his will. Cf. the series of engravings put together by Lequeu, 'Architecture de Soufflot'.

53. In his 'Diverses remarques sur l'Italie' Soufflot speaks of Italian Baroque as an 'architecture licencieuse, pour tant qu'un génie calme et pondéré peut en tirer de l'avantage et y profiter de quelques inventions heureuses'. Here he is in opposition to Borromini.

54. E. de Ganay, 'Le Jardin de la Fontaine à p. 282 Nîmes', *Revue de l'Art Ancien et Moderne*, LIX (1931), 117 ff.; idem, *G.B.A.*, LIV (1955), 203.

55. Cf. *C. d. A.* (March 1956), 68; Hautecœur, 549; also the Correspondence of Madame de Pompadour, ed. by A. P. Malassis. On her passion for building, she herself said: 'On se moque partout de la folie de bâtir. Pour moi, je l'approuve fort, cette prétendue folie, qui donne du pain à tant de misérables.'

56. P. Biver, *Histoire du château de Bellevue* (Paris, p. 283 1933); L. Réau, *Les Monuments détruits de l'art français*, I (Paris, 1953), 220; Hautecœur, III, 552.

57. D'Argenson wrote about this in 1752: 'On a calculé que depuis 1726 jusqu' à présent les

bâtiments ont monté en dépenses à 350 millions, le tout pour ne faire que des nids à rats, à faire et à défaire. C'est le Château de Choisy qui est le plus grand théâtre de ces variations. Il n'y a point d'année où l'on ne détruise pour rebâtir ce que l'on change encore l'année suivante ...' (D'Argenson, *Journal et mémoires* (Paris, 1865), VII, 127).

58. The staircase well, which was now only seldom used and finally served for the theatrical performances arranged in the château by Madame de Pompadour, was to be replaced by a corresponding new one, situated at the beginning of the Grands Appartements before the Salon d'Hercule. It was begun by A.-J. Gabriel but was never completed.

59. Only the eastern half of the wing and the central pavilion were built under the supervision of Jacques Gabriel; the western half was completed along the same lines by his son Ange-Jacques in 1773-4. Cf. Y. Bottineau, *L'Art d'Ange-Jacques Gabriel à Fontainebleau* (Paris, 1962).

60. In 1728 Contrôleur Général des Bâtiments du Roi and at the same time a member of the Académie; in 1734, on de Cotte's retirement (the latter's son being passed over), Contrôleur du Château de Versailles; in 1741 Architecte Ordinaire du Roi. Cf. Fels, *op. cit.* (Note 29); G. Gromort, *Ange-Jacques Gabriel* (Paris, 1933); H. B. Cox, *Ange-Jacques Gabriel* (London, 1926); Hautecœur, III, 548; R. Laulan, *L'École Militaire de Paris* (Paris, 1950), 18.

285 61. The plans were drawn up at first by Lassurance and Garnier de l'Isle; only then was Gabriel commissioned. The two side buildings, which blur the outline, are later additions (cf. Bottineau, *op. cit.*, 48). The Fontainebleau hermitage is the only one preserved of the many hermitages built by the king for Madame de Pompadour.

62. For Choisy, cf. B. Chamechine, *Le Château de Choisy* (Paris, 1910); Hautecœur, III, 563; G. Poisson, 'Un Édifice de Gabriel retrouvé, Le Petit Château de Choisy', *B.S.H.A.F.* (1953), 10.

63. Illustrated in E. de Ganay, *Les Jardins à la française en France au XVIIIe siècle* (Paris, 1943), plate II b.

64. Connolly and Zerbe, *op. cit.* (Note 18), 88; Fels, *op. cit.*, 224.

286 65. Collected in the big set of engravings *Recueil des plans, élévations et coupes des châteaux, jardins et dépendances que le Roi de Pologne occupe en Lorraine* (Paris, 1750).

66. Hautecœur, III, 333; J. Evans, *Monastic* p. 287 *Architecture in France from the Renaissance to the Revolution* (Cambridge, 1964), discussed by Sir A. Blunt in the *Burl. Mag.*, CVI (1964), 467.

67. 'Les églises nouvellement bâties en France sont à quelque chose près toutes faites sur le même modèle' (Cordemoy, *Nouveau Traité de toute l'architecture* (Paris, 1706), 108).

68. E. Langenskjöld, *Pierre Bullet, The Royal* p. 288 *Architect* (Stockholm, 1959), 129; Strandberg, *op. cit.* (Note 49), 239.

69. J. Garms, 'Boffrand à l'Église de la Merci', *B.S.H.A.F.* (1964), 185.

70. Chanoine Gallet, *St Louis de Versailles* (Paris, n.d.).

71. Bullet's designs date from *c.* 1725, Meissonnier's from 1726, but they were only called upon when Oppenordt had lost the confidence of the church authorities. Bullet de Chamblain's drawings are today in Stockholm, National Museum, Cronstedt-Tessin Collection; illustrated in Langenskjöld, *op. cit.*, 126, and Strandberg, *op. cit.*, 248. Cf. catalogue to the exhibition *Louis XIV's Paris* (Stockholm, 1945), nos. 53-66.

72. He was at the same time Premier Peintre Décorateur de l'Académie Royale de Musique. His most important decorative works in France were: altar baldacchinos at Sens and in Saint-Bruno des Chartreux at Lyons; decorations in Paris in 1729 for the birth of the dauphin and in 1739 for the marriage of the king's daughter; and illusionistic paintings in the château of Condé-en-Brie about 1740. Cf. Kimball, 163; Hautecœur, 226; J. Bouche, 'Servandoni', *G.B.A.*, II (1910), 121 ff.; M. Bataille, in L. Dimier, *Les Peintres français du XVIIIe siècle*, II (Paris, 1930), 379; R. D. Middleton, 'The Abbé de Cordemoy and the Graeco-Gothic Ideal', in *J.W.C.I.*, XXV (1962), 278 ff.; E. Schlumberger, 'Un Génie d'opéra, Servandoni', *C.d.A.* (August 1965), 14; H. Démoriane, 'La Décoration et l'apparat de Condé-en-Brie', *ibid.* (January 1967), 37.

73. Brinckmann, *op. cit.* (Note 1), 188; Lemesle, *L'Église St Sulpice* (Paris, 1931); E. Malbois, 'Projets de la place devant St Sulpice par Servandoni', *G.B.A.*, II (1922), 283 ff.; *idem*, 'Oppenordt et l'église St Sulpice', *G.B.A.*, II (1933), 33. Sketches of the façade with details are to be found in P. Patte, *Mémoire sur l'achèvement du grand portail de l'église de St Sulpice* (Paris n.d.), and *idem*, *Mémoires sur les objets les plus importants de l'architecture* (Paris, 1769).

Servandoni's first and second designs for the façade are today in the B. N. Est., Coll. Destailleur, and the École des Beaux Arts.

p. 289 74. Engraved in 1742, but already allowed for in Turgot's town plan of 1738.

75. In Blondel's *Architecture françoise* of 1752 the façade is still illustrated and discussed without the third storey. But it appears on the medal struck in 1754 to commemorate the inauguration of the square in front of the church, in Patte, *loc. cit.*, and in the picture exhibited by P. de Machy in 1763 at the Salon, *Ruines de la Foire St Germain* (Paris, Musée Carnavalet).

76. On Patte's role in the completion of the façade and his rivalry with Oudot de Maclaurin, cf. M. Mathieu, *Pierre Patte* (Paris, 1940), 122.

77. W. Herrmann, 'Antoine Desgodets and the Académie Royale d'Architecture', *The Art Bulletin*, XL (1958), 23 ff. The two-storey portico, with its Doric and Ionic columns and its statues in the attics, is completely in the tradition of Palladio and Perrault. It could have been the model for the columned portico of the École Militaire (courtyard side) as well as for Saint-Sulpice.

p. 290 78. Illustrated in Mariette, ed. Hautecœur, plate 544.

79. Characteristically secular elements in these Rococo churches are the hollow moulding over the colonnade and the window decorations in the top storey. The aisles were separated from the nave by steps and balustrades, like boxes in the theatre.

80. In the north of France, too, the hall-church remained the usual pattern during the eighteenth century. There are examples in Lille, Douai, and Cambrai among other places. The link with the Low Countries was never broken in this region.

p. 291 81. Begun as the abbey church of Saint-Rémy. In 1745 the old parochial church of Saint-Jacques was demolished and the parish transferred to Saint-Rémy. For Saint-Jacques and Saint-Sébastien, cf. *Congrès Archéologique* (Nancy-Verdun, 1933/4), 41; P. Lavedan, 'Remarques sur quelques églises du XVIIIe siècle en Lorraine', *B.S.H.A.F.* (1947-8), 18.

82. On the reminiscences of Gothic modes of construction in Boffrand, cf. Middleton, *op. cit.* (Note 72), 310.

83. The activity of Jadot, presumably under Boffrand's supervision, is obvious from a longitudinal section (Mus. Hist. Lorrain, Nancy), and from a signed sketch of the façade dated 1731 which corresponds in almost every detail with the finished work, though it is true that the caps of the towers are different (Recueil Jadot, Bibl. d'Art et d'Archéologie, Paris). Jadot, however, came on the scene only after the façade had been built up to the figure niches, probably by Boffrand himself. On Jadot, cf. J. Schmidt, 'Die alte Universität in Wien und ihr Erbauer, J. N. Jadot', *Wiener Forschungen zur Kunstgeschichte* (1929), 83.

84. P. Moisy, *Les Églises jésuites de l'ancienne assistance de France* (Rome, 1958). Moisy links this group with the theories of Cordemoy and Laugier, although these theories are based on column-and-architrave construction, not on arcades of columns. Blunt on the other hand rightly points to Flemish models; cf. the discussion of Moisy's book in the *Burl. Mag.*, CI (1959), 112.

85. R. Tournier, *Les Églises comtoises* (Paris, p. 2 1954); idem, *L'Architecte Nicolas Nicole, 1702-84* (Besançon, 1942).

86. But cf. also the similarity with Desgodets' design for a monastic church in his *Traité des ordres de l'architecture*, which was certainly known to Nicole; Herrmann, *op. cit.*, 49.

87. Cf. *Cours d'architecture*, III, plates LV ff.

88. Only carried out in 1823-30 in an altered form. Nicole's plans bore a general resemblance to Servandoni's first design for Saint-Sulpice.

89. L. Charvet, *Les Delamonce* (Paris, 1892); R. de Nail, *Lyon, Architecture et décoration aux 17e et 18e siècles* (Lyon, n.d.).

90. The plans, strongly influenced by Mansart, p. 2 to put a turret and steeple on the crossing, after the style of the spire on the dome of the Invalides, did not last long. There is a similar clinging to Gothic in the abbey church of Saint-Pierre at Corbie, the Gothic façade of which was completed in 1719 by putting back a 'classical' alternative solution! Cf. G. Chenesseau, *Ste Croix d'Orléans* (Paris, 1921); R. Normand, *Saint Riquier* (Paris, 1955); P. Héliot, 'La Fin de l'architecture gothique en France durant les XVIIe et XVIIIe siècles', *G.B.A.* (1951), 127; Middleton, *op. cit.* (Note 72), 297. The most remarkable combination of Gothic and classical styles of building is to be found in Hénault's designs for Notre-Dame de Bonne Nouvelle at Orléans (1718); the outside is cathedral Gothic and the inside is modelled on the chapel of Versailles, while on the façade is the obelisk designed by Lemercier in 1642 for the cathedral. Cf. M. Petzet, *Soufflots Ste Geneviève und der französische Kirchenbau des 18. Jahrhunderts* (Berlin, 1961), plate XIV.

91. The main artists on whom he modelled himself were Giovanni Giardini in the goldsmith's art, and Guarini, Borromini, and Pietro da Cortona in architecture and decoration. He also seems to have been influenced by Giuseppe Galli-Bibbiena. Cf. M. Bataille, in Dimier, *op. cit.* (Note 72), II, 373; Kimball, 165; Bauer, *op. cit.* (Note 9), 16. Cochin's disparaging verdict is quoted in detail by Destailleur, *Notes sur quelques artistes français* (1863), 224.

92. Nothing from the hand of Meissonnier has been preserved, but the Parisian goldsmith Duvivier in particular worked from his designs. The first work in the *genre pittoresque* is a candelabrum of 1728, illustrated in Kimball, figure 201.

93. Daviler, in his 'Explication des termes d'architecture', defines rocaille as a 'composition rustique qui imite la nature'. On the concept and genesis of rocaille, cf. Bauer, *op. cit.* (Note 9); P. Ward Jackson, 'Some Main Streams and Tributaries in European Ornament, 1500–1750', part 3, *V. and A. Museum Bulletin* (October 1967), III, no. 4, p. 121.

294 94. The expression 'pittoresque' was first defined in 1726 by Coypel as 'un choix piquant et singulier des effets de la nature' (*Discours sur la peinture*, published in 1732). J.-F. Blondel, as a contemporary critic, described Pineau, Meissonnier, and Lajoue as 'les trois premiers inventeurs du genre pittoresque' (*Les Amours rivaux*, Amsterdam, 1774). 'Rocaille' and 'pittoresque' were equated quite early on; cf. Kimball, 164, 184; *idem*, 'J. A. Meissonnier and the Beginning of the Genre Pittoresque', *G.B.A.*, XXII (1942), 27.

95. Asymmetry in figured ornament – cartouches and trophies among other things – had long been known, but it had always been carefully avoided in wall panels. As a mathematical concept, it had only cropped up since Montesquieu's *Essai sur le goût*, where symmetry was no longer equated as before with proportion, but with bilateral balance. Cochin blamed Meissonnier for first introducing asymmetry, but J.-F. Blondel blamed Pineau.

96. G. Huard, in Dimier, *op. cit.* (Note 72), II, 347; C. Linfert, 'Die Grundlagen der Architekturzeichnung', in *Kunstwiss. Forschungen*, I (Berlin, 1931), 188; Kimball, 182.

97. Garms, *op. cit.* (Note 45).

98. J.-F. Blondel remarked of him: 'Son génie le portait toujours trop loin, lorsqu'il s'agissait d'Architecture: aussi n'a-t'il guère exécuté que quelques décorations intérieures' (*Cours d'architecture*, III, 349).

99. The wall decorations of the Hôtel de Villars p. 295 are now at Waddesdon Manor, those of Asnières are at Cliveden.

100. The vast majority of the drawings are in the Musée des Arts Décoratifs in Paris; published in L. Deshairs, *Nicole et Dominique Pineau* (Paris, n.d.). See also E. Biais, 'Nicolas Pineau, inventeur du contraste', *Réunion des Sociétés de Beaux-Arts des Départements* (1899), 381; G. Huard, in Dimier, *op. cit.*, I (1928), 331; Kimball, 174; Gallet, *op. cit.* (Note 13), 158. There is an accurate, if ironical, estimate of Pineau and Meissonnier in Cochin's 'Supplication aux orfèvres', *Mercure de France* (December 1754).

101. The first examples of this are the Hôtel de Rouillé and the gallery of the Hôtel de Villars, both dating from about 1732. A preliminary stage is represented by the wall panels leaning towards each other in the Hôtel Dodun by J. Bullet de Chamblain (1725).

102. Boffrand's own decorations were published p. 296 in the *Livre d'architecture* (1745); cf. C. V. Langlois, *Les Hôtels de Clisson, de Guise, et de Rohan Soubise* (Paris, 1922); Kimball, 190. Part of this new equipment was the built-in Cabinet Vert, now in the Hôtel de Rohan, with Aesop's fables carved on it. The princess's salon was doubtless the model for Cuvilliés' central salon in the Amalienburg in the park at Nymphenburg (completed in 1739).

103. Kimball, 187. Verberckt is first mentioned, alongside Degoullons and Le Goupil, and thus still under de Cotte, in connexion with the first redecoration of the Chambre de la Reine in 1730.

104. Besides the rooms accessible to the public on the first floor, the Petits Appartements also embraced the second and third floors, which were occupied by the king as well as by the current favourites. For their very complicated history, cf. P. de Nolhac, *Versailles au XVIIIᵉ siècle* (Paris, 1918); H. Racinais, *La Vie inconnue des Petits Appartements de Versailles* (Versailles, 1951); P. Verlet, *Versailles* (Paris, 1961).

105. The remodelling of the Cabinet Intérieur had already begun in 1738 with the insertion of a polygonal partition dividing it off from the Arrière Cabinet, whence the name 'Cabinet à Pans'. But it was not until 1753 that the present covering was applied to the walls, and in 1757 the polygonal partition was replaced by a rectangular one. The

Appartement de Madame Adélaïde originally comprised four rooms. Besides the Salon de Musique, the decoration of the dining room, altered in 1768 and now the Salle à Manger aux Salles Neuves, has also been preserved.

p. 296 106. The Cabinet du Conseil came into being out of the merging of Louis XIV's old Cabinet du Conseil and the Cabinet des Termes or des Perruques. Here Gabriel employed numerous sections of the old woodwork, in particular the old doors; this is what gives the room its divided character.

p. 297 107. Further panelling from this apartment is today incorporated in the Cabinets de la Reine on the first floor. On the Appartement des Dauphins, cf. M. Jallut, 'Château de Versailles, Cabinets Intérieurs et Petits Appartements de Marie Antoinette', *G.B.A.*, LXIII (1964), I, 289.

108. Bottineau, *op. cit.* (Note 59), 72; Kimball, 219.

109. Their date, to which there are no reliable clues of any sort, can only be deduced on stylistic grounds. The work is probably connected with the king's frequent visits between 1727 and 1733, and was certainly not carried out after 1736, the year in which the Comte de Toulouse died. Cf. F. Lorin, *Histoire de Rambouillet* (Paris, 1907); H. Longman, *Le Château de Rambouillet* (Paris, n.d.); Kimball, 193.

p. 298 110. The former bedroom (now the salon) and in particular the Cabinet des Singes with the Turkish motifs by Huet date from the time of the Marquise, who in 1747 rented Champs for her own use. Asymmetry and the *genre pittoresque* are still evident here; in later work they disappear.

111. Illustrated in Diderot's *Encyclopédie* and in Blondel's *Cours d'architecture*, V, plates I and II. Cf. Kimball, 210 (where too early a date is assigned); Hautecœur, III, 589.

112. Clerici, who came from the Ticino, had introduced this technique from Germany; it spread in France from the fifties onwards. His rival was to be Louis Mansiaux, known as Chevallier, court plasterer to King Stanislas at Nancy, who came to Paris in 1766 after the death of his master. Cf. Hautecœur, IV, 506; Jallut, *op. cit.*, 334.

113. The illusionistic paintings from the Hôtel de Luynes are now in the Musée Carnavalet in Paris.

114. J. Garms, 'L'Aménagement du parvis de Notre Dame par Boffrand', *Art de France* (1964), 153.

CHAPTER 7

1. On the historical situation, cf. E. J. F. Barbier, p. 2 *Chronique de la Régence et du règne de Louis XV* (Paris, 1885), IV and V; also the *Journal et mémoires du Marquis d'Argenson* (Soc. de l'Hist. de France) (Paris, 1859), VIII.

2. Cf. Duverney's letter to Gabriel on the occa- p. 3 sion of the reduction of the first design for the École Militaire of 29 December 1750: 'Entre le beau et l'utile il n'y a point à balancer quant on ne peut réunir les deux ... il faut subordonner et même sacrifier le beau à l'utile dès que les circonstances ne permettent pas que l'on concilie l'un avec l'autre'; R. Laulan, *L'École Militaire de Paris* (Paris, 1950), 20; similarly Milizia, 'La beauté de l'architecture naît toute du nécessaire et de l'utilité'.

3. Cf. on this point E. and J. de Goncourt, *Portraits intimes du XVIIIe siècle* (Paris, n.d.), 190; *Abécédario* (Paris, 1853–4); S. Rocheblave, *Essai sur le Comte de Caylus* (Paris, 1889); A. Fontaine, *A.C.P. Comte de Caylus* (Paris, 1910); S. Rocheblave, *L'Âge classique en France* (Paris, 1932); and especially J. Seznec, 'Le Singe antiquaire', in *Diderot et l'antiquité* (Oxford, 1957), 85.

4. *Mercure de France* (October 1750), 138. Notice sur Meyssonier, Orfèvre, B.N. Est., Coll. Deloynes, IV, no. 45, p. 418; 4 p. MS. unsigned (écrit par Mariette), according to information kindly supplied by Mlle Rosalie Bacou.

5. La Font de Saint-Yenne's criticisms in *Réflexions sur quelques causes de l'état présent de la peinture en France* (1746); *L'Ombre du grand Colbert* (1749); *Le Génie du Louvre* (1756).

6. *Discours sur la manière d'étudier l'architecture* (Paris, 1747).

7. Published in 1771–3, continued and completed by P. Patte (2 vols), 1773–7. From 1762 onwards Blondel also taught at the Académie as Loriot's successor; cf. J. Lejeaux, 'Jacques-François Blondel, professeur d'architecture', in *L'Architecture*, XL (1927), 23.

8. There had been plans since 1752 for a regularization of the square on the south side of the cathedral; they foundered at first on the resistance of the canons. Blondel's connexion with Metz arose out of his being commissioned to build the new abbey of Saint-Louis. The work is discussed in detail in the *Cours d'architecture*, IV, 397. The façade of the

cathedral was replaced in 1898 by a new Gothic façade. Cf. J. Lejeau, *La Place d'Armes de Metz* (Strasbourg, 1927); Hautecœur, III, 598.

9. *Encyclopédie ou Dictionnaire raisonné des sciences, des arts et des métiers*, which started to appear in 1751. The architectural section was written by Blondel. The first volume of illustrations, in which an important place is given to architecture, did not appear until 1761.

10. On what follows, cf. W. Herrmann, *Laugier and Eighteenth Century French Theory* (London, 1962); also R. D. Middleton, 'The Abbé de Cordemoy and the Graeco-Gothic Ideal', *J.W.C.I.* (1963), 90 ff.

301 11. In reply to the opposition of Frézier, Guillaumot, and La Font de Saint-Yenne, Laugier published in 1765 his *Observation sur l'architecture*, in which he substantially reduced his demands.

12. J.-F. Blondel, *Discours sur la nécessité de l'étude de l'architecture* (Paris, 1754), 88: 'Ouvrage plein d'idées neuves et écrit avec sagacité.'

13. N. Cochin, *Voyage d'Italie* (Paris, 1758); H. Roujon, *Le Voyage du Marquis de Marigny en Italie* (Paris, 1898); M. Benissovitch, 'Ghizzi and the French Artists in Rome', *Apollo* (May 1967), 340; Kimball, 211.

14. Recapitulated in *Œuvres diverses de Cochin* (Paris, 1771).

15. L. Hautecœur, *Rome et la Renaissance de l'antiquité à la fin du XVIIIᵉ siècle* (Paris, 1912); F. J. B. Watson, 'Neo-classicism on both sides of the Channel', *Apollo* (1967), 239; A. Focillon, *G. B. Piranesi* (Paris, 1963), 54; J. Harris, 'Le Geay, Piranesi and International Neo-classicism in Rome, 1740–50', *Essays on the History of Architecture presented to Rudolf Wittkower* (London, 1967), 189; idem, in the *Journal of the Royal Society of Arts* (April 1966), 429.

16. For a detailed discussion of Legeay, see J. M. Pérouse de Montclos, *Étienne-Louis Boullée* (Paris, 1969), 39.

302 17. On the Festa della Chinea, cf. H. Tintelnot, *Barocktheater und barocke Kunst* (Berlin, 1939), 290, and the *Essays presented to R. Wittkower* (London, 1967). On Le Lorrain's role in the formation of the neo-classical style, cf. S. Eriksen, 'Om salen paa Åkerö og dens Kunstner Louis-Joseph Le Lorrain', *Konsthistorisk Tidskrift*, XXXII (1963), 94 (see Note 15).

18. Sir William Chambers, who came from the same circle, introduced in his *Treatise on Civil Architecture* (1759) window shapes by Michelangelo, Vignola, Ammanati, and Buontalenti, and chimneypieces by Scamozzi and Palladio.

19. Cf. on this R. P. Wunder, 'Charles Michel-Ange Challes', *Apollo* (1968), 220.

20. E. Kaufmann, 'Three Revolutionary Architects', *Transactions of the American Philosophical Society* (Philadelphia, 1952), 450; Harris, *loc. cit.*; Kimball, 214; N. Cochin, *Œuvres diverses*.

21. F. G. Pariset, 'L'Architecte Barreau de Chefdeville', *B.S.H.A.F.* (1962), 77. The furniture is illustrated in *C.d.A.* (July-August 1968), 118. On the priority of this furniture and comparable English pieces, cf. R. Edwards, J. Harris, P. Thornton, and F. Watson in *Apollo* (January 1968), 66, (April 1968), 310; Grimm, *Correspondance littéraire, philosophique, et critique*, I (Paris, 1753–69), V, 282; S. Eriksen, 'La Live de Jully's furniture à la grecque', *Burl. Mag.*, CIII (1961), 340; P. Thornton, 'Proto-Neo-classicism: The Battle of the Giants', *Apollo* (1968), 310; M. Gallet, *Demeures parisiennes, L'Époque de Louis XVI* (Paris, 1964), 60.

22. Particularly important are J.-D. Leroy, *Ruines des plus beaux monuments de la Grèce* (1758), and J. Stuart and N. Revett, *Antiquities of Athens* (1st vol. 1762); also Soufflot's measurements of the temples of Paestum, published by Dumont in 1764. Winckelmann's *Geschichte der Kunst des Altertums* appeared in the same year, 1764. On the history of the rediscovery of Antiquity, see above all N. Pevsner and S. Lang, 'The Doric Revival', *Studies in Art, Architecture and Design* (London, 1968), 197. On the *style grec* see in particular Hautecœur, IV, and Herrmann, *loc. cit.* (Note 10).

23. Cochin, *Mémoires inédites* (Paris, 1880), 142; Grimm, *op. cit.*, V, 282. On the other hand, authentic copies of Greek temples were first built in England (temple at Hagley, 1758). Cf. B. Fitzgerald, 'The Temple of the Winds', *The Connoisseur* (April 1948), 206.

24. Gallet, *op. cit.*, 60. One of the earliest examples was the façade, later remodelled, of the church at Nérac, by Barreau de Chefdeville (1762 onwards); cf. Pariset, *op. cit.*, 94.

25. Hautecœur, *op. cit.* (Note 15), 123; idem, *Histoire de l'architecture classique*, IV, 225.

26. Peyre expressed his modern ideas clearly in p. 303 the *Œuvres d'architecture* – 'rassembler les principes des Grecs et des Romains qui serviront à combattre

en France l'architecture dite française'. In the Supplement he says: 'Toutes les fois qu'on a voulu s'écarter des principes généraux que les anciens ont adoptés, on a fait de mauvaises choses.'

p. 303 27. See especially the designs for the Hôtel de Condé and a royal palace.

28. J. Lejeaux, 'Charles-Louis Clérisseau, architecte', *L'Architecture* (1928), 115; T. Waterman, 'French Influence on Early American Architecture', *G.B.A.* (1945), II, 87; T. J. MacCormick and J. Fleming, 'A Ruin Room by Clérisseau', *The Connoisseur* (April 1962); Gallet, *op. cit.*, 51. In 1779 he sold to the Empress Catherine of Russia eighteen volumes containing drawings of classical views and compositions of Panini, the product of a twenty-year stay in Rome. They are now in the Hermitage in Leningrad.

29. His triumphal arch for St Petersburg is discussed by L. Hautecœur in *B.S.H.A.F.* (1922), 170.

p. 304 30. J. Stern, *À l'ombre de Sophie Arnould, François-Joseph Bélanger, architecte des Menus Plaisirs* (Paris, 1930), 19; Hautecœur, IV, 303.

31. Both had collaborated on David le Roy's series of engravings, *Les Ruines des plus beaux monuments de la Grèce.* Cf. Eriksen, *loc. cit.* (Note 21). On François de Neufforge (1714–91), who came from the Liège region but had lived since 1738 in Paris, where he worked at first for Babel as an ornament engraver, cf. *C.d.A.* (1958), 80; Cte. de Limburg-Stirum in the Bibliographie Nationale de Belgique; Hautecœur, IV, 59, 461; Kaufmann, *op. cit.* (Note 20), 151.

32. The list of subscribers contains the following names: Blondel, Le Roy, Barreau de Chefdeville, Pajou. Kimball erroneously names five subscribers.

33. *Rural Architecture* (1750) and *Architecture Improved* (1755) are slightly altered new editions of the lectures.

34. Kimball attributes Ledoux's round temple in the park at Louveciennes, the Belvedere, and the Temple of Love in the Petit Trianon, to a 'partiality for ruins in gardens'. F. Kimball, 'Les Influences anglaises dans la formation du style Louis XVI', *G.B.A.,* V (1931), 29; Watson, *op. cit.* (Note 15), 239. For a different view, see Hautecœur, V, 30.

35. Cf. on this point Gallet, *op. cit.* (Note 21). Gallet's division into stylistic phases does not always coincide with the one given here.

36. F. Kimball, 'The Beginnings of the '*style Pompadour*', *G.B.A.,* XLIV (1954), 56; S. Eriksen, 'Marigny and *le goût grec*', *Burl. Mag.* (1962), 96.

37. M. Gallet, 'Un Baroque attardé, Pierre-Louis p. 3 Hélin', *Art de France*, III (1963), 187.

38. Marquiset, *Le Marquis de Marigny* (Paris, 1918); Hautecœur, IV, *passim.*

39. La Font de Saint-Yenne, *L'Ombre du Grand Colbert, Le Génie du Louvre,* and *Réflexions sur quelques causes de l'état présent de la peinture en France* (La Haye, 1747).

40. The square was to stretch to Saint-Germain l'Auxerrois. Cf. L. Hautecœur, *Histoire du Louvre* (Paris, n.d.), 73 ff.

41. Cf. d'Argenson's note of February 1752: 'J'apprends chaque jour de nouvelles extrémités à la finance, les plus petites caisses sont épuisées; ceci devient un grand désastre en France; rien de plus funeste à un gouvernement que de vivre au jour le jour ...' (*Mémoires,* VII, 125 ff.).

42. Louvre, Cabinet des Dessins, Rec. Louvre II/57.

43. According to Fels, the break lies round p. 3 1760. Cox (*Ange-Jacques Gabriel,* London, 1926) distinguishes four periods in Gabriel's creativity; Gromort sees no differences at all. Cf. Kaufmann, *op. cit.* (Note 20), 134.

44. Comte de Fels, *Ange-Jacques Gabriel* (Paris, 1924), 63; Hautecœur, III, 569.

45. *Entretiens,* II (1872), 199, quoted by Hautecœur, III, 570.

46. Fels, *op. cit.,* 93; Hautecœur, III, 557; Laulan, *op. cit.* (Note 2); A. Mayeux, 'La Chapelle de l'École Militaire', *L'Architecture* (1929), 23.

47. First established by H. Willich: Thieme-Becker, article 'Gabriel', 1920.

48. Such columned halls appear already in p. 3 Neufforge, I, plates 1–3.

49. Described and illustrated in Perrault's translation of Vitruvius (1676). Alongside the central space run two-storey aisles, which do not continue the spatial shape as such.

50. Fels, *op. cit.,* 159; G. Gromort, *Ange-Jacques Gabriel* (Paris, 1933), 82; Hautecœur, III, 565; J. Ferrier, *Le Palais de Compiègne* (Compiègne, 1959). The extensions to the old château began in 1736. By 1747 the first design for a complete reconstruction was ready, made according to Fels by Billaudel; cf. on this point A. Marie, 'Quelques notes sur le château de Compiègne avant sa transformation par Gabriel', *Bull. de la Soc. Hist. de Compiègne* (1944). In the design of 1751 Gabriel had only provided for

two storeys with a mansard roof and big skylights; it was not until building was in progress, about 1760, that he replaced the roof by an attic storey with balustrade.

51. This is characteristic of Campbell's buildings – Stourhead and Hall Barn, for example, among other places – and goes back to Inigo Jones.

52. Here, since 1749, besides a hermitage for Madame de Pompadour, a menagerie had been established. In 1750 the Pavillon Français was built and in 1751 the Salon Frais and the dairy were added. The king was particularly fond of the botanical garden. Cf. Hautecœur, III, 573; Fels, *op. cit.*, 207; P. Verlet, *Versailles* (Paris, 1961), 579.

53. Kimball, 230, claims that a vignette by Morris was the model. Kauffmann does not consider this proved. Direct influence by Morris need not be postulated in view of Neufforge's role as an intermediary.

54. Madame de Pompadour died in 1764. It was first used by Madame du Barry.

55. As early as 1685 Mansart had planned a Salle des Ballets for the end of the north wing. Vigarani delivered the drawings and the garden façade was actually built. In his designs of 1748 Gabriel took account of this project and made use of it. On the Versailles opera house cf. P. de Nolhac, *Versailles au XVIIIe siècle* (Paris, 1918), 30; Fels, *op. cit.*, 120; P. Pradel, 'Les Projets de Gabriel pour l'opéra de Versailles', *G.B.A.*, 1 (1937), 109; Hautecœur, III, 577; J. Feray, *Les Théâtres successifs du château de Versailles*, *Les Monuments historiques de la France* (1957), 1 (opéra de Versailles); P. Verlet, in *Revue de l'Histoire du Théâtre* (1957), 133; *idem, Versailles*, 438.

308 56. Built in 1738–40 by Alfieri, engraved by Dumont. Cochin reports on it in his *Voyage d'Italie*, I, 15. Cf. H. Tintelnot, *op. cit.* (Note 17) (1939), 118.

57. The theatre was decorated and equipped in 1768–70 by Gabriel and Arnoult working in collaboration. Arnoult erected the stage with its complicated machinery, making use in the process of the latest Italian experience.

58. Fels, *op. cit.*, 145; de Nolhac, *op. cit.*, 42; Hautecœur, III, 580; Verlet, *op. cit.*, 358. The plans are in the Service d'Architecture at Versailles, the detailed drawings in the Archives Nationales. Voltaire had already demanded the demolition of the courtyard façade in his *Temple du goût* of 1733.

59. It was no longer the king's bedchamber that p. 309
lay under the dome as the centre of the power of state, but the Salle du Conseil or, in one variant, the Grand Cabinet.

60. Y. Bottineau, *L'Art d'Ange-Jacques Gabriel à Fontainebleau* (Paris, 1962), 60. The final plans are dated 1773.

61. *Exposition des principes* (Paris, 1769); Hautecœur, IV, 439; *idem*, 'Projet d'une salle de spectacle par N. M. Potain (1763)', *B.S.H.A.F.* (1924), 30; *idem*, in *L'Architecture*, XXXVII (1924).

62. Porticoes of this sort occur already in Peyre's cathedral design of 1753 and in Neufforge, who is particularly fond of using them.

63. F. Mazerville, *L'Hôtel des Monnaies* (Paris, 1907); Hautecœur, IV, 249; five volumes with drawings for the mint in the B.N. Est. Original design in the Musée Carnavalet; model in the mint. On Antoine, cf. Hautecœur, IV, 247; E. Kaufmann, *Architecture in the Age of Reason* (Cambridge, 1955), 144; Lussault, *Notice sur Antoine*, Paris, an x.

64. This rhythm is still present in the group of houses in the Rue Saint-Honoré, nos. 229-35, dating from 1782.

65. Berland, *L'Hôtel de l'Intendance de Champagne* p. 310
(Châlons-sur-Marne, 1928); J. Ache, 'L'Hôpital de la Charité', *Urbanisme et architecture* (Paris, 1954); Hautecœur, IV, 154.

66. Ceineray had been Franque's colleague for several years. He had been in Nantes since 1752 and city architect there since 1760. His development plan of 1761 was the starting-point for a grand modernization of the city. Cf. Renoul, 'Ceineray', *N.A.A.F.* (1898), 101; Lelièvre, *L'Urbanisme et l'architecture à Nantes au XVIIIe siècle* (Nantes, 1942); Hautecœur, III, 481, 607, IV, 135.

67. The Estates of Languedoc had turned first to Soufflot and then, when he declined, to Franque, who, however, as a member of an Académie committee was not eligible to take part in the competition. Hautecœur, IV, 141.

68. J. Schmidt, 'Die alte Universität in Wien und ihr Erbauer, J. N. Jadot', *Wiener Forschungen zur Kunstgeschichte* (1929), 94.

69. B. Lespinasse, *Les Artistes français en Scandinavie* (Paris, 1928), 143; Hautecœur, 209.

70. Hautecœur, III, 607.

71. Pérouse de Montclos, *op. cit.* (Note 16), 39.

p. 310 72. M. H. Klaiber, *Der Baumeister Philippe de la Guêpière* (Forschungen der Komm. f. gesch. Landesk. in Baden-Württemberg, IX) (Stuttgart, 1959). For French architects in Germany in general, see P. du Colombier, *L'Architecture française en Allemagne au XVIIIᵉ siècle* (Paris, 1956); idem, 'Un Architecte français à Stuttgart', *Art de France*, I (1961), 320.

p. 311 73. Besides P. du Colombier cf. L. Vossnack, *Pierre-Michel d'Ixnard* (Remscheid, 1938); M. Jadot, in *Congrès archéologique*, CV, *Souabe* (1949); H. Haug, in *Arch. als. d'hist. de l'art*, VI (1927), 113.

74. J. d'Orliac, *Chanteloup* (Paris-Tours, n.d.); P. Hallays, E. André, and R. Engerrand, *Le Château de Chanteloup* (Paris, n.d.); E. André, 'Documents inédits sur l'histoire du château et des jardins de Chanteloup', *B.S.H.A.F.* (1935), 21.

75. Hautecœur, IV, 198.

p. 312 76. *Ibid.*, 200.

77. *Ibid.*, III, 588; Kaufmann, *op. cit.* (Note 63), 137; d'Argenson, *Mémoires*, VII (Mars 1752), 168; Champier-Sandoz, *Le Palais Royal* (Paris, 1900), 363; E. Dupezard, *Le Palais Royal de Paris* (Paris, 1911), 10. For Penthémont see also J. Evans, *Monastic Architecture in France from the Renaissance to the Revolution* (Cambridge, 1960), 61 and 64 and figures 328–9 and 356–9.

78. Gallet, *op. cit.* (Note 21), *passim;* Hautecœur, IV, 120, 289; G. Pillement, *Les Hôtels de Paris* (Paris, 1945), I, no. 50; II, no. 41.

79. The counterfeiting of his early style was brought out clearly only recently in J. Langner's excellent piece of work, based on a Freiburg dissertation, 'Ledoux' Redaktion der eigenen Entwürfe', published in the *Zeitschrift für Kunstgeschichte*, XXIII (1960), and in the contemporaneous essay by W. Herrmann, 'Chronology in Claude Nicolas Ledoux's Engraved Work', *The Art Bulletin*, XLII, no. 3 (1960), 191.

80. E. Kaufmann, *Von Ledoux bis le Corbusier* (Vienna and Leipzig, 1933): G. Levallet-Haug, *Cl. N. Ledoux* (Strasbourg, 1936); M. Raval and J.-Ch. Moreaux, *Ledoux* (Paris, 1945); Kaufmann, *op. cit.* (Notes 20, 63); J. Langner, *Claude-Nicolas Ledoux, die erste Schaffenszeit 1762–4*, unpublished dissertation (Freiburg, 1959); idem, *op. cit.* (Note 79), 136.

81. Contemporary description in Fréron, *Années littéraires* (Année 1762), vol. VI, and Saint-Foix, *Essais historiques sur Paris* (1766–77).

82. 'C'est là, c'est dans ce fastueux édifice que p. ₃ brille le sentiment inépuisable de l'architecture française.'

83. They appear for the first time in the second volume of Neufforge's *Recueil élémentaire* (1757/8).

84. For the first time in Neufforge, in the sixth volume of the *Recueil élémentaire* (1765).

85. Cf. on this point Langner, *op. cit.* (Note 80), 28; Herrmann, *op. cit.*, 198; and Gallet, *op. cit.* (Note 21), illustrations 13–14. The state of the third design is reflected in the façade of the Hôtel de Tessé, after the design of P.-N. Rousset, 1765; cf. on this point Pérouse de Montclos, *op. cit.* (Note 16), 85.

86. Rebuilt several times during the nineteenth p. ₃ century, and torn down and replaced with an exact copy by C. E. Mewes in 1930, when an attic storey was added. Hautecœur, IV, 279; C. Conolly and J. Zerbe, *Les Pavillons* (London, 1962), 134.

87. *Recueil élémentaire*, I, 23; III, 170, 174; IV, 244, 253.

88. There is already an elliptical dining room of this sort behind an open hall in Neufforge, IV, 264. Illustrated in the watercolour by Moreau le Jeune in the Louvre.

89. Cf. Neufforge, V, 331. A sculptured group in front of a coffered background on a free-standing entablature appears already in a church design in Neufforge, VII, 442, here in front of a side chapel.

90. There is the same effect of depth in the pavil- p. ₃ ion of Louveciennes. In this Ledoux differs radically from Gabriel.

91. Madame du Barry and the Emperor Joseph II themselves visited the hôtel. The building was demolished in 1862.

92. After the banishment of the countess both the stables and the house passed into the possession of the Comte de Provence. Today the stables are a police barracks, while the house is occupied by the Versailles Chamber of Commerce.

93. In the *Architecture de Claude-Nicolas Ledoux* (Paris, 1847), the design appears with flat roofs and the middle rising in a block-shaped attic storey; on the other hand, the real design with mansard roofs is shown in a pen-and-ink wash drawing in the Musée de l'Île de France at Sceaux.

94. Hautecœur, IV, 221; Kaufmann, *op. cit.* (Note 20), 453; idem, *op. cit.* (Note 63), *passim:* H. Rosenau, *Boullée's Treatise on Architecture* (London, 1953); Gallet, *op. cit.* (Note 21), illustrations 32, 22, 34; Pérouse de Montclos, *op. cit.* (Note 16).

95. In 1765 the Hôtel de Bourbon was largely rebuilt by Le Carpentier (who added two long wings alongside the cour d'honneur) according to plans by Barreau de Chefdeville. In 1776 the Place de Bourbon was laid out, at first in a semicircular shape, then from 1780 in a rectangular shape; cf. H. Contant, *Le Palais Bourbon au XVIIIᵉ siècle* (Paris, 1905); A. Macon, *Les Arts à la cour des Condé* (Paris, n.d.); F. G. Pariset, 'L'Architecte Barreau de Chefdeville', *B.S.H.A.F.* (1962), 80.

317 96. The mausoleum of Halicarnassus may have served as a model. On this point, cf. Pérouse de Montclos, *op. cit.*, 175.

97. D. Maynial, *St Thomas d'Aquin (nefs et clochers)* (Paris, 1946), 13.

98. *Congrès Archéologique*, LXXXIIᵉ Session (1920), 56.

99. *Mercure de France* (Mai 1755) and *Étude d'architecture* (Paris, 1755).

100. M. Petzet, *Soufflots Ste Geneviève und der französische Kirchenbau des 18. Jahrhunderts* (Berlin, 1961), 102. The portico for Saint-Eustache has at any rate freed itself from the limiting side walls.

318 101. On the return to Gothic, see especially Middleton, *op. cit.* (Note 10), and Herrmann, *op. cit.* (Note 10).

102. All these qualities were already present on a small scale in the Chapelle de Communion in Saint-Jean en Grève.

103. Cf. the letter of 20 January 1774 from Canon van der Driesch at Arras, published by Middleton, *loc. cit.*, and Herrmann, *loc. cit.*; also Petzet, *loc. cit.*

104. A. Krieger, *La Madeleine* (Paris, 1937); Hautecœur, III, 592; IV, 337 ff.; Middleton, *op. cit.*, 93; Petzet, *op. cit.*, 122; Herrmann, *op. cit.*, 124.

319 105. Cf. W. Herrmann, 'Antoine Desgodets und die Académie Royale d'Architecture', *The Art Bulletin*, XL (1958), 23.

106. *L'Église et la paroisse St Géry de Cambrai* (presentation volume of essays) (Cambrai, 1933).

107. Hautecœur, IV, 88; Petzet, *loc. cit.*; Herrmann, *loc. cit.*

108. It was only through this elimination that Destouches' plan of 1753, which anticipates decisive features in Soufflot's design, did not become known until 1772, after the death of its author. Cf. Petzet, *op. cit.*, 58.

109. Cf. Grimm's remark of 15 October 1764: p. 321 'Quand une fois huit cent mille personnes s'assemblent quelque part sous un tas de pierres, et qu'ils aiment à parler, il faut qu'ils disent bien des sottises' (Petzet, *op. cit.*, 48).

110. Described in Blondel, *Architecture française*, IV, 9.

111. He compares Soufflot's plan with the church of Toussaint at Angers, 'Le monument le plus hardi que nous ayons en ce genre'. On Gauthey, cf. Hautecœur, IV, 205 ff.

112. Cf. Laugier, *Observations sur l'architecture* (1765), *passim*, and Le Roy, *Histoire de la disposition et des formes différentes que les Chrétiens ont donné à leurs temples* (Paris, 1764).

113. These alterations went back to Quatremère de Quincy – director of the building operations since 1791 – who wanted to give the building a Roman dignity corresponding to its new purpose, and thereby destroyed Soufflot's 'gaieté' and 'légèreté'. Cf. R. Schneider, *Quatremère de Quincy et son intervention dans les arts* (Paris, 1910).

114. Not built until 1844–50 – by Hittorf, as Mairie of the fifth arrondissement.

115. Cf. *Cours d'architecture*, III, plates LV ff.

116. Herrmann, *op. cit.* (Note 10), 113; Haute- p. 322 cœur, IV, 208. The same type, but with ambulatories, also occurs in Cherpitel's design for Saint-Pierre du Gros Caillou (1775); Petzet, *op. cit.*, 122.

117. Middleton, *op. cit.*, 120; Herrmann, *op. cit.*, 249, with bibliography; D. Nyberg, 'La Sainte Antiquité', *Essays on the History of Architecture presented to Rudolf Wittkower* (London, 1967), 159. A church directly based on Saint-Philippe du Roule is Notre-Dame de Bonne Espérance at Binche (1770–6; architect, L. Dewez).

118. Y. Christ, 'Un Décor d'opéra dans une petite église', *C.d.A.* (February 1958).

119. Further column-and-entablature buildings, but with a cruciform plan, are Saint-Vincent in Lyon (1759), Notre Dame at Guebwiller (1766–85), and the Madeleine in Rouen (begun before 1767); there are also Patte's designs for a cathedral of Paris (1765) and those of Dupuis for Saint-Paul in Paris (1766).

120. For what follows, cf. Tournier, *op. cit.* (Chapter 6, Note 85).

121. There is an affinity, pointed out by Middleton, with Gauthey's contemporaneous church at Givry, but it probably lies more in the general

intellectual kinship and the influence of the new Sainte-Geneviève. Nicole had already put forward in 1748 a design featuring columns and entablature for the Jesuit chapel at Vesoul.

p. 322 122. On what follows, cf. Herrmann, *op. cit.*, 91 ff.

p. 323 123. Cf. G. Chenesseau, *Sainte-Croix d'Orléans* (Paris, 1921), 315.

124. W. Braunfels, *François de Cuvilliés* (Würzburg, 1938), 94.

p. 324 125. Now Préfecture; cf. E. Schlumberger, in *C.d.A.* (February 1966), 76.

126. Cf. F. J. B. Watson, *Furniture* (Wallace Collection Catalogues) (London, 1956), xi.

127. Y. Bottineau, 'Précisions sur le Fontainebleau de Louis XVI', *G.B.A.*, LXIX (1967), 139; M. Jallut, 'Cabinets intérieurs et Petits Appartements de Marie Antoinette', *G.B.A.*, LXIII (1964), I, 289.

128. Except for the salon, which has retained its coving.

129. The griffins holding vases, bracket mouldings, and coffered door arches occur in Piranesi's architectural designs of the early sixties, among other places; the griffins also appear at Holkham Hall, begun in 1734, by William Kent.

p. 325 130. There are similar bracket mouldings in the Salle des Colonnes. For the big medallions in the salon, cf. Lassurance's decorations at Versailles and in Louis XIV's menagerie.

131. The most famous piece of this sort, the Bureau du Roi, was begun in 1760 by Oeben and finished in 1769 by Riesener.

132. This garland ornamentation occurs already about 1767 in the Hôtel d'Uzès. On Marie-Antoinette's library, cf. Jallut, *loc. cit.* The return to the Style Louis XIV in decoration had already been encouraged by the Comte de Caylus; Hautecœur, IV, 464.

p. 326 133. Eriksen, *op. cit.* (Note 21), 94.

134. University Library Warsaw; published by F. G. Pariset, 'Les Découvertes du Professeur Lorentz sur Victor Louis et Varsovie', *Rev. Hist. de Bordeaux et du Dép. de la Gironde*, VII (1958), 38. On Prieur, cf. F. G. Pariset, 'Notes sur Victor Louis', *B.S.H.A.F.* (1960), 41, with bibliography.

135. Born in Paris; 1772–3, journey to Corsica; from 1774, Professor of Drawing; 1781, member of the Académie in Bordeaux. Most of his drawings are in the Musée des Arts Décoratifs. Cf. G. Levallet,

'L'Ornemaniste Jean Charles Delafosse', *G.B.A.* (1929), I, 158; Hautecœur, IV, 461; *C.d.A.* (January 1955), 26.

136. Significantly he is called by the *Journal de Guienne*, in a review of his designs published in 1787, 'plus peintre qu'architecte', and his architectural imagination is compared with the literary imagination of Milton.

137. The second edition was published in 1771 by Chéreau. The full title runs: 'Nouvelle Iconologie historique ou Attributes Hiéroglyphiques qui ont pour objets les quatre parties du monde, les quatre saisons et les différentes complexions de l'homme'. Further publications: 'Ordres d'architecture' (*c.* 1785) and 'Recueil d'ameublement' (*c.* 1787).

138. Neufforge had included in his *Recueil* only a few examples which hardly counted.

139. Blondel described them as being 'd'une pesanteur assommante'.

140. Stern, *loc. cit.* (Note 30); Hautecœur, IV, 303. p. 32

141. Hautecœur, III, 587.

142. Gallet, *op. cit.* (Note 21), 53; Hautecœur, IV, 483.

143. L. Réau in *B.S.H.A.F.* (1937), I, 7; F. Kimball in *G.B.A.* (1931), I, 29.

CHAPTER 8

1. The first houses on the Seine bridges were p. 32 demolished in 1786 and the Pont de la Concorde was built in 1787–91. Pavements for pedestrians were introduced in 1781 and street lighting in 1783. The decisive street-building law which was to put an end to the cramped and dirty conditions in the centre of the city appeared in 1783.

2. Cf. Hautecœur, IV, 14 ff. p. 32

3. L. Lawrence, 'Stuart and Revett, their literary p. 33 and architectural Careers', *J.W.C.I.*, II (1938–9), 128; N. Pevsner and S. Lang, 'The Doric Revival', in *Studies in Art, Architecture and Design*, I (London, 1968), 196; D. Watkins, *Thomas Hope and the Neo-Classical Idea* (London, 1968). On the conflict of opinion over the pre-eminence of Greece or Rome, cf. N. Pevsner and S. Lang, 'Apollo or Baboon', in *Studies in Art, Architecture and Design*.

4. Hautecœur, IV, 21. Mariette's criticism in the *Gazette littéraire* of 1764. R. Wittkower, 'Piranesi's "Parere sull'Architettura"', *J.W.C.I.*, II (1938–9), 147.

5. In Ledoux's Hôtel Thélusson (1778–81) and in the house which de Wailly built for himself.

6. Cf. R. Crozet, 'David et l'architecture néo-classique', *G.B.A.*, XLV (1955), 211.

7. Vol. III, lviii.

8. W. Chambers, *Designs of Chinese Buildings* (London, 1753); idem, *A Dissertation on Oriental Gardening* (London, 1772); Le Rouge, *Détails de nouveaux jardins à la mode. Jardins anglo-chinois à la mode* (Paris, 1776–87). Chambers' Chinese buildings for Kew served as models in France; his great pagoda of 1761 was imitated at Chanteloup and Montbéliard.

331 9. Examples are collected in J. C. Krafft, *Plans des plus beaux jardins pittoresques de France, d'Angleterre et d'Allemagne* (Paris, 1809–10); see also E. von Erdberg, *Chinese Influences on European Garden Structures* (Cambridge, 1936); Hautecœur, V, 33; H. Honour, *Chinoiserie* (London, 1961).

10. L. Hautecœur, *Rome et la Renaissance de l'antiquité à la fin du XVIIIᵉ siècle* (Paris, 1912); idem, *Histoire de l'architecture classique*, IV, 23; N. Pevsner and S. Lang, 'The Egyptian Revival', in *Studies in Art, Architecture and Design* (op. cit.), 213.

11. F. L. Norden, *Drawings of some Ruins and Colossal Statues at Thebes in Egypt, with an Account of the Royal Society* (London, 1741); idem, *Travels in Egypt and Nubia* (French ed. 1755, English ed. 1757); R. Pococke, *Observations on Egypt* (London, 1743–56) (a French translation of this, entitled *Description de l'Orient*, appeared in 1772–3).

12. *Recueil d'antiquités égyptiennes, étrusques, grecques et romaines*, III, Avant-propos; V, 3.

13. Bernstein Berström Collection, Gothenburg.

14. Written and doubtless known in 1785; not published until 1803.

15. On the Turkish influence, cf. 'La Turquerie au XVIIIᵉ siècle', *C.d.A.* (February 1953), 52.

16. T. Boelkin, 'Le Tombeau de Jean-Jacques Rousseau', *G.B.A.*, XVI (1936), 156. For the preliminary stages, cf. F. Kimball, 'Romantic Classicism in Architecture', *G.B.A.*, XXX (1944), 95.

332 17. H. F. Clark, 'Eighteenth Century Elysiums, the Role of "Association" in the Landscape Movement', *J.W.C.I.*, VI (1943), 65; Hautecœur, IV, V, 3.

18. S. Giedion, *Spätbarocker und romantischer Klassizismus* (Munich, 1922); Hautecœur, V, *passim*.

19. He was appointed 'Premier architecte honoraire' and as such retained control of the Académie until his death. His influence on Versailles was assured for a long time afterwards through his colleague of many years' standing, François Heurtier, inspector general of Versailles.

20. Sometime pupil of Blondel and, after Héré's death, director general of the royal buildings under Stanislas. With the help of the queen, Mique succeeded in getting to Versailles. A. Hachet, *Le Couvent de la Reine à Versailles* (Paris, 1922); P. Morey, *Richard Mique* (Nancy, 1868); Hautecœur, IV, 77.

21. M. Terrier, 'Où en est la campagne de restauration pour Compiègne', *C.d.A.* (August 1967), 22; J. Robiquet, *Pour mieux connaître le palais de Compiègne* (Compiègne, 1938); P. Verlet, *Le Mobilier de Louis XVI et de Marie-Antoinette à Compiègne* (Diss. École du Louvre, 1937).

22. P. de Nolhac, *Versailles au XVIIIᵉ siècle* p. 333 (Paris, 1918); H. Racinais, *La Vie inconnue des Petits Appartements de Versailles* (Versailles, 1951); P. Verlet, *Versailles* (Paris, 1961).

23. It was never made to serve its original purpose, that of providing access to the Grands Appartements. In 1785 the king had a small theatre built here in place of Gabriel's staircase; de Nolhac, *op. cit.*, 115.

24. Preserved in the Service d'Architecture at Versailles.

25. Assertion of A.-F. Peyre in his *Œuvres d'architecture*. The designs were collected in an album by Dufour in 1811; now in the Service d'Architecture at Versailles. Peyre the Younger's design in his *Œuvres d'architecture*, published in 1818 by Percier and Fontaine; de Nolhac, *op. cit.*, 112; Verlet, *op. cit.*, 643. According to another version the competition did not take place until 1783; cf. J. M. Pérouse de Montclos, *Étienne-Louis Boullée* (Paris, 1969), 144.

26. Pâris's designs are in the Bibliothèque p. 334 Municipale at Besançon.

27. A. Marie, 'Les féeriques baraques qui se griffaient sur le château de Versailles', *C.d.A.* (January 1968), 68. On Marie-Antoinette's attitude to Versailles, cf. de Nolhac, *op. cit.*, and Verlet, *op. cit.*

28. Hautecœur, 309; Marie, *op. cit.* His designs and the buildings actually erected by him are collected in his *Études d'architecture* (Besançon, Bibliothèque Municipale).

P. 334 29. G. Haug-Levallet, 'L'Hôtel de Ville de Neuchâtel', *B.S.H.A.F.* (1933), 88; Hautecœur, IV, 313. The same return to Ledoux can be observed – in the combination of columns and rocky grotto – in the entrance to the baths at Bourbonne-les-Bains (*c.* 1782); cf. H. Ronot, 'Bourbonne-les-Bains et les établissements thermaux en France au 18e siècle', *B.S.H.A.F.* (1959), 125.

P. 335 30. The temple was intended to contain Bouchardon's marble statue *Cupid cuts himself a Bow out of Hercules' Club*, already on show at that time in the Louvre. It was later replaced with a copy by Mouchy.

31. In 1776 the queen, following the example of the Duc d'Orléans at Monceau, had had a Chinese merry-go-round put up for herself alongside the Pavillon Français at Trianon.

32. P. Gluth, 'La Laiterie de Rambouillet', *C.d.A.* (May 1958), 74; J. Langner, 'Architecture pastorale sous Louis XVI', *Art de France*, no. 3 (1963), 171, which also contains important suggestions about the origin and iconography of dairies.

33. The reliefs are now in the Georges Wildenstein Collection; only the medallion over the entrance is still *in situ*.

34. 'Never did architects have such an opportunity to display their talents as in the last thirty years before the Revolution. A new city rose round the old Paris and wide stretches of marshland became covered with stately buildings.' Guillaumot, *Considérations sur l'état des beaux arts à Paris, an X* (1802); cf. also M. Gallet, *Demeures parisiennes, L'Époque de Louis XVI* (Paris, 1964), *passim*.

P. 336 35. Hautecœur, IV, 212; E. Kaufmann, *Architecture in the Age of Reason* (Cambridge, 1955), 169.

36. C. Connolly and J. Zerbe, *Les Pavillons* (London, 1962), 68; E. Schlumberger in *C.d.A.* (March 1964), 88.

37. Hautecœur, IV, 256.

38. Hautecœur, IV, 231. Known as the Odéon since 1794. Plans in the B.N. Est. After a fire in 1799 it was rebuilt in an altered form in 1807 by Chalgrin. After a second fire an exact reconstruction was carried out about 1819 by Peyre's son (*Projets de reconstruction de la salle de l'Odéon*, par Peyre fils, Paris, 1819).

39. The design is presumably identical with Design Va. 263c in the B.N. Est., which shows a semicircular columned portico in front of a rectangular building (reproduced in Pérouse de Montclos, *op. cit.* (Note 25), figure 73).

40. Soufflot's design of 1763 had envisaged here a circular room with rows of columns running round it, after the style of Palladio.

41. A similar theatre was planned by Peyre and de Wailly for Brussels in 1785 (Théâtre de la Monnaie).

42. De Wailly had made trips to Italy, Germany, and England especially to make studies for the staircase. The statements about these in Hautecœur are contradictory. In view of the allusion to Abbé Terray they must have taken place between 1770 and 1774. On de Wailly, cf. B. Lossky, 'Les Ruines de Spalato, Palladio et le néoclassicisme', *Urbanisme et architecture* (Paris, 1954), 245.

43. The work had already been commissioned P. 3 in 1769; Louis XVI laid the foundation stone retrospectively in 1774. J. Adhémar, 'L'École de Médicine, sa place dans l'architecture française du XVIIIe siècle', *L'Architecture* (1934), 105; Hautecœur, IV, 242; Kaufmann, *op. cit.*, 167; Kimball, 226.

44. In his *Description des Écoles de Chirurgie* (published in 1780), Gondoin gave detailed reasons for the many columns. Besides adducing Antiquity he also pointed to the University of Turin and the Collegio Helvetico in Milan. Open columned halls as conclusions to courtyards also appear in Neufforge, I, 43–5, and in Peyre, *Œuvres d'architecture*.

45. The same 'nose-heaviness' also occurs in Antoine's mint for Bern (1789).

46. Only the fountain in front of the façade of the Franciscan friary was built – in 1806 – in an altered form. Precise information about this interesting plan in Gondoin's *Description des écoles d'architecture*.

47. He was originally called Nicolas Louis, but P. 3 on his return from Warsaw, full of pride at his successes, he christened himself Victor. Cf. Marionneau, *Victor Louis* (Bordeaux, 1881); Hautecœur, IV, 260; F. G. Pariset, 'Notes sur Victor Louis', *B.S.H.A.F.* (1959), 41; exhibition catalogue, *Victor Louis et Varsovie* (Paris, Musée Jacquemart-André, 1958).

48. For details of Louis' work for Warsaw, see S. Lorentz, 'Victor Louis à Varsovie', *Urbanisme et architecture* (Paris, 1954), 233; F. G. Pariset, 'Les Découvertes du Professeur S. Lorentz sur Victor Louis à Varsovie', *Rev. Hist. de Bordeaux* (1957), 281; S. Lorentz, 'Victor Louis à Varsovie', *Rev. Hist. de Bordeaux* (1958), 38.

49. The drawings of his student years in Rome are strongly influenced by Bernini. The latter's colonnades in front of St Peter's are taken up again in the designs for the square in front of the palace in Warsaw. Most of the contents of the folio volumes in Bordeaux (Archives Municipales), originally four in number, have been destroyed by fire; only a few sheets are still extant. Further drawings in the Musée d'Art Ancien at Bordeaux.

50. Y. Christ, 'Un Décor d'opéra dans une petite église', *C.d.A.* (February 1958), 18 ff.

51. H. Demoriane, 'Besançon se blanchit', *C.d.A.* (November 1967), 106.

52. Hautecœur, IV, 263.

339 53. Both in Warsaw and Bordeaux a few steps precede the staircase in the dark hall. On the relationship to Warsaw, cf. Pariset, *op. cit.* The designs for the staircase are in the Musée d'Art Ancien, Bordeaux.

54. The immediate model, although on a smaller scale, already existed in the ballroom at Versailles, by Gabriel, 1770. The giant columns of the auditorium were to be found in Neufforge, VIII, e.g., 507 and 510, whence, as so often with Louis, the idea probably came.

55. The construction of shops and dwellings round the garden was nothing but a brilliant piece of property speculation. Cf. Champier-Sandoz, *Le Palais Royal* (Paris, 1900), 424; Hautecœur, IV, 268.

56. 'La grande fassade en ligne droite et l'uniformité des détails donnent à l'architecture un caractère de grandeur, qu'on n'obtiendrait jamais par des variétés de masse' (H. Prudent, *Victor Louis*, *L'Architecte*, I (1906), 28).

57. First design already produced by Lhote in 1775 to replace the demolished Château de la Trompette, as counterpart to the Place Louis XV. The decree that it should be put into effect and the commissioning of Louis did not come until 1785. Designs in the Musée d'Art Ancien, Bordeaux. Cf. Hautecœur, IV, 148; Lavedan, *Histoire de l'urbanisme* (Paris, 1959), I, 445.

58. W. H. Dammann, 'Das untere Schloss von Zabern', *Rev. ill. alsacienne*, XII (1910), 28; Hautecœur, IV, 321.

59. P. du Colombier, *L'Architecture française en Allemagne au XVIIIᵉ siècle* (Paris, 1956), 214.

60. A further important parallel to Ledoux's château design is Desprez's design for Haga; cf. N. Wollin, *Desprez i Sverige* (Stockholm, 1936), 73.

61. Champier-Sandoz, *op. cit.*, 428; here Louis' p. 340 designs are published too.

62. In the Archives Municipales at Bordeaux there is an undated plan of the town from the end of the eighteenth century, with all the houses built by Louis indicated. Of his châteaux, Le Bouilh (1787) should be mentioned in particular.

63. J. Stern, *À l'ombre de Sophie Arnould, François-Joseph Bélanger* (Paris, 1930); Hautecœur, IV, 302; Gallet, *op. cit.* (Note 34), 172; Kaufmann, *op. cit.* (Note 35), 170; Kimball, *op. cit.* (Note 16), 226. Bélanger's designs are collected in the *Œuvres d'architecture*, Paris, B.N. Est.

64. The addition of an attic storey with an excessively high cupola has distorted the proportions of the exterior. G. Pascal, *Histoire du château de Bagatelle* (Paris, 1938); Connolly-Zerbe, *op. cit.* (Note 36), 114; Stern, *op. cit.*, 57. An excellent description by Friedrich Gilly, who visited Bagatelle in 1797, is published together with plan, sketches of the interior, and a contemporary engraving in A. Rietdorf, *Gilly – Wiedergeburt der Antike* (Berlin, 1940), 157.

65. Hautecœur, IV, 304; Connolly-Zerbe, *op.* p. 341 *cit.*, 158.

66. The Halle au Blé, built by Le Camus de Mézières in 1763 like an open amphitheatre – 'la seule en ce genre qui existe à Paris et qui puisse donner une idée de la masse des théâtres et des amphithéâtres des anciens' – had been covered in 1781 by Legrand and Molinos with a wooden dome on the girder system; cf. Hautecœur, IV, 171, V, 224; Stern, *op. cit.*, 201.

67. J. Silvestre de Sacy, *A. T. Brongniart* (Paris, 1940); Launay, *Les Brongniart* (Paris, 1940); Hautecœur, IV, 287; Kaufmann, *op. cit.*, 169.

68. The 'Folie' of the Duc d'Orléans in the Rue de Provence ascribed to him by de Sacy and Hautecœur was not by him but by Henri Piètre, Contant's successor at the court of the duke; cf. M. Hébert, 'Les Demeures du Duc d'Orléans et de Madame de Montesson à la Chaussée d'Antin', *G.B.A.*, LXIV (1964), 161.

69. Hôtel de Montesquiou (1780), Hôtel de p. 342 Condé (1781), Pavillon des Archives de l'Ordre de Saint-Lazare (1782).

70. How far the courtyard is the result of Peyre the Younger's reconstruction of 1804 or of L.-M. Berthault's later one in 1811–15 cannot be precisely determined.

71. Krafft and Ransonette, *Plans, coupes, élévations des plus belles maisons . . .* (Paris, n.d.).

72. H. Lemoine in *B.S.H.A.F.* (1945–7), 28; E. Terry, 'Le Palais abbatial de Royaumont', *Art et Style*, no. 5, p. 41; J. Ch. Moreux, 'Louis le Masson, Château de Royaumont et Église de Courbevoie', *Revue des Arts* (1951), 31.

73. 'Le grand nombre des maisons particulières qui ont été érigées dans de nouveaux quartiers, et pour des propriétaires opulens qui avaient rapporté de leurs voyages en Italie ou d'autres contrées, le goût de la nouveauté, un certain penchant à s'écarter des anciennes routes, et à les affranchir de plusieurs préjugés, ont totalement changé la physiognomie de notre architecture' (preface to Krafft and Ransonette, *op. cit.*).

74. Giedion, *op. cit.* (Note 18); H. R. Hitchcock, *Architecture, Nineteenth and Twentieth Centuries* (Pelican History of Art) 3rd ed. (Harmondsworth, 1968), 1 ff.

75. F. Kimball, 'Romantic Classicism in Architecture', *G.B.A.*, xxv (1944), 95; Hautecœur, v, 3 ff.

76. The nature of Revolutionary Architecture was first recognized and fully evaluated by Emil Kaufmann in 'Architektonische Entwürfe aus der Zeit der französischen Revolution', *Zeitschrift für bildende Kunst* (1929/30), 38; *idem, Von Ledoux bis Le Corbusier* (Vienna, 1933); *idem,* 'Three Revolutionary Architects, Boullée, Ledoux and Lequeu', *Transactions of the American Philosophical Society* (Philadelphia, 1952); *idem, Architecture in the Age of Reason* (Cambridge, 1955); *idem, Les Architectes visionnaires de la fin du XVIIIᵉ siècle*, exhibition catalogue (Geneva, 1965), with preface by J. C. Lemagny; Pérouse de Montclos, *op. cit.* (Note 25).

77. 'Les projets envoyés sont plutôt des compositions gigantesques, d'une exécution impossible, que les productions d'architectes, qui, mettant le dernier sceau à leur instruction, sont prêts à revenir dans la patrie réclamer la confiance de leurs concitoyens' (Hautecœur, *op. cit.* (1912) (Note 10), 135); M. Lemonnier, 'La Mégalomanie dans l'architecture à la fin du dix-huitième siècle', *L'Architecture* (December 1908).

78. Poyet's design after 1785 for the Hôtel-Dieu envisaged a huge circular building like the Colosseum in Rome, with radiating three-storeyed wards with more than 6,000 beds. Cf. Hautecœur, IV, 164.

79. 'L'esprit capricieux de ces deux architectes s'est emparé d'un grand nombre d'artistes, les a détournés de l'étude unique qu'ils devraient faire du style pur des anciens et a opéré une véritable révolution dans l'ordonnance des édifices' (quoted by Pérouse de Montclos, *op. cit.*, 122).

80. From 1778 to 1782, as Contrôleur du Bâti- p. 34 ment at the Hôtel des Invalides and the École Militaire (from 1780), he occupied official positions in the building administration, but then resigned all his offices in the hope of obtaining commissions from the state. However, his interest in public architecture – Versailles project, 1780; opera house, 1781; Bibliothèque Royale, 1784 – gradually became purely theoretical. His last plans point, as with Ledoux, to an 'ideal city'.

81. A.-L. Vaudoyer, in his *État de l'architecture en France* (1806), puts Ledoux and Boullée alongside Peyre and Pâris as the leaders of the dominant schools under Louis XVI. On Boullée's pupils, cf. Pérouse de Montclos, *op. cit.*, 209. The impression produced by his personality is described in the letter of 7 June 1794 from Madame Brongniart to her husband published by De Sacy, *op. cit.* (Note 67), 107.

82. B.N. Est. and Manus. The *Essai sur l'art* was written in the Revolutionary period; published with commentary by H. Rosenau, *Boullée's Treatise on Architecture* (London, 1953); see also the detailed discussion in Kaufmann, *op. cit.*

83. In 1793 he was arrested. 'Depuis, comme Aréthuse, j'ai voyagé sous terre' (preface to *Architecture*). In spite of his rehabilitation in 1795 he received no more commissions and gradually became completely embittered.

84. The plans for the Saline de Chaux were originally envisaged, in a still completely Baroque style, as a square complex of factory buildings and dwellings, with the administrative offices forming the centre. In the second design the square became an ellipse, only half of which was actually built. The use of giant orders was here extended for the first time to a functional building. J. Langner, *Claude-Nicolas Ledoux, die erste Schaffenszeit 1762–74* (unpublished dissertation, Freiburg, 1959), 56; *idem,* 'Ledoux' Redaktion seiner eigenen Werke für die Veröffentlichung', *Zeitschrift für Kunstgeschichte*, XXIII (1960), 151, with further literature.

85. The part that appeared was planned as the first volume of a multi-volume work. By the time Ledoux died most of the copper plates for the

further volumes had already been prepared or at any rate begun. They were published in 1847, with a preface by Daniel Ramée, as *Architecture de Claude-Nicolas Ledoux*. For details, cf. Langner, *op. cit.*, 84.

86. Langner, *op. cit.*, 136; W. Herrmann, 'Chronology in Claude-Nicolas Ledoux's Engraved Work', *The Art Bulletin*, XLII, 3 (1960), 191. Both authors rightly put the beginning of Revolutionary Architecture round 1780.

87. The block-like shapes and the dominating horizontality began with his designs for the reconstruction of the Madeleine and of Versailles, both of about 1780.

88. Cube: 'La forme d'un cube est la forme de l'immutabilité; on asseoit les dieux, les héros sur un cube'. Pyramid: 'C'est l'idée de la flamme qui s'effile par la pression de l'air et en détermine la forme.' Circle: 'Everything is circular in Nature.' Ledoux, *L'Architecture*, xi.

89. Rosenau, *op. cit.*, 35.

346 90. Boullée's library included the works of Buffon, Bailly, Valmont de Bomare, and others.

91. Cf. the preface to Ledoux's *Architecture*: '. . . la non-interruption des lignes qui ne permettent pas que l'œil soit distrait par des accessoires nuisibles . . .'

92. Ledoux's editing of his early works in his *Architecture* is significant in this connexion.

93. Rosenau, *op. cit.*, 82.

94. E. Kaufmann, 'Étienne-Louis Boullée', *The Art Bulletin*, XXI (1939), 213.

95. These archetypes appear already in Montfaucon, *L'Antiquité expliquée et représentée en figures* (published in 1719–24) and in the *Hypnerotomachia Poliphili*, a new edition of which appeared in 1804. On the other hand, the verdict of the period on Vitruvius was damning. Viel de Saint-Maux asserted in the *Lettres sur l'architecture des anciens et celle des modernes* (1787) that the Romans of the Augustan age had only laughed at him.

96. He explained his predilection for Palladian forms in this way: 'Ses ordres nous ont paru les plus convenables aux pays septentrionaux. Je les ai souvent employées avec succès à distances éloignées. Leur mâle contenance jamais ne se compromet; voyez-les de près, elles offrent des proportions majestueuses; voyez-les de loin, elles reprennent en élégance ce qu'elles perdent de leur force.'

97. As the original building limit of Paris had long been exceeded by the violent growth of the city, the tax-contractors had managed to secure the construction of a new city wall which included the suburbs. The Parisians' anger at this wall was still further increased by the extravagance of the towers, the so-called 'Propylaea of Paris'. As a result, after some of the toll houses had been destroyed in the early days of the Revolution, Ledoux was dismissed in 1789 and replaced by Antoine. Of the forty-seven towers, four are still standing. Cf. Bachaumont's Memoirs.

98. The plan approved by Louis XV provided p. 347 only for the saltworks; there was no question yet of a town. The plans for this did not come into existence until after 1780, on a purely Utopian basis; in 1789 they were for the most part wound up. Cf. Langner, *op. cit.* (1959), 151 ff.

99. 'Function' is to be understood here, in accordance with the *Encyclopédie*, as 'une action correspondante à sa destination'. This utilitarian tendency also occurs in, among other places, the gigantic designs by Petit and Poyet for a new Hôtel-Dieu and Combes' design for the port of Bordeaux. Cf. H. Rosenau, 'The Functional Element in French Neo-Classical Architecture', *Die Kunst des Abendlandes* (1967), 226 ff.

100. The social and moral basis is the thread that runs through Ledoux's *Architecture*. The preface contains these words: 'Peuple! Unité si respectable par l'importance de chaque partie qui la compose, tu ne seras pas oublié dans les constructions de l'art; à de justes distances des villes s'élèveront pour toi des monuments rivaux des palais des modérateurs du monde.' And again: 'Rien de ce qui peut propager les bonnes mœurs, corriger les mauvaises, en punir et surtout en prévenir les effets, n'est négligé.'

101. Cf. J. Langner's excellent study, 'Ledoux und die "Fabriques"', *Zeitschrift für Kunstgeschichte* (1963), 1.

102. Diderot had had this idea before. See also C. L. Becker, *The Heavenly City of the Eighteenth Century Philosophers* (New Haven, 1952); H. Sedlmayer, *Verlust der Mitte* (Salzburg, 1949), 25.

103. A. M. Vogt, *Der Kugelbau um 1800* (Zürich, p. 348 1962), 16; *idem*, 'Die französische Revolutionsarchitektur und der Newtonismus', in *Die Kunst des Abendlandes* (1967), 229; H. Rosenau, 'The Sphere as an Element in the Montgolfier Monu-

ments', *The Art Bulletin*, I (1968), 65; K. Lankheit, *Der Tempel der Vernunft* (Basel-Stuttgart, 1968).

p. 348 104. There were two designs for the interior – by day and by night. The former had a radiant sun hanging in the middle of the sphere.

105. The Galerie des Globes in the erstwhile Hôtel de Nevers (now the back wing of the Bibliothèque Nationale) contained two such giant globes, to which Boullée alludes in his essay. Cf. in particular Vogt, *loc. cit.* (1967).

106. Here belongs too the roughly contemporaneous spherical ranger's house in Ledoux's designs for the park of Maupertuis. The sources for Newton's tomb and its descendants are given in full by Pérouse de Montclos, *op. cit.*, 200.

107. H. Rosenau, 'Boullée and Ledoux as Townplanners, A re-assessment', *G.B.A.* (1964), 173, and Langner, *op. cit.* The same tendency appears in Desprez – in his designs for Haga: cf. Wollin, *op. cit.* (Note 60); H. Demoriane, 'Gustave III', *C.d.A.* (June 1967), 54.

108. The design for an interior view of the cathedral with a nocturnal service in progress was probably influenced by a drawing of Desprez's of 1782, which shows the nocturnal Maundy Thursday Mass in St Peter's in Rome. The picturesque effect of the fall of light was Boullée's main interest. In this he differed essentially from Soufflot. Pérouse de Montclos, *op. cit.*, 161.

109. 'Nos édifices publics devraient faire en quelque façon de vrais poèmes. Les images qu'ils offrent à nos sens devraient exciter dans nos cœurs des sentiments analogues à la destination.' Further: 'Il est des sujets en poésie, en peinture, comme en architecture plus ou moins favorables; en architecture par exemple un théâtre, un cénotaphe, un temple sont des sujets marqués.'

110. 'Architecture ensevelie' hangs closely together with the cult of ruins. Its models lie in Piranesi. The first example in Ledoux is the triumphal arch in front of the Hôtel de Thélusson; cf. O. Reutersvärd, 'De sjunkne bagarna hos Ledoux, Boullée, Cellerier och Fontaine', *Konsthistorisk Tidskrift*, XXIX (1960), 98.

111. On this see Wollin, *loc. cit.*

112. Kaufmann, *op. cit.* (Note 35), 150.

113. Hautecœur, V, 86; Kaufmann, *op. cit.*, 538; G. Metken, 'Jean-Jacques Lequeu ou l'architecture rêvée', *G.B.A.*, LXV (1965), 213; *Les Architectes visionnaires*, exhibition catalogue (Geneva, 1966); J. Guillerme, 'Lequeu et l'invention du mauvais

goût', *G.B.A.*, LXVI (1965), 153; H. Rosenau, 'Jean-Jacques Lequeu', *Architectural Review* (August 1949). In Lequeu the urge towards the picturesque is combined with the English predilection for battlemented castles and 'cottages'; N. Pevsner, 'The Genesis of the Picturesque', *Architectural Review*, XCVI (1944), 139 ff.; *idem*, 'Richard Payne Knight', *The Art Bulletin*, XXXI (1949), 293 ff.

114. Hautecœur, V, 118 ff.

115. Hautecœur, V, 114; F. Boyet, 'Projets de p. 3 salles pour les assemblées révolutionnaires à Paris (1789–92)', *B.S.H.A.F.* (1933), 170; *idem*, 'Note sur les architectes Jacques-Pierre Gisors, Charles Percier et Pierre Vignon', *B.S.H.A.F.* (1933), 258; *idem*, 'Les Tuileries sous la Convention', *B.S.H.A.F.* (1934), 197; *idem*, 'Les Salles d'assemblée sous la Révolution française et leurs répliques en Europe', *B.S.H.A.F.* (1952), 88; Pérouse de Montclos, *op. cit.*, 34.

116. Hautecœur, V, 134; F. Boyet, 'Six statues des législateurs antiques pour le Palais Bourbon sous le Directoire', *B.S.H.A.F.* (1958), 91; *idem*, 'Le Conseil des Cinq Cents au Palais Bourbon', *B.S.H.A.F.* (1935), 59; *idem*, 'Le Palais Bourbon sous le Premier Empire', *B.S.H.A.F.* (1936), 91; J. Marchand and J. Boulas, *Le Palais Bourbon* (Paris, 1862).

117. Hitchcock, *op. cit.*, 20 ff.

118. Cf. the detailed study by M. Jallut, 'Cabi- p. 3 nets intérieurs et Petits Appartements de Marie Antoinette', *G.B.A.*, LXIII (1964), 289, and also Verlet, *op. cit.* (Note 22), 681.

119. Both brothers, Hugues-Jules as carver and p. 3 Jean-Siméon, known as Rousseau de la Rottière, as painter, had been called upon since 1774 by their father Antoine to assist in the decoration at Versailles, and subsequently succeeded him; cf. Hautecœur, IV, 485.

120. Jallut, *op. cit.*, 349. The cabinet was described by Charles Constant, a citizen of Geneva, on the occasion of a visit in 1796.

121. 'L'Influence de Marie-Antoinette sur l'art de son temps', *C.d.A.* (May 1955), 44. On the artists named, cf. Thieme-Becker. Henri Salembier (1753–1820) in particular influenced the Style Louis XVI decisively in the direction of elegance and grace through his numerous designs for ornaments.

122. In the time of Marie Leczinska there was

already a small salon of the same name here, with wooden panelling by Verberckt (1746). In 1770 it was replaced by a staircase communicating with the dauphin's apartment on the ground floor.

123. Further examples in Jallut, loc. cit.

124. Pergolesi, *Designs for Various Ornaments* (London, 1777); Colombani, *A New Book of Ornaments* (London, 1775); T. Chippendale, *Sketches of Ornament* (London, 1779); C. Richardson, *Book of Ceilings* (London, 1781).

125. Cf. the paintings on the mirrors at Fontainebleau ('the Bathroom of Napoleon'), with cherubs at play, which anticipate compositions of the Romantic period.

126. Etruscan motifs appear for the first time in Dugourc's decorations at Bagatelle (1777) and in the Folie Saint-James (1778). At the court the Etruscan fashion did not set in until the middle of the eighties. In 1786-7 the Salon Frais of the dairy at Rambouillet acquired Etruscan furniture based on designs by Hubert Robert; cf. F. J. B. Watson, *Furniture* (Wallace Collection Catalogue) (London, 1956), xlvii. On Etruscology in the eighteenth century cf. *C.d.A.* (May 1958), 74; M. Horster, 'Eine Elfenbeinpyxis mit Szenen aus der etruskischen Mythologie', in *Mouseion, Studien aus Kunst und Geschichte für O. H. Förster* (Cologne, 1959).

352 127. On the dating of the Cabinet de Toilette, cf. P. Verlet, 'Le Boudoir de Marie Antoinette à Fontainebleau', *Art de France*, I (1961), 159.

128. P. Kjellberg, *C.d.A.* (October 1964), 116.

129. E. Schlumberger, in *C.d.A.* (March 1964), 88.

130. 'La chambre à coucher du Prince était à elle seule tout un poème.' Description of the bedroom in C. Gailly de Taurines, *Aventuriers et femmes de qualité* (Paris, n.d.); illustrated in Stern, *op. cit.* (Note 63).

131. On Dugourc, cf. Stern, *op. cit.*, II, 280; Hautecœur, IV, 493.

132. F. Kimball, 'Les Influences anglaises dans la formation du style Louis XVI', *G.B.A.*, V (1931), 29. The number of visitors from Paris to Bagatelle was so great that the Comte d'Artois had entrance cards printed; cf. also Connolly-Zerbe, *op. cit.* (Note 36), 114. p. 353

133. The original group of three rooms which Bélanger had to redecorate comprises, apart from the dining room, the Salon des Jeux, with green imitation marble covered with white plaster arabesques, and a room altered under the Empire. There were also plans in existence to rebuild the vestibule in the ancient style (B.N. Est.); cf. H. Demoriane, 'Le Château de Maisons retrouve une vie brillante', *C.d.A.* (October 1967), 87.

134. 'Du goût anglais imitateur fidèle ...', contemporary prize poem on Bélanger; cf. Stern, *op. cit.*, 73. On the anglomania of the period, cf. Kimball, 29.

135. Kimball; Hautecœur, IV, 481; P. Thornton, 'Proto Neo-Classicism: The Battle of the Giants', *Apollo* (1968), 130; Gallet, *op. cit.* (Note 34), 53.

136. House for the dancer Dervieux, folie for the Comte d'Artois, house for Adeline Colombe, Bélanger's own house in the Rue Saint-Georges, all round 1786.

137. These pilasters also occur at Syon House and Kenwood, and on the outside façade here.

138. Illustrated in Krafft and Ransonette, *op. cit.* (Note 71).

139. G. Janneau, 'Sur le style Directoire', *Revue de l'Art Ancien et Moderne*, LXXI (1937), 341. p. 354

140. R. G. et C. Ledoux-Lebard, 'La Décoration et l'ameublement de la chambre de Madame Récamier sous le Consulat', *G.B.A.*, XL (1952), 175.

BIBLIOGRAPHY

PART ONE

SCULPTURE AND PAINTING

This bibliography does not aim at completeness, but is offered as a partial guide to an intricate subject; an invaluable work already exists in C. du Peloux, *Répertoire biographique et bibliographique des artistes du XVIIIᵉ siècle français* (Paris, 1930–41). The bibliography below does not include periodical literature, to which a good many references are given in the Notes. No attempt has been made to list all exhibitions of French eighteenth-century art but some major ones, especially those covering both painting and sculpture, have been listed. The Bibliographies in the volumes of *The Pelican History of Art* between which the present volume comes chronologically should also be consulted.

I. SCULPTURE AND PAINTING

A. SOURCES

CAYLUS, COMTE DE. *Vies d'artistes du XVIIIᵉ siècle*. Paris, 1910.

DUPLESSIS, G. *Mémoires et journal de J.-G. Wille*. Paris, 1857.

DUSSIEUX, L., a.o. *Mémoires inédits sur la vie et les ouvrages des membres de l'Académie Royale de Peinture et de Sculpture*. Paris, 1854.

FURCY-RAYNAUD, M. *Correspondance de M. de Marigny (N.A.A.F.)*. Paris, 1904–5.

FURCY-RAYNAUD, M. *Correspondance de M. d'Angiviller (N.A.A.F.)*. Paris, 1906–7.

GUIFFREY, J. *Livrets des Salons* (reprinted). Paris, 1869–70.

GUIFFREY, J. *Notes et documents inédits sur les expositions du XVIIIᵉ siècle*. Paris, 1873.

HENRY, C. *Mémoires inédits de Charles-Nicolas Cochin*. Paris, 1880.

JOUIN, H. *Conférences de l'Académie Royale de Peinture et de Sculpture*. Paris, 1883.

MONTAIGLON, A. DE, and GUIFFREY, J. *Correspondance des Directeurs de l'Académie de France à Rome*. Paris, 1887–1908.

MONTAIGLON, A. DE. *Procès-verbaux de l'Académie Royale de Peinture*. Paris, 1875–92.

RAMBAUD, M. *Documents du Minutier Central concernant l'histoire de l'art (1700–1750)*. Paris, n.d. [1965?].

SEZNEC, J., and ADHÉMAR, J. *Diderot Salons*. Oxford, 1957–67.

WILDENSTEIN, G. *Le Salon de 1725 (Compte rendu par le Mercure de France)*. Paris, 1924.

B. GENERAL WORKS

1. Exhibition Catalogues

Les Artistes du Salon de 1737. Paris, Grand Palais, 1930.

Exposition esquisses/maquettes . . . de l'école française du XVIIIᵉ siècle. Paris, Cailleux, 1934.

Exposition de l'art français au XVIIIᵉ siècle. Copenhagen, 1935.

French Painting and Sculpture of the XVIII Century. New York, Metropolitan Museum, 1935–6.

Louis XV et Rocaille. Paris, Orangerie, 1950.

Kunst und Geist Frankreichs im 18. Jahrhundert. Vienna, 1966.

Dessins français du XVIIIᵉ siècle. Paris, Louvre, Cabinet des Dessins, 1967.

France in the Eighteenth Century. London, Royal Academy, 1968.

The World of Voltaire. Ann Arbor, Michigan University Museum, 1969.

2. Books

BENOIT, F. *L'Art français sous la Révolution et l'Empire.* Paris, 1897.

BOUCHER, F., and JACOTTET, P. *Le Dessin français au XVIIIe siècle.* Lausanne, 1952.

CASTAN, A. *L'Ancienne École de Peinture et de Sculpture de Besançon 1756–1791.* Besançon, 1888.

COURAJOD, L. *L'École Royale des Élèves Protégés.* Paris, 1874.

DACIER, E. *L'Art au XVIIIe siècle (Époques Regence-Louis XV).* Paris, 1951.

FONTAINE, A. *Les Doctrines d'art en France . . . de Poussin à Diderot.* Paris, 1909.

HILDEBRANDT, E. *Die Malerei und Plastik des 18. Jahrhunderts in Frankreich.* Wildpark-Potsdam, 1924.

RÉAU, L. *L'Art au XVIIIe siècle (Style Louis XVI).* Paris, 1952.

ROSENBLUM, R. *Transformations in Late Eighteenth Century Art.* Princeton, 1967.

SCHNEIDER, R. *L'Art français au XVIIIe siècle.* Paris, 1926.

II. SCULPTURE

A. SOURCES

DÉZALLIER D'ARGENVILLE, A. N. *Vies des fameux sculpteurs depuis la Renaissance des arts.* Paris, 1787.

FURCY-RAYNAUD, M. *Deux Musées de sculpture française à l'époque de la Révolution.* Paris, 1907.

FURCY-RAYNAUD, M. *Inventaire des sculptures exécutées au XVIIIe siècle pour la Direction des Bâtiments du Roi.* Paris, 1927.

PATTE, P. *Monumens érigés en France à la gloire de Louis XV.* Paris, 1765.

B. GENERAL WORKS

Dessins de sculpteurs de Pajou à Rodin (exhibition catalogue). Paris, Louvre, Cabinet des Dessins, 1964.

DILKE, Lady. *French Architects and Sculptors of the XVIIIth Century.* London, 1900.

GONSE, L. *La Sculpture française depuis le XIVe siècle.* Paris, 1895.

INGERSOLL-SMOUSE, F. *La Sculpture funéraire en France au XVIIIe siècle.* Paris, 1912.

LAMI, S. *Dictionnaire des sculpteurs de l'école française au XVIIIe siècle.* Paris, 1910–11.

RÉAU, L. *Les Sculpteurs français en Italie.* Paris, 1945.

ROSTRUP, H. *Franske portraetbuster fra det XVIII aarhundrede.* Copenhagen, 1932.

VITRY, P. *La Sculpture française classique de Jean Goujon à Rodin.* Paris, 1934.

ZARETSKAYA, Z., and KOSAREVA, N. *La Sculpture française des XVII–XX siècles au Musée de l'Ermitage.* Leningrad, 1963.

C. INDIVIDUAL SCULPTORS

ADAM
Thirion, H. *Les Adam et Clodion.* Paris, 1885.

BOUCHARDON
Colin, O. *Edme Bouchardon* (exhibition catalogue). Chaumont, 1962.
Roserot, A. *Edme Bouchardon.* Paris, 1910.

CAFFIÉRI
Guiffrey J. *Les Caffiéri.* Paris, 1877.

CLODION
See under ADAM.

COUSTOU I, Guillaume
Gougenot, L. *Vie de Coustou le jeune* (Société des Bibliophiles François, Mélanges, no. 4). Paris, 1903.

COUSTOU II, Guillaume
Anon. *Éloge de Monsieur Coustou.* Paris, 1778.

DESEINE, Louis-Pierre
Le Chatelier, G. *Louis-Pierre Deseine.* Paris, n.d. [1906].

FALCONET
Benot, Y. *Diderot et Falconet: le Pour et le Contre.* Paris, 1958.
Hildebrandt, E. *Leben, Werke und Schriften des Bildhauers E. M. Falconet.* Strassburg, 1908.

Réau, L. *Correspondance de Falconet avec Cathérine II*. Paris, 1921.

Réau, L. *Étienne-Maurice Falconet*. Paris, 1922.

Vallon, F. *Falconet, Diderot et Cathérine II*. Grenoble, 1930.

Weinshenker, A. B. *Falconet: His Writings and his Friend Diderot*. Geneva, 1966.

HOUDON

Arnason, H. H. *Houdon* (exhibition catalogue). Worcester, Mass., 1964.

Giacometti, G. *Le Statuaire Jean-Antoine Houdon et son époque*. Paris, 1918–19.

Giacometti, G. *La vie et l'œuvre de Houdon*. Paris, 1928.

Réau, L. *Houdon, sa vie et son œuvre*. Paris, 1964.

JULIEN

Pascal, A. *Pierre Julien, sculpteur, sa vie et son œuvre*. Paris, 1904.

LEMOYNE

Réau, L. *Une Dynastie de sculpteurs au XVIIIe siècle, Les Lemoyne*. Paris, 1927.

PAJOU

Bapst, G. *Les Statues des quatre saisons par Pajou*. Paris, 1922.

Stein, H. *Augustin Pajou*. Paris, 1912.

PIGALLE

Réau, L. *J.-B. Pigalle*. Paris, 1950.

Rocheblave, S. *Jean-Baptiste Pigalle*. Paris, 1919.

SALY

Jouin, H. *Jacques Saly*. Mâcon, 1896.

SLODTZ

Souchal, F. *Les Slodtz, sculpteurs et décorateurs du roi*. Paris, 1967.

III. PAINTING

A. SOURCES

ARGENS, Marquis BOYER D'. *Réfléxions critiques sur les différentes écoles de peinture*. Paris, 1752.

COCHIN, C.-N. *Recueil de quelques pièces concernant les arts*. Paris, 1757.

DÉZALLIER D'ARGENVILLE, A.-J. *Abrégé de la vie des plus fameux peintres*. Paris, 1745–52.

ENGERAND, F. *Inventaire des tableaux commandés et achetés par la Direction des Bâtiments du Roi (1709–1792)*. Paris, 1900.

LA FONT DE SAINT-YENNE. *Réfléxions sur quelques causes de l'état présent de la peinture en France*. The Hague, 1747.

LÉPICIÉ, N. B. *Vies des Premier-Peintres du Roi depuis M. le Brun jusqu'à présent*. Paris, 1752.

ORLANDI, P. A. *L'Abcedario pittorico*. Bologna, 1719.

TELLIAB (MYLORD) [BAILLET DE SAINT-JULIEN] *Caractères des peintres actuellement vivants*. Paris, 1755.

WILDENSTEIN, D. *Documents inédits sur les artistes français du XVIIIe siècle*. Paris, 1966.

WILDENSTEIN, D. *Inventaires après décès d'artistes et de collectionneurs français du XVIIIe siècle*. Paris, 1967.

B. GENERAL WORKS

BLANC, C. *Les Peintres des Fêtes-Galantes*. Paris, 1854.

DILKE, Lady. *French Painters of the XVIII Century*. London, 1899.

DIMIER, L. (ed.). *Les Peintres français du XVIIIe siècle*. Paris–Brussels, 1928–30.

DUMONT-WILDEN, L. *Le Portrait en France*. Brussels, 1909.

FLORISOONE, M. *La Peinture française: le dix-huitième siècle*. Paris, 1948.

FRIEDLAENDER, W. *David to Delacroix*. Cambridge, Mass., 1952.

GONCOURT, J. and E. DE. *L'Art au XVIIIe siècle*. Paris, 1880–2.

LOCQUIN, J. *La Peinture d'histoire en France de 1747 à 1785*. Paris, 1912.

MARCEL, P. *La Peinture française au début du dix-huitième siècle 1690–1721*. Paris, n.d. [1906].

Paris et les ateliers provinciaux au XVIIIe siècle (exhibition catalogue). Bordeaux, 1958.

RÉAU, L. *Histoire de la peinture française au XVIIIe siècle*. Paris–Brussels, 1925–6.

THUILLIER, J., and CHATELET, A. *French Painting: From le Nain to Fragonard*. Geneva, 1964.

C. INDIVIDUAL PAINTERS

AUDRAN, Claude
Duplessis, G. *Les Audran*. Paris, 1892.

AVED
Wildenstein, G. *Le peintre Aved*. Paris, 1922.

BOUCHER
Ananoff, A. *L'Œuvre dessiné de Boucher*, I. Paris, 1966.
François Boucher – Premier Peintre du Roi. Paris, Cailleux, 1964.
François Boucher: Gravures et dessins . . . Paris, Louvre, 1971.
Macfall, H. *Boucher*. London, 1908.
Mantz, P. *Boucher, Lemoyne et Natoire*. Paris, n.d.
Michel, A. *Boucher*, Paris, n.d.
Nolhac, P. de. *Boucher, premier peintre du roi*. Paris, 1925.

BOILLY
Harrisse, H. *Louis-Léopold Boilly*. Paris, 1898.

CHARDIN
Pascal, A., Rothschild, H. de, and Gaucheron, R. *Documents sur la vie et l'œuvre de Chardin*. Paris, 1931.
Rosenberg, P. *Chardin*. Geneva, 1963.
Wildenstein, G. *Chardin*. Paris, 1933.

COYPEL, C.-A.
Jamieson, I. *Charles-Antoine Coypel*. Paris, 1930.

DAVID
Cantinelli, R. *Jacques-Louis David*. Paris–Brussels, 1930.
David, J. L. Jules. *Le Peintre Louis David*. Paris, 1880.
Delécluze, M. E. J. *Louis David, son école et son temps*. Paris, 1855.
Hautecœur, L. *Louis David*. Paris, 1954.

DUCREUX
Lyon, G. *Joseph Ducreux*. Paris, 1958.

DUPLESSIS
Belleudy, J. *J. S. Duplessis*. Chartres, 1913.

FRAGONARD
Ananoff, A. *L'Œuvre dessiné de Jean-Honoré Fragonard*. Paris, 1961.
Nolhac, P. de. *J.-H. Fragonard*. Paris, 1906.
Wildenstein. G. *Fragonard*. London, 1960.

GILLOT
Poley, J. *Claude Gillot. Leben und Werk*. Würzburg, 1938.
Populus, B. *Claude Gillot (1673–1722), Catalogue de l'œuvre gravé*. Paris, 1930.

GREUZE
Hautecœur, L. *Greuze*. Paris, 1913.
Martin, J., and Masson, C. *Œuvre de J.-B. Greuze*. Paris, 1908.
Mauclair, C. *Greuze et son temps*. Paris, 1926.

GRIMOU
Gabillot, C. *Alexis Grimou*. Paris, 1911.

HOUËL
Vloberg, M. *Jean Houël*. Paris, 1930.

LANCRET
Wildenstein, G. *Lancret*. Paris, 1924.

LANTARA
Bellier de la Chavignerie. *Lantara*. Paris, 1852.

LATOUR, M. Quentin de
Besnard, A., and Wildenstein, G. *La Tour*. Paris, 1928.

LEMOYNE, François
Mantz, P. *Boucher, Lemoyne et Natoire*. Paris, n.d.

LÉPICIÉ, Nicolas-Bernard
Dreyfus, P. G. *Lépicié*. Paris, 1923.

LE PRINCE
Hédou, J. *Jean Le Prince et son œuvre*. Paris, 1879.

LIOTARD
Fosca, F. *Liotard*. Paris, 1928.
Humbert, E., Revilliod, A., and Tilanus, J. W. R. *La Vie et les œuvres de Jean-Étienne Liotard*. Amsterdam, 1897.

LOO, Carle van
Dandré-Bardon, M.-F. *Vie de Carle Vanloo*. Paris, 1765.

MOREAU, Louis-Gabriel
Wildenstein, G. *Louis Moreau*. Paris, 1923.

NATOIRE
Mantz, P. *Boucher, Lemoyne et Natoire*. Paris, n.d.

NATTIER, Jean-Marc
Nolhac, P. de. *Nattier, peintre de la cour de Louis XV*. Paris, 1905.
Nolhac, P. de. *Nattier*. Paris, 1925.

OUDRY, J.-B.
Cordey, J. *Esquisses de portraits peints par J. B. Oudry*. Paris, 1929.
Lauts, J. *Jean-Baptiste Oudry*. Hamburg and Berlin, 1967.
Locquin, J. *Catalogue raisonné de l'œuvre de Jean-Baptiste Oudry (A.A.F.)*. Paris, 1912, reprinted 1968.

PARROCEL
Parrocel, E. *Monographie des Parrocel*. Marseilles, 1861.

Roeingh, R. *Vom Schritt zur Capriole*. Berlin–Paris, 1943.

PATER
Ingersoll-Smouse, F. *Pater*. Paris, 1928.

PILLEMENT
Pillement, J. *Jean Pillement*. Paris, 1945.

PERRONNEAU
Vaillat, L., and Ratouis de Limay, P. *J. B. Perronneau, sa vie et son œuvre*. Paris, 1923.

ROBERT, Hubert
Beau, M. *La Collection des dessins d'Hubert Robert au musée de Valence*. Lyon, 1968.
Burda, H. *Die Ruine in den Bildern Hubert Roberts*. Munich, 1967.
Exposition Hubert Robert. Paris, Orangerie, 1933.
Leclere, T. *Hubert Robert et les paysagistes français du XVIIIe siècle*. Paris, 1913.
Nolhac, P. de. *Hubert Robert*. Paris, 1910.

ROSLIN, Alexandre
Lundberg, G. W. *Roslin, Liv och verk*. Malmö, 1957.

SAINT-AUBIN
Dacier, E. *Gabriel de Saint-Aubin*. Paris, 1929–31.
Moureau, A. *Les Saint-Aubin*. Paris, n.d.

SANTERRE
Potiquet, A. *Jean-Baptiste Santerre*. Paris, 1876.

TOCQUÉ
Doria, A. *Louis Tocqué*. Paris, 1929.

Doria, A. *Le Comte de Saint-Florentin, son peintre et son graveur* (Tocqué and Wille). Paris, 1933.

VERNET
Ingersoll-Smouse, F. *Joseph Vernet*. Paris, 1926.
Lagrange, L. *Joseph Vernet et la peinture au XVIIIe siècle*. Paris, 1864.

VIGÉE-LEBRUN
Hautecoeur, L. *Madame Vigée-Lebrun*. Paris, 1914.
Nolhac, P. de. *Elizabeth Vigée-Lebrun*. Paris, 1911.

WATTEAU
Adhémar, H., and Huyghe, R. *Watteau*. Paris, 1950.
Champion, P. *Notes critiques sur les vies anciennes d'Antoine Watteau*. Paris, 1921.
Dacier, E., Vuaflart, A., and Herold, J. *Jean de Jullienne et les graveurs de Watteau au XVIIIe siècle*. Paris, 1922–9.
Mathey, J. *Antoine Watteau, peintures réapparues*. Paris, 1959.
Nemilova, I. S. *Watteau et ses œuvres à l'Ermitage*. Leningrad, 1964.
Parker, K. T., and Mathey, J. *Antoine Watteau, Catalogue complet de son œuvre dessiné*. Paris, 1957.
Rey, R. *Quelques satellites de Watteau*. Paris, 1931.
Rosenberg, P., and Camesasca, E. *Tout l'œuvre peint de Watteau*. Paris, 1970.

PART TWO

ARCHITECTURE

This bibliography does not include publications of architectural engravings without text. Such publications are referred to in the notes. Papers in French journals are also, with a few exceptions, omitted, but the names of the most important journals are listed. It goes without saying that such a bibliography as this is not complete. It is confined to the essential and the most recent publications, which in their turn as a rule carry their own bibliography. In addition the adjoining volumes of *The Pelican History of Art* ought to be consulted.

A. SOURCES

ANDRÉ, P. *Essai sur le Beau*. Paris, 1741 and 1770.

ARGENSON, R. L. DE, Voyer de Paulmy, Marquis d'. *Journal et mémoires du Marquis d'Argenson*. Paris, 1861–7.

AVRIL, P. *Temples anciens et modernes ou observations historiques et critiques sur les plus célèbres monuments d'architecture grecque et gothique*. London–Paris, 1774.

BAUCHAUMONT, L. P. DE. *Mémoires secrètes pour servir à l'histoire de la République des Lettres en France depuis 1762 jusqu'à nos jours*. London, 1777–89.

BARBIER, E. J. F. *Journal historique et anecdotique du règne de Louis XV*. Paris, 1866.

BLONDEL, J.-F. *De la distribution des maisons de plaisance et de la décoration des édifices en général*. Paris, 1737, 1738.

BLONDEL, J.-F. *Architecture française*. Paris, 1752, 1754, 1756.

BLONDEL, J.-F. *Cours d'architecture* (continued by Patte). Paris, 1771–7.

BLONDEL, J. F. *L'Homme du monde éclairé par les arts*. Amsterdam, 1774.

BRICE, G. *Description de Paris*. Paris, 1702, 1715, 1723, 1725, 1752.

BRISEUX, C.-É. *Traité du beau essentiel dans les arts appliqués particulièrement à l'architecture*. Paris, 1752, 1753.

COCHIN, C.-N. (ed. C. HENRY). *Mémoires inédites de Charles-Nicolas Cochin*. Paris, 1880.

CORDEMOY, J. L. DE. *Nouveau Traité de toute l'architecture*. Paris, 1706.

DANGEAU, Marquis de (ed. P. DE COUREILLON). *Journal de la cour de Louis XIV depuis 1684 jusqu'à 1715*. 19 vols. London, 1774.

DAVILER, C. (ed. A. LE BLOND). *Cours d'architecture*. 2nd ed. Paris, 1710.

DELAFOSSE, C. *Nouvelle Iconologie historique*. Paris, 1768.

DÉZALLIER D'ARGENVILLE, A. J. *La Théorie et la pratique du jardinage*. Paris, 1722.

DÉZALLIER D'ARGENVILLE, A. J. *Vie des plus fameux architectes et sculpteurs*. Paris, 1787.

DÉZALLIER D'ARGENVILLE, A. J. *Voyage pittoresque de Paris*. Paris, 1749 ff.

DÉZALLIER D'ARGENVILLE, A. J. *Voyage pittoresque des environs de Paris*. Paris, 1749, (1755, 1778).

DIDEROT, D., and D'ALEMBERT, J. *Encyclopédie, ou Dictionnaire raisonné des sciences des arts et des métiers*. Paris–Amsterdam, 1751–77.

DIDEROT, D. (ed. J. ADHÉMAR). *Diderot Salons*. Oxford, 1957–67.

GUIFFREY, J. *Comptes des Bâtiments du Roi 1644–1715*. Paris, 1881–1901.

Inventaire général des richesses d'art de la France. Paris, 1886.

LA FONT DE SAINT-YENNE. *L'Ombre du Grand Colbert, Le Louvre et la ville de Paris*. The Hague, 1749.

LA FONT DE SAINT-YENNE. *Le Génie du Louvre aux Champs Élysées*. Paris, 1756.

LA MARE, DE. *Traité de la police*. Paris, 1738.

LAUGIER, M.-A. *Essai sur l'architecture*. Paris, 1753.

LAUGIER, M.-A. *Observations sur l'architecture*. Paris, 1765.

LEDOUX, C.-N. *L'Architecture considérée sous le rapport de l'art, des mœurs et de la législation.* Paris, 1804.

LEMONNIER, H. *Procès verbaux de l'Académie Royale d'Architecture.* Paris, 1911–26.

LUBERSAC, Abbé de. *Discours sur les monuments publics.* Paris, 1775.

MARIETTE, J. (ed. P. DE CHENNEVIERES and A. DE MONTAIGLON). *Abécédario.* Paris, 1851–60.

MONTAIGLON, A. DE, and GUIFFREY, J. *Correspondance des directeurs de l'Académie de France à Rome.* Paris, 1887–1908.

PATTE, P., *Monuments érigés à la gloire de Louis XV.* Paris, 1765.

PATTE, P. *Mémoires sur les objets les plus importants de l'architecture.* Paris, 1769.

PATTE, P. *Mémoires sur la construction de la coupole projetée pour couronner la nouvelle église de Ste Geneviève à Paris.* Paris, 1770.

PATTE, P. *Mémoires sur l'achèvement du grand portail de l'église de St Sulpice.* Paris, n.d.

PELOUX, C. DE. *Répertoire biographique et bibliographique des artistes du XVIIIe siècle français.* Paris, 1930–41.

PIGANIOL DE LA FORCE. *Description de Paris.* (1718, 1736, 1742, 1756).

PIRANESI, G. B. *Parere su l'architettura.* Rome, 1765.

POMPADOUR, Madame de (ed. A. P. MALASSIS). *Correspondance.* Paris, 1878.

QUATREMÈRE DE QUINCY, A. C. *Notices historiques.* Paris, n.d.

QUATREMÈRE DE QUINCY, A. C. *Vie des plus célèbres architectes.* Paris, n.d.

ROSENAU, H. *Boullée's Treatise on Architecture.* London, 1953.

ROUBO, A. *Traité de la construction des théâtres.* Paris, 1777.

SAINT SIMON, Duc de. *Mémoires.* Paris, 1830 ff.

THIÉRY. *Guide des amateurs et des étrangers voyageurs à Paris.* Paris, 1787.

VIRLOYS, C.-F. Roland de. *Dictionnaire d'architecture.* Paris, 1770–1.

VOLTAIRE. *Le Siècle de Louis XIV.* Paris, 1751.

B. GENERAL WORKS

Les Architectes visionnaires de la fin du XVIIIe siècle. Exhibition catalogue. Paris, 1964; Geneva, 1965.

BADOLLE, M. *L'Abbé Pier-Jacques Barthélemy et l'hellenisme en France dans la seconde moitié du XVIIIe siècle.* Paris, 1926.

BAUCHAL, P. *Nouveau Dictionnaire biographique et critique des architectes français.* Paris, 1887.

BELOVITSCH-STANKEVITCH, H. *Le Goût chinois en France au temps de Louis XIV.* Paris, 1910.

BENISSOVITCH, M. 'Ghezzi and the French Artists in Rome', *Apollo* (1967).

BLOMFIELD, A. *A History of French Architecture 1661–1774.* London, 1921.

BOYÉ, P. *Les Châteaux de Stanislas et les beaux arts.* Nancy, 1927.

BOYÉ, P. 'Les Châteaux du Roi Stanislas', *Le Pays lorrain* (Nancy, 1906).

BRINCKMANN, A. E. *Baukunst des 17. und 18. Jahrhunderts in den romanischen Ländern* (Handbuch der Kunstwissenschaft). Berlin, 1915.

CASSIRER, K. *Die ästhetischen Hauptbegriffe der französischen Architekturtheoretiker von 1650–1780.* Berlin, 1909.

COLOMBIER, P. DU. *L'Art français dans les cours rhénanes.* Paris, 1930.

COLOMBIER, P. DU. *L'Architecture française en Allemagne au XVIIIe siècle.* Paris, 1956.

CONOLLY, C., and ZERBE, J. *Les Pavillons. French Pavilions of the Eighteenth Century.* London, 1962.

CORDIER, H. *La Chine en France au XVIIIe siècle.* Paris, 1910.

DESHAIRS, L. *Architecture et décoration au XVIIIe siècle.* Paris, 1908.

DESTAILLEUR, H. *Recueil d'estampes relatives à l'ornementation des appartements aux XVIe, XVIIe et XVIIIe siécles.* Paris, 1863–71.

DEVILLERS, P. *L'Axe de Paris et André le Nôtre.* Paris, 1959.

DIMIER, L. *Les Peintres français du XVIIIe siècle.* Paris–Brussels, 1928.

DORST, F. 'Charles Mangin und seine Bauten in den Trierer und Mainzer Landen (1779–93)', *Mainzer Jahrbuch* (1917).

DUMOLIN, M. *Études de topographie parisienne.* Paris, 1929, 1931.

DUMOLIN, M., and OUTARDEL, G. *Les Églises de France, Paris et la Seine.* Paris, 1936.

ERDBERG, E. VON. *Chinese Influences on European Garden Structure.* Cambridge, 1936.

GALLET, M. *Demeures parisiennes l'époque de Louis XVI.* Paris, 1964.

GANAY, E. DE. *Les Jardins à l'anglaise en France au XVIIIe siècle* (thesis). Paris, 1923.

GANAY, E. DE. *Les Jardins à la français en France au 18e siècle.* Paris, 1943.

GANAY, E. DE *Châteaux de France.* Paris, 1948–50.

GANAY, E. DE. *Les Jardins de France et leur décor.* Paris, 1949.

GIEDION, S. *Space, Time and Architecture.* London, 1952.

GONCOURT, E. and J. DE. *Portraits intimes du 18e siècle.* Paris, n.d.

HAUG, H. *L'Architecture Régence à Strasbourg* (Archives alsaciennes d'Histoire de l'art). Strasbourg, 1924, 1926, 1927.

HAUG, H. *Trois Siècles d'art alsacien.* Strasbourg, 1948.

HAUTECŒUR, L. *L'Architecture classique à St Pétersbourg à la fin du 18e siècle.* Paris, 1912.

HAUTECŒUR, L. *Rome et la renaissance de l'antiquité à la fin du XVIIIe siècle.* Paris, 1912.

HAUTECŒUR, L. *L'Architecture en Bourgogne.* Paris, 1929.

HAUTECŒUR, L. *Histoire de l'architecture classique en France.*
 II. *Le Règne de Louis XIV.* Paris, 1948.
 III. *Première moitié du XVIIIe siècle – Le Style Louis XV.* Paris, 1950.
 IV. *Seconde moitié du XVIIIe siècle – Le Style Louis XVI.* Paris, 1952.
 V. *Révolution et Empire.* Paris, 1953.

HELIOT, P. *La Fin de l'architecture gothique dans le nord de la France aux XVIIe et XVIIIe siècles* (Bull. de la Comm. Royale des monuments et des sites, VIII). Brussels, 1957.

HEIMBURGER, M. *Antikken og Faubourg Saint-Germain Privatarkitektur.* Copenhagen, 1963.

HERRMANN, W. 'Antoine Desgodets and the Académie Royale d'Architecture', *The Art Bulletin,* XL (March, 1958).

HONOUR, H. *Chinoiserie.* London, 1961.

KALNEIN, W. Graf. *Schloss Clemensruhe in Poppelsdorf.* Bonn, 1956.

KAUFMANN, E. 'Contribution of J. F. Blondel to Mariette's Architecture Française', *The Art Bulletin,* XXXI (1949).

KAUFMANN, E. *Von Ledoux bis Le Corbusier. Ursprung und Entwicklung der autonomen Architektur.* Vienna–Leipzig, 1933.

KAUFMANN, E. 'Three Revolutionary Architects, Boullée, Ledoux and Lequeu', *Transactions of the American Philosophical Society,* XLII, part 3. Philadelphia, 1952.

KAUFMANN, E. *Architecture in the Age of Reason, Baroque and Postbaroque in England, Italy and France.* Cambridge, 1955.

KIMBALL, F. *Le Style Louis XV.* Paris, 1949. (English translation: *The Creation of the Rococo.*)

Kunst mit Zwedens Gouden Eeuw. Exhibition catalogue. Amsterdam, 1961.

LANG, S. 'The Early Publication of the Temples at Paestum', *J.W.C.I.,* XIII (1950).

LANSON, R. *Le Goût de moyen âge en France au XVIIIe siècle.* Paris, 1926.

LAVEDAN, P. *Histoire de l'urbanisme.* Paris, 1941.

LAVEDAN, P. *French Architecture.* Harmondsworth, 1944.

LAVEDAN, P. *Les Places Louis XVI.* Paris, 1958.

LAVEDAN, P. *Les Villes françaises.* Paris, 1960.

LÉON, P. *Les Monuments historiques.* Paris, 1917.

LÉON, P. *La Vie des monuments français.* Paris, 1951.

LESPINASSE, P. *L'Art français et la Suède de 1673 à 1816.* Paris, 1913.

LESTOCQUOY, J. 'L'Architecture gothique aux XVIIe et XVIIIe siècles', *L'Art sacré* (January–February 1948).

LINFERT, C. *Die Grundlagen der Architektur.* Berlin, 1931.

MÂCON, S. *Les Arts dans la maison de Condé.* Paris, 1903.

MARIE, A. *Jardins français classiques des XVIIe et XVIIIe siècles.* Paris, 1949.

MAROT, P. *Visages de la Lorraine.* Paris, 1950.

MAUBAN, A. *L'Architecture française de Mariette.* Paris, 1946.

MIDDLETON, R. D. 'The Abbé de Cordemoy and the Graeco–Gothic Ideal', *J.W.C.I.,* XXV (1962), XXVI (1963).

MOISY, P. *Les Églises jésuites de l'Ancienne Assistance de France.* Rome, 1958.

PARENT, P. *L'Architecture des Pays-Bas méridionaux des XVIᵉ, XVIIᵉ et XVIIIᵉ siècles*. Paris–Brussels, 1926.

PETZET, M. *Soufflots Sainte Geneviève und der französische Kirchenbau des 18. Jahrhunderts*. Berlin, 1961.

PEVSNER, N. *An Outline of European Architecture*. 7th ed. Harmondsworth, 1963.

PEVSNER, N., and LANG, S. 'Apollo or Baboon', *Architectural Review*, CIV, no. 624 (1948).

PFISTER, C. *Histoire de Nancy*. Nancy, 1908.

PLANTENGA, J. H. *L'Architecture religieuse de Brabant au XVIIᵉ siècle*. The Hague, 1926.

RÉAU, L. *Les Monuments détruits de l'art français*. Paris, 1959.

ROCHEBLAVE, S. *L'Art et le goût en France de 1600 à 1900*. Paris, 1930.

ROSENAU, H. *The Ideal City*. London, 1959.

SEDLMAYER, R. *Die Grundlagen der französischen Rokoko-ornamentik in Frankreich*. Leipzig, 1917.

SCHMARSOW, A. *Barock und Rokoko*. Leipzig, 1897.

SCHNEIDER, R. *Quatremère de Quincy et son intervention dans les arts*. Paris, 1910.

TOURNIER, R. *Les Églises comtoises, leur architecture des origines au XVIIIᵉ siècle*. Paris, 1954.

Urbanisme et architecture (Études écrites et publiées en l'honneur de Pierre Lavedan). Paris, 1954.

VALLERY-RADOT, J. *Le Recueil de plans d'édifices de la compagnie de Jésus, conservé à la D. N. en Paris*. Rome, 1960.

VOGT, A. M. *Der Kugelbau um 1800 und die heutige Architektur*. Zürich, 1962.

WEIGERT, R. A. *Le Style Louis XIV*. Paris, 1941.

ZOLTAN, H. *La Cour de Léopold*. Paris, 1938.

ZUCKER, P. *Town and Square*. New York, 1959.

C. INDIVIDUAL ARCHITECTS

BÉLANGER
Stern, J. *À l'ombre de Sophie Arnould. François Joseph Bélanger*. Paris, 1930.

BERNARD
Tournier, R. 'L'Architecte Comte Joseph Alexandre Bernard', *Académie des Sciences, Belles Lettres et Arts de Besançon, Procès Verbaux et Mémoires*. Besançon, 1943.

BETTO
Marot, P. *L'Architecte Jean Betto*. Nancy, 1944.

BOFFRAND
Garms, J. *Studie zu Boffrand* (thesis). Vienna, 1962.
Morey, L. P. *Notice sur la vie et les œuvres de Boffrand*. Nancy, 1866.

BOULLÉE
Coulon, M. *Étienne-Louis Boullée, architecte des Bâtiments du Roi* (thesis). Paris, 1947.
Pérouse de Montclos, J. *Étienne-Louis Boullée*. Paris, 1969.

BRONGNIART
De Lanney, L. *Les Brongniart*. Paris, 1944.
Silvestre de Sacy, J. *Alexandre Théodore Brongniart*. Paris, 1940.

BULLOT
Langenskjöld, E. *Pierre Bullot, The Royal Architect*. Stockholm, 1959.

CHALGRIN
Quatremère de Quincy, A. C. *Notice sur Chalgrin*. Paris, 1816.

COTTE, DE
Marcel, P. *Inventaire des papiers manuscrits du cabinet de R. de Cotte*. Paris, 1906.
Rauch-Elkan, A. *Acht Pläne und ein Bau-Memoire Robert de Cottes für Schloss Tilbourg in Brabant*. s'Hertogenbosch, 1958.

DELAMONCE
Charvet, L. *Les Delamonce*. Paris, 1892.

DESPREZ
Wollin, N. G. *Desprez en Italie*. Malmö, 1934.
Wollin, N. G. *Desprez en Suède*. Stockholm, 1939.

DUGOURC
Trévise, Duc de. *Dugourc, Renaissance de l'art français*. Paris, 1925.

GABRIEL
Cox, H. B. *Ange-Jacques Gabriel (1698–1782)*. London, 1926.
Fels, Comte de. *Ange-Jacques Gabriel*. Paris, 1912.
Gromort, G. *Ange-Jacques Gabriel*. Paris, 1933.

HÉRÉ
Jacquot, T. 'Emmanuel Héré premier architecte de Stanislas et ses collaborateurs', *Le Pays lorrain* (Nancy, 1952).
Marot, P. *Emmanuel Héré*. Nancy, 1954.
Pfister, C. *Emmanuel Héré et la place Stanislas*. Nancy, 1905, 1906.
Schulenburg, J. Gräfin. *Emmanuel Héré de Corny und die Baukunst in Lothringen unter Stanislaus Lesczynski* (thesis). Frankfurt, Kunsthistorisches Institut.

IXNARD
Vossenack, L. *Pierre-Michel d'Ixnard* (thesis). Remscheid, 1938.

JADOT
Schmidt, J. 'Die alte Universität in Wien und ihr Erbauer J. N. Jadot', *Wiener Forschungen zur Kunstgeschichte* (1929).

KLÉBER
Danis, R. *Kléber, architecte à Belfort* (1789–92). Strasbourg, 1926.

LA GUÊPIÈRE, DE
Klaiber, A. J. *Der württembergische Oberbaudirektor Phil. de la Guepière.* Stuttgart, 1959.

LE BLOND
Lasky, B. 'J. B. A. Le Blond, architecte de Pierre le Grand, son œuvre en France', *Bulletin de l'association russe pour les recherches scientifiques à Prague*, III (1936).

LE CARPENTIER
Chirol, P. *L'Architecte le Carpentier et le projet du nouvel hôtel de ville de Rouen* (Congrès du millénaire de la Normandie). Rouen, 1913.

LEDOUX
Christ, Y. *Ledoux. Architecte du roi.* Paris, 1961.
Herrmann, W. 'The Problem of Chronology in Claude-Nicolas Ledoux' Engraved Work', *The Art Bulletin*, XLII, no. 3 (1960).
Langner, J. *Claude-Nicolas Ledoux. Die erste Schaffenszeit 1762–74* (thesis). Freiburg, 1959.
Langner, J. 'Ledoux' Redaktion der eigenen Entwürfe für die Veröffentlichung', *Zeitschrift für Kunstgeschichte*, XXIII (1960).
Levallet, G., and Haug, H. *Claude-Nicolas Ledoux.* Strasbourg, 1936.
Raval, M., and Moreux, J. C. *Ledoux.* Paris, 1945.
Rosenau, H. 'Claude-Nicolas Ledoux', *Burl. Mag.*, LXXXVIII (1946).

LEQUEU
Rosenau, H. 'Jean-Jacques Lequeu', *Architectural Review* (August 1944).

LOUIS
Marionneau, C. *Victor Louis.* Bordeaux, 1881.
Pariset, F. G. 'Les Découvertes du professeur S. Lorentz sur Victor Louis à Varsovie', *Rev. Hist. de Bordeaux et du Dép. de la Gironde* (1956).
Victor Louis et Varsovie. Exhibition catalogue. Bordeaux, 1958.

MIQUE
Morey, P. *R. Mique.* Nancy, 1868.

NICOLE
Tournier, R. *L'Architecte Nicolas Nicole 1702–84.* Besançon, 1942.

OPPENORDT
Mathey, J., and Nordenfalk, C. 'Watteau and Oppenordt', *Burl. Mag.*, XCVII (1955).

PÂRIS
Estignard, P. *Pierre-Adrien Pâris.* Paris, 1902.
Garcier, C. *L'Architecte Adrien Pâris. La Renaissance de l'art français.* Paris, 1920.

PATTE
Mathieu. M. *Pierre Patte, sa vie et son œuvre.* Paris, 1940.

PINEAU
Deshairs, N. *Nicolas et Dominique Pineau.* Paris, n.d.

PIRANESI
Focillon, H. *G. B. Piranesi.* Paris, 1918.

SOUFFLOT
Mondain-Monval, J. *Soufflot, sa vie, son œuvre, son esthétique.* Paris, 1918.

TESSIN
Josephson, R. *L'Architecte de Charles XII, Nicodème Tessin, à la cour de Louis XIV.* Paris–Brussels, 1930.

D. INDIVIDUAL PLACES

PARIS: GENERAL
Colas, R. *Paris qui reste. Vieux Hôtels, Vieilles Demeures.* Paris, 1919.
Rochgyde, Marquis de, and Dumolin, M. *Guide pratique à travers le vieux Paris.* Paris, 1923.

PARIS: CHURCHES
Christ, Y. *Églises parisiennes, actuelles et disparues.* Paris, 1947.
Krieger, A. *La Madeleine.* Paris, 1937.
Vloberg, M. *Notre Dame de Paris et le vœu de Louis XIV.* Paris, 1926.
Monval, J. *Le Panthéon.* Paris, 1928.
Petzet, M. *Soufflots Ste Geneviève und der französische Kirchenbau des 18. Jahrhunderts.* Berlin, 1961.
Michaud, M. L. *L'Église de St Roch.* Paris, n.d.
Lemesle, G. *L'Église St Sulpice.* Paris, n.d.

PARIS: HÔTELS
Pillement, G. *Les Hôtels de Paris.* Paris, 1945.
Babelon, J. *Musée de l'Histoire de France Historique et description des bâtiments des Archives Nationales.* Paris, 1958.

PARIS: HÔTELS – contd.

Babelon, J. *Le Cabinet du Roi ou le Salon Louis XV de la Bibliothèque Nationale.* Paris–Brussels, 1927.

Courtois, F. *Les Emplacements successifs du Cabinet des Estampes de 1667 à 1917.* Paris, 1918.

Laulan, R. *L'École Militaire de Paris.* Paris, 1950.

Contet et Vacquier. *Les Vieux Hôtels de Paris. Architecture et décoration.* Paris, 1910 ff.

Langlois, C. V. *Les Hôtels de Clisson, de Guise, de Rohan-Soubise au Marais.* Paris, 1922.

Paris, P. *Le Marquis de Lassay et l'hôtel de Lassay.* Paris, 1848.

Mazerolle, F. *L'Hôtel des Monnaies.* Paris, 1907.

Guiffrey, J. *Documents sur l'hôtel de Soubise.* Paris, 1915.

Laudet, F. *L'Hôtel de la Vrillière.* Paris, n.d.

PARIS: PALACES

Coutant, H. *Le Palais Bourbon au XVIIIe siècle.* Paris, 1905.

Marchand, J., and Boulas, J. *Le Palais Bourbon.* Paris, 1962.

Hautecœur, L. *Histoire du Louvre.* Paris, n.d.

Champier, V., and Sandoz, R. *Le Palais Royal.* Paris, 1900.

Dupezard, E. *Le Palais Royal de Paris.* Paris, 1911.

Espezel, A. d'. *Le Palais Royal.* Paris, 1936.

PARIS: PLANNING

Lavedan, P. *Le IIme Centenaire de la Place de la Concorde.* Paris, 1956.

Cain, G. *La Place Vendôme.* Paris, 1906.

BELLEVUE

Biver, P. Comte. *Histoire du château de Bellevue.* Paris, 1933.

BERCY

Deshairs, L. *Le Château de Bercy.* Paris, n.d.

BESANÇON

Garcier, G. 'Les Projets d'embellissement de Besançon au XVIIIe siècle', *Ann. hist. de Franche Comté* (1946).

BORDEAUX

Courteault, P. *Bordeaux cité classique.*

Lheritier, J. *Tourny intendant de Bordeaux.* Paris, 1920.

Welles, J. de. *Le Palais Rohan, hôtel de ville de Bordeaux.* Bordeaux, 1954.

CHÂLONS-SUR-MARNE

Berland, J. *L'Hôtel de l'Intendance de Champagne.* Châlons-sur-Marne, 1928.

CHAMPS

Cahen d'Anvers. *Le Château de Champs.* Paris, n.d.

CHANTILLY

Ganay, E. de. *Chantilly.* Paris, 1935.

Malo, H. *Le Château de Chantilly.* Paris, 1948.

CHOISY

Chamchine, B. *Le Château de Choisy.* Paris, 1910.

COMPIÈGNE

Robiquet, J. *Pour mieux connaître le palais de Compiègne.* Compiègne, 1938.

Verlet, P. *Le Mobilier de Louis XVI et de Marie-Antoinette à Compiègne* (thesis). Paris, 1937.

DIJON

Chabeuf, H. *Dijon. Monuments et souvenirs.* Dijon, 1894.

Cornereau. *Le Palais des États à Dijon.* Paris, 1890.

FONTAINEBLEAU

Bottineau, Y. *L'Art d'Ange-Jacques Gabriel à Fontainebleau.* Paris, 1962.

Bray, A. *Le Château de Fontainebleau.* Paris, 1956.

Bray, A. *Les plus excellents bâtiments de France: Le Château de Fontainebleau.* Paris, 1955.

Deroy, L. *Les Chroniques du château de Fontainebleau.* Paris, n.d.

Terrasse, C. *Le Château de Fontainebleau.* Paris, 1946.

LA MUETTE

Franqueville, Comte de. *Le Château de la Muette.* Paris, 1715.

LUNÉVILLE

Joly, A. *Le Château de Lunéville.* Paris, 1859.

LYON

Charvet, E. L. G. *Lyon artistique.* Lyon, 1899.

Le Nail, R. *Lyon, architecture et décoration aux 17e et 18e siècles.* Paris, n.d.

METZ

Lejeaux, J. *La Place d'Armes de Metz, un ensemble architectural du 18e siècle.* Paris, 1927.

Lejeaux, J. *La Place d'Armes de Metz.* Strasbourg, 1927.

MEUDON

Biver, P. Comte. *Meudon.* Paris, n.d.

MONTPELLIER

Fliche, A. *Montpellier.* Paris, 1935.

NANCY

Lepage, P. *Le Palais ducal de Nancy.* Nancy, 1852.

Marot, P. 'Jules Hardouin-Mansart et le plan de la primatiale de Nancy', *Le Pays lorrain* (Nancy, 1930).

Marot, P. 'La Genèse de la Place Royale de Nancy', *Annales de l'Est* (1954).

Marot, P. *Le Vieux Nancy*. Nancy, 1935.

Pfister, C. *Histoire de Nancy*. Paris–Nancy, 1902–9.

NANTES

Géraud-Mangin, J. *Nantes au 18ᵉ siècle*. Nantes, n.d.

Lelièvre, P. *L'Urbanisme et l'architecture à Nantes*. Nantes, 1942.

Martin, C. *Nantes au XVIIIᵉ siècle*. Nantes, 1928.

ORLÉANS

Chenesseau, G. *Ste Croix d'Orléans*. Paris, 1921.

REIMS

Bazin, G. *Reims*. Paris, 1900.

RENNES

Banéat, P. *Le Vieux Rennes*. Rennes, n.d.

Nitsch, G. *L'Hôtel de Ville, La Tour de l'Horloge, Le Présidial de Rennes*. Rennes, 1928.

SAINT-HUBERT

Maillard, J. *Le Château royal de St Hubert*. Versailles, 1905.

SAVERNE (ZABERN)

Dammann, W. H. 'Das untere Schloss in Zabern', *Revue alsacienne illustrée*, XII (1910).

STRASBOURG

Haug, H. 'Le Style Louis XIV à Strasbourg', *Archives alsaciennes d'histoire de l'art* (1924).

Polaczek, E. 'Der Strassburger Stadtregulierungsplan des Pariser Architekten Blondel', *Zeitschrift f. d. Geschichte des Oberrheins* (1915).

VERSAILLES

Brière, G. *Le Château de Versailles, Architecture et décoration*. Paris, 1910.

Deshairs, L. *Le Grand Trianon, architecture, décoration, ameublement*. Paris, n.d.

Deshairs, L. *Le Petit Trianon, architecture, décoration, ameublement*. Paris, 1907.

Hachette, A. *Le Couvent de la Reine à Versailles*. Paris, 1922.

Mauricheau-Beaupré, C. *Versailles, l'histoire et l'art*. Paris, 1949.

Nolhac, P. de. *La Chapelle royale de Versailles*. Paris, n.d.

Nolhac, P. de. *Histoire du château de Versailles*. Paris, 1911.

Nolhac, P. de. *Versailles au 18ᵉ siècle*. Paris, 1918.

Racinais, H. *La Vie inconnue des petites appartements de Versailles*. Versailles, 1951.

Verlet, P. *Versailles*. Paris, 1961.

E. PERIODICALS

L'Architecture

Art de France

Bulletin Archéologique

Bulletin Monumental

Bulletin du Musée Carnavalet

Bulletin de la Société de l'Histoire de l'Art Français

Congrès Archéologique

Connaissance des Arts

Gazette des Beaux-Arts

Les Monuments Historiques de la France

Procès Verbaux du Comité du Vieux Paris

Revue de l'Art Ancien et Moderne

Revue des Arts

Revue de l'Histoire de Versailles

Revue des Sociétés de Beaux Arts des Départements

THE PLATES

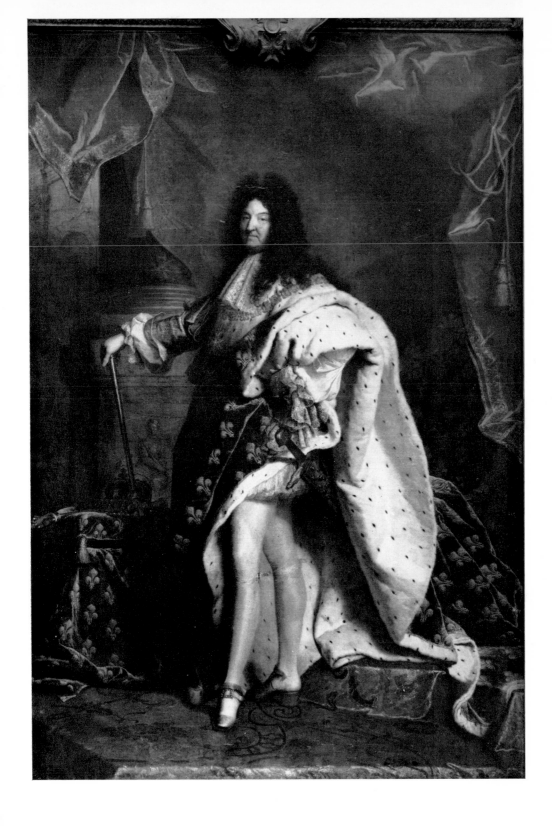

1. Rigaud: Louis XIV, 1701. *Paris, Louvre*

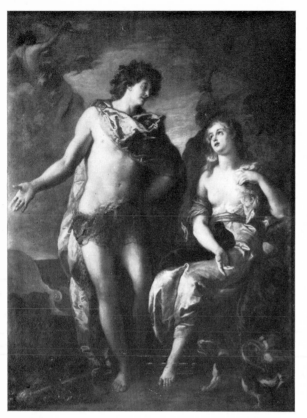

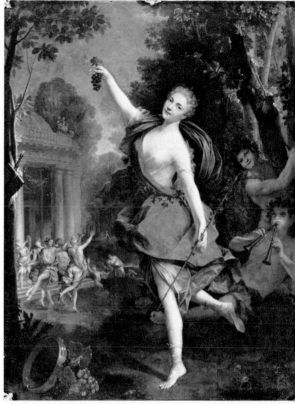

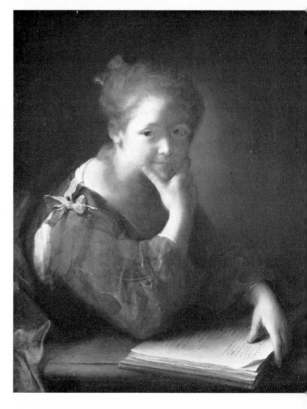

2. Charles de La Fosse: Bacchus and Ariadne, *c.* 1699. *Dijon, Musée*

3. Jean Raoux: Mademoiselle Prévost as a Bacchante, 1723. *Tours, Musée*

4. Alexis Grimou: Girl reading, 1731. *Karlsruhe, Kunsthalle*

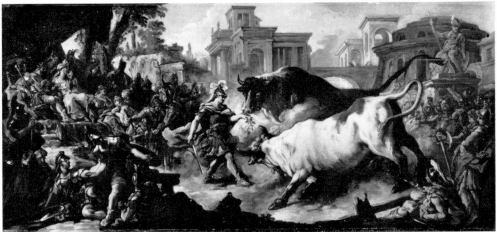

5. Jean-François Detroy: Reading from Molière. *Marchioness of Cholmondeley*

6. Jean-François Detroy: Jason taming the Bulls, 1748. *Birmingham, Barber Institute of Fine Arts*

7. Claude III Audran: Decorative drawing, *c.* 1704. *Stockholm, National Museum*

8. Claude Gillot: Quarrel of the Cabmen. *Paris, Louvre*

9. Watteau, engraved by C.-N. Cochin: 'Belles, n'écoutez rien'. *London, British Museum, Print Room*

10. Watteau, engraved by L. Cars: Escorte d'équipages. *London, British Museum, Print Room*

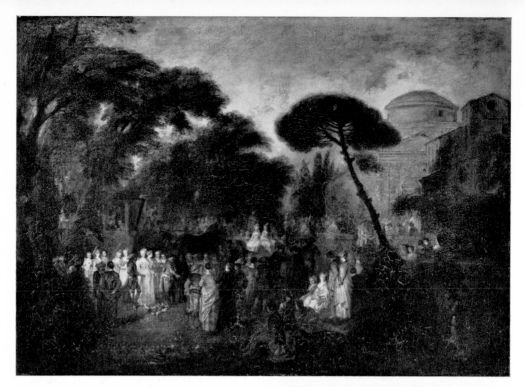

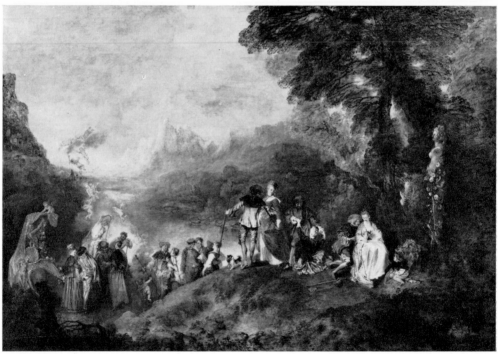

11. Watteau: La Mariée de Village. *Schloss Charlottenburg (Berlin)*

12. Watteau: Pèlerinage à Cythère ('Embarquement'), 1717. *Paris, Louvre*

13. Watteau: Pèlerinage à Cythère ('Embarquement') (detail), 1717. *Paris, Louvre*

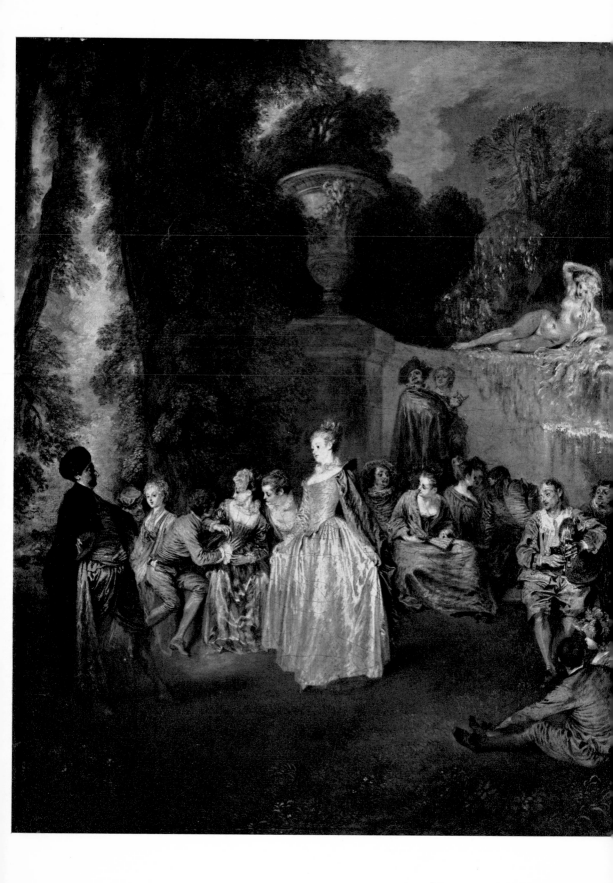

14. Watteau: Les Fêtes Vénitiennes. *Edinburgh, National Gallery of Scotland*

15. Watteau: Gilles. *Paris, Louvre*

16. Watteau: Enseigne de Gersaint, 1721 (?). *Schloss Charlottenburg (Berlin)*

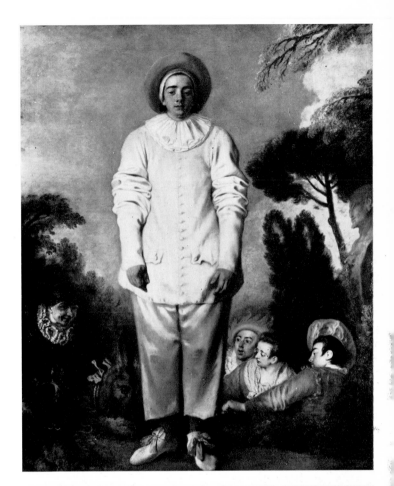

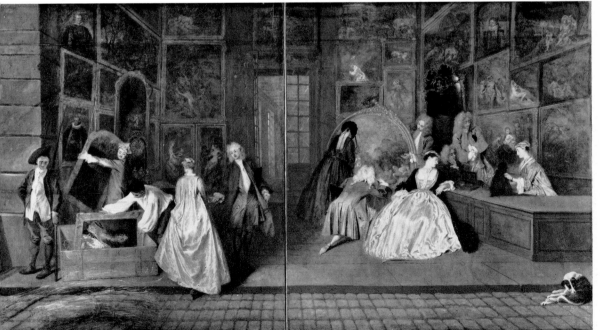

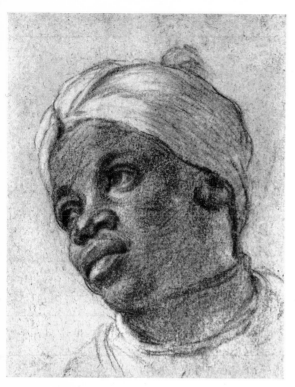

17. Watteau: Head of a Negro Boy. Drawing.
London, British Museum, Print Room

18. Watteau: Studies of Women's Heads. Drawing.
Paris, Louvre

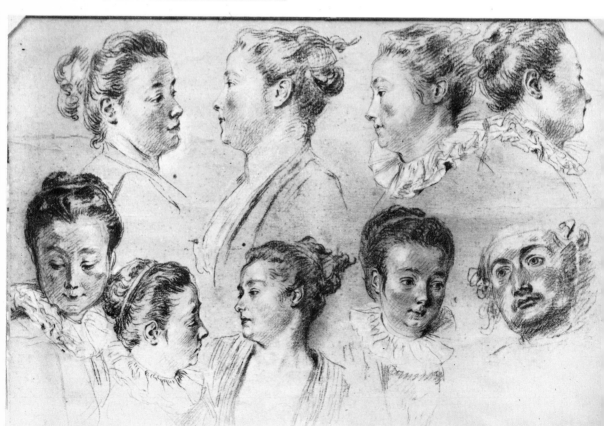

19. Nicolas Lancret: La Tasse de Chocolat, 1742. *Knightshayes Court, Sir John Heathcot-Amory*

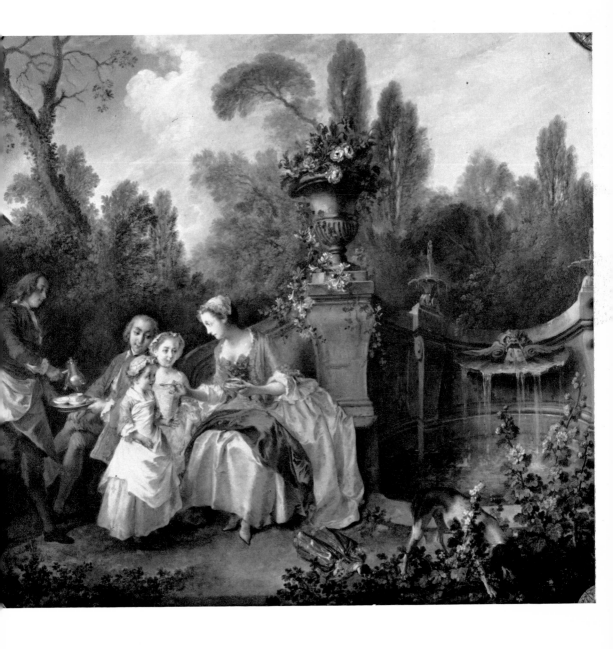

20. Jean–Baptiste Pater: Landscape with a Cart. *Schloss Charlottenburg (Berlin)*

21. Jean–Baptiste Oudry: The Dead Wolf, 1721. *London, Wallace Collection*

22. Jean–Baptiste Oudry: The White Duck, 1753. *Marchioness of Cholmondeley*

23. Charles Parrocel: Halte de Grenadiers, c. 1737. *Paris, Louvre*

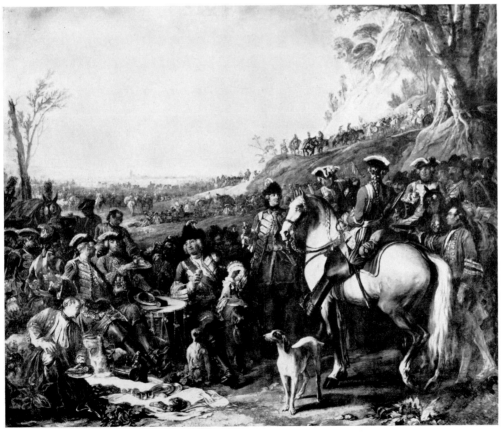

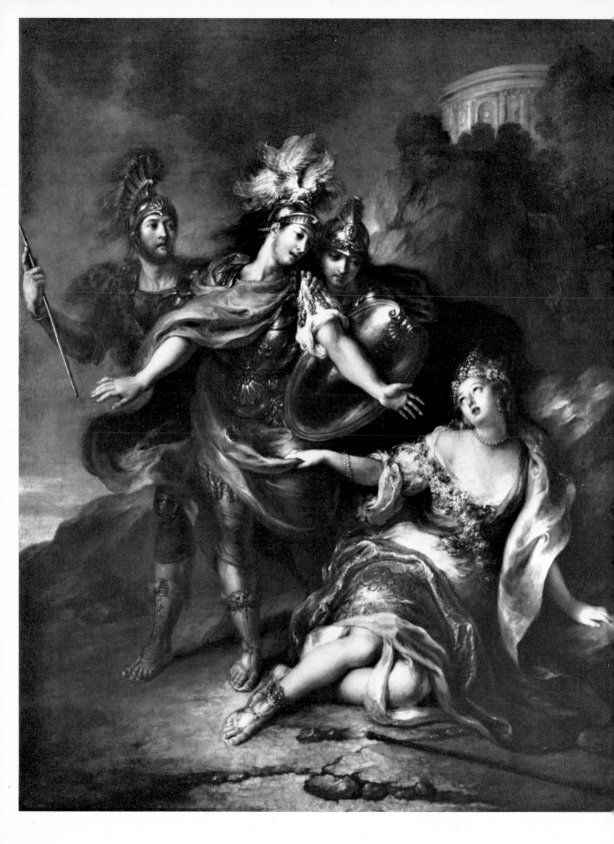

24. Charles Coypel: Rinaldo abandoning Armida, 1725. *Paris, Baron Élie de Rothschild*

25. Charles Coypel: Supper at Emmaus, 1746. *Paris, Saint-Merry*

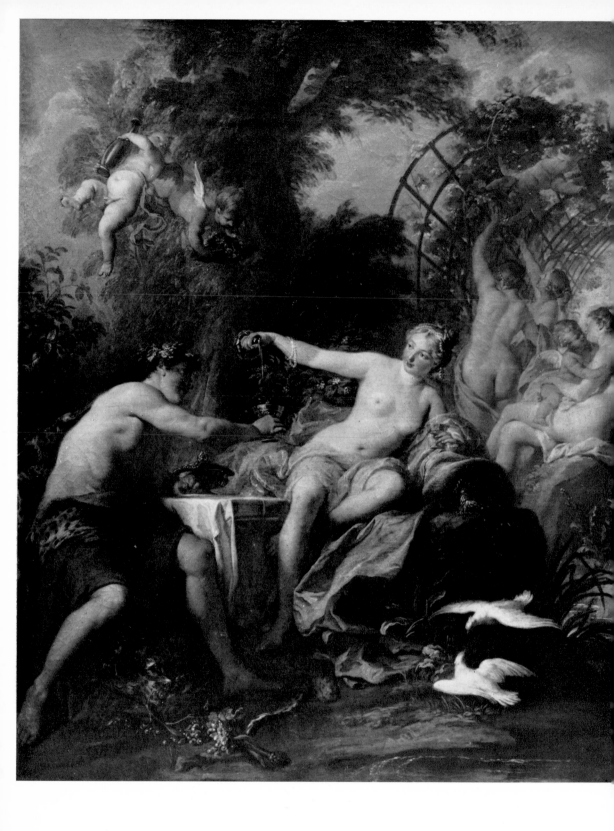

26. Noël-Nicolas Coypel: Alliance between Bacchus and Venus, 1726. *Geneva, Musée d'Art et d'Histoire*

27. Jean Restout: Death of St Scholastica, 1730. *Tours, Musée*

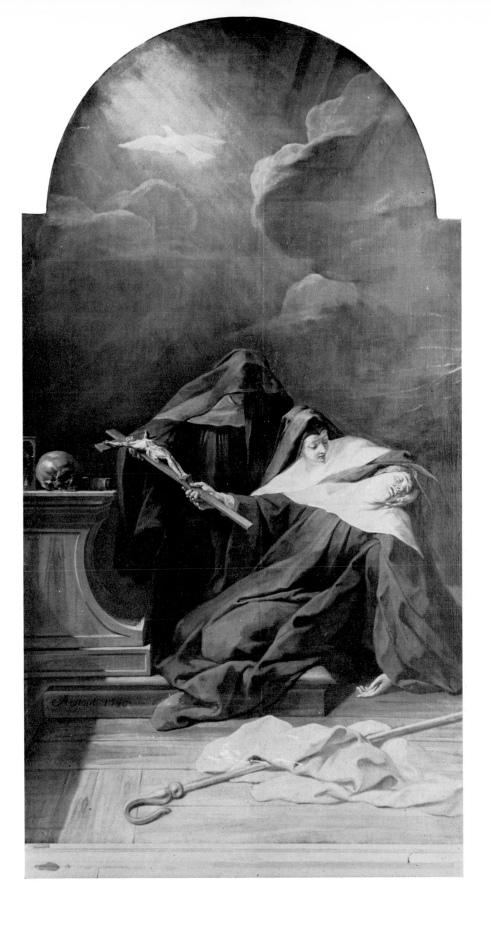

28. François Lemoyne: Baigneuse, 1724. *Leningrad, Hermitage*

29. François Lemoyne: Salon d'Hercule (detail), completed 1736. *Versailles*

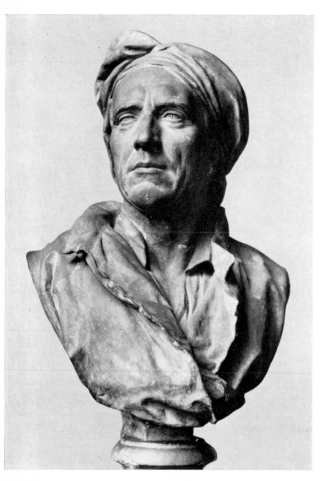

31. Guillaume I Coustou: Nicolas Coustou.
Paris, Louvre

32. Nicolas Coustou: Apollo, 1713-14.
Paris, Tuileries

33. Guillaume I Coustou: Daphne, 1713.
Paris, Tuileries

34. Nicolas Coustou: Pediment, 1716. *Rouen,
Custom House*

35. Nicolas Coustou: Seine and Marne, 1712.
Paris, Tuileries

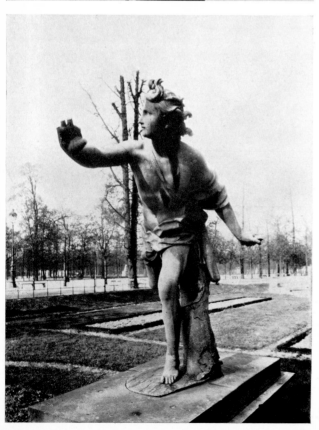

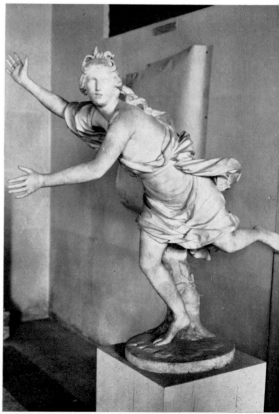

36. Guillaume I Coustou: Tomb of Cardinal Dubois, *c.* 1725. *Paris, Saint-Roch*

37. Guillaume I Coustou: Marie Leczinska as Juno, begun 1726. *Paris, Louvre*

38 and 39. Guillaume I Coustou:
The Marly Horses, set up in 1745.
Paris, Place de la Concorde

40. Corneille van Clève:
Polyphemus, 1681.
Paris, Louvre

41. Claude-Augustin Cayot:
Cupid and Psyche, 1706.
London, Wallace Collection

42. Claude-Augustin Cayot:
Death of Dido, 1711.
Paris, Louvre

43. Robert Le Lorrain:
Horses of the Sun.
Paris, Hôtel de Rohan

44. Robert Le Lorrain: Galatea, 1701. *Washington, National Gallery*

45. Jean-Louis Lemoyne: A Huntress (or Nymph) of Diana, 1724. *Washington, National Gallery*

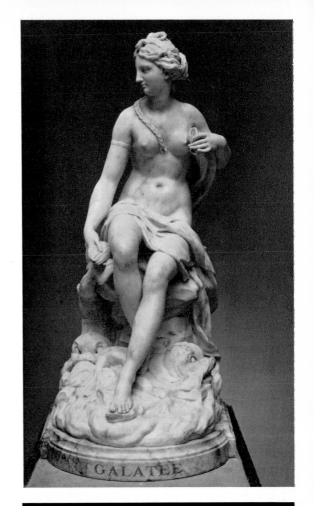

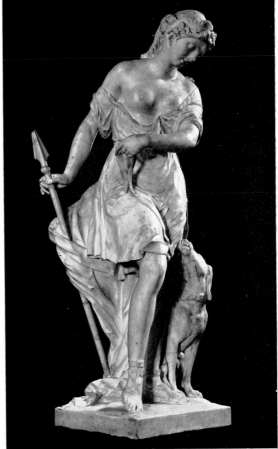

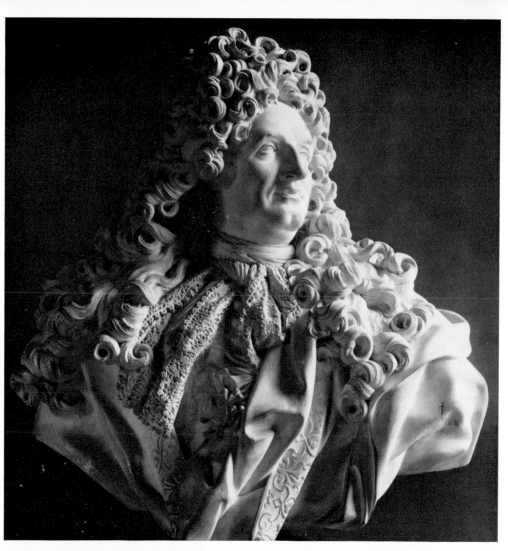

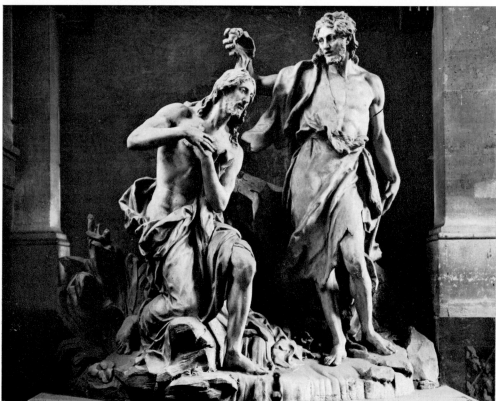

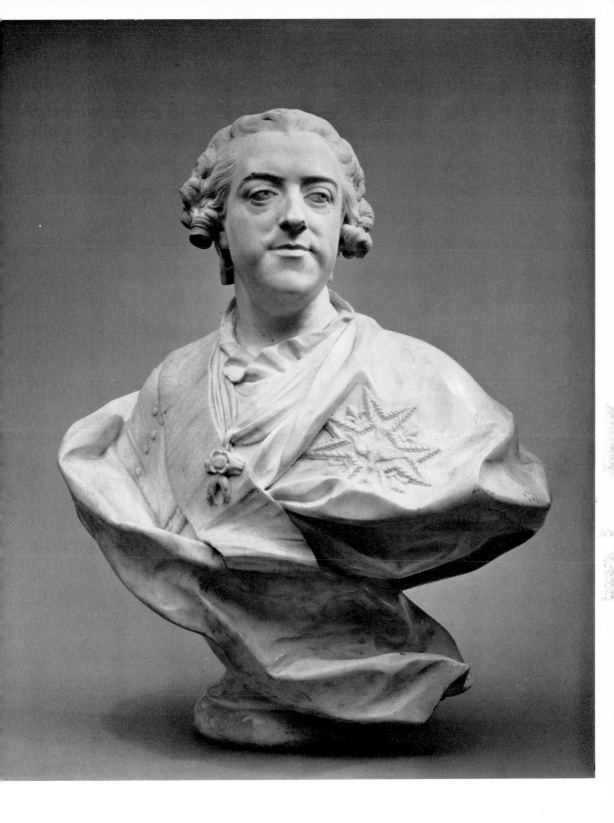

46. Jean-Louis Lemoyne: Jules Hardouin Mansart, 1703. *Paris, Louvre*

47. Jean-Baptiste Lemoyne: Baptism of Christ, 1731. *Paris, Saint-Roch*

48. Jean-Baptiste Lemoyne: Louis XV, 1757. *New York, Metropolitan Museum of Art*

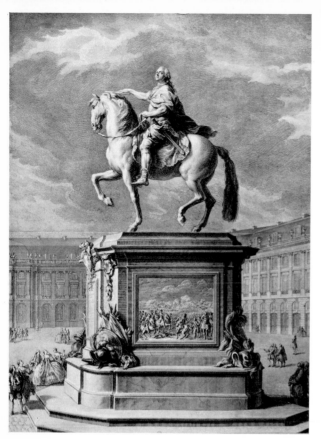

49. Jean-Baptiste Lemoyne, engraved by
N. Dupuis: Louis XV, set up at Bordeaux
in 1743. *Paris, Bibliothèque Nationale*

50. Jean-Baptiste Lemoyne: Monument to
Mignard, 1735-43. *Paris, Saint-Roch*

51. Jean-Baptiste Lemoyne, engraved by
N.-B. Lépicié: Monument to Mignard,
1735-43. *Paris, Bibliothèque Nationale*

52. Jean-Baptiste Lemoyne:
Arnaud de la Briffe, 1754.
*Paris, Musée des Arts
Décoratifs*

53. Jean-Baptiste Lemoyne:
Maupeou, 1768.
*Paris, Musée Jacquemart-
André*

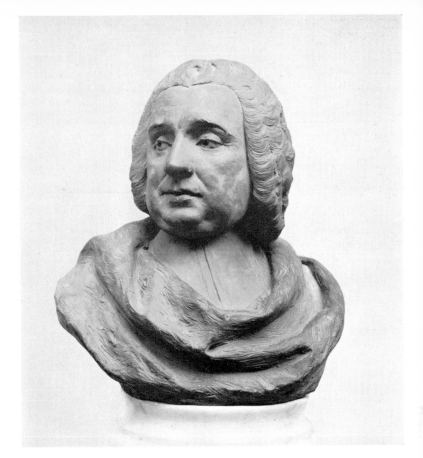

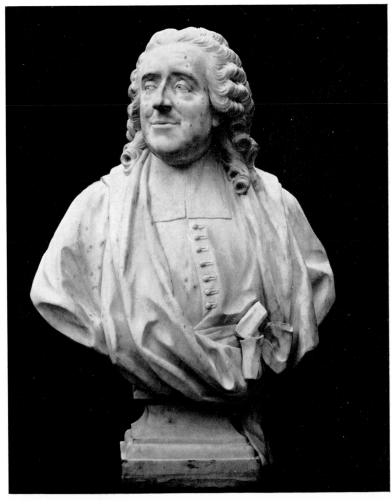

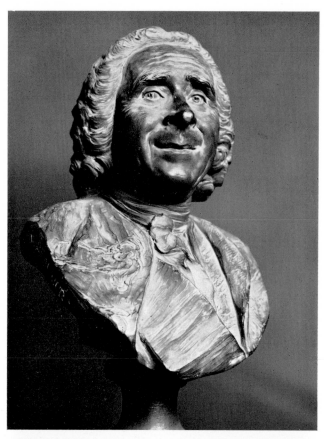

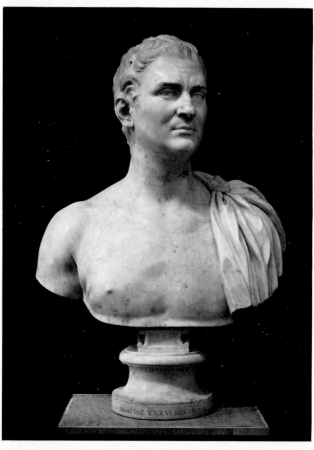

54. Jean–Baptiste Lemoyne:
Réaumur, 1751. *Paris, Louvre*

55. Bouchardon: Philipp Stosch,
completed 1727. *Berlin-
Dahlem, Staatliche Museen*

56. Bouchardon: Amour se faisant u[
arc de la massue d'Hercule, *c.* 1750.
Paris, Louvre

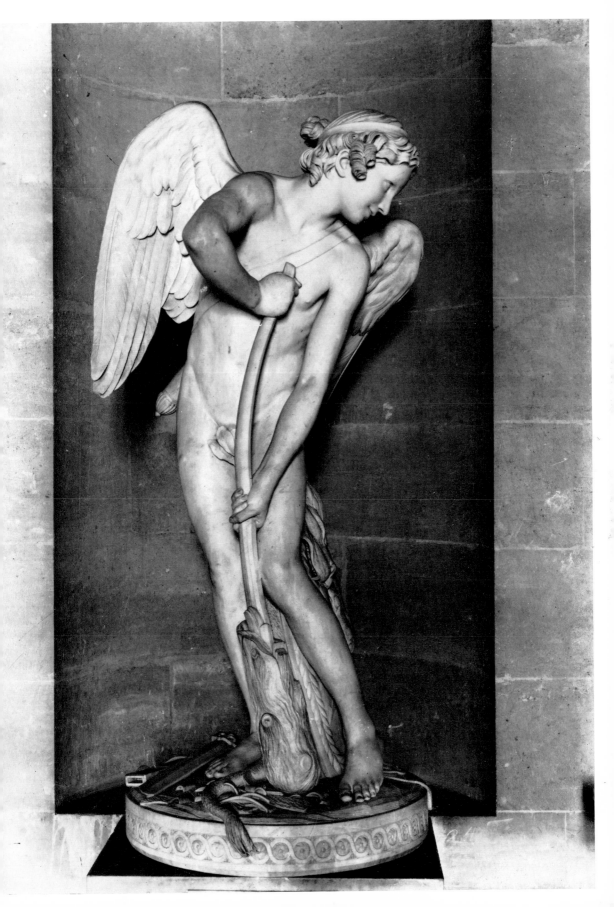

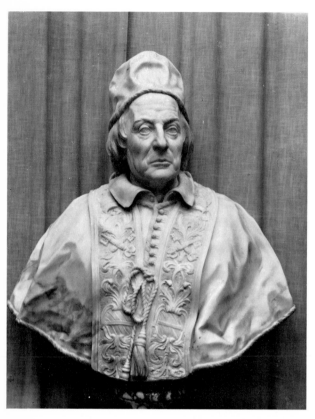

57. Bouchardon: Pope Clement XII, 1730.
Florence, Prince Tommaso Corsini

58. Bouchardon: Drawing for a fountain.
Paris, Louvre, Cabinet des Dessins

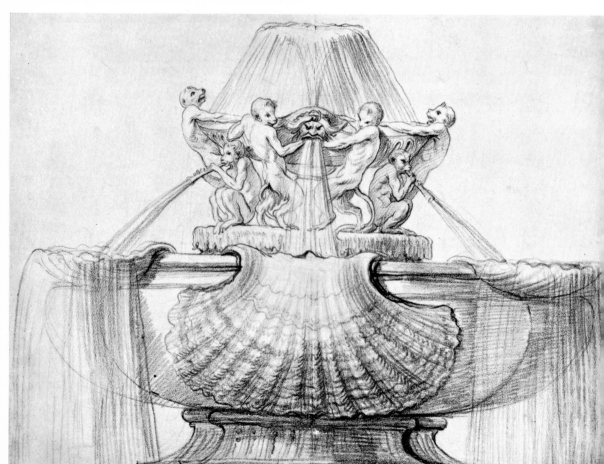

59. Bouchardon: Fountain of the
Rue de Grenelle, commissioned
1739. *Paris*

60. Bouchardon: Fountain of the
Rue de Grenelle (detail),
commissioned 1739. *Paris*

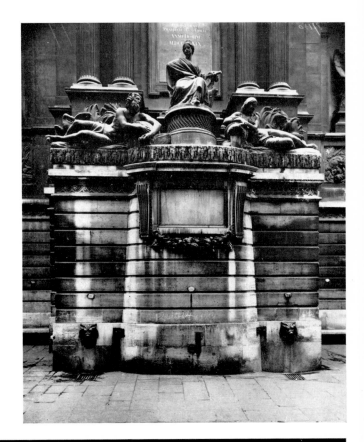

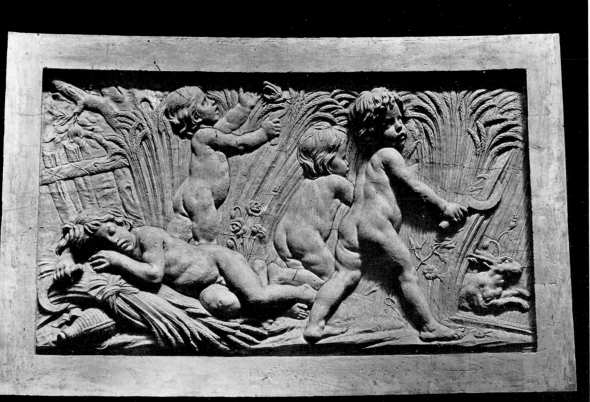

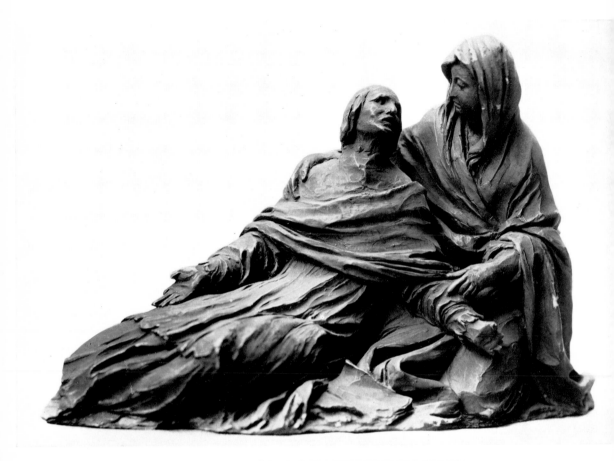

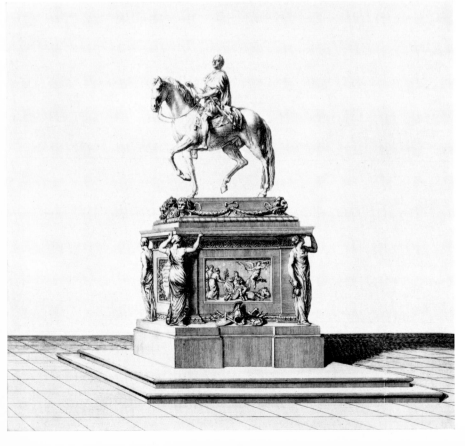

61. Bouchardon:
Cardinal Fleury
dying in the Arms
of Religion, 1745.
Paris, Louvre

62. Bouchardon,
engraving after:
Louis XV,
commissioned
1749.
*Paris, Bibliothèque
Nationale*

63. Lambert-Sigisbert Adam:
Neptune calming the Waves,
completed 1737. *Paris, Louvre*

64. Lambert-Sigisbert Adam:
Head of 'Water', 1737.
Leningrad, Hermitage

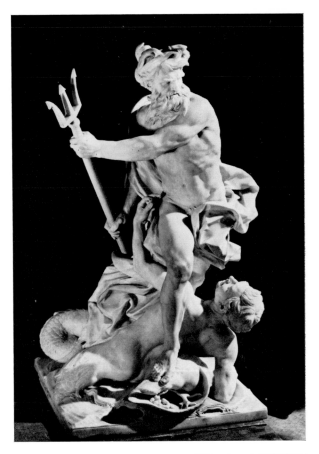

65. Lambert-Sigisbert Adam: Neptune and Amphitrite, completed 1740.
Versailles, Bassin de Neptune

66. Lambert-Sigisbert Adam: Self-Portrait, *c.* 1740. Drawing.
Oxford, Ashmolean Museum

67. Nicolas-Sébastien Adam: Monument to Queen Catharina Opalinska, set up in 1749.
Nancy, Notre-Dame de Bon Secours

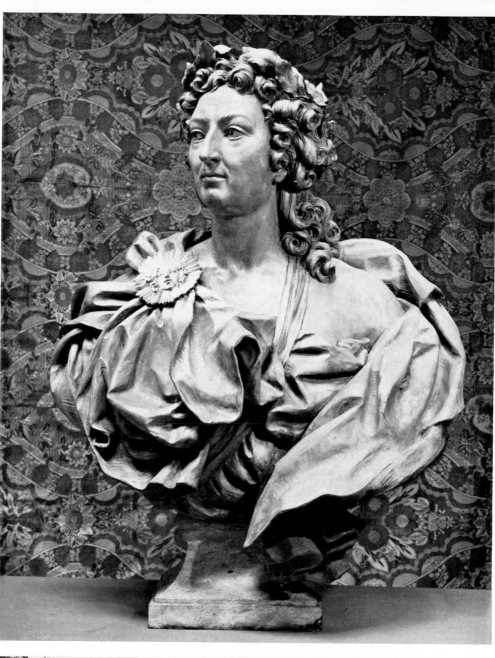

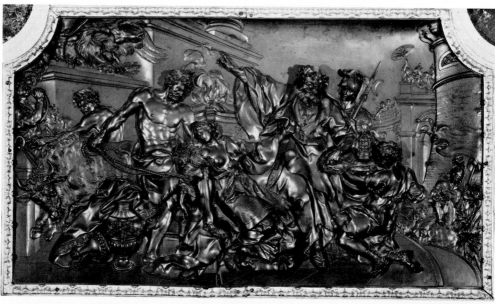

68. Lambert–Sigisbert Adam:
Louis XV as Apollo, probably
not after 1741. *London, Victoria
and Albert Museum*

69. Nicolas-Sébastien Adam:
Martyrdom of Sainte Victoire,
placed *in situ* in 1747.
Versailles, chapel

70. Les Slodtz, engraved by
C.-N. Cochin: *Pompe
funèbre* for the dauphine,
Marie-Thérèse of Spain,
1746. *Paris, Bibliothèque
Nationale*

71. Paul-Ambroise Slodtz:
Dead Icarus, 1743.
Paris, Louvre

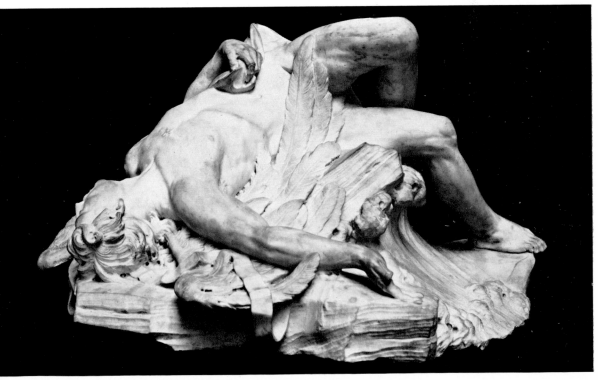

72. Michel–Ange Slodtz: St Bruno, 1744. *Rome, St Peter's*

73. Michel–Ange Slodtz: Capponi Monument, early 1740s. *Rome, San Giovanni dei Fiorentini*

74. Michel–Ange Slodtz: Archbishop Montmorin, detail of the Montmorin Monument, 1740–4. *Vienne Cathedral*

75. Michel–Ange Slodtz: Monument to Archbishop Montmorin, 1740–4. *Vienne Cathedral*

76. Michel-Ange Slodtz: Languet de Gergy Monument, completed 1753. *Paris, Saint-Sulpice*

77. Christophe-Gabriel Allegrain: Venus at the Bath, 1756-*c*. 1767. *Paris, Louvre*

78. Guillaume II Coustou: Vulcan, 1741. *Paris, Louvre*

79. Guillaume II Coustou: Monument to the Dauphin, designed before 1767. *Sens Cathedral*

80. Guillaume II Coustou: Conjugal
Love and Time, detail of the Monument
to the Dauphin

81. Nineteenth-century painting of the
Monument to the Dauphin in its
original position

82. Louis-Claude Vassé: Sleeping
Shepherd, 1751. *Paris, Louvre*

83. Jacques Saly: Faun holding a Goat, 1751.
Paris, Musée Cognac-Jay

84. Jacques Saly: Hebe, 1753.
Leningrad, Hermitage

85. Jacques Saly: Head of a Child.
Copenhagen, Ny Carlsberg Glyptothek

86. Marie-Anne Collot: Falconet,
c. 1768. *Nancy, Musée*

87. Falconet: Milo of Crotona,
completed 1754. *Paris, Louvre*

88. Falconet: Baigneuse, 1757. *Paris, Louvre*

89. Falconet: Amour menaçant, 1757. *Paris, Louvre*

90. Falconet: Monument to Peter the Great, unveiled 1782. *Leningrad*

PETRO primo
CATHARINA secunda
MDCCLXXXII

91. Pigalle: Mercury (terracotta), 1742.
New York, Metropolitan Museum of Art

92. Pigalle: Mercury (marble), 1744.
Paris, Louvre

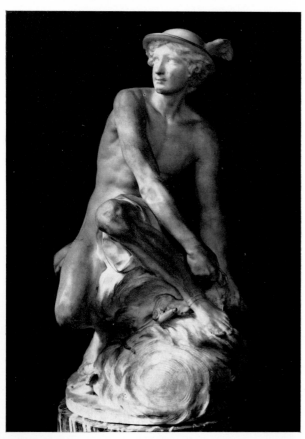

93. Pigalle: Self-Portrait, 1780.
Paris, Louvre

94. Pigalle: Enfant à la Cage, 1750.
Paris, Louvre

95. Pigalle: Thomas-Aignan Desfriches. *Orléans, Musée*

96. Pigalle: Citizen, detail of the Monument to Louis XV, completed 1765. *Reims, Place Royale*

97. Pigalle: Monument to Maréchal de Saxe, designed 1753. *Strasbourg, Saint-Thomas*

98. Pigalle: Detail of the monument to Maréchal de Saxe, designed 1753. *Strasbourg, Saint-Thomas*

99. Pigalle: Death, detail of the Monument to Maréchal de Saxe, designed 1753. *Strasbourg, Saint-Thomas*

100. Jean-Jacques Caffiéri: Jean de Rotrou, 1783. *Paris, Comédie Française*

101. Jean-Jacques Caffiéri: Bust of Madame du Barry. *Lenigrad, Hermitage*

102. Felix Lecomte: Marie-Antoinette, 1783.
Versailles

103. Jean-Baptiste Defernex: Madame Favart,
1762. *Paris, Louvre*

104. Claude-François Attiret: La Chercheuse
d'Esprit, 1774. *Dijon, Musée*

105. Pajou: Princess of Hesse-Homburg as Minerva, 1761. *Leningrad, Hermitage*

106. Pajou: Hubert Robert, 1789. *Paris, École des Beaux-Arts*

107. Pajou: Psyche abandoned, completed by 1791. *Paris, Louvre*

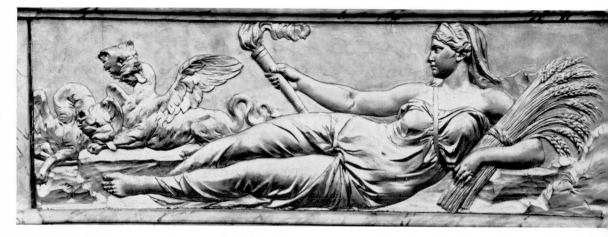

108 and 109. Pajou: Bas reliefs, 1768–70. *Versailles, opera house*

110. Boucher, engraved by L. Cars: Le Malade imaginaire, from the *Œuvres de Molière* (1734). *Paris, Bibliothèque Nationale*

111. Boucher: Madame de Pompadour, 1758. *London, Victoria and Albert Museum*

112. Boucher: Madame Boucher, 1743. *New York, Frick Collection*

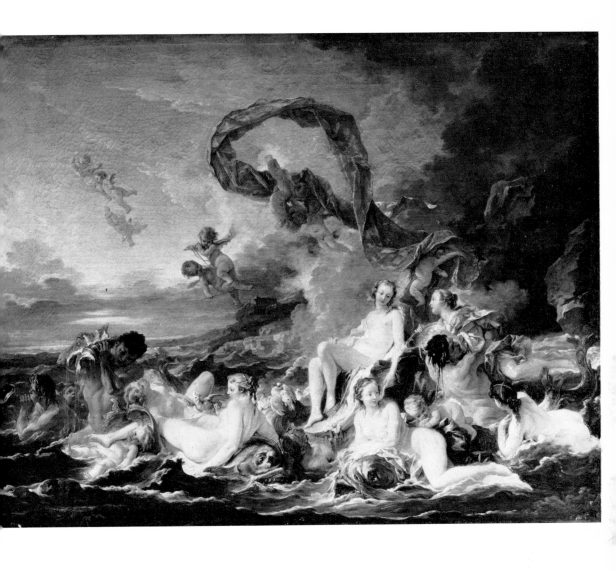

113. Boucher: Triumph of Venus, 1740. *Stockholm, National Museum*

114. Boucher: Rising of the Sun, 1753. *London, Wallace Collection*

115. Boucher: Setting of the Sun, 1753. *London, Wallace Collection*

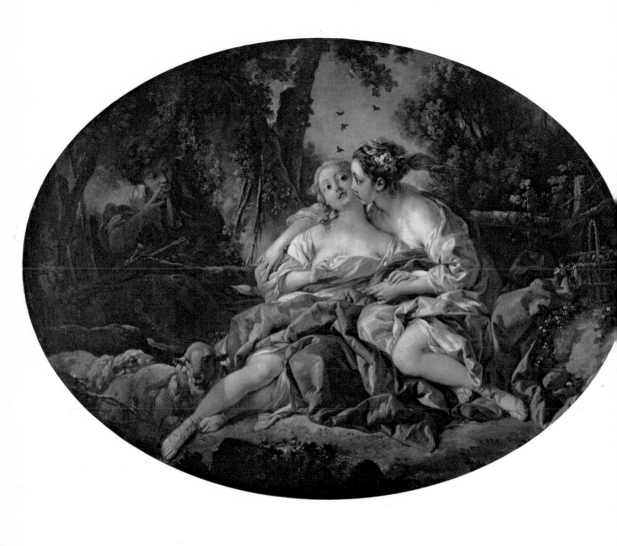

116. Boucher: Sylvie guérit Philis d'une piqûre d'abeille, 1755. *Paris, Banque de France*

117. Boucher: Evening Landscape, 1743. *Barnard Castle, Bowes Museum*

118. Louis-Michel van Loo: Marquis et Marquise de Marigny, 1769. *Scotland, private collection*

119. Carle van Loo: Venus at her Toilet, 1737. *Paris, Hôtel de Soubise, Salle d'Assemblée*

120. Carle van Loo: Grand Turk giving a Concert, 1737. *London, Wallace Collection*

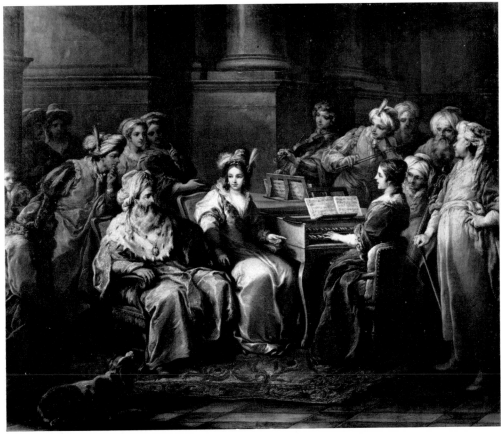

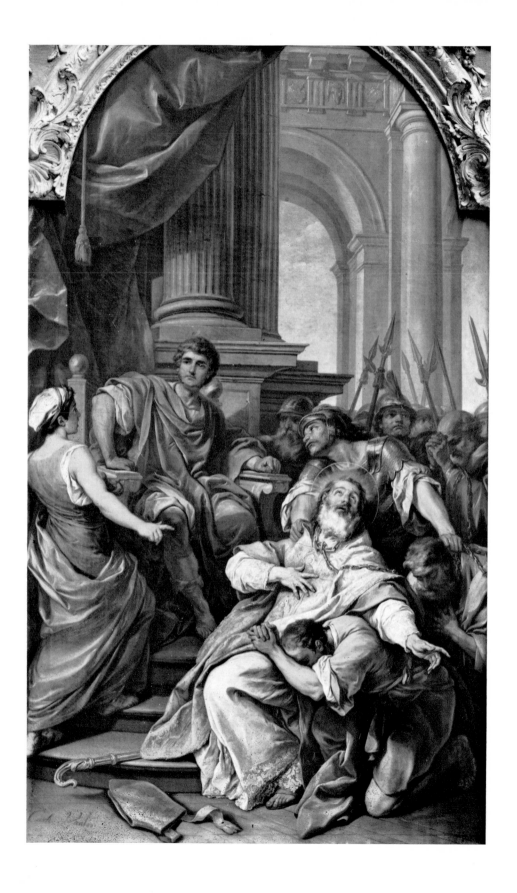

121. Carle van Loo: Condemnation of St Denis. *Dijon, Musée*

122. Charles-Joseph Natoire: Cupid and Psyche, 1737-8. *Paris, Hôtel de Soubise*

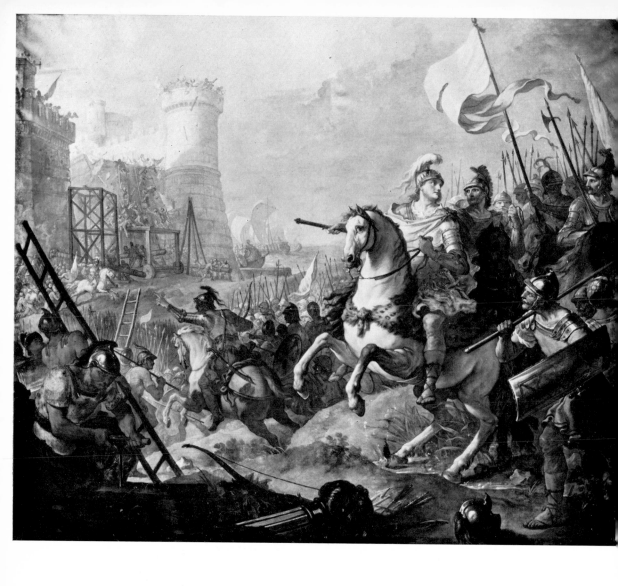

123. Charles-Joseph Natoire: Siege of Avignon, *c. 1736. Troyes, Musée*

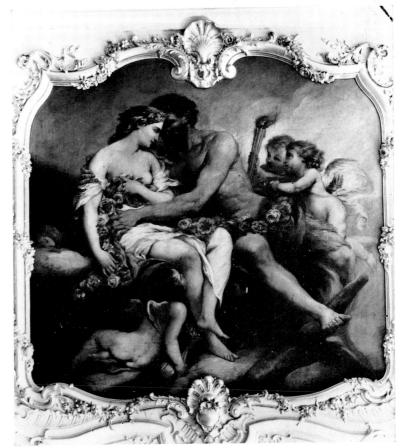

124. Charles-Joseph Natoire:
View of San Gregorio,
Rome, 1765. *Edinburgh,
National Gallery of Scotland*

125. Pierre-Charles Trémolières:
L'Hymen d'Hercule et
d'Hébé, 1737. *Paris, Hôtel de
Soubise, Chambre du Prince*

126. Pierre Subleyras: The Painter's Studio, after 1740. *Vienna, Akademie*

127. Joseph-Marie Vien: Sleeping Hermit, 1750. *Paris, Louvre*

128. Joseph-Marie Vien: St Denis preaching, 1767. *Paris, Saint-Roch*

129. Joseph-Marie Vien: Greek Girl at the Bath, 1767. *Ponce, Museum*

130. Jean-Marc Nattier: Queen Marie Leczinska, 1748. *Versailles*

131. Jean-Marc Nattier: Madame Adélaïde, 1758. *Paris, Louvre*

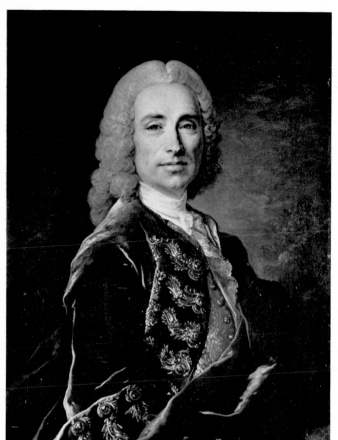
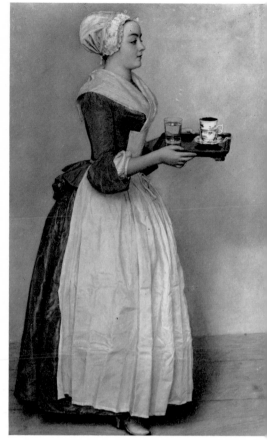

132. Louis Tocqué: Marquis de Lücker, 1743. *Orléans, Musée*

133. Jean-Étienne Liotard: Maid carrying Chocolate, before 1745. *Dresden, Gemäldegalerie*

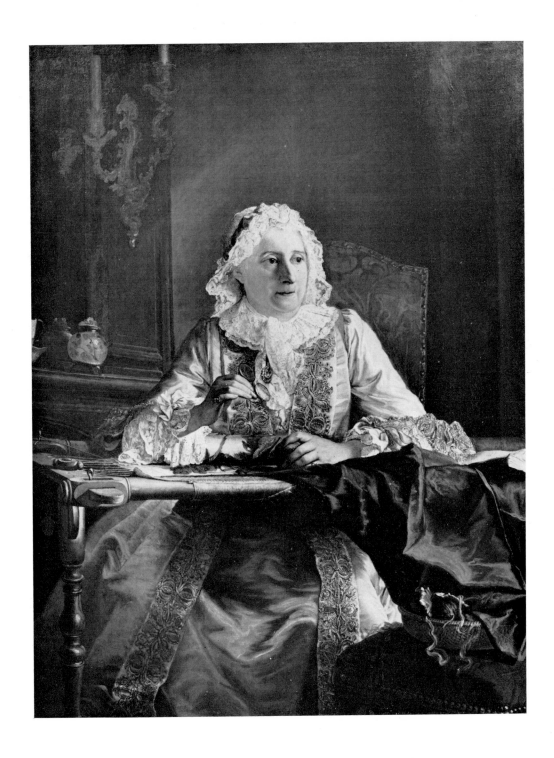

134. J.-A.-J.-C. Aved: Madame Crozat, 1741. *Montpellier, Musée*

135. Maurice-Quentin de Latour: Mademoiselle Fel (préparation). *Saint-Quentin, Musée*

136. Maurice-Quentin de Latour: The Abbé Huber reading. *Geneva, Musée d'Art et d'Histoire*

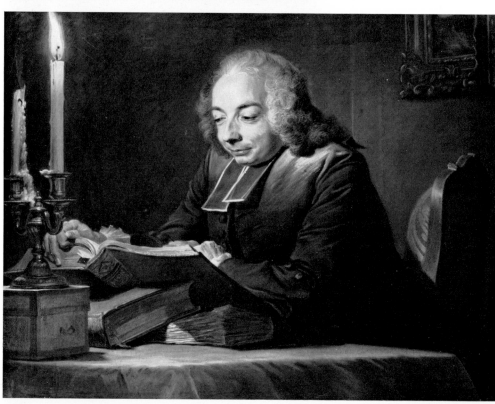

137. Jean-Baptiste
Perronneau: Portrait of
a Man, 1766.
*Dublin, National
Gallery of Ireland*

138. François Hubert Drouais:
Madame de Pompadour,
begun 1763. *Mentmore,
Earl of Rosebery*

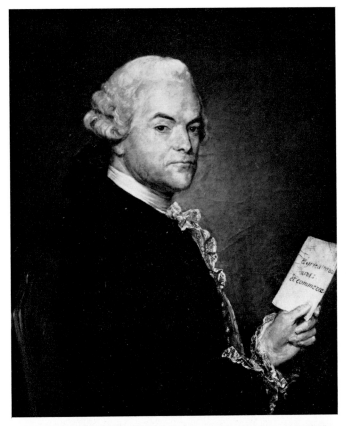

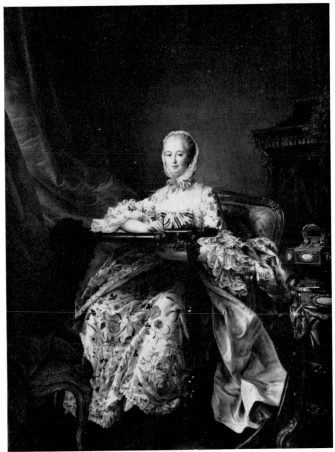

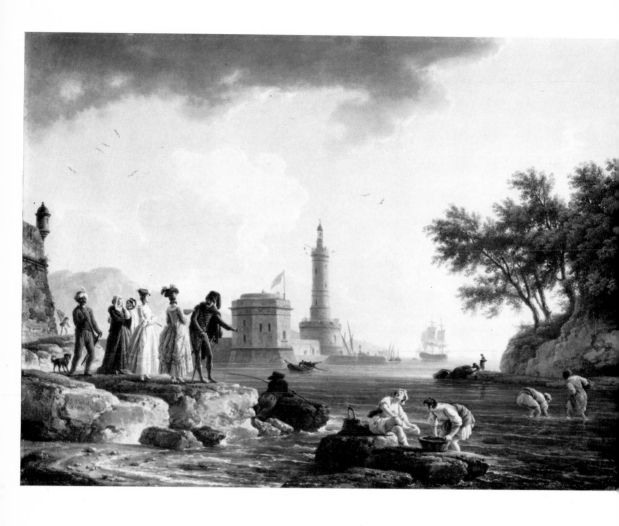

139. Claude-Joseph Vernet: A Sea Shore, mid 1770s. *London, National Gallery*

140. Jean-Baptiste Lallemand: View of the Château de Montmusard, *c.* 1770. *Dijon, Musée*

141. Jean-Baptiste Pillement: Shipping in the Tagus, 1783. *London, Louis Speelman*

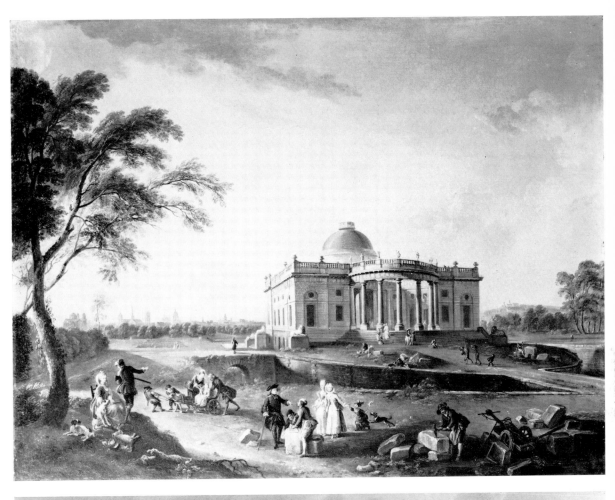

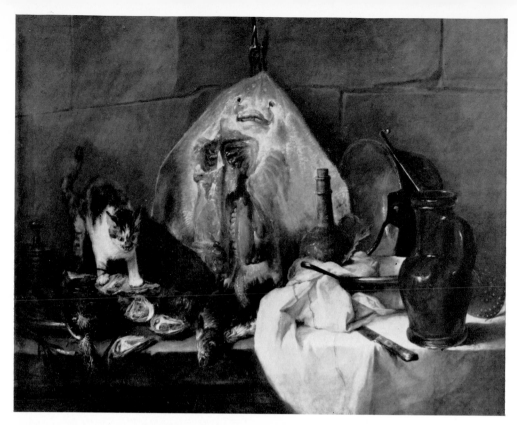

142. Chardin: La Raie,
1728.
Paris, Louvre

143. Chardin:
Copper Cistern,
c. 1733 (?).
Paris, Louvre

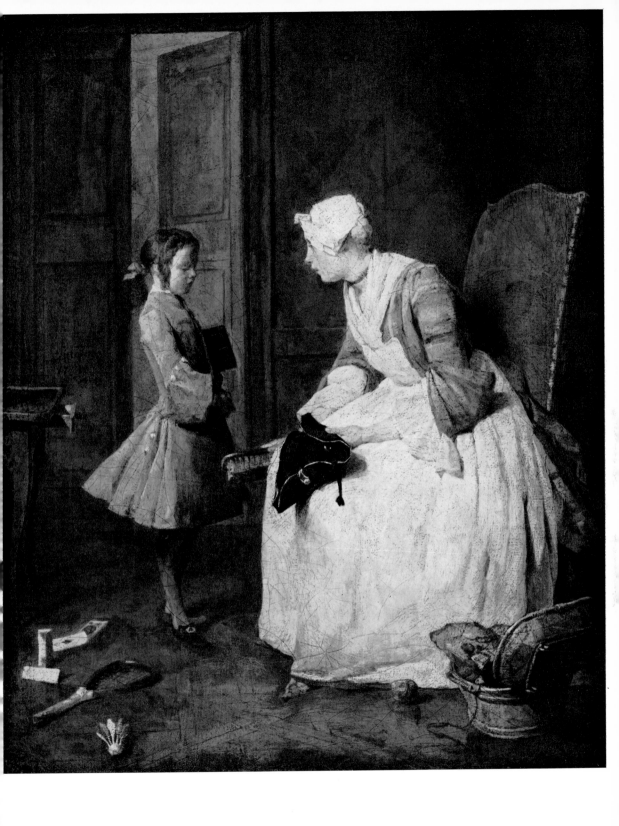

144. Chardin: La Gouvernante, 1738. *Ottawa, National Gallery of Canada*

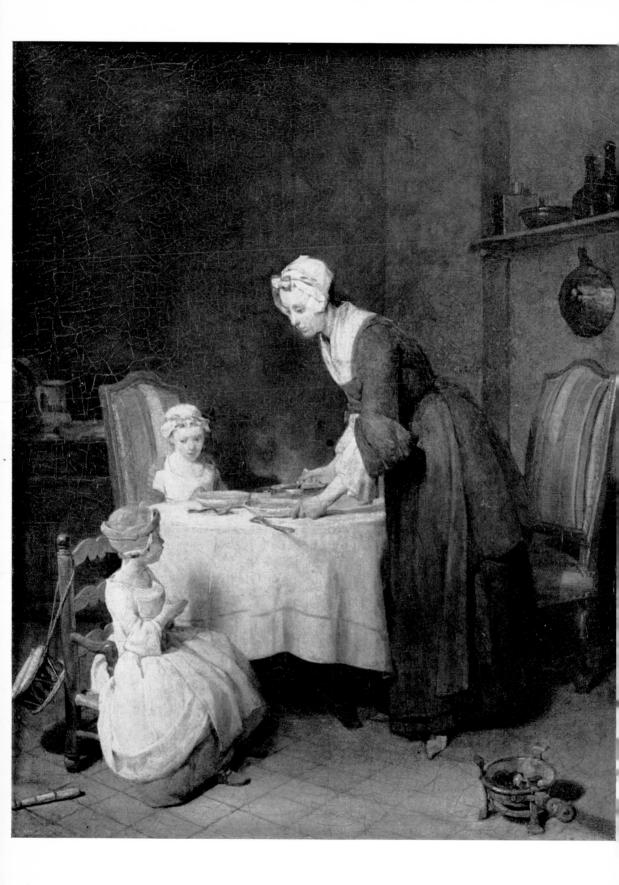

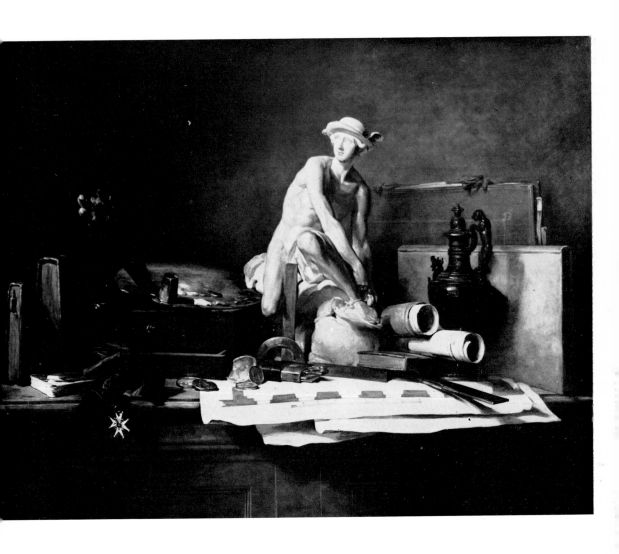

145. Chardin: Le Bénédicité, *c.* 1740. *Paris, Louvre*

146. Chardin: Attributes of the Arts, 1766. *Minneapolis, Institute of Arts*

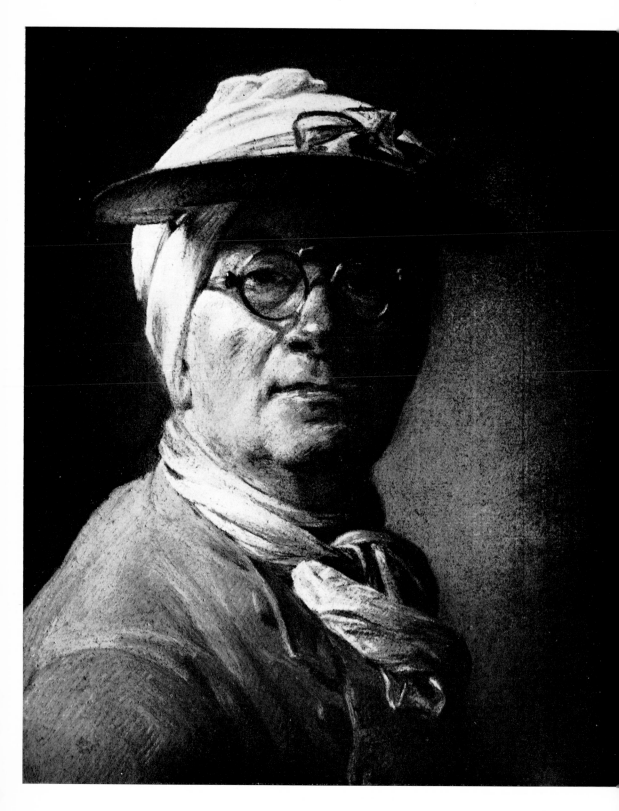

147. Chardin: Self–Portrait, 1775. Pastel. *Paris, Louvre*

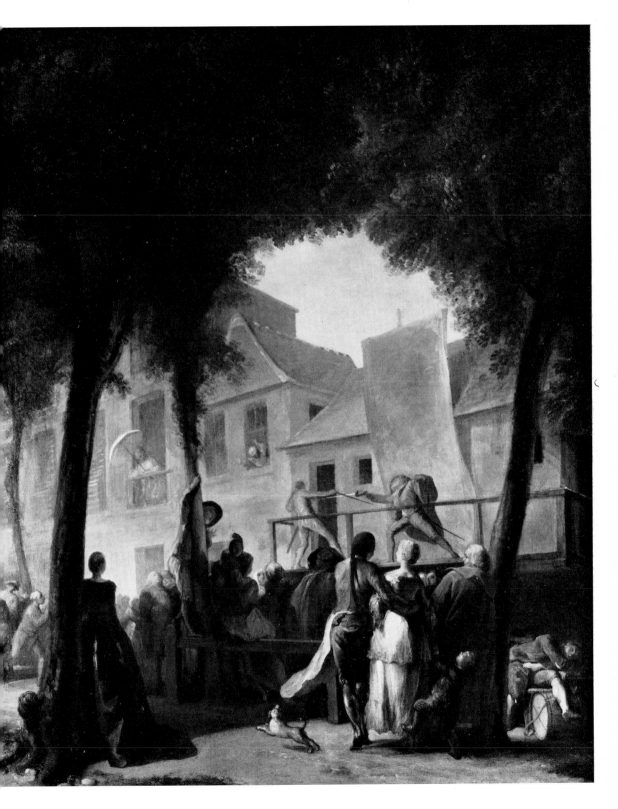

148. Gabriel de Saint-Aubin: La Parade du Boulevard, 1760 (?). *London, National Gallery*

149. Henri-Horace Roland de la Porte: Little Orange Tree, no later than 1763. *Karlsruhe, Kunsthalle*

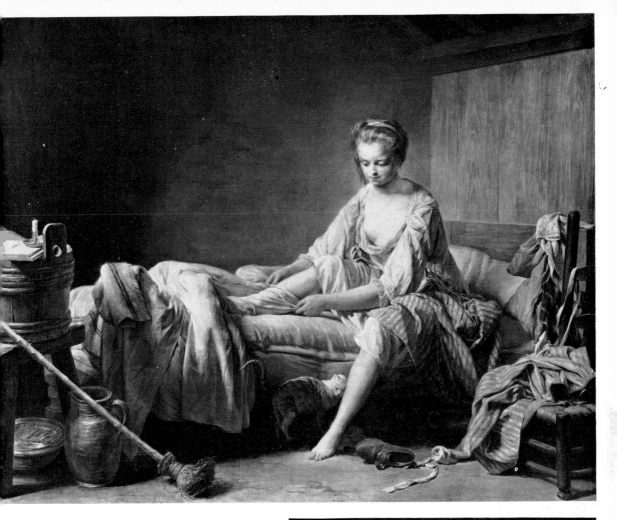

150. Nicolas-Bernard Lépicié: Le Lever de
Fanchon, 1773. *Saint-Omer, Musée-Hôtel-
Sandelin*

151. Greuze: J.-G. Wille, 1763.
Paris, Musée Jacquemart-André

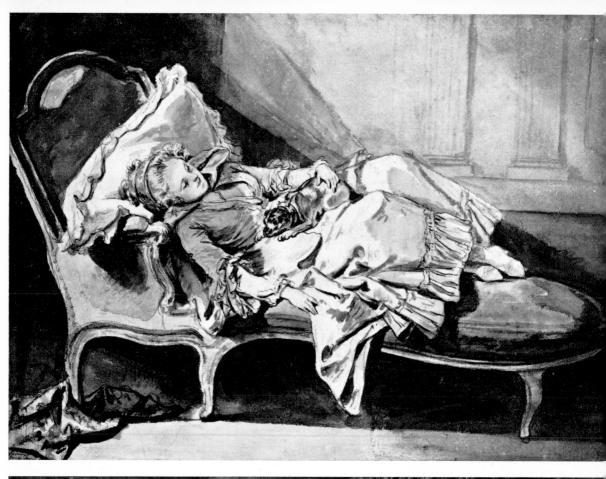

152. Greuze: Madame Greuze. Drawing. *Amsterdam, Rijksmuseum*

153. Greuze: L'Accordée de Village, 1761. *Paris, Louvre*

154. Greuze: Septime Sévère, 1769. *Paris, Louvre*

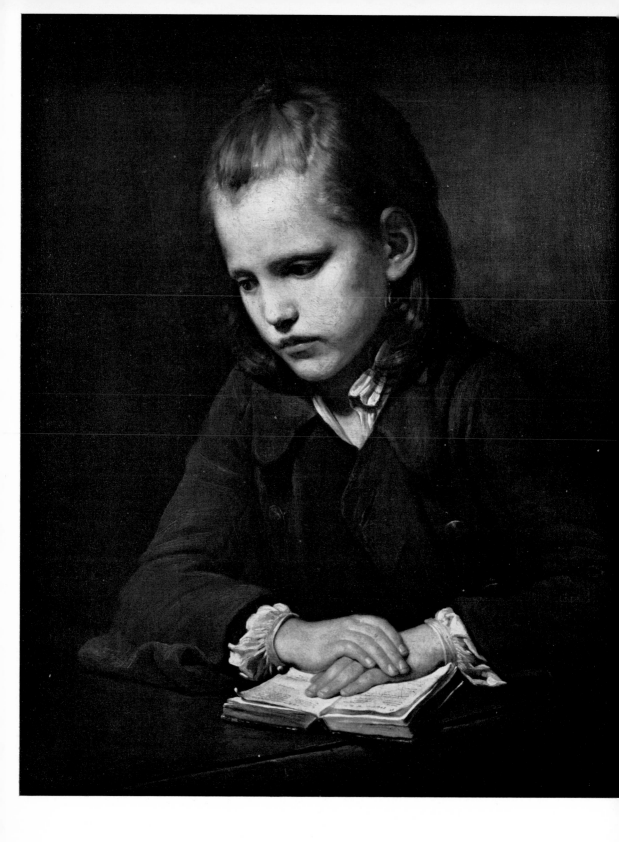

155. Greuze: Écolier qui étudie sa leçon, 1757. *Edinburgh, National Gallery of Scotland*

156. François-Gabriel Doyen: Le Miracle des Ardents, 1767. *Paris, Saint-Roch*

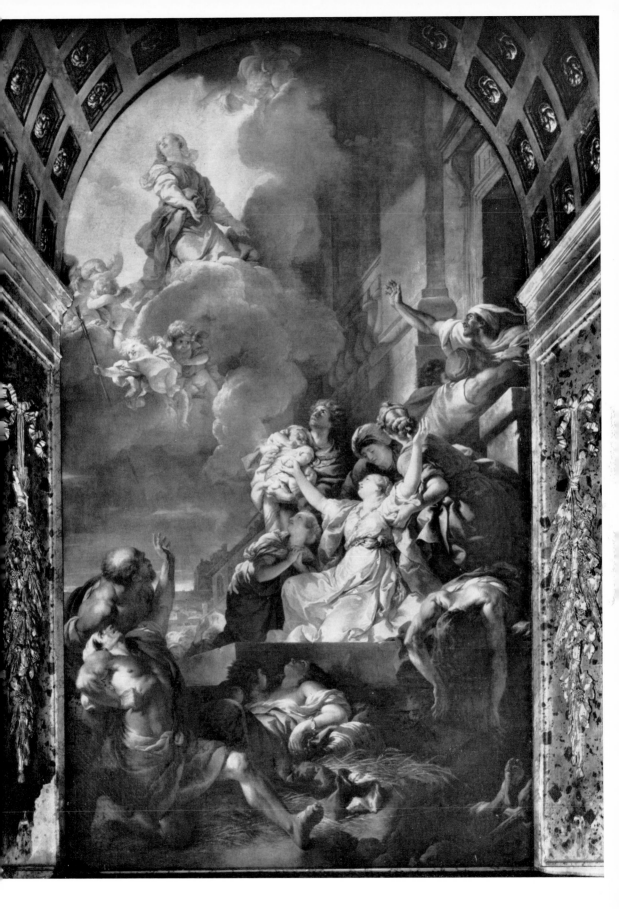

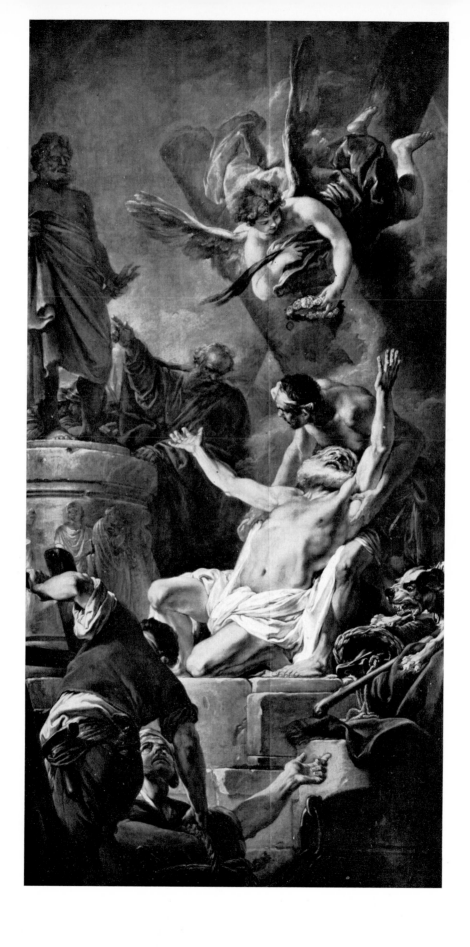

157. Jean–Baptiste Deshays: Martyrdom of St Andrew, 1759. *Rouen, Musée*

158. Nicolas-Guy Brenet: Homage rendered to Du Guesclin, 1777. *Versailles*

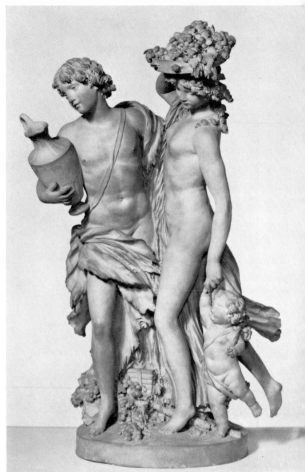

159. Clodion: Nymph, Satyr, and Baby Satyr. *Waddesdon Manor, National Trust*

160. Clodion: Pair of Bacchic Figures with a Child. *Waddesdon Manor, National Trust*

161. Clodion: Montgolfier Balloon Project, 1784-5. *New York, Metropolitan Museum of Art*

162: Clodion: Montesquieu, 1783. *Versailles*

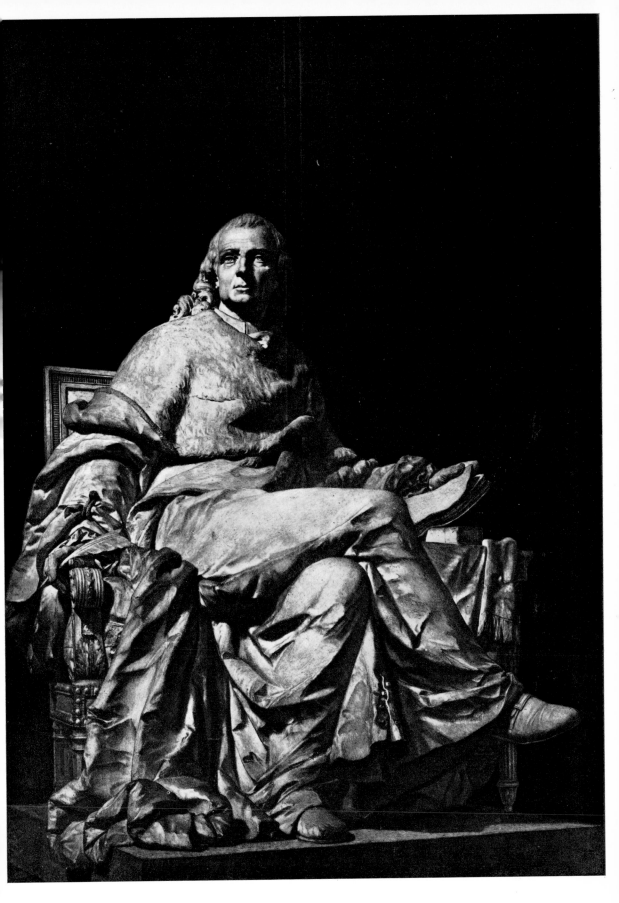

163. Clodion: Ram and Ewe, 1759. *Nancy, Musée Historique Lorrain*

164. Pierre Julien: La Fontaine, designed 1783. *Paris, Louvre*

165. Pierre Julien: Girl tending a Goat, 1786-7. *Paris, Louvre*

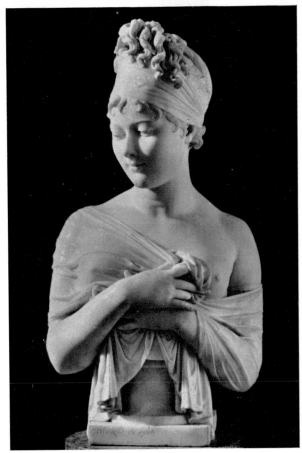

166. Simon-Louis Boizot: Cupid, 1772. *Paris, Louvre*

167. Denis-Antoine Chaudet: Cupid presenting a Rose to a Butterfly (model of 1802). *Paris, Louvre*

168. Joseph Chinard: Madame Récamier. *Lyon, Musée des Beaux-Arts*

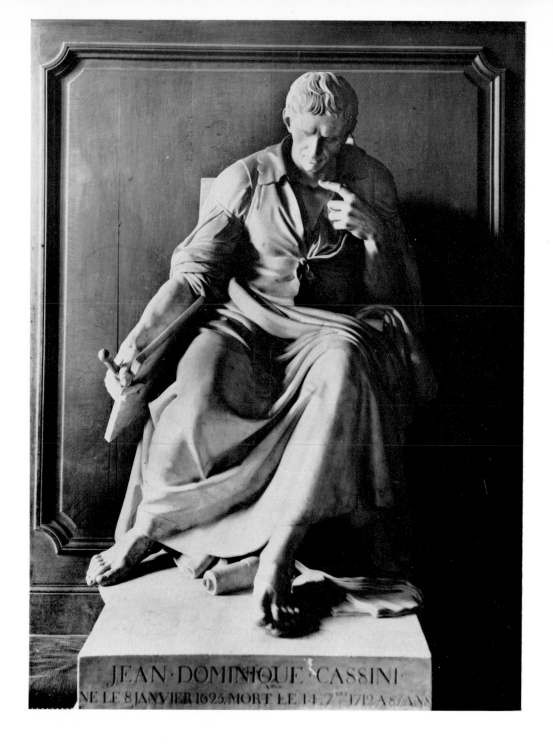

169. Jean-Guillaume Moitte: Cassini, ordered 1787. *Paris, Observatory*

170. Houdon: St Bruno, 1767. *Rome, Santa Maria degli Angeli*

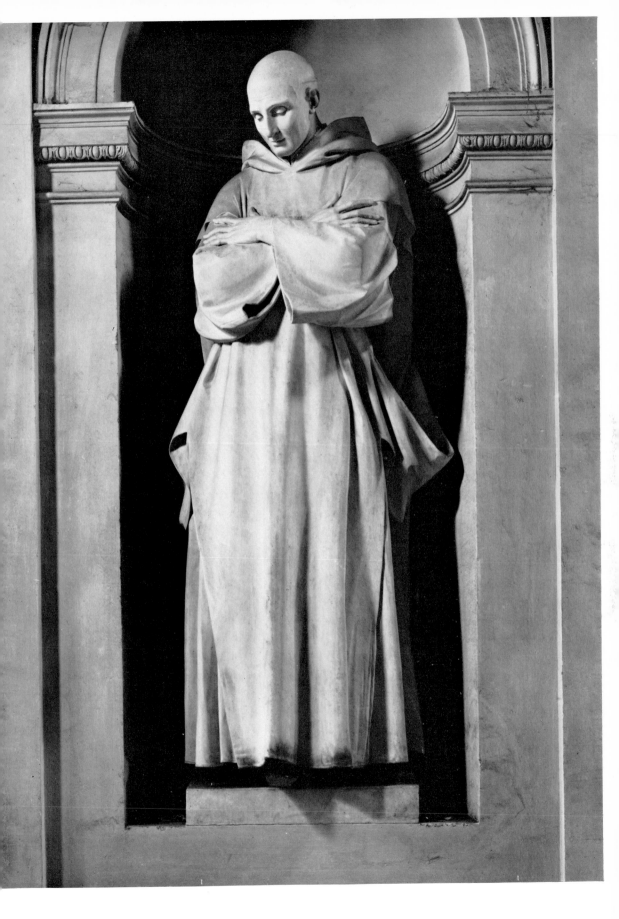

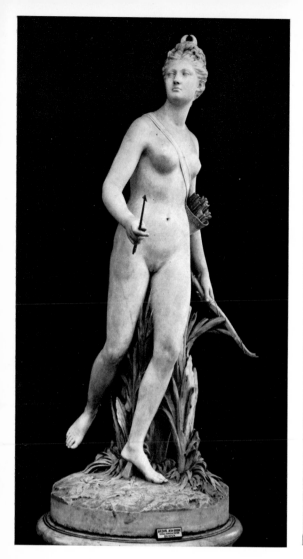

171. Houdon: Diana, 1780. *Lisbon, Gulbenkian Foundation*

172. Houdon: Diderot, 1771. *New Haven, Connecticut, Mr and Mrs C. Seymour, Jr*

173. Houdon: Napoleon, 1806. *Dijon, Musée*

174. Houdon: Seated Voltaire, 1781. *Paris, Comédie Française*

VOLTAIRE.

175. Fragonard: Cypresses in the Garden Avenue at Villa d'Este. Drawing. *Besançon, Musée*

176. Fragonard: Fête at Saint-Cloud, *c.* 1775. *Paris, Banque de France*

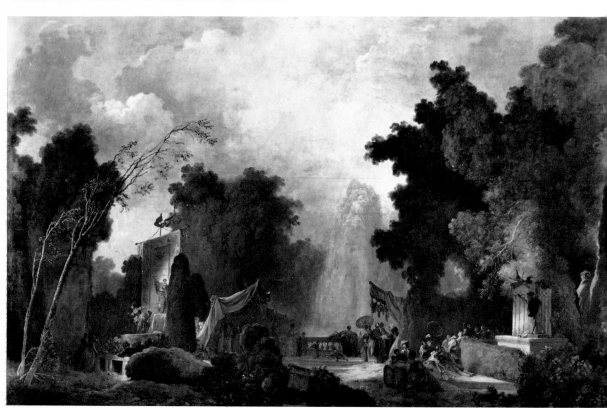

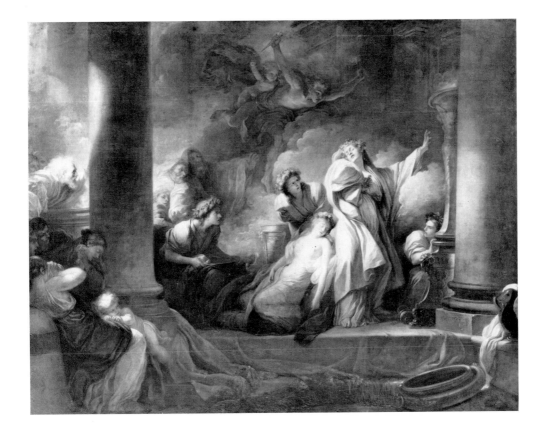

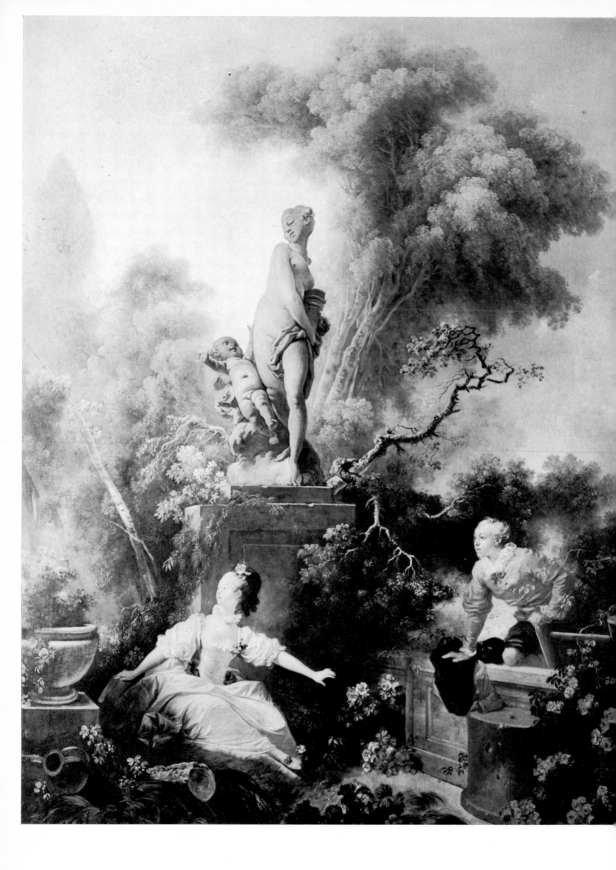

178. Fragonard: Progress of Love: The Meeting, 1771-3. *New York, Frick Collection*

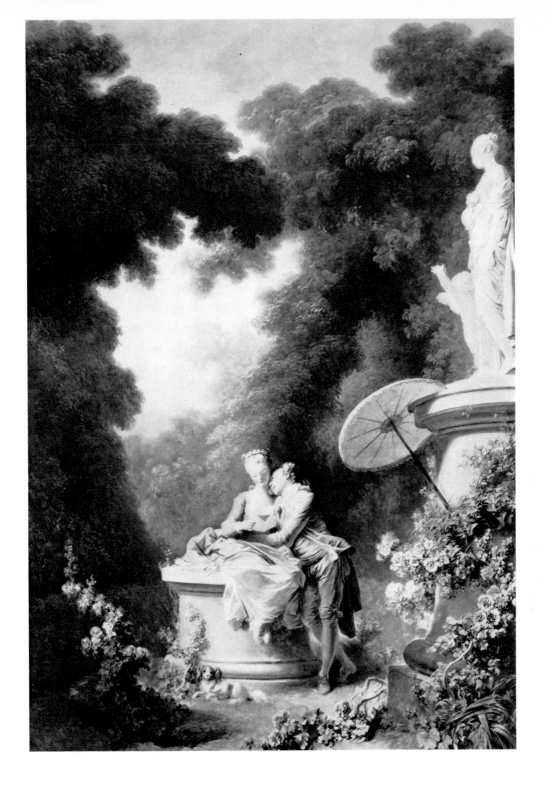

179. Fragonard: Progress of Love: Love Letters, 1771-3. *New York, Frick Collection*

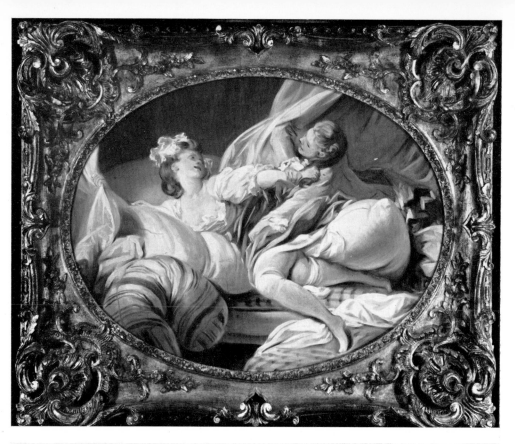

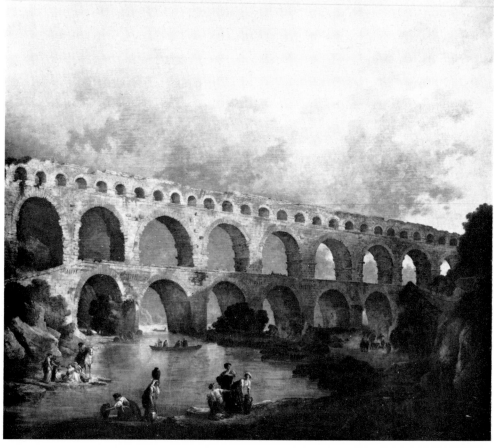

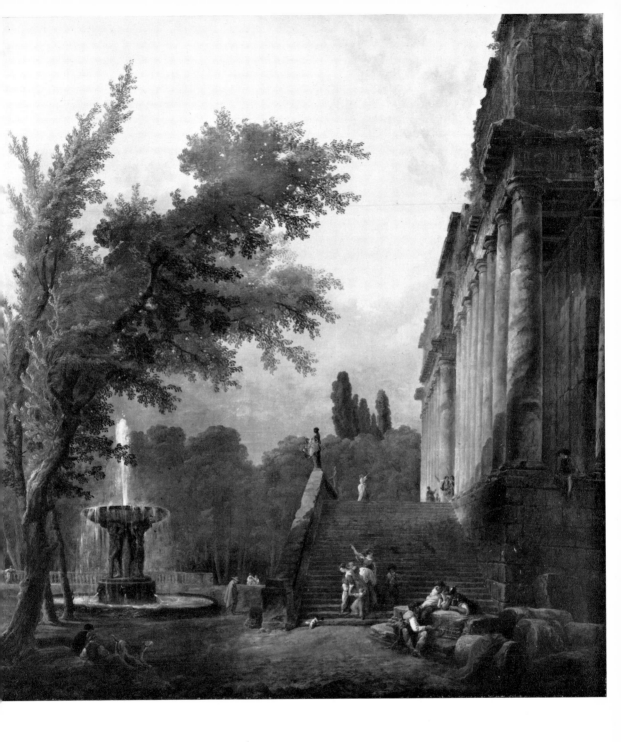

180. Fragonard: The Useless Resistance. *Stockholm, National Museum*

181. Hubert Robert: Pont du Gard, by 1787. *Paris, Louvre*

182. Hubert Robert: Garden Scene with Fountain, 1775. *Fernand Houget Collection, Belgium*

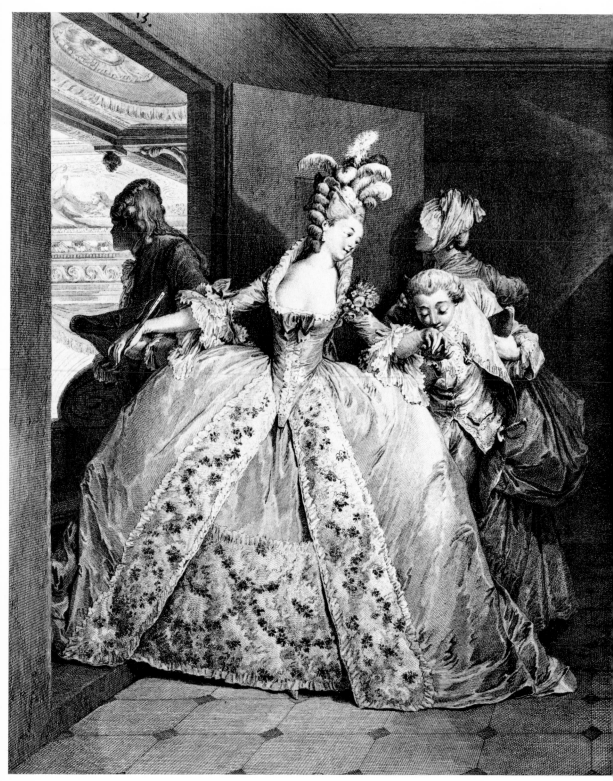

183. Jean-Michel Moreau, engraved by de Launay: Les Adieux, from the *Monument du Costume* (1783). *Paris, Bibliothèque Nationale*

184. Louis–Gabriel Moreau: View of Vincennes from Montreuil. *Paris, Louvre*

185. Jean–Laurent Houël: Vue de Paradis, 1769. *Tours, Musée*

186. Joseph-Siffred Duplessis: Gluck composing, 1775. *Vienna, Kunsthistorisches Museum*

187. Adélaïde Labille-Guiard: Madame Adélaïde, 1787. *Versailles*

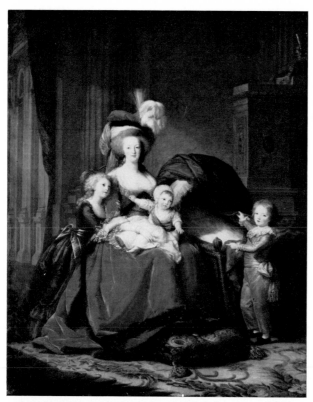

188. Élizabeth-Louise Vigée-Lebrun: Marie-Antoinette and her Children, 1787. *Versailles*

189. Élizabeth-Louise Vigée-Lebrun: Self-Portrait with her Daughter, *c.* 1789. *Paris, Louvre*

190. Antoine Raspal: Atelier des Couturières, 1760 (?). *Arles, Musée Reattu*

191. Étienne Aubry: L'Amour paternel, 1775. *Birmingham, Barber Institute of Fine Arts*

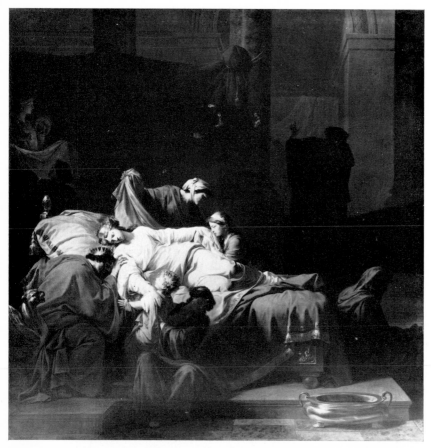

192. J.-F.-P. Peyron:
Alceste mourante,
1785. *Paris, Louvre*

193. François-André
Vincent: Président
Molé stopped by
Insurgents, 1779.
*Paris, Chambre
des Députés*

194. François Ménageot:
Death of Leonardo
da Vinci, 1781.
Amboise, Musée

195. David: Death of
Seneca, 1773.
Paris, Petit Palais

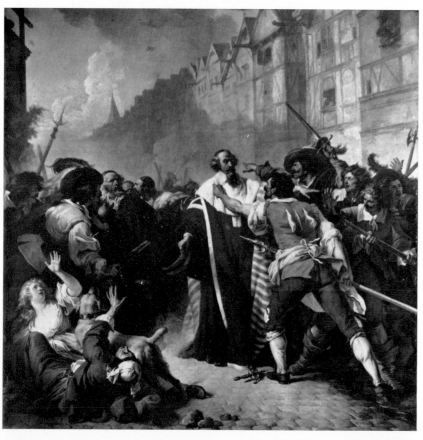

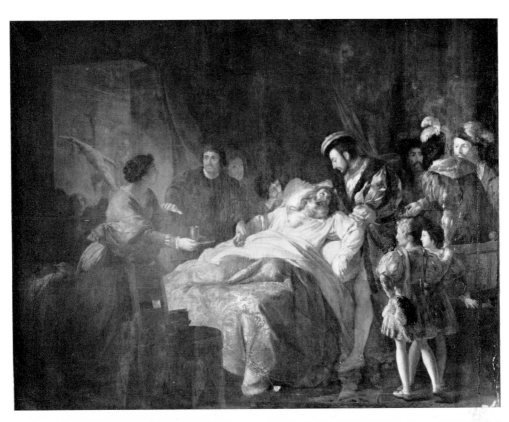

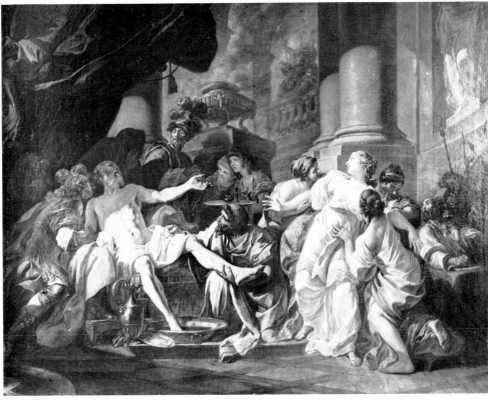

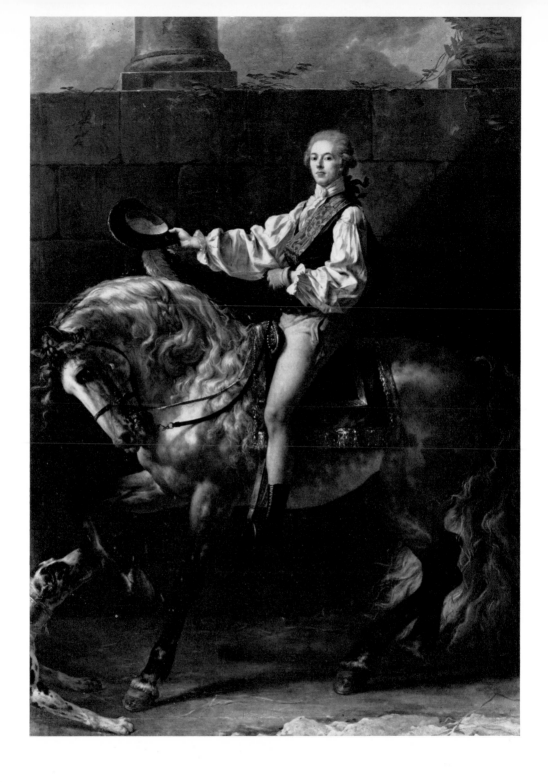

196. David: Count Potocki, 1781. *Warsaw, National Gallery*

197. David: Belisarius, 1781. *Lille, Musée*

198. David: Oath of the Horatii, completed 1785. *Paris, Louvre*

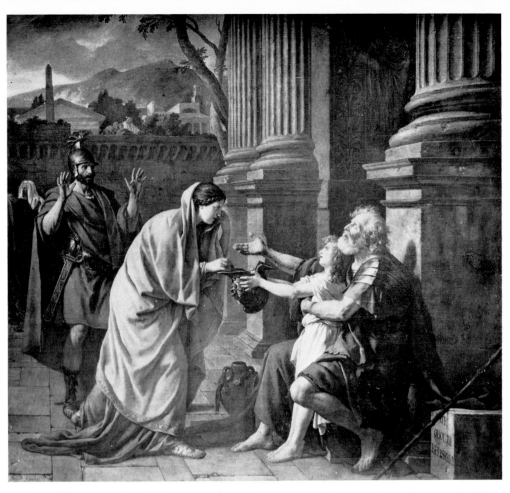

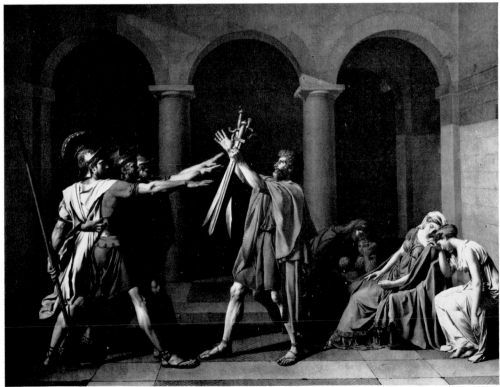

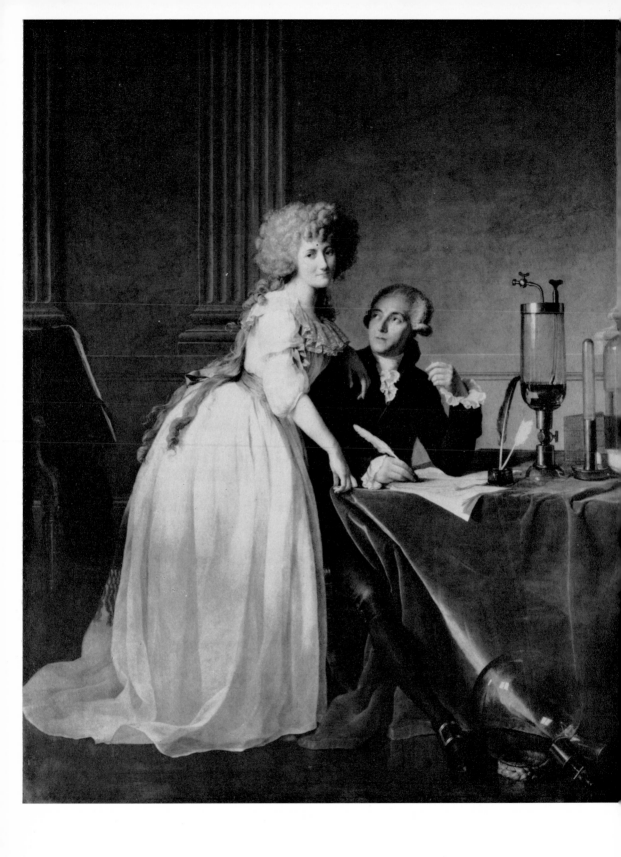

199. David: Lavoisier Double Portrait, 1788. *New York, The Rockefeller University*

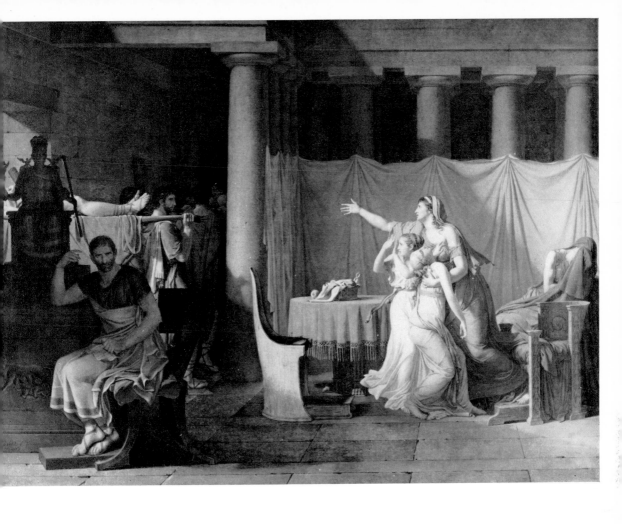

200. David: Lictors bringing Brutus the Bodies of his Sons, 1789. *Paris, Louvre*

201. David: Napoleon crossing the Alps, 1800. *Versailles*

202. Jules Hardouin Mansart: Nancy, Primatiale, 1699–1736, façade

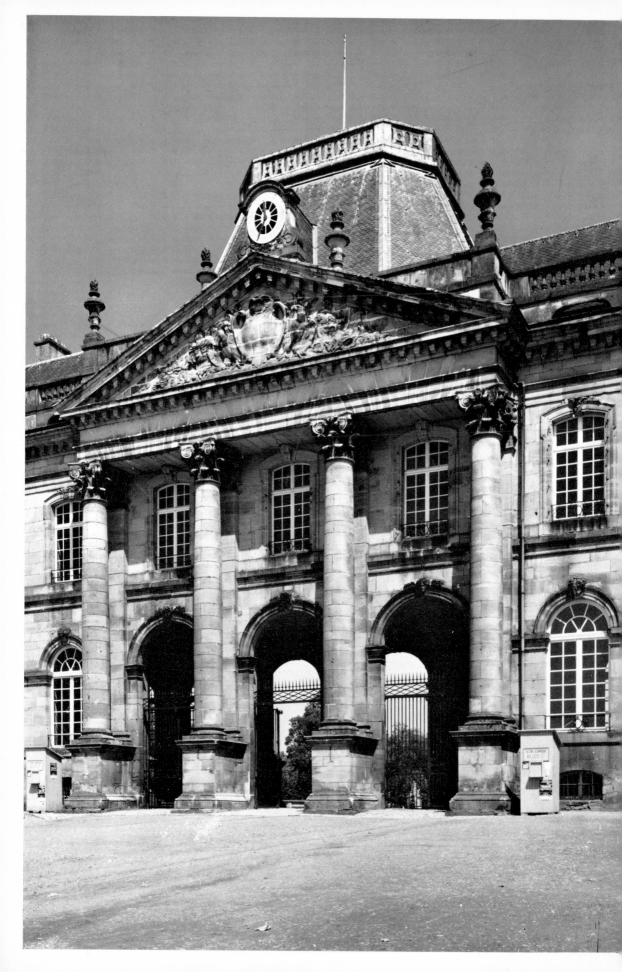

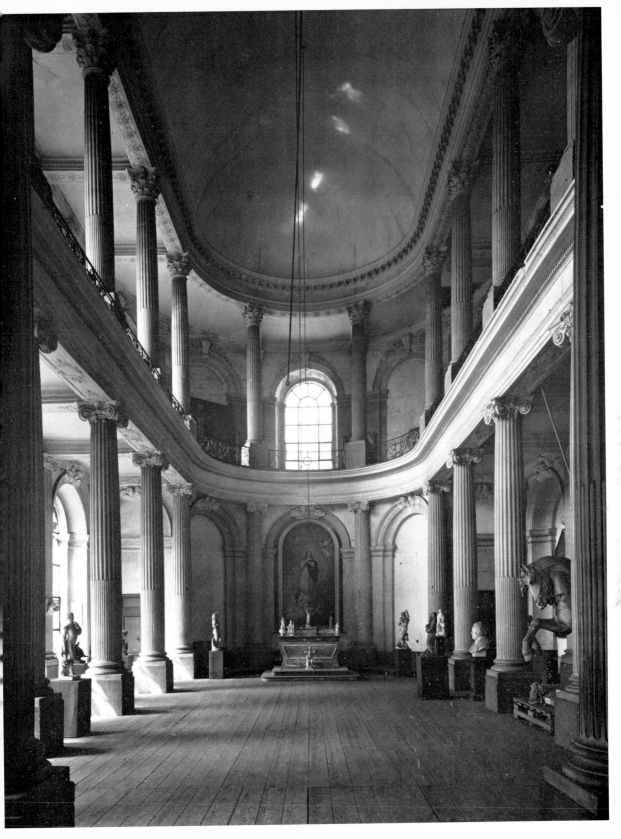

203. Germain Boffrand: Lunéville, 1702–6, façade

204. Germain Boffrand: Lunéville, chapel, 1720–3

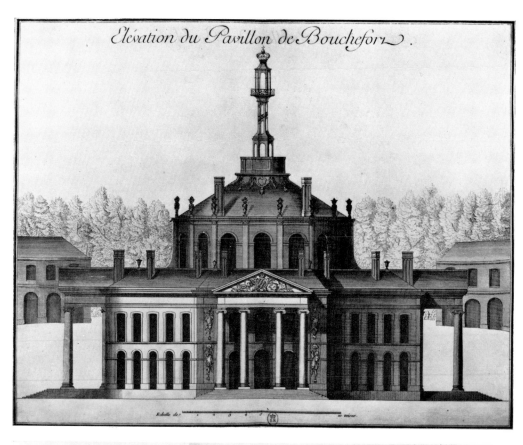

Elévation du Pavillon de Bouchefort.

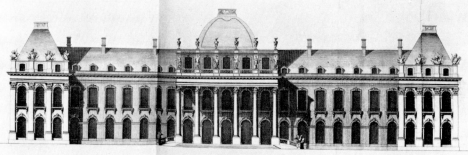

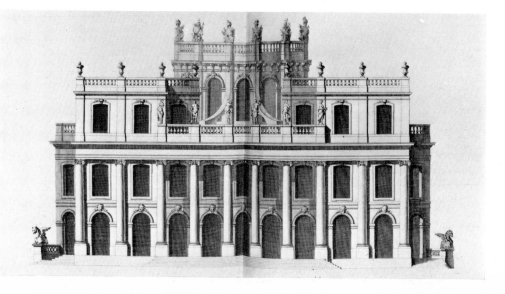

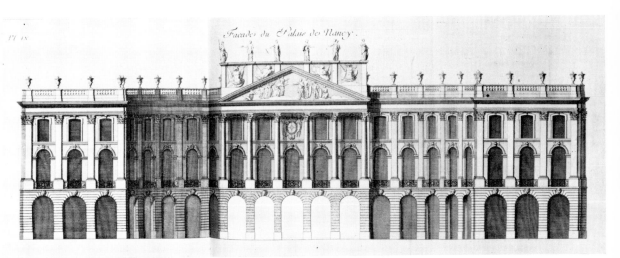

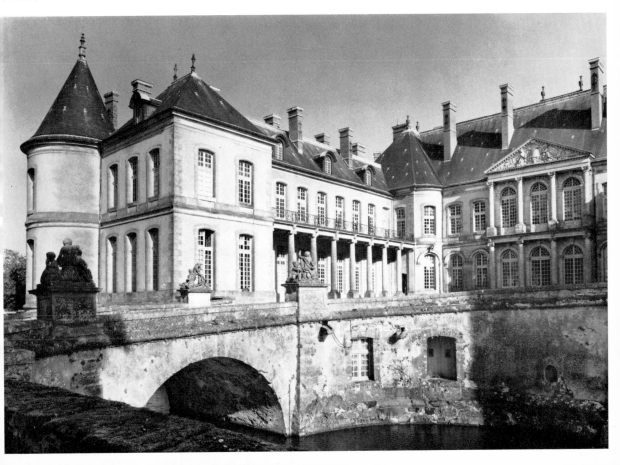

210. Lassurance: Paris, Hôtel Desmarets, 1704, garden façade

211. Robert de Cotte: Paris, Hôtel d'Estrées, 1713, courtyard façade

212. Germain Boffrand: Paris, Hôtel de Torcy, 1713, garden façade

213. Germain Boffrand: Paris, Hôtel Amelot de Gournay, 1712, courtyard façade

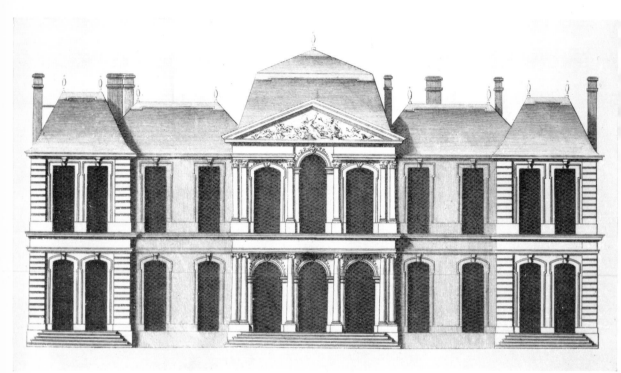

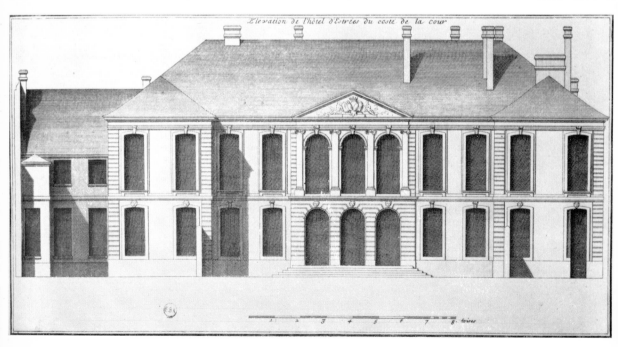

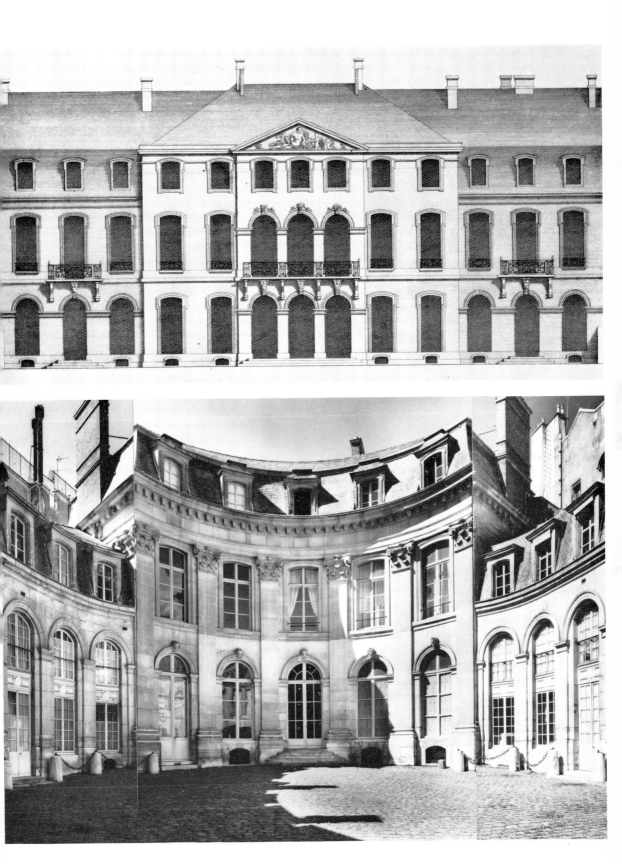

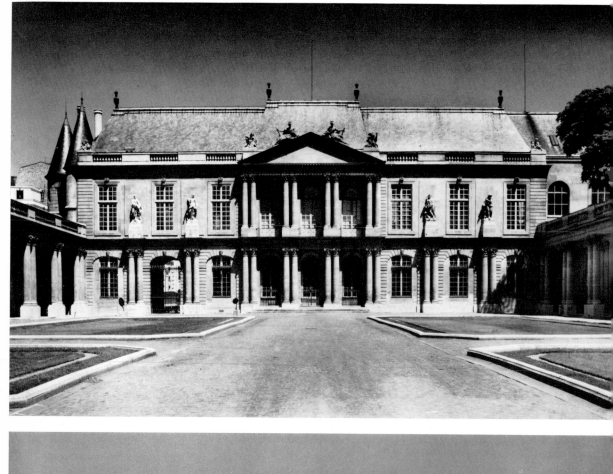

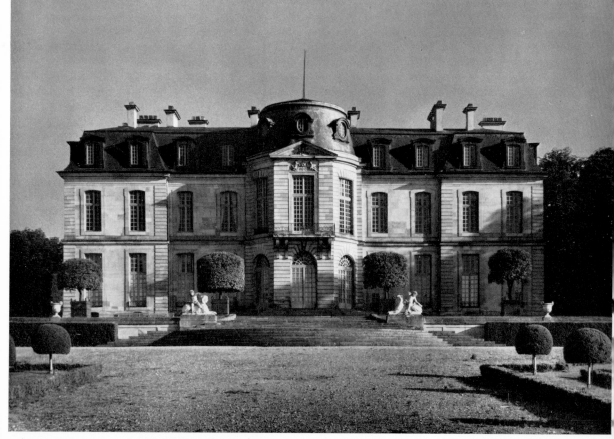

214. Pierre-Alexis Delamair: Paris, Hôtel de Soubise, 1705–9, courtyard façade

215. Jean-Baptiste Bullet de Chamblain: Champs, 1703–7, garden façade

216. Germain Boffrand: Saint-Ouen, c. 1710, courtyard façade

217. Pierre Le Pautre: Designs for three chimneypieces for Marly, 1699

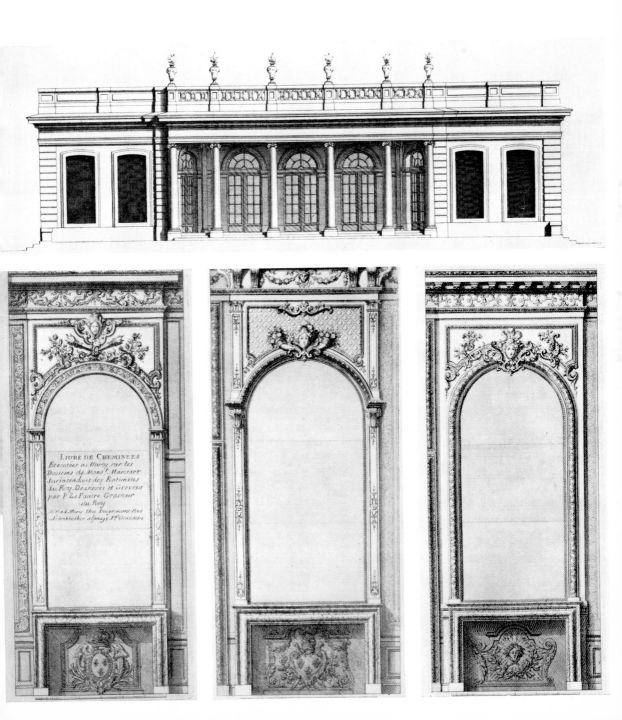

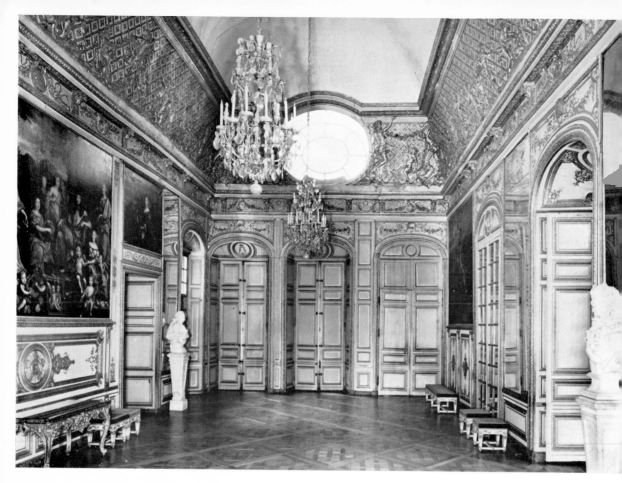

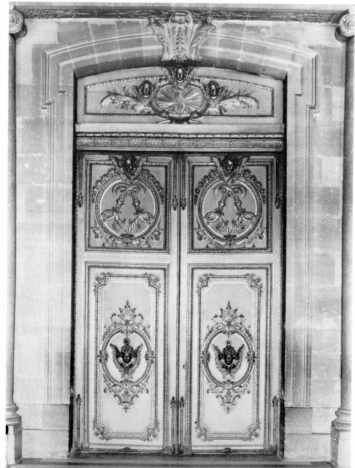

218. Pierre Le Pautre: Versailles, Salon de l'Œil de Bœuf, 1701, south wall

219. Pierre Le Pautre: Versailles, chapel, door, 1709–10

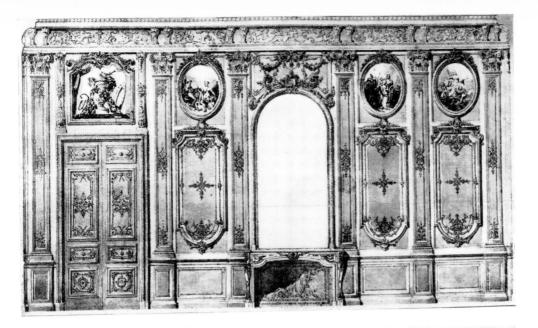

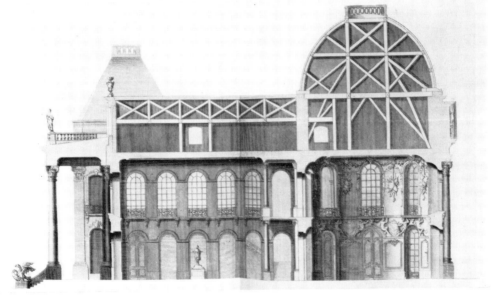

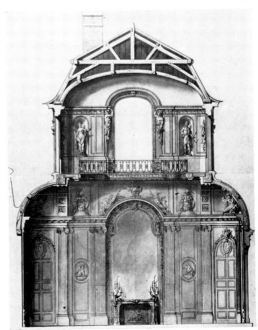

220. Germain Boffrand: Bercy, grand salon, 1715

221. Germain Boffrand: Malgrange I, central salon, c. 1715

222. Gilles-Marie Oppenordt: Paris, Palais Royal, corner salon, 1719–20, sketch

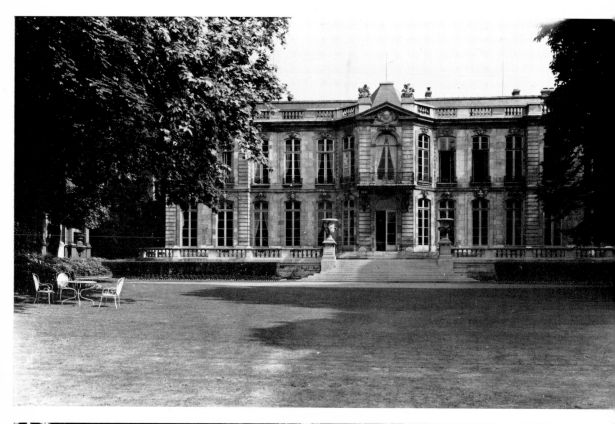

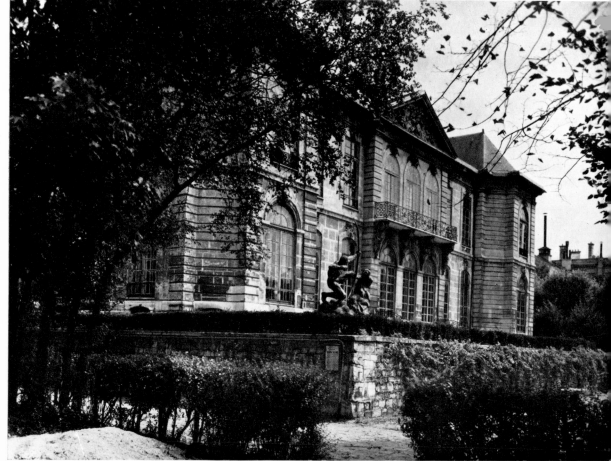

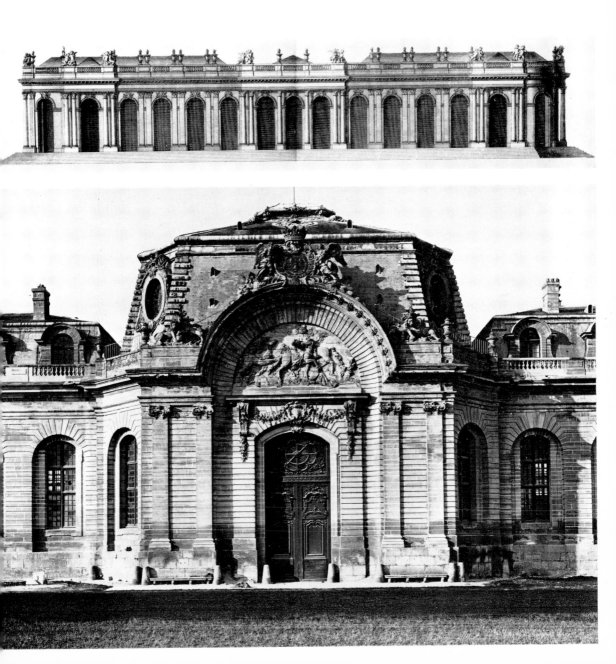

227. Jean-François Blondel: Genthod, Maison Lullin, *c*. 1722, façade

228. Beaumont-sur-Vingeanne, 1724, courtyard façade

229. Robert de Cotte: Poppelsdorf, after 1715, air view

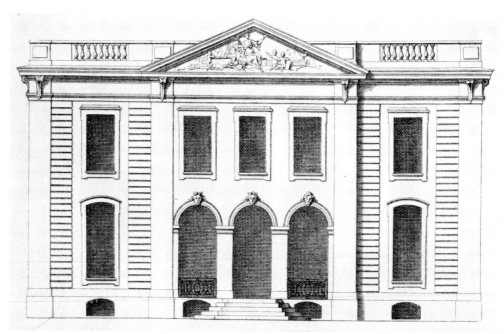

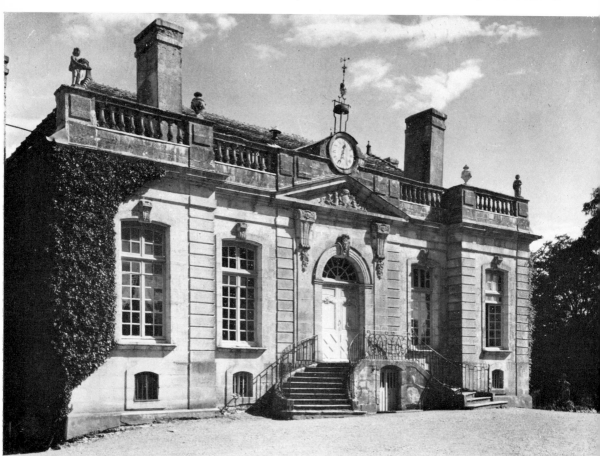

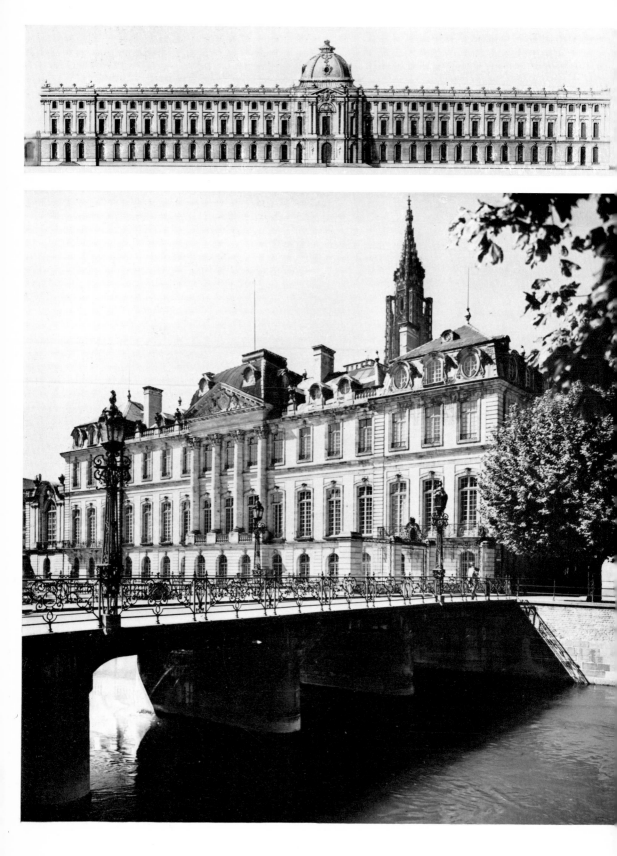

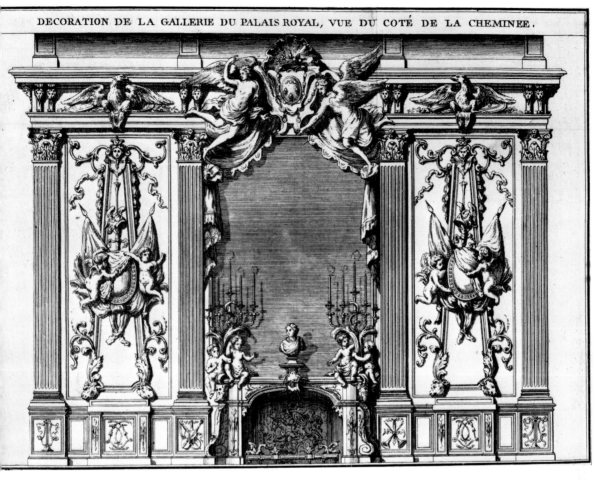

230. Robert de Cotte: Buenretiro, first design, 1715, façade

231. Robert de Cotte: Strasbourg, Château de Rohan, 1731–42, river façade

232. Gilles–Marie Oppenordt: Paris, Palais Royal, Galerie d'Énée, 1717

233. Gilles–Marie Oppenordt: Paris, Palais Royal, Grands Appartements, 1720

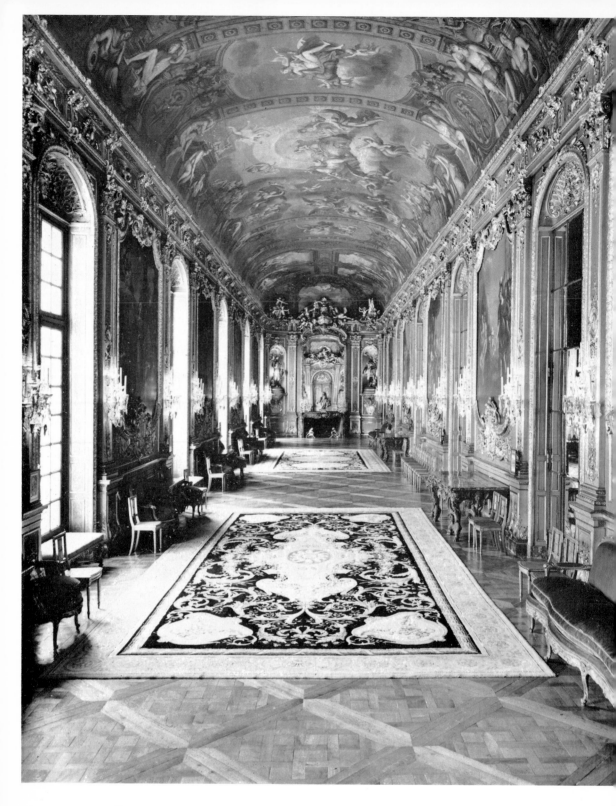

234. François-Antoine Vassé: Paris, Hôtel de Toulouse (Banque de France), Galerie Dorée, 1718–19

235. Robert and Jules-Robert de Cotte: Paris, Bibliothèque Nationale, Cabinet du Roi, 1721–41

236. Germain Boffrand: Paris, Hôtel de Parabère, c. 1720

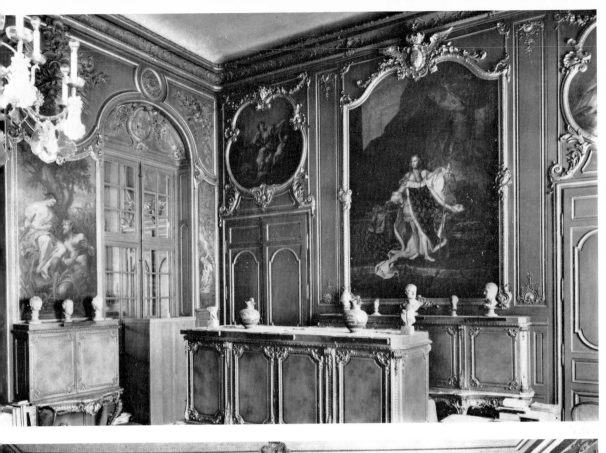

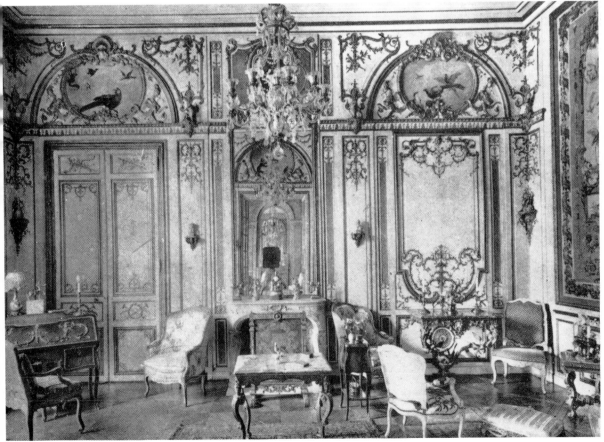

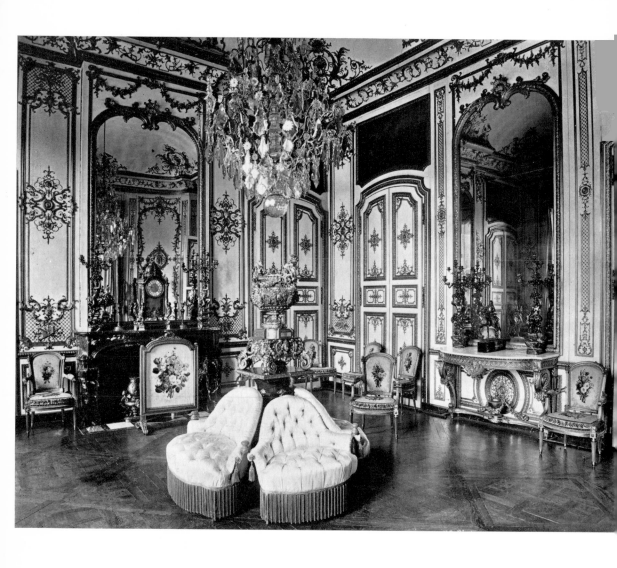

237. Jean Aubert: Chantilly, Petit Château, Salon de Musique, 1722

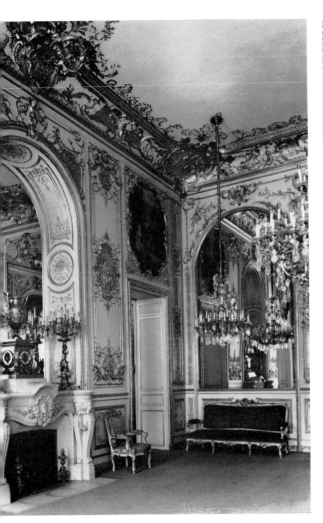

238. Jean Aubert: Paris, Hôtel de Lassay, Grand Salon, after 1725

239. Paris, Hôtel Gouffier de Thoix, side portal, c. 1730

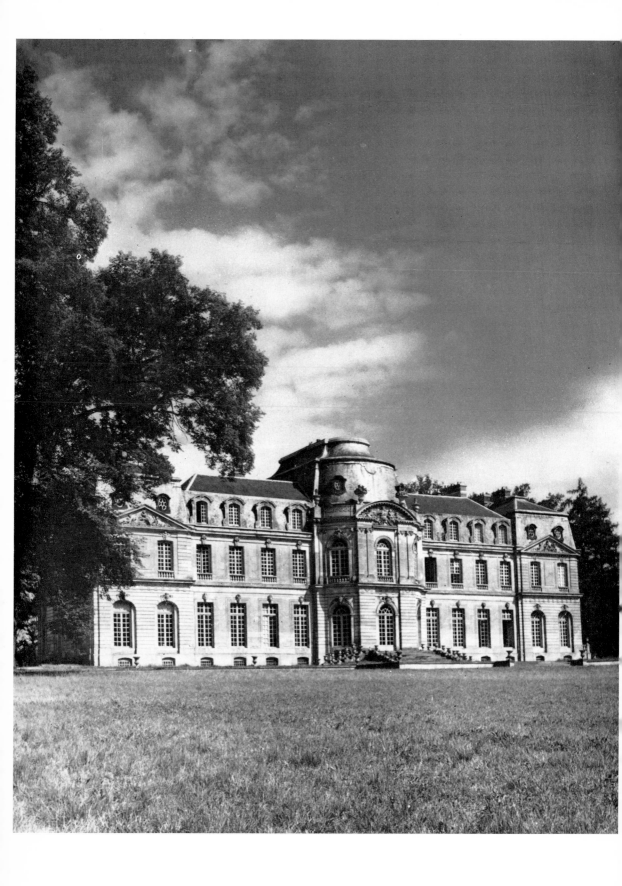

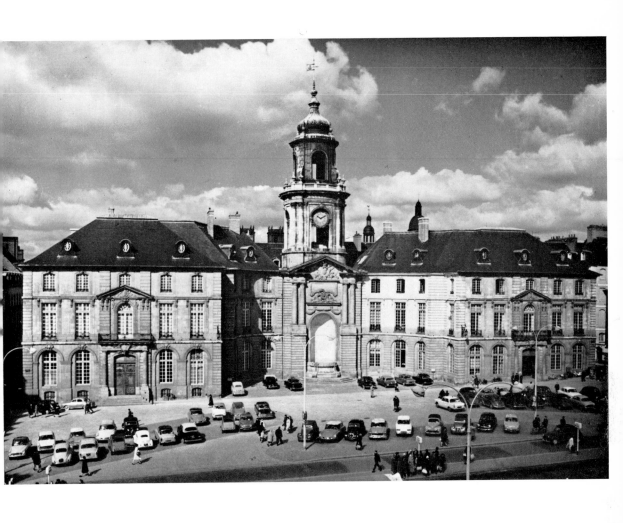

240. Jean-Michel Chevotet: Champlâtreux, 1733, garden façade

241. Jacques Gabriel: Rennes, town hall, 1736–44

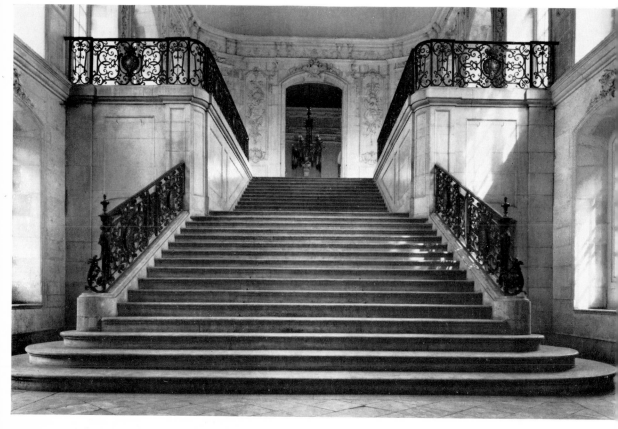

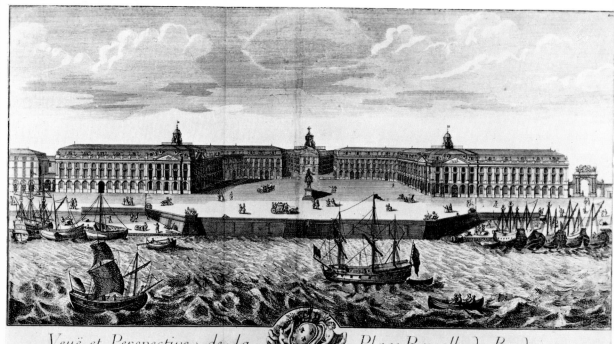

Veuë et Perspective de la *Place Royalle de Bordeaux.*

A Paris chez Crepÿ rue S.t Jacque

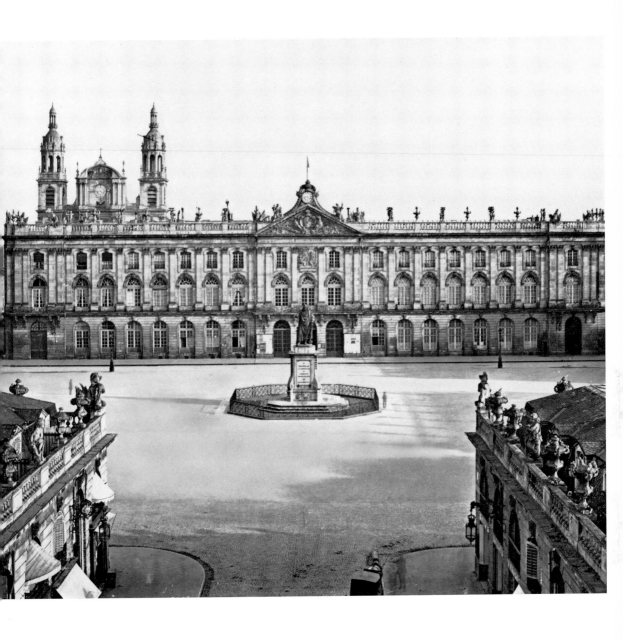

242. Jacques Gabriel: Dijon, Palais des États, staircase, 1733

243. Jacques Gabriel: Bordeaux, Place Royale, 1735–55

244. Emmanuel Héré: Nancy, Place Stanislas, town hall, 1752–5

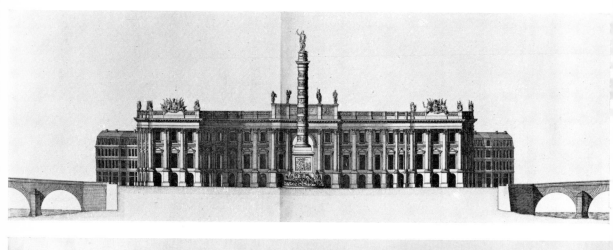

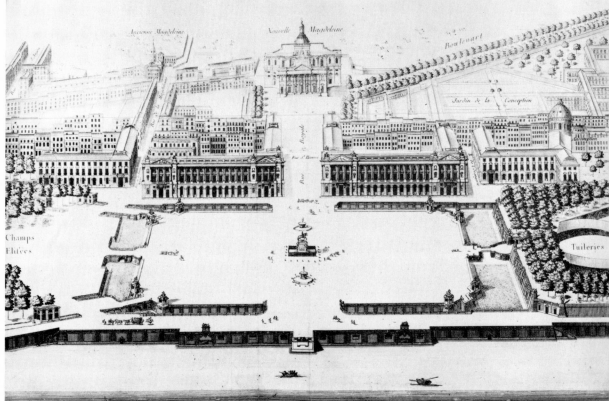

245. Germain Boffrand: Plan for the Place Dauphine, Paris, 1748

246. Ange-Jacques Gabriel: Paris, Place de la Concorde (originally Place Louis XV), engraving

247. Germain Soufflot: Lyon, Hôtel-Dieu, 1741-8, façade

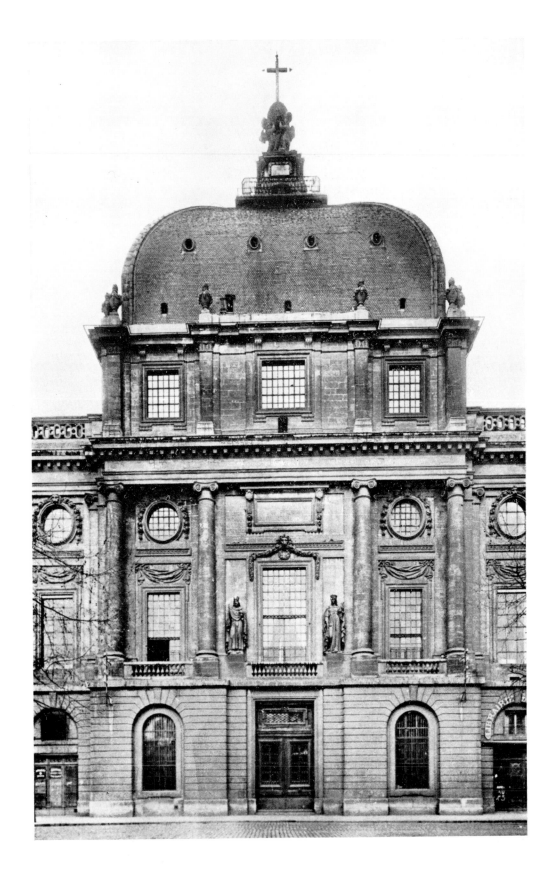

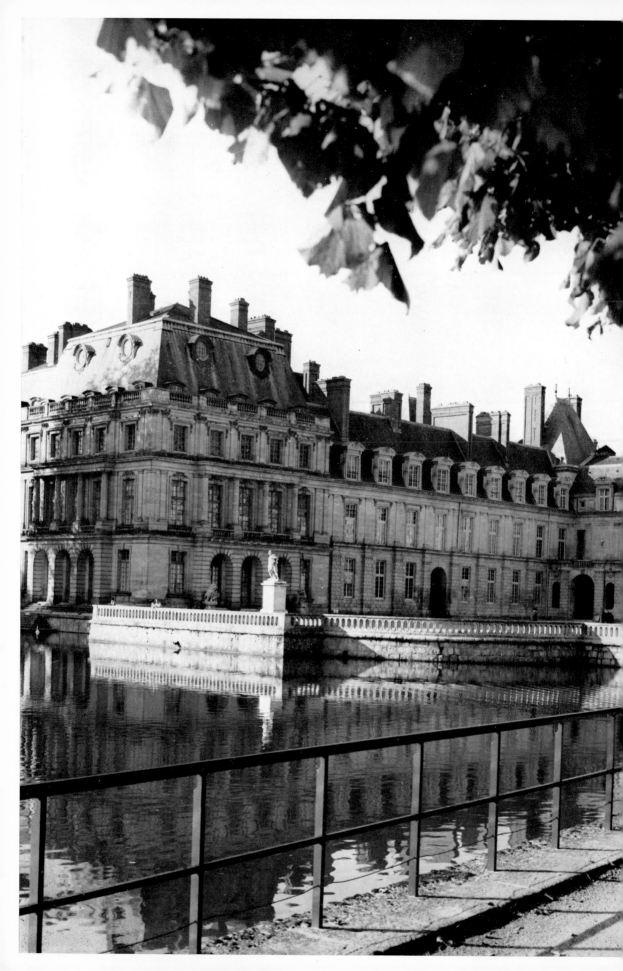

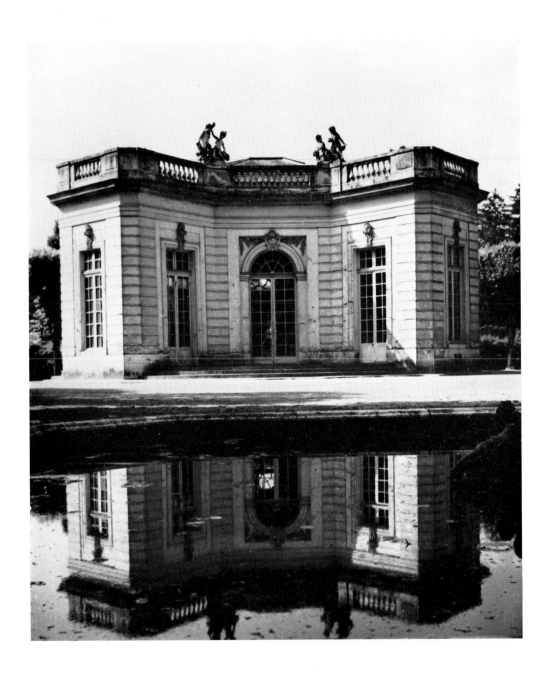

248. Ange-Jacques Gabriel: Fontainebleau, Gros Pavillon, 1750–4

249. Ange-Jacques Gabriel: Versailles, Petit Trianon, Pavillon Français, 1749

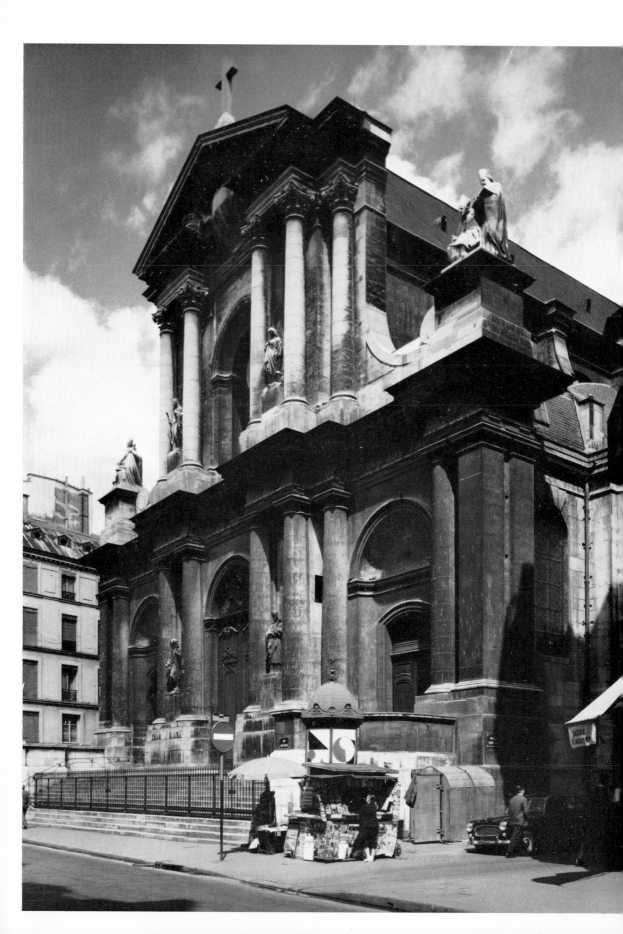

250. Jules-Robert de Cotte: Paris, Saint-Roch, façade, 1736
251. Jacques Hardouin-Mansart de Sagonne: Versailles, Saint-Louis, 1743–54

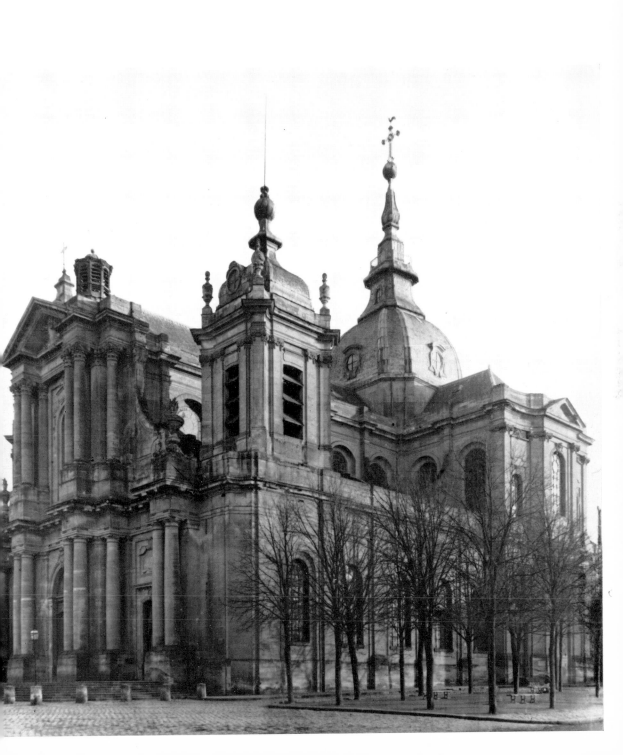

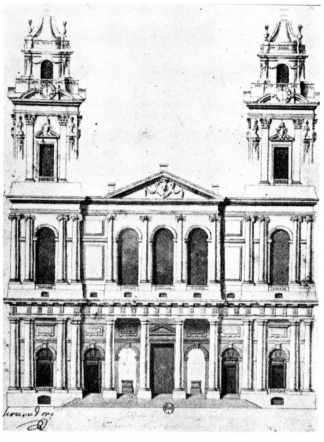

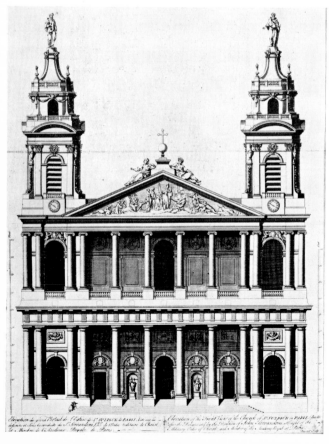

252. Jean-Nicolas Servandoni: Paris, Saint-Sulpice, first design for façade, 1732

253. Jean-Nicolas Servandoni: Paris, Saint-Sulpice, second design for façade, 1736

254. Lunéville, Saint-Jacques, 1730–47, façade

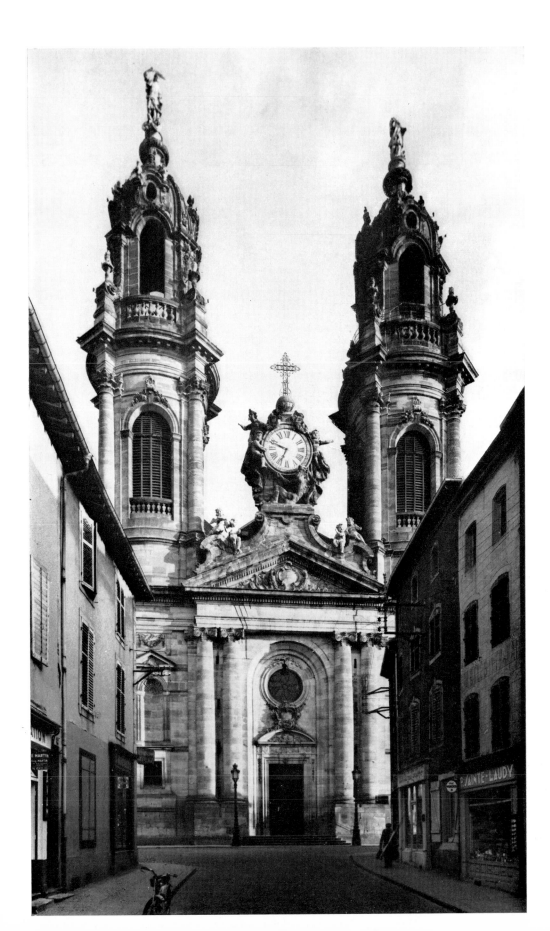

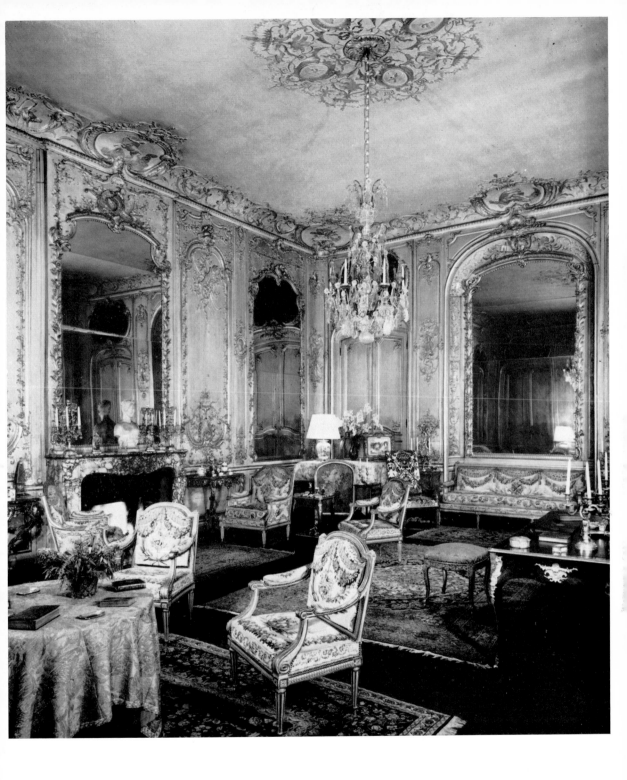

255. Nicolas Nicole: Besançon, Sainte-Madeleine, 1746–66, interior

256. Nicolas Pineau: Paris, Hôtel de Maisons, Salle de Compagnie, c. 1750

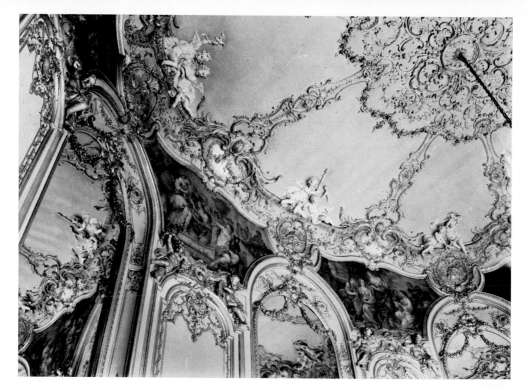

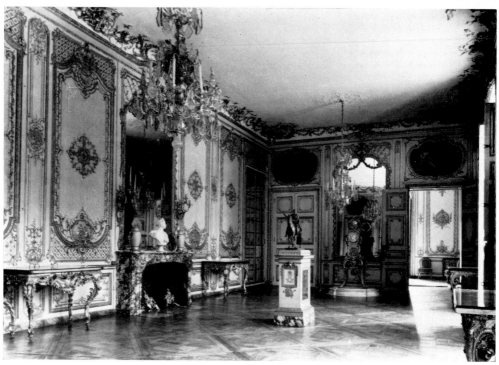

257. Germain Boffrand: Paris, Hôtel de Soubise, Salon de la Princesse, 1736–9

258. Ange-Jacques Gabriel and Jacques Verberckt: Versailles, Cabinet de la Pendule, 1738-9

259. Ange-Jacques Gabriel and Jacques Verberckt: Versailles, Cabinet du Conseil, 1755–6

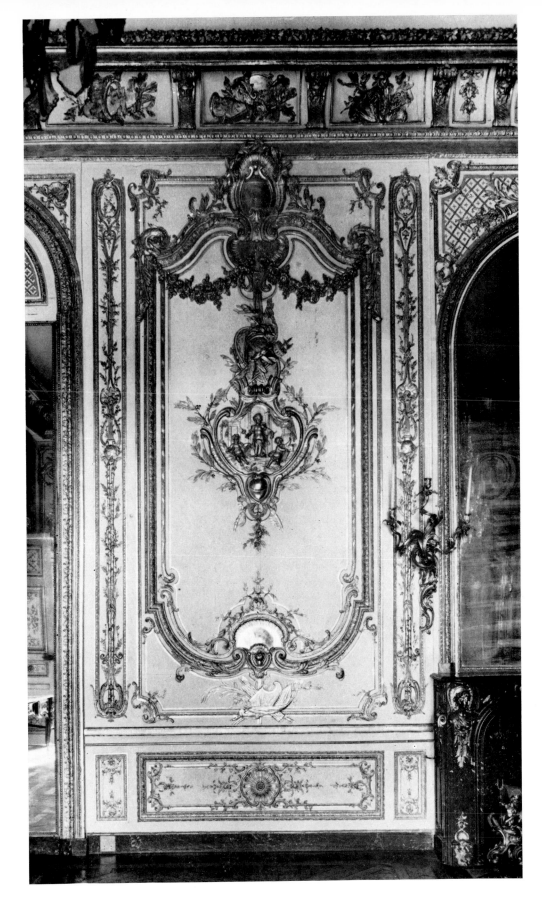

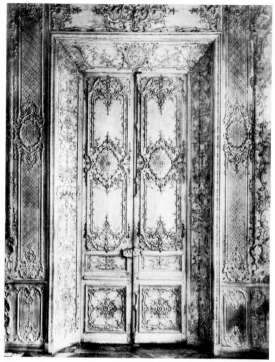

260. Jacques Verberckt: Rambouillet, boudoir of the Comtesse de Toulouse, *c.* 1735

261. Pierre Contant d'Ivry: Paris, Palais Royal, Chambre de Parade, 1755–60

262. Jean-Laurent Legeay: Engraving from *Tombeaux*, 1768

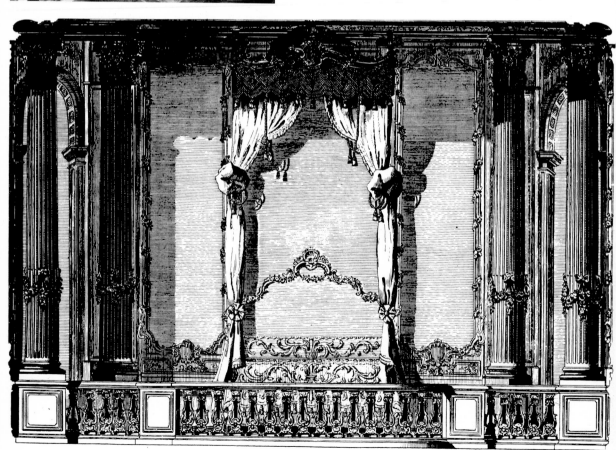

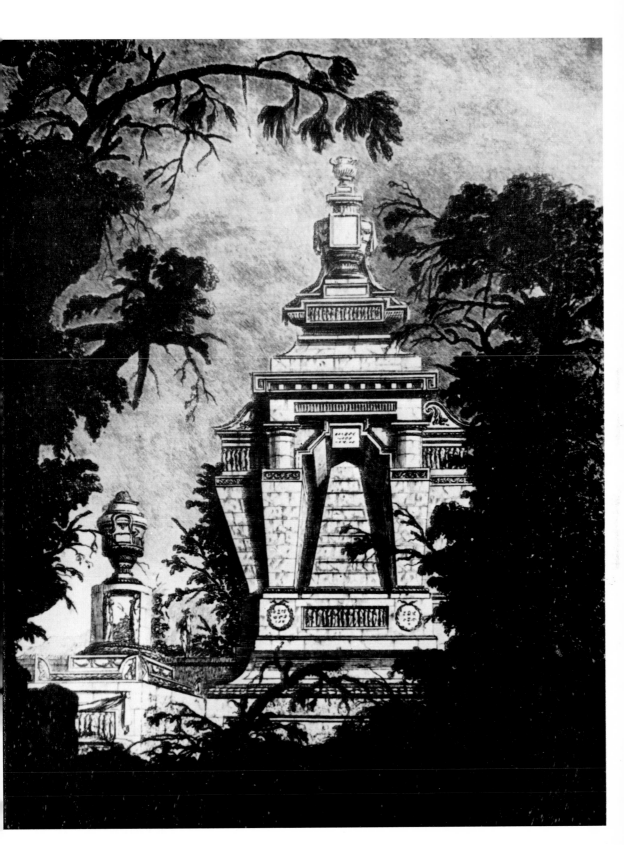

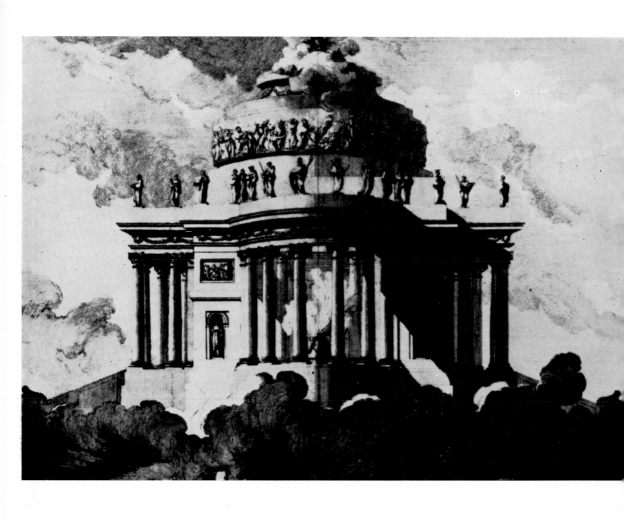

263. J.-F. Le Lorrain: Decoration for the Festa della Chinea at Rome, 1746

264. M.-J. Peyre: Design for a cathedral, 1753

265. Ange-Jacques Gabriel: Paris, Place de la Concorde (originally Place Louis XV), façades, 1757–75

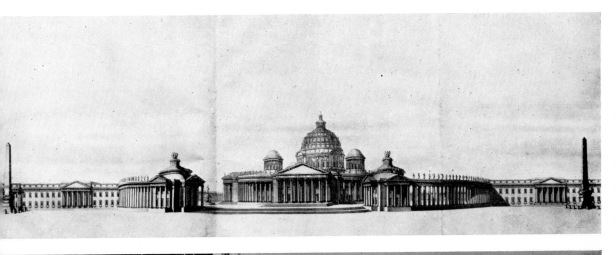

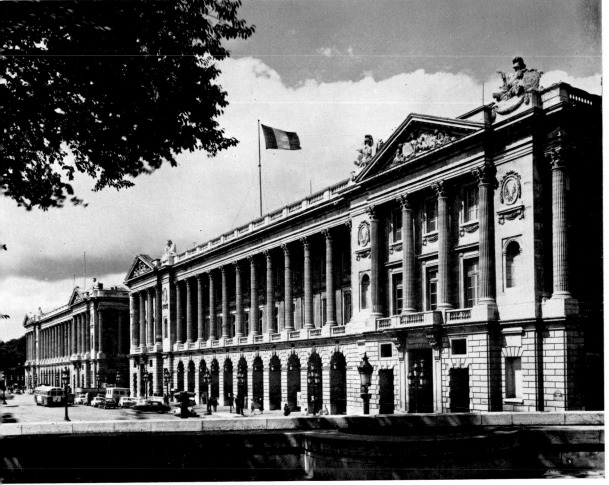

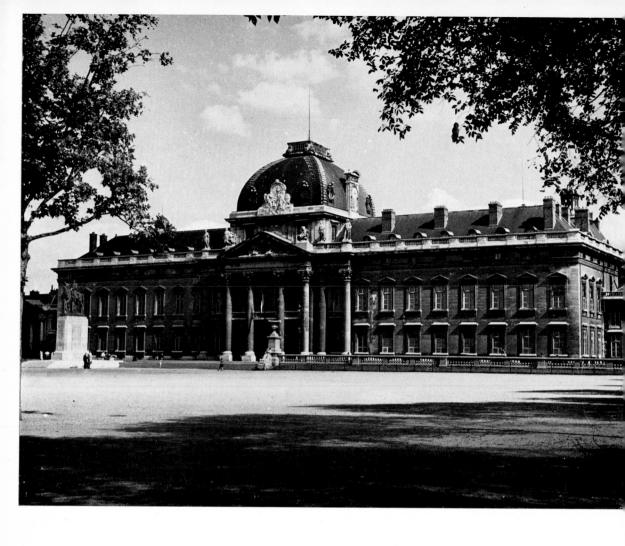

266. Ange-Jacques Gabriel: Paris, École Militaire, façade, 1768–73
267. Ange-Jacques Gabriel: Paris, École Militaire, chapel, *c.* 1770

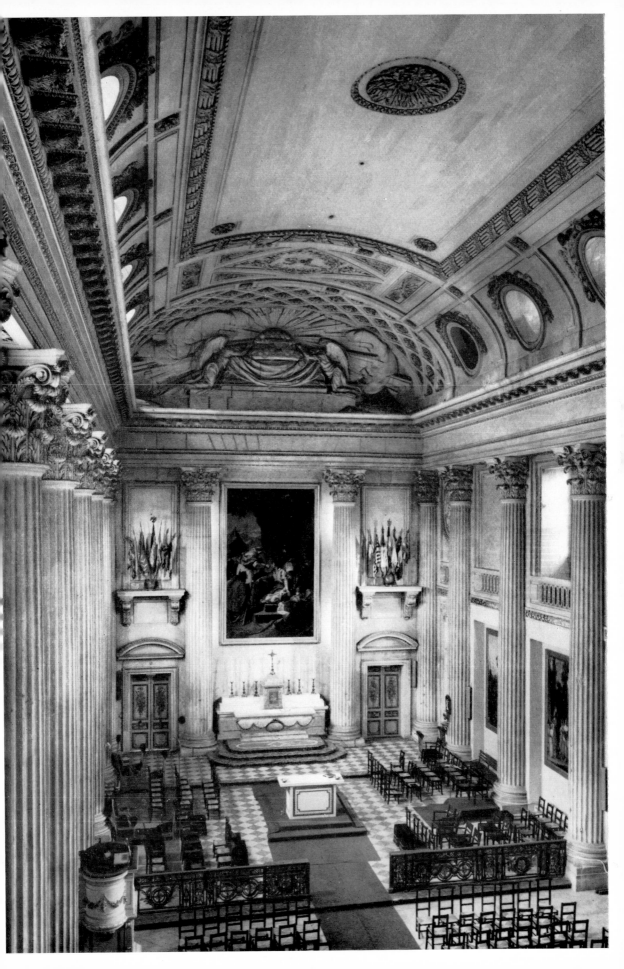

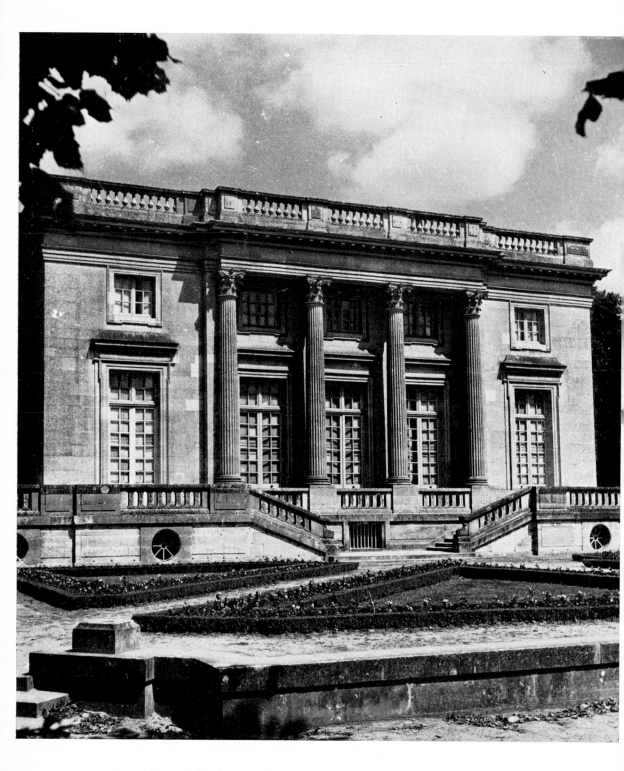

268. Ange-Jacques Gabriel: Versailles, Petit Trianon, 1762–8, garden façade

269. Ange-Jacques Gabriel: 'Grand Projet' for Versailles, c. 1765

270. Jacques-Denis Antoine: Paris, mint, 1768–75, façade

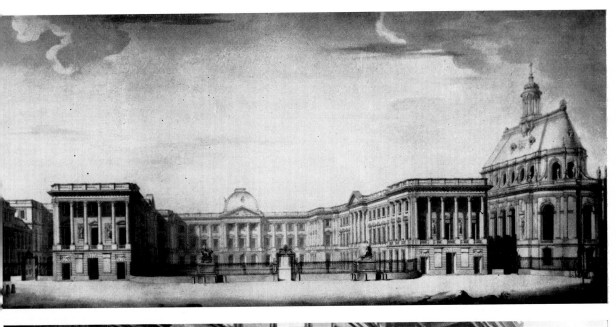

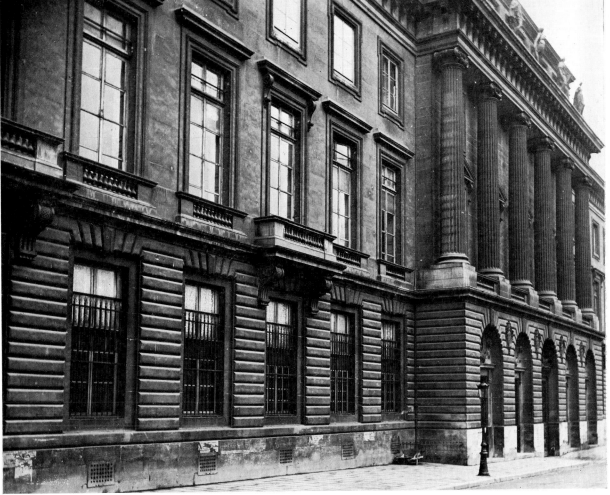

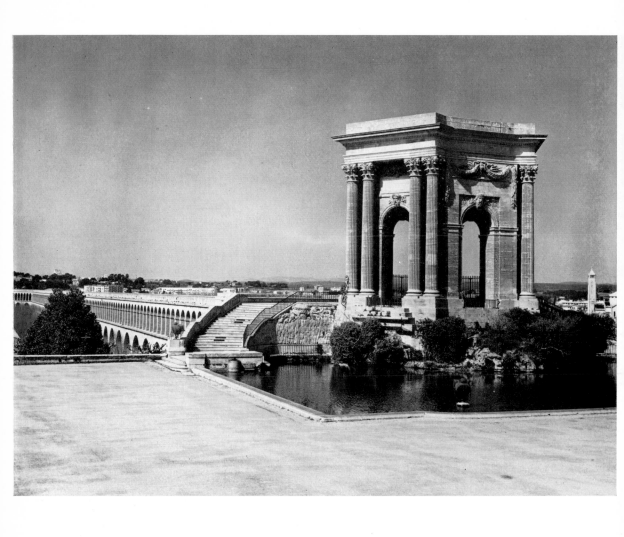

271. Étienne Giral: Montpellier, Peyrou, begun in 1767

272. Pierre Contant d'Ivry: Paris, Palais Royal, staircase, 1766–8

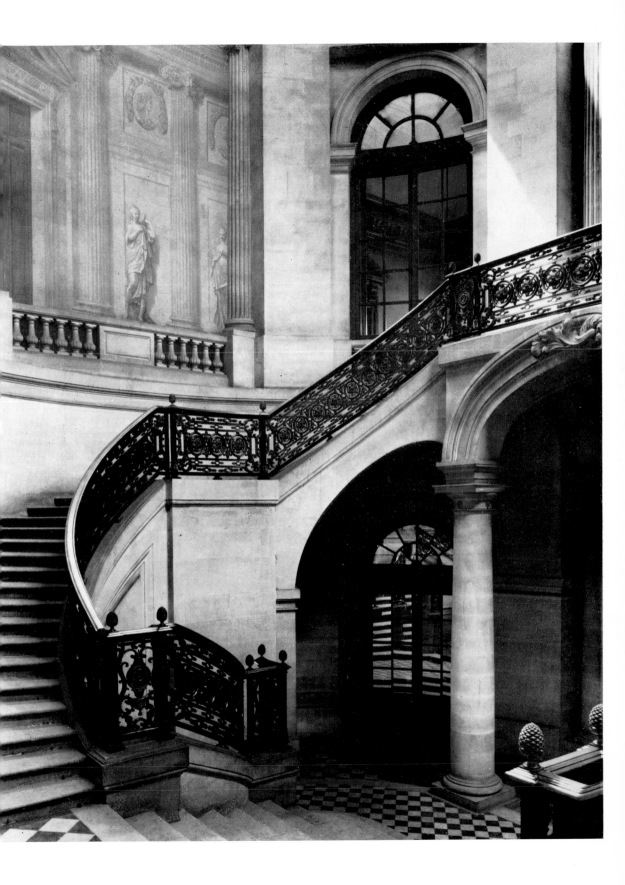

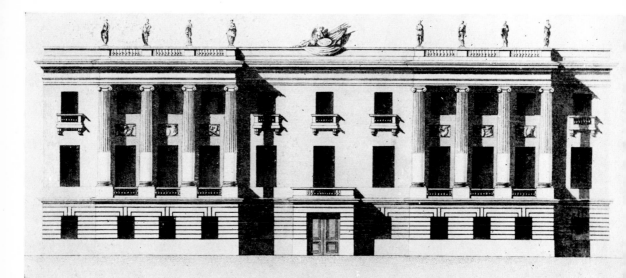

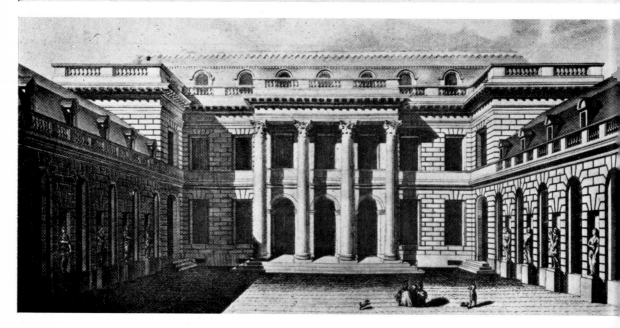

273. Claude-Nicolas Ledoux: Paris, Hôtel de Montmorency, 1769–70, façade

274. Claude-Nicolas Ledoux: Paris, Hôtel d'Uzès, 1764–7, courtyard façade

275. Claude-Nicolas Ledoux: Louveciennes, Pavillon de Madame du Barry, 1770-1

276. Étienne-Louis Boullée: Paris, Hôtel de Brunoy, 1772–9

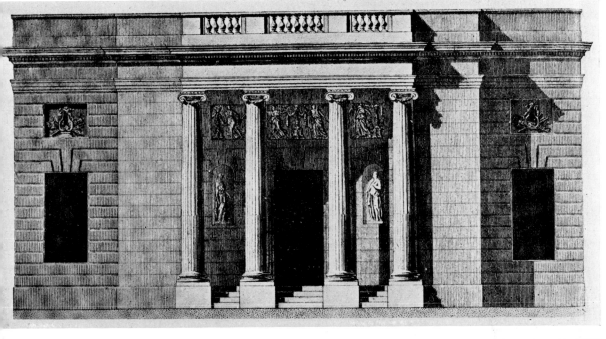

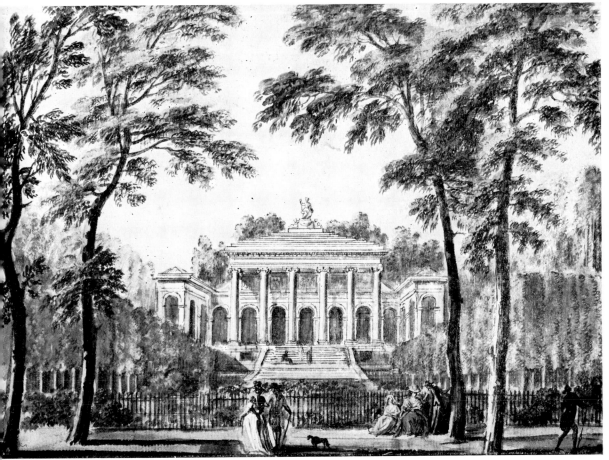

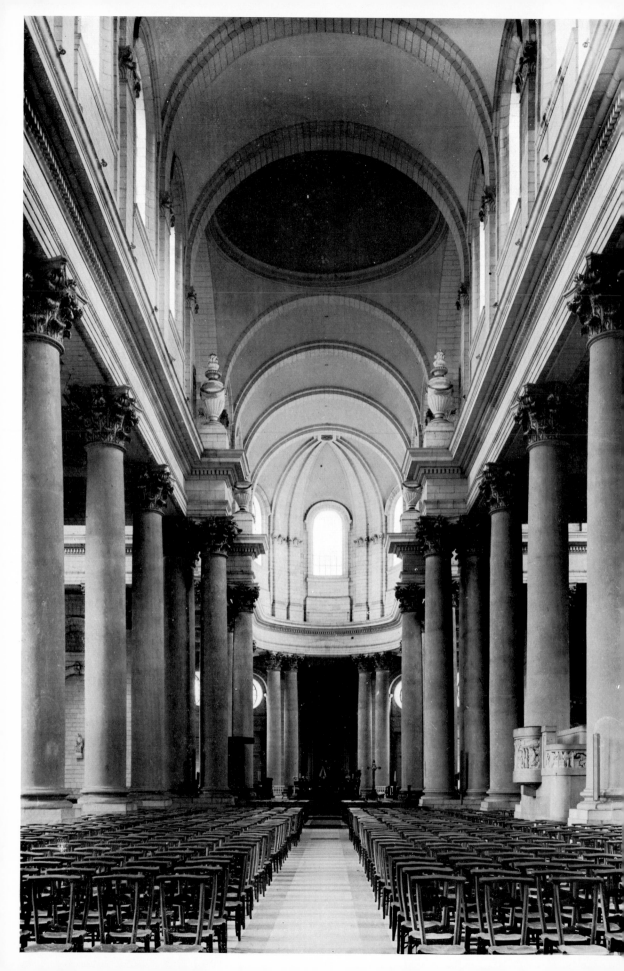

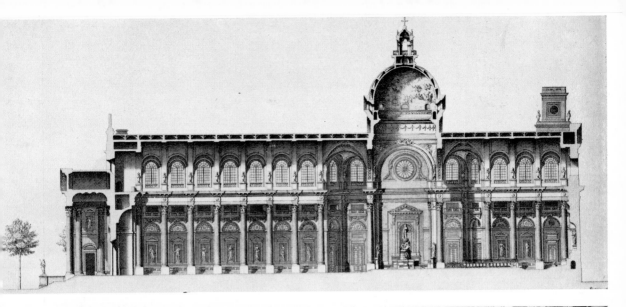

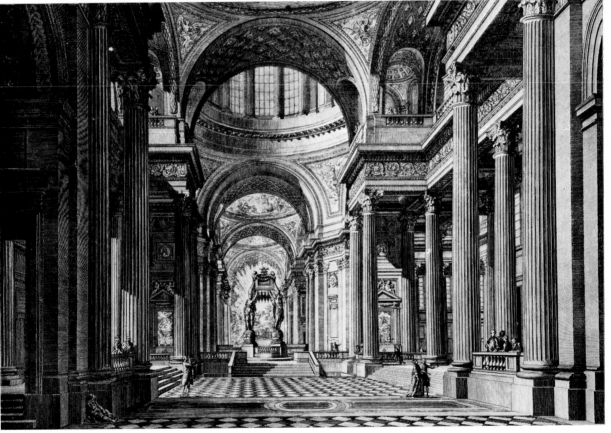

277. Pierre Contant d'Ivry: Arras, Saint-Vaast, begun *c.* 1755, interior

278. Pierre Contant d'Ivry: Design for the Madeleine, Paris, 1757

279. Germain Soufflot: Paris, Sainte-Geneviève (Panthéon), 1757–90, interior; engraving by Boulleau, 1775

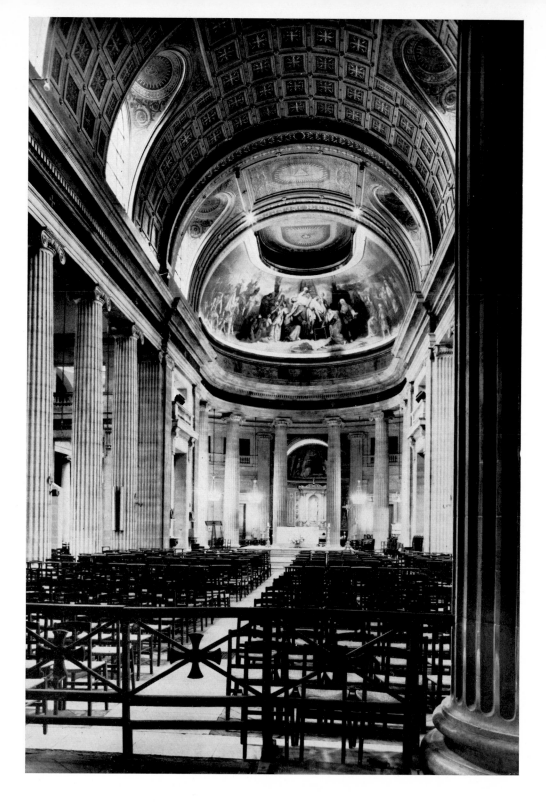

280. Jean-François Chalgrin: Paris, Saint-Philippe-du-Roule, 1774–84, interior

281. Versailles, Petit Trianon, Salon de Compagnie, 1768

282. Ange-Jacques Gabriel: Paris, Gardemeuble de la Couronne (Ministry of Marine), Galerie Dorée, 1768–72

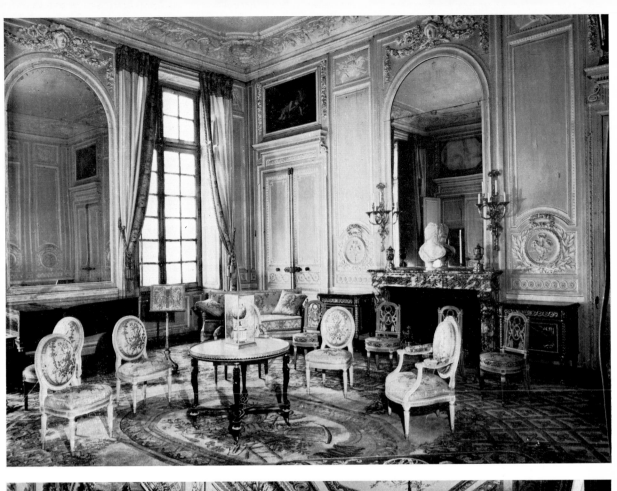

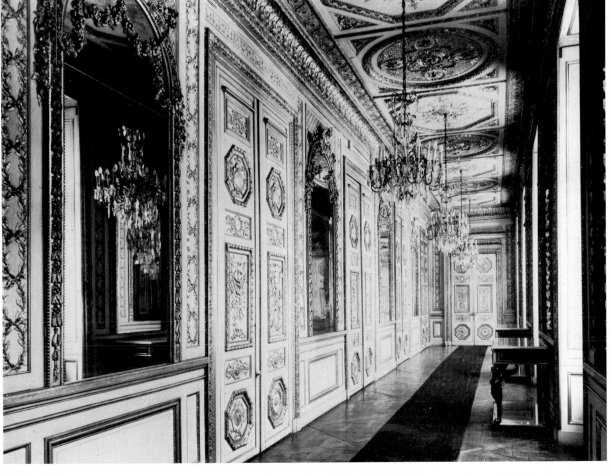

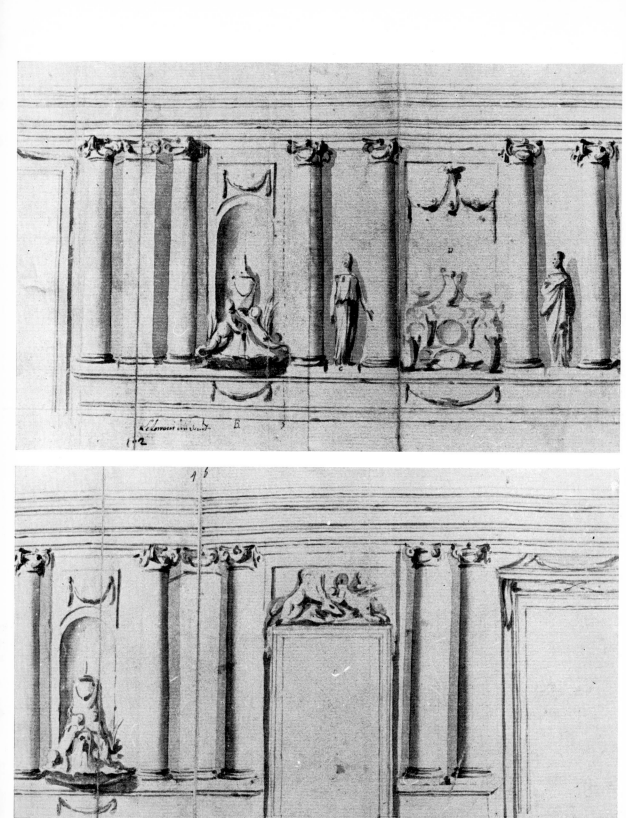

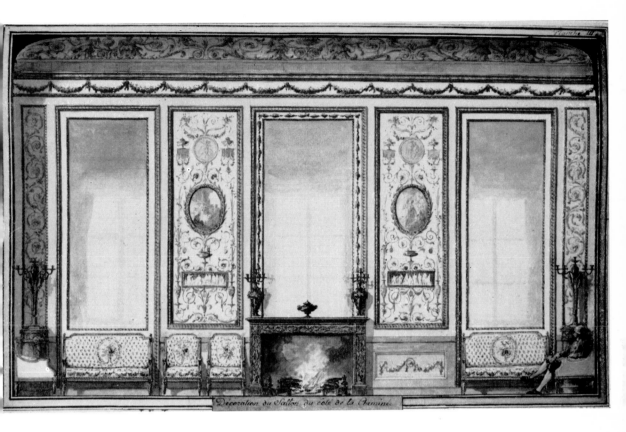

Decoration du Salon du cote de la Cheminée

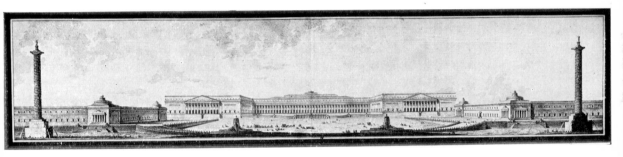

283. J.-F. Le Lorrain: Design for the decoration of the castle of Åkerö, 1754

284. C.-L. Clérisseau: Paris, Hôtel Grimod de la Reynière, decoration, c. 1775

285. Étienne-Louis Boullée: Grand Projet for Versailles, 1780

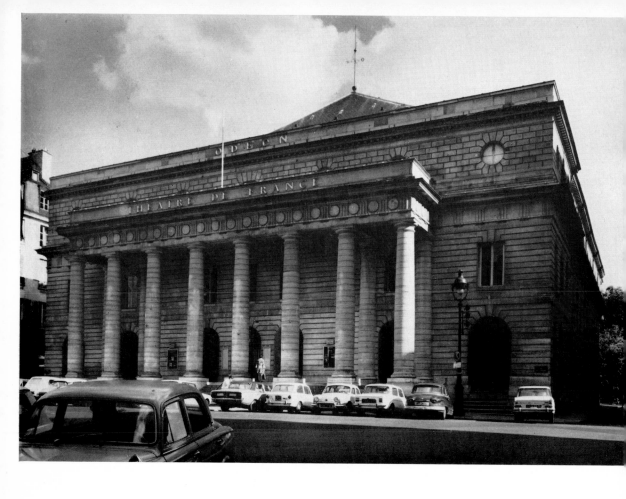

286. M.-J. Peyre: Paris, Odéon, 1778–82, façade

287. Jacques Gondoin: Paris, École de Chirurgie, 1771–6, façade

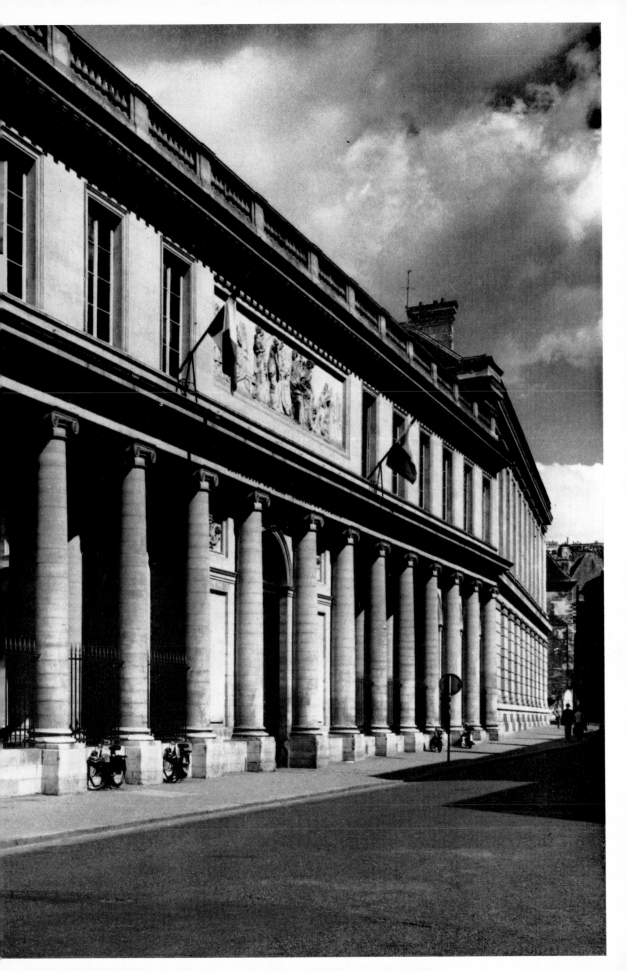

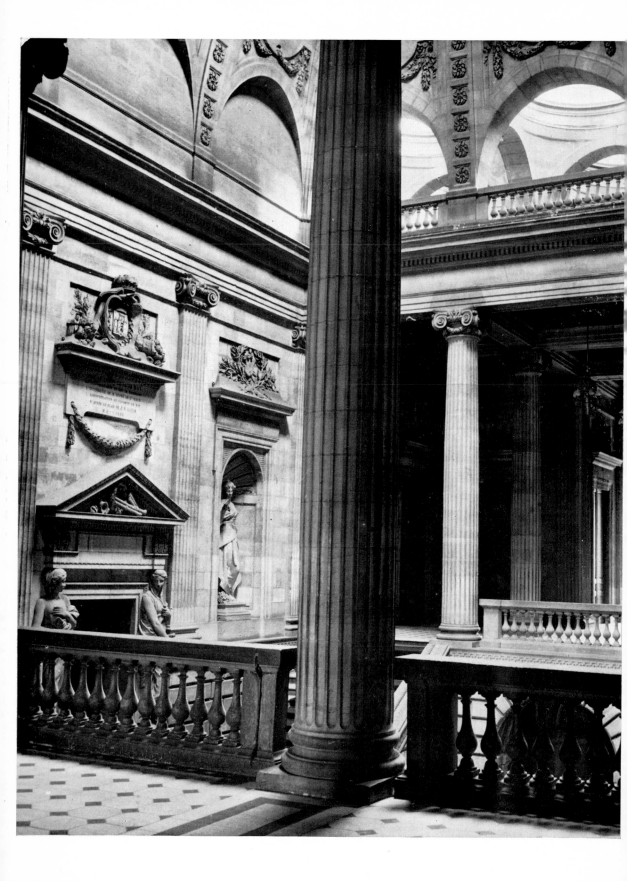

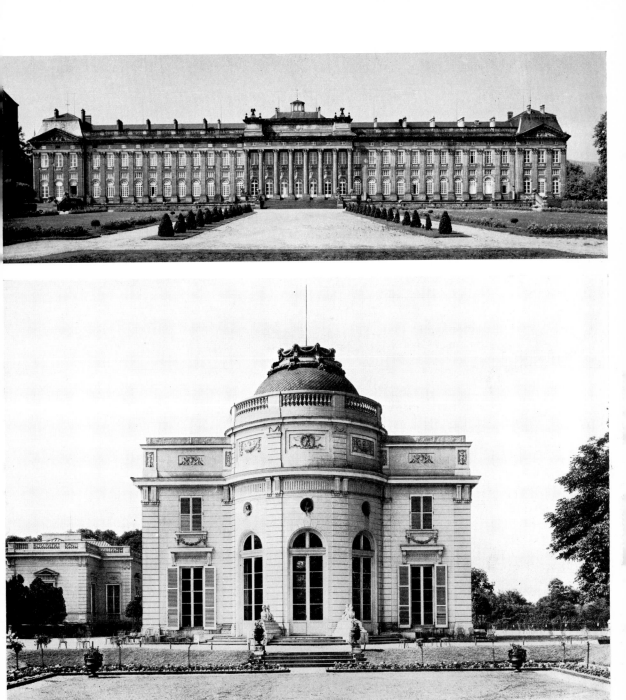

288. Victor Louis: Bordeaux, Grand Theatre, 1772–88, staircase

289. Nicolas Salins: Saverne (Zabern), château, 1779–89, garden façade

290. François-Joseph Bélanger: Paris, Bagatelle, 1777, garden façade

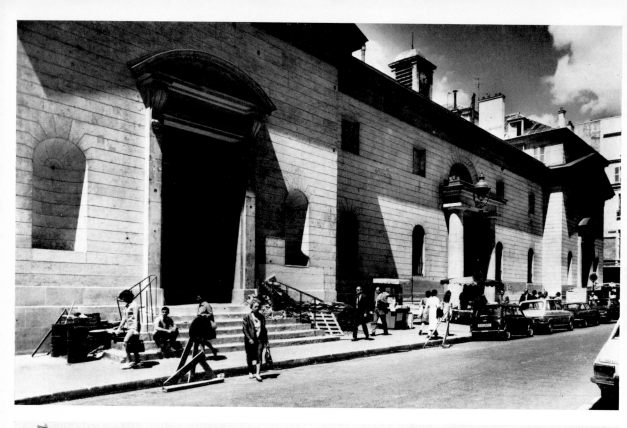

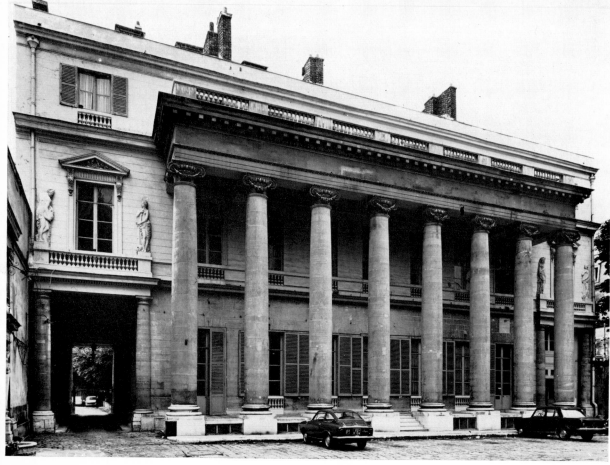

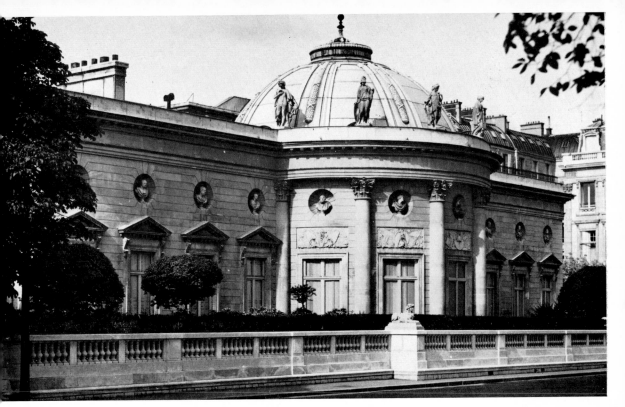

291. Alexandre-Théodore Brongniart: Paris, Couvent des Capucins, 1780

292. J.-G. Legrand: Paris, Hôtel de Gallifet, 1775–96, court façade

293. Antoine Rousseau: Paris, Hôtel de Salm, 1784, garden façade

294. Claude-Nicolas Ledoux: Arc et Senans, Saline de Chaux, 1774–9, entrance

295. Claude-Nicolas
Ledoux: Paris,
Barrière de l'Étoile,
1785–9

296. Claude-Nicolas
Ledoux: Ideal City
of Chaux, house of
the river authority,
c. 1785

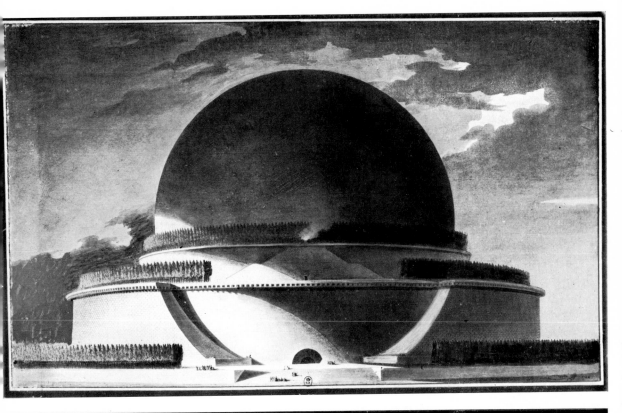

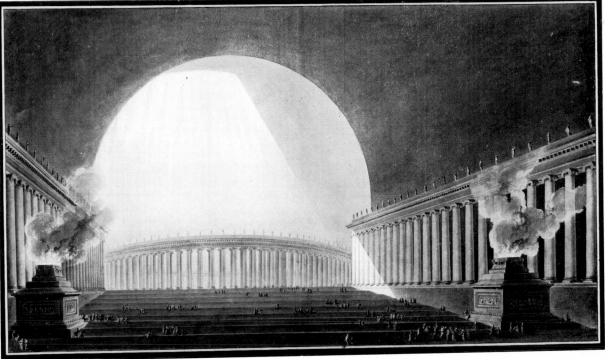

297. Étienne-Louis Boullée: Design for the Tomb of Newton, 1784

298. Étienne-Louis Boullée: Design for a museum, 1783

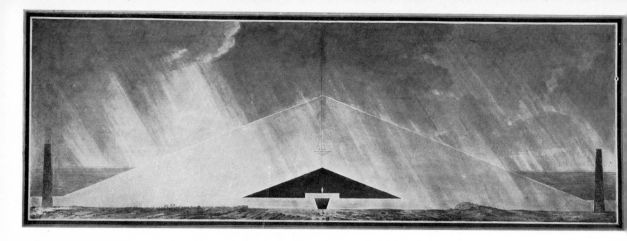

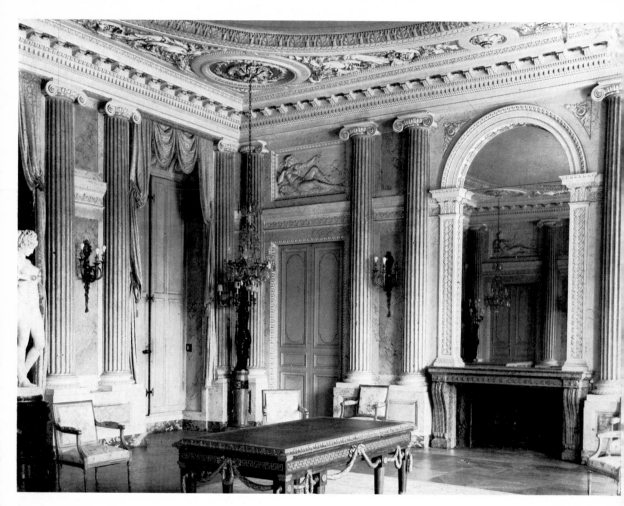

299. Étienne-Louis Boullée: Design for a monument of the 'architecture ensevelie' type

300. Nicolas Barré: Le Marais, Grand Salon, c. 1770

301. Rousseau Brothers: Versailles, Petits Appartements, Cabinet Doré, 1783

302. Rousseau Brothers: Fontainebleau, Appartement de la Reine, Cabinet de Toilette, 1785

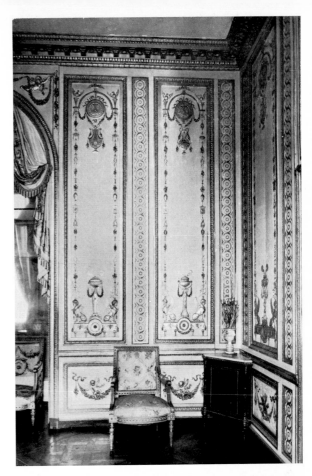

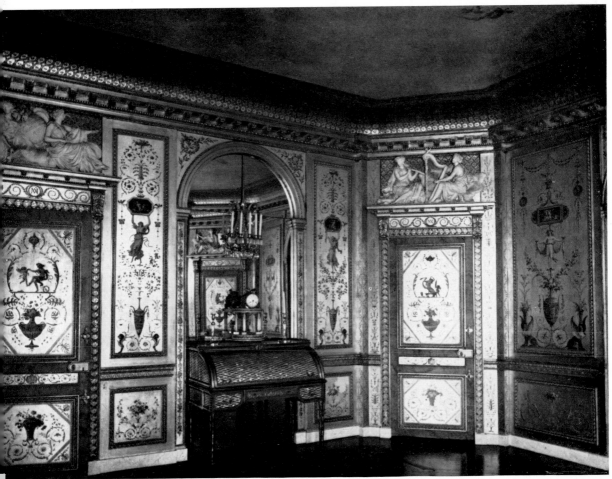

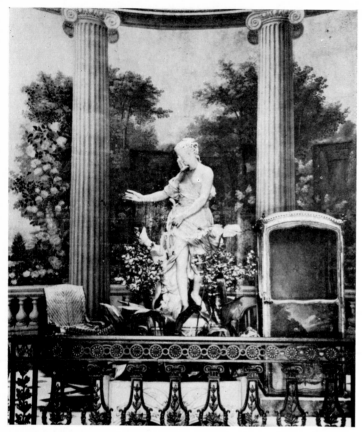

303. Jean-François Chalgrin:
Versailles, Pavillon de Musique de
Madame, 1784, central salon

304. François-Joseph Bélanger: Paris,
Hôtel Dervieux, 1786, Salle de Bains

INDEX

Numbers in *italic* refer to plates. References to the notes are given to the page on which the note occurs, followed by the number of the note; thus 363[99] indicates page 363, note 99. Only those notes are indexed which contain matter to which there is no obvious reference from the text, and which do not contain purely bibliographical material. Where names of buildings are followed by the name of an artist in brackets, the entry refers to painting, sculpture, or decoration by that artist in such buildings or places; thus Paris, Invalides, Dôme des (C. Audran III) refers to Audran's paintings in the chapels of the Invalides.

A

Adam, Anne, 63, 157
Adam, Claude, 63
Adam, François-Gérard, 64
Adam, Jacob-Sigisbert, 63
Adam, James, 303, 353
Adam, Lambert, 63
Adam, Lambert-Sigisbert, 55, 56–7, 59, 60, 61, 63–6, 68, 70, 74, 90, 94, 95, 96, 157, 363[99]; *63–6, 68*; self-portrait, 65; *66*
Adam, Nicolas-Sébastien, 55, 63, 64, 66–7, 68, 157; *67, 69*
Adam, Robert, 303, 353
Adélaïde, Madame, 125, 284; portraits (Labille-Guiard), 187; *187*; (Nattier), 125, 187; *131*
Agostino di Duccio, 47
Agrigento, 329
Aguesseau, Henri-François d', portrait (Berruer), 369[22]
Aix-en-Provence, 116, 133, 382[63]
 Governor's Palace, 345
 Hôtel de Caumont, 250, 270
 Musée Arbaud (Dandré-Bardon), 368[98]
 Palais de Justice, 345
 Prison, 345, 347–8
Aix-la-Chapelle, Peace of, 107, 272, 279, 299
Åkero, castle (Le Lorrain), 325–6; *283*
Albani, Alessandro, Cardinal, 58
Alembert, Jean le Rond d', 299
Alessi, Galeazzo, 239
Alexander, Czar, portrait (Houdon), 153
Alfieri, Benedetto, 283, 317, 393[56]
Algardi, Alessandro, 58, 160
Allegrain, Christophe-Gabriel, 76, 77–8, 84; *77*; portrait (Duplessis), 186
Allegrain, Gabriel, 77
Amboise, Musée (Ménageot), 177, 190; *194*
Amiens, 283
 Cathedral, 323; altar (Oppenordt), 260
 Musée de Picardie (Vien), 122
Ammanati, Bartolomeo, 302, 312, 391[18]
Amsterdam, 128, 131
 Rijksmuseum (Aved), 129; (Greuze), 144; *152*

André, Père, 266–7
Anet (Audran III), 10
Angers
 Musée (Vien), 122
 Toussaint, 395[111]
Angiviller, Comte d', 29, 37, 97, 98, 102, 105, 108, 115, 121, 135, 148, 151–2, 155–6, 160, 161, 164, 165, 166, 167, 176, 177, 178, 184, 187, 188, 189, 190, 193, 195, 197, 332, 333, 335, 364[8], 366[39], 372[70]; portrait (Duplessis), 186
Angiviller, Comtesse d', 102
Anne of Austria, *pompe funèbre*, 67
Anthony, Georges, portrait (Prud'hon), 196
Antin, Louis-Antoine de Pardaillan de Gondrin, Duc d', 25, 28, 33, 34, 57, 58, 65, 70, 91, 206, 373[11], 376[46], 383[70]
Antoine, Jacques-Denis, 309, 309–10, 318, 325, 336, 398[45], 401[97]; *270*
Antwerp, 150
Arc-et-Senans (Chaux), saltworks, 330, 345, 347, 401[98]; *294*
Arcueil (Oudry), 26
Argens, Marquis d', 25
Argenson, Comte d', 65, 280, 386[57]
Argenville, Dézallier d', 7, 41, 46, 66, 68, 107
Arles
 Musée Reattu (Raspal), 188; *190*
 Town Hall, 270
Arnould, Sophie, 340
Arnoult, 393[57]
Arras
 Musée (Restout), 30
 Saint-Vaast, 318; *277*
Artois, Comte d', 184, 195, 340, 351, 352, 353, 403[132, 136]
Asnières-sur-Seine, château, 268; (Pineau), 295, 389[99]
Athens, Parthenon, 346
Attiret, Claude-François, 97, 101–2; *104*
Aubert, Jean, 242, 245–9, 263–4, 265, 267, 295, 380[28]; *224, 226, 237, 238*
Aubigny, Marquis d', 381[44]
Aubry, Étienne, 188–9; *191*
Audran II, Claude, 10